VANITIES OF THE EYE

Vanities of the Eye

*Vision in Early Modern
European Culture*

STUART CLARK

OXFORD
UNIVERSITY PRESS

Great Clarendon Street, Oxford OX2 6DP

Oxford University Press is a department of the University of Oxford.
It furthers the University's objective of excellence in research, scholarship,
and education by publishing worldwide in

Oxford New York

Auckland Cape Town Dar es Salaam Hong Kong Karachi
Kuala Lumpur Madrid Melbourne Mexico City Nairobi
New Delhi Shanghai Taipei Toronto

With offices in

Argentina Austria Brazil Chile Czech Republic France Greece
Guatemala Hungary Italy Japan Poland Portugal Singapore
South Korea Switzerland Thailand Turkey Ukraine Vietnam

Oxford is a registered trade mark of Oxford University Press
in the UK and in certain other countries

Published in the United States
by Oxford University Press Inc., New York

© Stuart Clark 2007

The moral rights of the author have been asserted
Database right Oxford University Press (maker)

First published 2007

All rights reserved. No part of this publication may be reproduced,
stored in a retrieval system, or transmitted, in any form or by any means,
without the prior permission in writing of Oxford University Press,
or as expressly permitted by law, or under terms agreed with the appropriate
reprographics rights organization. Enquiries concerning reproduction
outside the scope of the above should be sent to the Rights Department,
Oxford University Press, at the address above

You must not circulate this book in any other binding or cover
and you must impose the same condition on any acquirer

British Library Cataloguing in Publication Data

Data available

Library of Congress Cataloging in Publication Data

Data available

Typeset by Newgen Imaging Systems (P) Ltd., Chennai, India
Printed in Great Britain
on acid-free paper by
Biddles Ltd., King's Lynn, Norfolk

ISBN 978–0–19–925013–4

1 3 5 7 9 10 8 6 4 2

In memory of my mother and father

Acknowledgements

Several institutions and many individuals have given support, assistance, and encouragement in the course of this project and I am immensely grateful for all the help I have received. My most important debt is to the British Academy for awarding me a Research Readership between 1998 and 2000 to plan and begin work. I also benefited on no fewer than four occasions from very generous American academic hospitality. The book was sketched out in its entirety during the month of June 1999 in the exquisite surroundings of the Rockefeller Foundation Study and Conference Centre at the Villa Serbelloni in Bellagio on Lake Como, and then begun in earnest during a year spent as Lilly Fellow at the National Humanities Centre in North Carolina. I am grateful in particular to the Lilly Foundation for helping to make possible that visit and to the staff and, especially, the librarians of the NHC for creating such a stimulating and productive environment in which to work. A semester in 2003 as the Douglas Southall Freeman professor of history at the University of Richmond, Virginia, provided further invaluable time to write, and a similar period in 2004–5 as Stewart Fellow in the History Department and the Council of the Humanities at Princeton University helped considerably in finishing the book off, as well as allowing me to present some of its ideas to a class of enterprising Princeton undergraduates. I wish to thank both these universities for their invitations, and in particular Hugh West in Richmond and Anthony Grafton in Princeton, for their direct and indirect help with this book.

During the course of the project, I gave several papers to seminars and conferences in Europe, North America, and Australia from which—as a clumsy intruder in sometimes new terrain—I learned an enormous amount. In this respect, I was also given very significant individual advice and help, at the outset by Claudia Swan, and, in the final stages, by Christopher Wood, both of whose cautions and suggestions helped considerably in refining my arguments. My Swansea colleague John Spurr kindly read and commented on my entire manuscript, and others who generously offered specific guidance and information were: Bill Bulman, Terence Cave, D'Maris Coffman, Sarah Ferber, Rob Iliffe, Pierre Kapitaniak, Thomas DaCosta Kauffman, Paul Kottman, Peter Lake, Lyle Massey, Richard Newhauser, Helen Parish, Luc Racault, Moshe Sluhovsky, Ann Thompson, Alex Walsham, Marina Warner, Iain Wright, and Charles Zika.

Chapter 6 was published in a shorter version in the *Journal of Religious History* and reappears in modified form with the kind permission of the editor and Blackwell Publishers.

Above all, I would like to thank my wife Jan for her patience during the periods of deepest preoccupation with this book and for her unfailing interest in its contents. I am deeply in her debt both for her support and for her understanding.

S.C.

Swansea
May 2006

Contents

List of Figures	x
Introduction	1
1. Species: Vision and Values	9
2. Fantasies: Seeing Without What was Within	39
3. Prestiges: Illusions in Magic and Art	78
4. Glamours: Demons and Virtual Worlds	123
5. Images: The Reformation of the Eyes	161
6. Apparitions: The Discernment of Spirits	204
7. Sights: King Saul and King Macbeth	236
8. Seemings: Philosophical Scepticism	266
9. Dreams: The Epistemology of Sleep	300
10. Signs: Vision and the New Philosophy	329
Bibliography	365
Index	401

List of Figures

1. Jan Bruegel the Elder, *The Sense of Sight*, 1617 (Museo el Prado, Madrid, Cat. No. 1394).
2. Marten de Vos (engraved by Adriaen Collaert), *Visus*, 1575 (Albertina Museum, Vienna: Graphische Sammlung: Inv. H. 1. 24, 66685).
3. Laurens van Haecht Goidtsenhoven (Haechtanus), *Microcosmos. Parvus mundus*, trans. Henricus Costerius, engraving by Gerard de Jode (Antwerp, 1592), 74[r] (British Library, London: C. 125. c. 31).
4. Johannes David, *Veridicus Christianus* (Antwerp, 1601), opp. 218 (British Library, London: C. 27. k. 9).
5. 'F.B.' (Franz Isaac Brun), *Melancolia*, 1561 (British Museum, London: Dept. of Prints and Drawings, 1850, 0810.268).
6. Hieronymus Bosch (after), *The Conjuror*, late 15th century (Musée Municipal, Saint-Germain-en-Laye, Inv. 872.1.87).
7. Jean François Nicéron, *Thaumaturgus opticus, seu admiranda optices . . . catoptrices . . . et dioptrices* (Paris, 1646), plates lxvi and lxvii (British Library, London: 48. h. 2).
8. Jacques Ozanam, *Recréations mathematiques et physiques* (Paris, 1696), opp. 157 (British Library, London: 8531. aaa. 23).
9. Jean François Nicéron, *La Perspective curieuse ou magie artificiele [sic] des effets merveilleux* (Paris, 1638), title page (British Library, London: L. 35/44).
10. Athanasius Kircher, *Ars magna lucis et umbrae* (Rome, 1646), Iconismus xxviii, opp. 806 (British Library, London: 536. l. 25).
11. Athanasius Kircher, *Ars magna lucis et umbrae* (Rome, 1646), Iconismus xxxiii (fig. 4), opp. 900 (British Library, London: 536. l. 25).
12–13. Mario Bettini, *Apiaria universae philosophiae mathematicae* (2 vols.; Bologna, 1642), i. 'Apiarium quintum', 28–9 (British Library, London: 1605/110).
14–17. [Nicolaus Manuel], *Die war histori von den vier ketzern prediger ordens . . . zu Bern . . . verbrannt* (n.p., n.d. [1510?]), no pagination (British Library, London: 1369. g. 7).
18. Athanasius Kircher, *Ars magna lucis et umbrae* (Rome, 1646), Iconismus xxxiii (fig. 4), opp. 900 (British Library, London: 536. l. 25).
19–20. [Jean Dubreuil], *La Perspective pratique*, 2nd edn. (3 vols.; Paris, 1651), iii. 112 and 122 (British Library, London: 50. d. 19).
21. Salvator Rosa, *Saul e la pitonessa*, 1668 (Musée du Louvre, Paris: Inv. 584).

List of Figures xi

22. Jacques de Gheyn II (after), engraved by Andries Stock (?), *The Preparation for the Witches' Sabbath*, *c.*1610, published in Delft by Nicolaes de Clerck (Bibliothèque Nationale de France, Paris: Cabinet des Estampes, EC 77 Fo.–Fo. 49).
23. Jacob Cornelisz van Oostsanen (also known as Jacob van Amsterdam), *Saul and the Witch of Endor*, 1526 (Rijksmuseum, Amsterdam: SK-A-668).
24. Taddeo Zuccara, *Sleep*, 16th century (Musée du Louvre, Paris: Cabinet des Dessins, Inv. 10481).
25. Michel de Marolles, 'The Palace of Sleep', *Tableaux du temple des muses* (Paris, 1655), plate lviii (British Library, London: 1869. e. 11).
26. Detail of Fig. 25.
27. [René Descartes], *L'Homme de René Descartes et la formation du foetus*, 2nd edn. (Paris, 1677), 67 (British Library, London: C. 131. k. 8).

Introduction

In 1938 the art historian William M. Ivins published a book whose title spawned the phrase 'the rationalization of sight', applied many times thereafter to the impact of linear or one-point perspective on the visual culture of post-Renaissance Europe. It seemed almost to congratulate the artists and scholars of the Renaissance, and by extension early modern culture as a whole, for establishing an objective and logical basis for vision which exactly matched the natural reality of visual perception—how we do in fact see. This was achieved, as Ivins put it, by securing a 'two-way, or reciprocal, correspondence' with external fact, and it was 'the most important thing that happened during the Renaissance'.[1] By contrast, my argument in this book will be that during the early modern period, and more especially between the Reformation and the Scientific Revolution, vision was anything but objectively established or secure in its supposed relationship to 'external fact'. Many intellectuals, at least—and it is an intellectual history that I am proposing here—seem to have been preoccupied precisely with questions to do with whether human vision did give reliable access to the real world after all—with whether vision was indeed veridical.

Naturally, a great deal was invested in the hope that it was. It seems safe to assume that in every culture there are fairly strong imperatives of various kinds to accept the evidence of the eyes as broadly true and to maintain a consensus about what counts as visual reality. In this general sense, we can always speak of attempts to rationalize sight and of there being, within cultures, rational and irrational ways to see, just as there are rational and irrational ways to think, argue, or behave. We can conceive of this in a strongly political sense, in terms of, say, the visual protocols demanded by a religion or a ruler, and the consequent censoring of sight and the penalizing of visual error. It was, after all, forbidden to see a soul returning from Purgatory in Geneva after the Reformation but still required viewing just over the border in France. Alternatively, we might think more benignly about the psychological reasons, personal and social, for feeling generally confident about visual accuracy. Somewhere in between lies a remark by Norman Bryson in an essay of 1988 that puts the point well:

For human beings collectively to orchestrate their visual experience together it is required that each submit his or her retinal experience to the socially agreed description(s) of an intelligible world. Vision is socialized, and thereafter deviation from this social construction of visual reality can be measured and named, variously, as hallucination, misrecognition, or 'visual disturbance'.[2]

Ostensibly, visual experiences deemed to be accurate and reliable were secured between the fifteenth and seventeenth centuries largely by Aristotelian theories of

perception and cognition and by Renaissance psychology concerning the human 'faculties', especially those belonging to what was called the 'sensible soul'. In terms of these theories, recounted throughout the medical, psychological, and moral literature of the period, objects in the world gave off resemblances or replicas of themselves (*species*) which then travelled to the eyes and, via the eyes and the optic nerves, into the various ventricles of the brain to be evaluated and processed. All the metaphors associated with this process of visual cognition, notably those of mirroring, painting, and the making of impressions in wax, evoke an expectation of representational accuracy. They suggest that the doctrine of visible *species* was supposed to guarantee visual certainty, give or take the various errors or 'fallacies' of vision that were described and explained away in the textbooks on cognition, optics, and ophthalmology. Broadly speaking, the mind had direct access to accurate pictures of the world; the world was what it appeared visually to be.

What I wish to propose is that several important developments unique to the cultural history of Europe over roughly two and a half centuries worked to undermine this inherited confidence and disrupted the relationship between human beings and what they observed. What were supposed to be, in Bryson's phrase, 'socially agreed descriptions of an intelligible world' came to be marked by profound disagreement, and what he calls 'disturbances' to these descriptions came to be relativized—in effect, politicized—to a high degree by intellectual controversy. John Berger once wrote: 'The relation between what we see and what we know is never settled'; my argument will be that this relation was particularly unsettled in late Renaissance Europe.[3] In one context after another, vision came to be characterized by uncertainty and unreliability, such that access to visual reality could no longer be normally guaranteed. It is as though European intellectuals lost their optical nerve.

It is important here not to think just in terms of a quantitative increase in the attention given to particular visual mistakes, illusions, and the other fallacies of sight—errors which could be accounted for in the optical theory of the day and thus posed no ultimate threat to cognitive stability. Nor is it a question of simply filling out Martin Jay's sketch of a 'baroque ocular regime'—a 'subterranean' visual culture, alternative to what he calls the 'dominant scientific or "rationalized" visual order' achieved, in the Ivins sense, by linear perspective.[4] Although there is value in this idea it fails to take account of the sorts of broad cultural developments I have in mind. For between the fifteenth and seventeenth centuries European visual culture suffered some major and unprecedented shocks to its self-confidence. These brought qualitative changes to its discussions of veridicality and reduced many visual experiences, at the level of theory at least, to visual paradoxes—where distinguishing between the true and the false became impossible on visual grounds alone. In some ways, the conceptual situation I address in this book is therefore better captured in a question put by Galileo to an opponent in an argument: 'I should like to know the visual differences by which

he so readily distinguishes the real from the spurious.'[5] To borrow a phrase describing the anxieties that arose in another key arena—early modern theatre—I wish to look at what happens to intellectual life when 'visible signs of indeterminate meaning' suffuse a particular culture.[6]

First in terms of chronology, from the 1430s onwards European intellectuals embarked on a long and complex exploration of demonology. For between 250 and 300 years they discussed in endless detail the precise powers of demons to intervene in the not just spiritual but physical world. Amongst these powers, mostly granted, although always challenged and eventually refuted, were some that radically undermined any attempt to maintain human cognition on a secure basis—the power, for example, to suddenly displace objects so that they seemed to become invisible, the power to adopt any bodily form or shape whatever, the power to create exact simulations of people and events, and, above all, the power to disrupt the cognitive process itself by physically entering either brain or eye or both and moving images around them at will. In effect, the devil could control (and subvert) each of the stages of Aristotelian cognition—manipulating the world of perceived objects, tampering with the medium through which visual *species* travelled, and altering the workings of both the external and internal senses. Part of the reason for writing this book is to explore what were the implications for living and, especially, thinking in a culture that was prepared to grant this much power to the forces of evil.

Virtually in the same decade, vision began to be subjected to the fundamental rethinking associated with the adoption of perspectival techniques by the artists and art theorists of the Italian Renaissance. The implications of this are most apparent in the seriousness with which anamorphic art was explored and applied in the first 150 years of its history, prior to its decline to the status of a curiosity. This is a development that Martin Jay covers in his brief survey of baroque visuality, and most scholars now agree in seeing it as a commentary on the artificiality of normal perspective and an attempt to expose perspective's claims to objectivity and truth by adapting perspectival techniques for yet more manipulative and deceitful purposes—all the while evoking wonder and astonishment at the visual effects that resulted. I attempt to set both perspective and its anamorphic derivatives in the yet wider context of the powerful appeal of visual deception, or at least visual contrivance, mainly by mirror and lens technology, as a theme in the natural magic of the later Renaissance. This taxed the ingenuity, sometimes on a massive scale, of a whole series of intellectuals stretching from the magus of later sixteenth-century Naples, Giambattista della Porta, to the magus of mid seventeenth-century Rome, Athanasius Kircher—taking in figures like Francis Bacon, Jean-François Nicéron, Mario Bettini, and Emmanuel Maignan along the way.

The Protestant Reformation, especially in its Swiss form, was another major development that made the visual intelligibility of many things vastly more complicated and contested than ever before. The almost obsessive discussions of idolatry by Calvinist intellectual activists from the 1520s and 1530s onwards raised, as Margaret Aston has said, 'very basic questions about the nature of

perception and the mind's image-forming processes'.[7] Physical images in churches were said to be mendacious, either in claiming to represent the unrepresentable or in encouraging spectators to see in them not a piece of wood or stone but a person; either in deficit or excess they were what Calvin called 'phantoms or delusive shows'. Every single Catholic miracle from the apostles onwards was said to be false—either textually mythical, or visually fraudulent—with the consequence that Calvinist language became saturated with the idioms of 'juggling', 'dissembling', 'duping', and 'conjuring', all of them having visual implications. The abolition of Purgatory launched Europe on a fresh round of the debate about the visibility and visual interpretation of spirit manifestations, a debate already begun by later medieval theologians like Gerson and due to blossom within the Catholic establishment in the seventeenth century in the form of an extensive literature concerned with the 'discernment of spirits' and the pretence of holiness, particularly in female mystics. Above all, perhaps, Protestantism cast the central rite of the Catholic Church, the Mass, as a visual lie, reinforcing its own determination to see bread as bread and wine as wine—to accept *species* for what they seemed to be—and consigning what Michael Camille has called 'the most important of all sensory experiences for Christians' to the category of illusion.[8] Again, I want to ask: what were the consequences—for intellectuals at least—of living in an age when religious forms were reduced to this kind of visual uncertainty?

Lastly, from the 1560s onwards, intellectual Europe experienced a revival of ancient Greek scepticism, but on a scale unknown in the Greek world. The publication in 1562 of the first Latin edition of the *Outlines of Pyrrhonism* by the ancient sceptic Sextus Empiricus occasioned a sceptical debate of such seriousness that the historian Richard Popkin once labelled it a 'crisis of Pyrrhonism'. With implications throughout the worlds of humanism, theology, and natural philosophy, it was nevertheless grounded in radical doubts about the reliability of the senses, chiefly the evidence of the eyes. Between the 1570s, when Montaigne wrote his *Apology for Raymond Sebond*, and the 1630s, when Descartes composed the *First Meditation*, a whole series of sceptical tropes concerning vision entered intellectual debate. These tropes did not approach visual problems in the same way as standard late medieval optical theory treated them, as 'errors' or 'illusions' that were intelligible in relation to correct or normal vision. What mattered in the Pyrrhonian tropes was no longer the accuracy or inaccuracy of sensory experiences when compared to the external world, but their *difference* when compared to each other. Taken together, the tropes turned every aspect of visual experience, correct and incorrect alike, into something relative, not absolute. They established the principle that for every visual experience deemed to be true it was always possible to have a deemed-to-be false visual experience that was indistinguishable from it. They also encouraged the modern-sounding notion that human subjects 'make' the objects they perceive, fashioning them out of the qualities that belong intrinsically to perception, not to the objects themselves. As Montaigne wrote: 'External objects surrender to our mercy, they dwell in us as we please'.[9]

These were the innovations that seem to have been most important in unsettling the relation between what was seen and what was known in early modern Europe. They account directly for over half of my ten chapters (Chapters 3 to 8) and indirectly for Chapter 9 on the reassessment of dream experiences. This occurred, roughly, in the century between Montaigne and Malebranche and, since it focused on the difficulty of distinguishing between the waking and sleeping states, I interpret it as a further sign of dislocation in the cognitive system of Aristotle. Chapter 2 deals likewise with another tell-tale indication of the currency of the visual paradox—the popularity of the subject of 'melancholia' in psychological, medical, and moral writing throughout Europe from about the 1580s to the early eighteenth century. Melancholia was an affliction of the imagination and completely disrupted the image-processing that went on there, causing severe sensory delusion. Here was another contributor, not so much actual as conceptual, to the de-rationalization of sight, and—assuming that the kinds of madness most discussed in a culture reveal the stress fractures in its assumptions about rationality—a further sign of the plight that rational seeing was in.

The book opens and closes with chapters intended to frame the issues I have chosen to explore. Chapter 1 seeks to illustrate the normative role of Aristotelian vision in early modern culture and the way rational seeing relied on the expectation of accurate resemblance built into the doctrine of visible *species*. But it also points forward to the chapters that follow by showing how ambiguously sight was regarded even in an already ocularcentric age. This is best revealed by the text that, more than any other from the period, poses the questions that I too want to ask: the Oxford intellectual George Hakewill's *The vanitie of the eye* (1608). Such is the extent to which his book sets the agenda for mine that I have chosen to adapt for my title the reference to ocular 'vanity' in his, rather than opting for the somewhat less nuanced connotations of visual illusion or mendacity. I also allow Hakewill to set the agenda for the earliest sequence of chapters which deals in turn with the three kinds of visual unreason identified in his world: natural, artificial (human), and demonic. The book thus mixes two kinds of organization of topics: Chapters 2, 3, and 4 match the conceptual typology used by contemporaries for identifying 'vanities' of the eye, but from Chapters 3 and 4 onwards it also treats in broadly chronological terms the major historical developments already mentioned: the vogue for visual artifice, the exploration of demonology, religious reformation, and philosophical scepticism.

In contrast to Chapter 1, the last chapter, Chapter 10, looks back reflectively over the visual turbulence described in the others by considering seventeenth-century attempts to do away with it by re-establishing visual rationality on entirely different philosophical principles. One looks to the philosophers to grasp the essential nature of the intellectual problems faced in a culture and so it proves, not surprisingly, with Descartes, Hobbes, and to a lesser extent Joseph Glanvill, the Restoration apologist for science. Well aware of the insuperable difficulties that Aristotelian seeing had encountered—familiar, indeed, with many of the

contexts in which this had occurred—these thinkers sought to give up resemblance as the basis of cognition and substitute a mechanical account of sensation and an interpretative account of perception, intending thereby to put sight and the other senses back on a stable foundation, fit for the new philosophy. Just as Hakewill provides the starting point for my argument, so too I allow Descartes and Hobbes in particular to tell me what was ultimately at stake in the cultural debates I try to describe. Historians of philosophy have always known them as revolutionaries of the cognitive process but largely neglected the problems in the visual culture of the previous two centuries that made their revolution something of a necessity and help to explain the form that it took. These are the problems that I examine. A book whose chronological span begins with the unusual and unnoticed conjunction of perspectival theory and witchcraft theory in the 1430s ends, accordingly, with a similar conjunction in the 1670s, the moment when Joseph Glanvill published a collection of *Essays on several important subjects in philosophy and religion* which included one on scepticism and certainty and another 'Against Sadducism in the matter of witchcraft'.

In 1966 three American scholars could ask: 'Is human perception culturally influenced? Can the same stimulus appear differently to different people simply because they are members of different cultures?', and conclude merely that this was highly likely.[10] Four decades on, virtually unanimous assent has made the questions themselves obsolete, but the history of how they first came to be asked with any persistence—the history, that is, of how visual cognition and the seeing subject came to be understood in relative terms—is still being written. That in *any* age visual experience, like its linguistic equivalent, can only mean something in relation to pre-existing cultural and social formations is, again, now readily granted. Bryson himself continues by stating the general principle:

Between the subject and the world is inserted the entire sum of discourses which make up visuality, that cultural construct, and make visuality different from vision, the notion of unmediated visual experience. Between retina and world is inserted a *screen* of signs, a screen consisting of all the multiple discourses on vision built into the social arena.[11]

The intriguing historical question, therefore, is: when did such 'discourses' themselves take up the issue of their own mediating role: when did they become, so to speak, self-conscious of their own discursiveness in the field of vision? It is tempting to assume that this is a modern, even a post-modern, phenomenon, but, as we shall eventually see, the idea that external objects or states of affairs can only ever be grasped 'in relation to a given way of life or law or custom' was already current in second-century Greek scepticism—and was repeated, as we have just seen, by Montaigne and the New Pyrrhonians. My argument will be that it was, indeed, in the early modern centuries that intellectuals, forced, almost, by a concurrence of visual instabilities, began systematically to consider the idea that visual experience had a cultural (that is, semiotic) foundation, not a natural one. In her influential

study of microvisibility, *The Invisible World*, Catherine Wilson has suggested that 'only gradually did the early modern epistemology of immediate apprehension give way to one of negotiated meaning'. This is precisely the change whose origins I wish to examine.[12]

I have tried to pay attention to what Bryson rightly identifies as one of the key features of the 'discourses on vision'—their multiplicity—by bringing together materials from fields that historians do not always conjoin: debates in early modern psychology, medicine, art theory, natural magic, catoptrics and dioptrics, demonology, theology, the discernment of spirits, epistemology, dream theory, and the philosophy of cognition. To attempt this has meant willing dependence on the work of others: readers will easily identify those areas of the book that owe much, in particular, to the scholarship of Margaret Aston, Jurgis Baltrušaitis, Rosalie Colie, Lucy Gent, Gary Hatfield, Martin Kemp, David Lindberg, Katharine Park, and Richard Tuck. The one topic relevant to my case that I have not ventured to broach, assuming it to be already very well covered by others, is that of the theatre as a newly controversial site of perspectival illusion and other visual fictions. I would nevertheless ask the reader to bear at least the cognitive and epistemological aspects of what Jonas Barish called the 'anti-theatrical prejudice' in mind as my argument is developed.

In what follows, all the quotations from sources in English or in other languages have been given with spellings and punctuation unmodernized, with the exception of the customary silent alterations to letters and expansions. The translations of quotations from texts in languages other than English are my own, unless a modern edition of the work in translation is indicated. Biblical quotations are taken from the English Bible in the 'Authorized Version' of 1611.

NOTES

1. William M. Ivins, Jr., *On the Rationalization of Sight: With an Examination of Three Renaissance Texts on Perspective* (New York, 1973), esp. 7, 10.
2. Norman Bryson, 'The Gaze in the Expanded Field', in Hal Foster (ed.), *Vision and Visuality* (Seattle, 1988), 91; cf. id. and Mieke Bal, 'Semiotics and Art History', *Art Bull.* 73 (1991), 199: Bryson derives these remarks from the work of Jacques Lacan. For broadly similar and equally influential remarks about the observer 'as an *effect* of an irreducibly heterogeneous system of discursive, social, technological, and institutional relations', see Jonathan Crary, *Techniques of the Observer: On Vision and Modernity in the Nineteenth Century* (Cambridge, Mass., 1990), 6 and *passim*.
3. John Berger, *Ways of Seeing* (London, 1972), 7.
4. Martin Jay, *Downcast Eyes: The Denigration of Vision in Twentieth-Century French Thought* (Berkeley, 1993), 45–9.
5. Quotation in Martin Kemp, *The Science of Art: Optical Themes in Western Art from Brunelleschi to Seurat* (New Haven, 1990), 96.
6. Huston Diehl, *Staging Reform, Reforming the Stage: Protestantism and Popular Theatre in Early Modern England* (Ithaca, NY, 1997), 8.

7. Margaret Aston, *England's Iconoclasts*, i: *Laws against Images* (Oxford, 1988), 436.
8. Michael Camille, 'Before the Gaze', in Robert S. Nelson (ed.), *Visuality before and beyond the Renaissance: Seeing as Others Saw* (Cambridge, 2000), 209.
9. Michel de Montaigne, *The Complete Essays of Montaigne*, trans. Donald M. Frame (Stanford, Calif., 1958), 422.
10. Marshall H. Segall, Donald T. Campbell, and Melville J. Herskovits, *The Influence of Culture on Visual Perception* (New York, 1966), 3, 209–14; for comparison with much later views on the subject, see Marcus Banks and Howard Morphy (eds.), *Rethinking Visual Anthropology* (New Haven, 1997), 1–35.
11. Bryson, 'Gaze', 91–2 (author's emphasis); for later, and extremely helpful, remarks on the nature and history of 'visuality', see Robert S. Nelson, 'Introduction: Descartes's Cow and Other Domestications of the Visual', in id. (ed.), *Visuality before and beyond the Renaissance*, 1–10.
12. Catherine Wilson, *The Invisible World: Early Modern Philosophy and the Invention of the Microscope* (Princeton, 1995), 218.

1

Species: Vision and Values

All cultures apportion values to vision, both positive and negative. In our own case, an entire revaluation has taken place in which the traditional hegemony of vision has been dismantled and many different ways of theorizing about seeing now compete for attention. Western modernity, at least from the eighteenth century onwards, is associated with a particular model of cognition designed to secure for vision a commanding place in science, in the field of political power, and in the construction of communal solidarity and personal identity in bourgeois societies. After a century of the 'denigration' of this model, particularly in French philosophy, and the emergence of post-modernism throughout Western culture, 'ocularcentrism' is now on the defensive. An iconoclastic history of ways of seeing was one essential component of Michel Foucault's work, and mirroring, imaging, and anamorphosis were all part of the reconceptualizing of vision that was fundamental to the psychoanalytical theories of Jacques Lacan. Richard Rorty's influential assault on modern philosophy was built, likewise, on undermining its dependence on the metaphor of the mind as the 'mirror' of nature. Above all, perhaps, thanks to developments in art history, visual anthropology, and visual hermeneutics we now take for granted the constructed nature of vision and the extent to which visual perception and visual meaning are fused.[1]

What, then, in the broadest terms, were the values assigned to vision in the pre-modern world?[2] A kind of ocularcentrism was already prevalent in sixteenth- and seventeenth-century European culture, in which the twin traditions stemming from the perceptual preferences of the Greeks and the religious teachings of St Augustine combined to give the eyes priority over the other senses. The very opening of Aristotle's *Metaphysica* spoke of love of the senses, 'above all others the sense of sight', preferred because it 'makes us know and brings to light many differences between things'.[3] Plato's *Timaeus* was equally favourable, describing sight as 'the source of the greatest benefit' to men by enabling them to grasp number, time, and philosophy, 'than which no greater good ever was or will be given by the gods to mortal man'.[4] With such endorsements it is not surprising that seeing took precedence in the hierarchy of the senses in arguments that became commonplace in later ages. That sight was first in the order of knowing was the conclusion, we are told, of 'every medieval and Renaissance philosopher

who considered the matter', many of them—Roger Bacon, for example—going to 'considerable lengths to reveal and extol the cognitive virtues of this sense'.[5] Towards the end of the sixteenth century, the court mathematician to the Duke of Savoy in Turin, Giovanni Battista Benedetti, summarized the by-now customary views in his *Comparatio visus, et auditus* (1585). Sight, he argued, was more essential than its nearest rival, hearing, for bodily well-being and locomotion, and, in intellectual terms, gave faster, more certain, and more permanent access to objects in the world, and over greater distances.[6]

Throughout Renaissance Europe the general opinion was that the eyes provided the most direct knowledge of things, based on the most distinctions and the widest range; in functional terms, they were organs of power, liveliness, speed, and accuracy. Of all the senses, said the English rhetoric expert Thomas Wilson, 'the eye sight is most quicke, and conteineth the impression of thinges more assuredly'.[7] The celebrated French anatomist Ambroise Paré called eyesight the 'most excellent' sense: 'For by this wee behold the fabricke and beauty of the heavens and earth, distinguish the infinite varietyes of colours, we perceive and know the magnitude, figure, number, proportion, site, motion and rest of all bodyes.'[8] Ophthalmologists were, predictably, among the eyes' most enthusiastic encomiasts, their doyen the Saxon eye-surgeon Georg Bartisch describing them in 1583 as 'the most necessary, noblest, clearest, and most subtile member above all others' in the human body.[9] 'The eye', wrote the English oculist Richard Banister in his 'Aphorismes describing the nature and use of the eyes, and opticke spirits', 'is the sunne of this little world', and excelled for 'the certainty of the apprehension'.[10] The eyes were evidently the most spiritual and least material of the senses. There was a purity and subtlety about the entities associated with them, notably fire (sight's 'element'), light, and colour, and as a consequence nobility attached to their objects. Even their location gave them superiority. They were the most precious parts of the body—given the task, as the English microcosmographer Helkiah Crooke typically put it in 1615 (adopting the very common allegory of the human body as a citadel or castle), of 'Centinels or Scout-watches in the top of the Towre, whence they may discerne farther off'.[11] In effect, they were the guides and rulers not just of the other senses but of the whole body.

It is scarcely surprising that the life of the mind and the advancement of learning were deemed to be impossible without vision. For one of early modern France's most influential popularizers, Pierre de La Primaudaye, writing in his much reprinted and translated knowledge compendium the *Academie françoise*, it was the 'mistress' that led men first to wonderment at things seen, then to the understanding and science of them. Astronomy, anatomy, and mathematics were cited as obvious examples.[12] Very much more significant is the way the eyes were associated with the internal image-making processes that were deemed crucial for all thought. It was common in Greek, medieval, and early modern psychology to think of perception as a visual process, whatever the particular source of data. What eventually found its way into the memory, according to an authoritative

modern account, was a mental picture or 'phantasm'—a 'final product of the entire process of sense perception, whether its origin be visual or auditory, tactile or olfactory'—and this phantasm was something that could be 'seen' by the 'eye' of the mind. In this originally Greek view, all perceptions were 'encoded as *phantasmata*, "representations" or [in Aristotle's words] a "kind of *eikón*" '. There is, apparently, no equivalent *ear* of the mind in Greek, Hebrew, or medieval thought, and, consequently, none in early modern thought either.[13]

In religious terms, routine but revealing connections were often made in the latter period between the eyes and the divinity (or Providence), between corporeal vision and spiritual enlightenment, and between seeing the visible world and understanding it as the work of an invisible and omnipotent God. Verse 9 of Psalm 94 posed the obvious but still searching question: 'he that formed the eye, shall he not see?', and single, unblinking eyes representing the deity looked down panoptically over the contents of many early modern title pages—like the large, vigilant eye of 'Providentia' surveying the globe held aloft by 'history' on the title page of Walter Raleigh's *The history of the world* (1614).[14] To the matching question whether God could *be* seen, most gave the answer offered in Augustine's *De trinitate*: 'Let us therefore use in particular the testimony of the eyes, because this sense far excels the rest, and although it is a different kind of vision, it is close to spiritual vision.' Spiritual 'seeing' could be modelled metaphorically on physical seeing: the 'gaze of the mind (*acies animi*)' on the gaze of the body.[15] The eyes were assumed to be closest to the soul and to the human spirit (and, in one specific cliché, were the 'windows' of the soul), and light was still thought of metaphysically as the common medium of both physical vision and divine world order. 'Throughout the Renaissance', writes one of the eye's cultural historians, it 'assists—and implicitly *embodies*—the soul in its vigilant rule over both body and world'.[16] Contemporaries quoted Galen's view (in *De usu partium*, iii. 10) that as the sun was in the world, so the eyes were in the human body; they were 'divine members' of it. Apart from anything else, they were so exquisitely fashioned that no anatomist of them could end up as an atheist. God had made the eyes, explained Crooke—in another book which came to have a divine eye on its title page—as 'a curious modell to manifest his Majesty and wisedome'.[17]

Combining many of these ideas, especially those of Augustine, La Primaudaye was able to argue that light infused spiritual insight and human vision in analogous ways:

So that Angels and the spirits of men, which are spirituall and invisible creatures, are illuminated by the meanes of understanding, with that spirituall and heavenly light whereof God hath made them partakers: as the bodies of living creatures, and chiefly of man are illuminated with the corporall light of the Sunne by meanes of the eyes.

Thus, the human spirit 'sees' God in an act of understanding, just as the human eyes see his created world, while the image of God is imprinted on the human mind 'as in a glasse' in the same manner as an image is 'mirrored' naturally in the

human eye—by direct confrontation.[18] Similar associations were the subject of sermons and devotional works across Europe, and were also represented pictorially and emblematically—for example in the Englishman George Wither's emblem for the verses: 'The minde should have a fixed eye | On objects, that are plac'd on high.'[19] Richard Brathwaite, author of a moralizing portrait of the five senses, chose one such object to summarize the spiritual benefits of sight: 'If I eye any thing, it shall be my Saviours crosse.'[20] More broadly, early modern intellectuals, like their medieval predecessors, practised the kind of religious semiotics in which anything in the visible world could act as a symbol of the invisible one and all visual perceptions could refer to something additional to physical reality.[21]

The social and political metaphors associated with eyesight were as important as the religious ones, and were likewise aligned positively with the prevailing concepts of pre-modern society and politics, particularly those associated with divinely bestowed rulership. The eyes were first in honour in the nobility of the senses, just as the optical nerves had first place amongst all the nerves and the crystalline humour enjoyed the 'vassalage' of the eye's other parts.[22] Above all, sight was the sovereign sense and an image of the 'sovereign gaze'; the visual field, we might say, was tantamount to a visual kingdom.[23] Like God and the perfect magistrate, the eyes saw and comprehended all things. Watchful looking was already the analogue of vigilant justice and social control, long before the advent of Jeremy Bentham's Panopticon. It also signified just government. Proverbs 20: 8 contained the statement: 'A king that sitteth in the throne of judgment, scattereth away all evil with his eyes.' John Dod and Robert Cleaver, among the most widely read English biblical commentators of their time, glossed this verse in a commentary of 1611. It meant, they said:

That [the] supreme magistrate principally, and others also of great authority, 'sitting upon the throne of justice', executing his office faithfully, 'chaseth away every evill one', affrighteth lewde malefactors and either cutteth them off, or otherwise punisheth them, or they amend their waies, or flye out of his jurisdiction; or at the least from his presence, 'with his eyes', by looking into causes, and taking knowledge of offences, whether it be by sight or hearing, and therewith also he daunteth the wicked that appear before him, his lookes and countenance being terrible to them.

This was a doctrine, they added, of vigilance versus vice, predicated on the magistrate being 'armed with Gods authority, whose substitute he is, and by him established in his place', empowered with the sword of Romans 13: 5 to take vengeance against the guilty.[24] In the view of a later commentator, the London preacher Arthur Jackson, the text applied both to each and every magistrate and also to the supreme ruler, keeping 'a watchfull eye over the whole kingdome' and sitting in personal judgement over causes in order 'to see things, with his own eyes, and accordingly to judge of them'. Such a king, he said, 'may with a frown awe his people from doing evil'.[25] The Spanish Jesuit Fernando Chirino de Salazar, in his commentary on Proverbs, besides repeating most of

these ideas, even allowed for comparisons between kings and the basilisk.[26] These were commonplaces of contemporary political theory, but they do reveal an association between positive evaluations of vision and its capacities on the one hand and the attributes—occasionally mystical—of divinely bestowed rulership on the other. There was a politics of vision in early modern Europe—at least of vision seen as uncomplicated access to the world—and it was the politics of traditional authority guaranteed by the surveillance achieved by what Foucault was to call the 'absolute gaze'.[27]

Most of the routinely positive associations of vision we have been rapidly surveying were depicted in the visual arts of the period, notably in the moralizing allegories of the senses, treated singly or together, which were popular with painters and engravers.[28] These ranged in scope and complexity from the crowded canvases of Jan Bruegel the Elder and Rubens to the almost emblematic engravings of artists like Georg Pencz of Nuremberg and Frans Floris and Marten de Vos of Antwerp, the last of whom completed no fewer than five cycles on the subject. In the former category, one finds virtually encyclopedic visual inventories of sight, seeing, and optics. In Bruegel's allegory *The Sense of Sight* (1617) (Fig. 1), for example, a female figure representing the sense and its genius looks intently at a small picture of Christ healing the blind man (held up for her to see by Cupid), surrounded by a multitude of objects and creatures signifying vision and its achievements, arranged in a studio-like space lit and shadowed iconographically by sunshine and looking out over a perspectively correct street scene. Completely filling the room are other paintings (by Rubens and his school), many sculptures, medals, jewels, and coins, books and drawings, mirrors, spectacles, eye- and magnifying glasses, a telescope, a sextant, other instruments of geometry, a globe and an armillary sphere, eagles (real and constructed), and a peacock. In what Hans Kauffmann called a 'workshop of sight', an ape wearing glasses examines a painted seascape.[29] Among the German and Dutch designers of series of engravings of the five senses, the imagery is similar but far simpler, although it remains constant. The attributes of vision are indicated by the natural world of light (sun, stars), by sharp-eyed animals (lynxes, eagles), and always by the mirror. De Vos's *Visus*, for example, engraved by Adriaen Collaert in 1575 (Fig. 2), portrays the sense in the standard guise of a noblewoman clad in antique costume, gazing into a convex mirror at her own likeness watched by the clear- and far-sighted eagle. Two biblical scenes, one from the Old Testament of God showing Adam and Eve the visible world of the Creation, and one from the New Testament of Christ healing the blind man and restoring his faith, lend obvious religious reinforcement.[30] Besides these two types of depictions, there are, of course, many examples of still life compositions of the five senses, in which sight is again represented by the symbolisms of accurate representation itself—naturalistic painting, reflected light, and perspective depth—or the symbolisms of objects designed to achieve or display it—spectacles, telescopes, terrestrial globes, and, above all, plain, flat mirrors.[31]

However, it was one thing to insist on the superiority and reliability of sight, and to invest it with such heavy responsibilities, and quite another to secure the veridicality of individual visual experiences—submitting them (in Norman Bryson's Lacanian language) to 'socially agreed description(s) of an intelligible world'.[32] How, given the very demanding roles required of it by ocularcentric theory and the countless actual visual encounters on which religious, political, and other practices fundamentally relied, was accurate, 'orchestrated' visual perception to be guaranteed? In any culture this is the work partly done by its account of optics and cognition—an account of the *manner* in which successful and agreed (i.e. 'intelligible') visual perceptions are obtained (as opposed to their content or substance, which we will confront in later chapters). In early modern culture this account was largely Aristotelian in origin, transmission, and attribution (albeit with some Platonic or Neoplatonic elements), and it was socially agreed, at least among the educated classes, because it was deeply embedded in the textual and other practices—textbooks, commentaries, syllabuses, examinations, disputations—that made up the normal, constant construction, iteration, and exchange of routine knowledge.

Reduced to school- and lecture-room simplicity—as it endlessly was—the Aristotelian 'chain of cognition' required three initial components: object, appropriate medium, and organ.[33] The special object or 'sensible' of vision was colour, its medium transparent and lit, and its organ the eye ('common sensibles' were objects of perception not peculiar to any one sense, such as movement, rest, number, figure, and size). In *De anima* Aristotle insisted that vision could never err in discerning colour (only in discerning 'what it is that is coloured or where it is'), because that was what it was uniquely designed to perceive. In general, sight was assumed to work as long as each of its three ingredients was properly 'disposed' and all the conditions of normality were consequently met. The object had to be suitably present and located, the medium adequately clear and accessible, and the eye whole and healthy.[34] Precisely how the organs of sense received information about their sensibles via a medium was considerably less simple, even when reduced to teachable form, and it was subject to considerable debate and some modification in the tradition. Certain essentials were, however, clear. Aristotle himself described each sense as having 'the power of receiving into itself the sensible forms of things without the matter'. This occurred in exactly the way 'a piece of wax takes on the impress of a signet-ring without the iron or gold'.[35] In *De memoria*, the point was amplified:

[I]t is clear that we must conceive that which is generated through sense perception in the sentient soul, and in the part of the body which is its seat,—viz. that affection the state whereof we call memory—to be some such thing as a picture. The process of movement [sensory stimulation] involved in the act of perception stamps in, as it were, a sort of impression of the percept, just as persons do who make an impression with a seal.[36]

This original distinction between the matter and form—or between the substantial form and the sensible form—of what was perceived and then stored in the memory came eventually to be expressed in terms of the doctrine of *species*, creatively mapped onto interpretations of Aristotle in Oxford, London, and Paris, during the period of the greatest medieval interest in cognition, the age of St Thomas Aquinas, Roger Bacon, and William of Ockham (the last a critic of *species*).[37] In the case of vision, the sensible qualities—whether special or common—of objects in the visual field were said to produce *species* (sometimes called 'intentional' or 'sensible' *species*) which radiated out from these objects into the surrounding medium, usually the air, transmitting images of the qualities physically (that is, by alteration) through the medium to the eye. In this way, the *species* carried the likenesses or 'similitudes' of visible forms from object to eye, without any of the associated matter, and enabled sight to proceed on a reliably representational basis. One of the most important expositions of these ideas was Bacon's *De multiplicatione specierum* (significantly rendered as 'On the propagation of likenesses'), plausibly dated to 1262, and, as its title suggests, based on an epistemology in which objects act *on* passive recipients, leaving impressions in their senses and intellects which translate into conceptual images having an exact likeness to the originating objects.[38]

What happened to visible *species* after their 'propagation' through the eyes, the optic nerves, and the ventricles of the brain—how, in other words, they were received by the 'internal' senses as 'phantasms' and, eventually, 'intelligible' *species*—is a subject we must mainly postpone until the next chapter. For the moment, it is only important to underline the way Aristotelian cognitive theory was couched in a particular language of veridicality—a kind of scholastic realism. To the foundational metaphor of wax being 'impressed' or stamped with an image were added others with the same connotations of the exact replication in sense of the images of external things. In *De memoria*, when exploring the difference between a mental impression and the 'objective thing' from which it derived, Aristotle compared it to a 'picture painted on a panel [which] is at once a picture and a likeness', adding 'that there is in [our memory] something like an impression or picture'.[39] Among the synonyms used by Bacon to describe *species*, Michael Camille lists 'similitude', 'image', 'idol', 'simulacrum', 'form', and 'shadow', all connoting the making of visual images. The metaphor of pressing or stamping, he says, was 'fundamental to medieval visuality' and was used by many Arabic and Western commentators on *De anima*, including Aquinas.[40] It was also available in both the Platonic and Augustinian traditions and their commentators, following its use by Plato in *Theaetetus*, 191D, and by Augustine in *De trinitate*, joined in his case by the statement that it was impossible to distinguish between the objective form of an external body and the form produced by it in sense.[41]

There is, perhaps, a way to read such metaphors in terms of cognitive, not actual likeness or resemblance—not as invitations to the literally pictorial copying or replication of objective reality but as referring to a more functional form of

representation in which mental 'phantasms' stand for what they represent only by a kind of convention.⁴² Besides challenges to Bacon from William of Ockham and others, there is evidence that some sixteenth- and seventeenth-century Aristotelians, even while speaking of *species* 'representing' external objects and acting as their 'similitudes', nevertheless resisted any complete assimilation to 'formal' picturing.⁴³ Even so, the sheer density of the vocabulary of copying seems to point in another direction. To suggest that scholastic mental representation functioned more like writing than picturing risks confusion with a later Cartesian account of cognition and makes a puzzle of both Descartes's own sense of his distance from scholasticism and also his gibe against 'all those little images flitting through the air, called "intentional forms", which so exercise the imagination of philosophers'.⁴⁴ A better route to understanding is the one offered in a seminal essay by Joel Snyder, who successfully traced Renaissance attempts to make linear perspective the pictorial equivalent to vision—and, indeed, post-Renaissance expectations about pictures having to resemble, or correspond 'realistically' to, what they depict—to the view that vision *itself* was pictorial, a view embedded enough in the medieval theory of optics and visual perception for Alberti to rely conservatively on it.⁴⁵

We need to remember, above all, that one of the results of the fusion of optical theory (largely that of the tenth- to eleventh-century Islamic philosopher Alhazen) and cognitive philosophy achieved in later medieval thought, and retained into much of the early modern period, was the idea of the point-by-point mapping onto the eye's crystalline humour of rays of light transmitted from objects along a 'visual pyramid', any cross-section of which—including the one sent physiologically onwards to the brain through the vitreous humour and the visual spirits in the optic nerves—necessarily produced an at-least two-dimensional image of the object(s) that formed the pyramid's base.⁴⁶ In an important sense, the integrity or coherence of this image was maintained throughout its journey from object to brain; even after leaving the eye as a 'mosaic of visible light and colour', the 'custodial' power of the optic nerve preserved it in 'perfect integral order . . . to reach the forefront of the brain intact'.⁴⁷ That the entire process was dictated by causal demands that made each form in the sequence a cause of its successor and an effect of its antecedent also helped to ensure that the picture of reality occurring in the brain was veridical. There was, indeed, both a real and a necessary—because natural—connection between extramental reality and the formation of concepts, ensuring both an exact correspondence between concepts and objects for single percipients and, given normal conditions of perception, an exact repetition of the same *species* in the souls of all of them.⁴⁸ '[I]f things external to us', comments another recent student of medieval sight, 'are able to reproduce their essential qualities in our senses and minds then the content of the mind is assuredly objective.'⁴⁹

Thus, it remained perfectly possible 'to characterize the physiology of vision according to Alhazen as the transmission of an "image" or "picture" of the objects

in the field of vision through the optic nerve to the brain'.[50] Here, for instance, in a fourteenth-century commentary on the essentially Baconian ideas of John Pecham, is the Hessian scholar Henry of Langenstein explaining hydrodynamically how the *species* of sensible things in the external world received by the external senses were identical to those received by the internal senses:

> In the hollow nerves descending from the brain and carrying the sensitive spirits there must be a transparent body suited, when illuminated, to the multiplication of species, which body is terminated at the exterior organ of the senses; or else it is necessary that in those hollows [of the nerves] there be most subtle and clear bodies, namely spirits, flowing continually from the brain to or toward the outside and afterwards flowing back with a certain motion, in which reflowing spirits the received *simulacra* of sensible things are carried to the common sense or the imagination.[51]

In a brief summary, the leading authority on this subject, Katherine H. Tachau, speaks of the multiplication of the Baconian *species* as an entirely continuous process from object to brain. She explains that even after the junction of the optical nerves (the optical *chiasma*), the 'coherent visual image continues to multiply into the chambers of the brain housing the internal senses'.[52] Whereas Descartes, whose own retinal images, like Kepler's, shared exactly the optical feature of 'similitude', refused to make this the guarantor of visual certitude beyond a certain physical point (the pineal gland), the scholastics and peripatetics took it to mean that under normal conditions the world was what it appeared to be and contained real qualities that matched those which were perceived. As one Italian scholar has put it, the fundamental philosopheme of medieval perspectival theory was that reality was what we *see* it to be.[53] In some formulations, like that in Averroes' paraphrase of *De sensu et sensibili*, for example, literal mirroring does seem to have been intended; he spoke of the eye comprehending the forms of things 'like a mirror whose nature is intermediate between that of air and that of water', and of the common sense 'seeing' these forms through the vitreous humour at the eye's rear.[54] But even when what was transmitted was not actually an optical image like the one reflected in a mirror, perception was deemed to occur *as if* this were true (as if percepts were visual copies of the world)—especially in the less technical, more disseminated versions of the theory. Michael Camille writes: 'The important thing about both the sealing and the mirror metaphors used to describe vision was that in both, the mind is described as perceiving through a process of representation.' *Species*, he reminds us, derived from the Greek root *spec*, denoting 'what a thing looks like'. Moreover, linked to the new emphasis on similitude was a 'fundamental shift' from extramission to intromission theories of vision, the latter dominant by the sixteenth century and implying not the projective power of the soul to—in some sense—produce objects of vision but the projective power of objects to emit their own likenesses and then have them propagated through a medium and replicated in the faculties of sense. 'This is the ultimate difference between the early and the late medieval notion of the image',

says Camille: 'One is seen as an externalization or projection of internal archetypal patterns onto the world, whereas the other is more like an inference taken from reality.'[55]

The complexities of these intellectual developments and their enormous implications for natural philosophy, religion, and art are still being worked out. But it is clear that early modern Europe inherited a by-now overwhelmingly Aristotelian view of cognition based on the doctrine of *species* and, with it, the assumption that visual certainty could be guaranteed by the principle of similitude. The encyclopedias and schoolbooks of the period certainly repeat this as the standard view. Gregor Reisch's *Margarita philosophica*, written in the 1490s as a university textbook, first published in 1503, and widely adopted thereafter, explained that although 'the sense object cannot be received by the sense in its essence on account of its materiality it produces an image which the sense can receive and by which it can be perceived'. This image resembled the object, in Katharine Park's summary of Reisch, 'as a portrait does the sitter'.[56] The hugely popular encyclopedia *De proprietatibus rerum*, originally by a thirteenth-century theologian at Paris, Bartholomaeus Anglicus, but cited throughout the centuries that followed (and based, in its optical sections, on the views of Alhazen), used 'likeness' to describe the visible *species* of objects, as in the statement from the English translation that 'the aire, that is next the thing that shall be seene, taketh a likenesse of the propertie of that thing: and in that lykenesse the aire profereth it selfe to the eye, whereof the spirit visible taketh a lykenesse'.[57] According to La Primaudaye, the first of the brain's 'internal' senses in the chain of cognition, the 'common sense', received

al the images and shapes that are offered and brought unto it by [the external senses], yea all the kindes and resemblances of materiall things, which they have received onely from without, as a glasse doth: and all this for no other cause but that they should discerne and sever every thing according to it[s] owne nature and propertie, and afterward communicate them to the internall senses.

All the senses, he added, were created by God to grasp the 'similitudes of things without'.[58] La Primaudaye's compatriot Scipion Dupleix spoke in similarly Aristotelian fashion of the crystalline humour receiving *species* like a mirror and of sight being achieved 'by the reception of images, *species*, or resemblance[s] of objects' after they had been painted by light on a medium.[59]

The allusion here to the operation of external sense as a 'glasse' was similar to Sir John Davies's in *Nosce teipsum* (ll. 973–4) to the eyes as 'Mirrors [that] take into their little space, | The formes of Moone, and Sunne, and every Starre'. The mirror was evidently far from what it has become for us, an occasion for reflexivity and self-consciousness. Whatever its use in everyday life, it was represented instead in a way that corresponded 'exactly to the standard Renaissance model of cognition'.[60] The converse was also true. On a blank page at the start of the chapter *De sensu* in a copy of Gerardus of Harderwyck's *Epitomata seu reparationes*

totius philosophiae naturalis Aristotelis (1496) there is a drawing of the functioning of the inner and outer senses which simply offers a round mirror as the appropriate symbol ('obiectum visus') for sight.[61] In Juan Luis Vives's essentially Aristotelian *De anima et vita* (1538), thought as a whole was said to be 'an image of things imprinted on the mind as in a mirror'.[62]

Monographs dealing with the 'second' internal sense, the imagination, and with the passions, spoke similarly. The first in time, by Gianfrancesco Pico della Mirandola, declared that the function of sense was 'to apprehend and retain the likenesses of present objects'.[63] A century later, in 1608, Thomas Fienus adopted the scholastic idea that objects became visible when they emitted 'species impressae' which passed to the eye.[64] When Thomas Wright, in a book on the 'passions' of the mind, asked how the human soul could possibly conserve so many visible forms within itself, he posed the question in this way: 'in what tables are they painted? in what glasses are they to be seene?'[65] The eye specialists and anatomists shared views which were also unmistakably still Aristotelian. A traditional, pre-Keplerian optics text like Franceso Maurolico's, written in the 1550s and published in 1575, could say that the aqueous or crystalline humour receives 'the picture (*species*) and transmits, through the optic nerve, what it has received for appraisal by the ordinary sense [of sight]'.[66] In medicine, the international authority André Du Laurens could describe the crystalline humour as the occasion for an 'inward spectacle'—'a mimetic re-enactment of the world, which the brain accepts as a true image of the world'[67]—while his equally eminent French colleague Jean Fernel spoke of how 'a visible image of the thing (*rei aspectabilis imago*) is received in the crystalline humour through the pupil [and] conveyed by spirit . . . reaches into the brain and general sensory headquarters, along the optic nerves'.[68] Paré spoke simply of the eyes receiving the forms of things 'like as a glasse'.[69] According to Helkiah Crooke (confessing he was talking more philosophically than anatomically, and citing *De anima*), the task of the crystalline humour was to 'discern the true portraitures and representations of all visible objects'. In it, the 'species or formes of visible thinges' were received—transferred 'by one right line from the object to the eyes' and 'imprinted therein . . . like unto waxe'. In this way, the humour acted like a pair of spectacles to the optic nerve, 'gathering the species which fall upon it and representing them in a larger forme unto the nerve'. In sum, the crystalline humour was the primary instrument of sight, transmitting instantaneously those visible forms 'whereof refraction is made in the membranes, perfection in the conjunction of the opticke nerves, and finally a perception in the braine'.[70]

The success of this inherited model of cognition in securing socially agreed certainty in the apprehension of objects of sense should not be underestimated. Quite apart from the grounding of visual experiences in daily life and material existence, it is impossible, without it, to make sense of the 'optical naturalism' at work in much of Renaissance aesthetic theory and criticism (and genres like

portraiture and landscape), in the emergence of new modes of naturalistic, and supposedly veridical, representation in sciences like astronomy, anatomy, mechanics, botany, physiognomy, topography, and natural history, in the faith placed, in all these and many other sciences, in direct observation, and in the practice of certain kinds of narrative realism in early modern literature.[71] Nor is it possible to imagine how the myriad forms of seeing and knowing that made up late medieval and early modern religiosity might have been expected to work without the minimum assurance of visual certainty, in at least physical encounters with religious objects, offered by the philosophical tradition to which most churchmen belonged.[72] Nevertheless, it takes only a moment's reflection to realize that a cognitive model which assumed that visual appearance would normally correspond with objective reality was ill equipped to deal with serious and repeated breakdowns of that particular relationship—and more especially with situations where appearances that were supposed to be true proved difficult, perhaps impossible, to distinguish from appearances that were deemed to be false: let us call these 'visual paradoxes'. In such circumstances, the model, like any other scientific paradigm, was very likely to collapse under the weight of the anomalies counting increasingly against it and be philosophically reassessed. Indeed, there were already warning signs, so to speak, in the arguments of its earliest, fourteenth-century critics, who found *species* inadequate in precisely those instances when appearance and reality most obviously clashed—in delusions, dreams, optical illusions, hallucinations produced by fevers, the manipulation of demons, and so on. In such cases, says Katherine Tachau, 'Bacon's account [of enduring images] intrinsically posed the major epistemological difficulty of endangering existential certainty . . . how was one to know infallibly that one was seeing a present, existing extramental object, and not an impression remaining in the object's absence?'[73]

It will eventually be the argument of this book that the collapse of the 'representational' model of vision based on *species* is exactly what happened in the 250 years between the early fifteenth and the late seventeenth centuries, when visual anomalies and paradoxes multiplied to such a degree that they overwhelmed the cognitive theory that permitted them to occur. But as a prelude to this, it is worth noting the many ambiguous and negative evaluations of vision that circulated even in an ocularcentric age. The very persistence with which the powers and privileges of the eyes were insisted upon in traditional accounts can be read as compensatory—an attempt to reaffirm the status of seeing in the face of challenges and doubts. Even intromission itself, largely preferred in optical theory after the thirteenth century, might be said, in its rejection of visive fires and pneumas emanating from the eye, to have reduced the organ to 'a vulnerable orifice, a passive receiver of light'.[74] Discussions of the hierarchy of the senses did not always choose sight as the prime vehicle of learning, opting instead for hearing and less frequently touch.[75] Frequently noted, for example, were remarks by Aristotle in *De sensu et sensibili* that, whereas seeing was superior 'as a supply for

the primary wants of life', hearing took precedence in the development and growth of intelligence: 'For rational discourse is a cause of instruction in virtue of its being audible . . . since it is composed of words, and each word is a thought-symbol. Accordingly, of persons destitute from birth of either sense, the blind are more intelligent than the deaf and dumb.'[76] Hearing was more obviously an avenue of religious instruction and had been the sense of faith from the early Christian era onwards. The sixteenth century produced an original, if somewhat mystical, statement of the idea that it was the most elevated of the senses in the Noyon scholar Charles de Bovelles's *Liber de sensibus*, completed in 1509. Eccentrically, Bovelles thought that the ears were more important than the eyes because they were further in distance from each other, higher in bodily position, and connected by the widest angle—a straight line. But he also chose hearing as the more simple and less materially based sense, the one with greater rarity of object (sound) and nobility of source (voice), and the one more capable of reaching beyond the firmament to the invisible heavens, the realm of the soul.[77]

Few were unaware of the doubts and hesitations of the ancients regarding the errors and uncertainties of sensory perception, many of these going beyond the visual 'fallacies' allowed for within the Aristotelian model and in medieval optics. La Primaudaye, for example, thought that the Stoics and Academics (and Plato too) had identified so many failures of the senses that 'all was compassed about with darkenesse, and hid'.[78] The figure of Plato loomed especially large, of course, since matching his view in the *Timaeus* that sight was the least material of the senses and therefore provided the most direct access between the physical world and the soul were the notorious misgivings about appearance and the visual arts expressed in *The Republic*. Many early modern authors chose to express their own reservations about sight by playing with paradoxical arguments in favour of blindness, cued perhaps by Aristotle's *paragone* on the subject and by Cicero's more extensive remarks in book v, 111–15 of the *Tusculan Disputations*.[79] The simplest sixteenth-century version occurred in a paradox entitled 'That it is better to be blinde, th[a]n to see cleerely' in Ortensio Landi's *Paradossi* (1543), a collection translated first into French, and then from French into English by Anthony Munday as *The defence of contraries* (1593). Among the disadvantages of sight were the many 'voluptuous delights and pleasures, which daily ende in bitternes, alienation of sense, provocation to envie, irritation and commotion against the heart'. The eyes gave access to all manner of physical horrors and moral evils which corrupted the seer and destroyed his or her moral and psychological stability. Their essential function—instantly to 'represent and deliver (without finding any hidden ambush) all that they see and perceive abroad'—was thus also their essential failing. A great philosopher like Democritus had blinded himself, the argument continued, while others, including Homer, had excelled despite the condition. Blindness, indeed, freed the individual from peril and temptation—not to mention the need for 'eie medicines'—and led to strength of spirit, clearer apprehension and imagination, perfect memory, and, above all, better

contemplation of things 'high and heavenly'.[80] The Englishman Robert Heath took what can only be called a one-eyed approach to the issue in a paradox entitled 'That he that hath but one eye, sees better, farther, and more, then he that hath two eyes', citing examples from perspectival optics, marksmen lining up their sights, and Galileo using his 'glass'. Heath could not resist the joke that the 'Monoculi', a one-eyed race of Indians, saw more eyes on other men's faces than these men did on theirs. But he did add the more serious observation that 'when the body is wholly depriv'd of sight, the eyes of the soul then see best'. In his view, by now a commonplace, 'corporeal darkness causeth a greater light of judgement and strength of memory, the minde being not then by dilitation carried away after several objects and distracted'.[81] In the same vein, another English paradoxist declared that it was 'almost impossible, for a seeing man to become a seer'.[82]

To the extent that the traditional model of visual probity rested on the metaphor of the mirror (and, indeed, in the case of the functioning of the crystalline lens, on almost literal mirroring), it ran the equal and opposite risk of being associated with mirroring's increasingly ambiguous moral and epistemological character. Definitionally, a reflection is never what it seems to be. In exact counterpoint to the mirror's widespread adoption as a symbol of faithful representation (evident, for example, in the countless writings that claimed, in title or in content, to hold a true, exemplary, or picturing 'mirror' up to their subject[83]) there developed an equally powerful symbolism of specular deceit.[84] The sixteenth-century Jewish intellectual from Ferrara, Raphaël Mirami, captured the dilemma exactly: 'I say that for some, mirrors constitute a hieroglyph of truth in that they uncover everything which is presented to them, like the habit of the truth which cannot remain hidden. Others, on the contrary, hold mirrors for a symbol of falsity because they so often show things other than as they are.'[85] Mirami might have had many things in mind here, ranging from the enchanted mirrors of magicians to the catoptrical mathematics set out in his own book. More broadly, mirrors signified pride and vanity, as in the many depictions by (male) artists of women gazing at their reflections while devils or skeletons looked over their shoulders, sometimes superimposing their own images on the surface of the glass.[86] The Ovidian legend of Narcissus had become, by the sixteenth century, a universal symbol of self-love, as in the many versions of the episode in the emblem books of the period. According to Paula Findlen, the prominence of mirrors in baroque museums further ironicized and subverted the same legend: 'Distorting, transforming, and multiplying the image of the viewer, they suggested that seeing was hardly a transparent activity . . . [and] had more than one aesthetic.'[87]

Poetry, indeed, was another rich source of suspicions concerning the eyes.[88] In secular love poetry, desire was not simply the inevitable product of vision but almost its curse. It was an old theme that love ensnared the lover via the eyes. For all the lauding of the attributes of the female eye (and other parts of the female body) in the poetic genre of the *blasons du corps feminin*, where 'the eye, symbolizing love, is the gate to the soul and a choice object of worship', there was also a

parallel theme of visual pain and punishment in love via the 'lethal gaze' of the beloved, especially in Platonic and Petrarchan verse. The dominant role of the eye in love imagery was also matched by the themes of 'possession with the eye' and voyeurism that flourished more darkly in contemporary misogyny.[89] In Michael Drayton's sonnet 'To the Senses' (1599), sight is corrupted by beauty and the lover's soul betrayed 'to cruell love', though all his other senses fail to protect him as well.[90] All five are again invoked in book 2 of Edmund Spenser's *Faerie Queene* where they are assaulted by rather more serious versions of their matching faults, temptations, and sins. In the besieging of sight, beauty is joined by money to produce 'lawlesse lustes, corrupt envies, | And covetous aspectes . . . '.[91] The extraordinarily complicated English allegorical play *Lingua, or the combat of the tongue and the five senses* (1607) features a competition to see which sense is best, a feast to celebrate the predictable winner, 'Visus', and the consequent reduction of all five to intoxication and 'wild and brutal uselessness'.[92] With six English editions down to 1657, a German translation, and parallels in French and Italian comedies, the farce contains all the usual positive commonplaces to do with sight in the form of an elaborate defence before the court of 'common sense'. But it also alludes to some negative traits as well, as is fitting for a kind of morality play: these include succumbing easily to excess, Narcissism, and pride (suggested by the peacock with 'eyes' on its tail, emblematic of both sight and its principal vice).

The ambiguity with which vision was regarded in artistic contexts is perhaps nowhere better expressed than in treatments of a traditional story, known throughout early modern Europe—and to every modern art historian[93]—and taken universally to represent the very character of artistic mimesis itself. This was the tale told in Pliny's *Natural History* of the competition between the two ancient painters Zeuxis and Parrhasius, the first of whom tricked real birds with painted grapes, only to be outdone by the second, who tricked Zeuxis into drawing aside a painted curtain.[94] This was at one and the same moment an obvious allegory of the perfectibility of art and an equally direct warning of the consummate deceptions of the artist. It was something both to wonder at and feel threatened by, a paradox captured not merely by the illusionistic subject matter but also by the self-referentiality of painters drawing attention to painting.[95] Many cited the story in admiration, but the cautions and moral doubts are more obvious in the disquieting emblem devoted to it by Laurens van Haecht Goidtsenhoven entitled: 'Homines atque folucres picturis decipiuntur' (Men and birds are deceived by paintings) (Fig. 3).[96] One assumes that Leon Battista Alberti's remark that Narcissus was the inventor of painting ('What else can you call painting but a similar embracing with art of what is presented on the surface of the water in a fountain?') carried the same enigmatic implications.[97]

It was, however, the religious judgements on seeing that were the most critical, betraying Christianity's virtually perennial unease over its relationship to the senses. Not surprisingly, they concentrated on the eyes as the gateway to vice and immorality, prompted perhaps by Luke 11: 34: 'The light of the body is the

eye . . . when thine eye is evil, thy body also is full of darkness.' The obvious corollary of the analogy between spiritual sight and bodily sight was that the spirit and mind could be poisoned if the eyes were allowed to see profane or evil things. Sight was the most noble and certain sense but also the most corruptible and most corrupting—by a kind of necessary symmetry. The danger of sensuality in religion was a theme that went back at least to Augustine and was encapsulated in the anointing, during the sacrament of extreme unction, of the sense organs through which the dying had sinned.[98] Augustine's was the single most influential account of 'ocular desire' and all the more pronounced in his case through his acceptance of the Platonic and Neoplatonic extramission theory of vision, which 'opened' sight to invasive dangers and attacks. He spoke in his *Confessions* of all the manifold entrapments of the eyes—'beautiful and varied forms, [and] glowing and pleasant colours' that, even though they were sights made by God, distracted the soul at every moment from its inward visions (seen with 'invisible eyes') and enticed it with love of the world; precious objects and images that replaced the Maker with the made and dissipated love of a higher beauty in the mere pleasure of 'beautiful externals'; and, above all, an ocular cupidity that delighted 'in perceptions acquired through the flesh', even those of 'knowledge' and 'science', and was therefore inseparable from knowing. 'The general experience of the senses', said Augustine, 'is the lust . . . of the eyes', and given his pervasive authority in early modern religious culture, it is hardly surprising to find that his warnings were heeded.[99] To balance the resort to sight among religious visionaries—from Cusanus to Loyola and beyond—there was a parallel invocation of the suspension of the senses and even of blindness as aids to religious awareness. At the Last Judgement in Agrippa d'Aubigné's *Les Tragiques*, the Protestant elect regained a purified set of senses: ' . . . the same senses we had, | But, being of pure act, they will be made of action | And shall not bear infirm passions.'[100]

Like their medieval counterparts, early modern churchmen and other moralists warned of the inherent dangers in eyesight and of looking as a cause of wickedness. If the senses were windows on the soul they were also doors, allowing entrance to temptation, vice, and evil spirits. The human moral citadel was continually under assault. 'We do not sin from other causes', Isidore had stated in his *Sententiae*, 'than from seeing, hearing, smelling, tasting and touching.' For Vincent of Beauvais, the eyes were even traitors, betraying the heart's secrets and making the way open for death itself.[101] Well might the eyes weep, complained the English Puritan divine Richard Greenham, for the evil they conveyed to the heart. According to St Jerome, added Greenham, they were 'the streames or springs of lust'—more capable than the other senses of persuading men and women of holy things and, for the same reason, more forcible in leading them into sin. Even original sin itself, claimed Greenham (adopting a conventional trope, and echoing Genesis 3: 6), was due to Eve's eyes: 'She seeth the tree to be faire and beautifull, [so] the eye had offended before the apple went downe her throat.' The eye was the source of covetousness, adultery, idleness, and pride, as well as things

like excess and costliness of apparel; in each of these cases the sinful action followed a sinful perception. Thus, seeing always came between sin and the heart and innocence was always compromised by sight. For Greenham, vision was still the sense of certainty but it needed to be strongly 'governed' for this to be true.[102] He would no doubt have approved of the verses from Proverbs 4: 25 inscribed below an allegorical female figure of 'Sight'—complete with sunlight, eagle, and convex mirror—which fills the right-hand margin of a much illustrated Tudor book of prayers: 'Let thine eyes behold [w]hat is right.'[103]

The Counter-Reformation equivalent is provided by the Netherlands Jesuit Johannes David, whose *Veridicus Christianus* (1601) contained one chapter on the five senses and one on sight, both accompanied by engravings (by Cornelius Galle), all of them disparaging the visual faculty as fragile and treacherous, an occasion for sin, and a cause of the Fall. The eyes might be the most noble and delightful members of the body, the essential guides and protectors in all human activities, and the contemplators of the creation—David repeated the usual conventions—but they were also highly dangerous and the chief reason for Eve's catastrophic curiosity and its legacy. One of the engravings, entitled 'Adspectus incauti dispendium' (The cost of careless looking), centres on the metaphor of the human head as a house, its eyes depicted as two windows (Fig. 4). All the superfluous, errant, and damaging products of curiosity are able to enter the one that is propped open, while death clambers conveniently through the other. In the background are Eve herself clutching her apple, King David gazing at the bathing Bathsheba (signifying the adultery described by Christ in Matthew 5: 28: '. . . whosoever looketh on a woman . . . '), and Dinah, the daughter of Leah and Jacob, ravished by Shechem when she 'went out to see the daughters' of Canaan (Genesis 34: 1–2).[104]

But the most thoroughgoing denigration of vision in sixteenth- and seventeenth-century English, if not European, thought was offered by George Hakewill in his *The vanitie of the eie*, first published in 1608 and written for someone who had gone blind.[105] As the best example of the demolition of Renaissance optimism about vision, his book serves as an appropriate final introduction to what follows in this one. For Hakewill sought to comfort his dedicatee by removing all eyesight's privileges as a sense and blaming it for everything that was wrong in the world. Like Greenham he began by arguing that it was responsible for all the major sins—for those on Greenham's list plus wantonness, gluttony, theft, idolatry, jealousy, contempt, envy, and witchcraft. The natural benefits of sight were thus outweighed by the risks it posed to grace and virtue, all of them contained in biblical cautions. Dedicated by 'heathens' to Cupid, the eye was necessarily the seat of adultery. Idolatry—the worship of things 'apprehended by the eye, and adored by the mind'—was likewise impossible without it.[106] Pride was occasioned by the abuse of visible show, which tied the eyes to 'pomp, magnificence of masks, pageants, triumphs, and monuments, theatres, [and]

amp[h]itheatres', to excessive possessions, and to ostentatious clothes. The fact that the eyes could see neither themselves nor the faces in which they were set made mirrors the artificial, but dead, eyes of pride, so that physical blemishes discovered in them were far outnumbered by those imprinted on the soul. According to Hakewill, 'the use of [the mirror] in the art of seeing, is not of such consequence as it can in any sort countervaile the damage arising from it, in the art of manners'.[107] Given the disdain brought on by seeing even revered things too often, religions had to be built on invisibility and secrecy and princes kept out of the public, and each other's, eye. Human affairs were often ruined by men's eagerness to pry into the affairs of others while remaining blind to their own. The human eye delighted in unspeakable cruelty and bloodshed, but lust remained its favourite and extensive domain. For Hakewill, this embraced the masking and transvestism of Carnival, Jesuit religious drama, any kind of sensuality in artistic imagery, the comedies and dances of the French, and the common plays and interludes of the English. Following Greenham, he attributed the Fall to the fairness of an apple apprehended by a woman's eye; the 'sense of seeing' thus - provided the original motive for sin and the reason for its repetition down the ages.

There is much else in this comprehensive onslaught on ocularcentrism. Hakewill argued that any kind of hypocrisy was certain to fool the eyes because of its superficial plausibility, and that they opened men and women to moral exploitation by betraying their states of mind and their inner passions and weaknesses to would-be predators. In grasping only the corporeal and accidental properties of illuminated objects situated directly before them they not only depended on hearing for correctly perceiving things but often missed 'that which hath greatest force in actuating, and quickning the thing we see'—as, for example, the soul in the body.[108] Hearing, indeed, was the sense of precept and rule, whereas sight was the sense of example and imitation, 'no lesse dangerous, th[a]n incertaine'.[109] Hakewill was not even sure that man's upright bearing gave his eyes an advantage in contemplating the heavens, since star-gazing led only to astrology and divination. Besides, the eyes were prey to an infinite number of diseases—even light itself being dangerous to them—as well as the possible cause of others, especially bewitchment by fascination and/or infections carried by the effusion of pestilential vapours. In a telling reflection on the artistic naturalism of the Renaissance, he spoke of the complete visual deception achieved (in Pliny's story) by painters who tricked birds into flying at painted bunches of grapes and their competitors into drawing aside the curtains on their canvases: 'For so it is that this sense . . . is so bewitched that its then most delighted when tis most deceived by shadowings, and land-skips [*sic*], and in mistaking counterfeits for truths.'[110]

Hakewill (1578–1649) was a member of the Calvinist theological establishment in Jacobean England and a fellow (finally, rector) of Exeter College, Oxford. He was made chaplain to Prince Charles in 1612 but lost the post due to his dislike of the Spanish marriage and the rise of Arminian interests at court. One would not expect from him the total subversion of the values normally associated

with vision and this is not, necessarily, the effect of what he says. The book—standing apart from his other writings, which dealt with doctrinal and confessional matters, the Prince's marriage, and (the best-known work) the nature of Providence[111]—might even be read as simply a collection of the usual paradoxes about blindness taken to extremes. Hakewill does indeed conclude with several chapters in which the tropes for preferring blindness to sight are repeated, and he refers specifically to Jean Passerat's 'De caecitate oratio'. On the other hand, his arguments, and those of others writing in the same manner, do suggest in a preliminary way what kind of damage might be done to early modern beliefs and institutions in criticizing the assumptions about vision on which they usually rested. If the eyes were the gateways of sin, what then of their capacity for real or metaphorical enlightenment? If they were the occasion of such moral debasement what of their association with nobility? Hakewill cited as the opinion of Hermes Trismegistus the notion that the eyes were the tyrants of reason, enslaving it and delivering it to the lower faculties, like a magistrate in a city shaken by civil unrest. He talked of how they were the instruments 'of the whole rebellion, and apostasie, as well of the body, as the mind',[112] transgressions easily transferred from the realm of religious and ethical (and sexual) discourse into social and political life. Although he was careful to exempt his own monarch from it, the principle that 'presence much weakneth report, and diminisheth reverence'[113] cut deeply into the mysticism on which much of the power of early modern rulers depended, as well as exposing their personal inadequacies. Princes were simply not as awesome as they pretended to be when exposed to the gaze of their subjects.

We could say that all this was only a warning against the dangers and inadequacies of a vision unregulated by Calvinism; properly 'governed' the eyes might still perform their allotted tasks. The book is certainly intensely anti-Catholic and many of its targets are drawn from Catholic practices; Hakewill had recently returned from spending four years of his life among Swiss and German Calvinists, part of the time in Heidelberg. The Roman religion, he says memorably, depended more on 'eye-service' than the Reformed:

Our adversaries indeed, place a great and maine part of their superstitious worship in the eye-service; in the magnificke and pompous fabrick, and furniture of their Churches and attiring of their Priests; in gazing upon their dumb ceremonies . . . in beholding the daily elevation of their Idoll in the masse, (for the greatest part heare nothing) and lastly in fixing their eyes upon pictures, and images; giving them the titles of remembrances for the learned, and books for the laity.[114]

The true religion, by contrast, regarded sight as a hindrance to the serious business of praying and listening to sermons. All too often, men and women were distracted physically from spiritual exercises by the temptations in the things they saw around them—most commonly, the men *by* the women who accompanied them to church (Hakewill wanted more partitioning to prevent this). But even eyes fully focused on the sacraments actually saw only their 'outward

circumstances', the lack of which could be compensated for by hearing. A blind person might perform true service to God but not a deaf one, since it was the word that was made incarnate, not any colour or shape. 'We walke by faith', wrote St Paul, 'not by sight', a faith that was 'the substance of things hoped for, the evidence of things not seen' (2 Corinthians 5: 7; Hebrews 11: 1). Hakewill searched the Pauline texts on hope and charity to show that their objects too were things 'not seen'—hope because it referred to things eternal, not temporal (Romans 8: 24–5; 2 Corinthians 4: 18), and charity because it rested on love of a Saviour only seen by few.

Even so, what Hakewill intimates, perhaps not altogether intentionally, is that all religious and political power depended on a contrived, not a real transcendence—in other words, one that worked for the 'wrong' religions and rulers too. It is hardly surprising to find him saying that the relics of the papists had to be kept away from the demystifying gaze. But the same was true, he argued, for matters that Protestants too took seriously—even matters as important as God, the devil, Heaven, and Hell. Holy things were to be guarded from too frequent visual inspection—like the 'great Turke' from the eyes of his people—not because they were beyond its grasp but because they might not survive its scrutiny.

However, we have not yet reached the full extent of Hakewill's (probably rhetorical) ocularphobia. There is too in his book a survey of the principal epistemological doubts expressed in the late sixteenth and early seventeenth centuries concerning the degree to which the eyes and the visual faculties might simply be mistaken about the physical reality of what they perceived, never mind its moral or religious or political significance. Instances of this, he said, were plentiful:

I might here take occasion to enlarge of the delusion of the sight by the subtiltie of the divel, by the charmes of sorcerers, by the spells and exorcismes of conjurers, by the legerdemaine of juglers, by the knavery of Priests and Friers, by the nimblenesse of tumblers, and rope-walkers, by the sleights of false and cunning marchants; by the smooth deportment and behaviour of hypocrites, by the stratagems of Generals, by the giddines of the braine, by the distemper of phrensies, and lastly by the violent passions of feare and melancholy; besides a thousand pretty conclusions drawne out of the bowels of naturall Philosophy, and the Mathematicks; by the burning of certaine mixt powders, oyles, and liquors: By the casting of false lights, by the reflexion of glasses, and the like.[115]

Not content with a list, Hakewill also indicates for us the general traditions to which the doubts provoked by these instances belonged—and in which we too must place them. To begin with, there was the question of the false reporting of natural phenomena—distortions 'in discerning magnitudes, distances, proportions, colours' which made straight sticks bend in water, horizon and sky meet, and round towers look square.[116] According to Hakewill, these were errors that were explained in the optics of Aristotle (in his *De sensu et sensibili* and *Meteorologica*) and by the thirteenth-century expert Witelo (in his *Perspectiva*) and that were also corrigible by the intellective soul, but they were still evidence of the

fallibility of the eyes themselves. For this reason, they were grounds for a broader philosophical scepticism stemming from the Greek Stoics and Academics and recently enshrined in Pierre Charron's *De la sagesse* (1601), a book published in English some time before 1612 and described by Hakewill as 'second to none in this age for morall discourses'.[117] Here, then, he was situating his own scepticism about vision in an entire tradition of ancient and late Renaissance thought, where epistemological doubts far more serious than anything encountered in Aristotle and Witelo underpinned a certain kind of moral discourse.

Secondly, Hakewill blamed visual delusion about physical things on the 'imposture of Priests and Friers', voicing once more his fierce personal anti-Catholicism but, again, placing his treatise in a post-Reformation tradition in which Protestants in general explained away religious phenomena they were no longer able to accept. Hakewill himself singled out ghosts, exorcisms, and miracles to do with images, and cited attributions of them to 'delusion of the beholders sight' and to 'legerdemaine'. The fact that he drew on Erasmus here alerts us to the way that Catholic reformers too could associate the practices they sought to discredit with the tricking of the eyes. But the abolition of Purgatory was always likely to make such arguments appeal more to Reformed theologians like Hakewill. In his view, only Catholics could say, for example, that in 1 Samuel 28 the 'witch' of Endor had truly summoned an apparition of Samuel; the truth was that Saul had been taken in by a 'cunning and artificiall counterfeit, which hee saw represented before his eyes'.[118]

Next, we should take up Hakewill's colourful appeal to 'the bowels of naturall Philosophy, and the Mathematicks' for examples of delusion of the eyes by artificial but now more licit (but not wholly uncontested) means. Nature afforded many opportunities for the manipulation of sight in ways that seemed astonishing to the uninitiated but were accounted for by the more arcane of the laws of optics. This was to invoke yet another major line of enquiry in early modern Europe, the pursuit of things that seemed beyond nature but were nevertheless located in its obscurest, most hidden recesses. Marked by curiosity and by wonder and intersecting at every point with other forms of natural philosophical knowledge, this too was a preoccupation of many other intellectuals, and Hakewill chose an example that was also often given by them—the camera obscura. Set it up, he said, in the usual manner, with a 'window' the size of a pea covered by a glass lens and a white sheet held up to it, 'and you shall perfectly discerne by the shaddowes, the shapes, the motions of men, and dogs, and horses, and birds, with the just proportion of trees, and chimnies, and towers which fall within the compasse of the sun neare the window'.[119]

Finally, Hakewill also turned to perhaps the most pervasive of all the forms of visual delusion talked about in his culture and age—the demonic. The devil of his Christianity had the power not only to turn himself into any shape or colour but also to change the appearance of all other objects in the visible world, 'in such sort, that sometimes he makes them seeme to be present when they are not, and

sometimes not to seeme when they are, and at other times againe, to appeare in another shape and fashion than they are indeed, and in their own nature'.[120] Sorcerers too could simulate the metamorphosis of one thing into another, or of humans into animals, as in the examples of Pharaoh's magicians and their rods and an old woman of Mecklenburg who had recently turned into a dog. The term for this, Hakewill acknowledged, might be 'enchantment' but since real transformation was an impossibility, what occurred was all too clearly a matter of 'imposture of the sight'—the 'casting' of mists and vapours 'before the beholders eyes', the use of legerdemain and 'conveiance', or the fitting of animal skins onto men and women who were rabid or lycanthropic. Additionally, the devil was usually involved in such sorceries as a manipulator of shapes and a producer of illusions, 'all by the delusion of the eye, and none of them by any reall or true change'.[121] The same was true of the feats of 'conjurers' like Trithemius, who 'raised' an exact replica of the dead Duchess of Burgundy for the Emperor Maximilian, like Agrippa and Faustus, who produced the faces of criminals in mirrors and made counterfeit banquets, and like Albertus Magnus, who achieved 'a perfect representation of spring'—complete with chirping and singing birds—in the chamber of the Earl of Holland. In support of these arguments and stories Hakewill cited books on demonic magic and witchcraft by late medieval and sixteenth-century writers, including *Malleus maleficarum* (*c*.1486), Johann Weyer's *De praestigiis daemonum* (1563), and Hermann Witekind's *Christlich Bedencken und Erinnerung von Zauberey* (1585).

What Hakewill does, in effect, is locate the question of the fallibility of the eyes and the malleability of eyesight in several of the major languages of European intellectual debate in the early modern centuries—especially those associated with philosophical scepticism, religious reformation, natural magic, and demonology. This will be my intention too in the chapters that follow, although in not quite this order of topics nor restricting myself entirely to his choice of them. Initially, at least, we must arrange things in a slightly different way, identifying the more elemental categories with which Hakewill was working. For underlying his arguments—and those of many other early modern intellectuals like him—was a taken-for-granted typology of visual error which traced it, in the broadest terms, to one or more of three causes: nature, human artifice, or demons. Whatever the precise reasons for exploring the waywardness of vision, these three modes of delusion, singly or in combination, were the framework within which more complex arguments could be constructed and to which they can, in consequence, be reduced. It will be important, then, in the next three early chapters, to examine each of these modes in turn, before looking in later chapters at how they manifested themselves in the religious, philosophical, and other developments alluded to by Hakewill, in the course of which visual experiences were rendered paradoxical by ideology and polemic, and, in one celebrated instance close in time to *The vanitie of the eye*, by literary invention. Each of these three preliminary

modes will tell an important individual story of the false appearances traceable to one particular kind of agency, while, together, they will begin to show just how powerfully Aristotelian assumptions about visual rationality were challenged during the sixteenth and seventeenth centuries.

NOTES

1. See esp. Nicholas Davey, 'The Hermeneutics of Seeing', in Ian Heywood and Barry Sandywell (eds.), *Interpreting Visual Culture: Explorations in the Hermeneutics of the Visual* (London, 1999), 3–29; Teresa Brennan and Martin Jay (eds.), *Vision in Context: Historical and Contemporary Perspectives on Sight* (New York, 1996), *passim*.
2. Only summary is needed here, given the accounts available in David C. Lindberg and Nicholas H. Steneck, 'The Sense of Vision and the Origins of Modern Science', in Allen G. Debus (ed.), *Science, Medicine and Society in the Renaissance: Essays to Honour Walter Pagel* (2 vols.; New York, 1972), i. 35–40; Louise Vinge, *The Five Senses: Studies in a Literary Tradition* (Lund, 1975), *passim*; Martin Jay, *Downcast Eyes: The Denigration of Vision in Twentieth-Century French Thought* (Berkeley, 1993), 21–45; Robert Jütte, *A History of the Senses: From Antiquity to Cyberspace*, trans. James Lynn (Cambridge, 2005), 19–101.
3. *Metaphysica*, 980a, 24–8, trans. anon., in *The Works of Aristotle*, ed. W. D. Ross (12 vols.; Oxford, 1908–52), viii. 980a; cf. *De sensu et sensibili*, 437a, 6–9: 'The faculty of seeing, thanks to the fact that all bodies are coloured, brings tidings of multitudes of distinctive qualities of all sorts', in *Parva naturalia*, trans. J. I. Beare and G. R. T. Ross, in *Works of Aristotle*, ed. Ross, iii. 437a.
4. Plato, *Timaeus*, 47, in *The Dialogues of Plato*, trans. B. Jowett (5 vols.; Oxford, 1892), iii. 466.
5. Lindberg and Steneck, 'Sense of Vision', 36; cf. David Summers, *The Judgment of Sense: Renaissance Naturalism and the Rise of Aesthetics* (Cambridge, 1987), ch. 1 ('The primacy of sight').
6. The work is described in Thomas Frangenberg, '*Auditus visu prestantior*: Comparisons of Hearing and Vision in Charles de Bovelles's *Liber de sensibus*', in Charles Burnett, Michael Fend, and Penelope Gouk (eds.), *The Second Sense: Studies in Hearing and Musical Judgment from Antiquity to the Seventeenth Century* (London, 1991), 71–4.
7. Thomas Wilson, *The arte of rhetorique* (London, 1553), 116r.
8. Ambroise Paré, *The workes*, trans. Th[omas] Johnson (London, 1634), 181–2.
9. Georg Bartisch, *Ophthalmodouleia, That is the Service of the Eyes*, trans. Donald L. Blanchard (Ostend, 1995), 4, cf. 10.
10. Richard Banister, *Breviary of the eyes*, sigs. b1r, a12v, in id., *A treatise of one hundred and thirteene diseases of the eyes, and eye-liddes* (London, 1622).
11. Helkiah Crooke, *Microcosmographia* (London, 1615), 530; cf. Jean Fernel, *The 'Physiologia' of Jean Fernel (1567)*, introd. John Henry and John M. Forrester, trans. John M. Forrester (Philadelphia, 2003), 113.
12. Pierre de La Primaudaye, *The French academie* (London, 1618), 368. This work appeared first in Thomas Bowes's translation in 1586, followed by five editions down to 1614. Three other editions by different translators also appeared down to 1605, with a final complete version (with dedicatory epistle by Bowes) in 1618. Another

popular standard French account is Scipion Dupleix, *Corps de philosophie* (Paris, 1627), pt. 2 ('La Physique'), bk. 8, 390–412.
13. Mary J. Carruthers, *The Book of Memory: A Study of Memory in Medieval Culture* (Cambridge, 1990), 17 (my interpolation), 27.
14. For this and other examples of the all-seeing eye of Providence, see Alexandra Walsham, *Providence in Early Modern England* (Oxford, 1999), 10–11, 19, 253, 255, 264, and plates 1, 33, 35, 40. Ralegh termed Providence '*oculus infinitus*, an infinite eye'. Margery Corbett and Ronald Lightbown, *The Comely Frontispiece: The Emblematic Title-Page in England 1550–1660* (London, 1979), 41–2, report that this was a new religious symbol, not used before the 16th century in England; cf. 37, 129–35.
15. Full details in Margaret Miles, 'Vision: The Eye of the Body and the Eye of the Mind in Saint Augustine's *De trinitate* and *Confessions*', *J. of Religion*, 63 (1983), 125–42, with quotations from *De trinitate* at 126, 137; and David Chidester, 'Symbolism and the Senses in Saint Augustine', *Religion*, 14 (1984), 31–51.
16. Sergei Lobanov-Rostovsky, 'Taming the Basilisk', in David Hillman and Carla Mazzio (eds.), *The Body in Parts: Fantasies of Corporeality in Early Modern Europe* (New York, 1997), 201.
17. Crooke, *Microcosmographia*, 536; the title page with the eye was added to the 1632 edn.
18. La Primaudaye, *French academie*, 368.
19. George Wither, *A collection of emblems, ancient and moderne* (London, 1635), 43.
20. Richard Brathwaite, *Essaies upon the five senses* (London, 1620), 63.
21. R. W. Scribner, 'Ways of Seeing in the Age of Dürer', in Dagmar Eichberger and Charles Zika (eds.), *Dürer and his Culture* (Cambridge, 1998), 97–9; id., *Religion and Culture in Germany (1400–1800)*, ed. Lyndal Roper (Leiden, 2001), 85–9, 115–16.
22. André Du Laurens, *Discours de la conservation de la veuë: des maladies melancholiques: des catarrhs: et de la vieillesse* (Paris, 1597), with numerous further editions and translations into Latin, English, and Italian. I have used the English version in id., *A discourse of the preservation of the sight: of melancholike diseases; of rheumes, and of old age*, trans. Richard Surphlet (London, 1599), 32.
23. Lobanov-Rostovsky, 'Taming the Basilisk', 201, for the phrase 'sovereign gaze'.
24. John Dod and Robert Cleaver, *A plaine and familiar exposition: of the eighteenth, nineteenth, and twentieth chapters of Proverbs* (London, 1611), 115–17 (internal quotation marks added); cf. Joseph Hall, *Salomons divine arts* (London, 1609), 117; [Thomas Wilcox], *The works of that late reverend and learned divine, Mr. Thomas Wilcocks . . . containing an exposition upon the whole booke of David's Psalmes, Salomons Proverbs* (London, 1624), 95; John Trapp, *Solomonis panaretos: or, a commentarie upon the books of Proverbs, Ecclesiastes, and the Song of Songs* (London, 1650), 233.
25. Arthur Jackson, *Annotations upon the five books, immediately following the historicall part of the Old Testament . . . To wit, the Book of Job, the Psalms, the Proverbs* (London, 1658), 847.
26. Fernando Chirino de Salazar, *Expositio in Proverbia Salomonis* (2 vols.; Paris, 1619), ii, col. 241. The tract *De regimine principum*, usually attributed to St Thomas Aquinas during the early modern period, contains a chapter (bk. iii, ch. 2) discussing why the eyes of kings were brightened by a greater light than those of private men: see Thomas Aquinas, *De regimine principum ad regem Cypri . . .* , ed. Joseph Mathis, 2nd edn.

(Turin, 1971), 39–40. See also Shakespeare's *Richard II*, 3. 3. 68–70: 'Yet looks he like a king. Behold his eye, | As bright as is the eagle's, lightens forth | Controlling majesty.'
27. On these themes see 'The Eye of Power', in Michel Foucault, *Power/Knowledge: Selected Interviews and Other Writings 1972–1977*, ed. Colin Gordon, trans. Colin Gordon et al. (New York, 1980), 146–65.
28. There are three main older studies: Hans Kauffmann, 'Die Fünfsinne in der niederländischen Malerei des 17. Jahrhunderts', in Hans Tintelnot (ed.), *Kunstgeschichtliche Studien: Festschrift für Dagobert Frey* (Breslau, 1943), 133–57; Carl Nordenfalk, 'The Five Senses in Late Medieval and Renaissance Art', *J. Warburg and Courtauld Inst.* 48 (1985), 1–22; and id., 'The Five Senses in Flemish Art before 1600', in Görel Cavalli-Björkman (ed.), *Netherlandish Mannerism* (Stockholm, 1985), 135–54. These have now been superseded by Sylvia Ferino-Pagden (ed.), *Immagini del sentire: i cinque sensi nell'arte* (Cremona, 1996). Andor Pigler, *Barockthemen: Eine Auswahl von Verzeichnissen zur Ikonographie des 17. und 18. Jahrhunderts* (3 vols.; Budapest, 1974), ii. 483–5, also lists depictions of the senses.
29. Kauffmann, 'Die Fünfsinne', 137–8.
30. Ferino-Pagden (ed.), *Immagini del sentire*, 112–13.
31. Examples ibid. 45, 241–9.
32. Bryson, 'Gaze', 91.
33. For present purposes, the best introduction to the Aristotelian 'chain of cognition' is Gary Hatfield, 'The Cognitive Faculties', in Daniel Garber and Michael Ayers (eds.), *The Cambridge History of Seventeenth-Century Philosophy* (2 vols.; Cambridge, 1998), ii. 954–61. Hatfield summarizes Renaissance and late scholastic commentators on Aristotle's *De anima* (Thomas Aquinas, Duns Scotus, the Coimbra Jesuits, Philipp Melanchthon, Francisco Suárez, Antonius Rubius, Franciscus Toletus, and Jacopo Zabarella) and authors of physics textbooks (Eustachius a Sancto Paulo, Bartholomaeus Keckermann, and Melanchthon). The standard texts on cognitive psychology among such intellectuals were, besides *De anima*, those contained in Aristotle's *Parva naturalia*: *De sensu et sensibili* (On sensation and what can be sensed), *De memoria et reminiscentia* (On memory and recollection), *De somno* (On sleep), and *De somniis* (On dreams). On Aristotle himself, there are helpful commentaries in Stephen Everson, *Aristotle on Perception* (Oxford, 1997), *passim*, esp. ch. 5: 'Perceptual Content'; T. K. Johansen, *Aristotle on the Sense-Organs* (Cambridge, 1998), 23–147; and Stephen Gaukroger (trans. and ed.), *A. Arnauld: 'On True and False Ideas'* (Manchester, 1990), 4–10.
34. *De anima*, trans. J. A. Smith, in *Works of Aristotle*, ed. Ross, iii. 418a, 5–419b. For later medieval versions, see the statements by Pierre d'Ailly and John Pecham cited in Lindberg and Steneck, 'Sense of Vision', 34.
35. *De anima*, 424a, 15–25.
36. Aristotle, *De memoria et reminiscentia*, in *Parva naturalia*, 450a, 25–32; the Platonic equivalent is in *Theaetetus*, 191D, in *Dialogues*, iv. 255.
37. I use this form—*species*—throughout this book to distinguish the technical cognitive meaning of something that is sensed (a kind of image) from the more common modern use of the word to denote the categorizing of individuals at a lower level than genus. The subject is handled in great detail by Katherine H. Tachau, *Vision and Certitude in the Age of Ockham: Optics, Epistemology and the Foundations of Semantics, 1250–1345* (Leiden, 1988); cf. ead., 'The Problem of the *Species in medio* at Oxford in

the Generation after Ockham', *Mediaeval Stud.* 44 (1982), 394–443; and Robert Pasnau, *Theories of Cognition in the Later Middle Ages* (Cambridge, 1997), *passim*, esp. 11–27, 63–85, 86–124. An expert overview of the 'prevailing model of visuality' in the later middle ages is offered by Michael Camille, 'Before the Gaze: The Internal Senses and Late Medieval Practices of Seeing', in Nelson (ed.), *Visuality before and beyond the Renaissance*, 197–223, esp. 202–11, but the best short account of visual cognition among the later medieval 'perspectivists' is A. Mark Smith, 'Getting the Big Picture in Perspectivist Optics', *Isis*, 72 (1981), 568–89. See also David C. Lindberg, *Theories of Vision from al-Kindi to Kepler* (Chicago, 1976), 104–46; id., *Roger Bacon and the Origins of 'Perspectiva' in the Middle Ages: A Critical Edition and English Translation of Bacon's 'Perspectiva' with Introduction and Notes* (Oxford, 1996), 'Introduction', esp. pp. lxviii–lxxxvii; Summers, *Judgment of Sense*, 153–64; and Suzannah Biernoff, *Sight and Embodiment in the Middle Ages* (London, 2002), esp. 63–84.

38. Tachau, *Vision and Certitude*, 3–26, esp. 16–17 (which I follow). The work is ed. and trans. in David C. Lindberg, *Roger Bacon's Philosophy of Nature: A Critical Edition, with English Translation, Introduction, and Notes* (Oxford, 1983).
39. Aristotle, *De memoria*, in *Parva naturalia*, 450a, 10–30.
40. Camille, 'Before the Gaze', 208–9; Tachau, *Vision and Certitude*, 8, and on mirroring, 4, 26; Lindberg, *Theories of Vision*, 114.
41. Chidester, 'Symbolism and the Senses in Saint Augustine', 40.
42. The fullest and most persuasive of such readings is by Carruthers, *Book of Memory*, 21–32.
43. Hatfield, 'Cognitive Faculties', 957 (and nn. 22 and 23)
44. René Descartes, 'Optics', in *The Philosophical Writings of Descartes*, trans. and ed. John Cottingham, Robert Stoothoff, and Dugald Murdoch (3 vols.; Cambridge, 1984), i. 153–4; for more on Descartes, see Ch. 10 below.
45. Joel Snyder, 'Picturing Vision', *Critical Inquiry*, 6 (1980), 499–526, repr. in W. J. T. Mitchell (ed.), *The Language of Images* (Chicago, 1980), 219–46.
46. Hatfield, 'Cognitive Faculties', 957–9; Lindberg, *Theories of Vision*, 58–86; id., 'Introduction', in *Opticae thesaurus* (optical works by Alhazen and Witelo, orig. ed. Friedrich Risner, Basel, 1572) (New York, 1972), p. xvii (Lindberg summarizes the influence of Alhazen and Witelo through the 16th and 17th centuries at pp. xxiii–xxv); id., 'The Science of Optics', in id. (ed.), *Science in the Middle Ages* (Chicago, 1978), 342–9. Carruthers, *Book of Memory*, 48, emphasizes the way images were thought to be materially present in the brain as physically stamped there. She writes that the assumption 'within which psychological explorations were framed [by Aristotle's medieval heirs] was that the whole sensing process, from initial reception by a sense-organ to awareness of, response to, and memory of it, is somatic or bodily in nature'.
47. Smith, 'Getting the Big Picture', 582.
48. Ibid. 587; Tachau, *Vision and Certitude*, 16–17, 19.
49. Biernoff, *Sight and Embodiment*, 85, cf. 75 on perceptual certitude being ensured because *species* are *natural* signs of their objects, making the external object, its *species*, and the mental representation of it 'ontologically continuous'.
50. Gary C. Hatfield and William Epstein, 'The Sensory Core and the Medieval Foundations of Early Modern Perceptual Theory', *Isis*, 70 (1979), 369, and see 365–79, for visual theory down to Descartes.

51. Cited by Lindberg, *Theories of Vision*, 150.
52. Katherine Tachau, '*Et maxime visus, cuius species venit ad stellas et ad quem species stellarum veniunt*: *Perspectiva* and *Astrologia* in Late Medieval Thought', in 'La visione e lo sguardo nel Medio Evo, i/View and Vision in the Middle Ages, i', special issue of *Micrologus*, 5 (1997), 212; cf. Tachau, *Vision and Certitude*, 8–10.
53. Gabriella Federici Vescovini, 'Vision et réalité dans la perspective au xive siècle', in 'La visione e lo sguardo nel Medio Evo, i/View and Vision in the Middle Ages, i', special issue of *Micrologus*, 5 (1997), 177, and 161–80 *passim* on theories of *visio certificata* during the 13th and 14th centuries.
54. Cited by Giorgio Agamben, *Stanzas: Word and Phantasm in Western Culture*, trans. Ronald L. Martinez (Minneapolis, 1993; orig. pub. 1977), 80–1; cf. Lindberg, *Theories of Vision*, 55.
55. Camille, 'Before the Gaze', 210–11, 208, 206. On the last point Camille quotes Smith, 'Getting the Big Picture', 571: 'the abstracted meanings in sense experience are veridical—not merely read *into* the phenomena, but actually drawn from them.' Cf. also ibid. 574 n. 24, where Smith comments: 'it is no wonder that *species*, even when intended as purely intelligible, was taken as a sort of pictorial representation in the mind.' For the persistence of optical metaphors for perception down to Kepler, see Lindberg, *Theories of Vision*, 202–5.
56. Reisch's chapters on cognition and sense perception are summarized from the edn. of 1517 by Katharine Park, 'The Organic Soul', in Charles B. Schmitt, Quentin Skinner, et al. (eds.), *The Cambridge History of Renaissance Philosophy* (Cambridge, 1988), 465–73 (quotations at 471); on the 'shift toward Aristotelianism', see Lindberg, *Theories of Vision*, 144, and on the persistence of 'medieval visual theory' in the perspectival and anatomical experiments of the Renaissance, 147–77.
57. *Batman uppon Bartholome, his booke De proprietatibus rerum* (London, 1582), 17ᵛ–19ʳ ('Of the virtue visible'). This was an edn. and commentary by Stephen Batman (or Bateman) of John of Trevisa's translation of *De proprietatibus rerum*. The encyclopedia was first printed in 1472, translated into English in 1495, and reprinted many times down to 1582 (with at least 22 continental editions in other languages down to 1601).
58. La Primaudaye, *French academie*, 414.
59. Dupleix, *Corps de philosophie*, pt. 2, 410.
60. Debora Shuger, 'The "I" of the Beholder: Renaissance Mirrors and the Reflexive Mind', in Patricia Fumerton and Simon Hunt (eds.), *Renaissance Culture and the Everyday* (Philadelphia, 1999), 31 and, for Davies, 27–9.
61. Nordenfalk, 'Five Senses in Late Medieval and Renaissance Art', 5–6; Ferino-Pagden (ed.), *Immagini del sentire*, 78–9. The copy is at the Wellcome Institute for the History of Medicine, MS Inc. 283.
62. Cited in Shuger, 'The "I" of the Beholder', 33.
63. Gianfrancesco Pico della Mirandola, *On the Imagination*, trans. and ed. Harry Caplan (New Haven, 1930), 29. For more on this text, see Ch. 2 below.
64. L. J. Rather, 'Thomas Fienus' (1567–1631) Dialectical Investigation of the Imagination as Cause and Cure of Bodily Disease', *Bull. of the Hist. of Medicine*, 41 (1967), 352–3.
65. Thomas Wright, *The passions of the minde* (London, 1601), 245.
66. Franceso Maurolico, *Photismi de lumine et umbra ad perspectivam, et radiorum incidentiam facientes*, ed. and trans. Henry Crew, *The Photismi de lumine of Maurolycus* (New York, 1940), 106 (editor's interpolation).

67. Lobanov-Rostovsky, 'Taming the Basilisk', 202, commenting on Du Laurens, *Discourse*, 32.
68. Fernel, *'Physiologia'*, 473.
69. Paré, *Workes*, 897.
70. Crooke, *Microcosmographia*, 557, 568, 569, 571.
71. I am thinking, in particular, of the sorts of naturalisms explored (though not necessarily endorsed) in such studies as the following: Svetlana Alpers, *The Art of Describing: Dutch Art in the Seventeenth Century* (London, 1983); Summers, *Judgment of Sense*; Martin Kemp, *The Science of Art: Optical Themes in Western Art from Brunelleschi to Seurat* (New Haven, 1990); id., ' "The Mark of Truth": Looking and Learning in Some Anatomical Illustrations from the Renaissance and Eighteenth Century', in W. F. Bynum and Roy Porter (eds.), *Medicine and the Five Senses* (Cambridge, 1993), 85–121; Thomas DaCosta Kaufmann, *The Master of Nature: Aspects of Art, Science, and Humanism in the Renaissance* (Princeton, 1993); Peter Parshall, 'Imago contrafacta: Images and Facts in the Northern Renaissance', *Art Hist.* 16 (1993), 554–79; Brian S. Baigrie (ed.), *Picturing Knowledge: Historical and Philosophical Problems Concerning the Use of Art in Science* (Toronto, 1996), esp. the essays by Martin Kemp ('Temples of the Body and Temples of the Cosmos: Vision and Visualization in the Vesalian and Copernican Revolutions', 40–85), and Bert Hall ('The Didactic and the Elegant: Some Thoughts on Scientific and Technological Illustrations in the Middle Ages and Renaissance', 3–39); Alastair Fowler, *Renaissance Realism: Narrative Images in Literature and Art* (Oxford, 2003); Claudia Swan, *Art, Science, and Witchcraft in Early Modern Holland: Jacques de Gheyn II (1565–1629)* (Cambridge, 2005), 5–12, 29–120, esp. 10 on the currency of the 'ad vivum' ideal, used to guarantee 'the substitutability of the image for the thing [it] described'.
72. The 'intensely visual' nature of much of popular piety, at least insofar as bodily seeing was concerned, is highlighted in the later work of Bob Scribner. For what he called the 'apprehension of the sacred through seeing', see Scribner, *Religion and Culture*, 85–128.
73. Tachau, *Vision and Certainty*, 23–4, cf. 37, 57, 90–3, 102–5, 130–5, 140–8.
74. See, for example, Lobanov-Rostovsky, 'Taming the Basilisk', 198–9, who mainly highlights the threats from ocular anatomy's 'reduction of the eye to flesh' and the Petrarchan literary conceit of the eroticized and effeminized eye (see esp. 197).
75. Bruce R. Smith, *The Acoustic World of Early Modern England: Attending to the O-Factor* (Chicago, 1999), 101–6 (concentrating on Francis Bacon); on touch, see the 'Introduction' and essays in Elizabeth D. Harvey (ed.), *Sensible Flesh: On Touch in Early Modern Culture* (Philadelphia, 2003). For well-known older, but now discredited, views on the primacy of hearing and touch, taken from the writings of Lucien Febvre and Robert Mandrou, see Jay, *Downcast Eyes*, 34–5.
76. Aristotle, *De sensu et sensibili*, in *Parva naturalia*, 437a, 3–17.
77. Details in Frangenberg, *'Auditus visu prestantior'*, 74–89.
78. La Primaudaye, *French academie*, 367.
79. Cicero, *Tusculan Disputations II and V with a Summary of III and IV*, ed. and trans. A. E. Douglas (Warminster, 1990), 137–41. Typical early modern examples of this popular genre are the French poet Jean Passerat's 'De caecitate oratio', published separately in Paris in 1597 and in Caspar Dornavius, *Amphitheatrum sapientiae socraticae joco-seriae* (2 vols. in 1; Hanau, 1619), ii. 262–4, and the Dutch humanist

Jacobus Gutherius' 'Encomium caecitatis', in anon., *Admiranda rerum admirabilium encomia* (Nijmegen, 1666), 245–76.

80. [Ortensio Landi], *The defence of contraries*, trans. A[nthony] M[unday] (London, 1593), 33–40 (also issued in 1602 by Thomas Lodge as *Paradoxes against common opinion*). The French trans. of the collection by Charles Estienne appeared in Caen in 1554 under the title of the first paradox in it: *Paradoxe qu'il vaut mieux estre pauvre que riche*.
81. R[obert] H[eath], *Paradoxical assertions and philosophical problems* (London, 1659), 46–8.
82. S.S., *Paradoxes or encomions in the praise of being lowsey. Treachery. Nothing. Beggery. The French pox. Blindnesse. The Emperor Nero. Madnesse* (London, 1653), 17; cf. Vinge, *Five Senses*, 124, talking of the French author Jean-François Senault.
83. See Herbert Grabes, *The Mutable Glass: Mirror-Imagery in Titles and Texts of the Middle Ages and the English Renaissance*, trans. Gordon Collier (Cambridge, 1982); Shuger, 'The "I" of the Beholder', 22–30.
84. On the oscillating ambiguity of mirrors, see esp. Barbara Maria Stafford and Frances Terpak, *Devices of Wonder: From the World in a Box to Images on a Screen* (Los Angeles, 2001), 20–30, esp. 25; Jonathan Miller, *On Reflection* (London, 1998), 172–5.
85. Raphaël Mirami, *Compendiosa introduttione alla prima parte della specularia* (1582), quoted by Edward Peter Nolan, *Now Through a Glass Darkly: Specular Images of Being and Knowing from Virgil to Chaucer* (Ann Arbor, 1990), 291.
86. Examples in Miller, *On Reflection*, 156–75; cf. Ferino-Pagden (ed.), *Immagini del sentire*, 117.
87. Paula Findlen, *Possessing Nature: Museums, Collecting, and Scientific Culture in Early Modern Italy* (Berkeley, 1994), 303.
88. Vinge, *Five Senses*, 71–103; see also J. F. Kermode, 'The Banquet of Sense', *Bull. of the John Rylands Library*, 44 (1961–2), 68–99, on sense-by-sense temptations in early modern poetry and the 'banquet' of them all as the 'pagan shadow of the Eucharist'.
89. Marc Bensimon, 'Modes of Perception of Reality in the Renaissance', in R. S. Kinsman (ed.), *The Darker Vision of the Renaissance: Beyond the Fields of Reason* (Berkeley, 1974), 250, 252–3.
90. *The Works of Michael Drayton*, ed. J. William Hebel (5 vols.; Oxford, 1961), ii. 325 (*Idea*, sonnet 29).
91. Edmund Spenser, *The Faerie Queene*, bk. 2, canto xi, 8–9, in *The Poetical Works of Edmund Spenser*, ed. J. C. Smith (3 vols.; Oxford, 1909, repr. 1961), ii. 309.
92. Kermode, 'Banquet of Sense', 79.
93. Notably via its use by Norman Bryson, *Vision and Painting: The Logic of the Gaze* (London, 1983), 1–12 and *passim*.
94. Pliny the Elder, *Natural History*, trans. H. Rackham (10 vols.; London, 1938–63), ix. 309–11 (bk. 35, 65–6).
95. Rosalie L. Colie, *Paradoxia epidemica: The Renaissance Tradition of Paradox* (Princeton, 1966), 276–7.
96. Laurens van Haecht Goidtsenhoven (Haechtanus), *Microcosmos. Parvus mundus*, trans. into French Henricus Costerius (Antwerp, 1592), 74r.
97. Leon Battista Alberti, *On Painting*, trans. and ed. John R. Spencer, rev. edn. (New Haven, 1966), 64.
98. Nordenfalk, 'Five Senses in Late Medieval and Renaissance Art', 3.

99. St Augustine, *Confessions*, trans. and ed. Henry Chadwick (Oxford, 1991), 209–11 (bk. x, caps. 34–5).
100. Cited by Bensimon, 'Modes of Perception', 268, and cf. 267–9, on visionaries.
101. Vinge, *Five Senses*, 63–4 (Isidore), 66–9 (Vincent), and 47–70 *passim* for other medieval views.
102. Richard Greenham, 'Of the government of the eyes', in *Workes*, 5th edn. (London, 1612), 675–8. On Eve's eyes betraying her soul, see also S.S., *Paradoxes*, 16; Ernest B. Gilman, 'Word and Image in Quarles' *Emblemes*', in Mitchell (ed.), *Language of Images*, 59–84. For the 'visual moment' in the Fall as a traditional element in commentary, see Biernoff, *Sight and Embodiment*, 41–6.
103. Richard Day, *A booke of Christian prayers* (London, 1578), 55ʳ, cf. 75ᵛ; the full verses read (King James version): 'Let thine eyes look right on, and let thine eyelids look straight before thee.'
104. Johannes David, *Veridicus Christianus* (Antwerp, 1601), 218–25 (engraving opposite 218), cf. 131–2.
105. All references are to the fourth edition published at Oxford in 1633 (which says 'second' on its title page); the second and third editions appeared in 1608 and 1615. Constantijn Huygens also wrote a poem, *Eufrasia-oogen-troost-grootendeelr toegelicht* (Leiden, 1647), in which he comforted a woman who had lost an eye by referring to the blindness of those who still had two; see Gill Speak, 'An Odd Kind of Melancholy: Reflections on the Glass Delusion in Europe (1440–1680)', *Hist. of Psychiatry*, 1 (1990), 198.
106. Hakewill, *Vanitie*, 6, 14.
107. Ibid. 22.
108. Ibid. 102.
109. Ibid. 104.
110. Ibid. 90.
111. Commentary in Victor Harris, *All Coherence Gone: A Study of the Seventeenth Century Controversy over Disorder and Decay in the Universe* (London, 1966), 47–85.
112. Hakewill, *Vanitie*, 11.
113. Ibid. 27.
114. Ibid. 127–8.
115. Ibid. 55–6.
116. Ibid. 51.
117. Ibid. 54.
118. Ibid. 75.
119. Ibid. 57.
120. Ibid. 60.
121. Ibid. 67, 73.

2

Fantasies: Seeing Without What was Within

To begin with, it was obvious that nature itself was responsible for a whole range of visual phenomena that undermined the certainties of sight, without any other agency being involved. Late Renaissance physiology and psychology offered many fresh accounts of these visual failures, covering everything from impairments to the eyes to the far-reaching effects of malfunctions in the mind. A key impetus for this literature was the new importance and attention given to the human imagination. Few doubted its power to influence as well as facilitate visual perception, or, in reverse, the occurrence of visual experiences so powerful that they impacted via the imagination on the body. What drew unprecedented comment, rather, was the extent to which unstable mental states could cause wholesale visual disruption—or as Hakewill put it: 'delusion of the sight . . . by the giddines of the braine, by the distemper of phrensies, and . . . by the violent passions of feare and melancholy'.[1] Madness, melancholy, and lycanthropy were widely discussed in this period, and were in some respects preoccupations of the age. An endless series of theoretical analyses and dramatic individual illustrations of these conditions circulated through Europe, both confirming an older philosophical scepticism based on the relativity of visual perception and establishing a new series of naturalistic benchmarks for illusion as well. Here as elsewhere, contemporary intellectuals were confronting an issue that has seemed to inform modern discussions of visuality—the extent to which sight is a constructed medium and the eye not the innocent, objective reporter of the world but its creator and interpreter.

Of course, it might be objected that sickness and, especially, madness can hardly be considered telling indicators of the conditions of sight when seeing is mostly done in states of health and sanity. The illusions of the mad can easily be discounted in favour of the normal perceptions of the sane. To this the reply can only be the one given originally by the sceptical relativists of antiquity and repeated by their sixteenth-century disciple Montaigne—that normality is as much a condition as its opposite:

[S]ince the accidents of illnesses, madness, or sleep make things appear to us otherwise than they appear to healthy people, wise men, and waking people, is it not likely that our normal state and our natural disposition can also assign to things an essence corresponding

to our condition, and accommodate them to us, as our disordered states do? And that our health is as capable of giving them its own appearance as sickness? Why should the temperate man not have some vision of things related to himself, like the intemperate man, and likewise imprint his own character on them?[2]

We will return to this idea in a much later chapter, but it is well to bear it in mind throughout what immediately follows.

The vision theories of all ages and cultures allow for physical pathologies of the eyes and those of early modern Europe were no exception.[3] General medical textbooks, treatises on the body (especially the head), and specialist ophthalmological monographs—the latter ranging in size and complexity from the comprehensive, graphically illustrated, and widely cited *Ophthalmodouleia*, published by the Saxon eye-surgeon Georg Bartisch in Dresden in 1583, to the 'uncommon observations about vitiated sight' that Robert Boyle appended to his *A disquisition about the final causes of natural things* (1688)—described what were often said to be the especially numerous 'hurts' which the eyes could suffer, along with the means for preserving sight and combating eye diseases. Ocular illusion was not always involved here; the eyes might weaken without showing other abnormalities, or they might simply give up altogether. But between these two possibilities, as the noted French anatomist and royal physician André Du Laurens explained, lay a third—the 'falsifying' of sight, 'when the object sheweth it selfe to be of another colour, forme, quantitie or situation then it is'. This was the case, for instance, with jaundice, vertigo, and ocular palsy, not to mention drunkenness.[4] These three alternatives—*diminutio, privatio, depravatio*—were in fact commonly adopted in the medical world, and so was Du Laurens's definition of the last. The leading medical authority at Wittenberg University in the early seventeenth century, Daniel Sennert, said that the distortion of vision (*depravatio visus*) occurred when 'in various ways things are represented to sight other than they are'.[5]

Du Laurens's contemporary, the surgeon Jacques Guillemeau, a fellow royal physician and both the pupil of Ambroise Paré and his collaborator, listed 113 eye diseases in his *Traité des maladies de l'œil* (1585), many of which led to 'falsifications'. Those with bloodshot eyes (*hyposphagma*) saw everything as red, as if through coloured glass, while those with permanently dilated pupils (*mydriasis* or *platycoriasis*) or narrow and weak ones (*ophthalmophthisis*) magnified every visual object. The disease of the optic nerve known as *amaurosis* caused its sufferers to 'take one thing for another', a form of 'deceitfull sight' also termed *hallucinatio*. Cataracts caused the greatest problems, slicing off or dividing up parts of the visual field or obscuring its centre, and generally hindering 'the discerning and judging of such things as are before our eyes'. Guillemeau noted that among the Latin terms for the condition was *imaginatio*, since one of its early signs was that 'we imagine we see that which indeede wee see not'.[6] 'Cataracts', wrote Du Laurens in agreement, 'have alwaies for their forerunners, certaine false visions, which men call imaginations: for men thinke they see flies, haires, or

threeds of a spider web in the ayre, which yet are not there.' The unnatural humours and vapours which intruded between the corneal membrane and crystalline lens in the eye to cause this particular 'falsifying' of sight were interpreted as things in the external world simply because the mind was so used to seeing outward objects 'that it thinketh that which is within the eye to be without it'.[7] The thinking mind, it seems, was more responsible for what was seen than the presence or absence of objects in the visual field.

Clouds of small flies seem to have flown (or perhaps swum—many eyes were lice inhabited) disconcertingly across the diseased eyes of early modern Europeans.[8] Cataracts were mostly to blame, as the theory demanded. One authority, who cited Galen on the subject, explained that they induced the mind to imagine gnats and midges (*culices*) in the outside world when none were there.[9] The great French physician Jean Riolan said much the same thing, and so in Heidelberg did Christoph Wirsung in his hugely popular *Artzney Buch*, and in Wittenberg, Sennert.[10] The distinguished German mathematician and astronomer Christoph Scheiner, who famously observed sun spots in 1612, was presumably not confusing *maculae* (spots) with *muscae* (flies) when he blamed 'suffusions' for the latter, adding that they fooled the eye with 'false likenesses of things'.[11] Robert Boyle reported the case of a man with pre-cataract symptoms before whose eyes 'divers black flyes and litle leaves . . . pass'd now and then'.[12] According to the popular Elizabethan medical authority Philip Barrough, too much of the melancholic humour could also make patients think that there were 'flies flying in the aier', as well as multiple moons and 'three or four faces' when only one was viewed.[13] 'Dotage' had much the same effects, in Felix Platter's opinion, causing 'flies, locks of wooll, [and] straws' before the eyes. Sufferers imagined seeing 'divers apparitions', which they then tried to seize or drive away.[14] Cataracts could also be blamed for more elaborate delusions. The Évreux physician Jourdain Guibelet was asked to give an opinion on a local man who claimed that a firebrand kept appearing beside him, and warned him that it was the sign of a coming 'suffusion'.[15] In among the fleas, gnats, flies, beetles, and spiders seen by the diseased eyes described by his Netherlands colleague Levinus Lemnius were 'Hobgoblins, witches, [and] fairies'.[16]

Eye problems could, indeed, take very bizarre forms, as evinced by the striking illustrations of them in Bartisch's textbook or the story told by Robert Bayfield of the man who raised his eyes so violently in his head that he displaced the crystalline lenses and 'saw all things afterwards turned upwards, as though men walked upon their heads'.[17] Nevertheless, although probably more numerous and complex in exposition, none of them was very different in kind from afflictions that had always been identified. Moreover, none had conceptual implications beyond the confusion between things 'within' and 'without' the eye, and the significance of even this potentially fundamental issue was largely missed in technical ophthalmology, with its perfectly legitimate concentration on eye pathology rather than visual theory.[18] For real awareness of its implications we

need to turn to how disturbances of the mind—and specifically of the imagination—made a new and devastating impact on theories of the visual process.

In the decades either side of 1600, the imagination was still essentially an internal sense (an 'inner wit') charged with the perception of absent sense objects, just as the five external senses (the 'outer wits') perceived present ones. By its particular virtue, according to a popular English account of the period, were apprehended the 'likenesse[s] and shapes of things of perticulars receyved, though they bee absent'.[19] This made the early modern imagination essentially what it had been for Aristotle, who had declared canonically in *De anima* that 'visions appear to us even when our eyes are shut'.[20] It was still known as much by the Greek name *phantasia* ('fantasy' or 'fancy' in English) as by the Latin *imaginatio*, and the sensible forms (*species*, *idola*, or *similitudines*) of external things which it retained and manipulated were also still called *phantasmata* (hence 'phantasies', or 'fantasies').[21] The systematic psychology into which the role of the imagination was fitted varied a good deal, however. Traditionalists continued to invoke a 'faculty psychology', already current for several centuries, whereby the workings of the soul were distributed between two organic functions, the 'vegetative' or 'vital' (shared with plants) and the 'sensitive' (shared with animals), and one non-organic function, the 'intellective' or 'rational' (unique to humans and immortal). In this scheme, the imagination belonged to the sensitive (or animal) soul and shared with other internal senses, notably 'common sense' and memory, the responsibility for apprehension, appetition, and local motion. An absolutely standard version of this traditional account was given by the Counter-Reformation theologian and bishop Nicolas Coëffeteau, in a work that must have virtually dominated orthodox seventeenth-century French discussions of the human passions. Once the exterior senses had done their job of gathering the forms (*species*) of external objects and sending them to the common sense for preliminary comparison and analysis, explained Coëffeteau, the imagination's task was to preserve them after the objects themselves had disappeared, transmit them onwards to the memory for long-term retention and retrieval, and propound them to both the appetite and the understanding for higher-level decisions in the spheres of judgement and action.[22]

Alternatively, psychological theory could be much more streamlined. In 1578, in a work with an even greater dispersion than Coëffeteau's, entitled *Examen de los ingenios para las sciencias*, the Spanish physician Juan Huarte accounted for the aptitudes that made particular men successful in some occupations and not in others by mapping every variation in natural ability onto the simple psychological triad of imagination, memory, and understanding.[23] A standard German Protestant treatise of the same period by the Hanau theologian and philosopher Otto Casmann relied likewise on imagination, memory, and reason, and in Francis Bacon's *The advancement of learning* (1605) these were assumed to be the three parts of 'Man's Understanding' (his rational soul) to which the three

divisions of human learning—poetry, history, and philosophy—must therefore conform. These more simplified schemas still dealt in 'faculties' with different roles in human mental life and decision-making, but were otherwise distinct from the philosophical psychology of the traditionalists.[24]

Indeed, these main differences in how mental powers were classified and arranged at the turn of the seventeenth century tell an important story about the Renaissance imagination, first uncovered by the historian Katharine Park, over three decades ago.[25] For while Coëffeteau's complicated faculty psychology was certainly still usable in 1620 and beyond, particularly in more conservative and popularizing contexts, it was nevertheless in overall decline.[26] The simplifications of Huarte, Casmann, and Bacon, by contrast, reflected a trend stretching back for most of a century. Faculty psychology, although originally inspired by ancient texts like *De anima*, was mainly the product of the medieval Arabic commentators on Aristotle, Avicenna and Averroes, and, later, of Western Latin scholars like Albertus Magnus, Thomas Aquinas, and Duns Scotus.[27] By the 1530s, however, anatomists of the brain had questioned and abandoned its ventricular basis, and philosophers were under twin pressures to reform its complicated divisions and subdivisions of psychological categories. The first of these arose from the scholarship that drove Renaissance readers back to the original texts of Aristotle and Galen, where they discovered that triadic classifications had only ever been on offer—in Aristotle's case that of the internal senses of common sense, imagination, and memory, and in Galen's, that of the broader faculties of imagination, memory, and reason. The second stemmed from the increasing influence of competing Neoplatonic ideas which, again, tended to divide perception between the sensible and the intellective, with the imagination acting in a third mediating role.

The key beneficiary of these widespread shifts in emphasis, according to Katharine Park, was the imagination. What was new in early modern theoretical psychology gave the imagination a unity and a uniqueness that were impossible in the context of late medieval Aristotelianism. In the faculty psychology of Avicenna, for example, the internal senses had multiplied to five, with the result that the imagination's functions were split up and shared with other senses. With the decline of this arrangement and the eclipse of faculty psychology in general, imagination subsumed all the functions of internal sense and so 'acquired greater importance in the psychological literature of the sixteenth century—particularly with those writers that showed strong [N]eoplatonic influence—than ever before'.[28] The imagination was no longer one among many auxiliary powers of the soul, but one of the three or four dominant ones that made up its operations. More than that, it became the single mediator between the incorporeal soul and the corporeal human body.

This new-found importance is clearly reflected in the very many positive evaluations of the imagination that one finds in early modern writing. As a motion of the soul with the power to conceive of likenesses of sensible objects and place

them in or before the memory, will, and intellect, the *vis phantastica* was indispensable to human perception and cognition, which would have failed without it. In 1501, in the earliest of the imagination monographs that began to appear for the first time in early modern Europe, Gianfrancesco Pico della Mirandola wrote that, tied to the body as it was, the soul could not 'opine, know, or comprehend at all, if phantasy were not constantly to supply it with the images themselves'.[29] The imagination was positioned at a crucial borderline, being required to complete both a sequence and a hierarchy; before and below it came sense, after and above it, intellect. While external sense was tied strictly to the presence of objects and the task of reporting them, imagination combined perception and reproduction with the freer mental processes of constructing, combining, and manipulating images. Only the intellect had greater significance, being alone capable of ascending to the world of the universal and immaterial.

Not surprisingly, the combinatory functions of the imagination helped in particular to justify the revaluation of artistic and poetic production that marked Renaissance creative theory—a process first seen in the new claims concerning the cognitive operations of *phantasia* made by intellectuals like Leonardo, Michelangelo, and Dürer. Earlier than any of these, Cennino Cennini wrote around the turn of the fifteenth century that painting demanded 'fantasy' in order to represent 'things not seen . . . showing that which is not, to be'.[30] Much later, in the appropriately rhetorical terms adopted by one of seventeenth-century England's best-known anatomists of the soul, Edward Reynolds, the value of the imagination was said to lie in enticing the understanding with 'matter of invention' and the will with persuasive arguments, in each case by adding 'delight' to the process. Not just the matter but the manner of its imaging was therefore fundamental to things as important as individual religious conviction and the establishing of 'civill societie', as well as to moral choice in general. But besides these mental offices, the imagination also possessed infinite latitude in the form of 'multiplicitie of operations', 'abundance of objects', and 'quicknesse of apprehension'; its mental travels were marked by 'suddennesse of journey, and vastnesse of way'. Reynolds, like many of his contemporaries, was able to portray the imagination positively as a normative but highly attractive faculty, combining seriousness of content with beauty of form, and exhibiting limitless range, liveliness, and creativity. In the 'framing of objects', no other faculty could match its freedom or ambition to recreate, recompose, and relocate images. Even reason was literal minded and constrained by the truth of things, '[b]ut the Imagination is a facultie boundlesse, and impatient of any imposed limits'. To it could be attributed 'all poeticall fictions, fabulous transmutations, high metaphors, and rhetorical allegories; things of excellent use, and ornament of speech'.[31]

The imagination's new importance to early modern intellectuals also led to much fresh debate about its material power to effect natural change—for example, in the causes of illnesses and their cures, the foetation of human embryos, and (most controversially of all) the efficacy of miraculous healing.

Another of the new-style monographs on the subject, *De viribus imaginationis* (1608) by the Antwerp physician Thomas Fienus, was composed with these psychosomatic issues—as we might call them—largely in mind.[32] Like Fienus, the Wittenberg philosopher and medical academic Hieronymus Nymann was also intrigued by the question of how the imagination's normal role as an internal sense concerned with 'the images and likenesses (*simulachra*) of things' might interact psychosomatically with the body (and perhaps even with other bodies) with sometimes quite abnormal consequences. Why did looking fixedly at red fabric produce flushing of the skin? Why did watching somebody yawn or urinate produce the compulsion to do the same? And how was it that a foetus might be imprinted by the shapes of the frightening or otherwise literally impressionable things seen by its mother? Such questions were typical of those endlessly debated by the many authors who looked to the imagination for startling physical effects.

Equally, however, and of much greater relevance in the present context, the imagination's new prominence in sixteenth-century cultural debate brought with it a dramatic increase in its epistemological notoriety. It was an old but persistent idea that, whatever its indispensable contribution to human mental processes and social life, the imagination was also an unreliable faculty and prone to error, and not just when affected by illness. Another of Aristotle's universally cited maxims was that while the external senses generally did not err, or erred only to the least possible extent, the imagination most definitely did. 'Imaginations', he stated bluntly, 'are for the most part false.'[33] Aristotle's association of this falsehood with the combining and separating role of the imagination was widely adopted in the Renaissance period, despite the weight of artistic opinion steadily pushing in the opposite direction. For Pico della Mirandola, the very fact that the imagination functioned only when sense objects were removed from its attention made it intrinsically dubious, irrespective of any impairment. This gave it licence, he wrote, to conceive 'not only what now is no more, but as well what it suspects or believes is yet to be, and even what it presumes cannot be created by Mother Nature'. With its help, men and women might imagine chimeras at will; 'even such things as are not, and cannot be'.[34] According to Francis Bacon, a century later, the compounding and dividing of the images of individual objects was a perfectly proper mental activity and could be done 'according to the nature of things as it exists in fact'. It was the essence of scientific logic, after all, to isolate what was common and what was different about natural things. But when divorced from natural reality and done at the mind's pleasure it was arbitrary and scientifically misleading. The synthetic likenesses that resulted were purely the work of the imagination (*phantasia*), 'which, not being bound by any law and necessity of nature or matter, may join things which are never found together in nature and separate things which in nature are never found apart'.[35] Such remarks make it clear that, to offset any confidence in the imagination's ability to transmit reliable images of absent things, there were serious anxieties about its capacity to

mislead and deceive. Of this theme in the English context, William Rossky concludes: 'It remains essentially a faculty tied to sense and disease, uncontrolled, easily distorted and distorting and hence lying, idle and purposeless, flighty and inconsistent, and therefore irrational and immoral in the instrumental scheme.'[36]

Nowhere was this more obvious than in the field of vision. It is easy to forget that in all of the guises mentioned so far, the workings of the early modern imagination were conceived of primarily as visual processes. The imagination had nothing but sensible forms as its objects, and amongst these, visual forms predominated. It was, indeed, the 'eye' of the mind, in the sense that, in an ocularcentric psychology, the rational powers were deemed to 'see' the external world only via its agency. According to Pierre de La Primaudaye, in the many editions of whose *Academie françoise* conventional later sixteenth-century beliefs on every conceivable subject were set out for the instruction of French—and then English and Italian—readers, Cicero had translated *phantasia* 'into a Latine word, which is as much as *vision*':

This facultie therefore and vertue of the soule is called fantasie, because the visions, kindes, and images of such things as it receiveth, are diversly framed therein, according to the formes and shapes that are brought to the common sense.[37]

Another, slightly later, indicator of conventional views, and on a truly European scale, was Laurentius Beyerlinck's massive dictionary of 1631, which reported (correctly) that *phantasia* derived from the Greek word for light and hence from vision: 'it takes its name from sight, which holds the principle place among all the external senses, inasmuch as sight is concerned with light, without which vision cannot exist.'[38] Whether one thought of the imagination in positive or negative terms, therefore, and whether as active or passive in relation to the human body, the implications for vision were uppermost.

By definition, its normal—and normative—role as faithful receiver of images from, and purveyor of them to, the brain's other occupants demanded the utmost reliability. On this depended not just the internal workings of the mind but the ordering of the religious and political world too—the 'social order of *phantasia*', as this has been aptly called.[39] This need for visual fidelity accounts for Pico's reminder that Plato had likened the perceptual role of the imagination to the presumed reliability of the act of painting, saying (in *Philebus*) that, like an artist, the imagination drew pictures of objects perceived in the soul.[40] This comparison might conceivably have been stretched to include the imagination's productive, as well as reproductive, functions—even its role in fashioning images of things that could not 'be created by Mother Nature'. It probably had to be if it was to match the sense of illusion so strongly expressed in Platonic thinking about images and artistic representation. But it could not have excused outright error in the initial *eikastic* repertoire of images themselves—as the many alternative comparisons to the images reflected in mirrors or imprinted in wax testify.[41] Similarly, the

sometimes very abnormal (and, potentially at least, socially dislocating) side effects of the imagination's psychosomatic powers stemmed from its visualizing capacity, whether the thing seen was a simple yawn or a monster sufficiently terrifying to imprint its shape on an unborn child.

In equal measure, the imagination's proneness to deceiving its host was best seen as a visual matter. The common image of the imagination as a mirror might have worked to shore up its cognitive accuracy, but at the same time it served to undermine it, relying as it did on an optical experience that was already being talked of as far from neutral. If what one saw in a 'glass' was no mere reflection but 'shadowed with selfe-application', as Fulke Greville put it, then comparing imagining to mirroring was already to acknowledge the constructedness of sight—the possibility of visual encounters that seemed lifelike but could never be so. The imagination, said Greville, was:

> A glasse, wherein the object of our Sense
> Ought to reflect true height, or declination,
> For understandings cleare intelligence:
> But this power also hath her variation,
> Fixed in some, in some with difference;
> In all, so shadowed with selfe-application
> As makes her pictures still too foule, or faire;
> Not like the life in lineament, or ayre.[42]

In depictions of the perennial battles between reason and the passions, it was said that the imagination acted like a 'deceitfull Counsellor', seeking to blind the eyes of the judge.[43] For Reynolds, the imagination was a natural disrupter of vision, as well as its essential facilitator. It is not difficult in his account to anticipate levity as one of its faults, and obsessiveness too, both of which Reynolds duly discusses. Its chief corruption as a faculty, however, is simple error:

Hence, those strange and yet strong delusions, whereby the mind of melancholy men (in whom this facultie hath the most deepe and piercing operation) have beene peremptorily possessed: Hence, those vanishing and shadowy assurances, hopes, feares, joyes, visions, which the dreames of men (the immediate issues of this facultie) doe produce: Hence those gastly apparitions, dreadfull sounds, blacke thoughts, tremblings, and horrors, which the strong working of imagination doth present unto, or produce in men.

Such images were not received 'from without, but by impression and transfusion from within'. In other words, apparitions only seemed to be real because the fears of disquieted men led their imaginations to invent them and convey their shapes to the outward senses via the spirits of sensation, so that the eyes, for example, when moved by such visible forms, seemed to see them. Similar delusions could result when the imagination was imbalanced by its constituent humours, misled by the external senses, or subject to 'strange and false *species*' cast into it by the devil.[44]

Reynolds derived this last suggestion from Pico's *De imaginatione*, which is another book notable for the extent to which it mistrusts its subject, both in moral

and cognitive terms, for the errors it causes. Pico was clearly one of the modernizers in the field, dispensing with complicated faculty psychology and using the term 'imagination' to cover the entire sensitive soul. As we saw earlier, he was well able to acknowledge the imagination's positive value, defining it as 'a power of the soul which conceives and fashions likenesses of things, and serves, and ministers to, both the discursive reason and the contemplative intellect', and stating conventionally that the rational soul 'acquires all its knowledge and science from the senses through the medium of phantasy'. Yet he also saw the imagination as evil—as a brutish, vain, wandering, and irrational (or at least pre-rational) force. It had to be guided by the higher powers of intellect and reason, without which it could corrupt and doom a man and make him bestial and unfit for either religion or 'civil life'. From it came not just individually defective judgements but all sorts of monstrous philosophies and heretical religions. 'Therefore', he wrote, 'we can without difficulty affirm that not only all the good, universally, but also all the bad, can be derived from the imagination.'[45]

Why do 'false phantasies' arise in us, asks Pico, meaning by this: why do different men see the same things differently, and why does the same man see differently in different circumstances? The answer has partly to do with things outside the imagination or its control, but for which Pico nevertheless holds it to account. It can be easily misled by the external senses themselves, on which it initially depends. These commit errors in the perception of the common sensibles of objects, especially changing ones—that is, in relation to their magnitude, form, number, and motion—and likewise when one sense is allowed to provide the only evidence for an object common to the others. The imagination can also be filled with good or bad phantasms by good or evil angels, the latter running riot, for example, in the fantasies of witches. In both types of cases, Pico was following routine arguments—the one set stemming again from *De anima* and elaborated endlessly in medieval optical theory, and the other from traditional demonology, a subject on which he himself later wrote in his *Strix, sive de ludificatione daemonum* (1523).[46] We shall have occasion elsewhere in this book to consider the implications for visual theory of both of these possibilities.

Mainly, however, the imagination is itself to blame for its mistakes, and there are physiological reasons for this. Here, Pico followed Galenic ideas about the bodily sources of cognitive error. Depending on its supply of blood, phlegm, red bile, or black bile, the imagination perceives cheerful, dull, grim, or sad images respectively: 'Influenced by these humo[u]rs in the act of cognizing, the spiritual eye of the soul, the intellect, changes and is deceived, just as the bodily eye experiences illusions through tinted, parti-colored lenses (*specillis*).'[47] This comparison with artificial lenses seems odd, in the sense that their use is a matter of choice whereas the intellect's reliance on images is not. But Pico perseveres with it, presumably to underline not just the nature and extent of the deception itself but the intellect's lack of any visual remedy for it. Lenses and mirrors can multiply, colour, or otherwise distort the likeness of any sensible object so that it imprints on the

eye now one image of itself and now another, but at least we can verify that the object 'is of one and its own nature' by removing them. The intellect too assumes that truth 'is of one and its own nature' but has only 'diverse and contrary phantasms' (*phantasmata*) to work with and so can never perceive truth visually as anything but 'manifold, corrupted, and mixed'. Pico reinforces this relativism concerning visual truth by listing the other contingencies that affect the visual acuity of the imagination and prevent it from retaining the appearances of things 'as conceived'. These include practice, atmospheric conditions, the varying dispositions of the body 'which we obtain from our parents, from our native land, and from our manner of living', and the presence of excessive dryness, humidity, heat, or cold.[48] While there are, in principle, physical ways of adjusting all these variables and restoring an equilibrium of humours and temperaments (substituting 'correct and clear' lenses for the 'distorted and corrupted' ones), only by exercising the dominance and immunity guaranteed by greater and greater incorporeality can reason and intellect, and eventually faith itself, rise above—far above—the injuries and errors of the imagination.[49]

La Primaudaye was another revisionist who thought it was immaterial whether the internal senses were to be distinguished from each other or not, and he too declared that the imagination was 'a very dangerous thing'. Even though it was rooted initially in sense impressions, there was no other restraint on its capacity to 'counterfaite' things 'which never have beene, shall be, or can be', whether or not its host was asleep or awake. It was wonderful, he reported, to see 'what new and monstrous things it forgeth and coyneth, by sundry imaginations arising of those images and similitudes, from whence it hath the first paterne'. Only reason, then, could prevent the human senses and understanding being swept away in a 'tempest' of visual inventions, prompted by the imagination's inherent instability, the troubling of its organic humours, and the promptings of evil spirits. The fantasy, argued La Primaudaye, was particularly accessible to movement by spirits because of an essential, if incomprehensible, agreement in their natures. While this meant that angels found it easy to 'represent to our mindes the images of good, heavenly, and divine things', it also made the imagination an ideal vehicle for the devil, himself a great counterfeiter. Divine visions and demonic illusions were, in fact, the products of exactly contrary spiritual interventions in human mental imaging, and 'discerning' the difference between the images that resulted was one of the greatest challenges to religion and morality. Vision is patently at the heart of this argument but La Primaudaye underscores its centrality by comparing the visual deceptions of demons to the 'strange sights' achieved by jugglers—and this is another idea to which we must return.

The pattern that emerges from these and other discussions of the imagination is clear. As it assumed more and more importance in the psychological reflections of the period, so its reputation as an unreliable and undisciplined faculty, as well as a sustaining and creative one, was greatly augmented. The mental power most intimately involved in human visual experiences was designated as disruptive and

error-ridden, threatening not just the visual judgements of individuals but the institutions that depended on these judgements and, in turn, sought to guarantee them—institutions as important as states and religions. The imagination could be a powerful disrupter of the natural order, and its ability to shape the unborn was an unmistakable symbol of this.[50] But it could also be a dangerous disturber of the order of perception and a site of insanity, for which demonism provided an apter parallel. Hence the need to impose on things imagined the rigours of a yet higher faculty—the faculty of reason.

Hieronymus Nymann's study, which began life as the address that inaugurated his public lectures on medicine at Wittenberg university in December 1593, is worth recalling at this point, partly because it came to be widely cited but mainly because it is typical in summarizing the visual implications of the disorderly imagination. Nymann expressed the conventional sentiments about the inventive powers of the imagination and its crucial importance to all forms of knowledge, but, like Pico and the others, blamed it for many defects and vices of behaviour, even amongst the sane and healthy. Amongst the insane and the sick the imagination was a major cause of melancholia and madness and responsible for precisely the symptoms which defined these conditions—the seeing of absurd things under the strong impression that they were nonetheless true. More than this, Nymann itemized those visual experiences that, while not necessarily accompanied by mental or physical illness, betrayed the actions of an imagination malfunctioning or impeded in some way and so capable of flooding the mind with 'images and likenesses' that bore no relation to reality. The cases ranged from the relatively benign one of dreamers, whose imaginations were 'overturned' by *species* left over from the day's activities or excited by humoral spirits and vapours, to the relatively serious one of lycanthropes, deceived by their disordered humours or the deceptions of the devil into behaving like wolves. In between came sufferers from nightmare (*incubus*), sleepwalkers, ecstatics, and witches. The list is revealing as an accurate indication—bearing in mind Nymann's references to melancholia and lunacy, and his posing of the question: why are spectres most often seen by the fearful?—of virtually the entire scope of early modern speculations about disturbances to vision produced by natural causes.[51] We will come back to most of these topics in later chapters, although not necessarily under the rubric of natural agency; for the moment, nature's role in these kinds of disturbances can best be illustrated if we choose just one of them for closer analysis—melancholia.

Like many of the other things to be discussed in this book, we should try to think of 'melancholia' as a peculiarly early modern phenomenon. As an affect that was inconceivable without its eponymous humour, and humoral medical theory in general, it was unable to survive their demise from the middle of the seventeenth century onwards, already signalled by the results of William Harvey's experiments with blood and completed in studies like Georg Ernst Stahl's *Lehre von den Temperamenten* (1697). Despite the temptation to assume otherwise, modern

sadness and depression are not, therefore, melancholia's synonyms, nor modern melancholy its equivalent.[52] Its prehistory was considerably longer, stretching back to Galen, the chief exponent of humoral theory in the later ancient world, and his contemporary Aretaeus, and beyond these to Hippocrates, Aristotle, and other authorities. Even so, melancholia was not particularly prominent in medical literature before the sixteenth century, beyond standard appearances in encyclopedias and textbooks. To these, early modern intellectuals added an abundance of fresh discussions—in many new treatises on the diseases of the head (*de capitis affectibus*, *de morbis cerebri*), in countless university theses and disputations, and in virtually every account of the human faculties, passions, and soul.[53] Like the imagination itself, melancholia also became the subject of monographs, culminating in Robert Burton's magisterial and suitably obsessional *The anatomy of melancholy* of 1621, a book rooted not only in humoral physiology but in traditional faculty psychology. In England, indeed, it seems to have become the most talked-of malady of the age, an intellectual vogue reflected in the many references to melancholia—and the many melancholic characters—in Elizabethan and Jacobean literature.[54] But the interest was in fact continental in scope; across Europe, especially from the 1580s onwards, writing on the subject 'mushroomed within a few years to an industry'.[55] The period between Ficino and Burton has been called the 'great era of melancholia', and the disease itself a 'dramatic cultural phenomenon'.[56] In Germany, writes Erik Midelfort, 'the second half of the sixteenth century was increasingly an "age of melancholy"', a situation largely attributable to learned physicians trained in traditionally Galenic medicine, and resulting in melancholic disorders proliferating, here and across Europe, 'at an unheard-of rate'.[57] Few indeed of Europe's medical authorities had nothing to say about what had become a cardinal form of madness, but amongst those who discussed it in detail were Girolamo Cardano, Levinus Lemnius, Thomas Erastus, Felix Platter, André Du Laurens, Jason Van der Velde (Pratensis), Jourdain Guibelet, and Daniel Sennert.

This is not the place to explore fully the reasons for this explosion of interest, although several spring to mind. Melancholia was depicted as a protean disease and its many different characteristics and bizarre symptoms—Babel-like in their confusion, said Burton in a famous passage—were both complicated and extraordinary enough to intrigue not just the professionals but anyone interested in the vagaries of human behaviour. Defined as preternatural, it fell within a category of occurrences that was of extraordinarily wide appeal, appearing in Simon Goulart's wonder tales, for example, in the form of contemporary cases culled from Europe's medical literature.[58] Apart from anything else, melancholia was a worst-case disease, in the sense of thriving on the qualities—coldness and dryness—most opposite to life. As Burton more than any one else showed, it intersected with other experiences—the infatuations of the lover, the anxieties of the sinner, the inspirations of the poet and artist—that gave it relevance and importance way beyond the medical classroom or consultation. It was important, for example, for

Timothy Bright, towards the end of his *A treatise of melancholie* (1586), to distinguish between natural melancholy and the afflictions of a distressed conscience, lest a key component of the Calvinist psychology of guilt be reduced to a disorder of the humours.[59] An influential and obviously positive association—though a declining one, in most recent assessments—between the melancholy temperament and exceptional male creativity made melancholia a critical as well as a clinical category and helped early modern scholars to explore the nature of genius in the form of the neuroses of the 'atrabilious man of letters'.[60] Some melancholic people were just funny and stories about their strange delusions and the ingenious remedies found for them circulated as widely and as repetitively as any of the other cultural narratives that enlivened contemporary conversation and entertainment.

More seriously, melancholics could be dangerous and subversive—potential threats to law and order and to notions of civility. This was not just a question of misanthropy, or their potential for evil-doing and self-destruction. The condition was closely linked to serious disorders of the passions and, therefore, had important negative political and ethical implications in an age increasingly wedded to neo-Stoic and Lipsean traditions of pragmatism and prudence in public affairs. This made it the subject of juridical as well as medical disputations and even a topic for theorists of the state like Adam Contzen and Hermann Conring.[61] In the age of Shakespeare, in whose plays (according to one reading) madness reached 'epidemic proportions', its various forms served easily as metaphors for sedition, such was the obvious challenge to the sovereignty of reason.[62] We shall see in a later chapter that melancholia was also blamed for the hugely disruptive phenomenon of witchcraft by those sceptical of the objective reality of the crime and the guilt of those accused of it. Melancholia was, indeed, a demonic disease, in the sense that sufferers were particularly vulnerable to the devil; the melancholic humour, according to a common saying, was *balneum diaboli* (the devil's bath). This too gave discussions of the condition a currency that was both very extensive in time and place, and yet, in the end, limited to the era of witches. The same temporal frame could be applied—and this too will be examined in more detail later—to the capacity of melancholics to imagine apparitions, spectres, and other manifestations of spirit, a psychic trait that linked them to debates central to the Reformation and to questions about Purgatory and the afterlife, as well as implicating melancholia whenever the enemies of 'superstition' or 'enthusiasm' tried to explain away these dangers to public tranquillity.

If, from the early sixteenth century onwards, melancholia became fascinating for all these reasons, it is nevertheless the aspect of sensory delusion alluded to in the last that concerns us here. For this, too, was one of melancholia's main, and increasing, attractions as a topic of intellectual debate and enquiry—so much so that we can, I think, interpret its appeal as a type of madness as symptomatic of much broader contemporary concerns about the rationality of seeing. The way one modern scholar of melancholy has put this is to say that it was a subject that

helped to frame epistemological norms; another, the art historian Claudia Swan, sees the disruptions of melancholy running as the vital thread through many sixteenth- and seventeenth-century explorations of the pictorial basis of thinking—notably in images of witchcraft.[63] For a contemporary writer like Robert Burton—like Hakewill before him—it meant placing the 'phantasms, chimeras, [and] visions' of the melancholic alongside all the other much discussed visual 'vanities' of the time: the apparitions and illusions produced by strange natural causes, the tricks of legerdemain and lighting effects, the images achieved by 'perspective glasses' or the camera obscura, the delusions of devils, 'the knavish impostures of jugglers, exorcists, mass-priests, and mountebanks', and the visions that accompanied weak sightedness, senility, and dying.[64] There is, in any case, no real dividing line here between epistemology and public affairs, given that ethical, religious, and political stability (and instability) were themselves assumed to rest on perceptual accuracy and conformity. At the heart of melancholia's potential to disrupt these wider areas of experience lay its catastrophic effects on the sufferers' individual powers of cognition.

Melancholia was, after all, a disease specifically of the imagination, even if, secondarily, of the reason and memory too, and in the medical textbooks was invariably considered under afflictions of the inner senses. The author of one of them, Philip Barrough, declared that 'they that be melancholious, have straunge imaginations'.[65] 'In this disease especially', agreed Thomas Erastus, a Heidelberg medical professor and author of one of the earliest sets of theses on melancholy, 'the *phantasia* is very often troubled.'[66] In Edward Reynolds's view, as we saw earlier, it was the melancholic 'in whom this facultie hath the most deepe and piercing operation'.[67] 'All melancholike persons have their imagination troubled', noted Du Laurens (writing for a sufferer, the Duchesse d'Uzès), 'for that they devise with themselves a thousand fantasticall inventions and objects, which in deede are not at all.'[68] This orthodoxy became enshrined in countless academic disputations, like that on melancholy at Leiden University in 1660, when one Johannes ab Hoobroeck defended the idea that sufferers 'believe they see many things which are not'.[69]

The medical view was reflected in literary convention; in Spenser's *The Faerie Queene*, the imagination, 'Phantastes', appeared allegorically as a melancholic, born under Saturn, inhabiting a 'chamber' of the brain whose 'dispainted' walls carried the shapes of things 'such as in the world were never yit, | Ne can devized be of mortall wit'.[70] It was also reflected in popular stereotypes of insanity, at least in England, where delusions and false perceptions were accorded to the melancholic and the 'mopish', rather than to the more violently, incoherently, and no doubt spectacularly mad.[71] Melancholia's primary psychological malfunctions were thus to do with image-making, which became chaotic under its impact. The result was a total failure in accurate perceptions of the external world—a capacity to construct completely convincing mental replicas of utterly non-existent things. The Italian Tomaso Garzoni stated the general view that melancholics were

'deceived for the most part about things to be seene or discern'd'.[72] The Netherlands physician Levinus Lemnius agreed (quoting Horace) that they saw 'that which was not so in deede'.[73] Another medical writer, Benedetto Vettori, diagnosed sufferers as having 'an inordinately exerted and fixed deliberation (*cogitatio multa et fixa*) that does not correspond to what is in the real world (*in re ipsa*)'.[74] In Burton's encyclopedic *Anatomy* (which he advised melancholics not to read in case it made them worse), their symptoms included 'many phantastical visions about their eyes'; an individual might imagine 'a thousand chimaeras and visions, which to his thinking he certainly sees', and 'divers terrible monstrous fictions in a thousand shapes and apparitions . . . by which the brain and phantasy are troubled and eclipsed'.[75] Of one of his melancholic patients, the English astrological physician Richard Napier wrote in his practice notes: 'Mind much troubled with false conceits and illusions. . . . Supposeth that he seeth many things which he seeth not.'[76] An eighteenth-century French writer on apparitions put it as simply when he said that the melancholic had 'eyes without sight . . . they see everything except what is in front of them'.[77]

To make things worse, as Vettori's diagnosis indicates, delusion was matched with obsession, a yet further feature of the condition. From Rufus of Ephesus, Galen, and Aretaeus of Cappadocia onwards, it was usual to think of the 'phantastically' mad as fixated on particular, though widely differing, conceits—Hamlet's 'thinking too precisely on th' event'. 'Melancholike folkes', wrote Levinus Lemnius, 'will hardly be disswaded or brought from theyr opynions, that they once lodge wythin their owne conceipts.'[78] According to Samuel Butler, in his 'character' of the melancholy man: 'Whatsoever makes an impression in his imagination works it self in like a screw, and the more he turns and winds it, the deeper it sticks, till it is never to be got out again.'[79] Du Laurens explained that this was because the brain became dry and hard, and thus tenacious and possessive; any idea gaining access to it 'suffereth not it selfe to be blotted out', he wrote.[80] But even quite different physiological principles found room for this kind of delirium. In the course of an essentially mechanistic account of disturbances to perception, Herman Boerhaave's early eighteenth-century *Aphorisms* defined melancholia as 'the distemper in which a patient lies long and obstinately delirious, without a fever, and with thoughts fixed almost continually upon one and the same idea'. His pupil Gerard van Swieten, commenting on this text, remarked that an image could become so ingrained in a diseased mind that it overruled any competing idea excited by the senses: 'For when a melancholic patient is persuaded his legs are made of straw, no touching of his hard bones, nor any looking upon the flesh that covers them, will convince him of the falsity of the notion.'[81]

The melancholic man was thus caught in a cognitive nightmare, at once stubbornly convinced of the truth of his mental images and yet totally misled as to their objective accuracy. This could not have been true had melancholia been considered a state of complete, all-embracing derangement. Unlike the actions of

the merely mad, whose berserk behaviour was without all sense and shape (the conditions of 'hot' forms of insanity ranging in severity from *furor* and *mania* to *phrenitis*), the melancholic's conformed to a colder kind of reasoning, albeit a false one, and this made them far more intriguing to study and, eventually, philosophically emblematic. The distinction, as it might have been put at the time, was between 'frenzy' and 'fancy', and it seems to have held across Europe.[82] Aretaeus was one of its originators, noting that the melancholic 'see things as present which are not so, objects being represented to their sight which do not appear to others, whereas the maniacal see only as they ought to see, but do not judge of what they see as they ought to judge'.[83] Most of the later commentators agreed that, unlike a lunatic's, a melancholic's judgement and memory might remain intact even while his or her imagination ran riot. To the English Puritan divine Thomas Adams, citing the general opinion of physicians, madmen who hallucinated were 'not deceiv'd so much in common cogitation and reason; but [erred] in phantasie and imagination', the position also argued by Tomaso Garzoni in his *Hospitale de pazzi incurabili*.[84] 'It is possible', said Daniel Sennert, 'for [the melancholic] not to err while reasoning if, even though the *phantasia* is damaged, the memory retains true images and offers these up for thought.'[85] Reason made 'but foolish discourses', thought Du Laurens, but only because it was 'misse-informed by a fayned fantasie'.[86] For Burton, too, after considering all the authorities (and quoting one of them), melancholy was 'first in imagination, and afterwards in reason', making it far less vehement and violent than 'madness'.[87] The point came to be enshrined in Locke's statement that madmen of this kind did not, like 'idiots', appear to him 'to have lost the faculty of reasoning: but having joined together some ideas very wrongly, they mistake them for truths; and they err as men do, that argue right from wrong principles. For by the violence of their imaginations, having taken their fancies for realities, they make right deduction from them.'[88] This was another reason, presumably, why melancholic fixations were partial rather than total, and the delusions that accompanied them limited to specific things. In a diagnosis going back at least to Avicenna, sufferers could be identified by their constant gazing at single objects.

With this perhaps in mind, a *Melancolia* of 1561 portrays a female victim, typically sad, solitary, listless, and staring, seated in a long corridor whose tiled floor and lined ceiling are both marked out in rigid perspective—almost as if orthogonals have been drawn on the surface of the work by some analyst of its technical correctness (Fig. 5). The eye of the spectator, like that of the melancholic subject herself, is forced to follow this unyielding organization of space, thus risking the same visual fixity that has obviously overwhelmed her. James Elkins speaks not just of perspectival confinement here, but of a kind of ocular paralysis and this would have had many parallels in contemporary medical and psychological descriptions of the visual fixations of melancholics. Citing John Pecham's thirteenth-century warning that objects could act 'painfully' on the eye, Elkins writes: 'Unmediated "corridor spaces" are evil eyes, *mal occhi*, that transfix and

confine the viewer's gaze.' The creator of this particular *Melancolia*, signed simply 'F.B.', seems to have seen the condition, as did so many others, in terms of this kind of visual pain.[89]

In effect, melancholia—and linear perspective too, for that matter—provided a dramatic early modern instance of the sensory paradox that arose when ancient Greek intellectuals debated whether false impressions could be just as 'perspicuous' or 'evident' (*kataleptikos*) as true ones. In their case, as we shall see in a later chapter, one outcome was 'Pyrrhonian' philosophical scepticism—the very scepticism that the sixteenth century was in the process of reviving as the vogue for melancholy got under way. Burton's *Anatomy* is the best-known and most substantial example of what happened when these two themes came together. It expresses, according to one typical modern reading, 'a general scepticism extending to all forms of knowledge, ancient and new, Stoic and scholastic, as well as scientific', formulated in terms of endless controversy, radical uncertainty and inconstancy, and the impossibility (classic in scepticism) of deciding what to believe and what to do.[90] But in John Marston's comic play *What you will* (1601) there is just as vivid an illustration (other than in the title itself) of melancholia's sceptical potential. One character, Lampatho Doria, is both a sufferer *and* a sceptic, and this conjunction is then reinforced by the experiences of another, Albano, who, as the victim of an impersonator, comes to realize that his very identity depends on the sense impressions of others—none of which can be relied upon to provide anything stronger than an opinion of who he is.[91]

It was in this sceptical guise, moreover, that the condition of melancholy was often associated with dreaming, since dreamers not only saw in their dreams the same absurd things that melancholics imagined by day, but likewise accepted them at the time as real. It was Sennert's view, for example, that nothing that occurred to the sleeping, however ridiculous or incredible, could not be imagined by melancholics when wide awake, for which reason their deliriums were rightly said to be like dreams. Appealing to the commonplace idea that sensation should normally mirror the world, Sennert cited with approval Aristotle's statement (in *De somniis*, iii) comparing dreams and deliriums alike to reflections in troubled water.[92] Burton, following Avicenna, said of melancholics, 'they wake, as others dream'.[93] More revealing still is a comment in Butler's 'character', published in 1659. Not only was the melancholic man's head haunted, like a house, with evil spirits and apparitions; 'His sleeps and his wakings are so much the same, that he knows not how to distinguish them, and many times when he dreams, he believes he is broad awake and sees visions.' Conversely, added Butler, he 'dreams much, and soundest when he is waking'.[94] The deliriums of melancholics, confirmed the influential medical authority Friedrich Hoffman in the 1690s, were 'the dreams of the waking'.[95]

The philosophical high point of this analogy between melancholics and dreamers, and the moment when the former achieved the rare distinction of a mention in a piece of abstract philosophy, exactly confirms both the cognitively paradoxical

features of their condition and also its association with scepticism. As Descartes considered the grounds for doubting elementary sense information, before eventually hitting on demonic interference as the worst hypothetical case, he reviewed the parallel cases of both dreaming and madness. But the terms he employs for the latter and the examples he gives of it are unmistakably those of the black bile:

> How could it be denied that these hands or this whole body are mine? Unless perhaps I were to liken myself to madmen, whose brains are so damaged by the persistent vapours of melancholia that they firmly maintain they are kings when they are paupers, or say they are dressed in purple when they are naked, or that their heads are made of earthenware, or that they are pumpkins, or are made of glass.[96]

There is an important distinction being made here, scarcely noticed by modern philosophical commentators on the *Meditations on First Philosophy* who talk as if Descartes was simply referring to something unitary called 'madness'.[97] Evidently, outright insanity was too crude and formless an affliction to qualify as a state of complete uncertainty for him; only the more precise and paradoxical melancholia, with its unique combination of utter conviction and total error—the defining contradiction of wholesale delusion, after all—met the demanding standards of his hypothetical scepticism. Unless this is realized, the extent and force of the hyperbole, and, more importantly, its historical derivation from the melancholia debates of the late Renaissance are both missed.

Where did Descartes get these bizarre examples from? The answer will be known to anyone familiar with Renaissance writing: embedded in a series of tales about melancholic delusion, dating from Galen and Aretaeus, they were endlessly recycled throughout Europe during the sixteenth and seventeenth centuries, irrespective of their moorings in any kind of social reality. They were amusing and memorable, both for the cases and their treatments, and they qualified too as curiosities and wonders. But their more serious purpose, as Descartes obviously recognized, was to warn of what could happen to the sensible soul when the normal connections between its inner and outer senses were disrupted, distorted, or completely broken. In 1663, the English physician Robert Bayfield, having defined melancholia as 'a dotage arising from a melancholy phantasm' with which the afflicted became wholly preoccupied, went on to summarize many of the usual anecdotes:

> Some think themselves to be kings, princes, prophets; Others that they are made of glass, or potters clay; or that they are barly corns, ready to be devoured by the hens: Some think they are melting wax, and dare not approach the fire: Others, that they are dogs, cats, wolves, cuckows, nightingals, or cocks, whose voices they imitate. Others fancy themselves dead, and will neither eat nor drink: Others dare not piss, lest they should drown the world by a second deluge. Some think they have lost their heads, or some other member; or that they carry the world upon their fingers end, or that they have sparrows in their heads, or serpents, frogs, mice, and other creatures in their bellies.[98]

Bayfield's contemporaries laughed at but also pondered the cases of the ancient Greek who sat in an empty theatre and applauded non-existent plays, his compatriot Artemidorus the Grammarian, who was so terrified by the sight of a crocodile that he believed one of his arms and one of his legs had been bitten off by it, the man who thought his nose was elephantine (cured by a blindfold, a small incision, and a large piece of offal left in a dish), and the man who believed he was a god and, having been denied food in deference to his divinity, was starved into admitting his mistake.[99] To these stereotypical tales, the medical academics in the universities added descriptions of cases they claimed to have actually encountered, like that of the Louvain student who imagined—not implausibly, perhaps—that he had a bible in his head, and of another student who seemed always to see the head of Medusa.[100]

Of course, such stories required the simultaneous delusion of all the outer senses, as well as the unshakeable convictions of certainty typical of the melancholic. Thomas Walkington described sufferers as 'in bondage . . . imagining they see and feele such things, as no man els can either perceive or touch', while according to Robert Burton melancholic persons 'think they see, hear, smell, and touch, that which they do not'. Johann Weyer gave examples involving hearing and smelling, and Jourdain Guibelet smelling and tasting.[101] To isolate the *seeing* of false things is not to deny this uniformity; it is simply to concentrate on the theme of this chapter. It does, however, reflect the most frequently cited form of melancholic delusion, as well as the manner in which the stories were transmitted. Galen cited them as instances of 'abnormal sensory images', whereas his tenth-century follower, the Arab scholar Ishaq ibn Imran, used them to illustrate his view of melancholics that 'horrible pictures and forms pass before their eyes'.[102] According to Du Laurens, accounting for their individual delusions was simply a matter of ocular fixation: 'if they happen commonly to looke upon some pitcher or glasse', he wrote, 'they will judge themselves to be pitchers or glasses.'[103]

More importantly, focusing on melancholy vision also captures the ocularcentrism that arose whenever the condition was explained. Essentially, it arose from two physical causes. First, excessive quantities or the overheating of the natural humour of melancholy might reach pathological levels (lower levels could be absorbed in a melancholic complexion or temperament) and lead to its normally benign qualities—coldness, dryness, thickness, and blackness—becoming dangerously influential over the body's spirits. As *De proprietatibus rerum* laconically put it: 'Some melancholy is kindlye and some unkindly.'[104] Alternatively, excessive body heat might lead to the combustion of *any* of the four natural humours and the creation of an unnatural 'melancholy adust' (*atra bilis*) which, again, destroyed the normal workings of the spirits but with effects that differed according to which humour was burned.[105] It was, of course, important to give secondary reasons why these abnormal physiological conditions occurred, and Burton, for example, did so at very considerable length. Some of these were also physical in character (immoderate diet or climate, for example, or unhealthy

housing), others psychological (excessive passions like fear, grief, or anger, or other traumas), and yet others to do with lifestyle (unnatural work habits or sleep patterns, and so on). But it was the immediate disorders of the body that mattered most in the disruption of the visual processes of the soul, whether in its outer or inner senses, because the workings of the spirits meant that there was a direct physical connection between them.

Noxious bile and vapours escaped from organs—notably the spleen, but also the heart—desperately trying to cope with melancholy overload. In consequence, the animal spirits that governed the transmission of visible impressions from the eyes to the faculties of the brain (as well as all the other functions of the sensible soul) were cooled, dried, thickened, and, above all, blackened to the point of vitiation. With the breakdown of the spleen, said Levinus Lemnius, came the disquieting of the mind 'wyth sundry straung apparitions, and phantasticall imaginations'. According to Sennert: 'While the vapours are being stirred round in the brain in errant motion, its images are either completely overthrown or produce only certain disturbed and strange sights.' Joannes Le Clerc, defending his doctorate at Leiden in 1633, was more precise; from being 'temperate, clear, subtle, [and] pure', he explained, the brain's spirits became 'immoderate, obscure, thick, [and] cloudy'.[106] As Guibelet put it, melancholy forced the soul's maker of images to make them falsely ('de representer à faux'), like a dimly lit mirror or one stained with dirt. The imagination could neither accurately receive nor truly present the *species* of things 'according to nature' ('selon la nature') while its working spirits were so dulled. One could therefore refer things like fear directly to the colour of melancholy, since it was literally blackness (as well as coldness, etc.) that 'destroyed the certainty and surety of the faculties, [and] made them waver, and represent things wrongly'. Clear vision depended on transparent spirits, free of impurity or coarseness. An imagination damaged by melancholy was one that 'will see what is not, and create an infinite number of false and monstrous ideas'.[107] It was the Englishman Samuel Harsnett who, citing Scaliger, described the literal dimming of sight most forcefully, arguing that the melancholic saw more demons and witches than the sane, 'because from their blacke and sooty blood gloomie fuliginous spirits do fume into their brain, which bring blacke, gloomy, and frightful images, representations, and similitudes in them, wherewith the understanding is troubled and opprest'.[108]

The 'blacke formes and strange visions' presented to the imagination as a result were 'seene with [the] eye', according to Du Laurens, 'notwithstanding that they be within'. He thought that this was a profound point, but not sufficiently understood—a 'deepe reach', he said, 'which no man hitherto (it may be) hath attayned'.[109] In a sense we can agree with him; this *was* the most crucial emphasis of the whole Renaissance debate on melancholy, as far as vision was concerned, and Du Laurens knew he was suggesting something controversial but highly significant. He noted that Galen had written as if the mind 'saw' the darkness engendered by melancholy and had been rebuked by Averroes for saying so.

Yet there was an important sense in which vision was a mediated faculty. Eyes, it turned out, saw not only external things but things which were inside the brain, and they could not always tell the difference. Supposedly the most noble and reliable sense, vision was recognized to have a precarious material base that could destroy its ability to function in a fundamental way. More than that, the manner of its deception—misled by its habitual assumptions about externality—told of the priority of the mind in visual cognition, of the way visual experiences were constructed out of mental expectations as well as data transmitted by the crystalline lens. Moreover, every fresh account of melancholy, however derivative, reinforced this potentially sceptical point and its paradoxical outcome. The exhaustive and authoritative version by Robert Burton was again typical; with a reference to Galen and to Lodovicus Mercatus' *De melancholia*, it stated that, 'by reason of inward vapours, and humours from blood, choler, etc., diversely mixed [melancholics] apprehend and see outwardly, as they suppose, divers images, which indeed are not. . . . the fault and cause is inward'.[110]

Those with cataracts or about to vomit or haemorrhage, continued Du Laurens, suffered in a similar way when obstructions or 'inward' vapours affected the crystalline lenses of their eyes and caused 'false apparitions'. Thus, the melancholic person:

may see that which is within his owne braine, but under another forme, because that the spirits and blacke vapours continually passe by the sinewes, veines and arteries, from the braine unto the eye, which causeth it to see many shadowes and untrue apparitions in the aire, whereupon from the eye the formes thereof are conveyed unto the imagination, which being continuallie served with the same dish, abideth continuallie in feare and terror.

In such a way, the melancholic humour 'tainteth and brandeth with blackenes [the animal spirit], which passing from the braine to the eye, and from the eye to the braine backe againe, is able to move these blacke sights, and to set them uncessantly before the minde'. Chronic and irrational fearfulness, sadness, suspiciousness, and restlessness—the behaviour traits of melancholia discussed all over Europe by Du Laurens's contemporaries—were, in effect, directly attributable to a prior breakdown in the visual experience of the sufferer, which was reinforced every time the brain and the eyes cooperated in seeing false things, until the delusive cycle was broken.[111]

In the fullest English account of the condition before Burton's, written by a physician at St Bartholomew's Hospital in London, Timothy Bright, melancholy was again described as causing 'manie fearefull fancies, by abusing the braine with uglie illusions' instead of offering it 'true report[s]'. It 'counterfetteth terrible objects to the fantasie', he wrote, and led the brain to invent 'monstrous fictions' which, taken on trust, were passed on to the heart where they aroused the inordinate passions typical of the sufferings of melancholics. Powers and motions that normally provided 'due discretion of outward objectes' were rendered useless by

dark and cloudy vapours that destroyed the clarity of the animal spirits. A 'spleneticke fogge' enveloped the brain, producing an 'indifferency alike to all sensible thinges' and 'fansies' that were 'vayne, false, and voide of grounde'—just as real darkness made people imagine illusory things that light subsequently dispelled. In short, the melancholic imagination 'fancieth not according to truth: but as the nature of that humour leadeth it'.[112]

Bright was careful to commit all the internal senses to melancholy's illusions—the common sense and memory too, even though they might not be directly affected by the condition. The human mind, trying desperately to act normally, ended up applying rational thought to wholly 'deceitfull' cases. At the heart of the malady lay the disabling of the entire cognitive process. As if to emphasize this and exonerate the rational soul from any complicity in the misdeeds of its sensible partner, Bright reminded his readers of how the real world was usually perceived:

For those things which are sensible, and are as it were the counterfettes of ou[t]ward creatures, the reporte of them is committed by Gods ordinaunce to the instruments of the brayne furnished with his spirite, which if it be, as the things are in nature, so doth the minde judge and determine, no farther submitting it selfe to examine the credite of these senses which (the instruments being faultlesse, and certaine other considerations required necessary, agreeable unto their integrity,) never faile in their business, but are the very first groundes of all this corporall action of life and wisedome, that the minde for the most parte here outwardly practiseth.[113]

When the instruments of sense *did* fail and things were reported that were not 'in nature' at all, it was hardly surprising, in this view, if the mind continued to trust the reports it received and judge them as if they had a basis in reality. In this respect at least, the mad were as sane as the wise; the fault lay with 'the organicall parts which are ordained ambassadours, and notaries unto the mind [and] in these cases, falsifie the report, and deliver corrupt recordes' and generally act as 'importunate and furious sollicitors'.[114] In this way, discussions of melancholy became occasions for reflecting on human cognition as a whole and on the paradox of the mind's (and the heart's) inability to distinguish between sensible truths and sensible fictions. Again, within a few pages, the same action—'counterfeiting'—was associated with both. Bright assumed that, in normal conditions, the 'counterfeit' of an 'outward creature' (an external object) was simply an accurate copy of it (or *species*) presented by the internal senses to the mind. But he had just spoken of melancholy counterfeiting 'terrible objects to the fantasie'—terrible because they were not copies of anything at all but 'uglie illusions' and 'monstrous fictions'.[115]

What the melancholy debate seems to have hastened, in effect, is the change whereby the neutral meanings of the terms 'phantasy' and 'phantasm', adopted by Aristotle and his followers to denote the impressions or presentations left by the external world on the internal faculties of sense, and connoting simply 'image' or 'appearance', were gradually overtaken, and eventually engulfed, by the very

un-neutral meanings given to the same terms which suggested illusion and lack of correspondence with reality. These originated more with Plato and the Stoics and were invariably used whenever the combinatory functions of the imagination were discussed.[116] As we saw earlier, it was possible to think of the operation of the imagination in two guises: passive and active (distinguished on occasions in medieval psychology as *imaginatio* and *phantasia*). In the chain of cognition it was minimally a receiver and purveyor of—hopefully accurate—'phantasms' to the rest of the brain without the originating objects being necessarily present, and these 'presentations' were *phantasmata*. Its more active, combinatory role freed it from sense and allowed it to construct images outside nature that could also be called 'phantasms' but with the strong implication of fictions. In a diseased state such as melancholy, the imagination could *only* produce the latter. *Phantasmata* were replaced by 'phantastical apparitions' or 'fond phantasies'—synonymity by antonymity. In Philip Barrough's *Method of phisick*, the eyeball could yet be described anatomically as 'the fantasticall cell', but Richard Napier used the word 'fantastical' to describe what was mad about his patients' behaviour.[117] 'Imagination' and 'fancy' might still be interchangeable in Dr Johnson's eighteenth-century dictionary but 'fantasies' were fast becoming nothing but illusory.[118]

If, for early modern Europeans, melancholy was the most intriguing form of madness, lycanthropy was perhaps the most bizarre form of melancholy. Modern scholars tend to think of it in connection with werewolf trials, which occurred sporadically at the time, notably in francophone Lorraine. The subject also cropped up incessantly in connection with witchcraft, where the metamorphosis of humans into animals was in constant debate. Here, as we shall eventually see, it gave rise to descriptions of how devils could simulate an experience so exactly that, even though it was virtually always denied as a reality, it could nevertheless convincingly seem to happen. For this reason, the three main treatises devoted solely to lycanthropy were written by authors anxious to attribute it to demonic intervention—Claude Prieur, Beauvois de Chauvincourt, and Jean de Nynauld. Even so, each of these writers acknowledged that there was a purely natural form of lycanthropy, and every description of melancholy and many of the imagination allowed for it too, drawing on associations between the disease and the delusion that dated from antiquity. But assuming, as I think we can, that there existed no more actual Renaissance sufferers from the natural condition than in any other period of human history, we may well ask what else accounted for this intellectual urgency. One answer might be that lycanthropy offered up all the usual visual paradoxes of the melancholic imagination but in a particularly emblematic form. As one of its leading modern interpreters has said, it was the question of what witnesses to it had *seen* that took commentators way beyond the condition of lycanthropy itself to more profound issues to do with illusion and belief; it became an especially dramatic and troubling example of visual uncertainty in an age of

'mutation épistémologique'. As Prieur, for example, said: 'lycanthropes always seem to be what they are not.'[119]

The lycanthrope and his canine equivalent, the cynanthrope, were classic products of the melancholy of adustion. Its highly dangerous fumes rose to their inner senses—to what Beauvois de Chauvincourt called 'la partie fantastique et imaginative'—and destroyed any hope that their outer senses might tell them the truth.[120] According to De Nynauld, originally from Preuilly-sur-Claise in Touraine and described on his title page as 'docteur en medecine', they were duped in exactly the way Du Laurens had suggested: 'they believe', said Nynauld, 'that they hear and see without what is within.' What was within was merely a humour or vapour in their brain, but the errors caused by it in their imagination were carried and re-carried ('traduites et renvoyees') to their exterior senses. As a result, lycanthropes experienced one of the strangest yet most complete forms of delusion (described with formulaic sameness in these and hundreds of other texts). They went out at night, preferably in February, to frequent graveyards and sepulchres, howling and looking for wolves for companions. Not surprisingly, given the fuliginous images in their heads, they looked pale and could see 'only dimly, as if enveloped by clouds'. They had dry mouths and could shed no tears. Their natural condition was, moreover, long-lasting—outstripping any demonic trick or the effects of any opiate.[121] Above all—a feature noted by the observant Franciscan Claude Prieur—lycanthropes with diseased imaginations were as obstinately sure of being wolves as any of those deluded by other expressions of melancholy; only this could explain their grotesque actions. They convinced themselves 'of things which simply do not exist', and it was therefore impossible, initially, to persuade them that they were wrong.[122] This was an idea repeated in the 1670s by the philosopher Nicolas Malebranche, who felt that the overturning of the brain by melancholy required to create a 'werewolf' was so much more serious than the misleading dreams of 'sorcerers'.[123]

Descriptions of this sort multiplied in the medical and other literature of the period, where allusions to the visual complexities of lycanthropy and its implications for the rationality of seeing can regularly be glimpsed. According to the Spanish writer Pedro de Valderrama, for example, the general view of physicians was that the melancholic were often so afflicted by the illness 'that they think they see what they do not see, hear what they do not hear, [and] are what they are not'.[124] During a seminar devoted to the subject at Théophraste Renaudot's private academy, the Bureau d'Adresse, in mid seventeenth-century Paris, a discussant observed that the atrabilious humours, in flooding the brains of the melancholic with black and glutinous fumes,

not onely make them to believe that the species represented thereby to them are as true as what they see indeed, but impresse an invincible obstinacy in their Minds, which is proof against all reasons to the contrary, because reason finds the organs no longer rightly dispos'd to receive its dictates. And if he who sees a stick bow'd in the water can hardly rectifie that crooked *species* in his common sense, by reasons drawn from the opticks,

which tell him that the visual ray seemes crooked by reason of the diversity of the medium; how can he whose reason is not free be undeceiv'd, and believe that he is not a wolf, according to the *species* which are in his phancy?

The power of the imagination in alone bringing sickness and even death showed that it was well capable of persuading melancholics not simply that they were wolves but to act like them, 'tearing men and beasts, and roaming about chiefly in the night'.[125] Lycanthropy, one is tempted to say, was a case of bad *species* turning into bad species.[126]

Hallucinatory paradoxes remained a feature of English accounts of melancholy, even as the condition was losing its intellectual foundation and they were transferred to or absorbed by other, non-humoral afflictions, mainly those of the nervous system. One reason for this continuity was melancholy's recruitment by that small army of enemies of religious 'enthusiasm' who used it to explain away the evils and excesses of any doctrine or practice they deplored, chiefly those belonging to the mid seventeenth-century radical sects.[127] Attributing perceived forms of religious deviance to madness had long been standard practice, and one of the most discussed subsets of melancholy was its religious variant, characterized by inordinate fear of damnation, fanatical devotion, and other similar excesses. Burton's account—naturally one of the fullest—traced this particular variant of the black bile to the dieting and fasting that accompanied extreme asceticism, and talked of sufferers seeing God and angels, conversing with demons, having rapturous fancies, and claiming miraculous powers of prophecy.

But what made melancholy particularly useful to the opponents of enthusiasm—and makes their use of it relevant to us—was that it accounted with precision for the visual experiences that 'enthusiasts' allegedly accepted as real but which the more orthodox denounced as false. According to Richard Baxter, indeed, when the 'thinking faculty' became so diseased with melancholy that it created religious hallucinations and delusions, it acted 'like an inflamed eye'. John Trenchard went so far as to trace the belief in the 'inward light' to visual perceptions that, because the mind's normal relationship to the external world was blocked by melancholic vapours, had no connection with sensory data. [128] The first major contribution to this now well-documented literature was, however, Meric Casaubon's *A treatise concerning enthusiasme* (1655), which argued that melancholy was partly responsible for the symptoms of 'natural enthusiasm', a condition with entirely natural causes but mistaken for spirit possession. In line with the views we have already noticed, Casaubon thought of melancholy as a kind of partial insanity—'a sober kind of distraction', affecting the imagination rather than the intellect—and therefore especially able to account for what he regarded as the unfeigned fixations of visionaries and ecstatics. '[A] man', he wrote, 'through mere melancholy may become ecstaticall' and suffer 'illusions in the brain . . . with a reall apprehension of certainty and reality, where there is no

reall ground for either, but mere imagination'. The deeper cognitive principle involved was one that Casaubon derived from reading Du Laurens's work on melancholy and Girolamo Fracastoro's book *De sympathia et antipathia rerum* (1546): 'Whether the *species* comes to the eyes from without, or from within, is not materiall at all, in point of apparition: for [the melancholic] believe they see, and are astonished, and grow besides themselves.'[129]

It was, however, Henry More's *Enthusiasmus triumphatus* (1656) which made the closer links between enthusiasm and the disorders of the human senses. How, asked More (adopting a version of the usual faculty psychology), could the religiously 'inspired' be so fooled by their conceits, unless melancholy had destroyed the soul's ability to distinguish between 'fancies' and truths? The fact that the sleeping imagination, while receiving no countermanding 'motions' from the outer senses, could accept dreams as 'reall transactions' had clear implications for what might happen when it was awake:

if it were so strong as to bear it self against all the occursions and impulses of outward objects, so as not to be broken, but to keep it self entire and in equall splendour and vigour with what is represented from without, and this not arbitrariously but necessarily and unavoidably . . . the party thus affected would not fail to take his own imagination for a reall object of sense.[130]

This was precisely what happened to the mad and melancholic, and, a fortiori, to the melancholically religious, 'who have confidently affirmed that they have met with the Devil, or conversed with angels, when it has been nothing but an encounter with their own fancie'.[131] The sheer strength of the diseased imagination was enough to make a man 'believe a lie', whether in the form of 'the presence of some externall object which yet is not there', or in the claim 'to be God the Father, the Messias, the Holy Ghost, the angel Gabriel, the last and chiefest prophet that God would send into the world, and the like'.[132] More offers one of the most forceful accounts of the subjective visual and conceptual delusions brought on by melancholy available anywhere in the many tracts directed against enthusiasm. Words like 'God', 'angel', or 'prophet' were always accompanied in the minds of the deluded:

with some strong phantasme or full imagination; the fulnesse and clearnesse whereof . . . does naturally bear down the soul into a belief of the truth and existence of what she thus vigorously apprehends; and being so wholly and entirely immersed in this conceit, and so vehemently touched therewith, she has either not the patience to consider any thing alledged against it, or if she do consider and find her self intangled, she will look upon it as a piece of humane sophistry, and prefer her own infallibility or the infallibility of the spirit before all carnall reasonings whatsoever.[133]

Many 'enthusiastic' forms of religion were in fact nothing more than products of melancholic 'extasie', an especially intense form of sleep in which the imagination produced dream representations that were as clear and as full as those of the waking state. Since, under these conditions, the perception of the soul 'is at least

as strong and vigorous as it is at any time in beholding things awake' and the memory is thus as thoroughly 'sealed' with impressions 'as from the sense of any external object', the ecstatic had no option but to take his or her dreams 'for true histories and real transactions'.[134]

In the English medical texts of the later seventeenth and early eighteenth century too, melancholy continued to yield reflections on the disorders of the visual imagination.[135] However, melancholy itself became less portentous as time went by, most of its most alarming symptoms being taken over by madness in general. In an essay on mental pathologies and convulsive diseases, Thomas Willis seemed to speak in familiar terms of 'the black bile or melanchollic tumour in the spleen' disturbing the body's animal spirits and eventually producing 'inordinate phantasms' in the brain. But elsewhere, his writings indicate the decline in normal black bile theory and that he was using the term in a new sense to refer merely to waste products dealt with by the spleen. In his opinion it was true of all the insane that 'their phantasies or imaginations are perpetually busied with a storm of impetuous thoughts . . . [and] their notions or conceptions are either incongruous, or represented to them under a false or erroneous image'.[136] At the point in the mid eighteenth century where we must leave the issue, one of England's most renowned mad-doctors, William Battie, was still concentrating on unnatural sensation and defining madness as a whole as 'deluded imagination', insisting that 'that man and that man alone is properly mad, who is fully and unalterably persuaded of the existence or of the appearance of any thing, which either does not exist or does not actually appear to him, and who behaves according to such erroneous persuasion'. Nevertheless, the medical and cultural context had decisively changed. By this time, humoral theory had been displaced by mechanical and neuro-physiological explanations of madness (in Battie's case, pressure on the medullary substance of the nerves), and Battie's rival in the field, the Bethlem physician John Monro, was able to accuse him of deviating from what was now standard opinion by *not* implicating faulty reasoning and 'vitiated judgment' in the causes of the affliction. 'Total suspension of every rational faculty' was, in the latter's view, the hallmark of the lunatic, obliterating the distinction between 'fancy' and 'frenzy' on which melancholia had once thrived.[137] Melancholy had either been absorbed by the more general categories of insanity, where it could be policed more effectively, or reduced to something like a mood or a social malaise: either way, it lost its distinctive hold on the fears and fascinations of contemporaries.[138]

But for as long as it remained a medical and psychological talking point, melancholy was thought to have striking consequences not just for the visual experiences of the afflicted but also for how visual cognition in general was to be regarded. Even the suggested treatments for the condition finally bear this out. Of course, there were endless recommendations in the literature for changes to regimen—to diet, habitation, exercise, apparel, and so on—as well as more drastic

suggestions for purging humours and letting blood. But if it was thought unwise to leave melancholic people alone with knives or pieces of rope, it was also considered important to control what they looked at. It was not just a matter, as Bright suggested, of putting them in the hands of those who *did* perceive the external world correctly—therapists 'free from the corruptions' of the senses and therefore capable of sincerely reporting what that world was really like.[139] Rather, the eyes themselves had to be regulated. According to Sennert, the eyes of the melancholic gazed fixedly at things; what they gazed at could not therefore be left to chance. Looking too much at anything might affect the physical consistency and moisture levels of the spirits necessary to prevent melancholy, and Christoph Wirsung, the Heidelberg physician, actually forbade his patients from 'much watching'.[140] For Burton, the imagination 'raged' in melancholic persons 'in keeping the species of objects so long, mistaking, [and] amplifying them by continual and strong meditation, until at length it produceth in some parties real effects'.[141] Even for painters there was a risk of becoming melancholic by retaining mental images long enough to cause abstraction and detachment from reality.[142] But things that were irksome or odious, or spectacles that were tragic or frightening, were especially provocative. 'Of all sensible objectes', said Bright, 'the visible, except they be pleasaunt, and proportionall, give greatest discontentment to the melancholike.' Cheerful sights were obviously what was needed.[143] Other authorities suggested, yet more revealingly, that representation itself might be the problem. The Tudor physician Andrew Borde, who described melancholy as 'a sicknes full of fantasies, thynkyng to here or to se that thynge that is nat harde nor sene', declared that mad people in safe houses should not be exposed to 'paynted clothes, nor paynted walles, nor pyctures of man nor woman or foule or beest: for suche thynges maketh them full of fantasyes'.[144] In Stephen Bateman's version of *De proprietatibus rerum* the infected imaginations of the 'frenzied' were to be kept away from any kind of images at all.[145] Like modern-day seizures triggered by flash bulbs, melancholy could result directly from the impulse to interpret—in the case of images, to reinterpret. Better, then, to keep the image-making faculty of the 'phantastical mad' away from the images made in the imaginations of the sane.

NOTES

1. Hakewill, *Vanitie*, 55–6.
2. Michel de Montaigne, *The Complete Essays of Montaigne*, trans. Donald M. Frame (Stanford, Calif., 1958), 453.
3. Indispensable for this literature is the Becker collection in the medical library at Washington University in St Louis; see Lilla Vekhsler, Christopher Hoolihan, and Mark F. Weimer, *The Bernard Becker Collection in Ophthalmology. An Annotated Catalog*, 3rd edn. (St Louis, 1996).
4. Du Laurens, *Discourse*, 47–8. Du Laurens (Laurentius) was professor of medicine at Montpellier and physician to Marie de' Medici from 1603. He died in 1609.

On disease and ocular illusion, in addition to the works cited below, see Joannes Gellius, *Sugetesis medica de internis oculorum affectibus*, in id., *Decas (vii.) disputationum medicarum select[io]* (Basel, 1621), no. 27.

5. Daniel Sennert, *Institutionum medicinae*, in *Opera omnia* (3 vols.; Paris, 1641), i. 364; and see also his *Practicae medicinae*, in *Opera omnia*, ii. 278–329 ('De oculorum et visus morbis ac symptomatibus').
6. Guillemeau's *Traité* was trans. in 1587 by 'A.H.' as *A worthy treatise of the eyes* and this was reissued in London in 1622 by Richard Banister, along with Banister's own *Breviary of the eyes*, as *A treatise of one hundred and thirteene diseases of the eyes, and eye-liddes*; see sigs. F4r, H5r, H6v, K3v–4r, H8r–9r.
7. Du Laurens, *Discourse*, 56; cf. Juan Huarte, *Examen de ingenios. The examination of mens wits*, trans. (from the Italian version by Camillo Camilli) R[ichard] C[arew] (London, 1594), 71: 'The reason of this is, for that the thing within breeds an impediment to that without.' A summary of the causes of this particular confusion in visual cognition is given by Giambattista della Porta, *De refractione optices parte* (Naples, 1593), 158–72 (bk. 7).
8. For lice in the eyebrows (*phthiriasis*), see Robert Bayfield, *Tes iatrikes kartos, or, a treatise de morborum capitis essentiis et pronosticis* (London, 1663), 90–1.
9. Sebastianus Petraficta, *De sensuum externorum usu, affectionibusque . . . tractatus* (Venice, 1594), 18r.
10. Jean Riolan, *Opera omnia* (Paris, 1610), 439, cf. 443; Christoph Wirsung, *Praxis medicinae universalis; or, a generall practise of physicke*, trans. Jacob Mosan (London, 1598), 80–1; Sennert, *Institutionum medicinae*, in *Opera omnia*, i. 364, 392–3, and *Practicae medicinae*, in *Opera omnia*, ii. 308–12.
11. Christophorus Scheiner, *Oculus, hoc est: fundamentum opticum* (Innsbruck, 1619), 48.
12. R[obert] B[oyle], *A disquisition about the final causes of natural things . . . To which are subjoyn'd, by way of appendix some uncommon observations about vitiated sight* (London, 1688), 251.
13. Philip Barrough, *The method of phisick, containing the causes, signes, and cures of inward diseases in mans body from the head to the foote*, 3rd edn. (London, 1596), 58; cf. Banister, *Breviary of the eyes*, 40–1, in Guillemeau, *Treatise*.
14. Felix Platter, Abdiah Cole, and Nicholas Culpeper, *Platerus golden practice of physick* (London, 1664), 29.
15. Jourdain Guibelet, *Trois discours philosophiques . . . le troisième de l'humeur mélancolique* (Évreux, 1603), 273v–4r.
16. Levinus Lemnius, *The secret miracles of nature*, trans. anon. (London, 1658), 249, cf. 65.
17. Bayfield, *Tes iatrikes kartos*, 120.
18. Lindberg, *Theories of Vision*, 42.
19. *Batman uppon Bartholome*, 15r.
20. Aristotle, *De anima*, 428a, 16.
21. On these terms, and for other general information about early modern theories of the imagination, see Claudia Swan, 'Eyes Wide Shut: Early Modern Imagination, Demonology, and the Visual Arts', *Zeitsprünge: Forschungen zur frühen Neuzeit*, 7 (2003), 561–71; ead., *Art, Science, and Witchcraft*, 14–22. William Rossky, 'Imagination in the English Renaissance: Psychology and Poetic', *Stud. in the Renaissance*, 5 (1958), 50 n. 4, confirms that although 'imagination' and 'fantasy' might have been distinguished in classical writings, 'by Elizabethan times the distinction had,

for the most part been lost and terms like "phantasy", "fantsie", even "fancy", are used interchangeably with "imagination" '.
22. Nicolas Coëffeteau, *Tableau des passions humaines, de leurs causes et de leur effets* (Paris, 1620), 'Preface'. The work appeared in at least seven more editions down to 1664, and in English (trans. Edward Grimeston) as *A table of humane passions. With their causes and effects* (London, 1621). On Coëffeteau, see Anthony Levi, *French Moralists: The Theory of the Passions, 1585–1649* (Oxford, 1964), 142–52. On faculty psychology, see the summary by Lawrence Babb, *The Elizabethan Malady: A Study of Melancholia in English Literature from 1580 to 1642* (East Lansing, Mich., 1951), 2–5.
23. Huarte, *Examen de ingenios*, 51–68.
24. Otto Casmann, *Psychologia anthropologica; sive animae humanae doctrina* (Hanau, 1594), 371–6 ('De phantasia'); Francis Bacon, *Works*, ed. J. Spedding, R. L. Ellis, and D. D. Heath (14 vols.; London, 1857–74), iii. 329. Bacon eventually added understanding, will, and appetite but still wished for a 'simpler, more dynamic' explanation of the human faculties than that available in the traditional account; for this and other related aspects of his psychological theory, see Karl R. Wallace, *Francis Bacon on the Nature of Man* (Urbana, Ill., 1967), 2, 6, 154–6, and *passim* (on the imagination, see 69–95). For the division of the sentient soul into common sense, imagination, and memory, see Fernel, *'Physiologia'*, 335–43, who describes what the senses receive in Aristotelian terms as 'simulachra', 'spectra', 'formas', and 'imagines' that are 'branded' ('inusta') and 'carved' ('insculpta') on the brain (338–9).
25. In the continuing scarcity of studies in this area, I rely in what follows on Katharine Park, 'The Imagination in Renaissance Psychology', M.Phil. thesis (University of London, 1974), and her more recent accounts of psychological theory in 'Pico's *De imaginatione* in der Geschichte der Philosophie', in Gianfrancesco Pico della Mirandola, *Über die Vorstellung/De imaginatione*, ed. Eckhard Kessler (Munich, 1984), 16–40, and in ead., 'The Concept of Psychology' (with Eckhard Kessler) and 'The Organic Soul', in Schmitt et al. (eds.), *Cambridge History of Renaissance Philosophy*, 455–63, 464–84.
26. For faculty psychology in a traditional setting at a later date, see Caspar Voight, *Psychologia per theses succinctas de anima humana eiusque potentiis et operationibus* (Stettin, n.d. [1650?]).
27. On faculty psychology down to Aquinas, see E. Ruth Harvey, *The Inward Wits: Psychological Theory in the Middle Ages and the Renaissance* (London, 1975); Simon Kemp, *Cognitive Psychology in the Middle Ages* (Westport, Conn., 1996), esp. 45–57; Agamben, *Stanzas*, 1–101, calling it, in strictly correct terms, 'phantasmatic psychology' (85); Carruthers, *Book of Memory*, esp. 16–60; Eleonore Stump, 'Aquinas on the Mechanisms of Cognition: Senses and Phantasia', in Sten Ebbesen and Russell L. Friedman (eds.), *Medieval Analyses in Language and Cognition* (Copenhagen, 1999), 377–95. For the later medieval period and its 'prevailing model of visuality', see the summaries by Camillo, 'Before the Gaze', *passim*, esp. 211–14, and Smith, 'Getting the Big Picture', 572–5, and for Aristotle to the Coimbra Jesuits, see Dennis L. Sepper, *Descartes's Imagination: Proportion, Images, and the Activity of Thinking* (Berkeley, 1996), 13–28. There is much additional information on the 'inner wits' in Summers, *Judgement of Sense*, 12–21, 27, 71–106, 198–234.

28. Park, 'Imagination', 67; on these 16th- and 17th-century adjustments, see also Harry A. Wolfson, 'The Internal Senses in Latin, Arabic, and Hebrew Philosophic Texts', *Harvard Theological Rev.* 28 (1935), 124–9.
29. Pico della Mirandola, *Imagination*, 31. Apart from appearing in Pico's collected works, this was published again singly in 1536 and 1588, and in a French trans. by Jean-Antoine Baïf in 1557 and 1577.
30. For Cennini's and other similar claims, together with the modern scholarship on the subject, see Swan, 'Eyes Wide Shut', 570–1; cf. ead., *Art, Science, and Witchcraft*, 20–2.
31. Edward Reynolds, *A treatise of the passions and faculties of the soule of man* (London, 1640), 24, and 18–24 *passim*. Reynolds was Rector of Braunston in Northamptonshire at the time but later became Bishop of Norwich. His treatise was reprinted six times. For similar remarks, see George Puttenham, *The Arte of English Poesie*, ed. G. D. Willcock and A. Walker (Cambridge, 1936; 1970), 18–20.
32. On Fienus and the arguments of his book (republished in 1635 and 1657), including translated extracts, see Rather, 'Thomas Fienus' (1567–1631) Dialectical Investigation', 349–67.
33. Aristotle, *De anima*, 428a, 12; for Christian parallels, Agamben, *Stanzas*, 98.
34. Pico della Mirandola, *Imagination*, 29, 31.
35. Francis Bacon, 'A Description of the Intellectual Globe', in *Works*, v. 504 (Latin orig., iii. 727–8).
36. Rossky, 'Imagination', 62, and 53–64 for many examples; cf. Jay L. Halio, 'The Metaphor of Conception and Elizabethan Theories of the Imagination', *Neophilologus*, 50 (1966), 454–61; Alison Thorne, *Vision and Rhetoric in Shakespeare: Looking through Language* (London, 2000), 168–71; Huston Diehl, *Staging Reform, Reforming the Stage: Protestantism and Popular Theatre in Early Modern England* (Ithaca, NY, 1997), 67–93, on Calvinist distrust of the imagination as the vehicle of the illusory.
37. La Primaudaye, *French academie*, 414; La Primaudaye was referring to Cicero's *Academica*, i. 40, where *phantasia* is translated as *visum*; see Cicero, *De natura deorum. Academica*, trans. H. Rackham (London, 1933), 448. For the same point, see Hieronymus Nymann, *Oratio de imaginatione*, in Tobias Tandler, *Dissertatio de fascino et incantatione* (Wittenberg, 1606), 54: 'Latinis imaginatio et visio a visis . . . dicta'. Aristotle made the same associations in claiming that the (Greek) word for the imagination was formed from the word for light, 'because it is not possible to see without light': *De anima*, 429a, 1–5.
38. Laurentius Beyerlinck, *Magnum theatrum vitae humanae* (8 vols.; Lyons, 1678), iv. 326–31, *vide*. 'Imaginatio'.
39. Swan, 'Eyes Wide Shut', 579–81; ead., *Art, Science, and Witchcraft*, 154–6; cf. Rossky, 'Imagination', 51–3.
40. Pico della Mirandola, *Imagination*, 27; Plato, *Philebus*, 39a–d, in *Dialogues*, iv. 610; Agamben, *Stanzas*, 73–5.
41. M. W. Bundy, *The Theory of Imagination in Classical and Medieval Thought* (Urbana, Ill., 1927), 29; Rossky, 'Imagination', 51–2, and 54, on 'writer after writer' saying that the imagination should 'function as a "glasse" '; Camille, 'Before the Gaze', 209–11, on the mirror metaphor as 'rampant in medieval culture'. See also Ch. 1 above on this theme.
42. Fulke Greville, 'A treatie of humane learning', in *Poems and Dramas of Fulke Greville First Lord Brooke*, ed. G. Bullough (2 vols.; Edinburgh, n.d. [1938]), i. 156,

stanza 10 (cited Halio, 'Metaphor of Conception', 455). Stanzas 12 to 13 are also important:

> So must th'Imagination from the sense
> Be misinformed, while our affections cast
> False shapes, and formes on their intelligence,
> And to keepe out true intromissions thence,
> Abstracts the imagination, or distasts,
> With images preoccupately plac'd.
>
> Hence our desires, feares, hopes, love, hate, and sorrow,
> In fancy make us heare, feele, see impressions,
> Such as out of our sense, they doe not borrow;
> And are the efficient cause, the true progression
> Of sleeping visions, idle phantasms walking,
> Life, dreames; and knowledge, apparitions making.

43. For example, Daniel Tuvil, *Essaies politicke, and morall* (1608), cited by Babb, *Elizabethan Malady*, 18; Rossky, 'Imagination', 56–7.
44. Reynolds, *Treatise of the passions*, 25, 26–7.
45. Pico della Mirandola, *Imagination*, 37, 41–3, 43.
46. See esp. Thomas Aquinas, *Summa theologica*, pt. 1, q. 111, art. 3: 'Whether an angel can change man's imagination', in *Basic Writings of Saint Thomas Aquinas*, ed. A. C. Pegis (2 vols.; New York, 1945), i. 1027–8.
47. Pico della Mirandola, *Imagination*, 51.
48. Ibid. 53, 59.
49. Ibid. 63, 57–97.
50. La Primaudaye, *French academie*, 414–15.
51. Nymann, *Oratio*, 56–9, 61, 65.
52. I assume, with Michael MacDonald (and others), that 'the types of insanity people recognize and the significance they attach to them reflect the prevailing values of their society; the criteria for identifying mental afflictions vary between cultures and historical periods'; see id., *Mystical Bedlam: Madness, Anxiety, and Healing in Seventeenth-Century England* (Cambridge, 1981), 1. For surveys of the entire history of cultural representations of melancholy, assuming more continuity than is warranted, see Stanley W. Jackson, *Melancholia and Depression from Hippocratic Times to Modern Times* (New Haven, 1986), and Jennifer Radden (ed.), *The Nature of Melancholy from Aristotle to Kristeva* (New York, 2000), the latter with texts. An excellent introduction is Roy Porter, 'Mood Disorders: Social Section', in G. E. Berrios and Roy Porter (eds.), *A History of Clinical Psychiatry: The Origin and History of Psychiatric Disorders* (London, 1995), 409–20.
53. For the universities, see Oskar Diethelm, *Medical Dissertations of Psychiatric Interest Printed before 1750* (Basel, 1971), 32–49 (cf. 50–70, on 'mania'), and the lists of 1,100 dissertations in an appendix (161–206). An enormous contemporary bibliography on the subject can be constructed simply from Robert Burton's citations; see also the listings in Malachias Geiger, *Microcosmus hypochondriacus; sive, de melancholia hypochondriaca* (Munich, 1652), 513–22.

54. Bridget G. Lyons, *Voices of Melancholy: Studies in Literary Treatments of Melancholy in Renaissance England* (London, 1971); Babb, *Elizabethan Malady*. For melancholy's general modishness, especially with physicians and lay intellectuals, see MacDonald, *Mystical Bedlam*, 120, 150–60.
55. Park, 'Imagination', 132–3; on England, Babb, *Elizabethan Malady*, p. vii and *passim*.
56. Juliana Schiesari, *The Gendering of Melancholia: Feminism, Psychoanalysis and the Symbolics of Loss in Renaissance Literature* (Ithaca, NY, 1992), 2.
57. H. C. Erik Midelfort, *A History of Madness in Sixteenth-Century Germany* (Stanford, Calif., 1999), 20, 13–14; cf. id., *Mad Princes of Renaissance Germany* (Charlottesville, Va., 1994).
58. Simon Goulart, *Admirable and memorable histories, containing the wonders of our time*, trans. Edward Grimeston (London, 1607), 370–84. For the definition as 'preternatural', see Giovanni Francesco Armo, *De tribus capitis affectibus, sive de phrenetide, mania, et melancholia liber* (Turin, 1573), 42r; Joannes Siglicius, *praeses* (Joannes Leopoldus, *respondens*), *De melancholia morbo, disputatio pathologica* (Leipzig, 1613), sigs. a2v–a3r. On preternature and its appeal, see Lorraine Daston and Katharine Park, *Wonders and the Order of Nature 1150–1750* (New York, 2001), *passim*, esp. 146–72.
59. Timothy Bright, *A treatise of melancholie* (London, 1586), 184–242. Bright did concede that the melancholic person was more subject to scruples of conscience, being 'most doubtfull, and jelous of his estate, not only of this life, but also of the life to come' (199). Bright's book was quickly reissued and achieved a 3rd edn. in 1613.
60. See, in particular, Schiesari, *Gendering of Melancholia*, 7, and *passim*. Cf. Noel L. Brann, *The Debate over the Origin of Genius during the Italian Renaissance: The Theories of Supernatural Frenzy and Natural Melancholy in Accord and in Conflict on the Threshold of the Scientific Revolution* (Leiden, 2002), 15–19, 189–246, 333–441. For older studies of this important theme, see Rudolf and Margot Wittkower, *Born under Saturn* (London, 1963), esp. 98–132, and Raymond Klibansky, Erwin Panofsky, and Fritz Saxl, *Saturn and Melancholy: Studies in the History of Natural Philosophy, Religion, and Art* (London, 1964), 241–74. Winfried Schleiner, *Melancholy, Genius, and Utopia in the Renaissance* (Wiesbaden, 1991), emphasizes (like Brann) 'the age's general retreat from the concept of heroic melancholy and divination to a more ambivalent and often medical view of such states'; 233, cf. 12, 14, 39, 84–90, 98–108, 109, 123, 335.
61. Wolfgang Weber, 'Im Kampf mit Saturn: Zur Bedeutung der Melancholie im anthropologischen Modernisierungsprozess des 16. und 17. Jahrhunderts', *Zeitschrift für historische Forschung*, 17 (1990), 155–92, esp. 181–9.
62. Duncan Salkeld, *Madness and Drama in the Age of Shakespeare* (Manchester, 1993), esp. 1–2, 28, 80.
63. Radden, *Nature of Melancholy*, p. vii; Swan, *Art, Science, and Witchcraft*, 24, and 175–94 *passim*.
64. Robert Burton, *The Anatomy of Melancholy*, ed. Holbrook Jackson, with new introd. by William H. Gass (New York, 1932; 2001), 424–8 (pt. 1, sect. 3, mem. 3).
65. Barrough, *Method of phisick*, 45.
66. Thomas Erastus, *Theses de melancholia*, in id., *Comitis Montani Vicentini novi medicorum censoris, quinque librorum de morbis nuper editorum viva anatome* (Basel, 1581), 255; the theses were first published in Heidelberg in 1577, where and when they were presumably also defended; cf. for Germany, Wirsung, *Praxis medicinae universalis*,

130–1; Valentino Espich, *De melancholia medicae theses*, in id., *De errore externo* (Wittenberg, 1591), sig. E4[r–v] (defended at Wittenberg in 1585), and Sennert, *Practicae medicinae*, in *Opera omnia*, ii. 125. According to Agamben, *Stanzas*, 24, melancholy was from its origin 'traditionally joined to phantasmatic practice', and see 22–8 *passim*.
67. Reynolds, *Treatise of the Passions*, 25.
68. Du Laurens, *Discourse*, 87. In this English edition and some others, the analysis of melancholy is printed immediately after the treatise on the preservation of the eyes.
69. Adolfus Vorstius, *praeses* (Johannes ab Hoobroeck, *defendens*), *Disputatio medica inauguralis de melancholia* (Leiden, 1660), thesis ix.
70. Spenser, *Faerie Queene*, bk. 2, canto ix, 50–2, in *Poetical Works*, i. 284–5.
71. MacDonald, *Mystical Bedlam*, 120, 150, 150–60, 170; cf. 162 for disturbance of the senses as the 'characteristic psychological evidence' of mopishness. MacDonald argues (169–70) that delusion could not, and so did not, become a sign of outright madness until the educated elite 'abandoned their beliefs in divine inspiration and demonology'.
72. Tomaso Garzoni, *The hospitall of incurable fooles*, trans. Edward Blount [?] (n.p. [London], 1600), 16.
73. Levinus Lemnius, *The touchstone of complexions*, trans. Thomas Newton (London, 1576), 150[r].
74. Cited in Brann, *Debate*, 191.
75. Burton, *Anatomy*, 383, 387, 419 (pt. 1, sect. 3, mem. 1, subs. 1–2; pt. 1, sect. 3, mem. 3)
76. MacDonald, *Mystical Bedlam*, 157.
77. Anon, *Histoire d'une apparition avec des réflexions, qui prouvent la difficulté de sçavoir la verité sur le retour des esprits* (Paris, 1722), 14.
78. Lemnius, *Touchstone*, 151[r].
79. Samuel Butler, *Characters*, ed. Charles W. Daves (Cleveland, 1970), 97.
80. Du Laurens, *Discourse*, 97.
81. Baron Gerard Van Swieten, *The Commentaries upon the Aphorisms of Dr. Herman Boerhaave . . . concerning the knowledge and cure of the several diseases incident to human bodies*, trans. anon., 2nd edn. (18 vols.; London, 1771, 1744–73), xi. 1, 122–3.
82. On the distinction between mania and melancholy generally, see Jackson, *Melancholia and Depression*, 249–73. For England, see MacDonald, *Mystical Bedlam*, 120, 120–72, who reports a distinction between severe insanity (*madness, lunacy, distraction, mania, light-headedness*) and less violent mental disorders (*melancholy, mopishness*) in popular stereotypes of mental disorder; for the views of an Italian, see Girolamo Mercuriale, *Medicina practica* (Frankfurt, 1602), 27–41 (bk. 1, ch. x, 'De melancholia'), 60–5 (bk. 1, ch. xvi, 'De Mania'); for Germany, see Midelfort, *History of Madness*, 183–8, 218–23, 225–7.
83. Aretaeus, *Of the Causes and Signs of Acute and Chronic Disease*, trans. T. F. Reynolds (London, 1837), 70.
84. Thomas Adams, *Mystical bedlam, or the world of mad-men* (London, 1615), 35; Garzoni, *Hospitall*, 16; many further references in Schleiner, *Melancholy*, 98–108 ('*Laesa imaginatio*').
85. Sennert, *Institutionum medicinae*, in *Opera omnia*, i. 108.
86. Du Laurens, *Discourse*, 74.
87. Burton, *Anatomy*, 171 (pt. 1, sect. 1, mem. 3, subs. 2), 140 (pt. 1, sect. 1, mem. 1, subs. 4); cf. 159 (pt. 1, sect. 1, mem. 2, subs. 7: 'in melancholy men this faculty is

most powerful and strong, and often hurts . . . '), 253–8 (pt. 1, sect. 2, mem. 3, subs. 2: 'Of the Force of the Imagination').

88. John Locke, *An Essay Concerning Human Understanding*, ed. Peter H. Nidditch (Oxford, 1975), 161 (bk. 2, ch. xi, sect. 13); Locke continues by saying: '[M]ad men put wrong ideas together, and so make wrong propositions, but argue and reason right from them: But idiots make very few or no propositions, and reason scarce at all.' On Locke and 18th-century distinctions between idiots and madmen, see Michael V. DePorte, *Nightmares and Hobbyhorses: Swift, Sterne, and Augustan Ideas of Madness* (San Marino, Calif., 1974), 19–25.

89. James Elkins, *The Poetics of Perspective* (Ithaca, NY, 1994), 176 and plate 40; cf. Klibansky, Panofsky, and Saxl, *Saturn and Melancholy*, 380 and plate 116, commenting that the 'pedantic execution of the close-view perspective [achieves] great power of psychological expression' (n. 17). The artist is identified as Franz [Isaac] Brun by G. K. Nagler, *Die Monogrammisten* (5 vols.; Munich, 1857–79), ii. 709. For the iconography of the eyes and the gaze in artistic depictions of melancholy (notably Dürer's *Melencolia I* of 1513), see A. Ceccarelli Pellegrino, 'Iconografie "malinconiche" dell'immaginario rinascimentale', in L. Rotondi Secchi Tarugi (ed.), *Malinconia ed allegrezza nel Rinascimento* (Milan, 1999), 140–6.

90. Lyons, *Voices of Melancholy*, 113, and see 113–48.

91. Ibid. 67–9; *The Plays of John Marston*, ed. H. Harvey Wood (3 vols.; Edinburgh, 1938), see esp. ii. 269 (Act 3, Sc. 1).

92. Sennert, *Institutionum medicinae*, in *Opera omnia*, i. 408, cf. 369. Cf. Erastus, *Theses de melancholia*, 255: 'The *phantasmata* of melancholics are the ravings of dreamers. Who does not often see in dreams what the melancholic imagine while awake?'; Janus Matthaeus Durastantes, *Problemata* (Venice, 1567), 38r–41r: 'Not uncommonly a [melancholic] man perceives awake what he does asleep when dreaming. Indeed, he will see the very same form of a thing, not just a similar one (*ipsam rei formam, non suum simile*).' On dreams as visual paradoxes, see Ch. 9 below.

93. Burton, *Anatomy*, 394 (pt. 1, sect. 3, mem. 1, subs. 2).

94. Butler, *Characters*, 97–8.

95. Cited in Jackson, *Melancholia and Depression*, 118; cf. Thomas Tryon, *A treatise of dreams and visions* (London, 1689), 249–99: 'An appendix shewing the cause of madness . . . ', which opens by suggesting 'an affinity or analogy between dreams and madness . . . for madness seems to be a watching or waking dream' (249). For many other Restoration and 18th-century examples, see DePorte, *Nightmares and Hobbyhorses*, 25–30, who says (27) that the imagination came to be seen 'less as the reporter than as the rival of sensation'.

96. Descartes, 'Meditations on First Philosophy', in *Philosophical Writings*, ii. 13.

97. A glaring example is Harry G. Frankfurt, *Demons, Dreamers, and Madmen: The Defense of Reason in Descartes's Meditations* (Indianapolis, 1970), 36–9, and *passim*.

98. Bayfield, *Tes iatrikes kartos*, 41, definition at 39.

99. Typical tales in Leonhard Fuchs, *De curandi ratione* (Lyons, 1548), 77–82; Jasonis Pratensis (Jason van de Velde), *De cerebri morbis* (Basel, 1549), 270–1; Lemnius, *Touchstone*, 150–2; Du Laurens, *Discourse*, 100–4; Thomas Walkington, *The optick glasse of humors, or the touchstone of a golden temperature* (London, 1607), 69r–72v; Geiger, *Microcosmus hypochondriacus*, 481–95; *Batman uppon Bartholome*, 33^{r-v}; Garzoni, *Hospitall*, 17–19; Goulart, *Admirable and memorable histories*, 370–84;

[Thomas Milles], *The treasurie of auncient and moderne times* (London, 1613), 476–79; Burton, *Anatomy*, 402–9 (pt. 1, sect. 3, mem. 1, subs. 3–4); Nathaniel Wanley, *The wonders of the little world; or, the general history of man* (London, 1678), 94–6. For much additional material on the glass delusion (which included the symptoms of photophobia) in particular, see Speak, 'An Odd Kind of Melancholy', *passim*.
100. Diethelm, *Medical Dissertations*, 46–7.
101. Walkington, *Optick glasse*, 69^{r-v}; Burton, *Anatomy*, 384 (pt. 1, sect. 3, mem. 1, subs. 2); Johann Weyer, *De praestigiis daemonum*, in George Mora (gen. ed.), J. Shea (trans.), et al., *Witches, Devils, and Doctors in the Renaissance: Johann Weyer, 'De praestigiis daemonum'* (Binghamton, NY, 1991), 184 (bk. 3, ch. vii of edn. of 1583), on all the senses being deluded; Guibelet, *Trois discours*, 238v–45.
102. Jackson, *Melancholia and Depression*, 41–5, 57.
103. Du Laurens, *Discourse*, 97.
104. *Batman uppon Bartholome*, 32v.
105. See, for example, the summary of causes in Bright, *Treatise*, 1–3, 32–3, 110–16; cf. Pratensis, *De cerebri morbis*, 263–6; Lemnius, *Touchstone*, 135v–47; Franz Hildesheim, *De cerebri et capitis morbis internis spicilegia* (Frankfurt, 1612), 126–34; Philotheus Elianus Montalto, *Archipathologia, in qua internarum capitis affectionum essentia, causae, signa, praesagia, et curatio accuratissima indagine edisseruntur* (Paris, 1614), 236–64. On Pratensis, see Midelfort, *History of Madness*, 152–7 (and 140–81, for melancholy in German medical humanism generally). For a highly detailed conventional treatment of melancholy's causes see Sennert, *Practicae medicinae*, in *Opera omnia*, ii. 126–50.
106. Lemnius, *Touchstone*, 138v; Sennert, *Institutionum medicinae*, in *Opera omnia*, i. 408; Joannes Le Clerc, *Disputatio medica inauguralis, de melancholia* (Leiden, 1633), sig. A2^{r-v}.
107. Guibelet, *Trois discours*, 246v–7v, 266v–7r (I have conflated the two passages).
108. Samuel Harsnet, *A declaration of egregious popish impostures* (1603), in F. W. Brownlow, *Shakespeare, Harsnett and the Devils of Denham* (London, 1993), 304.
109. Du Laurens, *Discourse*, 91.
110. Burton, *Anatomy*, 425 (pt. 1, sect. 3, mem. 3).
111. Du Laurens, *Discourse*, 91–2; for a study of Du Laurens, see Philippe Desan, 'Pour une typologie de la mélancolie à la Renaissance: *Des maladies mélancholiques* (1598) de Du Laurens', in Rotondi Secchi Tarugi (ed.), *Malinconia ed allegrezza*, 355–66.
112. Bright, *Treatise*, 100, 102, 103.
113. Ibid. 104–5.
114. Ibid. 112.
115. Notice also ibid. 103: 'counterfet goblins', and 110: ' . . . counterfeit cause of perturbation, whereof there is no ground in truth, but onely a vaine and fantasticall conceit.'
116. Bundy, *Theory of Imagination*, 66–70, 88–9. Park, 'Organic Soul', 471 uses *phantasmata* for the combinatory function of the 'fantasy', which Reisch distinguished from the imagination, adding that they 'had no counterparts in external reality'.
117. Barrough, *Method of phisick*, 50; MacDonald, *Mystical Bedlam*, 114.
118. Something parallel may well have happened to the linked term *contrafactio*, whereby the sense of a portrayal faithful to fact (a true copy) gave way gradually to the idea of

a forgery (a false copy); see Parshall, 'Imago contrafacta', for the first of these meanings.
119. Nicole Jacques-Chaquin, 'Nynauld, Bodin et les autres: les enjeux d'une métamorphose textuelle', in Jean de Nynauld, *De la lycanthropie, transformation et extase des sorciers (1615)*, ed. Nicole Jacques-Chaquin, Maxime Préaud, et al. (Paris, 1990), 7–41, esp. 23, 31–2; Claude Prieur, *Dialogue de la lycanthropie ou transformation d'hommes en loups, vulgairement dits loups-garous, et si telle se peut faire* (Louvain, 1596), 18ʳ.
120. Sieur de Beauvois de Chauvincourt, *Discours de la lycantropie ou de la transmutation des hommes en loups* (Paris, 1599), 21.
121. Nynauld, *De la lycanthropie*, 103 (following not just Du Laurens but Weyer); Babb, *Elizabethan Malady*, 44; Jackson, *Melancholia and Depression*, 345–51, emphasizing the decline in medical interest during the 18th century. For a standard medical account, see Mercuriale, *Medicina practica*, 49–50 (bk. 1, ch. xii, 'De Likanthropia').
122. Prieur, *Dialogue*, 44ᵛ–45.
123. See below, Ch. 9.
124. Pedro de Valderrama, *Histoire generale du monde, et de la nature*, trans. Sieur de La Richardière (2 pts.; Paris, 1619–17), ii. 257.
125. *A general collection of discourses of the virtuosi of France, upon questions of all sorts of philosophy, and other natural knowledge*, trans. George Havers (London, 1664), 204–5; cf. *Recueil général des questions traitées és conférences du Bureau d'Adresse, sur toutes sortes de matières*, ed. Eusèbe Renaudot (6 vols.; Lyons, 1666), ii, conference 34, no. 1, 'De la Lycanthropie'.
126. As in the remark by the 18th-century physiologist William Cullen of Edinburgh that the melancholic in this condition suffered 'with false conception about the nature of his species'; cited in Jackson, *Melancholia and Depression*, 349.
127. On this large subject, see John F. Sena, 'Melancholic Madness and the Puritans', *Harvard Theological Rev.* 66 (1973), 293–309; Schleiner, *Melancholy*, 109–41; Michael Heyd, *'Be Sober and Reasonable': The Critique of Enthusiasm in the Seventeenth and Early Eighteenth Centuries* (Leiden, 1995), 44–108.
128. Sena, 'Melancholic Madness', 302, 304, citing Richard Baxter, *Preservatives against melancholy and overmuch sorrow. Or the cure of both by faith and physick* (London, 1713), 83; [John Trenchard], *The natural history of superstition* (London, 1709), 19–20.
129. Meric Casaubon, *A treatise concerning enthusiasme, as it is an effect of nature: but is mistaken by many for either divine inspiration, or diabolical possession*, 2nd edn. (London, 1656), 106, 87–8, 146, cf. 164, and 88–176 *passim*. Casaubon's argument is prefaced, significantly, with a discussion of seeing, and, in particular, of the idea that it is 'not the eye [that sees], but the soul through the eye' (71 ff.), a view which Casaubon describes as 'necessary . . . for the maintenance of publick peace' (75).
130. [Henry More], *Enthusiasmus triumphatus, or, a discourse of the nature, kinds, and cure, of enthusiasme* (London, 1656), 4, cf. 2.
131. Ibid. 5.
132. Ibid.
133. Ibid. 5–6.
134. Ibid. 27. The epistemological implications of dreaming in early modern visual culture are discussed in Ch. 9 below.

135. See for example, Richard Blackmore, *A treatise of the spleen and vapours: or, hypocondriacal and hysterical affections* (London, 1725), 162.
136. T. H. Jobe, 'Medical Theories of Melancholia in the Seventeenth and Early Eighteenth Centuries', *Clio medica*, 11 (1976), 222; Jackson, *Melancholia and Depression*, 111, 387; quotations from [Thomas Willis], *Dr Willis's practice of physick* (London, 1684), 86 (in 'An essay of the pathology of the brain and nervous stock: in which convulsive diseases are treated of'), 201 (in 'Two discourses concerning the soul of brutes', and cf. 188–201 on melancholy).
137. The two treatises are brought together in R. Hunter and I. Macalpine (eds.), *A Treatise on Madness by William Battie, M. D. and Remarks on Dr. Battie's Treatise on Madness by John Monro, M. D.: A Psychiatric Controversy of the Eighteenth Century* (London, 1962), see (for Battie) 5–6, 41–58, and (for Monro) 3–6 (sep. pag.).
138. The broad features of this change can be followed in Roy Porter, *Mind-Forg'd Manacles: A History of Madness in England from the Restoration to the Regency* (Harmondsworth, 1990), *passim*, esp. 81–9, 241–4, and Michael MacDonald, 'Insanity and the Realities of History in Early Modern England', *Psychological Medicine*, 11 (1981), 11–25, esp. 16 ff on the transference of delusion and hallucination from melancholy to acute insanity.
139. Bright, *Treatise*, 112.
140. Wirsung, *Praxis medicinae universalis*, 131.
141. Burton, *Anatomy*, 253 (pt. 1, sect. 2, mem. 3, subs. 2).
142. See Romano Alberti, *Trattato della nobilità della pittura*, cited in Wittkower, *Born under Saturn*, 105.
143. Bright, *Treatise*, 246–7.
144. Andrew Borde, *The breviary of helthe* (London, 1547), 91[r]; id., *A compendyous regyment or a dyetary of healthe* (London, 1547), sig. Jiiii[v].
145. *Batman uppon Bartholome*, 88[r]: 'Diverse shapes of faces and semblaunt of painting shall not bee shewed before him, lest he be tarred with woodnesse [i.e. vexed]'; Rossky, 'Imagination', 55.

3

Prestiges: Illusions in Magic and Art

If nature could bring confusion upon the human senses, so of course could human beings themselves; their activities fell into the second major category of irrational seeing in Hakewill's polemic against the eyes, summed up in his appeal to 'the bowels of naturall Philosophy, and the Mathematicks'. From the pretensions of high art to the ruses of the trickster, the eyes were subject to perpetual contrivance in the Europe of his time. Francis Bacon, for whom mimesis in science was virtually an article of faith, evidently thought it worth studying visual artifice across this range. The imaginary natural philosophers of 'Salomon's House' who are described in his blueprint for a perfect scientific (as well as political and religious) community, 'Bensalem', in *New Atlantis* (1626), spent part of their utopian time creating visual delusions (and, as it happens, the governor of Bensalem called Salomon's House 'the very eye of this kingdome'). In 'houses of deceits of the senses', they experimented with 'feats of juggling, false apparitions, impostures, and illusions; and their fallacies'. In 'perspective houses' they demonstrated the qualities of light and colour and the effects of prisms and lenses. As one of them said, they attempted

> all delusions and deceits of the sight, in figures, magnitudes, motions, colours: all demonstrations of shadows. We find also divers means, yet unknown to you, of producing of light originally from divers bodies. We procure means of seeing objects afar off; as in the heaven and remote places; and represent things near as afar off, and things afar off as near; making feigned distances. We have also helps for the sight, far above spectacles and glasses in use. We have also glasses and means to see small and minute bodies perfectly and distinctly; as the shapes and colours of small flies and worms, grains and flaws in gems, which cannot otherwise be seen; observations in urine and blood, not otherwise to be seen. We make artificial rain-bows, halos, and circles about light. We represent also all manner of reflexions, refractions, and multiplications of visual beams of objects.[1]

Visual delusion figured too in Bacon's 'prerogative instances'—a critical type of experiment (*experimentum crucis*) privileged by its exceptional capacity to disclose natural processes and expedite scientific theory and practice. The 'noblest and most consummate works in each art'—what he termed its 'miracles'—would sooner lead to knowledge of the higher forms that encompassed that art than either feats of no consequence or the obscurities of nature tackled directly. In the *Novum organum* such 'singularities' included the wit and dexterity shown by

jugglers and conjurors; in *Parasceve ad historiam naturalem et experimentalem*, Bacon listed again the 'History of Jugglers and Mountebanks (*Historia Praestigiatorum et Circulatorum*)' among instances of 'things artificial' taken from his proposed 'History of Arts, and of Nature as changed and altered by Man, or Experimental History'; and in *Sylva sylvarum*, the work closest to his idea of a natural history, the feats of jugglers were used to demonstrate the sympathy and antipathy of plants and the powers of the imagination.[2]

In the 1620s Bacon was perfectly positioned to articulate the keen interest shown by late Renaissance intellectuals in the visual technologies of machine and hand. Exactly balanced in *New Atlantis*, and throughout his *Magna instauratio* of the sciences, are an admission that the senses can be rendered uncertain and misleading and an equal intention to strengthen them and extend their reach. In this context, deceiving the eyes artificially was poised between scepticism and empiricism—a dilemma we must return to at the close of this book. Even the tricks of jugglers, it seemed, were not to be ignored: 'though in use trivial and ludicrous', wrote Bacon, 'yet in regard to the information they give [they] may be of much value.'[3] He was referring to the hidden natural causes at work, but also to the visual perceptions of those deceived—to 'figures, magnitudes, motions, [and] colours'. This is why visual uncertainty found a necessary place in what was intended to be the most complete and fruitful possible programme for natural philosophical enquiry in the Europe of the decade. The artificial manipulation of vision to the point of paradox, recognized by Bacon to be a technological hallmark and challenge of his age, had forced itself on the attention of those to whom he gave the responsibility of discovering 'the true nature of all things', the imaginary fellows of 'Salomon's House'.

The Latin word chosen by Bacon for 'juggler' was 'praestigiator', and 'prestiges' would have been the term used by his contemporaries, in France and Italy as well as England, for the visual deceptions they caused.[4] A prestige might involve anything from high-class subtlety to low-class duping, provided the twin elements of artifice and imposture were present, but it was invariably a visual matter. In particular, there was a long tradition of naming *magia praestigiatoria* as one of the formal branches of magic, where it was always discussed as the production of virtual visual effects. According to a widely cited definition from the *Etymologia* of Isidore of Seville, a *praestigium* was a 'binding' of the pupil of the eye, or, as the seventeenth-century Spanish authority on magic Gaspar Caldera de Heredia put it in his somewhat expanded version, a 'false representation by a subtle deception of the senses, especially the eyes, from the word *perstringo*, since it binds them in such a way that a thing appears to be what it is not'.[5] For the Jesuits at Coimbra magic was either evil or good, and the evil sort (*magia malefica*) involved the production of 'praestigiis' and 'veneficiis'.[6] In Johann Heinrich Alsted's seventeenth-century encyclopedia, 'magia praestigiatrix' (or 'fascinatrix') amounted to persuading someone 'that he sees that which in truth he sees not'.[7]

A German guide to magic published at the same time made it and 'mathematical magic' the twin components of *magia artificialis*, and ascribed its name to its effects: 'for these are shows (*ludicra*), and not what they seem'.[8] The Rostock lawyer and witchcraft expert Johann Georg Godelmann (who also called them 'fascinatores') described prestigiators as those who deceived the eyes 'so that they do not see that which is, and suppose they see that which is not (*ut non videant ea quae sunt, et videre se arbitrentur, ea quae non sunt*)', while in London, Walter Raleigh agreed that they 'dazell mens eyes, and make them seeme to see what they see not: as false colours, and false shapes'. Both these men, and countless others who said much the same thing, thought that the 'magicians' of Pharaoh, Jannes and Jambres, in Exodus 7, 8, and 9, were experts in prestiges. The author whose work provided a *summa* of these issues and the best-known categorizations of magic throughout the Catholic world (and, indeed, beyond it) was the Jesuit scholar Martín Antonio Del Río, whose *Disquisitionum magicarum* appeared first in 1599. According to Del Río, magic had three efficient causes—natural, artificial, and diabolic—and the artificial variety was either operative or divinatory. Operative magic that achieved real effects was 'mathematical' (that is, it was based on geometry, arithmetic, or astronomy); operative magic that did not was 'deceitful' (involving *ludicra et deceptoria*) and best called 'prestigious' (*praestigiatrix*), since its effects were never what they seemed.[9]

There was usually, therefore, an optical dimension to magic, making the mirror one of the magician's symbolic attributes and catoptromancy one of his divinatory skills.[10] And the profile of this visual magic could only have been accentuated by magic's own dramatic rise in intellectual popularity and esteem between the Renaissance and the end of the seventeenth century. Natural magic, in particular, conceived as the study of nature's most secret processes and powers, invariably occupied a place in the many surveys and systematizations of natural philosophy that occupied early modern academics and structured both their courses and their textbooks—and not just in faculties of philosophy. But wherever magic was discussed, references to the deceiving of the eyes were likely to multiply, with the consequence that another form of visual uncertainty—man-made—was added to those in plentiful circulation throughout Europe. It was always possible in principle to ask of a magical effect the either-or question posed (in connection with Diomedis and the companions of Ulysses) by the celebrated theologian and professor at Salamanca, the Dominican Franciscus a Vitoria: was it real, or merely a *praestigium* induced by 'an illusion of the eyes and the senses'?[11]

Indeed, *Magia optica* appears in a category of its own in one of the best-known later sixteenth-century surveys of magic, *Adversus fallaces et superstitiosas artes* by the Spanish-born Jesuit Benito Pereira. Pereira divided all magic, whether 'natural' or 'unnatural' (or demonic), into real effects and deceitful ones—between 'veros' and 'simulatos effectus'. Deceitful magic was best called *Praestigiatrix*, since it 'binds and deludes the human senses so that they see what does not exist and do not see what is actually there.' This might be done 'medically' (*Magia pharmatica*),

using 'salves, fumigations, bindings, and potions to confuse the inner and outer senses so that they make judgements about what actually exists that are contrary to external sensations'. Or it could be achieved 'optically' (*Magia optica*), in which case 'the gaze of spectators' was deceived 'by incredible dexterity and movement of the hands, fingers, and other parts of the body' or by 'lamens, rings, images, and mirrors set up and moved in various places and ways'.[12] Pereira's compatriot from Seville, Caldera de Heredia, again offered the customary account of *magia praestigiatoria* as the artificial deception of the senses but followed it with a summary of the optics involved that shows how conceptions of natural magic in this area followed the conventional organization of vision derived from Aristotle's *De anima* and *De sensu et sensibili* and transmitted by the medieval *ars perspectiva*. Object, intervening medium, and organ might all be manipulated in manifold ways, explained Caldera de Heredia in detail, so that visible *species* no longer gave a true account of the world that produced them. For example, magicians could mimic the conditions created by cataracts:

> either by intruding something between the pupil and the air, which divides or separates the *species* of the object, so that things seem to be multiplied or arranged differently from what they are: which indeed happens to us when some humour or vapour comes between the crystalline humour and the tunics.[13]

Such, then, were the outlines of an academic theory disseminated throughout Europe that alerted intellectuals to the possibilities, and usually the dangers, of visual artifice within the framework of Aristotelian cognition. But arguably of equal influence—and probably much wider dispersion in social terms—were the vivid examples and stories that illustrated the abstract idea. Individual magicians and conjurors, real or mythical, received considerable attention, though nothing compared to that lavished on Pharaoh's magicians and their possibly optical illusions. Endless debates over whether they substituted real serpents for real rods by sleight of hand, or made non-real serpents appear by ocular delusion, turned a biblical episode into a series of perceptual and epistemological puzzles—as well as making serpents one of early modern Europe's favoured objects of visual deceit. Many less portentous wonders were added to these biblical feats. To the Jesuit Pereira, *magia praestigiatrix* could be recognized when 'someone eating bread appears to spit out flour; someone drinking wine throws it up through his forehead or collar-bone; someone seems to swallow a sword; someone vomits an immense number of pins and brooches'.[14] The somewhat less restrained enthusiast for natural magic Girolamo Cardano opened a discussion of ways of 'representing many incredible things' with the Emperor Charles V's juggler, a Spaniard named Damautum, who was so good at prestiges and at 'binding the eyes of spectators' that he was assumed to be a magician. Cardano followed this up with detailed descriptions of techniques for fire-eating and rope-dancing, ways of vomiting thread, nails, or glass, and tricks to produce waking visions and illusions.[15] Early modern Europe saw the publication of one of the earliest and

fullest surveys of the then current techniques for deception of sight by 'juggling knacks', 'conveiance' (legerdemain), and 'cousenage'—all fully described (with some diagrams) in book 13 of Reginald Scot's *The discoverie of witchcraft* (1584), and later repeated in many derivative compilations. The last and most memorable of Scot's 'notable execution[s] by this art' was a way 'to cut off ones head, and to laie it in a platter, which the jugglers call the decollation of John [the] Baptist'.[16] All forms of magic were, of course, the subject of tales told for admiration and wonderment; this was intrinsic to the subject. Visual magic was no exception; its literature is filled with human torsos without heads (or heads without torsos), 'flying' men, men transformed into animals, bodies dismembered and reassembled, disappearing banquets, and—a favourite trick, it seems—the devouring of entire hay carts, including the horses and drivers.

The often very negative attention given to actual conjuring and juggling in social contexts associated with 'popular culture'—the alehouse, the fairground, and so on—and to the notion of visual duping that they obviously contained, is a further important aspect of the early modern history of the prestige. What might be enjoyed at court or in the houses of the aristocracy was not to be recommended for the general population. After the Reformation, popular illusionary practices for gain and entertainment were increasingly condemned as deviant by the social critics of the day who saw them as immoral, even demonic, 'cozening'. In France the attack fell typically on the *joueurs de passe passe*—players with cups and balls—whose deceptions were the subject of Hieronymus Bosch's *The Conjuror* (Fig. 6) and deemed in writings from the late 1570s by Pierre Massé, René Benoist, Pierre Nodé, and Pierre Crespet to fall under the prohibitions of Moses. For Richard Bernard, the Somerset minister, typical witches included 'jugglers', sporting with 'resemblances', and 'tumblers'.[17] In Germany, among the 'magicians' who, according to Godelmann, did *not* deserve to be absolved from the charge of demonism—as witches themselves did—were the *praestigiatores* who deceived the eyes.[18] As for Del Río, he explicitly condemned *agyrtes, circulatores*, and *funambules* as exponents of 'prestigious' magic.[19] No doubt much of this was a reflection of the 'reformation of manners' that historians now associate with the age, and therefore driven by considerations of religion and morality. The fear of economic fraud and vagrancy was also at work, as in the cases of other deceivers of ordinary people like cunning folk, astrologers, and charlatans. In an English poor relief bill of 1736, proposed by the Whig magistrate and MP William Hay, it was intended to outlaw 'jugglers' for pretending to have skills in 'crafty Science' and 'subtle craft', and in the same year an anonymous tract entitled *The witch of Endor* singled out the 'hocus pocus vagrant' for attention.[20] Nevertheless, a more general anxiety about the boundaries between true and illusory perception may also be detected here, as in many contemporary criticisms of the virtual worlds created by the theatre, which, likewise, were condemned on religious, moral, and economic grounds as well. Heinrich Cornelius Agrippa linked jugglers and stage players and (citing Iamblicus) spoke of their ability 'to stretche out imaginations even unto

apperaunce, of whiche there shall afterwarde no signe appeare'. Beyerlinck's dictionary depicted the 'Gauckelbuben' of Europe entertaining the crowds in squares and at crossroads with stories but also with 'prestiges', while in England in the 1640s, John Stearne spoke again, as Bernard had done, of jugglers and their 'legerdemain companions' sporting with 'resemblances'.[21]

We shall see later in this book that the concepts of juggling and legerdemain entered metaphorically into a good deal of contemporary religious polemic, with similarly visual implications for 'lying' images, false miracles, and even the Mass itself. Eventually, the development of 'artful science' out of *magia praestigiatoria*—brilliantly described in the work of Barbara Maria Stafford—made playing with vision far more innocuous and therefore still fit for the rational entertainment of polite society. By 1747, for example, Beckmann's *Inventions and Discoveries* was able to speak of jugglers as those who 'for the sake of money, by quick and artful motions of their hands, bodies, and limbs, and by various preparations, delude the senses in an agreeable manner, or practice an innocent deception on the spectators, so that they think they hear and see what they do not really hear and see'. But until this way of talking became common, juggling was the occasion for moral and intellectual anxieties about the quality of popular seeing.[22]

We must return to the optics of the natural magicians in more detail later in this chapter, but, first, where else were prestiges like those so frequently described in the texts on magic and the commentaries on Exodus actually practised? One answer is so obvious and yet its subject matter so privileged that it is easy to overlook it: in the contrivances of perspectival art. The adoption of geometric or linear perspective by European artists ranks as such an epochal event in the history of seeing, and holds the attention of art historians to such a degree, that to suggest its affinity with magic may seem merely to trivialize it. Yet reputation alone—amounting in the past to reverence—ought not to deter us, especially as many contemporaries made the same suggestion themselves. The timing too is important, as well as the degree of innovation involved. Alongside the many other incentives to re-examine the nature of visual experience, this, from the early fifteenth century onwards, was a radical departure from former artistic practice that rapidly became an early modern orthodoxy. What Martin Kemp has called 'optically-minded theory and practice in art' emerged as a major intellectual and observational concern of the sixteenth and seventeenth centuries.[23] Among the multitude of claims made for linear perspective the relevant ones here are not just that it became 'the naturalized visual culture of [a] new artistic order',[24] or that it led to a wholly different way of seeing the world, but that it was essentially illusionary.

In essence—and again, the point is both banally familiar and yet fundamental—perspective rests on the ultimate visual paradox: complete deception in the service of utter veracity. The optical illusion is given of three-dimensional forms receding behind a two-dimensional plane, but this is

conceived as a window on what (and through which) the eye actually sees, constructed according to the way it sees. The deceptive 'picture plane' is a vertical intersection made at a certain point through a visual pyramid whose apex is the eye, mirrored by the 'centric' point to which forms do appear illusionistically to recede. This, by definition, is what mimetic art is—an ambiguous and irresolvable combination of the false and the true. Technique consists in heightening the paradox by aiming for the most perfect copy and, in consequence, the most thorough deception, and the artist is judged in terms of proximity to this mimetic ideal. One can, if one chooses, see this not just as paradoxical but as subversive (not to mention tautological). The secure vantage point of the ideal spectator, says Ernest Gilman, is undermined even as it is being established:

The more perfect the representation of reality achieved in a perspective picture, the more perfect is the deception practiced on the viewer. [Leon Battista] Alberti's window opens onto an *illusion* of *reality*; these two irreconcilable categories are joined in the perspective painting, which thus takes on an intriguing and complex dimension not found in conceptual art. . . . Alberti's unexamined assumption that 'the painter is solely concerned with representing what can be seen' bestows a double role on the painter as truth-teller and liar, and on the viewer as either ideal perceiver or dupe.[25]

Gilman points to a growing fascination with these constitutive paradoxes of perspectivalism in the theoretical treatises of the later sixteenth and early seventeenth centuries, whereas, initially it seems, the illusionistic aspects were more suppressed. 'Alberti's world', he continues, 'is fully manifest and comprehensible; the world implied in the writings of later perspectivists is shifting, multifaceted, and ambiguous.'[26]

Of course, the claim to represent accurately was always insistently made. By their theorists and defenders, perspectival practices were deemed to be objectively true in two senses. Of Daniele Barbaro's *La pratica della perspettiva* (1559), for example, Kemp writes: 'Barbaro's efforts are dedicated to the construction of works of art and other artefacts which mirror the geometrical structures behind natural forms—as comprehended by the proportional procedures of sight.'[27] The geometry that informed perspectival representation was thought to be inherent both in the objective world being depicted *and also* in the natural processes of human vision. To look this way at the world was therefore to capture ('reflect') its true reality and 'mirroring' was indeed the ubiquitous metaphor applied to it.[28] Besides committing themselves to the rhetoric of verisimilitude at every opportunity—in parallel, it is usually said, to the artistic language developed by many of the creative artists of the same period—treatises on perspective became more and more technical through the sixteenth century and elaborately mathematical by the early seventeenth. It is now clear that strictly geometric or 'Euclidean' perspective was never hegemonic or uniform across the visual cultures of early modern Europe, encountering lack of interest and then a slow and mixed reception in England, undermining by theorists like Lorenz Stoer in Germany,

and replacement by techniques more in line with Kepler's account of vision in the Netherlands.[29] But it was initially presented in terms of the orderly control of the entire visual environment—of visual clarity and certainty achieved by manipulating calculable forms and measurable spaces according to strict scientific (geometrical, optical, and ophthalmological) rules. To this extent, it conformed closely to what, after all, were always the instinctive aims of normal visual theory—to guarantee secure and reliable access to perceptual truth.

Moreover, from the beginning, such aims had moral and religious connotations; they were concerned with higher truths too. It was felt that the rules of perspective brought art into correct alignment not just with the principles of optics but with the immutable laws of the Creation and the way grace 'radiated', like light, within it. This gave artists, and theorists like Alberti, a sense of moral responsibility and of contributing to the order and welfare of the Church, as well as improving what they saw as the didactic and edifying function of individual works (especially those with religious subjects). Artists, says Samuel Edgerton, 'took seriously the moral imprimatur of the centric ray' and, hence, the corresponding didactic force of the 'centric' point.[30] In these circumstances, it is hardly surprising that perspectival art was thought to represent reality itself, seeming to be 'equivalent to natural vision'.[31]

Much has been made in modern commentary of perspective's so-called 'rationalizing' of sight and its emergence as the apparently dominant metaphor for cognition.[32] Its theorists seemed to appeal to abstract rules and procedures, existing independently of any individual artist, in terms of which representation became the standardized and uniform product of linear coordinates. The visual world was objectified, both in the sense that it became something observed from outside the picture plane, 'imagined as a windowlike transparent "intersection" standing between the artist and the scene he is about to represent', and also in the sense that this observation became centred on the single, sovereign, but disembodied, unchanging, and unmoving eye.[33] The visual world also became homogeneous, since all its contents were now interrelated in terms of a single, coherent organization of space. Above all, for some at least, perspective has been judged to be rational not just in its own logically and mathematically rigorous *claim* to emulate natural vision, but in its success in actually doing so. In this view, perspective theorists were not just offering another version of visual perception and dressing it up theoretically as 'reality'. They were defining the real visual world in once-and-for-all terms in conformity to universal visual and perceptual traits. Perspective did indeed correspond with the natural reality of visual perception, and it had now been 'discovered'. This was the idea challenged by Erwin Panofsky in his celebrated essay of 1927, 'Perspective as Symbolic Form'.[34] Panofsky argued that perspective was certainly a characteristic expression of modernity, emerging at a historical moment when the social and intellectual conditions were conducive to this particular organization of space. But this very fact made it a local and autonomous, not universal, cultural and symbolic form, 'a construction that is

itself comprehensible only for a quite specific, indeed specifically modern, sense of space, or if you will, sense of the world'.[35] The implication was that each type of culture had its own 'sense of the world', and, so, of space, and that none of these was more inherently natural, real, or true than any other.

This is obviously not the moment to review a long and complex debate. Even so, to appreciate the perceptual ambiguities in linear perspective it is probably better to adopt Panofskian principles than any others. The simultaneity of authenticity and deceit seems to sit ill with any idea that the Renaissance succeeded in defining visual reality and truth for all time, unless we are to suppose, with Plato, that illusion is a constituent of all our encounters with the objective world. Panofsky's sense of perceptual schemes being culturally relative constructions of space seems better able to deal with the elements of artifice in perspectival art—elements which not only dominated the elaboration of the technique itself but also allowed for its self-conscious dependence on deception. For perspective to be what its early users took it to be means paying attention to their reliance on the fallibility of the eyes.

On this side of the paradox, there were also many witnesses, meditating, as it were, on the falseness of appearances. 'Painting', says David Summers, who plots the development of this idea, 'was generally understood by Renaissance writers as paradoxical illusion'; it provided, he adds, 'a schema within which the best known of Renaissance illusory means—perspective—was given specific meaning'. With origins in Plato and St Augustine, the idea was expressed with increasing frequency from Cennino Cennini's *Libro dell'arte* onwards in the form of statements about the visual acceptance of the false as true, or the invisible as visible, or 'that which is not, as if it were'.[36] In Milan, the fifteenth-century sculptor and architect Antonio Filarete, for example, conceded that perspective was only 'true in drawing'; otherwise, it was false, 'for it shows you a thing that is not'.[37] One of the most widely cited books of the entire period, Heinrich Cornelius Agrippa's *De incertitudine et vanitate scientiarum et artium* (1530)—in itself a paradoxical exercise—denounced perspective because it 'deceiveth the sighte, and in an image diversely placed, doth caste many fourmes over the eies of the beholders: and . . . maketh the thinges seene whiche are not, as those whiche are, and maketh the thinges that are not so, to appeare in another manner', adding a hostile account of Pliny's Zeuxis and Parrhasius story as illustration.[38] The account of perspective given half a century later by Lomazzo, who, according to Kemp, tackled art theory 'on an intellectual scale unmatched by any artist since Leonardo', was premised on the unavoidable truth that lifelike painting 'by meere arte, upon a flat, where it findeth onelie length, and breadth, it representeth to the eie the third dimension, which is roundenesse and thicknesse: and so maketh the bodie to appeare upon a flatte, where naturally it is not'. Later in his book, Lomazzo subdivided sight into its physical processes ('physiologica') and its optical rules ('grammica' [*sic*]), the latter being further divided between the rules of natural vision and those of artificial vision—vision in art. The name given to

this last category, on which Lomazzo naturally concentrated, was 'false and deceiptfull [sightes]' ('viste finte, o mentite'), a vision which mimicked the 'real' as closely as possible but remained illusory and mendacious.[39] Similarly, Daniele Barbaro spoke of painting's aim to make the eye think 'it sees what it does not see', and the Mantuan architect Giovanni Bertani described perspective as 'a lie and a fiction'.[40] In early seventeenth-century England, Henry Peacham added an entire chapter on the 'manifold deceptions of the sight by perspective' to a revised edition of his *Art of Drawing*, while Lomazzo's English readers presented his ideas in the same limited terms. His translator and adaptor Richard Haydocke recommended the *Trattato dell'arte della pittura* for its account of how 'the unskilfull eye is so often cozened and deluded, taking counterfeit creatures for true and naturall', and another borrower, Nicholas Hilliard, followed a citation from Lomazzo with the observation that perspective worked paradoxically by expressing truths in falsehoods: 'For perspective, to define it briefly, is an art taken from or by the effect or judgment of the eye, for a man to express anything in shortened lines and shadows, to deceive both the understanding and the eye.'[41]

The very title of Pietro Accolti's treatise published in Florence in 1625, *Lo inganno de gl'occhi, prospettiva pratica*, tells of perspective's conceptual foundation, as does the text's claim to have explained the principles 'of so many different effects, and of such evident deceptions, as our eye receives by them'.[42] Jean François Nicéron, who (as we shall see) certainly thought of optics as a kind of natural magic, thought perspective was so effective in the 'perfect' representation of solid bodies that it deceived not only the eyes but the judgement and reason too: 'In effect, the artifice of painting consists in particular in making something appear in relief that is only depicted on the flat (*en plat*).'[43] Jurgis Baltrušaitis says of Gaspar Schott that he treated perspective 'as essentially anamorphic magic', whose illusions were thoroughly supernatural.[44] 'Through certain proportions of perspective, with strange and ingenious appearances', Emmanuele Tesauro wrote in his *Il cannocchiale aristotelico* (1654), 'optics' itself made 'you see what you do not see (*le Optiche . . . ti fan vedere ciò che non vedi*)'.[45] Indications like these (and many others could be cited) prepare us well for Descartes's often-quoted remark, itself reminiscent of Plato's *Sophist* (and, nearer to home, Hakewill's *Vanitie*) that the human eye was happy to be tricked by the effects of perspectival art, thus supporting his view that mental images need not resemble the objects they represented:

> [I]n accordance with the rules of perspective, [engravings] often represent circles by ovals better than by other circles, squares by rhombuses better than by other squares, and similarly for other shapes. Thus it often happens that in order to be more perfect as an image and to represent an object better, an engraving ought not to resemble it.[46]

In some ways, the most obvious indications of the duplicity that was intrinsic to perspective lay in the very experiments with which Filippo Brunelleschi first demonstrated its potential as a painters' technique in 1425.[47] His famous

depiction of the Florentine Baptistery, made while he was standing just inside the door of the cathedral opposite, was not intended to be viewed directly. Instead, according to his biographer Antonio Manetti, Brunelleschi made a small hole through the painted panel at the point where his own line of sight had originally struck the Baptistery, and then positioned a plane mirror in front of the panel so that it reflected the whole of his painted scene. The viewer, standing where the painter had originally stood, had to look through the hole from the back of the panel at this reflection. In addition, Brunelleschi heightened the illusion of looking at the real Baptistery by adding 'burnished silver' instead of painted sky to the depiction on the panel, so that the natural sky above and around the real building at the moment of viewing was also reflected—in motion—in the mirror. The result, according to Manetti, was that it seemed 'as if the real thing was seen', an impression possibly dramatized, it has been surmised, by the sudden removal of the mirror and its replacement in the viewer's exact line of sight by the actual Baptistery, surrounded by the same moving skies. In a second panel of the Palazzo de' Signori (Palazzo Vecchio) executed around the same time, Brunelleschi again aimed at lifelike representation, this time without the peephole but with the area of sky above the painted buildings cut out from his panel. 'Here', says Manetti, 'he left a void, which he made from the buildings up: and betook himself with it to look at it in a place where the natural air showed itself from the buildings upwards.' Again, then, we have an 'unusual interest in pure illusionism' designed to demonstrate the nature of perspective 'in the most forceful terms possible'.[48] One further suggestion concerning the completion of the Baptistery panel is that it was modelled on a reflection of the building in a mirror placed by Brunelleschi at his side in the cathedral doorway, as he painted with his back to the original. Catoptrics, more generally, may also have inspired his grasp of linear perspective in the first place, an idea encapsulated in Filarete's remark that Brunelleschi had devised its rules 'through considering what a mirror shows to you'.[49]

Additionally, and more obviously, one might appeal to the extensive art history of *quadratura* painting, a genre whose early exponents included Mantegna and Raphael. The technique involved exploiting the rules of perspective in order to paint fictive architectural features onto the interior walls, ceilings, vaults, and domes of buildings. Predictably, these attempts at full illusionism became more complex and more virtuosic as time went by, aided by the increasingly learned guidance on how to achieve them offered in the technical treatises on perspective. At the time, it has been said, 'the illusionistic effects that artificial perspective put within the artist's reach were amongst the most praiseworthy, as well as the most revolutionary of its attributes'.[50] In one of the earliest and best-known examples of *quadratura*, Mantegna's *Camera degli Sposi* (or *Camera Picta*) in the Ducal Palace at Mantua (1470s), an oculus appears in the ceiling, filled with foreshortened putti and other figures who peer down at the spectator in the centre of the room.[51] In Baldassare Peruzzi's *Sala delle Prospettive* in the Villa Farnesina in Rome (*c*.1512) it is the walls—all of them—that are completely covered with

illusionistic decoration.[52] Of the frescoes added to Philip IV's Alcázar palace by the Bolognese painters Michele Angelo Colonna and Agostino Mitelli in the 1650s, Velázquez's eighteenth-century biographer Antonio Palomino wrote:

> Mitelli painted all the walls, uniting the real and imitation architecture with such perspective, art and felicity that it deceived the eye and made it necessary to touch it to make sure it was really only painted. By Colonna's hand were all the trompe l'oeil images—figures in high relief, scenes in bronze bas-relief ... and a little black boy going down a staircase looking like a real one—and the real little window introduced into the body of the painted architecture ... Those who looked at this vista, doubting whether it was simulated—as indeed it was not—were also in doubt as to whether it was real.[53]

According to Martin Kemp, the 'culmination of developments in religious illusionism' since the fifteenth century—their *elatio ad absurdam*, so to speak—was the spectacular frescoes giving the appearance of a vaulted nave and dome in the Jesuit church of S. Ignazio in Rome, painted between 1685 and 1694 by the 'greatest of the ecclesiastical perspectivists', Andrea Pozzo, and lavishly illustrated in his own treatise on illusionistic designs, *Perspectiva pictorum et architectorum* (1693, 1700).[54]

Entire careers could be fashioned from perspectival ingenuity, the most notable examples in the Netherlands being those of Hans Vredeman de Vries and Samuel van Hoogstraten. Hoogstraten, in particular, made a number of programmatic statements about the need for the consummate artist to master illusionistic techniques and employ them as a kind of 'honourable' fooling of the eye. His entire sense of the stature and purpose of art was bound up with the idea of deception as both virtuosic craftsmanship and the occasion for aristocratic and courtly esteem. 'A perfect painting', he wrote, 'is like a mirror of nature that makes things that do not exist appear to exist and deceives in a pleasurable, permissible, and praiseworthy manner.' Quite apart from a series of *trompe l'œil* masterpieces from the 1650s onwards, involving 'feigned' letter racks with papers and writing materials stuck in them and cabinet doors with objects hung on them, Hoogstraten executed 'threshold' perspectives, with illusionary rooms opening beyond fictional doorways, and perspectival boxes whose painted interior surfaces created the impression of completely realistic rooms when viewed through apertures in the sides: one of the latter survives in the National Gallery in London. In each case the aim was to make the transition from the visible world to the adjacent depictions of it as seamless as possible: even the 'rooms' inside the boxes contained their own threshold perspectives, as well as reflecting surfaces like window and mirror glass.[55]

To instance, as I have briefly done, the widespread illusionism in early modern artistic theory and practice—and the further extensive examples of 'scenographic' stage and garden design, *intarsia* decoration, the visual games and ambiguities derived from representations in and of mirrors, the immersive 'virtual realities' of the Italian Sacri Monti movement, and, above all, still life painting might easily be

added[56]—is not, of course, to suppose that human eyes were ever actually deceived or minds made radically uncertain. Pozzo, like many others, may have wished his designs to function as if they were real structures—'to possess', in Kemp's words, 'a literal, absolute validity which permitted the painted objects to be read optically as real'.[57] In England, where images were associated with idolatry, apparently genuine fears were expressed about the 'dissembling' qualities of perspectival art and its power successfully to dupe the beholder into mistaking the false for the true: 'where we see naturalism in the lifelikeness produced by perspective and chiaroscuro', writes Lucy Gent, 'they saw deception.'[58] But rather than relying on simple deceit or confusion, illusionistic effects owed everything to an eventual awareness of the artifice involved, the possession of the visual skills needed to appreciate it, and a psychological outcome that probably combined vanity, wonder, and delight. At the most, we might say that being deceived and being undeceived were in balance, perhaps tension. This means that the endless statements—clichés, in effect—about perspective tricking the eyes need not be read literally but rather as expressions of a sentiment about perception itself. It was the concept of deception that was being explored, not its manifestation in particular visual experiences—and explored with new intensity and frequency. The illusionist himself was refigured as a kind of magus; the more convincing his work, 'the greater the paradox that it was but a reflection or shadow, and the more the painter looked like a prestidigitator'.[59] As for the techniques of illusionism, perspective offered deception as a theoretical possibility and, in reflecting on this and pursuing its implications, perspectival conventions were manipulated almost to breaking point.

It is for this reason that, were there no other evidence of the paradoxes of perspective, there would still be anamorphosis. Widely practised and discussed between the sixteenth and eighteenth centuries and then relegated to curiosity status, this was the technique of distorting visual forms to such an extent that they bore no resemblance to anything real until viewed from an extremely oblique angle—'ey'd awry', as Shakespeare put it in *Richard II*.[60] Although not named as such in print until 1646,[61] anamorphic effects were well known over a century before this. 'Many times', exclaimed Barbaro in his *La pratica della perspettiva*:

with no less pleasure than wonder one looks at some of these pictures or perspective schemes in which, if the eye of the beholder is not placed at the predetermined point, the subject appears quite different from what is painted, but, subsequently looked at from the correct view-point, the subject is revealed according to the painter's intention, be it a matter of depiction of people, animals, lettering or other representations.[62]

Barbaro was drawing attention to several key features of anamorphosis, the first and foremost of which was that it was itself a 'perspective scheme'—a version (perhaps perversion) of perspective, not a rejection of it. The very title of Nicéron's later treatment of the subject itself confirms this: *La Perspective curieuse*.

Anamorphic representations followed the rules of perspective with utter mathematical strictness, except in one crucial respect; they reversed them. Without these rules the technique was impossible to practise, and without the technique, the rules seemed theoretically incomplete; hence, its elaboration in many of the other standard perspective manuals of the period, particularly from the beginning of the seventeenth century onwards.[63] At the same time, Barbaro was aware of the excitement and wonder that could be aroused by the apparently secret, even miraculous, virtuosity of anamorphic art, and which accounts for its strong appeal to collectors in the developing culture of the Kunst- and Wunderkammer. Above all, perhaps, he recognized that the beholder of this art form was very much at the mercy of its creator, both in being tied rigorously to a wholly contrived, predetermined viewpoint and also in having to wait upon a kind of revelation of the painter's hitherto withheld intention.

This last feature has made anamorphosis seem to most modern commentators like a commentary on the artificiality and contrivance of perspective itself, which was known, after all, as *perspectiva artificialis* (as well as *costruzione leggitima*) and governed likewise by the tyrannies of viewpoint and intention—what David Summers calls 'the systematization of relative knowledge'.[64] Precisely in being a derivation of perspective, anamorphosis was able to act as its interpreter, exposing its claims to objectivity and truth by adapting it for yet more manipulative and deceitful purposes. In this reading, anamorphosis expressed in an extreme form what even the most normal, sober perspective was really about; as a contemporary, Pietro Accolti, put it, speaking of his own anamorphic portrait of Cosimo II de' Medici, it 'demonstrated the power of perspective in its deceptions'.[65] For Jurgis Baltrušaitis, for example, who first rescued the subject from historical neglect in 1955, it revealed that perspective was not eternally uniform and universal to vision but contingent upon use—'a device the nature of which varies according to the intentions behind the work'. Anamorphosis, he added, was 'a continual reminder of the astonishing and artificial elements of perspective'—its ability being to realign, rather than merely rehearse, the act of seeing.[66] More recently, the Shakespeare scholar Alison Thorne has reiterated this capacity to expose what the *costruzione leggitima* suppressed—the relativistic implications of making visual appearances contingent upon a particular beholder. In her reading of *Troilus and Cressida*, in particular, Shakespeare presents Troilus' crisis over Cressida's identity in 5. 2 as an anamorphic puzzle whose 'bifold authority' (l. 151) exactly matches the 'relativity of perception' that marks his own oscillation between sense and heart when he sees her with Diomedes and also the play's wider obsession with the epistemological discrepancy between 'things as they are and what the perceiver makes of them'.[67]

Those who have cast perspective in a hegemonic role in the history of vision have thus seen anamorphosis as self-reflectively disruptive of that role, turning anamorphic and normal perspective into contrasting epistemological metaphors.[68] In much the same way, the eccentric grotesques of an artist like

Arcimboldo have been taken to relate transgressively to the conventions of portraiture and still life—and, indeed, to perspective's symbolisms of seeing and knowing and its 'representational grammar of knowledge'.[69] To Martin Jay, the use of anamorphosis by Holbein in the famous portrait *The Ambassadors* (1533) subverted and decentred the unified subject of vision 'painstakingly' constructed by the dominant perspectival regime, making it a heterodox, alternative visual practice tied to a 'baroque', rather than Renaissance, conception of vision. For Jonathan Crary, likewise, anamorphosis bore witness to perspective's own internal 'disruptive possibilities'.[70] Extended by analogy to the often 'oblique' strategies adopted by early modern writers, whether for mere ingenuity's sake or more serious purposes, the same idea has led to readings of many literary texts too as 'anamorphic' in their wit, ambiguity, or uncertainty.[71] Not surprisingly, the tropes of metaphor and allegory have been singled out in connection with this kind of parallelism between a linguistic and a pictorial rhetoric.[72]

More than anything else, anamorphosis can now be seen to threaten any assumption that perspectival art somehow brought appearance and reality successfully together. According to Baltrušaitis, anamorphosis was nothing less than 'an effective mechanism for producing optical illusion and a philosophy of false reality'. Under its impact, perspective ceased 'to be a science of reality and [became] an instrument for producing hallucinations'.[73] The depicted subject, to repeat Barbaro, appeared 'quite different' from what was painted, until resemblance was restored by a form of wholly artificial viewing, and by an eye rendered active in restoring realism to distorted forms. A vital point here is that, from the beginning, anamorphic designs underlined this idea—and their quite literally duplicitous intent—by often combining two visual orders in one image, one depicted naturalistically and the other distorted according to the rules of the technique. By definition, this made it impossible to see one of them correctly without simultaneously failing with the other. Presumably, then as now, the viewer's attention was first caught by the task of restoring proportion to what were obviously fantastic forms; the consequent *loss* of meaning from the naturalistic ones may have seemed a less urgent problem. Eventually too, experiments with anamorphism capitalized on this by requiring only this first visual manoeuvre and making it easy to achieve—for example, in the many circular anamorphic images produced in the seventeenth century and designed to be viewed, without much change of position, in cylindrical or conical mirrors.[74] One legacy of this is that it is the search for the correct but elusive viewpoint that still monopolizes most people's visual experience of anamorphic art today. The fact remains, however, that both gain *and* loss must have been irreducibly present in many early modern attempts to make visual sense of these deliberately enigmatic images.

This, indeed, is the visual lesson of *The Ambassadors*, where the dominant visual order is painstakingly naturalistic and yet is rendered utterly formless once the naturalism of the anamorphic skull is restored by its being seen from the required viewpoint. 'To bring the skull into focus', writes Rosalie Colie, 'the

beholder must forgo his sight of the four-square ambassadors . . . There is no way to see everything in that picture "right" from a single point of view.'[75] But the same paradox occurs in many less well-known and less brilliantly executed examples of the technique. In these other cases, too, the relative prominence of the two visual orders is often reversed; the dominant visual order is composed of anamorphically distorted forms, and its naturalistic partner is provided by depictions of landscapes, topographies, human figures, or animals superimposed on or continuous with the anamorphisms but still legible in direct vision. But again, it is these apparent images of real things that disappear when visual order is restored to the unapparent ones. Barbaro may be cited once more (via Baltrušaitis) as a guide to the practice:

The better to hide what he paints, in accordance with the practices indicated, the painter who is proposing to delineate the two [human] heads or other portrayals must know how to shade and cover the image so that instead of two heads, it shows landscapes, water, hills, rocks and other things. . . . The painter can and, indeed, must deceive (*ingannare*) our eyes by interrupting and separating lines which ought to be straight and continuous because, except at the viewing-point indicated, they do not reveal what they reveal at the chosen place.[76]

Over a century later the teacher of perspective at the Académie Royale in Paris, Grégoire Huret, was still offering much the same advice. Those looking at a violently distorted image could be 'diverted and amused by some kind of landscape that can be represented therein—with small shrubs, human figures, shepherds, sheep and other animals'. Once the picture was seen anamorphically, the elongated figure would be recognized 'at the moment when the violent diminution of the small objects, shrubs, figures, etc., causes them to disappear altogether'.[77]

There are early examples of this double imaging in the well-known *Vexierbilder* ('puzzle-pictures') created by Erhard Schön in Nuremberg in the 1530s, which combine, in one case, the vast distorted heads of four contemporary rulers with tiny vignettes of towns, riders on horseback, and country scenes, and in another an anamorphized man, relieving himself, with the disgorging of Jonah from the whale. In 1546, the anamorphized head and shoulders of Edward VI of England, then aged 9, were depicted in an elongated oval border superimposed on a perfectly naturalistic landscape. An anamorphic picture from later sixteenth-century Italy, possibly by Niccolò dell'Abate, similarly combines distorted images of the Baptism of Christ and the head of John the Baptist with ordinary scenes of pastoral tranquillity by a riverside and another of St Jerome kneeling before a cross. Christ appears again, hidden anamorphically, in a 1638 engraving of *The Fall* by the Basel artist J. H. Glaser, where his suffering occurs amidst an entirely surrounding depiction of the tasting of the apple, the expulsion, and the manifold flora and fauna of the Garden of Eden.[78]

In the 1640s, in some of the most complex and religiously charged pieces of anamorphic art of the entire period, Emmanuel Maignan and Jean François

Nicéron, both Minims with important connections to the scientific circles of Mersenne and Descartes, designed two frescoes, one of St Francis of Paolo (patron saint of the order) and the other of St John the Evangelist, to be executed along the side walls of a long gallery in the convent of the Minim house of Santa Trinità dei Monti in Rome. Both frescoes obviously presupposed a correct viewpoint at one end of the gallery matched by visual confusion as the viewer walked along its considerable length (34 metres), looking laterally at the now distorted images. But Maignan's (which can still be seen) nevertheless contains all the tell-tale details of the double visual order—in this case, a miniature view of the Straits of Messina, with a ship passing through them towards a harbour and a town, Calabrian roads and mountains beyond, and St Francis himself walking on the surface of the waters on a cloak, all emerging in sharp focus from the chaos that is the face and habit of the anamorphized, and thus invisible, saint. In his now lost fresco (later repeated in Paris in the Minim convent in the Place Royale) Nicéron likewise enclosed a landscape in the robes of St John, describing it in his treatise *Thaumaturgus opticus* (1646) as containing 'several trees, shrubs, flowers, etc, which the people who walk along the gallery see directly', without this interfering in any way 'with the oblique view of this kind of Perspective' (Fig. 7).[79] Imitations of these technical and spiritual feats followed in early eighteenth-century Aix-en-Provence, where closely similar anamorphoses were produced for the church of the Jesuit college, probably by its professor of mathematics. Here the beard of a repenting St Peter contained a detailed townscape of contemporary Lisbon.[80]

Clearly, the juxtaposing of incompatible visual orders in anamorphic depictions was not simply a display of technical ingenuity or the playing of a visual game; it gave rise to symbolisms too. In content, indeed, the two orders were not usually incompatible at all. What better way to represent St Jerome's visions of episodes from the life of Christ than to intrude them as inchoate shapes into his otherwise lucid world? For Christ to be prefigured as the redeemer at the very moment of original sin was only to make an obvious theological point; to hide him in an anamorphosed image and then bring him mysteriously into focus was to express that idea by means of the symbolism of vision itself. Even the portrait anamorphisms which were apparently so popular with secular rulers helped to symbolize their authority over their subjects. Schön's concealment of sixteenth-century sovereigns in the landscapes they ruled over spoke visually of their ability to control and subjugate, while the thaumaturgy in the actual technique for doing this also matched the kind of power they claimed to possess.[81] More generally, anamorphosis has been said to symbolize divine creativity itself: 'Chaos is brought into order: the great act of God at the Creation is graphically demonstrated by the artist's skill and wit.'[82] Through the seventeenth century, it was said to have the emblematic quality—as with other hidden images and enigmatic optical effects—of teaching the way to resolve spiritual confusion through the fixity and determination brought by faith. Bossuet, for example (preaching on Ecclesiastes 9: 11), said that anamorphic images were the perfect

natural emblems of a world whose justice, hidden behind appearances, it was impossible to see except from 'a certain point' revealed by faith in Christ.[83]

But irrespective of the content of anamorphic images, there are in addition important messages to be read into the form itself, bearing reflexively on sight and its uncertainties. To perfect a way of making different objects of vision appear and disappear at virtually the same moment was to pose the question which Schön actually inscribed on one of his anamorphic images: What do you see? ('Was siehst du?')—as well as its obvious unspoken corollary: What do you not see? One could cast this in a positive light, as an invitation to remain open to enlightening visual challenges, however initially puzzling they might seem. This is presumably what Maignan himself had in mind in controversially comparing the deceptive effects of perspective to the way the eyes were 'deceived' in the mystery of transubstantiation or in the appearances of Christ transfigured as a pilgrim or a gardener.[84] Alternatively, anamorphic art could—and can—be presented as reassuringly rational, both in origins and outcome. The creators adhered faithfully to geometrical and mathematical rules, thereby submitting in principle to the visual solutions eventually achieved by the viewers. Even so, it is impossible to ignore the moment of radical uncertainty at the centre of this particular artifice. Didier Bessot has suggested that in the life of an anamorphosis there were three stages, the first and the last allowing the exercise of reason but the one in between remaining 'un temps de trouble des sens'.[85] Nor can one miss the incipient visual relativism present in apprehending a world that, as Jean-Claude Margolin puts it, 'is not constituted in its entireness and fixity in advance of our gaze (*regard*) and our gestural and mental performance (*opérativité*)'.[86]

As we shall eventually see, it was these last features that brought anamorphosis to the attention of those intellectuals—Mersenne and Descartes among them—for whom visual uncertainty was central to philosophical doubt.[87] Anamorphosis, we might therefore agree, was paradoxical both in terms of images and in terms of meanings. It was a deceit, suggests Colie, that appealed to rationalists—Cartesians, Jesuits, and Minims; it exploited increased knowledge 'to insist upon relativity'; it appealed to the laws of perspective and the technicalities of optics 'to undo the normal rules of vision'; it disturbed what it was easy to feel was secure. '[A] kind of paradox occurs', she continues, 'that of self-denial, as when logic turns back upon itself in circular reasoning or infinite regression, or when rhetoric produces paradoxes that transcend and deform the rules of rhetoric.' The 'outburst' of anamorphosis during the sixteenth and seventeenth centuries was just such a turning back of vision on itself.[88]

Perhaps the most significant symbolisms of all, therefore, were those that arose when the content of an anamorphic image coincided exactly with the self-reflectivity of its production. One of the very first subjects chosen for what seems to be an early experiment with anamorphosis, contained in two drawings by Leonardo found in the *Codex Atlanticus*, is the human eye.[89] A century and a half later, Mario Bettini included anamorphic images of an eye in his *Apiaria universae*

philosophiae mathematicae, explaining that it belonged to Cardinal Colonna, Archbishop of Bologna, and symbolized both the Cardinal's own vision and— when restored to its true shape—the recovery of errant souls.[90] Grégoire Huret's *Optique de portraiture et peinture* (1670) included a design for an eye anamorphosis, and later still, in the 1690s, the mathematician Jacques Ozanam repeated Bettini's eye anamorphism in a version of his own in his *Recréations mathematiques* (a title already suggesting the decline of anamorphosis), but without identifying any owner or personalized symbolism (Fig. 8). The eye had ceased to belong to anyone and, instead, become a symbol on its own; it was just 'an eye'. What it symbolized was visual paradox itself. A technique capable of imaging any kind of object ('imaginem quampiam', in Bettini's words) had ended up as it began, as a commentary on seeing—as a way of imaging eyes. The anamorphic eye's distorted form would return to normal, said Ozanam, when seen 'in a glass' ('sur un verre') occupying the same position as the perforated board through which the image had originally been projected by candlelight, by a spectator whose eye was placed at the original point of illumination.[91] This is an odd explanation since, presumably, the restored image was better viewed in a flat mirror placed upright beyond the anamorphic version and by someone whose eye was positioned not at the original illumination point but directly opposite it. But whichever the case, there is the same paradox of an eye self-referentially regarding an eye—invited by the visual contrivance (to paraphrase Rosalie Colie) to say something about its own operation *by* its own operation. Like the Liar paradox, the anamorphic eye makes a statement, not only by a member of a class about the class to which it belongs, 'but also about itself as a statement, a fact which constitutes another degree of self-reference'.[92]

The links between 'normal' perspective, 'curious' (specifically anamorphic) perspective, and the magic of visual deceit needed to continue this brief survey of the Renaissance 'prestige' are provided for us in the 'Preface au Lecteur', as well as the very title, of Nicéron's *La Perspective curieuse ou magie artificiele des effets merveilleux* (1638). This was perhaps the most popular attempt to connect these three topics during the entire period when serious attention was paid to their relationship by artists and scholars. Its title page bears two anamorphic designs, one involving a conical and one a cylindrical mirror, together with putti observing another optical effect through a tube with a faceted lens in it: this is the technique described later in the book for producing a single image from parts of a series of images arranged in a circle—in this case depicted on the vertical surface of the left-hand pedestal (Fig. 9). Nicéron defended his resort to the term 'magie' in the by-now classic manner of Renaissance intellectuals. It was only 'the vulgar', he said, who suspected magic as an illicit or demonic form of knowledge, whereas the learned agreed with Pico della Mirandola in seeing it as the highest form of natural wisdom aimed at producing astounding technical marvels. Descended from ancient Persia, 'artificial' magic sought to emulate the magical effects hidden in

the natural world, and its achievements included the automata of Posidonius, Architas, Archimedes, Daedalus, and Albertus Magnus. Among such effects should now be included those of optics, catoptrics, and dioptrics and Nicéron planned to divide his book accordingly between ordinary perspective, flat anamorphoses, anamorphotic images in mirrors, and the technology of lenses. For him, perspectival and other forms of illusion clearly belonged in a tradition of natural wonders, or as the title of the expanded (but incomplete) Latin edition of his book suggested—*Thaumaturgus opticus*—a tradition of optical thaumaturgy.[93] Francis Bacon, with whom we began, would not have been totally uncomfortable with this either, since although he attacked traditional magic, his intention was to reform, not abandon, it. *Magia naturalis* therefore enters into his natural philosophy at many key points, not least in *New Atlantis*, conceived as an ideal community ruled by *magi* and dedicated to the pursuit of secret wisdom laid open for the public good. In this context, 'deceits of the senses' had an ultimately social benefit that went far beyond their intrinsic interest or any novelty value, but their intellectual justification fell within what Bacon, like any natural magician, called 'the science which applies the knowledge of hidden forms to the production of wonderful operations'.[94]

La Perspective curieuse and *New Atlantis* point, indeed, to a defining feature of early modern visual culture, and, more specifically, to what Martin Jay called the 'scopic regime' of the baroque. This is the conjunction of an advanced technology of visual artifice with elevated claims about the character and function of natural philosophy. When the mid seventeenth-century angelographer Giovanno Tommaso Castaldi divided natural magic into its constituent knowledges he listed them as physics, mathematics, astronomy, music, and the 'pars prospectiva'.[95] Forty years ago Rosalie Colie already saw Bacon's 'perspective houses' as a reflection of the actual activities and publications of natural magicians and optics experts all over Europe who were interested in the preternatural aspects of seeing. A commitment to the wonders of vision was indeed a distinctive feature of what she called 'paradoxical science'. This was apparent in the attention given to visual games and illusions in the work of Bettini, a Bolognese philosopher and mathematician, and his fellow Jesuits, the German polymaths Athanasius Kircher and Gaspar Schott, and in the 'outburst of anamorphosis' we have been considering. By these means, wrote Colie, 'the ambiguous, the paradoxical, the jocose-serious played an essential part in [the Jesuits'] considerations of God, of nature, and of themselves, and gave tone to the wonder and admiration they paid to God's universe'.[96] Since the 1960s, the magical features of early modern natural philosophy, together with the role of wonder itself, have been completely reassessed and their importance in scientific change has been greatly amplified. Much of what Colie meant by 'paradoxical science' is again recognizable in Herbert Knecht's 'science baroque', where visual artifice features just as prominently, and in Paula Findlen's description of catoptrics as 'the quintessential seventeenth-century science of mathematically rendered optical illusions'.[97]

The fact that natural magicians, in particular, showed considerable interest in the deceiving of the eyes testifies to the unusual contemporary significance of this aspect of optics, as well as indicating the general instability of vision in 'baroque' Europe. To the 'rationalization' of sight one now needs to add its considerable mystification.[98]

However, playing with vision in serious ways began, for most early modern intellectuals, not with Francis Bacon but with the Neapolitan Giambattista della Porta, whose *Magiae naturalis* (1558) was by far the best-known and most cited compendium of standard natural magical knowledge for at least a century, enjoying over fifty editions. Della Porta's importance in the natural philosophical circles of his time can hardly be exaggerated, given his extraordinarily wide interests, his European reputation as an authority on the 'science of the extraordinary', and his role in promoting scientific societies in Italy, notably his own Accademia dei Secreti and Federico Cesi's Accademia dei Lincei, of which Della Porta became the fifth and Galileo the sixth member.[99] His many publications included a monograph on optics, *De refractione* (1593), but he also devoted book 17 of the expanded twenty-book version of *Magiae naturalis* (1589) to catoptrics, entitling it 'De catoptricis imaginibus' ('Of Strange Glasses' in the English version) and dividing it between two main subjects—the construction of burning mirrors (in emulation of Archimedes, Proclus, and other ancient 'artificers') and the creation of prestiges.[100] Under the latter heading, Della Porta explores the many kinds of distortions to images ('imagines', 'apparitiones') that result from changes to the composition or shape of plain mirrors, the projection of reflected rays at a distance, and the 'illusions' ('illusiones') produced by manipulating two or more mirrors so that they reflect bizarre and unexpected objects and, in some cases, whole 'amphitheatres' of images. Concave mirrors are yet more 'curious and admirable', with their seemingly free-standing images and other 'strange wonders' and their ability to magnify light and generate fire. What seems to have particularly intrigued Della Porta was the phenomenon (more alleged than real) of the 'hanging image'—the reflected image for which the spectator could identify neither the original object nor the means of its production. Introducing book 17, he asks rhetorically: 'what could seem more wonderful, than that by reciprocal strokes of reflexion, images should appear outwardly, hanging in the air, and yet neither the visible object nor the glass seen? [so t]hat they may seem not to be the repercussions of the glasses but spirits of vain phantasms (*sed spectra, et praestigia videri possint*)?' One such image turns out to be of a dagger (an example not lost, perhaps, on the author of *Macbeth*), but any object might qualify for this 'wonder of wonders' and techniques for producing it are described five or six times in the space of a few pages.

Della Porta considers the properties and powers of cylindrical and pyramidal mirrors, lenticular crystals, and spectacles, all the while looking for significant disruptions to the visual process. The intention is to question the assumption of a one-to-one correspondence between the visual object (*visile*) and its reflected

image that lay behind the conventional and universal faith in 'mirroring'. Simply colouring or multiplying mirror-images achieved this at a low level, but Della Porta favoured more complicated outcomes, like that of the spectator looking into a mirror and seeing not his own face 'but some other face, that is not seen any where round about' ('How to make a glass that shall shew nothing but what you will'), or looking into a room and seeing in it reflections of objects outside it 'so clearly and certainly, that he will think he sees nothing but truth' ('How we may see in a chamber things that are not'). In the second case, Della Porta explained, the contrivance could be so successful that it was impossible for the spectator to suspect the deception ('impossibile est, ut se deceptum sentiat'). In the case of lenses, even humble spectacles—*especially* spectacles—do not escape similar manipulation. A spectacle ('specillum'), he concedes, is a glass 'we put to our eyes, to see the better with', but it is equally the perfect means to delude them, 'for [the medium] being changed, all things are changed'. Why not, therefore, construct a set that makes it impossible for the eyes to 'discern the truth'—for example, by endlessly multiplying objects so that a single ship becomes a navy and a lone soldier an entire army? 'Thus', comments Della Porta, in a phrase that captures the essence of the science of prestiges and its rationale, 'are there divers ways to see, that one thing may seem to be another . . . (*Et hinc fiunt diversi conspiciendi modi, ut res una alia videatur* . . .).'[101]

Della Porta was by no means the originator of all this material and acknowledged his 'ancestors', notably the thirteenth-century optics expert Witelo, in the field. It was to Witelo, in fact, that Della Porta traced the images that seemed to 'hang' in air 'without a glass or representation of any other thing', an allusion to a technique described in book 7 of Witelo's ten books of optics, a standard textbook available in several sixteenth-century editions and included in Federicus Risnerus' huge compendium of optical treatises published in Basel in 1572 entitled *Opticae thesaurus*.[102] Della Porta also freely availed himself of the optical instances in the literature of 'secrets', including Girolamo Ruscelli's *Secreti nuovi* and the 'secrets' of 'Alessio Piemontese', providing what he thought were natural magical explanations for them. Still, the pulling together of so many cases and the status of *Magiae naturalis* as virtually the manifesto and research programme of early modern natural magic does mean that it was Della Porta who was most frequently cited on the subject of prestiges from the mid sixteenth century onwards.

He was eventually overtaken only by the Jesuit scholar Athanasius Kircher, who wrote the most sustained and celebrated account of magical optics published during the seventeenth century, as part of a book devoted to the subjects of light and shadow which appeared in Rome in 1646. Kircher was born near Fulda and, having studied and taught at a series of Jesuit colleges, settled in Rome after 1633 as professor of mathematics and oriental languages at the Collegium Romanum, dying there in 1680. The term polymath—'polyhistor' would have been the contemporary equivalent—is often applied to people like Kircher, but in his case

not inaccurately since he authored around forty books on an encyclopedic range of subjects, several of them monumental in scope. Less fairly, he has been dismissed for intellectual dinosaurism (for which 'baroque' is sometimes the euphemism), and for being still immersed in outdated thought and faulty arguments long after they had been challenged. This is to miss his key role, demonstrated over twenty five years ago by Robert Evans and now being rediscovered by the rapidly growing number of Kircher scholars, in creating and disseminating the intellectual synthesis that underpinned central European Catholicism under the Habsburgs. Invited to, but never an inhabitant of Vienna, he maintained close links with the imperial court and articulated virtually all of its intellectual ambitions, exercising an unparalleled influence across Central Europe as a result.[103]

Categorizing Kircher can be difficult and judging him in terms of any kind of trajectory across the history of science—what Evans called 'any genealogy of modernism'—is clearly unwise. But *magia* seems the most inclusive label to apply to his work, given that this was a magic of the most elevated, ambitious, and yet emphatically naturalistic, even Aristotelian, kind.[104] Kircher defended natural magic and traced its intellectual history many times in his writings, while denouncing forms of astral and, of course, demonic or necromantic, magic, as well as alchemy and other forms of 'charlatanry'. It was certainly as a magus that his contemporaries perceived him, for example his student Johann Stephan Kestler and, notably, his most important follower and fellow Jesuit, Gaspar Schott of Würzburg. Others thought of him as a disciple of Della Porta, even though he denounced the Neapolitan's work. The Kircherian version of *magia* bore all the hallmarks of its late Renaissance inspirations, including Hermeticism, Neoplatonism, Pythagoreanism, and Lullism, and owed much to the general idea of a divine but recoverable wisdom lying hidden in the writings of *prisci theologi*, especially those of Hermes Trismegistus. His choices of subjects were often the classically magical ones, notably cryptography, numerology, hieroglyphics, and, above all, magnetism and the lodestone, to which he devoted his first publication in 1631 and two further books. His overarching concepts were those of the organic unity and syncretic harmonization of all knowledge, and his vocabulary was full of the secrets, mysteries, rarities, and wonders of nature. His was a vitalistic world, operating in terms of sympathies and antipathies, and analogizing and symbolizing it were among his favoured intellectual strategies.[105] This was the occult science that Kircher, as its curator from 1651, attempted to exhibit in one of the seventeenth century's most renowned museums, the Museo Kircheriano in the Collegium Romanum, which 'soon became one of the primary cultural centres of Baroque Rome, and one of the most important centres of scientific learning in the Catholic world'.[106] It was also the science he offered to his political and ecclesiastical patrons and which was supposed to blend, seamlessly in his own mind, with the intellectual orthodoxies of his order and the Catholicism of his Church. Occasionally, the latter feat seems to border on effrontery; in his first

book, *Ars magnesia*, he described the construction of a machine operated by magnets that depicted Christ walking on water and bringing help to the sinking Apostle Peter. To us, this is the reduction of miracle to artifice—a demonstration of the indemonstrable—but to Kircher, presumably, it was the reinforcing resemblance between the two kinds of miracle that mattered most.[107]

Like many of his writings, Kircher's *Ars magna lucis et umbrae* (which appeared again in Amsterdam in 1671) enjoyed considerable renown for at least half a century.[108] Light and shadow were capacious subjects, but Kircher made his usual attempt to be exhaustive by dealing not merely with their physical and metaphysical qualities and sources, but with the astronomy and astrology of the heavenly bodies, the phenomena of phosphorescence, luminescence, and fluorescence, the properties and transmission of colour and radiation, and the laws of optics and perspectival projection. Fully aware of the researches of Kepler and Descartes, which he both acknowledged and, in the case of Kepler, reproduced, Kircher regarded optics as a newly theorized field yet still capable, like every other art and science, of bearing magical significance. There was, indeed, no difference between *scientia* and *magia*, provided the latter was purged of its errors. The design for his title page already links optics, via catoptrics, to a metaphysics of light found generally in early modern alchemy and alchemical illustrations, and the last book of *Ars magna* is devoted to 'Magia lucis et umbrae', presented in the traditional manner of the natural magicians as a natural and wholly undemonic account of the rarities, prodigies, and *occulta* of its subject matter—mid seventeenth-century visual experience.[109] Kircher divides his attention between gnomonics (solar clocks), 'parastatics', and catoptrics, the first of limited relevance in the present context, but the second and third comprising representational practice in general and the properties of mirrors in particular.

It is hard not to conclude that Kircher's 'miracles and wonderful works' of light and shadow are nothing but disruptions to normal visual expectations and certainties by means of optical illusions—yet another attempt to unsettle 'the grammar of visibility', although, as we shall see, for very serious religious and other knowledge purposes.[110] Representations are made to bear two simultaneous but contradictory realities, or images are created that appear and disappear, unite or separate, invert or return to upright, mutate, or simply multiply without apparent cause or (pending Kircher's exegesis) explanation. In each case, the spectator is made to feel—besides bemusement, presumably—that what is seen is not determined by anything that is fixed in the visual environment but depends instead on his or her own interpretation and viewing point. Perspectival optics has become fluid and actively creative, as well as an indicator of the insubstantiality of appearances, which are 'flaunted' to the point of 'epistemological unreliability'.[111] Kircher explains that nature herself often 'paints' images onto natural things, leaving men and women convinced that they see apparitions above the straits of Messina, not clouds in the skies, and the Virgin and Child on a Chilean mountainside, not the play of natural shapes and colours seen 'from a certain fixed

point'.[112] One aim of natural magic is to imitate *natura pictrix* by bringing such parastatical feats under the rules of art and copying their ambiguous outcomes. Kircher offers, for example, a *campus anthropomorphus*, in which a mountainside is duly depicted as bearing the features of a man's head in its topography once it is turned through 90 degrees. This was inspired both by Dinocrates' legendary transformation of Mount Athos into a man (reported by Vitruvius) and by an actual sixteenth-century garden—that of Cardinal Montalti in Rome recorded in a painting in the Cardinal's collection. 'I have created a way', said Kircher, 'whereby any ordinary landscape, when viewed from a certain position, may present the like appearance (*phasma*).'[113]

Yet more contrived, but still imitating a natural effect, are the conditions of the portable camera obscura, which are also described and depicted in *Ars magna* (Fig. 10). Images of the outside world are projected like scenes in a theatre, with the added deception that the spectator, enclosed in a cube within a cube, cannot make out their physical source or the artifice that produces perfect (if inverted) simulacra of the outside world. A version seen by Kircher in Germany worked so well 'that no one will be able to persuade themselves that what was seen exhibited was done by natural skill'. Better than anything that the art of painting could offer, a machine that produced representations *ad vivum* would enable even the most unskilled painter to provoke the envy of his colleagues.[114] Refraction in water gave Kircher the opportunity to describe supposedly static images that increased and decreased in size, or came together and moved apart, and projections by lamplight the chance to revisit one of the hoariest questions in natural magic: whether rooms could be filled with simulated snakes and humans made to appear as animals. Lenses produced the most miraculous optical effects of all, making the microscope and telescope somewhat different instruments for Kircher from what they became for many of his contemporaries. Certainly, the microscope compensated for those deceptive failings ('fallaciae') of the human senses that left the most abstruse aspects of the natural world unperceivable (a point reinforced in the design for the frontispiece of *Ars magna*), but such were the wonders that had recently been revealed by it that no one could now be sure that what they normally saw was anything more than a false appearance. 'It is indeed absolutely plain', said Kircher, 'that all things seen by us are in truth other than what they seem (*quidem luculenter patet, omnia a nobis visa multo revera, ac videntur, alia esse*).'[115] Such was the power of the telescope to re-present the visual world that Kircher proposed to construct a 'panto-parastatical machine' that would achieve the ultimate in representational magic: 'Mountains, rivers, seas, immense plains of the countryside, huge chasms, lakes, forests, and in these all kinds of animals—represented in this way by the new art of the optical tube, such that absolutely nothing else compares with it in the perception of things.'[116]

For Kircher, mirrors were an equal source of 'prodigious' visual experiences, their hidden properties seeming to exceed the grasp of all human perception ('facultas . . . quae omnem humani intellectus captum excedere videantur').

Like Della Porta, he thought they could be constructed to yield any kind of image whatsoever ('per quam etiam ex quolibet repraesentari possit'), and like him too, he examined—in greater detail—the cases of 'flying' images, those that approached and receded, those that could be represented to infinity, and other 'fallaciae'.[117] What distinguishes book 10 of *Ars magna* from book 17 of *Magiae naturalis*, however, is the attention Kircher gives to creating visual artifices with the aid of machines, many of them lavishly illustrated in the text and demonstrated to visitors to his Roman museum. The most famous of these is the 'Lucerna Magica', or 'magic lantern', not by any means Kircher's invention and added to *Ars magna* only in the second edition. He also subtitled it, more indicatively, 'Thaumaturga', saying it deserved this name both from the extraordinary things displayed by it and from the additional deceit achieved by hiding the projection apparatus in an adjacent room and sending the images through a wall.[118] Another machine, Kircher's 'Smicroscopium Parastaticum' (also added in 1671), varies the slide show principle by allowing for the viewing of a sequence of scenes inscribed on a rotating disc through a tubular viewfinder. And yet another of the 1646 models, the 'Theatrum Catoptricum', is an attempt to harness the ability of plain mirrors to give 'true' reflections by arranging batteries of them in panels around a cabinet top with various objects on it, so that multiplication produces its own deceiving wonders—'mira rerum phantasmata'—from what are otherwise singly reflected objects.[119]

The last eye machine to be described in *Ars magna lucis et umbrae* might, at a stretch, qualify as Europe's first virtual reality device (Fig. 11). True to one of the oldest legends in his culture, and inspired in particular by Trithemius' reputation for transforming men into beasts and Della Porta's remarks on the same subject, Kircher wished to achieve (and explain) the illusion of metamorphosis by an arrangement of mirrors. Envisioning a square room with a single high window, he suggested that a sequence of images of animal heads plus an image of the sun should be rotated on a drum hidden in an open box and aligned with a plain mirror hanging at an angle above. This would give anyone entering the room, approaching the drum, and looking up at the mirror the impression of their own multiple transformation. The heads would be depicted sitting on human necks and have the same dimensions as human heads. The drum would be turned secretly, and a pulley and rope would make sure the mirror was aligned with both the drum and the subject, who would see first the sun and then the series of animal images alternating with his or her own face. Kircher thought that the realism could be enhanced if the animal heads were carved and given glass eyes and moving jaws and if fur was stuck onto them. A crane with its eyes lit up would be especially terrifying.

A whole series of further metamorphoses, nine in all, could be achieved by means of adaptations to the basic design of this virtual reality environment, which Kircher actually constructed and placed in the Museo Kircheriano.[120] To create phantoms in darkness (no. 2), the machine had to be used in a darkened, gloomy

room with any cracks in the walls carefully sealed up. The mirror would be placed opposite the narrow window letting in a narrow beam of light. Additional mirrors opening like wings would amplify the effect by multiplying the reflections (a king of Baghdad had apparently used this technique for creating apparitions). Anamorphic effects could be created if cylindrical or conic mirrors were used (no. 3). Kircher wanted to place a cylindrical mirror on the floor next to the drum and train the cones on the floor and the wall. Wherever one looked, high or low, to the front or behind, one would see a different figure instead of one's own. The substitution of images—of men's with women's and vice versa—could also be obtained by using a drum that had bits of paintings stuck on it, instead of animal heads (no. 4), and then prisms and mirrors so arranged as to reassemble the rest of the paintings in the required way. For Kircher even single mirrors were excellent metamorphic tools. An elliptical segment, or just a sheet of selenite, fitted to a piece of paper of the same shape, could change the appearance of the human face in a thousand monstrous ways (no. 5). Plain mirrors with some cylindrical curvature in them and bumps or humps on their surfaces (no. 6) did the same. There was no monstrous form, he thought, into which one could not be changed by mirrors of this kind. Proteus himself would not have been able to compete with such specular metamorphoses.[121]

There is something about this relentless striving for ever more novel visual effects that invites comment. Across the intellectual domain loosely known as early modern magic, and beyond it too, extraordinary ingenuity and versatility—not to mention time and other resources—went into creating them, anticipating, it has been said, 'the huge investment in visuality in modern culture'.[122] If entertainment, or more accurately, the aesthetic pleasure to be derived from wonder, was never far from the intentions of visual magic, this was invariably linked to explanation and instruction. Kircher's intention was obviously to leave spectators with no more than a moment's hesitation before explaining how his machines worked; for him, this represented one of the principal differences between good and bad natural magic.[123] Many optical devices and visual effects designed to deceive featured in the literature of scientific and mathematical games and recreations that began to be disseminated throughout Europe in the seventeenth century via works like Jean Leurechon's *Recréations mathématiques* (1624), Daniel Schwenter's *Deliciae physico-mathematicae* (1636), Georg Philipp Harsdörffer's two supplements to Schwenter, entitled *Delitiae mathematicae* (1651 and 1653), and Jacques Ozanam's *Recréations mathematiques et physiques* (1692). The genre was accurately represented by Kircher's own pupil and follower Gaspar Schott, whose *Joco-seriorum naturae et artis, sive magiae naturalis centuriae tres* appeared under a pseudonym in 1664.[124] The *serius* side of this learning-through-pleasure principle was provided by visual magic's relationship with current optical, catoptrical, and dioptrical theory and practice. Just as anamorphosis was a derivation of normal perspective, so every other visual artifice, however strained or outlandish

the contrivance, depended on the laws of these sciences as then understood and each was usually accompanied by careful mathematical elucidation. Kircher's *Ars magna* contained its own exposition of conventional post-Keplerian optics, placed earlier in the work in book 2, as did Schott's *Magia universalis*. These writings were, indeed, continuous with those, like Scheiner's *Oculus* or the French mathematician and royal treasurer Claude Mydorge's *Prodromi catoptricorum et dioptricorum* (1639), that paid less or no attention to the magical extensions of their subjects. In some respects they were actually more up to date. In its awareness of available optical theories, Kircher's *Ars magna* far outreached, in relative terms, the conservative textbook *Opticorum libri sex*, published in 1613 by the Rector of the Jesuit Maison Professe at Antwerp, François d'Aguilon (Aguilonius).[125] Nicéron, Kircher, Schott, and others talked about the 'magic' of optics but, as already noted, nothing separated in their minds the visual effects they aimed at from the natural philosophy they worked with other than degrees of familiarity and levels of delight-provoking puzzlement.

The ideological incentives to play seriously with vision were also considerable. The appeal to powerful courtly patrons and collectors of wonders, like that of magic in general, is already evident from the title pages and dedications that prefaced works of visual magic. *Ars magna* was dedicated to Archduke Ferdinand of Austria, the eldest son of Ferdinand III (and subsequently to the Archbishop of Prague), and supposedly inspired by questions posed to Kircher by the Emperor himself. Its title page confidently proclaims a number of imperial symbols, deftly linked to those of optics, and in the body of the text Kircher again uses a double-headed version of the imperial eagle, suggesting both optics itself and the empire of Ferdinand II, to illustrate the workings of his 'mesoptical' instrument for perspectival projection.[126] Using faceted lenses (polygon crystals), Nicéron flatteringly and with heavy symbolism produced a composite image of Louis XIII of France from twelve different images of rulers of the Ottoman empire ('despoiling themselves to honour his triumph', said Nicéron), an optical technique repeated by others eager to please contemporary statesmen and almost certainly seen by Thomas Hobbes during his visits to Paris.[127] The fact that the natural magic of visual illusion was embedded in, and thus partly constituted by, religious concerns, especially those of Counter-Reformation piety, is likewise obvious. It was produced by men nominally so involved in orthodox spirituality that it is inconceivable that the two things were not just compatible but closely related—or at least presented as such. Nicéron was, of course, a Minim and also a theologian. *La Perspective curieuse* was published with the approval of other Minims like the Provincial Gilles Cossart, Marin Mersenne, and François de la Noüe (whom Nicéron succeeded as vicar-general of the order), and it was dedicated to the Bishop of Ascoli. Again, individual illusionist techniques were themselves adopted to convey specific religious doctrines, the chosen technique and the aimed-for doctrine becoming a perfect symbolic match. The Italian Bettini, for example, used the 'tabula scalata', an arrangement of triangular prisms with

different images distributed on alternate faces, to symbolize the Resurrection and convey its exact meaning. A mirror attached to the device, or hung above it, produced the required image of Christ emerging from his tomb from one side of the prisms, while this inscription could be seen on the other: 'Surrexit. Non est hic. Vide illum per speculum in aenigmate' (see Figs. 12–13).[128] This recalls a reported version of the Crucifixion by Daniele da Volterra, 'which was painted to accommodate two visual perspectives: looked at first from the right, then from the left, it seemed to "shift" toward the beholder'.[129] Kircher's physics of light and shadow, and many of the resulting devices, should be read in the context of its thoroughly religious 'metaphysical' counterpart, expounded in the often unread epilogue to *Ars magna*.[130] Of many of his machines it has recently been noted that, whatever their other purposes, they served to reinforce religious teachings and dispel error and superstition, like the soul writhing in Purgatory or the figure of death projected by his 'magic lantern' or the hot-air balloon shaped like a dragon, with 'IRA DEI' on its side, designed (more ambiguously, perhaps, since it also saved Jesuit lives from an 'indian' attack) to correct the popular belief in aerial apparitions. A particular aim was to expose the visual frauds and cheats of the priests of the ancient religions. Visiting Kircher's museum, we must assume, was as much a conversionary as a pedagogic experience.[131]

There yet remains, however, the issue of visual perception itself. Whatever the political or religious messages emitted by a particular optical device, or the ideological capital to be derived from writing about them, there was still the visual deceit on which most of them relied. As one seventeenth-century traveller observed of the 'secrets of optics': 'It is that deceptive art which plays on our senses and with the rule and compass disorders all our senses.'[132] Accompanying all the other reasons for the considerable vogue for illusionism in natural magical and natural philosophical circles, therefore, must have been the idea of pushing the cognitive and epistemological paradoxes that arose from it to the limit. The full title of Bettini's book was *Apiaria universae philosophiae mathematicae in quibus paradoxa et nova pleraque machinamenta ad usus eximios traducta, et facillimis demonstrationibus confirmata*, and the word 'paradox' appears on most of its pages. The heading for its fifth section is 'Apiarium quintum in quo paradoxa et arcana opticae scenographicae' ('paradox' appears in the headings to other sections too), and the book is prefaced by a list of twenty-one of 'the many and excellent paradoxes and inventions' that it contains. Kircher used the word 'paradox' at several points in book 10 of *Ars magna*, starting with the preface ('quicquid rarum, curiosum, paradoxum, prodigiosumque sub umbrae squalore, Lucisque caligine abditum fuit'). Later in the text he referred to a specular machine by which 'colliges, flatu solo, vaporisque motu innumera exhiberi posse humano ingenio prorsus paradoxa', to memories of things he had seen in Rome ('qua variis in locis, tum potissimum hic Romae ad miraculum usque paradoxas vidisse me memini'), and to the well-known preface to Risner's *Opticae*, written by the

mathematician Joannes Peña and entitled 'De usu opticae' ('Ecce hae sunt praestigiae, quas tanquam paradoxas mundo vendit, Opticus parum in ipsa luce opticus').[133] According to Schott's *Magia universalis*, magical optics was that part of the subject 'in which is examined whatever in this universal science is rare, hidden, prodigious, and paradoxical, and remote from the common notion and use of optics'.[134]

What seems to be meant by the word 'paradox' in the contexts we have been considering is the intrusion into ordinary visual experiences of features that cut completely across normal cognitive expectations and, potentially at least, subvert them—ambiguity (even duplicity) of image and meaning, indeterminacy of appearances, irresolution between certainty and uncertainty, the indistinguishableness of convincing truth and revealed fiction, both of which are asserted simultaneously. This is what led Rosalie Colie, in her extraordinarily presentient book *Paradoxia epidemica* (1966), to compare sensory deceptions to verbal and logical contradictions, making 'prestiges' the visual equivalent of the logical and rhetorical paradox. She wrote: 'Deceits of the senses that are two things at once, two-or-more-in-one, are the parallel in natural philosophy of the verbal paradox of contradiction, since they raise and illustrate the same puzzles about the nature of perceived reality.'[135] Indeed, it was part of Colie's larger argument that magical optics was not only identified as yielding specific paradoxes but also belonged to a tradition of paradox and paradoxical techniques embracing many other aspects of late Renaissance thought and writing. She suggested that, whatever their type or context, paradoxical statements necessarily possess common features, notably the self-contradiction and perfectly balanced equivocation encapsulated in the example of the Cretan Liar. They are also always self-referential, both in the sense that the contradictory meanings they contain must be reflections of each other and in the sense that each paradox reflects only on itself, leaving no room for external resolution. It comments on its own method and technique as a statement, qualified by its own technical skill as a paradox to do so but disqualified by its own circularity from ever completely succeeding. In this lies the very paradoxicality, even anti-rationality, of the paradox, for to be both the subject and object of a statement, to invoke a technique in order to question or examine it, and, above all, to use one's knowledge for self-knowledge, are all inherently tautological, infinitely regressive; they are to be or to do things that cannot be reconciled. All paradoxes, said Colie, 'are self-enclosed statements with no external reference point from which to take a bearing upon the paradox itself'. Nevertheless, by their very attempt at making statements at all, they are dialectically challenging. They rely on the relativity of opinions and are critical 'of absolute and fixed conventional judgments'; they deny commitment and limitation. Although marked by mockery and *seria ludere*, and by the ability to dazzle and cause wonderment (George Puttenham's term for *paradoxon* was the 'wonderer'[136]), they stimulate further questioning and enquiry, and represent, in the case of the Renaissance, an attempt to confront the intellectual phenomenon of many 'ideas and systems in competition with one another'.[137]

In a book full of remarkable insights, Rosalie Colie traced her 'epidemic of paradoxy'—metaphysical, epistemological, and moral—across many areas of intellectual production, including rhetorical defences of 'unworthy' subjects (like folly), utopias and inverted worlds, places where ignorance was learned and opposites coincided, mystical and 'negative' theology, mathematical *insolubilia*, devotional and love poetry, and treatments of 'nothingness' and negativity (including suicide). This took her mainly to the writings of Rabelais, Donne, Montaigne, Spenser, and Burton, but she was also acutely aware of how paradox could be expressed both in visual metaphors and in visual practices, especially those relating to mirroring, *trompe l'œil*, and illusionism in general. The very equivocation of the paradox made it mirror-like; the Cretan Liar example, she wrote, was 'literally, speculative, its meanings infinitely mirrored, infinitely reflected, in each other'.[138] The mirror, indeed, was the paradox's visual emblem, its images being both themselves 'thinkings' ('reflections', 'speculations') and an invitation to thought on the part of those observing them. The paradox's mental gymnastics were, likewise, a kind of 'prestidigitation' of ideas.[139] Colie saw the art of still life, in particular, as an inherently paradoxical genre, both in content and technique. Like the rhetorician's praise of unpraisable things, it was consummate skill contradictorily invested in 'lowly', 'vain', or 'empty' subjects. Like all paradoxes it combined artistry with duplicity—in this case, the triumphant deceit of a naturalism so complete that it tricked men and women into believing in illusions. All artistic illusionism, especially in resorting to the aid of the mirror and the camera obscura, risked focusing too much on its own artifice and on the weakness of the human eyes. By aiming totally to deceive, it pointed to the relativities of perception. Colie thought that still life did this in paradoxical abundance: 'The still life seeks to transcend its medium in a curious way: by drawing attention to its craft, it flaunts its illusionism, its technical trickery.' This made it, again in the self-referential manner of all paradoxes, 'an overt commentary on the art of painting', as well as on all ocular experience.[140] Self-portraiture, too, had some of the same qualities: 'the more faithful the likeness, the greater the falsity of the picture, the greater its isolation from any reference point outside of the creating, re-creating self.'[141] Illusion and paradox were thus closely allied in two ways—in terms of relativity, in the sense that one thinks that something is 'real' when it is not, and in terms of what Colie called the tautology of the perfect fit (the better the match between the virtual and the real, the more superfluous and self-contradictory the illusion becomes). Like 'still life', illusion in general invokes a distinction that it then seeks to deny; in it, 'something is declared to be what it manifestly is not'.[142] If it is virtual, then it is not real; if it is not virtual, then the whole point of the enterprise is lost. Neither virtual nor real, the virtual reality of optical illusion begins an endless circularity ('oscillation' was her term) between real things and virtual things, from which, hypothetically at least, there is no escape. In doing so, however, it is what she again would have called 'self-critical'; it comments on what it is that it is exploiting. It calls into

epistemological question the processes of human perception—in particular, the conventions, relativities, and other limitations of visuality itself.

What Colie's study powerfully suggests, therefore, is that visual paradoxy, properly so called, was located in a particular intellectual culture that flourished at a particular historical moment, even if a rather extended one.[143] What it also suggests, moreover, is that visual illusion and deception—or just radical visual uncertainty—did not simply cause anxiety or vulnerability. It was also, without question, an opportunity for exploring the epistemological, psychological, and social attributes of vision and visual representation in original and challenging ways. One of the, again paradoxical, features of the virtual is that it usually becomes more interesting and intriguing than the reality it claims to replace. Yet there was no reason why this should not also have been broadly consistent with the religious sensibilities of most of the major exponents of magical optics. Yet another of Colie's insights, subsequently confirmed, was to recognize that the paradoxical mode played an essential part in their considerations of God and their sense of wonder and admiration at his created universe.[144] In Barbara Maria Stafford's more recent view, many of the eye machines of Kircher and his colleagues were 'spiritual tools' for meditating on theological problems: 'The complexities of virtuality', she writes, 'inform both Jesuit epistemology and their pedagogy.' In this sense, mirrors like those in the *theatrum catoptricum* 'enacted' doctrinal truths. There was the fairly routine sentiment that the uncertainty or duplicity of appearances was symbolic of the inconstancy of the world and the fickleness of its inhabitants, when compared to the unchanging, immaterial deity and the eternal truths of religion. And there was the less resigned idea of transforming that world into something more orderly and less sinful with the help of visual emblems and metaphors.[145] Of Hoogstraten's perspective boxes, originating in a resolutely Calvinist culture, Stafford says: 'In accordance with Baroque perspectivism, only the observer's particular point-of-view is able to create coherence out of a disintegrated optical miscellany. For Reformation and Counter-Reformation thinkers, the confused sights of this world always had to be converted. Only by the technological righting of a conspicuously wrong view could the undistorted likeness of divinely created forms be captured.'[146] In this reading, the 'glassy game' of Jesuit catoptrics was a strategy of revelation, even epiphany. Besides, even if religious practices are often dependent on visual realism, religious truths are not, invoking ineffability and mystery instead. Here, enigmatic, illusory, or paradoxical visual experiences can be as effective as 'straight' ones.

Nevertheless, there was a cost to the assumed stability of the cognitive theories of intellectuals who, in this area of thought as in their entire concept of natural magic, were still essentially—if with reservations—Aristotelians.[147] In a work from a later period in his life, *Ars magna sciendi* (1669), Kircher might have continued to use the human eye as a symbol of universal wisdom, and in the

1670s, Schott might have continued to speak of the transmission of 'visible species' as the foundation of seeing.[148] But while not intending to question representational theories of vision in any serious way—on the contrary, while depending on these theories for the very idea of the visual paradox itself, and the impact of specific visual marvels—their tireless elaboration of cases where visual sense impressions were manipulated to the point where they bore no resemblance to what was being perceived showed just how unworkable the inherited theories might become.[149] Whatever the reasons for the vogue for magical optics in the sixteenth and seventeenth centuries, or the uses to which it was put, the fact that it became a vogue *at all* vastly multiplied the instances where the correspondence between perception and reality on which Aristotelian seeing depended could be shown not to hold.[150] Writes Barbara Maria Stafford: 'Mutually incompatible verisimilar illusion and dissembling delusion were forced to become compatible, to refer ambiguously to one another as equals.'[151] Visual *fallaciae* had always featured as problems for the inherited paradigm to solve, but not on the scale of those discussed in the century between Della Porta and Kircher, the latter of whom applied the term to all perspective effects.[152] The implications of this could not be perceived by either of these two men themselves, or by other optical magicians like them, but they were definitely grasped by those with little or no investment in the Aristotelian model, and most of all (as we shall see in the final chapter of this book) by those 'new' philosophers anxious to re-establish visual cognition on an entirely different philosophical basis. It is with a certain sense of irony that one discovers that Christopher Wren compared Kircher and Schott to 'jugglers'.[153]

Meanwhile, there is a more urgent implication to consider which will lead us to what comes immediately next. It lies in Nicéron's admission that catoptrical effects could be so prodigious that their creators were able to pass for 'diviners, witches, or enchanters' with the power to make appear ('faire voir') anything they pleased, past or future, even with the help of demons. Indeed, such effects were often attributed explicitly to witchcraft, since to those who did not know their optical causes they seemed to be 'supernatural' or 'pure illusions or prestiges of diabolical magic'.[154] This seemingly alarming symmetry between two kinds of magic divided only by morality and use was discussed throughout early modern intellectual life and is not, in itself, surprising.[155] The Christian devil was theologically confined within nature and therefore limited to producing natural effects from natural causes—preternatural at the most. In principle, the gifted magician might achieve as much, and certainly by the same means. Good and bad magic were thus physically indistinguishable, and the only difference between them—a substantial one, of course—was motive. This made the prestige as much a demonic as a human medium, reminding us that many of the definitions of *magia praestigiatoria* we began with aligned it with evil. Like all magical effects, it was, indeed, ambiguous—partly an exciting technical wonder capable of revealing

nature's secrets and God's mysterious ways, and partly duplicitous and therefore dangerous and immoral.

The point is reinforced by the way one of the seventeenth century's last great encyclopedic accounts of magical optics, part 1 of Schott's *Magia universalis*, is introduced by a general discussion of magic which firmly places 'prestigious' magic (*magia praestigiatrix*) in the corrupt branch of the subject inaugurated by Zoroaster.[156] Good magic is either 'natural' or 'artificial' and only popular ignorance of how it is caused leads to the charge of visual trickery. Schott's treatment of optics itself is entirely derived from Kircher and repeats most of the master's discussions, examples, and images; the prologomena on magic is likewise faithful to the views of the late sixteenth-century Jesuit authority Martín Del Río. This pairing was not without its problems for Schott; he cited Del Río on how the devil was unable to make statues talk and had to make their 'voices' out of air, conveniently forgetting his description, just twenty pages before, of a 'mathematical' statue made by Kircher in Rome that gave replies when it was asked questions.[157] But it does allow us to move from a source of instability in the Aristotelian model of vision that was intended to be positive and productive to another that definitely was not—from the visual experiments of Renaissance artists and scholars to the cognitive chaos of demonism and witchcraft.

NOTES

1. Bacon, *Works*, iii. 161–2, cf. 164; Colie, *Paradoxia epidemica*, 300–4; Paolo Rossi, *Francis Bacon: From Magic to Science*, trans. S. Rabinovitch (London, 1968), 131–2. *New Atlantis* reappeared thirteen times with Bacon's *Sylva sylvarum* between 1627 and 1685, on its own in 1659, and in two French (1631, 1652) and two Latin (1648, 1661) edns.
2. Bacon, *Works*, iv. 170–2; iv. 253–70; ii. 496–7, 655–6.
3. Ibid. iv. 172.
4. Cf. in modern Italian, *prestigio* (= illusion, hence *prestigiatore*, *gioco di prestigio*, etc.); French, *prestige* (= marvel, hence *prestigieux*).
5. *Isidori Hispalensis episcopi etymologiarum sive originum libri xx*, ed. W. M. Lindsay (2 vols.; Oxford, 1911), i, unpaginated (viii, ch. 9, 'De magis', sect. 33); Gaspar Caldera de Heredia, *Tribunal magicum, quo omnia quae ad magiam spectant, accurate tranctantur et explanantur, seu tribunalis medici [pars secunda]* (Leiden, 1658), 15. The *OED* confirms the Latin derivation from *praestrigium* and *praestringere* (= to bind fast), and the meanings of illusion, deception, deceit, imposture, conjuring, tricking, cheating, and juggling. The English forms include 'prestigiate', 'prestigiated', 'prestigiating', 'prestigiation', 'prestigiator', 'prestigiatory', and 'prestigious'. The most frequent contemporary synonym for prestiges was 'sleights'.
6. [Collegium Conimbricense], *Commentarii ... in octo libros physicorum* (Cologne, 1609), col. 24.
7. Johann Heinrich Alsted, *Encyclopaedia* (Herborn, 1630), 2269; Alsted seems to have assumed that demons were usually involved, for which see Ch. 4 below.
8. [Anon.], *Ars magica sive magia naturalis et artificiosa* (Frankfurt am Main, 1631), 1–3.

9. Johann Georg Godelmann, *Tractatus de magis, veneficis et lamiis, deque his recte cognoscendis et puniendis* (3 vols. in 1; Frankfurt am Main, 1591), i. 23 (bk. i, ch. 3: 'De praestigiatoribus'); Walter Raleigh, *The History of the World* (London, 1614), 321; Martín Antonio Del Río, *Disquisitionum magicarum* (Mainz, 1617), 32.
10. On this very large subject, see Ernst Friedrich, *Die Magie im französischen Theater des xvi. und xvii. Jahrhunderts* (Leipzig, 1908), 216–20; Jurgis Baltrušaitis, *Le Miroir* (Paris, 1978); Kaspar Peucer, *Commentarius de praecipuis divinationum generibus* (Wittenberg, 1553), 124v.
11. Franciscus a Vitoria, *Relectiones theologicae* (Lyons, 1587), Relectio xii: 'De arte magica', 447 (1st pub. 1557).
12. Benedictus Pererius (Benito Pereira), *Adversus fallaces et superstitiosas artes, id est, de magia, de observatione somniorum, et, de divinatione astrologica* (Ingolstadt, 1591), 54–5; cf. the trans. in P. G. Maxwell-Stuart (ed.), *The Occult in Early Modern Europe: A Documentary History* (London, 1999), 117.
13. Caldera de Heredia, *Tribunal magicum*, 15.
14. Pererius, *Adversus fallaces et superstitiosas artes*, 54–5.
15. Girolamo Cardano, *De subtilitate*, in *Opera omnia* (10 vols.; Lyons, 1663), iii. 635–54 (bk. 18: 'De mirabilibus, et modo repraesentandi res varias praetor fidem'); a comparable survey is in Cornelius Agrippa, *Of the vanitie and uncertaintie of artes and sciences*, trans. Ja[mes] Sanford, ed. C. M. Dunn (Northridge, Calif., 1974), 140–2 (ch. 48: 'Of juglinge').
16. Reginald Scot, *The discoverie of witchcraft* (London, 1584), 321–52; for two typical English imitators, see Samuel Rid, *The art of juggling, or legerdemaine* (London, 1614), and J[ohn] C[otgrave], *Wits interpreter, the English Parnassus* (London, 1655), 118–75. A useful guide is Raymond Toole Stott, *A Bibliography of English Conjuring, 1581–1876* (2 vols.; Derby, 1976–8).
17. Richard Bernard, *A guide to grand-jury men*, 2nd edn. (London, 1630), 92–3; this contrasts with the view of Scot, who felt that as long as God's name and power were not abused and the techniques were openly acknowledged, juggling, especially for a livelihood, was 'not onlie tolerable, but greatlie commendable': *Discoverie*, 321.
18. Godelmann, *Tractatus*, i. 22–9 (bk. 1, ch. 3).
19. Del Río, *Disquisitionum magicarum*, 32 (bk. 1, ch. 5).
20. Malcolm Gaskill, *Crime and Mentalities in Early Modern England* (Cambridge, 2000), 116–17.
21. Agrippa, *Vanitie and uncertaintie*, 141; Beyerlinck, *Magnum theatrum*, ii. 216a; John Stearne, *A confirmation and discovery of witch craft* (London, 1648), 25.
22. Stafford and Terpak, *Devices of Wonder*, 39; cf. Barbara Maria Stafford, *Artful Science: Enlightenment Entertainment and the Eclipse of Visual Education* (Cambridge, Mass., 1994), 73–85.
23. Kemp, *Science of Art*, 1; it will be obvious that I rely considerably on Kemp in what follows.
24. Jay, *Downcast Eyes*, 52.
25. Ernest B. Gilman, *The Curious Perspective: Literary and Pictorial Wit in the Seventeenth Century* (New Haven, 1978), 31–3 (author's emphasis), cf. 50.
26. Ibid. 34.
27. Kemp, *Science of Art*, 78; on p. 83 Kemp makes a similar observation about Giovanni Paolo Lomazzo.

28. Thorne, *Vision and Rhetoric*, 66, identifies in Alberti's claim faithfully to replicate the world Norman Bryson's 'natural attitude' (see his *Vision and Painting*, ch. 1 and *passim*)—'the naïve assumption, epitomized by Pliny's tales of *trompe l'œil* realism and still ingrained in Western art theory, that such technological inventions edge the visual arts ever closer to their ultimate goal of producing a perfect copy of the visible world'.
29. On the history of perspective across Europe, see Lyle Massey (ed.), *The Treatise on Perspective: Published and Unpublished* (New Haven, 2003). For England, Germany, and the Netherlands respectively, see Thorne, *Vision and Rhetoric*, 40–56; Christy Anderson, 'The Secrets of Vision in Renaissance England', in Massey (ed.), *Treatise on Perspective*, 322–47; Christopher S. Wood, 'The Perspective Treatise in Ruins: Lorenz Stoer, *Geometria et perspectiva*, 1567', in Massey (ed.), *Treatise on Perspective*, 234–57; Arthur K. Wheelock, Jr., *Perspective, Optics, and Delft Artists around 1650* (New York, 1977), 1–190; Alpers, *Art of Describing*, esp. 26–71.
30. Samuel Y. Edgerton, Jr., *The Renaissance Rediscovery of Linear Perspective* (New York, 1976), 86, see also 7, 24, 30–1, 41, 56, 162 (1st pub. 1975); cf. Michael Baxandall, *Painting and Experience in Fifteenth-Century Italy* (Oxford, 1971), 40–56, 103–8; Jay, *Downcast Eyes*, 53–4. In medieval optics the 'centric ray' was the visual ray that travelled unrefracted from the centre of the visual field into the exact centre of both eye and optic nerve. In Albertian perspective there is a corresponding preference for the 'centric point', the vanishing point (in modern terms) in the middle of the painted scene where all orthogonal lines converge.
31. Jay, *Downcast Eyes*, 59.
32. The term derives in particular from William M. Ivins, Jr., *On the Rationalization of Sight: With an Examination of Three Renaissance Texts on Perspective* (New York, 1973), and his observation (7, 10) that perspective secured a 'two-way, or reciprocal, correspondence' with external fact. Whether one can speak of a dominant metaphor at all, or of perspective as a conceptual unity, is seriously questioned by Elkins, *Poetics of Perspective*, *passim*, esp. pp. xi–xiv, 1–44, 79–80.
33. Edgerton, *Renaissance Rediscovery*, 198 (Glossary: 'picture plane'); Jay, *Downcast Eyes*, 54–7.
34. Originally published as 'Die Perspektive als "symbolische Form"', in *Vorträge der Bibliothek Warburg, 1924–1925* (Leipzig, 1927), 258–330; trans. with an introd. by Christopher S. Wood, *Perspective as Symbolic Form* (New York, 1997).
35. Ibid. 34.
36. David Summers, *Michelangelo and the Language of Art* (Princeton, 1981), 42, 51, 50–5 (from a chapter entitled 'Quello che non è sia'); Summers believes (41) that 'the nature and awareness of the mysterious transformation from two to three dimensions wrought by the painter's hand was as powerful an impulse to the development of Renaissance painting as the force of the realization of the autonomy of the material object has been to modernist painting'. Cf. Jurgis Baltrušaitis, *Anamorphic Art*, trans. W. J. Strachan (Cambridge, 1977), 114, on the 'falseness and insubstantiality of appearances' in perspectival forms (Baltrušaitis's book appeared first in 1955 and was enlarged in 1969 as *Anamorphoses ou magie artificielle des effets merveilleux*, from which this trans. is taken); Lyle Massey, 'Configuring Spatial Ambiguity: Picturing the Distance Point from Alberti to Anamorphosis', in ead. (ed.), *Treatise on Perspective*, 161–75, together with her comment in the 'Introduction' to this volume to the effect

that perspectival images 'demand an epistemological resolution at the expense of an ontological one, or vice versa' (15).
37. Cited by Gilman, *Curious Perspective*, 32–3.
38. Agrippa, *Vanitie and uncertaintie*, 79–80 (ch. 24: 'Of paintinge').
39. Giovanni Paolo Lomazzo, *A tracte containing the artes of curious paintinge*, trans. Richard Haydocke (London, 1598), 15 (bk. 1), 188 (bk. 2); Kemp, *Science of Art*, 83–4.
40. Barbaro cited by Summers, *Michelangelo*, 52; Bertani cited by Elkins, *Poetics of Perspective*, 76.
41. Both quotations in Thorne, *Vision and Rhetoric*, 80; many more examples in Lucy Gent, *Picture and Poetry, 1560–1620: Relations between Literature and the Visual Arts in the English Renaissance* (Leamington Spa, 1981), 22–8, 60–1.
42. Pietro Accolti, *Lo inganno de gl'occhi, prospettiva pratica* (Florence, 1625), 144, cf. 2; Kemp, *Science of Art*, 134–6.
43. Jean François Nicéron, *La Perspective curieuse ou magie artificiele [sic] des effets merveilleux* (Paris, 1638), 'Preface au lecteur'.
44. Baltrušaitis, *Anamorphic Art*, 86, 89.
45. Cited by Gilman, *Curious Perspective*, 78, 252 (n. 14).
46. Descartes, 'Optics', in *Philosophical Writings*, i. 165–6; for a fuller discussion, see Ch. 10 below. Descartes's argument recalls Hakewill's comment on artistic deception of the eye: 'For so it is that this sense . . . is so bewitched that its then most delighted when tis most deceived by shadowings, and land-skips [sic], and in mistaking counterfeits for truths' (*Vanitie*, 90); see above, Ch. 1.
47. Elkins, *Poetics of Perspective*, 7 gives the date as 'shortly before 1413'.
48. John White, *The Birth and Rebirth of Pictorial Space* (London, 1972; orig. edn. 1957), 117. Ivins, *Rationalization of Sight*, 16, cites a *Vita anonyma* of Alberti on his demonstrations of perspective leaving both artists and laymen unsure 'whether they saw painted things or natural things themselves'.
49. Full description of the panels and Manetti's text in Edgerton, *Renaissance Rediscovery*, 125–9, 138–50, 150–2, with the subject of catoptrics at 134–8; cf. White, *Birth and Rebirth*, 113–21; Kemp, *Science of Art*, 12–13.
50. White, *Birth and Rebirth*, 189, cf. 189–201 for the technical features of illusionism.
51. Kemp, *Science of Art*, 42–3, 70; Ronald Lightbown, *Mantegna* (Oxford, 1986), 98–117; Michele Cordaro (ed.), *Mantegna's Camera degli Sposi* (New York, 1993).
52. Kemp, *Science of Art*, 70; C. L. Frommel, *Baldassare Peruzzi als Maler und Zeichner* (Vienna, 1968), 87–91 and plate 34b; Oliver Grau, *Virtual Art: From Illusion to Immersion*, trans. Gloria Custance (Cambridge, Mass., 2003), 37–40.
53. Kemp, *Science of Art*, 105, quoting from A. Palomino, *El museo pictórico escala optica* (Madrid, 1715–24), via the trans. by E. Harris, *Velásquez* (New York, 1982), 215; for more on Colonna and Mitelli, see Kemp, *Science of Art*, 136–7.
54. Kemp, *Science of Art*, 137–9; the treatise appeared in Rome in Latin and Italian, and was later translated into German, English, French, and Dutch. Martin Kemp, 'Perspective and Meaning: Illusion, Allusion, and Collusion', in A. Harrison (ed.), *Philosophy and the Visual Arts: Seeing and Abstracting* (Dordrecht, 1987), 255–68, relates the techniques and spiritual meanings of Pozzo's designs to the architectural language and natural magical interests of baroque Catholic Europe, as a way of

considering their relevance to the debate about perspective as a 'symbolic form'. See also Grau, *Virtual Art*, 46–52.
55. Celeste Brusati, *Artifice and Illusion: The Art and Writing of Samuel van Hoogstraten* (Chicago, 1995), *passim*, esp. 11–12, 63–74, 86–109, 152–68, 169–217 (quotation at 11); cf. Kemp, *Science of Art*, 118–19, 204–5; Miller, *On Reflection*, 81, 105–6.
56. On illusionism in general with many examples, see Fred Leeman (with Joost Elffers and Mike Schuyt), *Hidden Images: Games of Perception, Anamorphic Art: Illusion from the Renaissance to the Present*, trans. E. C. Allison and M. L. Kaplan (New York, 1976), *passim*; Hanneke Grootenboer, *The Rhetoric of Perspective: Realism and Illusionism in Seventeenth-Century Dutch Still-Life Painting* (Chicago, 2005), *passim*. On 'immersive' images and spaces, and the Sacro Monte dioramas at Varallo in particular, see Grau, *Virtual Art*, 3–23, 41–6.
57. Kemp, 'Perspective and Meaning', 263.
58. Gent, *Picture and Poetry*, 60; Thorne, *Vision and Rhetoric*, 74–86.
59. The theme of artist as magus is explored in Michael Cole, 'The Demonic Arts and the Origin of the Medium', *Art Bull.* 84 (2002), 621–40.
60. *Richard II*, 2. 2. 18–20: 'Like perspectives which, rightly gaz'd upon, | Show nothing but confusion,—ey'd awry, | Distinguish form!'; cf. Thorne, *Vision and Rhetoric*, 55, 135–65, for other references to, and applications of, anamorphosis in Shakespeare, esp. in *Troilus and Cressida*.
61. Athanasius Kircher, *Ars magna lucis et umbrae* (Rome, 1646), 184: 'intra quas lineas anamorphosis, sive transformatio figurae facienda est.'
62. As cited in Baltrušaitis, *Anamorphic Art*, 30. Cf. the title to bk. 2 of Nicéron's *La Perspective curieuse*, which describes anamorphosis as the art of making figures which, 'seen from elsewhere than the chosen view-point will seem distorted and senseless, but seen from the view-point will appear correctly proportioned' ('figures lesquelles hors de leur poinct sembleront difformes et sans raison, et veues de leur poinct paroistront bien proportionees').
63. 'Textbook' descriptions of anamorphic techniques are easily traceable via Alberto Pérez-Gómez and Louise Pelletier, *Anamorphosis: An Annotated Bibliography* (Montreal, 1995). For some examples, see Jacopo Vignola, *Le due regole della prospettiva pratica* (c.1530–40), pub. with comm. by Ignazio Danti (Rome, 1583), 94–6; Daniele Barbaro, *La pratica della perspettiva* (Venice, 1568), 159–61; Salomon de Caus, *La Perspective, avec la raison des ombres et miroirs* (London, 1611), bk. 1, chs. 28–9; Samuel Marolois, *Perspective contenant la théorie et pratique d'icelle* (The Hague, 1614), 280; Accolti, *Lo inganno de gl'occhi*, 48–50; Nicéron, *Perspective curieuse*, bks. 2 and 3; Joseph Moxon, *Practical perspective: or, perspective made easie* (London, 1670), 62–5. The subject is surveyed in Kemp, *Science of Art*, 208–12; Stafford and Terpak, *Devices of Wonder*, 235–48; Grootenboer, *Rhetoric of Perspective*, 97–133; and in more technical detail by Kim H. Veltman, 'Perspective, Anamorphosis and Vision', *Marburger Jahrbuch für Kunstwissenschaft*, 21 (1986), 93–117.
64. Summers, *Judgment of Sense*, 316, cf. 3–9.
65. Baltrušaitis, *Anamorphic Art*, 33, citing Accolti, *Lo inganno de gl'occhi*, 49.
66. Baltrušaitis, *Anamorphic Art*, 1–2; followed by Lyle Massey, 'Anamorphosis through Descartes or Perspective Gone Awry', *Renaissance Quart.* 50 (1997), 1150, 1165–85, who says (1168) that Baltrušaitis's argument is that 'anamorphosis reveals how the

apparent rationalization of sight proposed by perspective contains within it the possibility of its own de-rationalization'.
67. Thorne, *Vision and Rhetoric*, 36, 134–65, esp. 140; cf. Fowler, *Renaissance Realism*, 112–13; Christopher Pye, *The Regal Phantasm: Shakespeare and the Politics of Spectacle* (London, 1990), 90–3, esp. 92: 'the anamorphic device suggests that even vision is a function of difference.'
68. Elkins, *Poetics of Perspective*, 35.
69. Giancarlo Maiorino, *The Portrait of Eccentricity: Arcimboldo and the Mannerist Grotesque* (University Park, Pa., 1991), 34, 52–3, and see 37 on anamorphosis as 'an effective tool for producing optical distortions and a philosophy of false reality that displaced the humanist symbolism of linear perspective as a form of intellectual certainty'.
70. Jay, *Downcast Eyes*, 48–9; Crary, *Techniques of the Observer*, 33. Cf. Baltrušaitis, *Anamorphic Art*, 1–2; Stephen Greenblatt, *Renaissance Self-Fashioning: From More to Shakespeare* (London, 1980), 17–22, esp. 21; Daniel L. Collins, 'Anamorphosis and the Eccentric Observer: Inverted Perspective and the Construction of the Gaze', *Leonardo*, 25 (1992), 73–82. On Lacan's use of *The Ambassadors* as an allegory of the 'simultaneous process of possession and dispossession in the field of vision', see Bryson and Bal, 'Semiotics and Art History', 200.
71. Gilman, *Curious Perspective, passim*; César Nicolás, *Estrategias y lecturas: las anamorfosis de Quevedo* (Salamanca, 1986); David R. Castillo, *(A)Wry Views: Anamorphosis, Cervantes, and the Early Picaresque* (West Lafayette, Ind., 2001), esp. 1–17.
72. For metaphor see Noel Malcolm, *Aspects of Hobbes* (Oxford, 2002), 205; for allegory, see Jean-Claude Margolin, 'Aspects du surréalisme au xvie siècle: fonction allégorique et vision anamorphotique', *Bibliothèque d'humanisme et Renaissance*, 39 (1977), 503–30, esp. 507, asking of allegorical 'deviation': 'Cette déviation par rapport à la signification directe, immédiate, monosémique, ne présente-t-elle pas une analogie fonctionnelle avec la vision latérale ou oblique par laquelle nous éfinissions l'angle favorable à une perception reconstituée des étranges anamorphoses? Ici, vision latérale par opposition à une vision frontale; là signification dérivé, voire oppose.'
73. Baltrušaitis, *Anamorphic Art*, 1–2; cf. Thorne, *Vision and Rhetoric*, 136: 'the undisguised illusoriness of anamorphic images can only have intensified their power to unsettle. Simply by adjusting one's viewing position, distorted apparitions could be made to resolve themselves into intelligibility, or one image to metamorphose into another.... the effect of such ambiguity is to throw the beholder's normal ontological categories into disarray by compelling him/her to experience at first hand the difficulties of disentangling the fictive from the real, truth from falsehood.'
74. On these catoptric anamorphoses, giving many examples, see Baltrušaitis, *Anamorphic Art*, 131–58; Laurent Mannoni, Werner Nekes, and Marina Warner, *Eyes, Lies and Illusions* (London, 2004), 88–97, 195–7; Miller, *On Reflection*, 56–7. The fullest contemporary treatment is in J.-L. le Sieur de Vaulézard, *Perspective cilindrique et conique; ou traicté des apparences veües par le moyen des miroirs cilindriques* (Paris, 1630). Malcolm, *Aspects of Hobbes*, 205, comments that the psychological effects of the two visual experiences involved in anamorphoses were 'enhanced by bringing them as close together as possible, so that they become interchangeable and virtually simultaneous. When a mirror is employed, only a tiny movement of the eye is required to pass from seeing the distortion to seeing the resolution, and back again; in

some cases (such as cylindrical anamorphoses) it may even be possible to hold both in the field of vision at the same time.'
75. Colie, *Paradoxia epidemica*, 288–9.
76. Cited in Baltrušaitis, *Anamorphic Art*, 32.
77. Cited ibid. 78.
78. Ibid., see figs. 7–8, 11, 15, 17; Leeman, *Hidden Images*, 11–13, 16–17, 57 (plate 45), 86–7.
79. Jean François Nicéron, *Thaumaturgus opticus, seu admiranda optices . . . catoptrices . . . et dioptrices* (Paris, 1646), plates 66 and 67; quotation as cited in Baltrušaitis, *Anamorphic Art*, 57. This work was a modified and enlarged version of Nicéron's *Perspective curieuse*, but only of the first two books. For detailed accounts of how the frescoes were devised, see Baltrušaitis, *Anamorphic Art*, 50–60 (with reproductions of Maignan's design at fig. 38 and Nicéron's at fig. 40); Didier Bessot, 'La Perspective de Nicéron et ses rapports avec Maignan', in M. Bucciantini and M. Torrini (eds.), *Geometria e atomismo nella scuola Galileiana* (Florence, 1992), 158–69; Caterina Napoleone, 'Monastic Caprices: The Monastery of Trinità dei Monti: The Anamorphosis by Emmanuel Maignan', *FMR* 71 (1994), 20–30. Maignan's method was described and illustrated in his treatise *Perspectiva horaria, sive de horographia gnomonica* (Rome, 1648), bk. 3, prop. 77, 438–49; the illustration is opposite 444.
80. Full details in Pascal Julien, 'L'Anamorphose murale du collège jésuite d'Aix-en-Provence: jusqu'à Lisbonne par la barbe de saint Pierre', *Revue de l'art*, 130 (2000), 17–26; cf. Baltrušaitis, *Anamorphic Art*, 157–8.
81. On the politics of anamorphic art, see Malcolm, *Aspects of Hobbes*, 207–9.
82. Colie, *Paradoxia epidemica*, 289, cf. 307; Kemp, *Science of Art*, 211.
83. Julien, 'L'Anamorphose murale', 24, cf. 21; Koen Vermeir, 'The Magic of the Magic Lantern (1660–1700): On Analogical Demonstration and the Visualization of the Invisible', *British J. Hist. Science*, 38 (2005), 145 n. 46.
84. Geneviève Rodis-Lewis, 'Machineries et perspectives curieuses dans leurs rapports avec le Cartésianisme', *XVIIᵉ siècle*, 32 (1956), 471–3; Baltrušaitis, *Anamorphic Art*, 69; Malcolm, *Aspects of Hobbes*, 210–11. The visual paradoxes in transubstantiation are discussed in Ch. 5 below; for Maignan's comparison, see 191.
85. Bessot, 'Perspective de Nicéron', 168; cf. 167: 'En cherchant à démêler les fils de ces représentations imbriquées, la double position du regard induit un double jeu dans la recherché des significations.'
86. Margolin, 'Aspects du surréalisme', 511; Margolin continues (515, 519): 'Nos anamorphoses . . . répondent en outre à cette conviction ou à cette hypothèse métaphysique que le réel et l'imaginaire, le visible et l'invisible sont relatifs au point de vue ou à la situation du moment. Ainsi l'occultation et la dislocation d'un réel aux fausses prétentions d'objectivité, opérées soit par une vision oblique soit par l'interposition d'un miroir, engendrent toute une série de réactions psychologiques, de sentiment de l'ambiguïté fondamentale des êtres et du monde . . . Cette vision oblique, perspective d'un univers ou il n'y a jamais rien de sûr, ils l'anamorphose, constitue le dérangement initial et les symboles allusifs de l'allégorie, opèrent une véritable dérive du sens, une désharmonie ou un disaccord profond entre la perception naïve (ou prétendue telle), une réflexion au premier degré et les chaînes d'associations mi-conscientes, mi-inconscientes d'idées, de sentiments, d'images.'
87. See Ch. 10 below.

88. Colie, *Paradoxia epidemica*, 288, 312.
89. Kemp, *Science of Art*, 49–50 (plate 83), calling Leonardo the 'earliest promoter of this visual trick'; Massey, 'Anamorphosis through Descartes', 1169–72. For Leonardo's (and later medieval) views on optics and visual cognition, see James S. Ackerman, 'Leonardo's Eye', *J. Warburg and Courtauld Inst.* 41 (1978), 108–46.
90. Mario Bettini, *Apiaria universae philosophiae mathematicae* (2 vols.; Bologna, 1642), i. 'Apiarium quintum', 7–13, 17–23 (sep. pag.).
91. Jacques Ozanam, *Recréations mathematiques et physiques* (4 vols.; Paris, 1735), i. 442–3 and fig. 83. For a further example, see Johann Christian Sturm (Sturmius), *Mathesis juvenalis* (Nuremberg, 1704), 68–82, fig. xxviii, and for an anamorphic ear, see Accolti, *Lo inganno de gl'occhi*, 49.
92. Colie, *Paradoxia epidemica*, 6–7.
93. Nicéron, *Perspective curieuse*, 'Preface au lecteur'.
94. Francis Bacon, *De augmentis scientiarum*, in *Works*, iv. 366–7; on Bacon and natural magic, see Stuart Clark, *Thinking with Demons: The Idea of Witchcraft in Early Modern Europe* (Oxford, 1997), 221–4.
95. Giovanni Tommaso Castaldi, *De potestate angelica sive de potentia motrice, ac, mirandis operibus angelorum atque d[ae]monum, dissertatio* (3 vols.; Rome, 1650–2), ii. 56–65.
96. Colie, *Paradoxia epidemica*, 300–28, esp. 307, 312, 315–16.
97. Paula Findlen, 'Introduction', in ead. (ed.), *Athanasius Kircher: The Last Man Who Knew Everything* (New York, 2004), 28.
98. Herbert H. Knecht, 'Le Fonctionnement de la science baroque: le rationnel et le merveilleux', *Baroque*, 12 (1987), 53–70, esp. 66–70 (from a special issue entitled 'Le discours scientifique du baroque').
99. William Eamon, *Science and the Secrets of Nature: Books of Secrets in Medieval and Early Modern Culture* (Princeton, 1994), 195–233, quotation at 210.
100. For what follows on prestiges, see Giambattista della Porta, *Natural magick*, trans. anon. (London, 1658), 355–70; all Latin quotations from id., *Magiae naturalis* (Naples, 1589), 259–80.
101. Della Porta, *Natural magick*, 369. Both the comma and the verb *conspicio* suggest that Della Porta is saying that vision can take various forms (that there are different ways of seeing), and not just that, following his example, his readers can now see that one thing may appear to be another—for which *video* would have been the better verb.
102. Witelo, *Vitellonis Thuringopoloni opticae libri decem*, in Federicus Risnerus, *Opticae thesaurus Alhazeni Arabis libri septem . . . Item Vitellonis Thuringopoloni libri x* (Basel, 1572), esp. 308 (sep. pag.): 'Possibile est speculum columnare vel pyramidale convexum taliter sisti, ut intuens videat in aere extra speculum imaginem rei alterius non visae' (bk. 7, para. 60).
103. R. J. W. Evans, *The Making of the Habsburg Monarchy, 1550–1700: An Interpretation* (Oxford, 1979), 345, and 311–80, 429–41 *passim*; this is still the best place to start.
104. The use of 'magic' as an organizing principle for much of Kircher's output is found throughout recent commentary, but see esp. Daniel Stolzenberg, 'The Connoisseur of Magic', in id. (ed.), *The Great Art of Knowing: The Baroque Encyclopedia of Athanasius Kircher* (Stanford, Calif., 2001), 49–57; Horst Beinlich et al. (eds.), *Magie des Wissens: Athanasius Kircher 1602–1680. Universalgelehrter, Sammler,*

Visionär (Dettelbach, 2002), *passim*; Noel Malcolm, 'Private and Public Knowledge: Kircher, Esotericism, and the Republic of Letters', in Findlen (ed.), *Athanasius Kircher*, 297–308. A helpful overview of Kircher is given by Findlen in her 'Introduction' to the same volume (1–48), which concludes (41) that he 'was a barometer of virtually every intellectual transformation of the seventeenth century'.

105. On analogy in Kircher, see esp. Thomas Leinkauf, *Mundus combinatus: Studien zur Struktur der barocken Universalwissenschaft am Beispiel Athanasius Kircher SJ (1602–1680)* (Berlin, 1993), 163–74; on symbolic images, see Ingrid D. Rowland, *The Ecstatic Journey: Athanasius Kircher in Baroque Rome*, introd. F. Sherwood Rowland (Chicago, 2000), 14, 33.

106. Paula Findlen, 'Scientific Spectacle in Baroque Rome: Athanasius Kircher and the Roman College Museum', in Mordechai Feingold (ed.), *Jesuit Science and the Republic of Letters* (Cambridge, Mass., 2003), 227. There is also a great deal on Kircher's museum in ead., *Possessing Nature*, *passim*.

107. For the example and an analysis, see Michael John Gorman, 'Between the Demonic and the Miraculous: Athanasius Kircher and the Baroque Culture of Machines', in Stolzenberg (ed.), *Great Art of Knowing*, 68; cf. id. and Nick Wilding, 'Athanasius Kircher e la cultura barocca delle macchine', in Eugenio Lo Sardo (ed.), *Athanasius Kircher: il Museo del Mondo* (Rome, 2001), 234–5. Rowland, *Ecstatic Journey*, 1–29, notices Kircher's use of strategies for avoiding conflict with the Church.

108. Despite the recent enormous expansion of research on Kircher, specific studies of this work remain relatively rare; see, however, Baltrušaitis, *Anamorphic Art*, 79–90; Luciana Cassanelli, 'Macchine ottiche, costruzioni delle immagini e percezione visiva in Kircher', in Maristella Casciato et al. (eds.), *Enciclopedismo in Roma barocca: Athanasius Kircher e il Museo del Collegio Romano tra Wunderkammer e museo scientifico* (Venice, 1986), 236–46; Catherine Chevalley, 'L'*Ars magna lucis et umbrae* d'Athanase Kircher: Néoplatonisme, hermétisme et "nouvelle philosophie"', *Baroque*, 12 (1987), 95–110; Saverio Corradino, 'L'*Ars magna lucis et umbrae* di Athanasius Kircher', *Archivum historicum Societatis Iesu*, 62 (1993), 249–79; Vermeir, 'Magic of the Magic Lantern', 127–59; id., 'Athanasius Kircher's Magical Instruments: An Essay on Applied Metaphysics and the Reality of Artefacts', *Stud. Hist. Philos. Science* (forthcoming).

109. Urszula Szulakowska, *The Alchemy of Light: Geometry and Optics in Late Renaissance Alchemical Illustration* (Leiden, 2000), 101, picks out the Tetragrammaton in an aureole of light at the top of the title page, plus an owl drawn at the top right, and the figure of Apollo shining his light onto the mirror of the moon, which reflects it down to the earth: 'Another of his rays is projected onto the human senses through an optical instrument, while a third ray bounces off a mirror on the earth into a dark cave.' For Kircher's largely Platonic metaphysics of light, see the 'Epilogus' to *Ars magna*, 917–29; Leinkauf, *Mundus combinatus*, 334–42; and Vermeir, 'Athanasius Kircher's Magical Instruments' (forthcoming). Chevalley, 'L'*Ars magna lucis et umbrae*', 103–4, details Kircher's attacks on the existing natural magic of optics.

110. The phrase is from Malcolm, *Pursuit of Eccentricity*, 40.

111. Ibid. 57, in reference to Arcimboldo.

112. Kircher, *Ars magna*, 800–3, 808; for the larger theme, see H. W. Janson, 'The "Image Made by Chance" in Renaissance Thought', in M. Meiss (ed.), *De artibus opuscula XL: Essays in Honor of Erwin Panofsky* (2 vols.; New York, 1961), i. 254–66.

113. Kircher, *Ars magna*, 809–11; Stafford and Terpak, *Devices of Wonder*, 248–52.
114. Kircher, *Ars magna*, 812, and for further theatrical aspects of the camera obscura, 813; Stafford and Terpak, *Devices of Wonder*, 307–14.
115. Kircher, *Ars magna*, 834. This recalls Federigo Cesi's remark in his *Apiarium* (1625) concerning what David Freedburg calls the 'very principles upon which the use of [the microscope] was based', including the impossibility of ever enlarging anything enough for the sense of sight not to seem insufficient or the enlargement not to seem incomplete: 'If you can discern with it many subtly constructed things, you will conclude that there are still other much smaller things yet, which escape and elude the sharpest of instruments constructed by us. This also applies to our telescope: while it draws further things closer to our eyes, you can also judge that there remain other things even further away, which it could never reach. Therefore we accept the fact that there is no small number of very small and very distant things which cannot be seen': cited in David Freedburg, 'Iconography between the History of Art and the History of Science: Art, Science, and the Case of the Urban Bee', in Caroline A. Jones and Peter Galison (eds.), *Picturing Science/Producing Art* (New York, 1998), 285–6. For other instances: Alpers, *Art of Describing*, 17–23; Wilson, *Invisible World*, 215–18, and 251 on 'the sense of dislocation induced by the discovery of the microworld'.
116. Kircher, *Ars magna*, 837–8.
117. Ibid., quotations at 840, 844–'7'[= 5].
118. Athanasius Kircher, *Ars magna lucis et umbrae*, 2nd edn. (Amsterdam, 1671), 769 (with two images). On Kircher and the earlier history of the magic lantern, see Thomas L. Hankins and Robert J. Silverman, *Instruments and the Imagination* (Princeton, 1995), 43–8; Vermeir, 'Magic of the Magic Lantern', 136–51.
119. Kircher, *Ars magna* (1646 edn.), 892; commentary in Gorman, 'Between the Demonic and the Miraculous', 66–7; Gorman and Wilding, 'Athanasius Kircher', in Lo Sardo (ed.), *Athanasius Kircher*, 230–1; Stafford and Terpak, *Devices of Wonder*, 26, 256–66.
120. Georgius de Sepibus, *Romani collegii societatis Jesu musaeum celeberrimum . . . novis et raris inventis lucupletatum* (Amsterdam, 1678), 38 (a list of machines in the museum); Filippo Buonanni, *Musaeum Kircherianum sive musaeum a P. Athanasio Kirchero in collegio Romano societatis Jesu iam pridem incoeptum nuper restitutum, auctum, descriptum, et iconibus illustratum etc.* (Rome, 1709), 311.
121. Kircher, *Ars magna* (1646 edn.), 901–6. On this 'protean' machine, see Cristina Candito, 'Il Proteo catottrico', in Lo Sardo (ed.), *Athanasius Kircher*, 253; and, on the problems of reconstructing one, Filippo Camerota, 'Ricostruire il Seicento: macchine ed esperimenti', in Lo Sardo (ed.), *Athanasius Kircher*, 242–3. The details were repeated by Gaspar Schott, *Magia universalis* (4 vols.; Bamberg, 1674–7), i. 353–63 (1st pub. Würzburg, 4 pts., 1657–9).
122. Stafford and Terpak, *Devices of Wonder*, 245.
123. Chevalley, '*L'Ars magna lucis et umbrae*', 104–5.
124. Stafford, *Artful Science*, 39–47.
125. On d'Aguilon, see Kemp, *Science of Art*, 101; for Kircher's awareness of the newest optics (and astronomy) of his day, see Chevalley, '*L'Ars magna lucis et umbrae*', 100–3.
126. Kircher, *Ars magna* (1646 edn.), 809, cf. 183–4; William B. Ashworth, Jr., 'The Habsburg Circle', in Bruce T. Moran (ed.), *Patronage and Institutions: Science,*

Technology, and Medicine at the European Court, 1500–1750 (Woodbridge, 1991), 142, cf. 158, 162–3.
127. Nicéron, *Perspective curieuse*, tabulae 48 and 49; Gilman, *Curious Perspective*, 47–9; Stafford and Terpak, *Devices of Wonder*, 184–91. Malcolm, *Aspects of Hobbes*, 211–17, gives a detailed account of this optical device and its cultural and ideological context, linking it to anamorphic art and to the title page of Hobbes's *Leviathan* (see below Ch. 10).
128. Bettini, *Apiaria*, 'Apiarium quintum', 28–30; cf. Schott, *Magia universalis*, i. 143–53; Stafford and Terpak, *Devices of Wonder*, 222–35.
129. Colie, *Paradoxia epidemica*, 288; the reporter was Nicéron, *Thaumaturgus opticus*, 189. See also Colie, *Paradoxia epidemica*, 313: 'Or a painting might be made so that when seen from two different vantage points it presented two different pictures. Such a painting was the "Descent from the Cross" by Daniele da Volterra, now lost, a copy of which was formerly in Mersenne's Minim Church in the Place Royale.' Colie then gives Nicéron's description: 'He portrayed Christ as the principal figure of the picture with such skill that, seen from the left, He seems to incline transversely to the picture-plane, His right foot seeming to stretch out in that direction; but . . . seen from the right, the whole body seems erect, and that same foot which at first stretched out to the left, now appears stretched out to the right.'
130. A point recently re-emphasized by Vermeir, 'Athanasius Kircher's Magical Instruments' (forthcoming).
131. Rowland, *Ecstatic Journey*, 6–7; Findlen, 'Scientific Spectacle', 251, for details of the religious messages in Kircher's optical demonstrations; Chevalley, 'L'*Ars magna lucis et umbrae*', 104, on the flying dragon; Gorman and Wilding, 'Athanasius Kircher', 227; Koen Vermeir, 'Mirror, Mirror, on the Wall: Aesthetics and Metaphysics of Seventeenth-Century Scientific/Artistic Spectacles', *Kritische Berichte*, 32 (2004), 27–38. Sound effects were added to the dragon by Kircher in *Phonurgia nova* (Kempten, 1673), 147–8.
132. Charles Patin in a letter published in 1674, quoted in Laurent Mannoni, 'The Art of Deception', in id., Nekes, and Warner, *Eyes, Lies and Illusions*, 42.
133. Kircher, *Ars magna* (1646 edn.), 769, 804, 813, 897.
134. Schott, *Magia universalis*, i. 57, cf. 206 (describing the work of Della Porta on 'paradoxas'). Of Ozanam's *Recréations mathematiques*, which had many editions and adaptations through the 18th century, Baltrušaitis, *Anamorphic Art*, 117, says that it brought together the mathematical, geometrical, optical, physical, chemical, and mechanical paradoxes available in the magical tradition.
135. Colie, *Paradoxia epidemica*, 312; cf. Gilman, *Curious Perspective*, 78–87 (on metaphor).
136. Puttenham, *Arte of English Poesie*, 225–6.
137. Colie, *Paradoxia epidemica*, 3–40, quotations at 38, 10, 33.
138. Ibid. 6.
139. Ibid. 22.
140. Ibid. 104, and 2, 13–99 *passim*.
141. Ibid. 360.
142. Ibid. 516; cf. A. E. Malloch, 'The Techniques and Function of the Renaissance Paradox', *Stud. in Philology*, 53 (1956), 193, on paradoxes teasing the intellect 'as an optical illusion teases the eye'.

143. For some pertinent comments on early modern paradox and its cognitive potential, see Peter G. Platt, ' "The Mervailouse Site": Shakespeare, Venice, and Paradoxical Stages', *Renaissance Quart.* 54 (2001), 121–54. On paradox more generally, see M. T. Jones-Davies (ed.), *Le Paradoxe au temps de la Renaissance* (Paris, 1982), and for a contemporary treatment of the paradoxes of the senses in particular, see Daniel Georg Morhof, *praeses* (Andreas Plomann, *respondens*), *Dissertatio de paradoxis sensuum* (Kiel, 1685), esp. sigs. B3r–C4r (ch. 2: 'Paradoxis visus').
144. Colie, *Paradoxia epidemica*, 307, and 300–28 *passim*.
145. Stafford and Terpak, *Devices of Wonder*, 27–8.
146. Ibid. 107, 28.
147. For Kircher's use of essentially Aristotelian concepts to describe the transmission of visible *species*, see *Ars magna*, 108–11. Cf. Thomas Leinkauf, 'Athanasius Kircher und Aristoteles: Ein Beispiel für das Fortleben aristotelischen Denkens in fremden Kontexten', in Eckhard Kessler, Charles H. Lohr, and Walter Sparn (eds.), *Aristotelismus und Renaissance: In Memoriam Charles B. Schmitt* (Wiesbaden, 1988), 193–216; Chevalley, 'L'*Ars magna lucis et umbrae*', 102–3, on Kircher's attacks on scholasticism. For the essential congruence between Aristotelian physics and natural magic during the 16th and 17th centuries, see Clark, *Thinking with Demons*, 224–32. Findlen, 'Scientific Spectacle', 243, remarks that '[w]hile the synthesis that Kircher effected in the Roman College museum occurred in the name of Aristotle, it nonetheless was a prime example of the crumbling of this great edifice of knowledge.'
148. Athanasius Kircher, *Ars magna sciendi, in xii libros digesta* (Amsterdam, 1669), 478; Schott, *Magia universalis*, i. 74, 85–6.
149. For Kircher's 'epistemological conservatism', see Gorman and Wilding, 'Athanasius Kircher', 217, cf. 233.
150. The same might be said of the parallel vogue for automata, of which Stafford writes, in ead. and Terpak, *Devices of Wonder*, 40: 'The imitative urge to manufacture and animate simulacra, to *smoothly* counterfeit the gestures and motions of everything observable under the sun, produced a universe of doubled beings These are automata as thaumaturgical toys, as ritualistic re-performances of reality.'
151. Stafford, *Artful Science*, 106.
152. See, for example, Kircher (1646 edn.), *Ars magna*, 190.
153. Steven Shapin and Simon Schaffer, *Leviathan and the Air-Pump: Hobbes, Boyle, and the Experimental Life* (Princeton, 1985), 31.
154. Nicéron, *Perspective curieuse*, 74.
155. Clark, *Thinking with Demons*, 214–50.
156. Schott, *Magia universalis*, 8–53. The other three branches of 'universal magic' were acoustics, mathematics, and physics, with optics placed first because it had the most striking marvels and wonders. The optical material appeared also in German as *Magia optica, das ist, geheime doch naturmässige Gesicht- und Augen-Lehre*, trans. 'M.F.H.M.' (Bamberg, 1671).
157. Schott, *Magia universalis*, i. 42, 23.

4

Glamours: Demons and Virtual Worlds

Naturalia, artificialia, diabolica: we have reached the third of Hakewill's broad discursive categories. And yet the devil has been an implied presence throughout the two previous chapters: *his* visual delusions too were wrought by natural and artificial means and he was commonly thought to be implicated both in the optical disturbances caused by nature and—as Nicéron feared—in the contrivances of magicians and artists. Indeed, nothing said so far about the 'fantastical' or the 'prestigious' could not be extended to embrace the agency of demons. Nevertheless, the devil deserves a chapter of his own, so prominent was he in the Christian Europe of this period and so often depicted as the ultimate deceiver—the third main bringer of visual, as well as other forms of unreason. Early modern intellectuals inherited a conventional demonology couched in such terms, but developed and broadened it to such an extent that it became one of their defining preoccupations.[1] A widespread commitment to apocalypticism that lasted beyond even the seventeenth century, the prosecution of thousands of witches in civil and religious law courts all over Europe, and the onset of major international wars between rival religions gave the devil a presence in the minds and lives of their contemporaries that was not true of medieval Europeans or true ever again once history and warfare became more secularized and witchcraft was no longer a crime.

But what kind of devil? nothing less than the inventor of virtual worlds. As the supreme and worthy adversary of God, Satan had to come closest to him and wield almost identical powers, while necessarily falling short of complete equality. He was thus virtually a deity in the sense of being almost one—a fact that hinted often at an unwelcome and certainly unintended Manichaeism—but actually a creature and so confined within the bounds of nature and its realities. His role in traditional Christianity was to attempt to hide this deficiency and his own evil intentions by *appearing* as God's equal—having the same ends, performing the same things, expecting the same treatment, enjoying the same following. And this appearance of divinity had to be almost successful too. The devil was the indispensable agent of evil, false miracles, and idolatry, who nevertheless manifested himself as the 'angel of light' of 2 Corinthians 11: 14 and the Antichrist of

2 Thessalonians 2: 1–11 (which includes verse 11 on 'strong delusion' and the believing of a lie). Confined to the natural world, the world of sin, he could only pretend to go beyond it, but with powers to deceive that were all but total. In this further sense, the devil had to be (again there is a theological imperative here) a master of the facsimile and its paradoxes—covered always, as one seventeenth-century French bishop put it, by 'the cloak of verisimilitude'.[2] To give him the power to deceive totally was to end in religious and moral absurdity, with no criterion for distinguishing what was really good and true from demonic copies. But to give him something just short of this was to allow for demonically contrived situations where this same criterion might be all but impossible to find. Here lay one of the great defining themes of early modern religion (as well as of Cartesian philosophy, as we shall eventually see) and, I suggest, of early modern visuality.

The distinction at the heart of demonic deception was the one between *miracula* and *mira*—miracles and wonders—and it found its plainest and most influential late medieval expression in Aquinas's *Summa theologica*. True miracles were beyond devils for obvious naturalistic reasons (creatures cannot by definition control creation's laws) and for even more obvious religious ones: if demons performed true miracles to confirm error, the same miracles would never be able to confirm the truth. Proof by miracle, said Aquinas, was a useless argument if it worked both ways. Demons might still effect real things that went beyond most ordinary people's power and experience, like the feats performed by the magicians of Pharaoh, but these were 'wonders' not miracles; they fell within the 'transformations of corporeal things which can be produced by certain natural powers'. Anything that exceeded these natural powers—like demons changing the human body into the body of a beast, or returning a dead body to life—was 'not real but a mere semblance of reality', a 'lying wonder' in the words of St Paul.[3] The distinction and this last corollary about 'reality' were fundamental in structuring early modern religious and demonological thought and they reappear in vast numbers of texts. Thus, in a *summa* almost equivalent in influence to Aquinas's from the late sixteenth century (and modelled on his discussion of superstition), the international Jesuit authority Martín Del Río's *Disquisitionum magicarum*, publication of which began in 1599, divine miracles were distinguished from demonic wonders on five grounds: they surpassed all natural causes and effects (like raising the dead, or restoring sight to those blind since birth), their intention could only be for the good, they were perfect and complete, they overcame any competition, and they were done by openly appealing to God. The *mira* of demons and their magician allies, by contrast, remained within the bounds of nature (even if strangely and obscurely), had evil ends, were defective in detail, gave way before true miracles, and were accompanied by absurd and empty superstitions.[4] Other writers invoked a commonplace Aristotelian typology to condemn even the devil's best efforts as 'false miracles'—failing in terms of their

final, efficient, material, and formal causes. They had evil ends, depended on an inferior kind of power, and were often not what they seemed either in substance or in nature. The conclusion, however, was always the same, and universally drawn: the devil could not perform miracles. Otherwise, said Del Río, echoing Aquinas, a church founded on them would be impossible to defend ('non haberemus efficax argumentum probandae veritatis fidei, quam semper Ecclesia miraculis astruxit'). The devil could not even claim *mira* in absolute terms, since a wonder was always a wonder in relation to something. He was condemned, in other words, to make do with natural knowledge and natural powers that were, in the end, only relatively—if vastly—superior to those of other natural agents.[5]

But if the devil's natural skills made it sometimes difficult to distinguish real *mira* from real *miracula*, occasioning endless theoretical attempts of the sort we are considering, his powers to delude might be thought to have made the distinction impossible to enforce *anyway*. For having attacked him ontologically with one argument, Thomistic theologians gave him epistemological assistance with another: they disallowed him from doing all manner of things but nevertheless allowed him to *appear* to do them all. What, after all, did Aquinas mean by a 'semblance of reality'? Two things: first, the devil could work within the human senses, internal and external, 'so that something seems otherwise than it is'. Both good and bad angels could use their natural powers to alter the local motions of the animal spirits and humours which, in line with Aristotle's teaching in *De somniis*, caused the human *phantasia* to make images during sleep. Such motions, again in line with Aristotelian cognition theory, were 'impressions left from the movements of sensible things' and preserved in the spirits, 'so that a certain appearance (*apparitio*) ensues, as if the sensitive principle were being then changed by the external things themselves'. This could even happen to those awake, as shown by the powerful commotions caused in the spirits of 'mad people, and the like'. The only restriction on demonic power in this respect was that the form impressed on the imagination had to be one previously received from the external senses. But this was no restriction at all, given that these too might be affected by a demonic action that again moved the relevant 'spirits and humours'—like a sick man's tongue covered in a choleric humour that made everything taste bitter. And besides, there was always the second option: working externally to the senses altogether by presenting them with objects which were also 'semblances' of reality. These might be apparently real sensible objects that turned out to be only virtual ones, or really existing natural things manipulated in some virtualistic way: 'For just as from air [a demon] can form a body of any form or shape, and assume it so as to appear in it visibly, so, in the same way he can clothe any corporeal thing with any corporeal form, so as to appear therein, the demon, who forms an image (*aliquam speciem*) in a man's imagination, can offer the same picture (*similem speciem*) to another man's senses.'[6]

Well before the era of Del Río, these seemingly paradoxical ideas about demonic deception and semblances of reality had entered the intellectual mainstream,

notably via the inquisitorial manuals and demonologies of the clergy and theologians and in the discussions of jurists. As in his case, the focus of attention from the 1430s onwards was the status of crimes like magic, superstition, and (especially) witchcraft, all of them, we might think, deeply compromised as a result. The trend begins effectively with the leading Dominican reformer at the Council of Basel, Johannes Nider, whose arguments are best left until we consider their reappearance fifty years later in the most famous witchcraft textbook of the era, *Malleus maleficarum*. But there are many other examples from this first phase of early modern demonology. Towards the end of the 1450s, the Salamanca theologian and later Bishop of Orense Alphonsus de Spina enforced the miracles–wonders distinction while allowing for the devil's false miracles—false, he said, 'because he deceives the human senses with *phantasmata*, so that he does not do what he seems to do'.[7] About a decade later, the eminent Italian jurist Ambrogio de' Vignati, who taught law in Padua, Bologna, and Turin, was virtually quoting Aquinas in this description of the two modes of demonic illusion—the one internal, by means of alterations of the *phantasia* and the other senses, 'so that something appears other than it really is', and the other external, by the assumption of aerial or other bodies.[8] Vignati's compatriot, the Dominican theologian Giordano (Jordanes) da Bergamo, whose unpublished *Quaestio de strigis* was composed in Verona c.1470, was more explicit, dividing Aquinas's illusions into three categories—*prestigio*, *commotione sompniatica*, and *delacione de loco ad locum*—and describing each in some detail. A demonic 'prestige' for example, resulted either from the real presentation to correctly functioning eyes of nevertheless false 'similitudes' of things, made of air (and therefore having no real substance), or from an interference with the humours or other dispositions of the eyes themselves.[9] In 1489, when the professor of law at Constance, Ulric Molitor, inspired apparently by questions put to him by Archduke Sigismund of Austria, published a fictional conversation on witchcraft, one of its conclusions was that the devil could 'so fascinate the eyes and senses of men that they believe themselves to be where they are not or to see what is not in itself so or to appear different from what actually is'.[10]

By the opening of the sixteenth century, it must have seemed entirely commonplace for another theological *summa*, by another leading and much-cited exponent, the inquisitor Silvestro da Prierio, to say that witches sometimes took for real what was imagined or occurred 'only in the senses (*vel solo sensu*)', an idea vastly expanded in Da Prierio's own witchcraft treatise, *De strigimagarum daemonumque mirandis* (1521), in discussions of the demonic manipulation of *species*.[11] In 1508 Johannes Geiler von Kaiserberg was preaching in Strasburg cathedral that the devil 'can also change the streams [that go from the visible object to the eye] and can make other streams go into your eye . . . such that you think that you are seeing one thing, when in fact you are seeing another.'[12] Aquinas's modes of visual unreality were adopted by a further, entirely orthodox, writer on witchcraft from the same period, the inquisitor of Sicily Arnaldo Albertini, in his remark that

demons could 'fascinate' the eyes of beholders and 'superimpose' aerial bodies on real ones, and by Francisco de Toledo, author of a mid sixteenth-century guide to priests popular for at least a century afterwards, in instructing generations of readers that the devil could delude 'by offering to the senses real things, but not what they seem, being condensed air, such as serpents, dragons and other animals, which they move; [and] by affecting the senses and imagination so that things are seen which are not, as in dreams'.[13]

In Del Río's own commanding synthesis of the field, the devil was the author of three kinds of effects—true, false, and mixed. In effect, the practices of magic and witchcraft were never entirely real and never entirely unreal. Advanced ('preternatural') forms of local motion and the application of actives to passives might bring about the real effects he and his human allies desired. But when God prevented him from doing something he could otherwise do, threatening exposure of his impotence, or when he could not do something by natural means and wanted to pretend that he could, or even when he could do something naturally but still wanted to deceive by 'prestiges', the devil, like a juggler, turned to tricking the human senses 'with false *species*, so that through the deception things that are in no way done in reality seem to be effected'.[14] This grid of possibilities could be put to work to explain away the false miracles of Pharaoh's magicians. Either their serpents were pure illusions and prestiges, in the sense of being completely fictitious visual forms with no real substance, or they were real serpents substituted for the real rods so quickly that the substitution was undetectable to the human eye, or they were real serpents produced very quickly out of the corrupting matter of the rods by demonic natural powers. Del Río thought the first option was rather unsatisfactory, because it left Moses as the dupe of a demonic trick, which God would never have allowed in such a serious set of circumstances and when so much was at stake. But it is difficult to see how the two other options were, in visual terms, any different. Del Río explained the last one in terms of the normal processes of putrefaction and generation of imperfect animals from rotting matter, which the devil could speed up (with the help of the sun) to make the change from rods into serpents appear more or less instantaneous—'so suddenly and with such subtlety', indeed, that the Egyptian spectators took this for a miracle. When, therefore, Exodus 7: 12 spoke of the rods 'becoming' serpents, although theology precluded the meaning of a truly miraculous change, the text still conveyed the sense of a change taken to be miraculous by those using the evidence of sensible *species* offered to their eyes and judged, erroneously, by their minds ('hoc erroneum iudicium spectatorum').[15]

When a Protestant tradition developed in Europe, this made no essential difference to the way demonic deception of the senses was allowed for and discussed, although it did increase the intensity of the debate considerably—as we shall see in our next chapter. Despite their disbelief in modern miracles, Protestant theologians still had to defend the principle that the real versions ought not to be diluted by demonic copies. And precisely *because* they disbelieved in modern

miracles, they needed the demonic copies as an explanatory device. In German and Swiss theological circles, for example, one finds authorities like Otto Casmann and Hieronymus Zanchy employing the standard *miracula–mira* arguments and according the devil vital prestigiatorial powers.[16] In Lutheran Tübingen, the eminent theologian Jacob Heerbrand published two disputations inspired by the magicians of Pharaoh, the second of which defended the proposition that Satan, like his human counterparts the *praestigiatores*, could mock men and women with prestiges, and trick their senses so that objects appeared to them 'which seem real but are not'.[17] In Heidelberg the celebrated Zwinglian physician and theologian Thomas Erastus was of the usual view that the devil can only do things by local motion or by joining actives with passives. But once the limit of the real is reached he is able 'to set prestiges before the senses of men, to deceive by means of counterfeits, and to substitute for things themselves, semblances and empty illusions'. At this point, 'he achieves only representations, which seem to be truly the things they represent to sense, but in truth are not'. Most of the actions of magicians too are nothing but demonic 'prestige and deception': 'For those things that go beyond the power of nature and have not God for their author, have only the appearance of being, and are not in truth what one thinks them to be.' It is not that magicians and witches do nothing; rather, that 'what they do is not what it seems'—it consists of 'phantoms and pure prestiges', for which the latter are rightly called 'prestigiators' ('prestigiatrices'). Like someone who paints (the analogy returns us abruptly to the issues we discussed in the last chapter), they make something both real and unreal—a real portrait of a man, but not a real man.[18]

Another circumstantial account came from the widely read Netherlands-born divine Andreas Gerhard or Gheereards (Hyperius), who taught principally at Marburg and ended as its rector. This reads like a potted summary of late Renaissance optical, psychological, and cognitive theory, as might be expected from someone who also published a guide to Aristotle's *Physica*. Gerhard attributed witchcraft to demonic sensory delusions so powerful 'that thinges are beleved to be sene, harde, and perceyved, which not withstandinge are no such maner of thinges'. Objects (or at least shapes) might actually be perceived but turn out not to be anything true, solid, or real, but simply 'images of thinges, or els bodies for the time formed'. The external senses might be 'striken and hurt, by reason whereof they cannot decerne', like the eyes of those afflicted with bad humours, suffusions, or glaucoma, who saw gnats, hairs, and cobwebs in front of them. The devil could impede correct vision through a medium, just as might a 'glasse', or airy exhalations, or a refracting surface, with the result that men believed and perceived 'other things then in deed they see and perceave'. The internal faculties and senses were as vulnerable to attack by the devil as they were to 'phrensie, melancholie, or madnes'. Melancholic men imagined themselves beasts or prophets, dreamers (and even the awake) saw and did things that never were—why could the devil not make the brain behave in the same ways and

'witches' to have similar 'phantesies'? Simply the rapid alteration or replacement of external objects might lead to the belief in their metamorphosis, whereas it amounted to no more than demonic sleight of hand—the sort of thing practised by 'vacabunds [sic] jugglers' who appeared to plunge daggers into their bodies. Significantly, these details are framed by preliminary remarks on Pharaoh's magicians and a concluding definition of true and false miracles.[19]

In mid seventeenth-century France, the Huguenot writer François Perrault was still repeating the usual arguments about the devil mimicking the symptoms of melancholy in the human imagination to create 'fantasies and internal illusions' and the techniques of jugglers to create their external equivalents.[20] The English writer Thomas Lodge spoke of demons doing things 'in semblance true, and seeming to the fantasie', and his fellow student of sorcery James Mason analysed their false miracles by delusion of senses.[21] The perfect (and recognizably Aristotelian) summary of the issue was given by the leading theologian and cleric William Perkins, who explained that the devil could make a man 'thinke he sees that, which indeede he sees not . . . First, by corrupting the humour of the eye, which is the next instrument of sight. Secondly, by altering the ayre, which is the meane by which the object or *species* is carried to the eye. Thirdly, by altering and changing the object, that is, the thing seene, or whereon a man looketh.'[22] Later in the seventeenth century, it was the view of another preacher, John Gaule, that demons aimed 'but to produce phantasmaticall or false species of things', what Gaule also called 'things merely praestigious'.[23]

Many more instances of this sort could be cited from the demonological writings of the sixteenth and seventeenth centuries.[24] But we have seen enough to conclude that amongst the powers granted to the early modern European devil were several that fundamentally challenged the normal expectations of visual cognition. For a spirit defined by the condition of invisibility to appear in a visible form *at all* was, of course, tantamount to a deceit: it could not possibly be anything more than what the late sixteenth-century English divine George Gifford called 'an apparition and counterfeit shewe of a bodie'.[25] But of greater consequence—and with perhaps contradictory implications—was the power radically to manipulate objects in the visual field and control both the external and internal organs of the visual sense. In the end, this was to render Aquinas's 'proof by miracle' as useless as he feared it might be, at least in the realm of the senses. Here, for example, is a statement about miracles from the later seventeenth century, by Daniel Brevint (who later became Dean of Lincoln), that abandons any attempt to distinguish them as objects of sense:

Devils by Gods permission come very neer that which good angels attain unto, by Gods command; and this that in an image into the hignest the works of good and bad angels, as for instance the reviving of dead bodies, etc. yet there are none, but by some illusion or other, may be so exactly counterfeited, that tho they have no reality, yet will they have as much appearance to confirm lies, as the other have to confirm the truth. Hence comes in these last times . . . the absolute impossibility of discerning those from these any other

way, then by the end, which they aim at, to wit the reveled will of God, and the manifestation of his truth.[26]

Couched in terms of cognition in general, the same opinion was voiced on many other occasions. According to one German clergyman, Theodor Thumm, writing in 1621, the devil could make men and women think 'that that which is not, is, and imagine that which is, to be something else', and that the likenesses (*species*) of things were the things themselves.[27] According to another, Hermann Samson of Riga, this meant that 'a man sees not something that is, does see as something what is not, [and] sees a thing in another form than the one it truly has' ('ein Mensch, das etwas ist, nicht siehet, oder das nichts ist, für etwas ansiehet, oder ein Dinck in ein ander gestalt siehet, als es in der Warheit ist').[28] The devil could 'so imitate and counterfeit', agreed Meric Casaubon in 1672, 'that we shall find it a very hard task, to distinguish between the reality of that which he cannot, and the resemblance, which he doth offer unto our eyes'. He might not be able to create substances, men and women, or any 'generated' creature, but (Casaubon went on):

He may cast before our eyes such shapes of those things, which he cannot create; or so work upon our phancy, that it shall create them unto us so vigorously, so seemingly, that he may attain his ends by those counterfeits, as effectually, perchance, as if all were in good earnest, what it appears to our deluded eyes.[29]

In 1705, John Beaumont was more prosaic in stating an idea that had been in general currency for at least three centuries (even if it originated long before that): a demonic 'prestige' involved presenting to the senses 'a thing that is not, as if it were; as that an house, for instance, may seem to be there where there is none'.[30]

Such were the general principles and such was their widespread distribution across the literature designed to expound and teach religious orthodoxy to every kind of early modern audience. But we will not fully appreciate the impact of Thomistic demonology on Aristotelian cognition unless we notice how extraordinarily detailed accounts could be of what actually happened to the visual process when demons perverted it. It is, in a way, a momentous intellectual collision between two indispensable ingredients of late medieval thinking—the powers commensurate with and required by the corporeality of demons versus the presumed reliability of the workings of the sensible soul. And, equally, the argument is essentially self-destructive: demonic deceptions that radically undermine visual certainty cannot be described without using the very categories usually designed to secure it. The demonology of the senses carries conviction precisely to the extent that it draws on a cognitive system that it effectively subverts. The fact that demons could fill the soul with visions and images owed its very plausibility, said the witchcraft writer Nicolas Rémy, to the opinion of 'those opticians mentioned by Aristotle, that it is not by the penetration of rays but by the reception of images, as in the case of a mirror, that an object is perceived by the eyes and afterwards communicated to the brain'.[31]

In this respect as in others, *Malleus maleficarum* paved the way, with a circumstantial 'mechanics of *praestigium*' derived from Aquinas via Johannes Nider's commentary on the Ten Commandments, and applied, disconcertingly, to the illusory stealing of penises.[32] Citing the definitions of *praestigium* of Isidore of Seville and Alexander of Hales (which emphasized the 'binding' of the inner and outer senses), Heinrich Kramer offered no fewer than five types of demonic delusion: by the same 'artificial trickery' used by human conjurors and jugglers, by the 'natural method' of hiding objects of vision or confusing their appearance in the imagination, by assuming a body that simulated the appearance of someone or something, by confusing the organ of sight itself, and by 'working in the imaginative power, and, by a disturbance of the humours, effecting a transmutation in the forms perceived by the senses . . . so that the senses perceive as it were fresh and new images'. It is the description of this last process that is striking, both in its theoretical use of the usual faculty psychology of the era and its capacity to make it unworkable in practice. Kramer has moved on from penises to the apparent transmutation of humans into beasts:

Sensory images (*species sensibiles*) are long retained in the treasury of images of things the senses have perceived, which is the memory . . . which is in the posterior part of the head. These images are drawn out by the power of demons, as God occasionally permits, and are presented to the common sense of the imagination. And these images are so strongly impressed on that sense that a man must necessarily perceive the image of a horse or a beast because of the forcefulness with which the demon draws the image of a horse or a beast from the memory; thus the man must necessarily believe that he is actually seeing that beast with his external eyes alone. But in fact that beast is not there in the external world: it only seems to be there because of the forceful intervention of the demon, working by means of those images.[33]

As Walter Stephens has remarked, to argue like this was to 'redefine the nature of all reality', granting demons 'absolute control over human perception' by allowing them endlessly to 'shunt' images in the human brain and thereby 'make anything seem to be anything else, seem to be absent when it is present, or vice versa'. To deny it, however, brought something worse: the possibility that demons *themselves* might be illusions and hallucinations.[34] Only their own presence in assumed corporeality was to be excluded from the things that could be feigned in this way; otherwise, 'when demons are said to interact with witches and other men in assumed bodies . . . they could cause such apparitions by moving the sensory images in the imaginative faculty, so that when men thought the devils were present in assumed bodies, they were really nothing but [an illusion caused by] such transfers of sensory images in the inner faculties'.[35]

Returning again to Del Río, what seems significant in his case is the sheer amount of detail that he offers of the devil's subversion of the Aristotelian visual triad of object, medium, and organ, all the while following one of the greatest Aquinas commentators of the sixteenth century, the Portuguese theologian and philosopher (and Jesuit) Luis de Molina, who taught at Coimbra and Evora.[36]

Regarding the visual object, demons deceived in four ways. Most obviously, like the jugglers with their cups and balls, they manipulated the real things that comprised or were exhibited in the visual field—'agitating' them, hiding them, joining, separating, or just 'arranging' them. Less obviously, demons used the 'perspective art' ('artem perspectivae') to affect the disposition of the visual object in the line of sight ('in ordine ad oculum videntis'), like artists using an anamorphic technique. Del Río could not yet use the term but he did know the terminology, describing how an image that looked 'disorderly' ('confusus') when viewed from directly in front became 'a certain type of painted artifice' ('artificiosae alicuis picturae') when viewed through an aperture or when the image itself was moved. Thirdly, demons formed the shapes of objects suddenly from the elements, usually the air, and presented them to sight either directly or by assuming the shapes themselves or surrounding other objects with them. Finally, they placed objects side by side, one of which, usually a mineral, had either the natural power, or a power demonically transferred to it, to completely alter the appearance ('species') of the other.

Moving to the medium, Del Río explained that demons could prevent the visible *species* from carrying to the eye by hiding the entire object or part of it from view, or by placing in the medium some quality by which the *species* that passed through it were so changed that they represented the object other than it was. Comparable natural examples were the way a drapery ('lineus pannus') well soaked in a solution of salt and vinegar, when lit by a candle, gave off the *species* of terrifying, ghastly faces through the illuminated medium, or when human bodies seemed to have asses' heads in the light given off by candles made from asses' seed mixed with the wax. Demons could alter the composition of the air immediately around an object or between the object and the eye by thickening it so that its appearance was correspondingly changed by refraction (just as a coin thrown into a basin of water looked bigger than it was, and when thrown to the bottom seemed to lie on the surface). They could move the intervening air, so that the *species* of objects also appeared to move, like the trees that seemed to sailors to pass by their boats. Or, finally, they could simply change the shape and number of the sensible *species* ('specierum sensilium') themselves, as, indeed, happened when anyone used a single mirror to multiply images, or multiple mirrors to move images from one place to another, and when such *species* passed from the imagination to the external senses or the common sense, affecting them in the same way 'as if they had been truly emitted by external objects' ('si revera ab obiectis externis eo species mitterentur').

Over the eye itself demons seem to have had total control.[37] Del Río explained in detail how they might alter its physical shape and situation—like someone pushing a finger between eyeball and eye socket, or simply pressing the eyeball—and so make things appear to be in different places or appear double. The three humours in the eye could be agitated and disturbed to prevent the true perception of things, as happened in the cases of drunkards and maniacs. The operation of

the eye could be similarly affected if some 'gross' humour was used to block the transmission of the visual spirits to and from it. Beyond the eye lay the internal senses and the faculties of the soul, and, of necessity, a yet further layer of demonic intervention in the mechanics of cognition. Del Río dealt with each in turn, beginning with the *phantasia*, which demons easily filled with false images, apparitions, and ecstasies. Unable to impose entirely new *species*—for example, the *species* of colours or sounds in the imaginations of men blind or deaf since birth—they might still present fantastic and previously unseen bodies inwardly to the eyes. This was done either by reusing the visible *species* already there— combining them, for example, to form chimeras—or by exciting the motions and affections in the body in order to create novel 'representations' of things. Just as frenetics and others troubled in their senses imagined that the *species* arising from perturbations in their humours and vapours represented real things, so the demonically deceived saw and heard what had never passed before their eyes or struck their ears.[38] Such was the devil's skill in composing *phantasmata* that a waking person might be made to dream, or to sense, like a maniac, what he did not ('et putet se ea sentire, quae non sentit').[39]

Elsewhere Del Río dismissed the idea that animals destroyed and eaten by witches could somehow return to life and attributed it in detail to sensory interference. The devil, he said, could:

close the eyes of witnesses by sending into them a humour or some other sense-impression, or by agitating the spirits in the imaginative faculty and bringing them in this state to the senses in general and to the organs of the external senses, whither images and semblances (*simulacra et species*) impressed thereon by agitation of the spirit and the object of the sense-impression, normally descend. There, these semblances are usually held back, and when the process of apprehending them has once started, it is shifted about so often that the exterior sense thinks it is equally affected and genuinely altered as though by an external object. It is the kind of thing which usually happens to a sleeper in his dreams, but the Devil can make it happen to people while they are awake, because the physical organs obey incorporeal substances as far as local motion is concerned.

This last point Del Río derived, once again, from the pages of Thomas Aquinas.[40]

On such matters of detail, confessional differences were again of negligible significance. In a demonology read all over Europe, originating in his Latin commentary on the first book of Samuel and later inserted into both his own *Loci communes* (published in Latin in 1576 and in English in 1583) and the French editions of Ludwig Lavater's *Von Gespaenstern* (*De spectris*) in 1571 and 1581, the Zwinglian theologian Petrus Martyr (Vermigli) introduced his account of how the devil 'beguiled' the human senses by reminding his readers of how (according to elementary Aristotelian teaching) they were supposed to work:

[W]e must know that of those things, which by sense are conceived, there arise certeine images, and doo come unto the senses, afterward are received unto the common sense; then after that, unto the phantasie; last of all unto the memorie; and there are

preserved: and that they be imprinted and graven in everie of these parts, as it were in waxe. Wherefore when these images are called backe from the memorie unto the phantasie, or unto the senses; they beare backe with them the verie same seales, and doo so stronglie strike and move affection, that those things seeme even now to be sensiblie perceived, and to be present. . . . Wherefore that which is doone by naturall meanes, the same also may be done by the divell. For he can call backe the images of things from the memorie unto the phantasie, or unto the sense, and so deceive the eies of men.

According to the usual argument, the victim was thus in a position comparable to that of the mad, the possessed, and dreamers—thinking (in Martyr's marginal gloss) 'he seeth that which he seeth not'.[41]

Another typical example from a Protestant cultural context comes in the remarks of two English divines John Deacon and John Walker (via 'Physiologus') in their *Dialogicall discourses of spirits and divels* (1601), when explaining that the transformations attempted by Pharaoh's magicians were successful only 'in an outward appearance'. Taking advantage of the deep impression left behind in the sensitive faculties of the onlookers by Aaron's real miracles, Satan superimposed his own images on those produced by the physiology of vision:

For, much blood descending before into the sensitive facultie, there descends withall, many imagined formes, whereby there is forthwith procured a very lively resemblance of some such things as are not existing at all. By this meanes therefore (there being beforehand procured a commotion of humours, as well in the interiour, as exteriour senses of all the beholders) the Divel might both inwardly and outwardly also, applie certaine apparant formes to the very organons of all the senses; even as effectually, as if they had risen only from outward sensible objects: and (by such a legerdemaine) might cause the sorcerers rods to seeme in appearence, as though they had beene true serpents in deede.[42]

Probably the most complete, not to say exhaustive, account ever given of demonic powers over the human senses was offered by a provincial physician and public professor of medicine in Saxony-Coburg, Johann Christian Frommann, in his *Tractatus de fascinatione*, published in Nuremberg in 1675. A substantial proportion of its 1,067 pages are devoted to magical and demonic 'fascination' of the eyes, and in such detail as to defy any attempt at summary. Those interested in encyclopedic coverage of *deceptio visus*—the mantra, so to speak, of being made to see what is not and not to see what is[43]—will find a comprehensive résumé of later seventeenth-century thinking on such topics as the *prestige* and its multifarious practitioners, the literally spectacular technology of optical effects, and, above all, the devil as *opticus ingeniosissimus*, forming the visible shapes of things, manipulating the medium and the visual rays, creating forms and reflections in the clouds, 'binding' ('praestringere') the eyes 'in a thousand ways', and filling the *phantasia* with images. This comprehensive control over the principles and conditions of true vision—or as Frommann put it, over what was depicted on the 'tunic' of the retina—implied an exactly commensurate power to create its opposite.[44]

Given what was discussed in my last chapter, perhaps the most intriguing accounts of the devil's prestiges were those comparing them to the contrivances of art, a way of conceptualizing them that has helped recently to bring demonology much more to the attention of art historians.[45] In one sense, its authors were only matching Plato's remarks in *The Republic* about the 'magic' (in some translations, 'witchcraft') implicit in painting's manipulation of the fallacies of sight— weaknesses of the human mind 'on which the art of conjuring and of deceiving by light and shadow and other ingenious devices imposes, having an effect upon us like magic'.[46] Even so, comparisons in the other direction could be surprisingly exact. Whether or not demons, like John Locke's angels, possessed enhanced eyesight, they were, like them, able to use optical instruments and techniques commensurate with the latest versions of optical acuity.[47] The Jesuit scholar Gaspar Schott, for example, said that demons used the 'art of perspective' to deceive the senses, making 'square things look round, or scattered things look grouped together, or ugly things look graceful'. 'If art and nature', he said, 'can create such wonders as we see in the fields of *Magia Optica*, *Catoptrica*, *Dioptrica*, and *Parastatica*, what cannot the devil produce of the same sort through magicians?'[48] This is the kind of statement that makes better sense of an episode in April 1611 in Aix-en-Provence when exorcists treating Madeleine Demandols de La Palud, an Ursuline nun allegedly possessed at the instigation of her confessor, Louis Gaufridy, asked the devil inside her to guess the function of 'a certaine instrument of glasse made triangle wise', which none of those present professed to know. Beelzebub gave this helpful reply: 'It is an optick glasse to make a man see that which is not', which (the report says) 'was found agreeable unto truth, for it caused men to see woods, castels and arches in the aire of all manner of colours and other things of the like nature'.[49]

Otto Casmann, the German theologian, shared the standard doctrines about how demons could 'overwhelm (*devolvere*)' the external senses to produce perceptions of unreal things, either by presenting objects to them that were 'not what they seem to be, but only images or likenesses (*simulacra*) of them', or by stirring the animal spirits in which the *species* of sensible things were normally 'imprinted from without by the external senses' in such a way as to distort judgement. But he also likened the devil to a sculptor fashioning various forms and shapes from his materials (usually condensed air) that sometimes seemed 'to be real and natural (*verae ac naturales*)', and he invoked the customary benchmark for this kind of deceptive naturalism, the story of Zeuxis' grapes and Parrhasius' curtain.[50] Evidently, the trope of the devil as painter was also in wide circulation, testimony to a parallelism in the way artists and demons were thought to create and manipulate simulacra. The Italians Francesco Cattani da Diaceto and Girolamo Menghi, for example, both spoke of the way demons gave figure and colour to simulated bodies like painters using their brushes and other tools. Other writers and artists saw exact parallels in the formation of phantasms in the imagination, whether these were employed for creative or destructive purposes.[51]

One of the most revealing of such portrayals appeared in the course of a detailed description of demonic sensory delusion by the Spanish Dominican theologian Raffaele della Torre in his *Tractatus de potestate ecclesiae coercendi daemones* (1629). Della Torre was following both Del Río's prior account and another exposition virtually identical to it by the Spanish lawyer Francisco Torreblanca, and he shared fully in the doctrines of *deceptio visus*. He does, however, offer an especially detailed version of the topic. He explained in the usual way and at length that the devil could manipulate the object, medium, and organ of vision in any visual encounter, making it, strictly speaking, 'a prestige' (*praestigium*). Augustine and Thomas Aquinas were authorities for this fact, but so too was the story in Philostratus' *Life of Apollonius* (iv. 25) of Menippus, almost tricked into marriage and death by a *lamia* who appeared to him 'in a beautiful likeness' and offered him riches and a wedding feast which Apollonius promptly exposed as 'empty copies' of the real things. The issue here, said Della Torre, was one of representation. By forms of local motion the devil makes men and women take the images they see 'to be the things they represent' ('ut putent esse eas res, quas repraesentant'). It was, indeed, one of *artistic* representation, since the devil was only doing what sculptors and painters do when, by local motion too, they produce shapes or apply colours and sometimes make the things they depict 'seem real and natural' ('ut interdum verae, et naturales videantur'). The devil was like a consummate still life artist, able to deceive the viewer into confusing an image of something for the thing itself.

Della Torre's comparison at this point, also present in Francesco Torreblanca's demonology, is telling—precisely the supremely naturalistic representation achieved by Zeuxis and Parrhasius. What, he deduced, could the devil *not* represent to sight, being a more skilful artist ('artifex') than Zeuxis or any other painter or sculptor? Should it be a question of rearranging existing objects in a visual field, rather than creating new ones from air and vapour, he also had the skills to surpass all the jugglers ('circulatores'). And, finally, in the field of optics itself, he could out do the anamorphisms of the most dedicated 'perspectivists'. As in Del Río, the word 'anamorphosis' is unavailable for use, but the technical description is again unmistakable:

If those engaged in optics (*perspectivae*) can make the outlines of a long irregular painting look distorted if they are observed directly, but, when they are viewed through an aperture or with the painting rotated, restore the likeness of some artistic image, why cannot the devil, most skilled in every art, do this and stranger things?[52]

Artistry and duplicity in combination—such, indeed, was the devil's contribution to the Renaissance paradox.[53]

The English philosopher Henry More (as well as Thomas Erastus, whom we have already noticed) said that witches got at least their biblical name (Hebrew: 'Megnonen'; English: 'Praestigiator') 'from imposing on the sight and making the

by-stander believe he sees forms or transformations of things he sees not'.[54] We must return to this idea later, but we can already see that witchcraft was the area where the demonology of the senses produced the most dramatic and perplexing results, making it, almost as much as apparitions (which we consider in Chapter 6), a topic fundamentally concerned with the nature of vision.[55] At one end of the most intense period of witch-hating in European history, Girolamo Visconti, a Dominican from Milan, felt that he had to include in his *Lamiarum sive striarum opusculum* (c.1460) not only two chapters examining the power of devils to appear in assumed shapes and to 'bind' the eyes of men and women but a third entitled: 'How many ways are there for making one thing seem like another [?]' ('Quot modis fieri posit, quod una res videatur altera').[56] Two centuries later, the Italian Franciscan exorcist Candido Brognolo included in his lists of the true signs of witchcraft and demonic possession thirty-seven relating to the five external senses of the persons affected (the internal senses and the faculties each had their own). Of the eight signs drawn from their vision and eyesight, no. 3 is: 'When the sufferer sees a thing other than in its proper and natural disposition, as, for example, a man for a dog, a piece of wood for a man, etc. . . . , and no. 8 is: 'When somehow things visible to the eyes are removed and cannot be seen, and then suddenly reappear'.[57]

An important point here is that one did not necessarily have to doubt the overall truth of witchcraft to question the visual reality of some of its components. Even orthodox witchcraft theory—the theory of those who broadly accepted witchcraft's reality and wanted witches to suffer for their crimes—was committed to mental and sensory delusion by devils on some scale. This was because there were things that repeatedly appeared in the confessions of witches (and witchcraft narratives more generally) that everyone knew, for good theological and natural philosophical reasons, were not true phenomena and which therefore had to be discounted. Even those who believed in the criminality of witches, wrote the Englishman Thomas Ady (who himself did not), 'will yet yeeld thus farre, that these confessions of poor accused people do many times extend to impossibilities, and that they verily believe that the Devil deludeth these people'.[58] Witches supposedly flew off to 'sabbats' in spirit only, leaving their physical bodies at home in bed; they gave birth to children fathered by devils; and they changed themselves or other people into animals. It was in the course of the arguments that ensued—in order to save the phenomena, we might say—that the devil's ability to create virtual worlds, or at least virtual events, where unreal phenomena were scarcely, if at all, distinguishable from their real equivalents was most fully elaborated.

Attendance at the sabbat was perhaps the most pressing issue, arising at the very start of the witchcraft debate in the form of the so-called *Canon episcopi*, a ninth-century capitulary which declared that women who believed that they rode off at night to meet the goddess Diana were 'seduced by illusions and phantasms of demons'. Since, however, the experience was said to be, in effect, a

demonically induced dream, I want to postpone treatment of it until we arrive, in a much later chapter, at the philosophy and epistemology of sleep.[59] For the moment it is only important to note that broad acceptance of witchcraft's reality could nevertheless rest on an admission that one of its key physical components might sometimes be a complete illusion, planted by the devil in the heads of witches as a convincing but nevertheless deceptive visual experience.

Let us look instead at the metamorphosis of humans into animals. Since virtually no one accepted this as a physical possibility or saw anything in it but an outright delusion it was a more clear-cut matter than either attendance at the sabbat or the production of demonic offspring: *everything* about it could be explained away. Just why it was impossible was more complex, but only of relevance here as a clear instance of the *miraculum/mirum* distinction; the real transformation of a human body into the body of a beast could only be achieved miraculously (as Aquinas had specifically emphasized) and was therefore beyond the power of any creature. But exactly how metamorphosis was to be explained away could be complex to the point almost of absurdity—producing yet more striking instances of the visual paradoxes with which we are concerned. It was not difficult, as we saw in an earlier chapter, to attribute the phenomenon to melancholic madness, turning all cases of supposed metamorphosis into lycanthropy or similar diseases. (Some apparently miraculous transformations *not* involving metamorphosis of the human body—above all, those achieved by Pharaoh's magicians—were also easily explained as examples of what Aquinas called the 'transformations of natural things which can be produced by certain natural powers'.) However, once the devil was given a role—other than the mere enhancing of illness—it could only be one of trickery and, in order to cope with the phenomena, of trickery that was paradoxically total. Human–animal metamorphoses, as the Milanese witchcraft writer Francesco Maria Guazzo put it in 1608, were diabolical illusions, 'having the form but not the reality of those things which they present to our sight' ('quae habent speciem, et non veritatem earum rerum, quas ostendunt').[60]

There are countless instances of attempts to construct metamorphosis as a demonic semblance of reality, for this is one of the set-pieces of demonological argument in early modern Europe.[61] But for a fully-fledged version of the argument at the height of Europe's witch trials, we need look no further than a book written by one of the men who conducted them, Henri Boguet, magistrate of the district of Saint-Claude in Burgundy. Like most others, Boguet declared human metamorphosis to be impossible, but he did not think of werewolves as lacking all physical extension. One possibility was that Satan himself performed all the required actions in the shape of a wolf, while placing the *experience* of having performed them in the imagination of someone else—an imagination made suitably receptive by the additional use of delusions and/or drugs. In this case, he also had to make sure that any injury he sustained while acting as a wolf was also exactly replicated on their body. Boguet's preferred solution, however,

was that witches themselves acted as wolves either in physical disguise or as a consequence of a conviction that they had been transformed:

And this comes from the Devil confusing the four humours of which [the witch] is composed, so that he represents whatever he will to his fantasy and imagination. . . . And when people see the witch in this shape, and think that it is really a wolf, the fact is that the devil befogs and deceives their sight (*esbloüit, et fascine les yeux*) so that they think they see what is not; for such fascination is commonly used by the Devil and his demons, as we know from several examples.

Boguet was able to provide his readers with supportive comparisons of the sort we have already considered in previous chapters—the natural malady that made the sick believe they were 'cocks, or pigs, or oxen', and the natural magic (of Albertus Magnus, Cardano, and Della Porta) that showed how 'to cause men's heads to seem like those of horses and asses and other animals, and their snouts like a dog's'. The effect of his analysis, nevertheless, was the creation of a virtual event—an event whose reality no one, barring the devil himself, presumably, could possibly determine using their senses alone.[62]

It is not simply a modern reaction to suggest that there was a risk of serious perceptual confusion in such an outcome.[63] In Claude Prieur's dialogue on lycanthropy, published in Louvain in 1596, the argument reaches the point where demonic deception of the imagination ('phantasie') of those who think they are wolves (or horses in the case of the father of Praestantius in Augustine's *De civitate dei*, xviii. 18) is being discussed.[64] It is achieved, explains 'Proteron', by manipulation of the brain's spirits and humours and modification of the *species* ('especes et similitudes') already stored there. But the deception applies also to those who think they are witnessing such transformations, since 'those who thought they saw the same horse that the father of Praestantius is said to have become, were just as deceived as he himself'. At this point, 'Scipion' exclaims: 'What is it, then, that we see (*Qu'est ce donc, ce que nous voions*)?' The answer given (with citations to Johannes Nider and Bartolommeo Spina on the devil's power to dazzle the eyes) is: sometimes true bodies, which are what they appear to be, but often 'imaginary visions'—'species and images of the things that are represented'—or new bodies made by Satan from air. Distinguishing between these various categories can be difficult because it can happen that 'the senses (*sentimens*) lead us to believe that a body is present when there is nothing but an image and resemblance of it'. Nonetheless, lycanthropy has mostly to do with 'the *species* or image of the things than with true bodies'; in order to represent the living, after all, a simulacrum or image is enough. So even if the necessary 'appearances' can derive from real bodies—natural men, wolves, other beasts—or from bodies formed from air and 'worn' by demons, they are mostly imaginary.[65]

Following a discussion of biblical cases, Proteron reaffirms that apparent transformations into wolves are cases of 'magic, malefice, enchantment, sorcery, charming, a phantom, dazzling, the deception of the senses, illusion, or mockery'.

The best term of all is 'prestige', which he goes on to define conventionally as an 'abuse of the senses, and especially of the sight', a 'dazzling' of the pupil of the eye, so that things seem other than they are, and 'a diabolic illusion caused not by a change in the object but by a change in the person who sees it in that manner, being fooled and enchanted regarding the interior or exterior senses'.[66] All this means that 'our senses are sometimes dazzled internally and externally in such a manner that what we touch seems to be a body'.[67] Again, Scipion feels obliged to ask what seems like a telling question: '*Can all creatures then appear to us other than they are*? (*Toutes creatures peuvent elles donc nous apparoistre autres qu'elles ne sont?*)', to which Proteron replies: 'This can happen' (*Il se peut faire*).' And how can it be that a whole group of people ('tout un people') can be charmed and enchanted at the same moment, and who is it that can achieve this? Proteron replies that prestiges come in various forms, and turns to precisely the passage in *Malleus maleficarum* we noted earlier for the details. Not all are deceived, however—not the pious or even the 'gens de bien', but only those already in some way demonic.[68] It seems that what one saw—and my discussion in a later chapter of the theological and pastoral exercise known as the 'discernment of spirits' will confirm this—was as much a matter of religious or social status as it was of the transmission of *species*.

Contrary to expectation, then, it was often those who by and large *believed* in witchcraft who offered striking arguments for not taking at least some of it seriously, on the grounds that all-embracing illusion was at work. This did not stop them taking the rest of it very seriously indeed, however, and on what must be called empirical grounds. Thomas Erastus, for example, argued in solidly Aristotelian fashion that witchcraft could not be an imaginary crime because it was impossible that a man in full use of his faculties could mistake imagined things for real things if his senses reported the contrary. 'Imagine someone has given you a thousand écus', he wrote, reasonably enough: 'you would not believe it if your eyes could not see it, or your hands touch it, and if your other senses said it was false.' How else could dreams or the delusions of the sick be called imaginary? But witches made their pact while fully awake, in full sight and hearing of the devil and with their understandings intact. And though they dreamed about feasting, dancing, bewitching victims, and seeing people they did not in fact see ('et voir ceux qu'elles ne voyent pas'), they sometimes experienced all these things in broad daylight. 'One knows', said Erastus, 'that sometimes these things have really happened, and [that] those who saw these shapes of evil spirits with their eyes had healthy senses' ('les sens entiers'). Witnessing to the factual truth of witchcraft was thus a possibility.[69] Similarly, the lycanthropy expert Beauvois de Chauvincourt argued that the delusion might be caused in two ways: by the devil entering the bodies of victims and their interior organs 'and troubling their phantasia and imaginative faculty, [making] them believe that they are brute beasts', and giving them all the desires and affections required for acting like a

wolf, and by the devil using substances that overcome the exterior and interior senses and occupy the brain, again troubling the *phantasia* and imagination, and even operating on the external senses of the spectators, 'seizing their eyes ... which are persuaded the transformations are concealed'. But then he added: 'these strange cases *that we see with our eyes* ... should serve as a key to open the eyes of the understanding of those who are convinced there are no witches', a conviction that was dangerous because it led on to Sadduceeism and atheism.[70]

It was therefore left to those who largely questioned witchcraft belief and witchcraft prosecutions to bring out the awkward implications of combining an illusionistic devil with an empirically verifiable human crime. Of course, they had many other kinds of misgivings: authors deployed a whole range of arguments and strategies for undermining orthodox demonology and the credibility of witchcraft trials. There was nevertheless an epistemological, sense-based strand to scepticism about witchcraft, and understandably so. If the issues were whether witchcraft existed or not, whether it was possible or not, and whether it could be punished or not, then the very reality of the events—the phenomena, so to speak—had to be established. And what sceptics repeatedly said was that the reality of witchcraft phenomena was not just sometimes, but always vitiated by the possibility of deception, even when it was not compromised by abusive legal procedures or religious prejudice or other similar factors. True, this was not always *demonic* deception; it could be attributed to natural causes acting alone, most notably to melancholy. The same condition that led sufferers to think they were made of glass, or had sparrows in their heads, or were already dead easily led to the delusion of either being a witch or being bewitched. Melancholics, noted Robert Burton, suspected everything they heard or saw 'to be a devil, or enchanted', and were afraid they were 'bewitched, possessed, or poisoned by their enemies'.[71] Alternatively, the deception might be man-made and attributable to artifice or deceit, especially the counterfeiting of the symptoms of betwitchment or possession. '[T]here is nothing almost in things of this nature so really true', wrote Richard Bernard, 'but some can so lively resemble the same, as the spectators shall judge the parties to be so indeed, as they seeme to bee in outward apparance.'[72]

In England, attacks on the overall credibility of witchcraft relied particularly heavily on these non-demonic accounts of delusion, largely because of the long-term influence of Reginald Scot, whose *The discoverie of witchcraft* (1584) left virtually no room for the physicality of devils. Scot invoked the effects of melancholy to explain 'witches nightwalkings', pacts, and meetings with devils as 'but phantasies and dreames' and accused of lying those who maintained that such things were 'doone in deed and veritie, which in truth are doone no waie',[73] But he devoted far more of his argument to the counterfeiting of witchcraft by means of the visual delusions of prestidigitation and legerdemain, making his book as much a landmark in the history of juggling as it is in the history of demonology. Seventy or so years later, Scot's admirer Thomas Ady spoke of those who voluntarily confessed to witchcraft as

people 'deeply gone by infirmity of body affecting the minde, whereby they conceit such things as never were, or can be'. Melancholy or other distempers of the body, accompanied by a 'troubled phantasie', could cause them 'to imagine things so really, as to confess them to their own destruction, though most false and impossible'.[74] Later in the seventeenth century still, John Wagstaffe argued that witchcraft beliefs—and, indeed, religion in general—originated when the entirely false apparitions produced by the fears and melancholic imaginations of men and women were exploited by 'wise politicians' for the 'designs of government'.[75] His fellow sceptic John Webster thought that all witchcraft was delusory, either in the 'active' and outward sense, as the product of trickery and cheating, or in the 'passive' and internal sense, as something imagined in the minds of the ignorant, melancholic, and credulous. Both of these categories involved the deception of the senses. Among the tricksters and impostors were jugglers and experts in legerdemain (the point stressed by Scot), while the passively deluded were 'those that confidently believe they see, do, and suffer many strange, odd, and wonderful things, which have indeed no existence at all in them, but only in their depraved fancies, and are meerly *melancholiae figmenta*'.[76]

Continental scepticism about witchcraft was more varied in character but here too non-demonic delusion ranked significantly as a reason for doubting the reality of the crime. At the point when the argument was beginning substantially to be won, Balthazar Bekker devoted the third chapter of the fourth volume of his comprehensive onslaught on demonology to all the many ways in which visual appearances could be confused with natural reality. Just as people believe what they want to believe, he wrote, so also 'a person convinces himself that he sees what he wishes to see'. Even when the senses were sound and functioning properly, therefore, deception could take place. When they were not, or when the imagination was corrupted, then 'experience'—for which we might read 'empiricism'—could no longer be relied upon as the foundation of truth.[77]

Demonic possession was treated in similar fashion by those who, all over Europe, suspected that its symptoms were brought on by natural disorders or were entirely simulated and had nothing to do with devils. Thus, Marc Duncan, a Scot who became a physician in Saumur and eventually rector of the university there, after first countering the moral argument that the Ursuline nuns of Loudun were merely feigning possession, attributed their experiences to the effects of 'phrenitis, melancholy, or madness' and a 'false' imagination of things.[78] As Michel de Certeau has shown, the possessions at Loudun in the 1630s became caught up in arguments between rival physicians about the effects of melancholy on the human imagination and the capacity of reason to correct visual errors. Duncan's little tract was attacked by Hippolite Pilet de la Ménardière, from the medical faculty at Nantes, in his *Traité de la mélancholie* (1635), and then defended in the next year in a reply to Ménardière by 'Sieur de la F.M'. As an example of what was at stake, Ménardière had absolved the imagination from blame in the Loudun case on the grounds that it simply functioned like a mirror whose job was only to represent

the objects facing it by reproducing images of them. It was reason (or judgement) that was at fault since it 'makes a false reasoning on the quality of the *species* and wrongly approves an erroneous vision that, properly speaking, should not be called fallacious but for the fact that reason did not rectify it, and it was unable to discern true being from apparent, and truth from falsehood'.[79] What had begun as a specific case of alleged possession and witchcraft had become a theoretical controversy about the workings of the human faculties and the mechanics of perception, especially visual perception. De Certeau comments that the learned had been forced 'to take a position on the possible, whether in the name of a challenged tradition or on the strength of new theoretical options'. In the town of Loudun itself, a more pressing dilemma had occurred—what he calls 'the epistemological decision' that observers of the possessed had to face.[80] It therefore looks as though the campaign waged in earlier cases like that of Nicole Obry of Laon—recently described by Sarah Ferber and evidenced at the time in the writings of Jean Boulaese, the Catholic priest and Hebraist—to make human sensory perception authoritative in verifying cases of possession was of only limited success. Boulaese spoke of the public averral of Obry's case 'by the sight, hearing and touch of more than one hundred and fifty thousand people', but this was a claim that was deeply insecure in sixteenth- and seventeenth-century conditions.[81]

Usually, however, demonism too was implicated in the delusions that made witchcraft incredible to sceptics; giving up witches did not obviously mean giving up the devil. Instead, it meant extending the explanations given even by most believers in the crime for not accepting some of its aspects—above all, as we saw, metamorphosis—to *all* of them. Again, melancholia was the favoured medium, the devil amplifying the natural condition by using his own physical control over the body to add the additional and more extravagant symptoms that would account for witches sensing—above all, seeing—impossible things. Burton spoke at length of demonism as one of the causes of general melancholy and as an obvious explanation for many of the symptoms of its religious subtype, notably (and unsurprisingly) the fear of Hell.[82] The French physician Jourdain Guibelet, whose discussion of melancholy reads in places like a demonology, warned that great care was needed in apportioning the demonic and non-demonic effects of melancholy in cases that included visions, apparitions, 'false imaginations', ecstasies, sciences or languages acquired in a instant, predictions, and dreams. This was because devils could do everything that the melancholic humour could do on its own, having the capacity to occupy 'all the senses'. The sabbat could therefore be 'represented' to the soul of the witch while she was in bed and therefore exist only in her 'fantasie'.[83] The physician who made the very most of this argument, so much so that he came to disbelieve entirely in witchcraft, was, of course, Johann Weyer, whose *De praestigiis daemonum* (first issued in 1563 and then considerably expanded in later versions), as its very title suggests, extended the range of the demonic prestige until it engulfed the very phenomena that it was

supposed to warrant. We will return to Weyer's striking arguments when we consider the visuality of dreams.[84]

Of all the many questions concerning visual reality posed by witchcraft, perhaps the most extraordinary and most revealing concerns demonic impersonation—the ability of the devil to create simulacra of human beings that were so convincing that no one could tell them apart from the real thing. The principle itself was illustrated in countless stories, like the one told by the French magistrate Pierre de Lancre of a demon intent on sexual conquest who borrowed the identity and looks of a real man, 'assuming his shape and size and completely adopting his appearance, so that people said that he was not merely the man's exact replica but was the man himself'.[85] But three specific versions of this idea were discussed in early modern Europe and America, the second with perhaps more intensity than the other two. All three touch fundamentally on the matter of visual certainty and uncertainty and, in their very currency, help to mark out the concerns that affected a visual culture at a particular moment in time.

In the first two cases, it was attendance at the witches' sabbat that was the broader issue—a matter with obviously crucial consequences for the conduct of witch trials. First, the devil was said to provide copies of people while they were in reality at the sabbat, in order to cope with the obvious objection that they could be seen, whole and entire, somewhere else. One example was the provision of counterfeit wives, lying at home in the marital bed while the real versions went off to meet the devil. Sworn statements from their husbands that they had never left home could thus be disregarded. The *procureur général* of the duchy of Lorraine between 1591 and 1606, Nicolas Rémy, mentioned in his *Daemonolatreiae* cases of witches charming their husbands into a deep sleep, or leaving likenesses of themselves to take their places—'some dummy (*supposita*) . . . which their husbands should, if they happened to awake, imagine to be their wives'.[86] Andreas Alciatus' celebrated response to this particular meddling with appearances was to ask: 'why not rather presume the demon to be with his demons, and the woman with her husband? Why invent a real body in a fictitious Sabbat and a fantastic one in a real bed?' ('cur non potius cacodemonem cum suis daemonibus, illam vero cum marito fuisse praesumis? cur verum corpus in ficto lusu, phantasticum in vero lecto comminisceris?').[87]

Alternatively, the deception could be achieved in broad daylight in front of many witnesses, with paradoxical consequences for what witnessing meant in the first place. During the Spanish Inquisition's enquiries into witchcraft among the peoples of the Pyrenees early in the seventeenth century, one of the principal investigators, Alonso de Salazar, came to the conclusion that evidence against many hundreds of the accused could be disregarded after it was claimed by witnesses that the devil had carried off specific witches to their meetings while they were talking to their neighbours and put counterfeit persons in their places without anyone realizing. In March 1612, in a report to his superiors in Madrid,

he argued that if the devil could make people seem to be present when they were not, or absent (invisible) when they were present, then nobody could be sure 'that he or she who is present is any more real than he or she who is with the witches'. In one case a 'witch' called Catalina de Sastrearena had asserted that she was impersonated while at the sabbat, but the witness to this, her companion Mari Gorriti, could only say that it was 'so subtle and confusing that although she and others would affirm this phenomenon nobody could vouch for the truth of it'. Salazar drew the obvious conclusion:

> if we accept the truth of the semblances and metamorphosis which the witnesses claim that the Devil has effected, the trustworthiness of the witnesses' statements has been vitiated in advance. That is to say, first the Devil wants to mislead us into thinking that the body of the witch, who is apparently present before the witness, is a counterfeit of the real person who has gone in the meantime to attend the sabbat. Secondly, that witches can pass in front of and approach the witnesses, being invisible when they thus pass through the air before them. In both cases the witness is deprived of the ability to discern the truth, if he relies, as he ought, solely on what he can perceive by his senses.[88]

Salazar reported that 'witches' had confessed that they and the devil had attacked him personally, invading both the room where his tribunals were held and his bedroom and assaulting him—even setting fire to him—to no physical effect, all the while 'exercising the privilege claimed for them of being invisible so that their presence could not be felt'.

In a second version of the impersonation idea, the devil was said to be able to create counterfeits of innocent people (that is, non-witches) at the sabbat itself, so that real witches who attended could later confess to seeing them there and consequently denounce them too as guilty.[89] The blatantly obvious question, as put by the Counter-Reformation theologian Petrus Thyraeus of Mainz, was thus: 'whether those thus seen are justly suspect of witchcraft and belong to the sect of witches?'[90] Although the devil could conceivably have a serious interest in implicating innocent people in sin, most orthodox believers in witchcraft said that this form of impersonation could not happen: *all* those seen at the sabbat were guilty of a real crime. Witchcraft sceptics, by contrast, argued that it could, making the apportioning of guilt and the rendering of verdicts impossible. The issue was already being discussed in the 1480s, if not before, as seen in the question asked by 'Sigismund' in Molitor's dialogue *De lanijs et phitonicis mulieribus*: if witches do not really go to the sabbat, how do they know persons from distant towns whom they never saw before? 'Ulric' answers that it is by representation of images through the ministry of the devil.[91] Early in the new century, the Dominican inquisitor Bernard de Como was saying that since demons could assume the appearance of persons in order to defame them, denunciations by witches of other witches seen at sabbats was not in itself sufficient to justify arrest.[92] And in the following decade, the issue was again debated between the papal theologian Bartolommeo Spina, who argued that God would not permit

demons to 'present the appearance of others' to incriminate them, unless they were witches anyway, and the jurist Gianfrancesco Ponzinibio, who countered that innocent persons were at risk through the demon transforming himself into their shape.[93]

What eventually happened to this latter view and how it reinforced wider misgivings about trial procedures can be seen in the writings of the major opponents of witchcraft trials in Germany in the early part of the seventeenth century, most of them Jesuits. Adam Tanner, who taught theology at Munich and Ingolstadt, spoke of the devil 'representing' absent people by appearing in their guise at the sabbat, adding that one could never therefore be sure that this was not happening to entirely innocent women. In effect, he thought that witchcraft was, indeed, a *crimen exceptum* in this respect but that this worked in favour of defendants rather than against them; in no other crimes, he said, did 'the delusions and frauds of demons' intervene. Paul Laymann, another academic philosopher and theologian, also pointed out that witchcraft was a crime full of demonic illusions and deceptions, which meant that the 'semi-crazed' women who did go to its meetings were likely to 'see' others who were not actually present. How then could a judge arrest and torture a person merely from denunciations of other witches?[94] Similar views were recorded in an anonymous tract from the same period attacking witchcraft trials, *Malleus judicum*: a person seen at the sabbat was not a real corporal human being 'but a ghost (*Gespänst*)'—someone 'played (*gespielet*)' by the devil.[95] And it was another Jesuit—a confessor, indeed, to condemned witches—Friedrich Spee von Langenfeld, who built the devil's visual simulation of innocent people at sabbats into his broader case for extreme caution in witchcraft trials most successfully. The idea itself, said Spee, was no stranger than God allowing him 'to display the images of various people in mirrors as well as in water, oil, and other media' when soothsayers practised divination. There were many stories to prove it, including an innocent monk accused by witches who died adamant that they had seen him at the sabbat, when all his colleagues were with him 'actually engaged in the divine office'. Either the accusers had lied, said Spee, or they had taken 'an image to be the thing itself' ('imaginem pro re viderunt'). How then could any judge ever possibly distinguish between the vision and the real thing?[96]

The other side of the argument was also voiced well into the seventeenth century, ensuring, if nothing else, the widespread dispersion of both the concept of the demonic *simulacrum* itself and also some of its disturbing implications. Disturbing to witch hunters, at least, was the prospect of failing prosecutions and unpunished witches, the lament of the fifteenth-century inquisitor Nicolas Jaquier.[97] There must have been many other cases like the one at the General Synod of the Hessian clergy in 1582, when the Marburg preacher Helferich Herden was arguing, against the views of some of his colleagues, that the confession of a local witch might be discounted because the devil had the power to represent innocent people at sabbats in the form of their images.[98] Less self-serving was

the two-part argument offered by Peter Binsfeld, who was in no doubt that the denunciation of one witch by another had an absolutely sound empirical foundation:

> Witches denounce the deeds of their companions and associates in crime, whom they saw according to a determined place, time, and manner, being present themselves, where they truly and really drank, gave allegiance, and transacted various things, [and] they reveal the details of their comings and goings, which do not exceed human comprehension (*cognitio*) and were apprehended by the senses. . . . [at their meetings] they make use of the function of the bodily senses, they see, they hear, they touch, they dance, they drink, and they eat—which are all matters of the senses (*quae omnia sensibilia sunt*).[99]

Binsfeld's case was that if the devil could make images of innocent people, 'everyone would always be justly afraid of being transported into fables and tragedies, exposing the welfare of their bodies and their souls to danger', and that he might do the same for other crimes—murders, adulteries, fornications, and so on. All those accused of such crimes could plead that the devil had adopted their form and committed the deeds himself, making criminal justice impossible.[100]

A further counter-strategy was to claim, as Jaquier also did, that since impersonation of the innocent was only done with the special permission of God, accused witches could not possibly claim it as a defence—God's will being definitionally unknown to them, as to everyone else. This did not prevent others with the same point of view, including Binsfeld, Thyraeus, and Del Río, confidently pronouncing that it was God's will that demons should never impersonate the innocent but only those who were already tainted by witchcraft anyway.[101] Spee's reply was to accuse his opponents of inconsistency—of allowing the devil the greatest powers of delusion in all but this one instance. Witchcraft, he insisted, was not like crime in general because demonologists had already filled it full of illusions; murder, banditry, or adultery were never committed in such an illusion- and phantasm-filled context:

> They also say that [the devil] deceives the eyes of his lackeys with various representations and forms, now this shape (*specie*), now that, of a man, of a woman, a soldier, a maiden, a youth, a goat, a lion, etc. If any are absent from the sabbath, as my opponents admit, he himself fills their place. Many things are really done there, however many more fictitiously. [Witches] think that they eat and drink delicacies, that they sleep in ivory beds, etc., when all they did was feed on a corpse, drink a chamber pot, and rest under the gallows. I will omit all the other illusions which are so normal in these rites that the infernal actor seems to do nothing but indulge himself in fabricating mere ghosts, specters, and false images there.

Why then should 'the devil's license in his faculty of fabricating all kinds of specters in these places' not extend also to the fabrication of people?[102]

The third and final form of demonic impersonation concerned 'spectral evidence'—that is, evidence claiming that bewitchment had been caused not by a

witch in person but by her (or his) apparition or spectre, seen by the victim-accuser, and created with the witch's collusion by the devil, who took on the shape of the accused. The issue of whether this was allowable in law emerged most powerfully during the early phases of the outbreak of accusations and executions in Salem, Massachusetts, in 1692, during which spectral evidence was repeatedly cited in the initial accusations and charges against 79 of the 156 people indicted for witchcraft before a special court of oyer and terminer. The usual view that it was highly influential in securing guilty verdicts during the ensuing trials is now in doubt; even at the time it was reported that the judges believed they had not convicted anyone 'meerly on the account of what spectres have said, or of what has been represented to the eyes and imaginations of the sick bewitched persons'.[103] But the principle behind its deployment found expression in the Boston minister Cotton Mather's opinion that:

a spectre exactly resembling such or such a person, when the neighbourhood are tormented by such spectres, may reasonably make magistrates inquisitive whether the person so represented have done or said any thing that may argue their confederacy with evil spirits, altho' it may be defective enough in point of conviction.[104]

Clearly uneasy with the principle himself and (understandably) fearful lest it bring 'no less than a sort of a dissolution upon the world', Mather reported that a controversy raged in New England over whether 'the daemons might impose the shapes of innocent persons in their spectral exhibitions upon the sufferers [from witchcraft]'.[105] Deodat Lawson, the Salem minister, delivered a sermon on 24 March 1692 saying that Satan was dividing the community by attempting 'to take some of the visible subjects of our Lord Jesus, and use at least their shapes and appearances, instrumentally, to afflict and torture, other visible subjects of the same kingdom' and implying the consent of those impersonated.[106] Opponents of the idea, themselves clergymen, produced a 'Return of Several Ministers Consulted' on 15 June of the same year, after twelve of them were asked for an opinion by the Governor of Massachusetts, William Phips (who eventually suspended proceedings in October). This cites the English witchcraft writers William Perkins and Richard Bernard in arguing (point 6) that: 'Presumptions whereupon persons may be committed, and, much more, convictions whereupon persons may be condemned as guilty of witchcrafts, ought certainly to be more considerable than barely the accused person being represented by a spector unto the afflicted, inasmuch as 'tis an undoubted and notorious thing that a Demon may, by God's permission, appear, even to ill purposes, in the shape of an innocent, yea, and a virtuous man.'[107] Mather himself wrote to John Foster, a member of the Governor's council, on 17 August 1692, questioning the sufficiency of spectral evidence and welcoming the use of 'other, and more human, and most convincing testimonies'. All Protestant and some popish authors agreed, he said, that devils 'have a natural power which makes them capable of exhibiting what shape they please'.[108]

The irony was that in talking like this, the sceptical disbelievers in witchcraft (represented in the case of Salem by Increase, rather than Cotton Mather) were only really developing and expanding arguments used, as we have seen, by the believers themselves, arguments intrinsic to orthodox demonology and supportive of it. Nevertheless, one of the principal reasons why the Salem trials themselves eventually collapsed is because the doubts reported by Cotton Mather came to be generally shared and spectral evidence was suddenly rejected (even by the original jurors) as a form of judicial proof. Again, he himself was to concede that, quite apart from the devil's delusions and 'juggles', some 'over-powerful conjurer may have got the skill of thus exhibiting the shapes of all sorts of persons, on purpose to stop the prosecution of the wretches, whom due enquiries thus provoked, might have made obnoxious unto justice'.[109]

Undoubtedly the most interesting publication to come out of the episode, for our purposes, is Increase Mather's discussion of 'evil spirits personating men', published in 1693 and devoted to the issue 'most under present debate'—'spectre evidence'. Was it possible, asked Mather, for the devil to 'impose on the imaginations of persons bewitched, and to cause them to believe that an innocent, yea that a pious person does torment them, when the devil himself doth it'? The witch of Endor story in the Old Testament suggested that it was, and witchcraft itself had generated a debate concerning 'whether innocent persons may not by the malice and deluding power of the Devil be represented as present amongst witches at their dark assemblies'. Mather, already author of *An essay for the recording of illustrious providences* (1684), was the last person to deny God's permission in this or the devil's traditional role as a deceiving 'angel of light': 'He seems to be what he is not, and makes others seem to be what they are not', changing himself 'into what form or figure he pleaseth'. Even an unblemished man might therefore be 'represented' by Satan. Despite the telling objection that this would rule out all forms of criminal enquiry, Mather allowed no exceptions—at least in principle. The devil had the age-old will and power (witness the many 'untrue and delusive representations before Pharaoh', done by his sorcerers); but—and here Mather added the characteristically Renaissance inflection we have been examining—he also had 'perfect skill in opticks, and can therefore cause that to be visible to one, which is not so to another, and things also to appear far otherwise then they are: He has likewise the art of limning [painting] in the perfection of it, and knows what may be done by colours.'[110]

Even so, Mather was forced to recognize, as were many others by this time, that giving the devil total power over visual appearances risked absurdity. He asks: would it not make 'living in the world' impossible? If God allowed it, how would 'men live on the earth'? Here, providentialism again provided the answer. Citing Joseph Glanvill on the matter, Mather argued that 'divine providence has taken care, that the greatest part of mankind shall not be left to unavoidable deception, so as to be always abused by the mischievous agents of Hell, in the objects of plain sence'. Without placing limits on God's actions it was possible to conclude that

what might not be allowed 'ordinarily' might still be allowed by him in extraordinary cases—Christ himself, after all, was falsely accused and condemned—to reveal the secret sins of men. '[S]hould there be a continual intercourse between the visible and invisible World, it would breed confusion', conceded Mather; but this did not mean that it never happened. In any case, it was rare for an innocent person impersonated by a devil not to be vindicated, for example, by having an alibi: 'So that perhaps there never was an instance of any innocent person condemned in any court of judicature on earth, only through Satan's deluding and imposing on the imaginations of men, when nevertheless, the witnesses, juries, and judges, were all to be excused from blame.'[111]

Mather went on to consider the parallel visual illusions (the 'false representation of persons and things') caused by magic and enchantments, so that a man sees what others cannot, or has 'spectral sight', 'second sight', or other gifts, while remaining innocent of any crime. The same was true of those who were under 'such power of fascination, as that things which are not, shall appear to them as real', examples being the metamorphosis of men into animals and all such 'prestigious pranks'. If a magician by an 'enchanted glass' could achieve such visual effects, 'he may as well by the help of a daemon cause false ideas of persons and things to be impressed on the imaginations of bewitched persons'. There were cases of cynanthropes, bitten by mad dogs, who saw themselves as dogs when they looked into mirrors. The main protection lay in legal procedure, on which Mather turned for guidance to the earlier English writers on witchcraft, notably Perkins, Cooper, and Bernard, citing the latter's *A guide to grand jury-men* to this effect: 'An apparition of the party suspected, whom the afflicted in their fits seem to see, is a great suspicion; yet this is but a presumption, tho' a strong one, because these apparitions are wrought by the Devil, who can represent to the phansie such as the parties use to fear, in which his representation he may well lye as in his other witness.' Mather reported that the issue was discussed by the New England ministers in Cambridge on 1 August 1692, who decided that impersonation was possible but rare 'especially when such matters come before civil judicatures'. Still, it was the task of any judge to decide whether 'such an one did afflict such an one, or the Devil in his likeness, or his Eyes were bewitched'.[112]

It was often said at the time that demonology, like apparitions, was a subject, as François Perrault put it, 'removed ... from our senses', and it should not now be too difficult to see why.[113] Throughout the very considerable intellectual history of early modern witchcraft belief and witchcraft trials, sensory delusion either by natural illness or by demonic intervention—and by both of these—was a constant theme. Over and over again, witches themselves, together with their victims and others, were said to be incapable of distinguishing between experiences—usually presented in *visual* terms—that were true and experiences that were false. We shall be looking again at the consequences of this when we come to consider the subject of dreams—to which witchcraft was so often reduced. But it already seems clear

that those who conducted the witchcraft debate confronted some of the most fundamental questions to do with the workings of the human mind and of human perception—especially concerning the power of the imagination, the force and effects of mental disturbances like 'melancholia', the difference between the sleeping and waking states, the operation of the senses, and the possibility of sensory delusion in the form of visual paradoxes.[114] Those involved in particular witchcraft episodes were, in principle, just as implicated; in 1621 the visitor to Newgate jail in London, Henry Goodcole, reported that he had asked a witch called Elizabeth Sawyer if she ever 'handled' the devil when he came near her 'because some might think this was a visible delusion of her sight only'.[115] But at whatever level they were confronted, such questions focused on the central issue of distinguishing reality from non-reality—of deciding, as witchcraft writers repeatedly put it, whether what was done in the imagination was also done 'realiter'. One might even argue that the witchcraft debate was the most important context of all in which to pose this issue during the early modern centuries. Witchcraft obliged and enabled early modern intellectuals to confront issues that went to the heart of contemporary epistemology—and in a way that perhaps no other subject could match.

Eventually, the discussions affected the stability of witchcraft theory and of demonology as a whole by impinging in interesting ways on two of the themes concerning vision broached elsewhere in this book—the concept of juggling and the arguments of the philosophical sceptics.[116] For two or more centuries writers of demonology compared the devil metaphorically and literally to a juggler with the consummate skill to deceive the eyes of spectators. Yet this played into the hands of those disbelievers in witchcraft like the Englishmen Reginald Scot, Thomas Ady, and John Webster, who tried to show that witches and devils had *nothing but* the skills of jugglers—certainly nothing more sinister. One of the principal aims of Ady's *A candle in the dark* (1656), for example, was to show that what was condemned in witchcraft by the biblical injunctions was its delusiveness not its reality: 'Thou shalt not suffer a *juggler* (prestigiator) to live', was how the law ought to be translated. Ady applied this interpretation to those who worked false miracles but also to the jugglers who practised in seventeenth-century English fairs and markets, whose visual deceptions (the details of which he took from Scot) were backed up with spoken charms to impress and confuse the spectators, and he did not think of the latter as meriting death. His fellow-countryman Sir Robert Filmer agreed that the Hebrew word for witch properly signified a juggler—one 'that did hold the eyes, that is, by juggling and sleights deceived mens senses'—being a derivation from the idea of 'changing the formes of things to another hew'.[117]

In this way, attempts to show how great the devil's powers were ended up demeaning them by comparing them with lesser ones. Henry More, for example, saw the threat in turning the devil into a trickster in Webster's definition of witchcraft as mere sleight of hand: 'As if a merry juggler that plays tricks of legerdemain at a fair or market,

were such an abomination to either the God of Israel, or to his lawgiver Moses; or as if an hocus-pocus were so wise a wight as to be consulted as an oracle.'[118] Joseph Glanvill too feared the sceptical implications of reducing, in the most extreme case of all, even the miracles of the New Testament to deceptions and delusions, without any 'visible marks and signatures' of their truth, conceding that this offered the 'shrewdest objection' to his own arguments for witchcraft against Sadduceeism. His reply to this objection was to turn from Satanism to theology—insisting (as Mather later spotted) that God would never have give human beings faculties 'only to delude and abuse us'.[119] But one wonders whether the devil could be exorcized from this particular argument so easily. Were not the theological, and indeed metaphysical, certainties that the belief in witchcraft was supposed to secure always liable to be undercut by the radical uncertainty attached to demonic phenomena?

It seems that giving the devil so much power to deceive the senses meant that the absurd situation came about, in epistemological as well as legal terms, in which the difference between the real and the virtual could no longer be guaranteed. It was, indeed, precisely the point of those who wished to remove the devil from the physical world of witchcraft altogether, that not to do so left that world in danger of perceptual chaos, given the powers to delude that were normally allowed him. In this sense, orthodox witchcraft theory was self-defeating, and there were signs of this, as we have seen, in the course taken by some witchcraft episodes themselves. As the seventeenth century went by, and certainly after Descartes had started to publish, it became easier to make Salazar's epistemologically sceptical case in Europe. But the basic argument was the same. By the 1650s, for example, Ady was saying that orthodox witchcraft belief prevented men and women from believing 'their own eyes with confidence'; it brought nothing, he said, 'but deceit and cheat upon us, both within and without'.[120] In 1677, Webster argued that to believe in witchcraft led to conditions of perception in which a man would not know 'his father or mother, his brethren or sisters, [or] his kinsmen or neighbours'.[121]

This was still not enough to undermine the case for the prosecution in one late seventeenth-century trial. In 1698 in his book *Sadducismus debellatus*, the lawyer Francis Grant (later Lord Cullen) explained that the principal alleged victim in the Bargarran (Renfrewshire) trial of twenty-five witches the year before (Scotland's last major witch hunt, in which Grant had been a leading, if junior, prosecutor), an 11-year-old girl called Christian Shaw, had been able to see witches who were invisible to everyone else. This was because 'Satan's natural knowledge, and acquired experience makes him perfect in the optics and limning: Besides that, as a spirit, he excels in strength and agility; whereby he may easily bewitch the eyes of others.'[122] These were obviously Mather's arguments being put to the 'wrong' use. By the early eighteenth century, by contrast, Francis Hutchinson could insist that the devil's powers over visibility and invisibility reduced the concept of the judicial alibi to 'a mere jest'.[123] But until then, the argument seems to have been able to work in contradictory directions. Sceptical writers pointed

out that the belief in witchcraft threatened the principle of the certainty of the senses almost to the point of breakdown, while the more conservative commentators insisted that *not* to believe in it did the same.

A last example of a text grappling with these paradoxes is Richard Gilpin's *Daemonologia sacra* (1677). Gilpin admitted the many deceptions in witchcraft but refused to extend them to all instances of the crime because this would mean 'dangerously overthrowing all our senses; so that at this rate we may well question, whether we really eat, drink, move, sleep, and any thing else that we do'. Appeal was still possible, he thought, to the physical reality of the things done by witches and 'attested by sober and intelligent persons who were eyewitnesses'.[124] Yet within a few paragraphs he was also saying that the usual *miraculum–mirum* distinction (which he repeated) contained 'the danger of delusion', because the devil had to be given the power to deceive 'the uncautious and injudicious' by presenting actions that passed for miracles but were in reality 'no more but deceptions of sense'. Again, Gilpin's points of reference were those we, too, have considered—the 'naturalists', like Della Porta, who removed human heads or gave men the heads of horses, the 'glasses of various figures and shapes' that tricked the eyes and fooled the brain, the melancholic apprehension of the reality of impossible things ('and that with confidence'), the 'speedy conveyance' of common jugglers. Why not the devil too, powerfully working 'upon the fancy and imagination; by which means men are abused into a belief of things that are not'?[125]

NOTES

1. I make the case for this in Clark, *Thinking with Demons*.
2. Jean-Pierre Camus, 'De la magie', in id., *Les Diversitez de Messire Jean-Pierre Camus* (11 vols.; Paris, 1612–20), ii. 272ʳ.
3. Thomas Aquinas, *Summa theologica*, pt. 1, q. 114, art. 4, in *Basic Writings*, i. 1052–3.
4. Del Río, *Disquisitionum magicarum*, 116 (bk. 2, q. 7). The work has been trans., partly in summary, by P. G. Maxwell-Stuart (ed. and trans.), *Martín Del Rio: Investigations into Magic* (Manchester, 2000); for this passage, see 81.
5. Del Río, *Disquisitionum magicarum*, 116 (bk. 2, q. 7).
6. Aquinas, *Summa theologica*, pt. 1, q. 114, art. 4; pt. 1, q. 111, arts. 3 and 4, in *Basic Writings*, i. 1053, 1027–9. The perceptual permutations regarding reality and appearance made possible by giving such powers to an 'enchanter' are well brought out by Steven Nadler, 'Descartes's Demon and the Madness of Don Quixote', *J. of the Hist. of Ideas*, 58 (1997), 49–50.
7. Alphonsus de Spina, *Fortalitium fidei* (Strasburg, n.d. [before 1471]), sig. Kiiiiʳ.
8. Ambrogio de' Vignati, *Tractatus de haereticis* (written *c*.1460), cited by Joseph Hansen (ed.), *Quellen und Untersuchungen zur Geschichte des Hexenwahns und der Hexenverfolgung im Mittelalter* (Bonn, 1901), 221–2.
9. Hansen (ed.), *Quellen und Untersuchungen*, 197–9; on Da Bergamo, see Walter Stephens, *Demon Lovers: Witchcraft, Sex, and the Crisis of Belief* (London, 2002), 23, 136–7.

10. Ulric Molitor [Ulrich Müller], *De lanijs et phitonicis mulieribus/ Tractatus de pythonicis mulieribus*, cited by Henry C. Lea, *Materials toward a History of Witchcraft*, ed. A. C. Howland, introd. G. L. Burr (3 vols.; London, 1957), i. 352 (from the edn. at Frankfurt am Main, 1580; 1st pub. 1489).
11. Silvestro da Prierio [Mazzolini], *Summae Sylvestrinae quae summa summarum merito nuncupatur* (Antwerp, 1581), 435 (Lea gives an edn. at Bologna in 1504); cf. id., *De strigimagarum daemonumque mirandis* (Rome, 1575), 8, 117–19, 127–38, 164–6, 168–71, 180–9 (1st pub. 1521). On Da Prierio, see also Ch. 9 below.
12. Cited in Cole, 'Demonic Arts', 625.
13. Cited in Lea, *Materials*, ii. 454–5 (Albertini), 459 (Toledo). The vast literature of casuistry is a rich further source for discussions of demonic sensory *praestigiae*: a typical example is Gregory Sayer, *Clavis regia sacerdotum, casuum conscientiae* (Venice, 1615), 235–6.
14. Del Río, *Disquisitionum magicarum*, 119 (bk. 2, q. 8).
15. Ibid. 113–14 (bk. 2, q. 6).
16. Otto Casmann, *Angelographia* (Frankfurt am Main, 1605), esp. 516–20; Hieronymus Zanchy, *De operibus Dei intra spatium sex dierum creatis*, in id., *Operum theologicorum* (8 vols. in 3; Geneva, 1605), i (vol. 3), cols. 191–5.
17. Jacob Heerbrand, *praes* (Caspar Arcularius, *respondens*), *De miraculis disputatio ex cap. 7. Exo.* (Tübingen, 1571), 5–6; cf. id., *praes* (Nicolaus Falco, *respondens*), *De magia disputatio ex cap. 7. Exo.* (Tübingen, 1570).
18. Thomas Erastus, *Repetitio disputationis de lamiis seu strigibus*, trans. Simon Goulart as *Deux dialogues... touchant le pouvoir des sorcieres*, in Jean Wier [Johann Weyer], *Histoires, disputes et discours, des illusions et impostures des diables*, ed. D. M. Bourneville (2 vols.; Paris, 1885), ii. 486, 465, 474–5.
19. Andreas Gerhard (Hyperius), 'Whether that the devils have bene the shewers of magicall arts', in *Two commonplaces taken out of Andreas Hyperius*, trans. R.V. (London, 1581), sigs. F4[r]–G2[r]. The text is an extract from bk. 2 of one of Gerhard's systematic works (or 'methods') of theology but I have been unable to discover which. Seventeenth-century Dutch Calvinist orthodoxy on the same subject is exemplified by Gijsbert Voet, 'De natura et operationibus daemonum', in id., *G. Voetii... selectarum disputationum theologicarum* (Utrecht, 1648–69), i. 959–60.
20. François Perrault, *Demonologie*, 2nd edn. (Geneva, 1656), 95–120, 121–34.
21. Thomas Lodge, *The divel conjured* (London, 1596), sig. Civ[r-v]; James Mason, *The anatomie of sorcerie* (London, 1612), 17–21.
22. William Perkins, *A discourse of the damned art of witchcraft*, pub. Thomas Pickering ([Cambridge], 1610), 157–8. Perkins was followed closely by Thomas Cooper, *The mystery of witch-craft* (London, 1617), 171–2, and cf. 54.
23. John Gaule, *Select cases of conscience touching witches and witchcrafts* (London, 1646), 218, 98.
24. I have not been able to consult Johann Christoph Schubart, *praes* (Paulus Nicolaus Einert, *respondens*), *Dissertatio de potentia diaboli in sensus* (Erfurt, [1707]).
25. George Gifford, *A discourse of the subtill practises of devilles by witches and sorcerers* (London, 1587), sig. Ei[r]; cf. Paulus Grillandus, *Tractatus de sortilegis*, in *Tractatus duo: unus de sortilegis D. Pauli Grillandi... alter de lamiis et excellentia iuris utriusque D. Ioannis Francisci Ponzinibii...* (Frankfurt am Main, 1592), 96, on the visible

shapes of demons as 'quasi naturalia, et similitudinaria'. The epistemological and cognitive issues raised by the assumption of virtual bodies are fully dealt with, with many wonderful examples, in Stephens, *Demon Lovers*, esp. 58–86.
26. Daniel Brevint, *Saul and Samuel at Endor* (Oxford, 1674), 45.
27. Theodor Thumm, *Tractatus theologicus, de sagarum impietate, nocendi imbecillitate et poenae gravitate* (Tübingen, 1621), 28.
28. Hermann Samson, *Neun ausserlesen und wolgegründete Hexen Predigt* (Riga, 1626), sig. Niii[v].
29. Meric Casaubon, *A treatise proving spirits, witches and supernatural operations by pregnant instances* (London, 1672), 157–8.
30. John Beaumont, *An historical, physiological and theological treatise of spirits, apparitions, witchcrafts, and other magical practices* (London, 1705), 343.
31. Nicolas Rémy, *Demonolatry*, ed. Montague Summers, trans. E. A. Ashwin (London, 1930), 52 (originally pub. as *Daemonolatreiae libri tres*, Lyons, 1595).
32. See [Heinrich Krämer (Institoris)], *Malleus maleficarum*, pt. 1, q. 9, ed. and trans. M. Summers (London, 1928; repr. 1948), 58–61. Stephens, *Demon Lovers*, 305–12, gives a full summary and commentary, and the description 'mechanics of *praestigium*' is his (305). Kramer's sources were the Aquinas passages we have considered and Johannes Nider, *Praeceptorium legis sive expositio decalogi* (Cologne, 1470?), sigs. C3[r–v] (bk. 1, ch. 9; written *c*.1440).
33. [Krämer], *Malleus maleficarum*, 119–20, in the trans. by Stephens, *Demon Lovers*, 307; cf. the similar passage at p. 125, rendered by Stephens (310): 'Devils can, with God's permission, enter our bodies; and they can then make impressions on the inner faculties connected to the bodily organs . . . [T]he devils can draw out images retained in a faculty connected to one of the organs. For example, he draws from the memory, which is in the back part of the head, an image of a horse, and transports that phantasm to the middle part of the head, where is the cell of imaginative power; and finally to the common sense, which is in the front of the head. And devils can cause such a sudden change and confusion, that such impressions are necessarily thought to be external things seen with the eyes.'
34. Stephens, *Demon Lovers*, 308–9.
35. [Krämer], *Malleus maleficarum*, 121; trans. Stephens, *Demon Lovers*, 311.
36. Del Río, *Disquisitionum magicarum*, 119–21 (bk. 2, q. 8); all quotations from these pages, unless otherwise indicated. The entire account of deceptions by visual object, medium, and organ was repeated by Francisco Torreblanca, *Daemonologia* (Mainz, 1623), 238–40 (bk. 2, ch. 15).
37. Despite this, the devil and witchcraft do not seem to enter much into ophthalmological discussions of eye impairments; although see, in a very widely cited text, the remarks on sorcery in Bartisch, *Ophthalmodouleia*, 231[r]–6[v].
38. Del Río, *Disquisitionum magicarum*, 207–17 (bk. 2, q. 24); cf. Torreblanca, *Daemonologia*, 237.
39. Del Río, *Disquisitionum magicarum*, 121 (bk. 2, q. 8).
40. Ibid. 315 (bk. 2, q. 29, sect. 2); trans. from Maxwell Stuart (ed. and trans.), *Martin Del Rio*, 114.
41. Petrus Martyr (Vermigli), *The commonplaces of . . . Peter Martyr*, trans. Anthonie Marten (n.p. [London], n.d. [1583]), 89[a]. On Martyr's views concerning 1 Samuel 28, together with further publication details, see Ch. 7 below.

42. John Deacon and John Walker, *Dialogicall discourses of spirits and divels* (London, 1601), 143.
43. Johann Christian Frommann, *Tractatus de fascinatione novus et singularis* (Nuremberg, 1675), 768: 'ita ut non videat ea, quae sunt, vel ea videat, quae non sunt, vel nihil plane videat.'
44. Ibid. 730–892 (bk. 3, pt. 6), esp. 767–97.
45. I refer not to art historical commentary on specific images of witchcraft, which has long been practised, but to the use of early modern demonology to elucidate concepts of artistic creativity and the power of the imagination; see esp. Swan, *Art, Science, and Witchcraft*, pt. 2; ead., 'Eyes Wide Shut', *passim*; Cole, 'Demonic Arts', *passim*. These themes also partially inform Patricia Emison's reading of Agostino Veneziano's *Lo stregozzo* in ead., 'Truth and *Bizzarria* in an Engraving of *Lo stregozzo*', *Art Bull.* 81 (1999), 623–36.
46. Plato, *The Republic*, 602, in *Dialogues*, iii. 316.
47. Locke, *Essay Concerning Human Understanding*, 304 (bk. ii, ch. 23, sect. 13).
48. Schott, *Magia universalis*, i. 36–7. François Perrault, a 17th-century Huguenot pastor in the Pays de Vaud, even specified the technique: 'If humans, by artifice and the use of certain candles, vapours, and smokes, can make it seem that a whole room is full of snakes, even though it is only the eyes that are deceived . . . then all the more reason to suppose that demons . . . can deceive and illude our senses by a thousand false and deceiving appearances. This they do either themselves or by magicians and witches': Perrault, *Demonologie*, 121. One of Kircher's and Schott's catoptrical illusions was precisely this—to make a room seem to be full of snakes.
49. Sebastien Michaëlis, *The admirable historie of the possession and conversion of a penitent woman*, trans. W.B. (London, 1613), 402; Sarah Ferber kindly alerted me to this reference.
50. Casmann, *Angelographia*, 569–71, 567–8.
51. Cole, 'Demonic Arts', 623, 625, and *passim*, giving many examples.
52. Raffaele della Torre, *Tractatus de potestate ecclesiae coercendi daemones circa obsessos et maleficiatos*, in *Diversi tractatus de potestate ecclesiastica coercendi daemones circa energumenos et maleficiatos*, ed. and pub. Constantin Munich (Cologne, 1629), 212–14, esp. 214: 'Si enim perspectivae dediti homines, efficiunt, ut lineae in tabula longa confuso ordine ductae, si e directo aspiciantur lineae rudes videntur et sunt, si tamen aspicis per foramen, aut tabula rotata speciem reddunt alicuius artificiosae imaginis, cur non hec, et mirabiliora efficiet daemon in omni arte peritissimus' (see also 212–23, generally, from the second part of the *Tractatus*, entitled *De potestate daemonum de magorum ad effectus mirabiles et prodigiosos*); cf. Torreblanca, *Daemonologia*, 239.
53. There are further striking examples of the devil as painter in Swan, *Art, Science, and Witchcraft*, 184–9. For the devil as actor, capable of representing any role, see Bernhard Waldschmidt, *Pythonissa Endorea, Das ist: Acht und zwantzig Hexen- und Gespenstpredigten* (Frankfurt am Main, 1660), 470.
54. 'Dr. H.M. his Letter, with the Postscript to Mr. J.G.', in Joseph Glanvill, *Saducismus triumphatus: or, full and plain evidence concerning witches and apparitions*, 3rd edn. (1689), ed. C. O. Parsons (Gainesville, Fla., 1966), 31.
55. The history of witchcraft and the history of ways of seeing have hardly begun to be considered together, but see Bernd Roeck, 'Wahrnehmungsgeschichtliche Aspekte des Hexenwahns: Ein Versuch', *Historisches Jahrbuch*, 112 (1992), 72–103.

56. Girolamo Visconti, *Magistri Hieronymi Vicecomitis Lamiarum sive striarum opusculum ad illustrissimum Mediolani ducem Franciscum Sfortiam Vicecomitem* (Milan, 1490), sigs. Bi[v]–iii[v].
57. Candido Brognolo, *Alexicacon hoc est opus de maleficiis, ac morbis maleficis* (Venice, 1668), 195 ('Signa . . . ex visu').
58. Thomas Ady, *A candle in the dark; or, a treatise concerning the nature of witches and witchcraft* (London, 1656), 125.
59. The text of the *Canon episcopi* is given in Lea, *Materials*, i. 178–80; for a much fuller discussion of this issue, see Ch. 9 below on demonic dreams.
60. Francesco Maria Guazzo, *Compendium maleficarum*, ed. M. Summers, trans. E. A. Ashwin (London, 1929), 50–1.
61. For just a small sample of moderately full discussions, see Del Río, *Disquisitionum magicarum*, 186–90 (bk. 2, q. 18); Petrus Binsfeld, *Tractatus de confessionibus maleficorum et sagarum* (Cologne, 1623), 162–71 (1st pub. 1589); Torreblanca, *Daemonologia*, 240–4 (following immediately on 'De sensus deceptione, tam interni, quam externi'); Casmann, *Angelographia*, 531–43 (borrowing heavily from Leonardo Vairo, *De fascino*, Venice, 1589); Adam Tanner, *Disputatio de angelis* (1617), in *Diversi tractatus*, 72–5. The subject is also treated as a vehicle for arguments about illusion in Stephens, *Demon Lovers*, 289–99.
62. Henri Boguet, *An Examen of Witches*, trans. E. A. Ashwin, ed. M. Summers (London, 1929), 136–55 (quotations at 146–7, 148).
63. A point recognized by Nicole Jacques-Lefèvre, ' "Such an Impure, Cruel, and Savage Beast . . . ": Images of the Werewolf in Demonological Works', in Kathryn A. Edwards (ed.), *Werewolves, Witches, and Wandering Spirits: Traditional Belief and Folklore in Early Modern Europe* (Kirksville, Mo., 2002), 186–7.
64. Prieur, *Dialogue*, 45[v]–6[r].
65. Ibid. 46[v]–7[r].
66. Ibid. 51[r].
67. Ibid. 51[v].
68. Ibid. 53[v].
69. Erastus, *Repetitio disputationis*, 427–8.
70. Beauvois de Chauvincourt, *Discours*, 28, 29–30 (my emphasis).
71. Burton, *Anatomy*, 387 (pt. 1, sect. 3, mem. 1, subs. 2); see Schleiner, *Melancholy*, 171–97, for further instances of the attribution of symptoms of bewitchment, esp. impotence, to melancholy, and Brann, *Debate*, 36–7, 206–7, 208–9, 212–13, 333–43, 395–6, for a variety of authors on the subject of witchcraft's relationship with melancholy.
72. Bernard, *Guide*, 29, citing Reginald Scot (amongst others) on this point and bemoaning the 'simple apprehension of the outward apparances of things, not imagining that therein is deceit' (40).
73. Scot, *Discoverie*, 185–6.
74. Ady, *Candle*, 124–5, 126–7.
75. John Wagstaffe, *The question of witchcraft debated. Or a discourse against their opinion that affirm witches*, 2nd edn. (London, 1671), 125–43; cf. 1669 edn., 68–77.
76. John Webster, *The displaying of supposed witchcraft* (London, 1677), 32.
77. Balthasar Bekker, *Le Monde enchanté* (4 vols.; Amsterdam, 1694), iv. 37–61.
78. [Marc Duncan], *Discours de la possession des religieuses Ursulines de Lo[u]dun* (n.p., 1634), 19, 49.

79. Cited by Michel de Certeau, *The Possession at Loudun*, trans. Michael B. Smith (Chicago, 2000), 132.
80. Ibid. 130.
81. Sarah Ferber, *Demonic Possession and Exorcism in Early Modern France* (London, 2004), 23–39.
82. Burton, *Anatomy*, 180–202 (pt. 1, sect. 2, mem. 1, subs. 2), 325–45 (pt. 3, sect. 4, mem. 1, subs. 2).
83. Guibelet, *Trois discours*, 268[r]–71[r].
84. For examples of those who subsequently used or recommended Weyer's arguments about Satanic visual deception, see Tobias Tandler, *Dissertatio de fascino et incantatione* (Wittenberg, 1606), 10–11; Godelmann, *Tractatus*, 7–12, 40 (bk. 2, ch. 2 and ch. 4: sep. pag.); Johann Matthäus Meyfart, *Die Hochwichtige Hexen-Erinnerung* (Leipzig, 1666), 226–7 (1st pub. 1636). The relations between imagination, melancholy, and witchcraft are now best approached via Swan, *Art, Science, and Witchcraft*, esp. 157–74, 180–4.
85. Pierre de Lancre, *Tableau de l'inconstance des mauvais anges et demons, ou il est amplement traicté des sorciers et de la sorcelerie* (Paris, 1612), 219 (bk. 3, disc. 5, sect. 7: 'Histoire mémorable des amours d'un incube').
86. Rémy, *Demonolatry*, 43; for a Calvinist treatment, compare Lambert Daneau, *A dialogue of witches*, trans. attrib. to Thomas Twyne (London, 1575), sig. Gviii[v].
87. Cited from Hansen (ed.), *Quellen und Untersuchungen*, 311 (for Latin); Lea, *Materials*, i. 375 (English).
88. Alonso de Salazar Frías, 'Second Report to the Inquisitor General' (Logroño, 24 Mar. 1612), in Gustav Henningsen (ed.), *The Salazar Documents: Inquisitor Alonso de Salazar Frías and Others on the Basque Witch Persecution* (Leiden, 2004), 280, 308, 314, 286.
89. For devils making *themselves* invisible to the eyes of outside witnesses at the sabbat by manipulating the light there, see Nicolas Jacquier, *Flagellum haereticorum fascinariorum* (Frankfurt am Main, 1581), 48.
90. Summary in Lea, *Materials*, ii. 625, from Petrus Thyraeus, *De spirituum apparitionibus* (1594), 107 (bk. 1, pt. i, ch. 13, n. 183).
91. Lea, *Materials*, i. 351.
92. Ibid. i. 372, 373.
93. Bartolommeo Spina, *Quaestio de strigibus* (1523), in Lea, *Materials*, i. 385 ff; cf. *Apologia de lamiis contra Ponzinibium* (1525), in Lea, *Materials*, i. 394; Joannes Franciscus Ponzinibius, *Tractatus de lamiis* (written *c*.1520), in Lea, *Materials*, i. 377. On Spina and the empirical evidence for witchcraft, see Stephens, *Demon Lovers*, 80–6. Lea, *Materials*, ii. 886–7, has a section on 'Evidence of Accomplices'.
94. Adam Tanner, *Tractatus theologicus de processu adversus crimina excepta, ac speciatim adversus crimen veneficii*, in *Diversi tractatus*, 17, 19; Paul Laymann, *Theologia moralis* (orig. pub. 1625), cited in Lea, *Materials*, ii. 681, from the edn. at Padua, 1733.
95. *Malleus judicum, das ist: Gesetzhammer der unbarmherzigen Hexenrichter* (1627), in Johann Reiche (ed.), *Unterschiedliche Schrifften von Unfug des Hexen-Processes* (Halle, 1703), 14. For a Lutheran version of the argument which does extend impersonation to other crimes, see Meyfart, *Hochwichtige Hexen-Erinnerung*, 227–37.
96. Friedrich Spee von Langenfeld, *Cautio criminalis, or a Book on Witch Trials*, trans. and ed. Marcus Hellyer (Charlottesville, Va., 2003), 194, 187; Latin orig., [Friedrich

Spee], *Cautio criminalis, seu de processibus contra sagas* (Rinteln, 1631), 331. On the unreliability of ocular proofs—proofs derived from appearances—concerning sabbat attendance, see also Waldschmidt, *Pythonissa Endorea*, 347–8.
97. Jacquier, *Flagellum*, 171–4 (ch. 26), on the 'false representation' ('falsa repraesentatio') of the accused at sabbats.
98. Charles Zika, *Exorcising our Demons: Magic, Witchcraft and Visual Culture in Early Modern Europe* (Leiden, 2003), 509.
99. Binsfeld, *Tractatus*, 295–6.
100. Ibid. 324, 322.
101. Ibid. 320; cf. Lea, *Materials*, ii. 626–7, summarizing Thyraeus, *De spirituum apparitionibus*, 108–10 (bk. 1, pt. i, ch. 14, nn. 192–208).
102. Spee, *Cautio criminalis*, 193–4; cf. Latin orig., [Spee], *Cautio criminalis*, 343–4.
103. Increase Mather, *A further account of the tryals of the New-England witches . . . To which is added, cases of conscience concerning witchcrafts and evil spirits personating men* (London, 1693), 'Postscript', sig. f3[r]. For a reappraisal of the relative weight of spectral and non-spectral evidence at Salem, arguing that no one charged only with the former was even tried, see Wendel D. Craker, 'Spectral Evidence, Non-Spectral Acts of Witchcraft, and Confession at Salem in 1692', *Hist. J.* 40 (1997), 331–58. Cf. Dennis E. Owen, 'Spectral Evidence: The Witchcraft Cosmology of Salem Village in 1692', in Mary Douglas (ed.), *Essays in the Sociology of Perception* (London, 1982), 275–301.
104. Cotton Mather, *The wonders of the invisible world; being an account of the tryals of several witches, lately executed in New-England* (London, 1693), 13 ('Enchantments encounter'd').
105. Ibid. 8, 7.
106. Deodat Lawson, *Christ's fidelity the only shield against Satan's malignity*, 2nd edn. (Boston, 1693), 63.
107. Paul Boyer and Stephen Nissenbaum (eds.), *Salem-Village Witchcraft: A Documentary Record of Local Conflict in Colonial New England* (Belmont, Calif., 1972), 118; the 'Return' was also printed in the 'Postscript' to Mather's *A further account*.
108. Ibid. 119, 118.
109. Mather, *Wonders*, 8, 13 ('Enchantments encounter'd'); Brian P. Levack, 'The Decline and End of Witchcraft Prosecutions', in Marijke Gijswijt-Hofstra, Brian P. Levack, and Roy Porter, *Witchcraft and Magic in Europe: The Eighteenth and Nineteenth Centuries* (London, 1999), 12.
110. Mather, *A further account*, 1, 3, 4, 8–9.
111. Ibid. 8–9, 10, 11–12.
112. Ibid. 14, 15, 18, 19. The second case of conscience that Mather went on to handle concerned fascination by the look of a witch, which he solved by considering extramission and intromission ('reception of the visible species') theories of sight; see esp. 23–4.
113. Perrault, *Demonologie*, 'Au lecteur'.
114. A similar point is made by Lyndal Roper, *Witch Craze: Terror and Fantasy in Baroque Germany* (New Haven, 2004), 106, and underlined by the reading of Jacques de Gheyn II's images of witchcraft in Swan, *Art, Science, and Witchcraft*, esp. 169–74, 175. There are further examples in Italo Michele Battafarano, 'Die Imagination in Hexenlehre, Medizin und Naturphilosophie', *Morgen Glantz*, 13 (2003), 73–96.

115. Henry Goodcole, *The wonderful discovery of Elizabeth Sawyer, a witch* (1621), in Peter Corbin and Douglas Sedge (eds.), *The Witch of Edmonton* (Manchester, 1999), 147.
116. I have explored these issues more fully in *Thinking with Demons*, 172–7, 568–70, from which some of the present examples are taken.
117. Ady, *Candle*, 1–90, esp. 10–12, 28–46; cf. 152; [Robert Filmer], *An advertisement to the jury-men of England, touching witches* (London, 1653), 17, 23. Cf. Bernard, *Guide*, 91, who gave as the Latin version of Exodus 22: 18 'Praestigiatricem ne sinito vivere', in the 'feminine gender'; Stearne, *Confirmation*, 8.
118. 'Dr. H.M. his Letter', in *Saducismus triumphatus*, 31, cf. 41. See also the similar argument against reducing the magic of Pharaoh's magicians (Exodus 7–10) to deception of the eyes in George Sinclair, *Satan's invisible world discovered*, orig. edn. 1685 (Gainesville, Fla., 1969), 'To the Reader', p. xxviii, see also xx; and Joseph Glanvill's warning against seeing Moses and Aaron as simply having 'more cunning and dexterity in the art of juggling': *Saducismus triumphatus*, 294.
119. Joseph Glanvill, 'Against modern Sadducism in the matter of witches and apparitions', in *Essays on several important subjects in philosophy and religion* (London, 1676), 34; repr. as part of id., *Saducismus triumphatus*, 103.
120. [Thomas Ady], *The doctrine of devils, proved to be the grand apostacy of these later times* (London, 1676), 84, 89, 91–2; for Ady, even granting the devil powers to perform real natural actions was an argument by which 'a man may affirm for truth any vain imagination'; see also id., *Candle*, 14, and 40, where Ady ridicules the scholastic optical theories used to explain juggling: 'some saying, *sensus nunquam fallitur circa proprium objectum*, some have said that the jugler by his familiar doth thicken the air, some again that he hurteth the eye-sight, and so deceiveth the beholders.'
121. Webster, *Displaying*, 175–6.
122. Cited by Michael Wasser, 'The Western Witch-Hunt of 1697–1700: The Last Major Witch-Hunt in Scotland', in Julian Goodare (ed.), *The Scottish Witch-Hunt in Context* (Manchester, 2002), 158.
123. Francis Hutchinson, *An historical essay concerning witchcraft*, 2nd edn. (London, 1720), sig. A4[r–v].
124. [Richard Gilpin], *Daemonologia sacra: or, a treatise of Satans temptations* (London, 1677), 31–2; cf. Richard Baxter, *The unreasonableness of infidelity* (London, 1655), 89.
125. [Gilpin], *Daemonologia*, 34–6.

5

Images: The Reformation of the Eyes

In terms of historical developments, the next important shock to early modern Europe's visual confidence was administered by the Protestant Reformation. Like so many other aspects of European life and culture, vision became the subject of fierce and unprecedented confessional dispute. Such was the role of images and of 'sacramental seeing' in contemporary religious liturgy and worship that things could hardly have been otherwise. Late medieval piety invested heavily in the sense of sight, supported by visual theories that gave eye-contact with objects of devotion a virtually tactile quality. Seeing the elevated host, the crucifix, or other sacred images meant touching them with one's own visual rays or being touched by theirs. Sight itself became spiritually efficacious, a direct and immediate engagement with the sacred.[1] But in the 1370s the Lollard John Wycliffe was already revisiting an old argument about spiritual belief being incompatible with the indulging of the senses—in the case of sight, with 'costly spectacles of church ornaments'. Two and a half centuries later, as we saw at the outset of this book, his fellow Englishman, George Hakewill, accused Catholics of placing 'a great and maine part of their superstitious worship in the eye-service', in which he too included church furnishings and vestments but also the elevation of the host and the use of pictures as teaching aids for the laity.[2]

As has often been remarked, the general aim of many pre-Reformation and Protestant critics of the Church in the intervening years, Lutherans least wholeheartedly perhaps, was to replace eye-service with ear-service—the image with the word. Most of them would therefore have subscribed to the view that while a blind person might perform true service to God a deaf one could not; even Luther said: 'Do not look for Christ with your eyes but put your eyes in your ears.'[3] The lines of division were, however, more complicated than this, partly because image-meaning and word-meaning could never be entirely distinguished but mainly because there was ambivalence about the issue anyway.[4] Many Catholics themselves sympathized with the arguments against images, feeling, as Erasmus did, that perfect piety meant turning 'away from visible things, which are for the most part either imperfect or of themselves indifferent', and seeking instead the invisible, or, at least, the word-paintings of Scripture.[5] Meanwhile, the Reformation tradition continued to generate its own 'extensive image repertoire' in controlled conditions, including even the pious contemplation of commemorative portraits

of the reformers themselves. Attempts were made on all sides to reconsider the balance between seeing and hearing and to advance the claims of each over the other. 'The real division', it has been said, 'was epistemological, between those who believed that humans could attain knowledge of divine reality through fleshly means such as images and those who believed that they could not.'[6] It was the latter view that led to the far-reaching denigration of vision that accompanied the religious upheavals of the early modern centuries.

In a quite precise way, Protestant attempts to demystify the perceptual field of religion arose from problems of visual reality. It was all too obvious to its enemies that Catholic piety was built successfully on religious experiences with a predominantly visual content. Images wept, hosts bled, souls or saints or angels appeared in physical form, while holy men and women saw visions or were seen performing miracles by others. Since Protestant theology no longer allowed for such experiences, or for miracles in general, they had to be discredited as visually deceptive—sufficiently good copies of true visual experiences to be virtually indistinguishable from them, and, thus, convincing as aids to faith, but ultimately not good enough copies to save them from exposure as clever counterfeits. In other words, both Catholicism's success and also its failure had eventually to be explained in terms of something very like the concept of virtuality. The Reformers, it has been said, exhibited 'an obsessive concern with visible signs' and invested much in 'investigating their validity'.[7] But nowhere did the issue of visual pretence seem more precisely focused, or with more paradoxical consequences, than in the Mass, the defining sacrament of the traditional Church and the subject of unrelenting cultural debate. Here, visual appearances—the visible *species* of the bread and wine—had themselves to be miraculously discounted in favour of invisible real substance, with perhaps the most serious consequences of all for an inherited model of cognition that assumed the opposite. According to one of transubstantiation's multitude of critics, this was to have 'a white thing, yet nothing white; a round thing, yet nothing round; a smell, yet nothing that smelleth; a taste of bread, yet nothing that tasteth; a breaking, and yet nothing that is broken; so that heere we have somewhat made of nothing and nothing made of somewhat.'[8]

But first there was the matter of images themselves—not just their relationship to the other ingredients of worship and whether they should be central, auxiliary, or altogether absent, but their relationship to their originals, the question of imag*ing*, and the nature and limits of religious representation. 'Discussions of idolatry', writes Margaret Aston, 'raised very basic questions about the nature of perception and the mind's image-forming processes.'[9] Iconoclasm, another scholar confirms, 'drew attention to the act of seeing'.[10] These were issues to which the Swiss Reformation—the Reformation originating in Zurich and Geneva, and imported into England—most frequently turned, defined as it was by the common aim of destroying superstition and idolatry and transforming the visual culture held responsible for them. Eventually, in 1563, in a decree that was as

crucial to artists as it was to clergy, the Council of Trent reaffirmed the principle that the honour shown to images was referred to the prototypes whose 'likeness' they bore. In the twenty years that followed, there was a corresponding flourish of theoretical responses to iconoclasm, culminating in the treatises of men like Nicholas Sanders, Johannes Molanus, and Gabriele Paleotti. In a century 'obsessed by the power of images', arguments for removing them from religious worship continued to be developed down to about 1580, and for retaining them down to about 1600, whereupon fresh thinking on the subject mostly ceased. There was no lack of opportunity, then, for doubts that struck at the heart of any straightforward assumptions about visual reality to be both expressed and rebutted.[11]

Images were offensive to most Zwinglians and Calvinists for reasons additional to their capacity to represent or misrepresent something else.[12] The Tudor *Homily against Peril of Idolatry* argued that even if an exactly lifelike image of Christ could be achieved, like the one 'made truly after his own proportion in Pilate's time' and carried around by the heretical Gnostics, it would still be unlawful to reproduce it and set it up in a church.[13] Idolatry was not defined by the worship of the visible in place of the invisible but by the worship of the creature in place of the creator, which could be done without any visual representation at all. It therefore extended way beyond the issue of images to embrace any form of transference of the attributes of God to a person, place, time, or object.

Even so, there is no doubt that iconomachs—and most notably the Calvinists—insisted on some of the paradoxes of representation itself, at least in the religious sphere, in which they were helped by a restructuring of the Decalogue that allotted the prohibition of images to a separate second commandment. For whichever way they were considered, whether in terms of deficit or excess, images were what Calvin called 'phantoms or delusive shows'.[14] Exodus 20, the very source of the commandments, spoke against the making of *likenesses*, and Reformed Protestants came to think that similitude was at the heart of all the religious representations they condemned, whether one chose to call them 'images' (*simulacra*) or 'idols'. Attempting to capture the likeness of the living, incorruptible, and invisible God in a dead and corruptible image was intrinsically absurd and therefore impossible, while realistic likenesses of dead religious persons ran the opposite risk of endowing them with too much life. In failure or in success, therefore, the sort of visual realism that arises from a perceived correspondence between image and original was rejected as a distortion of religious truths.

'To whom then will ye make God like?', Isaiah 40: 18 had asked (in the translation adopted in the *Homily*): 'Or what similitude will ye set up unto him? Shall the carver make him a carved image? And shall the goldsmith cover him with gold, and cast him into a form of silver plates?' The Lord had allowed himself to be heard in the Old Testament, explained the homilist, but not seen, lest he be

endowed with the shape—the 'bodily similitude'—of something (indeed, anything) that was visible:

For how can God, a most pure spirit, whom man never saw, be expressed by a gross body, and visible similitude? How can the infinite majesty and greatness of God, incomprehensible to man's mind, much more not able to be compassed with the sense, be expressed in a small and little image? How can a dead and dumb image express the living God?

To call an image a representation of God, capable of teaching things about him, was thus a travesty. To honour him in this way was, in effect, to dishonour him— diminishing his majesty, blemishing his glory, and, above all, falsifying his truth, said the homilist. To frame 'any similitude or image of God, like a mortal man, or any other likeness, in timber, stone, or other matter' was to tell a kind of double lie, since the framers tended to think it 'to be no longer that which it was, a stock or a stone, and took it to be that which it was not, as God, or an image of God'.[15]

Much the same was to be said about images of Christ—God and man—whose divinity was beyond visible expression and whose human form and appearance were unknown, despite the countless (and very different) effigies of him that all claimed to be 'true and lively'. Images of Christ were impossible on both counts, and the *Homily*, in another telling phrase, described them accordingly as 'not only defects, but also lies'. Images of saints were no better, since their souls were again beyond representation and their bodies (the shapes also unknown) lay putrefying in their graves. The point could not have been more starkly made; here were visual depictions that simply could not be what they claimed. 'As soon as an image of Christ is made', the text insisted, 'by and by is a lie made of him, which by God's word is forbidden.' Such an image, according to Thomas Bilson, owed everything to the artist, and nothing to veracity: 'The forme is nothing but the skill and draught of the craftsman, proportioning a shape not like unto Christ whom he never sawe, but his owne fancie leadeth him . . . and in that case you worshippe not the similitude of our saviour, but the conceite of this maker.' It was as though Christ had been incarnated, complained the divines of Switzerland in the confession of faith presented to Charles IX of France at Poissy in September 1561, 'to geve a paterne to carvers and painters'. The German reformer Abraham Scultetus agreed that an image of Christ was simply whatever 'the painter holds in his opinion to be the best'. It might just as well be of the high priest Caiaphas, wrote another denouncer of idolatry, the Englishman Henry Ainsworth, since it could no more resemble Christ himself than Henry VIII's portrait resembled Julius Caesar's. It was arguments like these, of course, that helped to justify the actual removal of images from individual churches—on the occasion of Scultetus' sermon, from the castle church in Prague in December 1619. But more important in the present context is the consigning of one of the most fundamental aspects of traditional religion, past and present, to the realm of visual error—to what Calvin himself thought of as visual fiction. Very many 'false Christs' were identified in early modern religious polemic, and there were all sorts of reasons for calling them

false. Not the least significant of these, it seems, was an appeal to a visual criterion of truth—an appeal from false to true representation.[16]

All this did not mean that the reformed religion was without 'images'. They lay, rather, in God's works and his word. He 'appeared' and could be 'seen' in all his material creatures—living signs rather than dead ones—and especially in men and women. If Christians wished to see images of their God, said the Elizabethan reformer William Perkins, they needed only to look at themselves, at the New Testament, and at the 'pictures' of Christ painted in language by preachers of his word. This idea also found its way into the *Homily* in the form of quotations from Athanasius and Clement of Alexandria, the latter playing on the principle of similitude by saying that although the image of God was in every man, the true likeness of God was not—only appearing in those with 'a godly heart and pure mind'. To honour God or Christ in an image thus meant to do well to human beings. Representational truth became a matter of authenticity of belief and behaviour, which were based in turn on the verisimilitude of a text. The New Testament, wrote the homilist, was 'a more lively, express, and true image of our Saviour, than all carved, graven, molten, and painted images in the world be'.[17]

But if images of God, Christ, and the saints were self-contradictory, and therefore deceptive in claiming what they could not possibly do, there was, nevertheless, a second hazard (and, indeed, absurdity) in their use, to do with what they appeared to achieve—that is, lifelike representations of religious figures. Margaret Aston reminds us that, at least in the early decades of the Reformation, images were still assumed to be literally 'graven', consisting, in the homilist's description, of 'gold, silver, or other metal, stone, wood, clay or plaster . . . ; and so being either molten or cast, either carved, graven, hewn, or otherwise framed and fashioned after the similitude and likeness of man or woman'. They were three-dimensional statues or sculptures of human shapes and they could be made, arranged, coloured, and dressed to create the maximum realism.[18] The danger, alluded to in virtually every Reformation attack on images, was that this faithfulness to life might be so convincing in visual terms that spectators, especially the unlettered and uninformed, could no longer distinguish the copy from its prototype. Indeed, anyone could fall into this error; Calvin cited Augustine's view that 'the shape of the idol's bodily members makes and in a sense compels the mind dwelling in a body to suppose that the idol's body too has feeling, because it looks very like its own body'.[19] The 'double lie' was precisely one of forgetfulness on the one hand and false acceptance on the other—of seeing an image not as a piece of wood or stone but as the person it represented.

Basing its remarks this time on the Book of Wisdom, the Tudor *Homily* complained that 'the ignorant and the common people are deceived by the cunning of the workman, and the beauty of the image, to do honour unto it', believing also that saints 'should in those places, yea, in the images themselves, have a dwelling'.[20] Many intellectuals, both before and during the Reformation, agreed with this in claiming that images of saints were taken to be the saints

themselves, and that prayers addressed to statues of the Virgin Mary assumed that she resided in them. What resulted was not simply an act of adoration but a set of expectations, called 'superstitious' and 'magical' at the time, about a real power in images to do things like heal sicknesses and protect from evil—expectations that were underlined by the many reports of miracles associated with them. In sentiments expressed, again, throughout early modern Protestantism, the English homilist felt it necessary to remind his hearers and readers repeatedly that images were dead things. They had eyes that could not see, ears that could not hear, and feet that led them nowhere, and without feelings or understanding they could not appreciate the many gifts and ornaments lavished on them. Such things were bestowed 'as much in vain, as upon dead men, which have no sense'. Equally, images had no power to help or harm anyone, or defend themselves from thieves, even though some of them held axes, swords, and spears in their hands. In cases of fire, they tarried like the 'blocks' they were and were consumed in the flames, while their priests ran away and were saved.[21]

Professor Aston is right to wonder whether the 'simple' and 'uneducated' ever did fall into this confusion, as well as to ask whether the identity of the things depicted in images is ever a clear-cut matter.[22] Contemporary opponents of the iconomachs were quick to point out that even a child—even an animal—knew the difference between an image and what it represented, but there were also many long-standing complaints within the Catholic tradition that this was not always the case.[23] Modern histories of popular piety in the late medieval and early modern period are full of examples of the treatment of images, both iconodulic and iconoclastic, where there is at least a suspicion that they were thought of as alive or, in some other sense, real, or in need of disenchantment.[24] In 1532, reported John Foxe, three men seized a rood from Dovercourt in Essex and set fire to it, 'without any resistance of the said idol'.[25]

Moreover, contemporaries related this particular feature of religious images to precisely the kind of visual paradox with which this book began—the one arising from the legend of Zeuxis and Parrhasius. In 1607 the Calvinist controversialist Robert Parker published an enormous treatise aimed at showing that the sign of the cross was an 'antichristian' ceremony which contravened each of the Ten Commandments. He reported that no less a figure than Robert Bellarmine had not just admitted but proved 'that images have been taken for the persons represented, because birds flew to Zeuxes grapes which he had painted taking them for grapes in deed'. What Bellarmine was implying, wrote Parker, was that while men who followed only their senses might indeed be misled by the 'corpulencie of a common image', those who followed their intellect would 'see' only spiritual values in the symbol of the cross. What Bellarmine had actually said was that if the image of a man could be painted, so could God's, since man was the image of God. To the objection that a man was only the image of God with respect to what could *not* be depicted—his soul—and not with respect to what could— his figure and appearance—Bellarmine replied that, if this was a true distinction

in art, then a man could never be depicted at all, for what constituted a man was not his external appearance but his substance and especially his soul. And yet men were said to be truly and properly portrayed in art. This was because the shape and colour of an image did represent the whole man, and not just his external appearance; otherwise it could never be made to seem that the depiction of something was the actual thing itself ('alioqui nunquam fieret, ut res depicta videretur res ipsa vera')—which is precisely what had happened with Zeuxis' grapes and Parrhasius' curtain.[26]

There is much else in Reformation iconomachy that prejudiced the eyes; in fact, the idolatry condemned in the Second Commandment was blamed entirely on them and on the visualizing (idol-making) process. It was repeatedly said, for example, that men and women found it impossible to conceive of a deity or accept its presence without turning it into a nearby shape or image; that this shape or image was likely to express only anthropomorphism; that it was an obstacle to further, more spiritual, understanding; and that looking at images not merely indulged the eyes but reduced their owners to folly. Images, insisted the *Homily*, were 'for fools to gaze on, till they become as wise as the blocks themselves which they stare on, and so fall down as dared larks in that gaze'.[27] Once they were set up, or allowed to remain in churches with warnings—the preferred Lutheran and Catholic Reformation option—idolatry was inevitable. Again, the homilist is to the point; idolatry was to images 'an unseperable accident'.[28] It was sentiments like these, expressed in the language of pollution and cleansing, that helped to make necessary their destruction, rather than just their removal. But most of all, it seems, this was due to the perceived dangers—and surreptitious powers—of similitude itself.[29] Of this confusion, the story of Zeuxis and his grapes was the perfect allegory, but in 1566 the authors of the Second Helvetic Confession made it Calvinist orthodoxy:

An image, as Lactantius states . . . has its name from delusion. However, the object of delusion is of necessity something false, and it can never be called true because it pretends to be true by means of its external appearance and imitation. So if all imitation is not the thing itself but only play, then there is nothing of religion in images. Hence let us fashion a better, higher and more spiritual notion of the Christ than when we look at him by means of paint and images, which differ from the truth as far as is possible.[30]

To iconoclasts who cried 'Look!' it was evidently important to pay attention to what was being *seen* when images turned out to be wood or stone, and hosts turned out to be bread: 'The eye, believed to have been dazzled earlier into seeing a god is forced to gaze more closely and see nothing but an empty thing.'[31]

Nevertheless, the enemies of images, educated as they were in the traditional Aristotelian epistemology, knew very well that they were not just the objects of external vision or constructed only in the external world. The human mind made its own internal pictures as part of the normal processes of perception and

understanding: mental imaging was nothing less than essential to thought. And if the mind had its own eyes, it might also have its own idols. Another of Professor Aston's many valuable findings is that mental idolatry was not only a particularly sixteenth-century concern but, in English catechetical literature at least, one that eventually overtook the misuse of physical images in churches as the main issue with which reformers thought they had to contend.[32] 'Idolatry standeth chiefly in the mind', insisted the homilist in 1563, echoing Calvin's statement that 'man's nature . . . is a perpetual factory of idols' and anticipating William Perkins's that 'So soon as the mind frames unto itself any form of God (. . .) an idol is set up in the mind.'[33] The human imagination became not only the inspiration for outward idolatry but an idolater itself. Indeed, the entire vocabulary of visual transgression could be applied to its workings, and that of iconoclasm to avoiding them. In effect, Protestant arguments depended on forcing a distinction between what was admitted to be an indispensable function of the brain and its outcome in one particular area of human experience—what Perkins called 'divine or religious use'. Mental imaging—and the *phantasia* in general—had to be relied on in every other context but not in religious worship, where they became not just imperfect but highly dangerous. But how could mental visualizing and imagery be banned in just this single domain? How could Perkins insist that 'the right way to conceive God, is not to conceive any form', but to think of him only in the abstract? It was the philosophical implausibility of this idea—of separating learning from seeing—that struck many Catholic intellectuals and formed the basis of their response to the iconomachs.

The defence of images raised as many non-visual issues as did the attack on them—for example, whether Old Testament prohibitions were still in force (and what exactly they had prohibited), whether there were different degrees of honour due to image and prototype, and whether image miracles could or could not be upheld. It also raised several visual issues unconnected to verisimilitude. Nevertheless, it was vital for Catholics during and after the Council of Trent to stress the natural and non-threatening aspects of representation that were at work in image-making and image use, and one obvious way to achieve this was to restate the very epistemology that the iconomachs seemed to be contradicting. If it was incontestable that mental images were part of the natural processes of learning, why were their physical counterparts not as allowable in religious observance? William Perkins himself admitted that '[s]ome man may thus object: when we think on God, we conceive an internal image or form of him in our minds, and that which we conceive we may *proportionally* set down by painting or carving. Again, if the internal form of God be lawfully conceived, why may not the external be made?'[34]

The English exile Nicholas Sanders, who participated in the final sessions at Trent as a theologian to the papal legate Cardinal Hosius, might have been one of the Catholic 'objectors' that Perkins had in mind. It was ridiculous, Sanders later wrote in his *A treatise of the images of Christ, and of his saints* (1567), to treat the

reference to similitude in Exodus 20 as a general prohibition of imaging, since God himself had created men and women in such a way that they could not 'learne, know, or understand any thing, without conceiving the same in some corporal image or likenes'. Knowledge itself arose from the mind 'printing' images and similitudes—indeed, *graving* them—in the 'phantasie' from information 'powred' into it via the common sense from the individual senses, chief of which were the eyes. To read of Christ on the cross was necessarily to form a mental image of him, 'with his hands stretched and nailed upon the woode', and to construct any outward version of this internal figure, must, in consequence, be equally allowable.[35] It was, indeed, a law of nature that human beings were 'naturally borne to learne by internal images', and to ignore or reject this was to act like a brute beast.[36] In effect, said Sanders (making a point emphasized in their own way by many English catechism writers), iconoclasts should start with 'theyr owne braines, which are more full of images (that I may not say of idols) then al the Churches in Christendome are'.[37] What was prohibited was not, of course, the making of images but their adoration, not merely by a particular people at a particular time, but throughout the history of the Church. The lessons of Old Testament idolatry were that images should neither be taken for false gods nor given the honour due to the true God, not that they should be abandoned altogether.

Nor could it ever be supposed that 'God his own Divine substance and incomprehensible nature maie be represented by anie artificial image'; this was not the issue either (it was ruled out by the Trent decree on images).[38] Much better, thought Sanders, to consider how the Incarnation had removed any possibility of idolatry altogether. Given our imperfect need to worship with the help of 'some bodily image', Christ's very manhood had provided a 'corporal truthe of bodie and flesh', lawfully representable in an image, 'wherein we might boldlie worship the divine substance'.[39] Sanders explained this in terms of a distinction between the inward nature (or substance) of an individual and his or her outward person (or subsistence). A son might be the natural image of his father, but any artificial image of him could only capture his person—in effect, his outward shape. An image was, after all, a copy of something, defined in terms of imitation; it must be 'in al pointes like and correspondent to' its original.[40] It followed that the images made by painting and graving could only represent what the painter or graver had actually seen. Since only the outward person could be seen, only that—and never the inward and invisible nature of someone—could be represented in art.[41] Nevertheless—and this was the crucial point—the worshipper (or any viewer of an image) could still be 'brought into remembrance' (or simply 'in mind') of the nature of the individual being depicted by the very act of seeing a representation of his or her person. It was no sin, in other words, to show by things that were seen, things that could not be.

But if no image of Christ could ever capture his nature (his divinity), then it could hardly be called a lie for failing to do so. Conversely, since Christ's person

had originally been seen (and touched) there was now no bar to truthful depictions of 'such an external shape . . . as he had in dede'. Just as were the apostles, so viewers of these images in the present would be carried 'upward' from his outward figure to his human nature (or manhood), and from this to his divine nature. The apostles saw the shape of a man and took the rest on trust, and so could sixteenth-century Catholics; beyond that shape lay belief and faith, not visibility. Sanders was bluntly empirical and realist about the issue: 'If then we paint [only] as muche as the Apostles sawe, our image is no more a lying image, then their sight was a lying sight.'[42]

The same criterion could be applied to things like the Trinity, whose shape and form (excluding Christ's) had never been seen by anyone, let alone any painter, and could not therefore be lawfully depicted. Even the visual testimony of visions and revelations had only ever established that the persons of the Trinity were three, not that they had specific shapes or forms—again, other than Christ's. Images of them might therefore signify this, and this alone. The angels, by contrast, had been seen by both prophets and apostles and might be portrayed, wings included, as could the cross with its bars. Sanders knew that visual images only existed in perfect form in people's heads, and that making them visible to eyes meant some kind of diminution. But, equally, the viewer of an image could mentally separate its material form from its content and, so to speak, repair the damage. Provided the image was not purely 'phantasticall'—that is a 'vaine idol' (by which Sanders meant that it had no true referent; 'no truth at al to be referred unto')—it was a straightforward matter to refer it ('joyn' it) instantaneously to the real person or thing it represented, discarding from visual attention the brass or iron or wood from which it was actually put together. In effect, no distinction existed in the viewer's mind between image and (true) referent, 'one thought, one moving, one act, and one intention' sufficing to bridge the perceptual distance between them. From eye to common sense and on to the imagination and the reason, Sanders's account of how an image of the Crucifixion was seen and understood was entirely traditional; and this, of course, enabled him to say what he really wanted to insist on—that a visual sign or token (a 'remembrance') of a truth might share in its worthiness and be treated with some of its honour.[43]

The whole argument turned on the difference between 'idols' and 'images', the first having false referents and the second true ones. Here too Sanders exploited conventional categories relating to visual error—what he called 'false shewes' and 'wrongful appeerings'—to make a polemical point. On the one hand, there were things that were false in the sense of not existing in the real world, of which there could therefore be no 'similitudes'. The mind might idly invent what the eyes could never have seen—men with dogs' heads or animal bodies, or creatures with multiple forms like the sphinxes of the Greeks. On the other, there were things that did exist in the natural world but which were false in the sense of not bearing the religious significance or benefits claimed for them. Gentile and heathen religion was idol based in both these ways, worshipping images that represented

either nothing at all or nothing conducive to salvation, whereas New Catholicism was free of either fault. 'Looke what proportion is betwene thing and thing', concluded Sanders, 'the same proportion is betwene signe and signe of those things.' The matter was definitional—Protestant objections were valid against idols but not against images, the latter term being reserved for copies 'referred and joyned' to honourable patterns and so able to share in their honour.[44]

The extent of Sanders's commitment to ordinary visual realism and its place at the very heart of both his psychology and his defence of images are also shown by the comparisons he makes between painting and oratory—between visual signs and verbal ones. Eloquence could certainly inform and persuade, he thought, but such was the mind's dependence on its own visual images that it could learn nothing from the orator without taking the trouble (the 'paine') to change 'the shape of [his] words into an other foorme, and thereof to have foormed a visible image'. The images of the painter, by contrast, were in complete affinity with the processes of the mind and, in effect, anticipated them, providing 'the very expresse foorme and figure already made, which my understanding must conceave'. The eye was thus the best and most spiritual of the outward senses, precisely because it was able to instruct the mind 'after that sort, as it apprehendeth every thing'.[45]

Arguments about these issues circulated extensively in Counter-Reformation Europe and many other examples of them can be found—even if Catholic aesthetics after Trent, especially in the versions defended by Johannes Molanus and Gabriele Paleotti, was more occupied with questions to do with the content, and especially the use (and abuse) of rules of decorum, of religious art.[46] These matters were not entirely separate, of course: one of the main themes of Counter-Reformation criticism, as expressed by Paleotti, was that of the painter's iconographical duty to imitate things in their natural state and just as they appeared to the human eyes.[47] The Catholic response to iconomachy could thus be as deeply committed to visual realism as the protests of the iconomachs. The latter complained that religious images could not, in principle, act as visual copies because all the proper objects of religious attention were invisible. Calvin, like Sanders, said that the only things that could be sculptured or painted were those that the eyes were 'capable of seeing', which meant either 'histories and events' or 'images and forms of bodies'. The first might conceivably be of use in teaching or admonition but the second were of no value other than to give pleasure.[48] As we have seen, Calvinists went on to say that in attempting to act as visual copies, religious images created spurious, inappropriate, and dangerous forms of verisimilitude—in short, they lied. In purist terms—in the Helvetic Confession, for example—no image could ever be called true, but this does not seem to have prevented verisimilitude remaining an acceptable attribute of the non-religious ones, which should normally conform to the visual reality of whatever they depicted. Luther thought that religious narratives could be represented 'as in a mirror' and even called these depictions 'Spiegelbilder' (mirror-images).[49]

Of Calvin's praise for art—the ornamental and recreational art of landscapes, still lifes, and portraits—Alain Besançon has written that it was eventually to become 'the program[me] of Dutch painting'.[50]

But for Sanders too, although the respect due to images, and, indeed, the very definition of what an image—as opposed to an idol—was, depended on the truth of *what* they depicted (their truth content, as it were), it also depended on what he called their visual nearness to their original, and here the criterion was entirely naturalistic. Images necessarily deserved respect because they 'reported' 'according to the imitation of nature'. An artificial image, he said, was 'more nighly joyned to the original veritie (in that it beareth the natural shape thereof) then any other thing is', excepting that original's own natural parts and components or its 'natural' image (representing, we recall, its true substance). It was precisely this which enabled it to act as an aid to devotion, carrying the worshipper beyond itself to the true original in whose honour and estimation it shared.[51]

Both their opponents and proponents, therefore, tied images very literally to what could actually be seen, as well as assuming in principle that they could accurately simulate any true visual experience. They differed over how far the category of visible objects extended in the religious world, as well as over the reliability of visual witnessing and the perdurability of visual memories—for example, of Christ's outward form. But, most of all, they differed over the value for religious observance of something to which, in all other contexts, they would have attached the same merit—that is, visually realistic or faithful representation. For the defenders of images, this remained a crucial vehicle of spiritual enlightenment—and the better the representation, the greater the enlightenment.[52] For the enemies, it became doubly disqualifying—the source of visual lies that gave forms to things without physical shape and life to things that were inert. As the debate raged through the better part of the sixteenth century, with many reprises during the seventeenth, so it gave widespread currency to the idea that the truth of a visual experience could be an uncertain and contentious thing.

If lying images were fundamental to Protestant attacks on traditional religion, so too were false miracles. Indeed, there was scarcely an issue that was as important to the concept of a true church. For the critics of Catholicism, miracles had defined the earliest days of the Christian faith and ensured its success and were therefore no longer necessary. As a consequence, such critics were committed, at least officially, to the doctrine of the cessation of miracles.[53] Needless to say, the proponents of Catholic reform, while recognizing problems of verification and credibility, could not but reaffirm the claims of the Church to be a repository of true miracles and of its priesthood to channel and administer their benefits to the laity. Accepted or rejected, the miraculous thus impinged in an unprecedented way on every aspect of religious conflict in the sixteenth and seventeenth centuries.

Not so obvious or well explored, however, are the implications of this situation for the visual culture of the period—and, in particular, for opinions about the

stability of visual experience. So insistent was the clamour directed at the genuineness of Catholic miracles—miracles of every kind—that it is easy to forget that most of these attacks raised visual dilemmas as well as doctrinal and ecclesiological ones; easy to forget too that the Protestant equivalents (wonders, 'providences', and so on) must often have raised them as well. What, after all, did true and false mean when applied to miracles? The criteria may ultimately have been non-visual (for example, that miracles were supernatural occurrences, not preternatural ones) and the reasons for occurrence or non-occurrence may have been theologically abstract and theoretical. But the miracle that was experienced and then described and reported was a matter for the senses—and for vision, in particular. It hardly needs to be said that if miracles were not seen their entire point was lost: 'There was never any miracle read of', wrote Philippe Du Plessis-Mornay, aiming his remarks particularly at the Mass, 'whose effectes were not clear and manifest to the sences'.[54] Once the Reformation was under way, however, the visual identity of the miraculous became as precarious as its theological and liturgical status. For Protestants, *all* miracles since the days of the early Church were spurious and every single one of them had to be explained away—bearing in mind that they also thought of Catholicism as miracle bound. This staggering claim raised, at least in principle, the equally far-reaching but unavoidable question: what then had the witnesses to them actually seen? In answering it, the Protestant Reformation adopted and then vastly extended the language of visual deceit—an entire vocabulary of error, delusion, and imposture that reduced this particular kind of seeing to uncertainty.[55] In one way or another, false miracles were convincing visual copies of (what would have been) real ones: they *looked* exactly like them. Once more, a visual experience that had been relatively stable and uncontroversial turned into one that was not, and, given the sheer extent of the literature, on a massive scale.

We can begin to see this from the typology of false miracles that Protestant controversialists came to adopt—sometimes explicitly, usually implicitly—once the early modern miracle debate was in progress. Not all Catholic miracles were visually deceptive, of course. Many, they urged, had simply never occurred at all and were nothing more than 'mere tales'. Here the issue was not so much what exactly people had seen; rather it was what they had chosen first to invent and then to believe and how these myths were to be dismantled. Other miracles were false in a moral sense—in terms of their authorship and purpose, rather than their physical reality or their perception as real by witnesses. They involved real occurrences and real effects but none that were genuinely miraculous, that is, beyond nature. These were *mira* (natural wonders) not *miracula*, the devil's failed attempts to mimic divine power and lead men and women from the truth. Again, visual criteria were not necessarily involved, since a demonic wonder might be correctly apprehended (seen) even if it was wrongly interpreted (seen *as*).

All other miracles, however, were visually compromised, to the point of intractability. They were false because they were never what they visually seemed to be: they were things that happened only in outward appearance—'onely in

shew'. This was the most capacious category of all. Into it fell an entire history of clerical artifice—all the priestly impostures and tricks which, wrote a Spanish Calvinist, 'were seene to happen, but were not true miracles, though they seemed to be such to the spectators'.[56] Into it too fell much of demonology, since the devil (as we saw earlier), besides his capacity to produce real effects, could manipulate every form of appearance and present things that were entirely counterfeit to the senses. These included perfect visual copies of even the miracles he could not really perform, as well as all those the Catholic clergy could no longer perform, thus rendering the visual identity of a true miracle entirely ambiguous. In this key category could be found another agent of total sensory dissimulation and deceit, the Antichrist, whose 'signes, and lying wonders' contributed crucially to the maintenance of his power over the false church and also to the delusion of its members, and of antichristians everywhere, by false perceptions. And finally, embraced by the category of 'shews' too was the miracle on which, in a sense, all the others depended, the miracle of transubstantiation in the Mass.

It is impossible to convey in a few pages, or with a few citations, how thoroughly the anti-Catholic literature of the early modern period—naturally, a huge category of speaking, writing, and publishing in itself—became committed to these concepts, how constantly the idiom of visual deception was adopted, and how pervasively words like 'lying', 'juggling', 'dissembling', 'duping', and 'conjuring' were used to convey the miracle's literal, and not just not metaphorical, essence. John Bale captured the essence of the charge when he referred in *The actes of Englysh votaryes* (1546) to 'prestygyouse Papystes', but we are dealing here with a polemical style of such generality and familiarity that it can be met with everywhere in Protestant Europe and in every form and genre of Protestant and, later, 'Enlightened', expression through the eighteenth century and beyond.[57] Even so, there were particular episodes of alleged priestly fraud and trickery that seem to have seized the reformed imagination and become iconic as a result. These can be allowed to stand in for the countless others.

One was the execution in Berne in 1509 of four friars accused of perpetrating a whole series of false miracles in the Dominican cloister, as part of a long-running dispute with the Franciscan order over the Immaculate Conception (which the Franciscans argued for, and the Dominicans against). They made hosts become miraculously red with Christ's blood, acted out several apparitions of various saints, including Barbara and Catherine of Siena, and many of the Virgin herself, and eventually constructed an image of her and (in John Foxe's account) 'by privy gins, made it to stir, and to make gestures, to lament, to complain, to weep, to groan, and to give answers to them that asked; insomuch that the people therewith were brought in a marvellous persuasion' concerning the controversy.[58] These allegations and their outcome were quickly publicized in Latin and German pamphlets, among them one by Nicolaus Manuel (with images; see Figs. 14–17), and subsequently made their way into many of the chronicles

consulted by Protestants all over Europe.[59] The story also circulated widely and in several languages by virtue of a lengthy summary in Ludwig Lavater's *Von Gespaenstern* and briefer citations in the Protestant Antichrist tracts of Rudolph Walther, Nicolas Vignier, and Thomas Brightman.[60] In England it was acknowledged by Thomas More and elaborated on by John Foxe, and then found in all the later miracle analysts who drew on Foxe—which most did.[61] What seems to have been its last main outing in the British Isles in the seventeenth century, in a lengthy pamphlet by William Waller the younger, was inspired by the executions that followed the Popish Plot.[62]

England had many of its own candidates for what Thomas More accepted were 'fayned' miracles and Francis Hastings attributed to 'the craft and conveiance of idle monks'.[63] During the reign of Henry VII, for example, a holy woman of Leominster survived for a while in a rood loft without meat or drink, just 'aungels food', until the miracle by which the host flew to her mouth 'as though it came alone' was shown to involve a device with a thin hair attached to it.[64] Foxe reported from 1531 the 'heretical' belief 'that when there is any miracle done, the priests do anoint the images, and make men believe that the images do sweat in labouring for them'.[65] In 1608 an elderly man called Robert Shrimpton recalled an image at St Albans in Hertfordshire, 'wherein one being placed to govern the wires, the eyes would move and head nod, according as he liked or disliked the offering'.[66] The Tudor *Homily* itself spoke of weeping, sweating, and talking images and (the Englishman) Nicholas Sanders of 'the great abuses which have bene wrought about holy images, in making their eies to move, their lippes to wagge, and so foorth'.[67] According to John Jewel, in the days of Catholicism 'idols could go on foot, roods could speak, bells could ring alone, images could come down and light their own candles, dead stocks could sweat and bestir themselves, they could turn their eyes, they could move their hands, they could open their mouths...', all by means of 'engines and sleights... conveyances and subtilties... strings and wires'.[68]

The defining moment for English Protestantism in this respect was the unmasking of the rood of Boxley, near Maidstone in Kent. Foxe reported the removal of several images the same year ('of Walsingham, Ipswich, Worcester, the Lady of Wilsdon, Thomas Becket, with many more'), 'having engines to make their eyes to open and roll about, and other parts of their body to stir, and many other false jugglings'.[69] Installed in the twelfth-century Cistercian abbey there sometime before 1432, the Boxley rood had long been a site of pilgrimage and veneration for its miracles but on 24 February 1538 it was denounced as a deception (which was physically demonstrated) in a sermon on idolatry given at Paul's Cross by the Bishop of Rochester, John Hilsey. Allegedly, its eyes and lips were moved mechanically by hidden 'stringes of haire', and it was said to contain 'certain engines and old wire, with old rotten sticks in the back of the same, which caused the eyes to move and stir in the head... and also the nether lip in likewise to move as though it should speak'.[70] Foxe himself suggested that these effects

could have been produced by someone enclosed inside, 'with a hundred wires within the rood, to make the image goggle with the eyes, to nod with his head, to hang the lip, to move and shake his jaws, according as the value was of the gift which was offered'.[71] Eventually, as the story of its downfall became more and more embellished, the device was given so many lifelike attributes that it came to resemble not just a puppet but an automaton. In 1576, for example, William Lambarde wrote that

in straunge motion, varietie of gesture, and nimblenesse of joyntes, [it] passed all other that before had beene seene: the same being able to bowe downe, and lift up it selfe, to shake and stirre the handes and feete, to nod the heade, to rolle the eyes, to wagge the chappes, to bende the browes, and finally, to represent to the eye, bothe the proper motion of eche member of the bodye, and also a lively, expresse, and significant shewe of a well contended, or displeased mynde, byting the lippe, and gathering a frowning, frowarde, and disdainefull face, when it woulde pretende offence: and shewing a most mylde, amyable, and smyling cheare and countenaunce, when it woulde seeme to be well pleased.

One senses in this elaborate and exaggerated depiction (far removed from anything the deceit might originally have achieved) a striving after what, in a sense, the Protestant campaign against false miracles required—the possibility of total illusion. The Boxley contrivance featured prominently in the propaganda and folklore of English Calvinism not simply as an infamous example of Catholic duplicity but as a virtual human being.[72]

In Portugal (then annexed to Spain), European Protestants found an equivalent example of a real human being feigning miracles in the story of María de la Visitación, a Dominican nun of the convent of the Annunciada in Lisbon. During the 1580s she received visits from Christ that left the marks of the stigmata on her body and the wounds from his crown of thorns around her head, each of which subsequently bled. She also effected miraculous cures through things she had touched, consumed hosts that flew to her unaided, levitated while in prayer, and gave off a mysterious bright light in her cell. In 1588, in the course of an investigation by local clergymen and inquisitors, the stigmata were washed off, the bleeding shown to be self-induced, the levitation attributed to special shoes and wooden steps, and the divine glow explained as candlelight reflected in a mirror.[73] The main propagandist in this instance was the Spanish Calvinist Cipriano de Valera, who wrote an account of the scandal entitled *Enjambre de los falsos milagros y ilusiones del demonio . . .* (1588) and added it to two treatises of his on the papacy and the Mass, all of which were translated into English in 1600 by John Golburne.[74] Besides making comparisons with the Berne case, other false *beatas*, and the holy maid of Kent, De Valera's framework was the, by now, usual one of specious doctrines confirmed by visual illusions—dreams, fake apparitions, and 'visions of phantasmes of spirits and soules come (as they say) from another world'. The investigators had declared María's particular fictions not to be demonic, but even if she herself had 'fained' all the visions, who else but the devil

could have performed her healing miracles, vouched for as real by respectable professionals?[75]

In each of these three instances there were, of course, powerful political agendas at work—ideological and institutional interests and rivalries that were responsible for what originally occurred and how it was subsequently represented. But authenticity and accuracy are not the issues that matter here. What is important is the scale on which a Protestant tradition developed of exposing the piety associated with the miracle as visually deceptive. These examples and others like them were widely known and they were specifically associated with delusion of the eyes. It was said of the principal victim of the Berne Dominicans, a novice named Jetzer (who, with nice irony, escaped from imprisonment in disguise), that after being deceived so many times he developed 'such a habit of incredulousness, that he would hardly believe his own eyes'. When the friars produced tears of blood from their image of the Virgin, it was done so naturalistically that even the practised eyes of a professional deceiver—a local Freiburg painter—'could not discern the imposture, though it was put to him'. An ordinary curate from Berne, on the other hand, declared that he had looked at the tears 'with the best eyes he had' and that they were faked—and faked precisely *by* a painter (he said that they were 'nothing but red enamelled drops, with excellent art laid on her cheeks and eyes'). Apparently, the city of Berne became divided over a dispute which had the broadest ramifications; it was the view of a local canon that 'if the testimony of our eyes could not be believed in this cause, it would call in question the truth of the bodily presence of Christ in the Mass'.[76]

In England too, there were constant reminders that false miracles were visual experiences that could not be relied on. Those of the holy woman of Leominster were done 'in syght of the people with an hoste unconsecrate, and all the people lokyng upon'. The 'Declaration of the Faith' that circulated in 1539 among those close to Thomas Cromwell spoke of the way the Boxley clergy had devised 'prestigious ymages of Crist crucified', a specific reference (via the Latin word *praestigium*) to delusion of the eyes. According to Foxe, Catholicism was an abuse of 'the people's eyes'; it had emptied their purses but also 'beguiled' their senses. Lambarde's phrase 'to represent to the eye' is perhaps the most telling of all, capturing with precision both the role of the Boxley image and the dilemmas it caused. María de la Visitación's use of a primitive optical technique was thus symbolic. To create the impression of shining with a miraculous aura she had apparently 'kindled in a chafing dish a fire with small light, and put before it a lookeing glasse, [so] that the light stroke upon the glasse, and the reflection of the glasse [was] glimpsed in her face'. This exactly complemented Satan's ability to appear next to her, 'transforming himselfe into Christ our lord, and taking his forme upon him', and his conveying of hosts to her mouth, 'viisible [*sic*] coming through the aire', without any apparent means of support. By contrast, the symbolism in De Valera's plea to his countrymen may well have been overridden by its literal meaning: 'Open then thy eies, O Spain, and understand.'[77]

Protestants went on deploying this polemical style and exploiting its potential throughout the sixteenth and seventeenth centuries, in a literature far too vast to survey here but extending at least to Bishop Burnet and no doubt beyond. In England it is perhaps most typically represented by the writings of miracle denouncers like Samuel Harsnett, Richard Sheldon, and the indefatigable John Gee, the last two being converts from the Catholic Church. Gee was author of *The foot out of the snare* (1624) and *New shreds of the old snare* (1624), each of which catalogued the 'juggling knavery' and 'dog-tricke inventions' of priests and Jesuits—for example, the apparitions (called 'visibles' by Gee) produced by 'paper lanthornes or transparent glasses to eradiate and redouble light, and cast out painted shapes by multiplication of the *species visibiles*, and artificiall directing of refractions'.[78] Sheldon published *A survey of the miracles of the church of Rome* (1616), arguing that miracles could never guarantee the certainty of a church when so many of them were counterfeited by demons and magicians or could not survive the scrutiny of 'an indifferent and an unpartiall eye'. Scholasticism itself taught that Satan could copy anything, 'either by transfusion of *species* into the ayre, or by casting some cloudy or aerie resemblance; or else by corrupting and deceiving the phantasies of the beholders', with the implication that miracles were things that did not happen. But, claimed Sheldon, the English recusants had gone one better in the case of a young woman who had come away from the execution (and dismemberment) of the priest Edmund Gennings in 1591 with one of his consecrated thumbs, which had obligingly offered itself up as a relic 'invisiblie' to all the spectators. Sheldon sarcastically offered three 'explanations':

whereas the standers by did not observe or could not observe the miraculous parting of the thumbe from the hand, the same is to be imputed to Gods speciall power (or to the divels ministery by Gods permission) by which their senses were bound; or secondly, some mist [was] cast before them; or else thirdly the virgin and the thumbs were made strangely and prodigiouslie invisible, so that the standers by could not[,] *apertis oculis*, behold so sensible and apparent an action done before them and in their sight.

On this occasion, taunted Sheldon, prestiges were being drafted in to show that miracles were things that did *not* not happen.[79]

At a level beyond episode and anecdote, although always informed by these, the Protestant case that 'false miracles' were visually deceptive rested on demonology and eschatology. The first of these was explored in my last chapter, but the second requires attention here, expressed in the form of charges of 'antichristianism'. To call Catholic miracles 'antichristian'—as they invariably were by Protestant reformers—gave the campaign against visual delusion a specific scriptural foundation in key New Testament texts that spoke of 'lying' signs and wonders designed to seduce even committed Christians.[80] It also gave that campaign a historical foundation in the apocalyptic narrative that reformers derived from Revelation and applied fairly literally to the errors and persecutions that they wished to

remove from a supposedly 'antichristian' church. It made possible endless applications of the motif of sensory deception, whether literally or metaphorically interpreted, to any aspect of a church that was thought of as entirely false. But most important in the present context, it provided definition and precision for the idea of deception itself. Traditionally, the power of the Antichrist was twofold; it was upheld by tyranny and cruelty but also sustained by false appearances. The reformers were therefore able to exploit an established model of consummate deception—of appearances that were almost perfect replicas of the real thing. The Antichrist was archetypal in this respect, the symbol of absolute opposition combined with exact imitation. One of his Calvinist analysts, Lambert Daneau, wrote that the Antichrist's aim was to 'counterfaite as neere as was possible' the works of Christ, using 'craftie couzoning, and deceipt, and that under the goodlie pretence of godlinesse and of holie mysteries'.[81] In this duplicity, false miracles played a crucial role, just as true ones did in real Christianity. To those who believed that all miracles had ceased, the legend of the Antichrist explained not only why Catholicism continued to claim them but also how it could have duped 'even the elect' so successfully in the past. In the days of the Antichrist, wrote John Jewel, '[e]very country was full of chapels, every chapel full of miracles, and every miracle full of lies'.[82]

The extent to which this very old eschatology, embracing a long history of religious deception from Simon Magus onwards, was reemphasized and reanimated by the upheavals of the sixteenth century is now generally recognized.[83] Less appreciated is the impact of the almost obsessive concern with 'antichristianism' on the visual culture of the period. The Antichrist's 'lying' wonders conformed to the usual typology of falseness—if they were not, via St Augustine's comments on 2 Thessalonians, one of its inspirations.[84] If anything was actually achieved in the sense of being physically real (in the sense of 'things being such as they are seene'[85]), this was nevertheless false in every other way—formally, because it was achieved by using natural causes and not, as true miracles were, without them; efficiently, because it was done by the devil; and morally, because its intention was to corrupt and mislead. For the most part, however, nothing real was achieved at all; antichristian miracles were false in terms of their material causation because they were nothing more than visual illusions. The Antichrist's 'figures' were called 'lying', said Daneau, because 'for the most part they bee but meere illusions: not the thing it selfe which seemeth to bee done, and so appeareth to the eye'.[86]

This was an opinion repeated across Protestant Europe. In Zurich, Heinrich Bullinger spoke of some feats that were done 'in very dede', arising 'oute of no phantasye or imagynacion', but of others that 'by a false appearaunce do deceave men' with a 'false symilitude'. Another Swiss Protestant, the Zwinglian Rudolph Walther (Gualtherus) divided the 'false tokens' of the Antichrist into real demonic effects, 'that we heare or see done', and things like the 'miracles' of Berne: 'signes feyned, that are false in dede, wherby it is thought to be done, that is not done in dede . . . sleighty wiles, frauds, enchauntementes, and al deceaveable trickes.'

From francophone Calvinism, George Pacard wrote that some antichristian 'miracles' were physically what they seemed to be ('selon qu'elles sont veues'), even if they were not miraculous, but the rest were either purely imaginary, like the false *species* that arose first in the imagination and then in the eyes of 'phrenetiques', or were produced by demons acting exactly like jugglers and 'joueurs de passe passe' and making bodies from air that seemed visually real to the spectators. The divinity professor at Heidelberg, Georg Sohn, divided them into 'mere fables, or else, juggling sleights', the latter performed by priests or by the devil. Across Britain, Calvinists were in agreement with John Jewel, who in his commentary on 2 Thessalonians explained that all the visions, apparitions, and ghosts of English Catholicism—all the images that could walk, speak, sweat, and move their eyes, and all the 'sleights' and 'conveyances' that made this happen—were merely 'shews', 'visards', and 'colours', that is, 'miracles in sight, but in deed no miracles', miracles that only 'possessed' the eyes. Thomas Tymme, the rector of parishes in London and Suffolk, described the 'lying wonders' of 2 Thessalonians 2: 9 as illusions 'which beguile men under a false forme'. In Scotland, the Rector of Edinburgh College confirmed that the antichristian church was a 'counterfaiter' and that its wonders were, if not simply natural effects, 'onely delusions, nothing in substance, onely juglerie, [and] deceiving of the senses of men'. From Wales, in the form of a Paul's Cross sermon by the Montgomery preacher Thomas Thompson, came the view that such wonders were 'ficta non facta, coozening tricks, done in the sight of men, but deluding the same'.[87]

In 1610, in his *Théatre de l'Antechrist*, commissioned by the synod of La Rochelle three years before, the Huguenot pastor of Blois Nicolas Vignier drew together almost a century of such Protestant reflections on the Antichrist from across Europe. His examples of 'lying miracles' were, by now, standard—Satanic 'prestiges and illusions' like those of Pharaoh's magicians, evil spirits masquerading as angels or souls of the dead, and demons voluntarily abandoning the possessed or the sick when priests or saints had supposedly intervened. Vignier's categories were also the usual ones: the miracles of the Catholic Antichrist were either not real or not miraculous. Among the first were events so ludicrous as not to seem even plausible, but others that could easily have been perceived as true. This was because the very senses of men and women had been imposed on, 'so that falsehood might be received in the place of truth'; their eyes, in particular had been 'bewitched', so that they 'believed they saw what they did not see' ('ils creussent de voir ce qu'ils ne voioient [*sic*] point'). An example had occurred in the year 870, when, according to Baronius, the paint on an image of the Virgin turned into flesh on the surface of the wood, which then ran with an odoriferous oil. Nobody dared touch the painting but all were allowed to gaze at it. The reason, explained Vignier, was the fear

that this painting would not be able to deceive the fingers of those who touched it any more than Parrhasius's curtain, having deceived Zeuxis's eyes, could deceive his fingers when he thought to draw it aside, or [any more than] the grapes of Zeuxis which had completely deceived the eyes of the birds.[88]

Significantly, Vignier went on to cite the painted image at Berne that had shed tears of blood (as well as the host coloured with vermilion), other crying Virgins, and the simulations of the Abbess of the Annunciada—before attempting to prove that the Antichrist's biblical miracles, including making images speak, were exactly matched in papal history. But nothing in his argument is quite as significant—in the present context at least—as his appeal to Pliny's famous story about the visual paradoxes of the art of still life.

The Antichrist debate, alive through most of the sixteenth and seventeenth centuries, was anything but one-sided; it embraced, said one of the principal Catholic protagonists, Florimond de Raemond, everything over which the two main faiths disagreed. The medieval Catholic tradition had, after all, nourished the Antichrist legend in the first place and the subject was lively enough on the eve of the Reformation for the fifth Lateran Council of 1513 to pronounce a ban on preaching about it. Nevertheless, prominent preachers throughout Catholic Europe later took up the theme with enthusiasm, providing plentiful charges of 'antichristianism' to throw back at the Protestant heretics. Many came to see Luther and Calvin as precursors of the Antichrist, above all the authors of the two most authoritative Catholic pronouncements on the subject, Robert Bellarmine and Thomas Malvenda. Eschatology of this type was undoubtedly common to religious thinkers on both sides of the great religious divide, therefore, and this gave the concept of the 'false miracle' even greater extension and currency.[89]

Since Protestantism inevitably presented fewer targets in this respect, the main task of the Catholic polemicists was a negative one—to deny that there was anything 'antichristian' about their own miracles. But apart from this obvious difference, there is nothing to distinguish their account of what made the Antichrist's signs and wonders 'lying' from that of their enemies. In Franciscus Suárez, José de Acosta, Sebastian Verron, Peter Stevart, and many others, we find the same initial distinction between real effects with a nonetheless false meaning and 'phantastical' effects that deluded the eyes and the other senses with only an appearance of reality.[90] Just as popular too was Aristotle's typology of causes, with the faulty 'material' cause singled out to explain how effects could be, as Bellarmine put it, 'apparent and deluding to the sight of men, not solid and true'.[91] 'In the sight of men' ('in conspectu hominum') was no mere redundant phrase in this context since it derived from Revelation 13, where the public performance of two of the Antichrist's three 'miracles' was thought to be mentioned; the bringing of fire from heaven, and the giving of life and speech to images. Bellarmine concluded that these two might have true material causes without formally qualifying as miracles, whereas the third—the resurrection of the dead—was false in every respect and, like healing the sick, nothing more than a 'phantasm' or 'prestige'. 'In conspectu hominum' could thus be seen as a way of drawing attention to the visual paradox at work in antichristianism. It was usual to cite the Cappadocian Archbishop Arethas's commentary on this text, first published in 1532, since he interpreted the phrase to imply a kind of fascination

of the eyes by prestigiatorial art—something no pope could ever be accused of performing. Raemond, for example, took Arethas's reading to be consistent with the kind of enchantment that occurred in false miracles when one thing was made to seem visually like something else.[92]

In this way, theologians at the heart of the Catholic Reformation used the subject of the Antichrist not just to score points against their adversaries but as an opportunity to reaffirm the credentials of true miracles by stating the differences between them and either real effects within nature or mere visual trickery. The latter was supposed to mark the point where impostors—Antichrist, demons, magicians, and, yes, heretics like Luther and Calvin—tried to hide their failure to mimic God by deluding the human senses. Things totally above the order of nature could seem to be effected, explained Malvenda in a long analysis, because such agents could 'represent' amazing things:

yet not true or solid, but only phantasical and prestigious, no doubt created by some vain and secret art from the empty simulacra of things[;] and thus they dull the sharpness of sight, so that these things seem to men to be true and enduring, when they in no way are. In this cheating art no greater attention is given than to deceiving the senses, especially the faculty of seeing, with prestiges, and mocking them with the evanescent shapes of objects and the empty *species* of things.

Even jugglers (*circulatores*) had the skill to produce visual feats of this kind—and Malvenda listed them—and it was therefore no surprise that demons could do the same:

It is acknowledged by all that [they] can indeed fashion ethereal and temporary shapes (*umbrae*) from the air, from vapours, and from other ready and easy materials, by which they form astonishingly lively and substantial things, and that they can bind the keenness of the eyes so that they judge what they perceive to be genuine and true.

The Antichrist worked in the same way with 'prestiges, and the tricking of the senses'. Such were the lying signs and wonders of 2 Thessalonians 2, 'lying' precisely because 'the human senses are deceived by *phantasmata*, so that he seems to do what he does not'. Materially they were no more than 'prestiges' and 'shapes'.[93]

One can, of course, interpret the religion of the senses metaphorically, in the Augustinian (and, indeed, biblical) manner, extending this even to the confessionalization of the eyes. Discussions of the role and reliability of bodily vision in the new piety were vehicles for reflecting on its spiritual counterpart. 'Do we have eyes to discern the things that might merely hurt our bodies', demanded Vignier, 'and deny ourselves sight when it is a matter of the eternal salvation of our souls?'[94] Multiple transfers were therefore possible with every item in the lexicon of vision, and nowhere more obviously than with blindness, illusion, trickery, or deceit. Theology allowed for this in its perennial distinction between outer and inner seeing—between the eyes of the body and the eye of faith. Yet seeing still remained

a vitally literal matter. Protestant writers did not intend, by their attacks, to destroy the credibility of vision itself, even if the effect was to compromise the reliance normally placed on the sense of sight in the religious sphere. On the contrary, *reformed* eyes were needed to detect the implausibility of Catholic miracles in the first place, as they apparently did in all the alleged cases of fraud that were mentioned earlier. A form of religious seeing that was non-sacramental became possible, it has been suggested, once linear perspective made the viewing of images a more removed and dispassionate act—like looking at objects through a window, in Alberti's classic formulation.[95] It was also important to discriminate between allowed and disallowed ways of seeing Scripture whenever the authenticity of the visions of radical 'enthusiasts' was in question.[96] Clearly, control of the senses became an important aspect of Protestant social and intellectual discipline.[97]

Above all, and with enormous implications, desacralized eyes were needed both to detect the central implausibility of the one sacrament where outer and inner seeing collided—the Mass—and also to secure an alternative sacramental theology. The debate on transubstantiation was one of the most extensive and defining of the entire early modern period, reaching its high point in England in the 1540s and 1550s and in France in the 1560s. Needless to say, it raised many more questions than those concerning the human senses. Controversialists had to ask what counted as an adequate redemptive sacrifice, what it meant to talk of Christ's physical ascension, whether his real presence or real absence worked better for worshippers, and (as always) how the relevant scriptural and patristic texts were to be read. Nevertheless, Nicholas Ridley, Bishop of Rochester and then of London, was obviously correct in thinking that all eucharistic controversies hinged, in the end, on the question of the substance of the sacrament, and this made both the rite itself and its interpretation irreducibly visual.[98] It might seem odd that something so central to early modern religiosity, and invested with such fundamentally divisive meanings, could have rested, even partially, on anything as simple as the evidence of the eyes: the whole point of this sacrament, after all, was to transcend the literal act of seeing. Yet whatever the awe and mystery surrounding communion with Christ, the stark matter of visibility and invisibility kept recurring. 'How to see, what it is possible to see, and the power of what one sees', writes a modern scholar of the theatre, 'are thus central issues in any interpretation of the eucharistic sacrament.'[99] The 'evidence of the eyes' is never, in any case, a matter of simplicity, but this was especially true of what Michael Camille has called 'the most important of all sensory experiences for Christians'.[100]

The liturgical background is obviously significant here, given the importance accorded to viewing the consecrated elements of bread and wine in later medieval and early modern Catholic piety. Historians agree in stressing that the elevation of the host became the central moment in the Mass for most churchgoers from the later twelfth century onwards. Here, we need to recall again that in this context seeing could be as much a tactile as a visual experience. But the fact that elevation

now *coincided* with consecration is more significant still; writes Miri Rubin, '[a] gesture of elevation came to mark the moment of consecration, and to offer its meaning to the audience.' In effect, this meaning depended on bringing together the two most important visual components of the ritual in a climactic moment; on the one hand, a miracle that challenged normal visual recognition by leaving the visible accidents of the bread and wine unchanged, and on the other, an opportunity to perceive them, nevertheless, as something else. Informed and sustained by this liturgical conjunction, moreover, were the countless processions, miracles, dramas, and festivals that made up the wider devotional world of Corpus Christi.[101]

The doctrine of transubstantiation itself, given official form at the Lateran Council in 1215, drew a distinction between the seen accidents and the unseen substance of the consecrated elements that naturally invited, and received, a vast amount of commentary. But however elevated and complex the theology of the Mass, a simple visual paradox lay, by definition, at its core; appearance was one thing, reality quite another. Separated for the purposes of analysis by Aristotelian metaphysics and scholastic philosophy, accidents were indeed the visible, and substance the invisible, attributes of real bodies—but usually of the same bodies, not different ones, and never apart from each other. Aristotelian and 'perspectivist' optics was likewise built on the visual perception of *species* (appearances), as we saw in our opening chapter, but, again, such *species* were the visible aspects of the bodies they originated from and could not, therefore, normally exist apart from them or belong (in exactly the same combination) to some other body. These were the sorts of things, the reformers never tired of insisting, that everybody studying elementary philosophy was taught. But sense and experience were contradicted just as much as reason and logic. The suggestion was that the *species* of non-existent bread could somehow coexist with the real substance of Christ's natural body, without whiteness or roundness becoming its accidents. What then could it mean, it was demanded, to point to the consecrated host and ask 'what white or round thing is this?' What could it mean, demanded the future Bishop of Gloucester Richard Cheyney of the lords assembled in convocation in London in October 1553, for them to ride forty miles during the day and 'not be able to say at night, that they saw their horses all the day, but only the colour of their horses' or for Christ not to have seen Nathaniel under the fig-tree but only 'the colour of him'?[102] For such questions to remain insoluble posed visual dilemmas as paradoxical as any of the others discussed in this book—and, given their place at the very heart of early modern religious struggle, ones with far more profound social consequences.

It is true that, in a sense, this sets up the problem in Protestant terms. For Catholic theorists there was no paradox of any kind, visual or otherwise, in transubstantiation, simply because the whole point of the Church's defining miracle was to allow for a radical separation of unchanged appearance from transformed substance that did not otherwise occur in nature. Not to grasp this

was to miss the essence of what was miraculous about this particular case and about the priesthood's continuing sacrificial role. In addition (as we also saw in Chapter 1), it was commonplace in traditional religious accounts of vision to speak of the outward eyes seeing only the material accidents of things while the inward eyes of the mind—the eyes of faith—'saw' a different spiritual reality. While external vision, like all sense perception, was limited, fallible, and uncertain, internal vision might 'see' fully and perfectly and thus compensate for these defects—grasping, for example, what was miraculous about the Eucharist: the real presence of Christ. The evidence of the eyes and the testimony of faith were thus not in conflict after all.

Even in this account, however, an act of bodily vision remained an inseparable part of the rite, if only in contrast to the full 'seeing' of faith, and this act was palpably not what it seemed. The English government's Ten Articles of 1536 insisted on the entirely traditional belief that Christ was really and substantially present 'under the form and figure of bread and wine, which we there presently do see and perceive by outward senses'.[103] The eucharistic observer was asked to accept that a transformation took place in objects of direct vision despite the fact that they did not appear visibly to change at all. One and the same visual paradox, therefore, made transubstantiation for Catholics the greatest miracle of all, and for Protestants the falsest. Sensitivity on this subject in later medieval Catholicism is shown by the extraordinary proliferation between the 1460s and 1530s of images of the miraculous Mass of St Gregory, variously dubbed by historians a 'quintessential Eucharistic tale', the 'most popular' exemplum of the eucharistic miracle, and (more recently) 'the late medieval altarpiece's principal metasubject'.[104] The original story concerned the satisfaction of a woman's doubts about the real presence in the Mass when a host turned into a bleeding finger in front of the officiating priest, St Gregory the Great. In versions from the fourteenth century onwards, Christ himself began appearing on the altar in front of Gregory, and eventually, as the Man of Sorrows surrounded by the instruments of the Passion and other *arma Christi*, on many real altars across Europe as depictions of the legend on altar panels multiplied. Although obviously designed to provide a straightforward and graphic ocular confirmation of transubstantiation—Christ's suffering body was usually depicted appearing during the consecration or the elevation and sometimes shown dripping blood directly into a conveniently placed chalice—there was something nevertheless self-defeating about the visual rhetoric involved. As Christine Göttler has said: 'By making visible the essential nature of the Eucharist, which is, however, nonvisible to the corporeal eye, the imagery of Saint Gregory's miraculous mass also exposes the fictitious character of visual evidence. The otherwise inexplicable miraculous appearance of Christ is brought into being by the artist.'[105] Similarly problematic one might think, was Bosch's choice of conjuring as the subject of his painting (*The Conjuror*: Fig. 6) depicting the false faith, heresy, and magic of those who are duped into spiritual blindness and superstition and therefore fail to grasp the

nature of eucharistic sacrifice—fail, that is, to read it visually in the correct manner.[106]

Up to a point, the Protestant, and especially the Reformed, campaign against transubstantiation was driven by the claim, directed at all images, that the Catholic religion simply paid too much attention to the visual and the material, at the expense of the non-visual and the spiritual. Practices like the elevation and the other 'superstitions' associated with the real presence were said to leave ordinary Catholics in a yet deeper state of idolatry, unable to reach beyond outward things to any kind of inner spirituality. Calvin called this the 'fascination' of the sign.[107] Like all images, those representing the body and blood of Christ dishonoured him, but to the point of absurdity and ridicule. Not just the invisible and incorruptible expressed in the visible and corruptible, the host blasphemed even the manhood of Christ, wrote the seventeenth-century Norfolk vicar Edmund Gurnay, by enclosing him in a body that 'in the outward eyes of those that are present' had no similitude with his own.[108] Christopher Elwood has spoken of a 'sharp distinction' between the visible and invisible, the earthly and heavenly, and the material and spiritual in the writings on the Eucharist of early French reformers like Antoine Marcourt and Guillaume Farel, leading them not just to an attack on Catholicism's veneration of the consecrated elements, but to a 'devaluation of what the eyes may perceive' and an unwillingness to concede that anything about the divine could be communicated 'by means of things that are the objects of sense perception'. We can well understand, then, why they and their English colleagues saw an analogy between believing Christ to be really present in the bread and wine of the sacrament and believing that real contact might be made with the saints through their images.[109]

Nevertheless, there was something uniquely odd about the invisible reality of transubstantiation that drew the attention of Protestants to the visual paradox it seemed to contain and led them to use the metaphor of juggling to describe it. In the writings not just of Marcourt and Farel but of Calvin, Beza, Viret, and their many European followers the Mass became simply a piece of 'magic' or 'sorcery' in which the priest, aided by the devil, attempted to change one thing into another by the mere pronunciation of words, constraining Christ at the same time. Magic had always extended to visual delusion, both as a skill in itself and as a means of persuasion, and this feature of it (as we saw in Chapter 3) was greatly enhanced in sixteenth- and seventeenth-century natural magic. The widespread adoption of the vocabulary of 'juggling', 'legerdemain', and even 'enchantment' thus suggests that what was being attacked here was not just the (to Calvinists spurious) claim to transform substance but the manipulation of appearances that would have to take place for the claim to seem true. 'This wine and wafer now are common food', went a satirical English poem of 1679, 'but a few words shall make 'em flesh and blood. | Such plain impostures, such bold cheats as these | Can surely none, but fools, or mad men please.'[110] Henry More, in an altogether more serious work, was of the same view; '[T]heir being able to make a consecrated wafer

appear to be the very body and person of Christ', he wrote of Catholic priests, 'is such a piece of prestigiousness as has no parallel.'[111]

To its critics, then, the Mass was both a spiritual and a physical pretence—in material reality, the body and blood of Christ were absent not present and the bread and wine were present not absent. Consequently, exposing the deceit meant insisting on the literal truth of what was seen. If the two elements were indeed what they seemed visually to be, then transubstantiation was necessarily a lie; for it to be true they must be considered not just appearances (literally *species*) but *mere* appearances, bearing no relation to reality—in fact, bearing a deceitful or 'dissembling' relation to reality. According to Marcourt, Scripture spoke expressly of the bread being bread, 'not species, appearance, or likeness of bread', and could not possibly have been 'dissembling' when it did so. It was certain, therefore, 'that what one sees, that is, the bread or, as they say, the whiteness of bread, is not the body of Jesus Christ'.[112] Eucharistic truth was thus presented as visual truth and eucharistic error as visual error. Rudolph Walther, the Antichrist writer, classed the latter as a straightforward example of an antichristian 'feyned fantasie', denied by 'al the senses of man'.[113] In the Mass, said Calvin, there was 'neither bread to eat, nor wine to drink, but only some empty phantom to mock the eye'.[114] Throughout his eucharistic writings, the English Calvinist John Jewel repeatedly used the word 'shew' and the phrases 'outward shews' or 'shew without substance' to describe the elements of the Mass, and during his long argument with Stephen Gardiner's chaplain Thomas Harding spoke of the host as 'nothing else but the shew and appearance and fantasy of a body'.[115] 'Shadow' was another word commonly used in English writings in this context. Many opponents of transubstantiation argued that, in effect, it revived the ancient Marcionite (or Docetic) heresy, which had held the view that Christ had 'onely a phantasticall body without any materiall, flesh, blood or bone, in appearance and sight somewhat, but in[]deed and substance nothing'.[116]

To this extent, the Protestant campaign against the Mass—like the parallel one against relics—was not a devaluation of the senses at all but instead a blunt reassertion of the value of sensory evidence against a doctrine that seemed radically to undermine it.[117] To the essential question of what exactly the sacrament of the altar was, the Marian martyr John Bradford gave this as his first response: 'If we shall ask our eyes, our nose, our mouth, our taste, our hands, and the reason of man: they will all make a consonaunt aunswer, that it is bread and wine. And verelie, heerein they speake the trueth and lye not.'[118] Any miracle, it was repeatedly asserted, must be 'sensible'—palpable to the senses—and this one clearly failed that test. For Calvin it was a 'trumped up illusion, to which no eye on earth [was] witness'.[119] '[S]eeing our eyes see, and our taste disgerneth that it is bread, we cannot imagine there is any miracle', wrote the divine William Attersoll.[120] Quoting Augustine's 'The thing that you see is the bread and the cup; which thing your eyes do testify', Jewel complained that Catholicism invited men and women not to believe the 'witness' of their eyes. To say that the bread and

wine only seemed to be bread and wine to sight and taste was to say that 'we may not believe our eye-sight, nor stand to the judgment of our senses'.[121] The idea was often repeated. Attersoll too wrote that transubstantiation made a sacrament of truth into one of 'forgery and falsehood':

[F]or the senses of seeing, of tasting, of touching, of handling, and smelling, do judge bread and wine to be in the Sacrament, and not mans flesh truly and properly: neither can all the senses bee deceived in their proper objects, as even the Philosophers themselves doe teach, and that truly.[122]

For that to happen, said Edmund Gurnay, would make a mockery of the Creation itself, which had endowed 'man' with faculties of sense and enabled him, in innocence, to discern 'which was the middle tree in the garden [of Eden]':

And what other word or light have men now in the state of recovery, to tell them which is a man, and which is a beast; which is a fish, and which is a serpent; and to lay them out their particular tasks, portions and callings, but their common sense? This therefore so immediately created and sacred light, if it bee made a notorious lyar, (for what is it else if it constantly affirmes that to bee a morsell of bread which indeed is the perfit body of a man?) [i]s not therein the word of God blasphemed?[123]

Something of a summation of these arguments and the issues at stake in them was achieved in another high-level polemical exchange, this time between Stephen Gardiner himself and Thomas Cranmer, which Cranmer, as Archbishop of Canterbury, published in his *An answer . . . unto a crafty and sophisticall cavillation* (1551). In a chapter entitled 'The papistical doctrine is also against all our senses', Cranmer explained that while faith entailed belief in things beyond the reach of the senses this did not mean accepting things contrary to them or against the trust normally given to them: 'Our faith teacheth us to believe things that we see not, but it doth not bid us, that we shall not believe [what] we see daily with our eyes.' To think otherwise was to 'open a large field', not least regarding the Incarnation, Crucifixion, and Resurrection of Christ. There were some heretics who questioned Christ's very manhood, 'although to men's sights he appeared in the form of a man', and others who said that Simon Cyrenaeus was crucified in Christ's place 'although to the sight of the people' the opposite seemed true. How was it that Thomas was reassured by touching Christ without trusting his senses? Even to recognize the separated accidents of bread and wine *after* transubstantiation would require this kind of trust, and so does the recognition of its impossibility in their survival with their substances intact. '[O]ur eyes say, they see there bread and wine: our noses smell bread and wine: our mouths taste, and our hands feel bread and wine': to accept that this sensible sacrament was nothing 'but an illusion of our senses', concluded Cranmer, would be to concede that 'Christ was a crafty juggler, that made things appear to men's sights, that in deed were no such things, but forms only, figures, and appearances of them.'

To insist that substance was not sensible anyway, as Gardiner did in reply to this chapter, was, countered Cranmer, beside the point, since to know something by

its accidents was to know its substance too: 'is not a man discerned from a beast, and one from another by sight?' To say that the senses might be deceived about substance was also irrelevant, for deception occurred with accidents too. Here Cranmer resorted to the tropes of scepticism and illusion, supporting arguments about the Church's supreme rite with the clichés of medieval optics. Did not spectacles make everything look the same colour as themselves? 'And if you hold up your finger directly between your eyes and a candle, looking full at the candle, your finger shall seem two: and if you look full at your finger, the candle shall seem two.' Ordinarily, however, the witness of the senses was reliable enough to allow the sort of certainty required for distinguishing true objects from counterfeits. The question remained, therefore: if the accidents of the bread and wine were still to be perceived, 'what thing [is it] that is coloured, great, thin or thick, heavy or light, savoury or tasted' exactly as they are? To say that what 'our senses take for bread and wine . . . is not so indeed' was to reduce holy communion to an 'illusion', like the deceptions of a stage play or the tricks of a crooked apothecary. Worst still, it was to 'make Christ's acts illusions'—or at least to destroy the case against those who said they were. Either form and substance were inseparable, in which case transubstantiation was impossible, or they were not, and the Incarnation was a sham. If the accidents and forms of bread could be called 'bread' without bread being present, then the accidents and forms of a man might be called a 'man' without him being really there.[124]

These were, so to speak, the polemical, anti-Catholic reasons for reaffirming sensory realism. But there was an additional and very vital pro-Calvinist argument in its favour: without it, the eucharistic theory designed to replace transubstantiation would not work. In this theory, of course, the bread and wine became sacramental signs, pointing in a representational way to the things they signified and thereby enabling Protestants, as Christ had indicated during the Last Supper, to recall his unique sacrifice and receive its spiritual benefits. The bread and wine were certainly changed, even transformed, in this process, but in use and quality, dignity and pre-eminence, not in substance. They remained the substances they were but became signs of something else—of a spiritual truth lying invisibly beyond them and, indeed, beyond all sensory perception. As in so many manifestations of early modern religiosity, whether Catholic or Protestant, the emphasis was again on giving attention not to the things that were literally seen but to the things that were not. In Thomas Becon's *The displaying of the popish mass*, worshippers were urged to 'see and worship [Christ] in spirit . . . and not behold him in the sacramental bread with the corporal eyes, where nothing is to be seen, felt, tasted, or received with mouth, but bread only'. 'He seeth it' declared the Lutheran martyr John Frith of the communicant and the bread, 'and again he seeth it not'. '[W]e sequester our minds utterly from the sensible creatures', wrote Jewel in similar fashion, 'and with our faith behold only the things that thereby are represented.'[125] Here was the traditional distinction between eyes that could not

see spiritual mysteries and 'eyes' that could, together with the usual view that God had made up for the deficiencies of the first by offering them physically visible signs of physically invisible meanings. According to Calvin in the *Institutes*, the physical signs were 'thrust before our eyes, [to] represent to us, according to our feeble capacity, things invisible'.[126] Jewel chose the more paradoxical formulation of St Ambrose: 'Magis videtur quod non videtur': what is better seen is what is not seen.[127]

It followed—and this is the crucial point for the historian of the senses—that for the eucharistic sacraments to act as sacraments at all they must remain what they seemed to the eye to be, that is actual bread and actual wine, not 'shews' and 'appearances' of them. In order to represent something else—especially something as important as Christ's sacrifice—the elements had first to *be* themselves. Petrus Martyr Vermigli, disputing on the Eucharist in Oxford in 1549, insisted that 'phantasies, idolles, or thynges imagined and feigned' could not feed the soul.[128] If Christ, explained Calvin, 'had put forward only the empty appearance of bread and not true bread, where would be the analogy or comparison needed to lead us from the visible thing to the invisible'? How could baptismal water that deceived the eyes offer any pledge of washing?[129] 'Take away the matter, the substance, and nature of bread and wine', preached an English theologian to Eton College in 1552, 'and thou takest away all similitudes, which must of necessity be in the signs of bread and wine after the consecration, and in that they be sacraments.' There were clearly no such 'similitudes' in whiteness, roundness, or dryness.[130] Accurate visual confirmation of what the elements really were was, thus, indispensable to their sacramental function. As the communicants partook of the bread and wine, their very confidence in them as real objects made it possible for them to share in Christ's sacrifice.[131] Calvin thought of this as the conjunction of reality and sign, insisting 'that the nature of the sacrament requires that the material bread remain as visible sign of the body' and that 'there is no sacrament when there is no visible symbol to correspond to the spiritual truth which it represents.'[132] Not transubstantiation but its opposite, *separation*, was the key to this relationship, and for this human eyes had to provide the normally reliable testimony of the reality of what they saw. To suppose otherwise was to suggest that God had provided the sacraments as 'sensible' vehicles for grasping truths but made no provision for them to be correctly perceived—perceived, that is, with none of the dissimulation entailed by the doctrine of the real presence, but instead, the immediacy and veracity required by the fact that the sacraments, as Beza put it, 'cause us to touch with the finger and the eye, and as it were to already taste and actually feel the outcome of that which we await, as if we had it and possessed it already'.[133]

Thus, in the semantic movement from signs to signified (from earthly *signum* to heavenly *res*, or in Augustine's terms, from visible sign to invisible grace—from what we see to what we believe), the outer and inner eyes performed very different but equally vital tasks, both of which could be described in the language of visual accuracy. Catholicism, complained Jewel, 'shutteth up the hearers' [*sic*!] bodily

eyes, wherewith they see the bread and wine; and borroweth only the inner eyes of their minds'. Instead, the judgement of sense should be a vital partner of the judgement of the mind.[134] In the sacrament there were two things to see, 'with our bodily eyes the material bread, with our spiritual eyes the very body of Christ'. In a treatise on the sacraments he wrote (in line with the usual sacramental theory) that '[o]ne thing is seen and another understood' but this did not mean that the corporeal eyes were in any way mistaken; on the contrary, it was critical for spiritual understanding that they were not.[135] In effect, each person had two sets of 'senses'—bodily versions to serve the body and spiritual to serve the soul. In the sacrament nothing could be understood without something first being seen, and that 'seeing' must itself be a genuine encounter with reality. At the same time, the way it was described could be carried over from physical seeing to the seeing that was done by faith; for example, in Pierre Viret's statement that, with her spiritual eyes, faith beheld 'as it were in a glass' things that were 'a great deale more certaine then that which the body seeth with his eyes or that mans reason is able to comprehend or perceive with al her natural senses'.[136]

What was not required for 'similitude', of course, was any visual resemblance between sign and signified. Resemblance or correspondence—also termed 'analogy'—was certainly constitutive of the very idea of a sacrament but there was no necessity for it to be visual in character. In Calvinist theory it took the form of extensive use of metaphors having to do with the 'spiritual banquet'— nourishment, feeding, comforting, and refreshing; Jewel's version would again be a good example. In this classic account, Christ was received in body and blood but 'eaten' and 'drunk' in faith. The symbolism of nourishment related objects that were, again genuinely, edible and drinkable to the concept of the spiritual consumption of Christ. For this to mean anything, there had to be some form of likeness at work, but it was a likeness of effects, not of appearance.

Although it is impossible to follow the debate on transubstantiation any further here, enough has hopefully been said to illustrate its obvious concern with 'the viewing subjects' relationship to the objects of sense'.[137] Important mid seventeenth-century glimpses of how this continued to be the case (relating to matters discussed elsewhere in this book) can be seen in Emmanuel Maignan's rather telling comparison between the experience of transubstantiation and the deception of the senses by optical illusions, including those of anamorphosis (both kinds of illegibility being resolved by changes to one's point of view), and in Descartes's attempts to answer the criticism that his denial of sensible qualities directly threatened the Church's teaching on the Eucharist.[138] Moreover, there is a convenient round-up (from the Protestant side of the controversy) of how things stood at the very end of the seventeenth century in Jean La Placette's *Traité de l'autorité des sens contre la transubstantiation* (1700). As the new century opened, this Huguenot exile, minister of the French church in Copenhagen at the time and a noted polemicist, was not only still claiming that transubstantiation was the

most erroneous of all the doctrines of Catholicism but also still insisting that the 'witness of sense' was the strongest and least contestable argument against it. There is not much to choose between his arguments and those of Cranmer against Gardiner, except that the onset of philosophical scepticism in the intervening 150 years made La Placette even more determined to admit nothing that would weaken the certainty of sense. That congregations were sure they saw their priests at the altar, he concluded, and priests were convinced they saw the bread and wine they were about to consecrate, in themselves refuted any suggestion that religious observance was somehow exempt from the criteria that applied in every other walk of life.[139]

NOTES

1. Margaret R. Miles, *Image as Insight: Visual Understanding in Western Christianity and Secular Culture* (Boston, 1985), 96–9. The ancient and medieval optical idea of physical contact between eyes and object and its implications for 'sacramental seeing' were taken up by Lee Palmer Wandel, *Voracious Idols and Violent Hands: Iconoclasm in Reformation Zurich, Strasbourg, and Basel* (Cambridge, 1995), 27, and Scribner, 'Ways of Seeing', 97–103, and have now been developed in Scribner, *Religion and Culture*, 121–3, 131–3, and Biernoff, *Sight and Embodiment*, 85–107. For the intensely visual character of later medieval worship, see the whole of the section in Scribner, *Religion and Culture*, entitled 'Ways of Seeing' (83–145), and for the associated fear of visual deceit and uncertainty, Jeffrey F. Hamburger, 'Seeing and Believing: The Suspicion of Sight and the Authentication of Vision in Late Medieval Art and Devotion', in Alessandro Nova and Klaus Krüger (eds.), *Imagination und Wirklichkeit: Zum Verhältnis von mentalen und realen Bildern in der Kunst der frühen Neuzeit* (Mainz, 2000), 47–69.
2. Margaret Aston, *England's Iconoclasts*, i: *Laws against Images* (Oxford, 1988), 101; Hakewill, *Vanitie*, 127–8.
3. Quotation from Carl C. Christensen, *Art and the Reformation in Germany* (Athens, Oh., 1979), 64. Miles, *Image as Insight*, 95–125, explores the relative importance of visual and auditory worship to both the Protestant and Catholic reformers, concluding that with Protestantism vision lost 'its centrality to religion' and language use 'became pivotal' (123–5). The idea has often been repeated, or at least reported; see Carlos M. N. Eire, *War against the Idols: The Reformation of Worship from Erasmus to Calvin* (Cambridge, 1986), 315–18; Aston, *England's Iconoclasts*, 441–5; Clifford Davidson, 'The Anti-Visual Prejudice', in id. and A. E. Nichols (eds.), *Iconoclasm vs. Art and Drama* (Kalamazoo, Mich., 1989), 33–46; Michael Camille, *The Gothic Idol: Ideology and Image-Making in Medieval Art* (Cambridge, 1989), 346–9. For the related dichotomy between eye and heart, see Sergiusz Michalski, *The Reformation and the Visual Arts: The Protestant Image Question in Western and Eastern Europe* (London, 1993), 184–5.
4. For an attempt to dislodge the opposition of image and word, arguing that in the case of controversialists like Tyndale and More 'a theory of image-meaning and a theory of word-meaning [were] deeply entangled with one another' and the same problems of signification were common to both, see Brian Cummings, 'Iconoclasm and

Bibliophobia in the English Reformation, 1521–1558', in Jeremy Dimmick, James Simpson, and Nicolette Zeeman (eds.), *Images, Idolatry, and Iconoclasm in Late Medieval England: Textuality and the Visual Image* (Oxford, 2002), 185–206 (quotation at 192). Cf. William A. Dyrness, *Reformed Theology and Visual Culture: The Protestant Imagination from Calvin to Edwards* (Cambridge, 2004), *passim*.
5. Quotation from Eire, *War against the Idols*, 34, and see 28–53 *passim*; Aston, *England's Iconoclasts*, 195–201.
6. Scribner, *Religion and Culture*, 119–20 (quotations), and 119–28 *passim*.
7. Diehl, *Staging Reform*, 137.
8. William Attersoll, *The new covenant, or a treatise of the sacraments*, 2nd edn. (London, 1614), 349; cf. John Jewel, 'A Reply to M. Harding's Answer', in id., *The Works of John Jewel Bishop of Salisbury*, ed. J. Ayre (4 vols.; Cambridge, 1845–50), ii. 581.
9. Aston, *England's Iconoclasts*, 436; I have benefited greatly from Professor Aston's discussions. See also the remarks on the 'cognitive crisis' produced by Protestantism's assault on 'visual knowing' in Ellen Spolsky, *Satisfying Skepticism: Embodied Knowledge in the Early Modern World* (Aldershot, 2001), 23, cf. 16–17 and *passim*.
10. Diehl, *Staging Reform*, 46, and *passim* for the whole question of the Reformation's (and esp. the post-Reformation theatre's) impact on assumptions about sight and the visible world. For the rest of this paragraph, including the 'obsession' with images, see Giuseppe Scavizzi, *The Controversy on Images from Calvin to Baronius* (New York, 1992), 4–8 (quotation at 4), 75–6.
11. However, Alain Besançon, *The Forbidden Image: An Intellectual History of Iconoclasm*, trans. Jane Marie Todd (Chicago, 2000), 4, makes the point that by the 16th century all the reasons for attacking images 'had already been advanced'. The same seems true of the reasons for defending them; see Wandel, *Voracious Idols*, 26–51.
12. An overview of these other issues is Carlos M. N. Eire, 'The Reformation Critique of the Image', in Bob Scribner (ed.), *Bilder und Bildersturm in Spätmittelalter und in der frühen Neuzeit* (Wiesbaden, 1990), 51–68.
13. *Certain Sermons or Homilies Appointed to be Read in Churches* (Oxford, 1832), 204–5. This homily appeared for the first time in bk. 2 of the Elizabethan collection (1563), and may have been written by John Jewel. Thomas Cranmer had made the same point, rather more implausibly, with regard to a hypothetically perfect representation of God; see Aston, *England's Iconoclasts*, 431–2.
14. Eire, *War against the Idols*, 226, citing Calvin's *Commentary on the Last Four Books of Moses*.
15. *Certain Sermons or Homilies*, 202. The futility of trying to express God in images, because of their utter incommensurability, is one of the commonest themes in Calvinism's attack on idolatry; see Jean Calvin, *Institutes of the Christian Religion*, ed. John T. McNeill, trans. Ford Lewis Battles (2 vols.; London, 1961), i. 99–116 (bk. 1, ch. 11).
16. *Certain Sermons or Homilies*, 204; Bilson quoted by John Phillips, *The Reformation of Images: Destruction of Art in England, 1535–1660* (Berkeley, 1973), 87; [Théodore de Bèze], *A confession of fayth, made by common consent of divers reformed churches beyonde the seas* (London, n.d. [1568]), 10ᵛ; Abraham Scultetus, *A short information, but agreeable unto scripture: of idol images* (n.p. [London?], 1620), sig. B2ᵛ; Henry Ainsworth, *An arrow against idolatrie* (n.p. [Amsterdam?], 1611), 19; Calvin, *Institutes*, i. 101.
17. Perkins in Aston, *England's Iconoclasts*, 451; *Certain Sermons or Homilies*, 179, 244–6.

18. *Certain Sermons or Homilies*, 209; Aston, *England's Iconoclasts*, 17, 109–10, 401–9; cf. Scribner, *Religion and Culture*, 114–15.
19. Calvin, *Institutes*, i. 113; cf. the Lollard writing, *The Lantern of Light*, cited by Aston, *England's Iconoclasts*, 114: 'The painter maketh an image forged with diverse colours till it seems in the eyes of fools like a living creature.'
20. *Certain Sermons or Homilies*, 170 (cf. 221), 210.
21. Ibid. 172–3, 199, 242. Cf. Phyllis Mack Crew, *Calvinist Preaching and Iconoclasm in the Netherlands, 1544–1569* (Cambridge, 1978), 24–7. For Zwingli's list of the actions allegedly done to address images, see Christensen, *Art and the Reformation*, 22. For this aspect of the use of images in the era between antiquity and the Renaissance, see Hans Belting, *Likeness and Presence: A History of the Image before the Era of Art*, trans. Edmund Jephcott (Chicago, 1994).
22. Aston, *England's Iconoclasts*, 31–4; see also the sophisticated approach to the relationship between religious viewer and sacred object in Scribner, *Religion and Culture*, 85–103.
23. *Certain Sermons or Homilies*, 183, 206; Erasmus cited in Eire, *War against the Idols*, 39 and Christensen, *Art and the Reformation*, 22; Thomas More cited in Mack Crew, *Calvinist Preaching*, 28. A typical French example is René Benoist, *Response a ceux qui appellent idolatres les chrestiens et vrays adorateurs* (Paris, 1566), 22^{r-v}. For a late medieval reference to the 'manner off [*sic*] double entendement' in images, see Michael Camille, 'The Iconoclast's Desire: Deguileville's Idolatry in France and England', in Dimmick, Simpson, and Zeeman (eds.), *Images, Idolatry, and Iconoclasm*, 171.
24. Most recently, J. L. Koerner, *The Reformation of the Image* (London, 2004), 104–14, 132–6. See also Natalie Zemon Davis, *Society and Culture in Early Modern France* (London, 1975), 152–87; David Freedberg, 'The Hidden God: Image and Interdiction in the Netherlands in the Sixteenth Century', *Art Hist.* 5 (1982), 133–53; Aston, *England's Iconoclasts*, 114–15, 136; Eire, *War against the Idols*, 14–15, 21, 113, 126–7; Mack Crew, *Calvinist Preaching*, 12; Michalski, *Reformation and the Visual Arts*, 76–8, 90–2, 96; id., 'Das Phänomen Bildersturm. Versuch einer Ubersicht', in Scribner (ed.), *Bilder und Bildersturm*, 85–107; Olivier Christin, *Une révolution symbolique: l'iconoclasme huguenot et la reconstruction catholique* (Paris, 1991), 131–4; Eugène Honée, 'Image and Imagination in the Medieval Culture of Prayer: A Historical Perspective', in Henk van Os et al. (eds.), *The Art of Devotion in the Late Middle Ages in Europe, 1300–1500*, trans. M. Hoyle (Princeton, 1994), 157–74. For an account of iconoclastic actions that do not seem to have rested on this idea, see Wandel, *Voracious Idols*, *passim*.
25. John Foxe, *The Acts and Monuments of John Foxe*, ed. S. R. Cattley (8 vols.; London, 1841–89), iv. 706–7; Diehl, *Staging Reform*, 28, commenting that Foxe's narrative of the episode transfers power 'from the image that arouses devotion to the spectator who doubts what he sees'.
26. [Robert Parker], *A scholasticall discourse against symbolizing with Antichrist in ceremonies: especially in the signe of the crosse* (n.p. [Middelburg], 1607), 65; Robert Bellarmine, 'De reliquiis et imaginibus sanctorum', ch. 8 ('Non esse prohibitas imagines Dei'), in *Disputationes de controversiis christianae fidei, adversus huius temporis haereticos* (4 vols.; Paris, 1608), ii, cols. 767–8 (1st pub. Ingolstadt in 3 vols., 1586, 1588, and 1593). I was led to Parker on Zeuxis by Aston, *England's Iconoclasts*, 31 n. 40.
27. *Certain Sermons or Homilies*, 233. The *OED* gives for 'to dare': 'To daze, paralyse, or render helpless, with the sight of something; to dazzle and fascinate.'

28. Ibid. 209, cf. 228.
29. The idea that iconoclasm is itself a form of idolatry has often been expressed; see David Freedberg, *The Power of Images: Studies in the History and Theory of Response* (Chicago, 1989), 427, and recently, Camille, 'Iconoclast's Desire', 170 (citing Jean Baudrillard). Joseph Koerner has now questioned this equation in id., *Reformation of the Image*, 113–14.
30. Cited by Michalski, *Reformation and the Visual Arts*, 183–4; the identical remark is made by Heinrich Bullinger, *Catechesis pro adultioribus scripta, de his potissimum capitibus* (Zurich, 1559), 14r, who includes it in the catechumen's proper response to questions on the Second Commandment. The etymological point made by Lactantius derives from the origin of *simulachrum* in *simulare*—here interpreted as 'to falsify'; on this meaning, see Camille, *Gothic Idol*, 43–4.
31. Koerner, *Reformation of the Image*, 105.
32. See esp. Aston, *England's Iconoclasts*, 452–66 ('Idols of the Mind'), on which I depend for this paragraph.
33. *Certain Sermons or Homilies*, 202; Calvin, *Institutes*, i. 108; Perkins, see next note. Aston, *England's Iconoclasts*, 436–7, calls this the 'radical' view and illustrates it with the Decalogue teaching of John Hooper.
34. All Perkins quotations in this and the preceding paragraph in Aston, *England's Iconoclasts*, 453 (my italics), from William Perkins, *Warning against the idolatry of the last times* (1601), 107–8.
35. Nicholas Sanders, *A treatise of the images of Christ, and of his saints* (Louvain, 1567), 43^{r-v} (reissued in facsimile in the series English Recusant Literature, 1558–1640, vol. 282, Ilkley, 1976). The title page gives the author's name as: 'Nicolas Sander'. Sanders also published *De typica et honoraria sacrarum imaginum adoratione libri duo* (Louvain, 1569). The last remark is identical to Luther's position, cited by Aston, *England's Iconoclasts*, 437, for whom internal images (in her words) were 'both natural and innocent'. Luther wrote: 'For whether I will or not, when I hear of Christ, an image of a man hanging on a cross takes form in my heart, just as a reflection of my face naturally appears in the water when I look into it.' See also Christensen, *Art and the Reformation*, 51–2, 60; Michalski, *Reformation and the Visual Arts*, 25–7. On Sanders and Trent, see Thomas Veech, *Dr Nicholas Sanders and the English Reformation 1530–1581* (Louvain, 1935), 23–49.
36. Sanders, *Treatise*, 100r.
37. Ibid. 44^{r-v}.
38. Ibid. 46^{r-v}; *The Canons and Decrees of the Council of Trent*, trans. T. A. Buckley (London, 1851), 215.
39. Sanders, *Treatise*, 46v.
40. Ibid. 53v; see also 61r: 'what is an image, but the imitation, or making of a thing like to the real shape of such an other thing, as (in that behalf) is resembled, and thereby accompted more principal?'
41. The natural substance of the artificial image itself, Sanders explained, had to be borrowed from elsewhere (not being an expression of its subject's)—i.e. from the materials of wood, stone, gold, and paper that made it visible 'to our eyes': ibid. 58v–9r.
42. Ibid. 36v.
43. Ibid. 53v–61v; cf. 241v: 'the knowledge of the image, and of the thing whose image it is, make both but one knowledge' (and, so, one degree of worship).

44. Ibid. 61v–5r.
45. Ibid. 94^{r-v}.
46. See esp. Scavizzi, *Controversy on Images*, 63–6, 88–93, 115–48. For other surveys, see David Freedberg, *Iconoclasm and Painting in the Revolt of the Netherlands, 1566–1609* (New York, 1988), 67–94, 134–59; Keith Moxey, *Pieter Aertsen, Joachim Beuckelaer and the Rise of Secular Painting in the Context of the Reformation* (New York, 1977), 197–228.
47. Gabriele Paleotti, *Discorso intorno alle immagini sacre e profane* (1582), ed. Stefano della Torre et al. (Vatican City, 2002), 201 (bk. 2, ch. 32: 'Paintings that bring in novelties and are unusual'): 'Lasciando da parte per ora S. Giovanni, diciamo che, poiché dovere del pittore è imitare le cose nel loro naturale essere, così come esse si mostrano agli occhi degli uomini, egli non deve superare i limiti stabiliti dai teologi e dai dottori per esprimere sentimenti più profondi o nascosti.' On Paleotti, see Scavizzi, *Controversy on Images*, 131–40.
48. Calvin, *Institutes*, i. 112.
49. Moxey, *Pieter Aertsen*, 128.
50. Besançon, *Forbidden Image*, 189, but see Alpers, *Art of Describing*, p. xxvi.
51. Sanders, *Treatise*, 98v.
52. Aston, *England's Iconoclasts*, 181, citing Thomas More's view that a 'well workmanly wrought' image was better than a less realized one; cf. 152, for Reginald Pecock's similar argument.
53. Details in D. P. Walker, 'The Cessation of Miracles', in I. Merkel and A. G. Debus (eds.), *Hermeticism and the Renaissance: Intellectual History and the Occult in Early Modern Europe* (London, 1988), 111–24.
54. Philippe Du Plessis-Mornay, *Foure bookes, of the institution, use and doctrine of the holy sacrament of the Eucharist in the old church, as likewise, how, when, and by what degrees the masse is brought in, in place thereof*, trans. R.S. (London, 1600), 419 (orig. pub. La Rochelle, 1598).
55. Especially rich on this entire subject is Rob Iliffe, 'Lying Wonders and Juggling Tricks: Religion, Nature, and Imposture in Early Modern England', in James E. Force and David S. Katz (eds.), *Everything Connects: In Conference with Richard H. Popkin. Essays in his Honor* (Leiden, 1999), 185–209, which sets visual deceit in the context of wider Protestant anxieties concerning the authentic and sees 17th-century English natural philosophy as, in part, a response to them. I return to this suggestion in Ch. 10 below. I am most grateful to Dr Iliffe for alerting me to this essay. See also Eire, *War against the Idols*, 221–4.
56. Fernando de Texeda (or Tejeda), *Miracles unmasked. A treatise proving that miracles are not infallible signes of the true and orthodox faith: that popish miracles are either counterfeit or divellish*, trans. by author (London, 1625), 12; I cannot trace the original publication of this text.
57. John Bale, *The actes of Englysh votaryes* ('Wesel' [= Antwerp], 1546), 48v. For the later phases, directed at the Jesuit optical devices and effects we considered in Ch. 3 and at the 'wizardry of visualization' in general, see Stafford, *Artful Science*, 1–23, and Stafford and Terpak, *Devices of Wonder*, 48–53.
58. Foxe, *Acts and Monuments*, iv. 171.
59. The British Library catalogue lists edns. of pamphlets and tracts on the Berne scandal under the name of Johann Vetter, Prior of the Dominicans there; see esp. Anon.,

De quattuor heresiarchis ordinis Praedicatorum de Observantia nuncupatorum, apud Suitenses in civitate Bernensi combustis, anno Christi MDIX (n.p. [Berne?], n.d. [1509?]); [Nicolaus Manuel], *Die war histori von den vier ketzern prediger ordens . . . zu Bern . . . verbrannt* (n.p., n.d. [1510?]), from which I reproduce the images of the deceptions; Anon., *Historia und warhaffte Geschicht der vier Kätzer Mönch Prediger-Ordens* (Magdeburg, 1551). For some typical accounts in chronicles, see Johannes Stumpf, *Johannes Stumpfs Schweizer- und Reformationschronik*, ed. E. Gagliardi, H. Müller, and F. Büsser (2 vols.; Basel, 1953), i. 82–98; Kaspar Peucer, *Liber quintus chronici Carionis a Friderico secundo usque ad Carolum quintum* (Frankfurt am Main, 1566), 242^{r-v}; Andreas Hondorff, *Theatrum historicum illustrium exemplorum* (Frankfurt am Main, 1575), 75–7; Paulus Langius, *Chronicon Citizense* (*Episcoporum Citicensis ecclesiae historia*), in Johannes Pistorius, *Illustrium veterum scriptorium* (2 vols.; Frankfurt, 1583), i. 893–5.

60. Ludwig Lavater, *Of ghostes and spirites walking by nyght, and of strange noyses, crackes, and sundry forewarnynges, which commonly happen before the death of menne, great slaughters, and alterations of kyngdomes*, trans. Robert Harrison (London, 1572), repr. in Shakespeare Association edn., 1929, ed. J. Dover Wilson and May Yardley, 28–36. Full details of this work's publication history are given in Ch. 6 below. For Walther and Vignier see below, nn. 87–8; for Brightman see his refutation of Bellarmine's views on the Antichrist in Thomas Brightman, *A revelation of the Apocalyps* (Amsterdam, 1611), 589–90.

61. Sir Thomas More, 'A Dialogue Concerning Heresies', in Thomas M. C. Lawler, Germain Marc'hadour, and Richard C. Marius (eds.), *The Complete Works of St. Thomas More*, Yale Edition, vol. 6 (2 vols.; New Haven, 1981), i. 88; Foxe, *Acts and Monuments*, iv. 171–2.

62. William Waller, *The tragical history of Jetzer: A faithful narrative of the feigned visions, counterfeit revelations, and false miracles of the dominican fathers of the covent of Berne in Switzerland, to propagate their superstitions. For which horrid impieties, the Prior, Sub-Prior, Lecturer, and Receiver of the said Covent were burnt at a stake, Anno Dom. 1509* (London, 1679), with two further edns. in 1680 and one in 1683.

63. Francis Hastings, *An apologie or defence of the watch-word* (London, 1600), 60.

64. More, 'Dialogue', i. 87.

65. Foxe, *Acts and Monuments*, v. 33.

66. Clifford Davidson, ' "The Devil's Guts": Allegations of Superstition and Fraud in Religious Drama and Art during the Reformation', in id. and Nichols (eds.), *Iconoclasm vs. Art and Drama*, 97. Moving eyes take on added significance in the light of Scribner's remarks about eye-contact with images as an aspect of 'sacramental seeing'; see his *Religion and Culture*, 116–17, 130–1.

67. *Certain Sermons or Homilies*, 217; Sanders, *Treatise*, 68r.

68. John Jewel, 'An exposition upon the two epistles of Sainct Paule to the Thessalonians' (orig. pub. 1583), in *Works*, ii. 922.

69. Foxe, *Acts and Monuments*, v. 179; cf. William Thomas, *The Pilgrim: A Dialogue of the Life and Actions of King Henry the Eighth*, ed. J. A. Froude (London, 1861), 38, who said that there were few roods or statues 'but that with engines that were in them could beckon, either with their heads and hands, or move their eyes, or manage some part of their bodies, to the purpose that the friars and priests could use them' (quoted Aston, *England's Iconoclasts*, 235 n. 42).

70. Quotation from Iliffe, 'Lying Wonders', 205; cf. Aston, *England's Iconoclasts*, 235–6; Phillips, *Reformation of Images*, 73–4.
71. Foxe, *Acts and Monuments*, v. 397.
72. Full details of the scandal and its essential political context are in Peter Marshall, 'The Rood of Boxley, the Blood of Hailes and the Defence of the Henrician Church', *J. of Ecclesiastical Hist.* 46 (1995), 689–96 (the remark about the rood coming to be described as an 'automaton' is at 691). See also Davidson, ' "Devil's Guts" ', 95–7; Iliffe, 'Lying Wonders', 205–6; Aston, *England's Iconoclasts*, 234–6. The important contemporary account is in Charles Wriothesley, *A Chronicle of England during the Reigns of the Tudors from AD 1485 to 1559*, ed. W. D. Hamilton, Camden Series, NS 11 and 20 (2 vols.; London, 1875–7), i. 75–6, 78–81, 83. The long quotation is from William Lambarde, *A perambulation of Kent* (London, 1576), 183. '[A]s very an illusion' as the rood, said Lambarde, was a picture of St Rumwald in the same church, manipulated by means of 'a pyn of wood, stricken through it into a poste (whiche a false knave standing behinde, coulde put in, and pull out, at his pleasure' (186–7). For the 'persistent concern to identify and accentuate instances of the fraudulent and the counterfeit' during the Henrician Reformation, citing many episodes of all kinds of alleged 'feigning', see Peter Marshall, 'Forgery and Miracles in the Reign of Henry VIII', *Past and Present*, 178 (2003), 39–73.
73. Details in H. C. Lea, *A History of the Inquisition of Spain* (4 vols.; New York, 1922), iv. 83–6. The case was very similar to that of Magdalena de la Cruz of Córdova who was exposed in 1543, despite Europe-wide renown; see Goulart, *Admirable and memorable histories*, 548–52; Henning Grosse (pub.), *Magica; seu mirabilium historiarum de spectris et apparitionibus spirituum* (Eisleben, 1597), 74–7; Lea, *Inquisition*, iv. 82–3.
74. Cipriano de Valera, *Two treatises: the first, of the lives of the Popes, and their doctrine. The second, of the Masse ... Also, a swarme of false miracles, wherewith Marie de la Visitacion, prioresse de la Annuntiada of Lisbon, deceived very many: and how she was discovered and condemned*, trans. John Golburne (London, 1600), 420–38, from the second (1599) Spanish edition. There was a further English trans. by J. Savage in 1704 and the original work is repr. in Cipriano de Valera, *Los dos tratados, del Papa y de la Misa* (Madrid, 1851; facs. repr. Barcelona, 1982), 554–94.
75. Valera, *Two treatises*, 420, 433–4.
76. Waller, *Tragical history*, 24, 18, 20.
77. More, 'Dialogue', i. 87; Marshall, 'Rood of Boxley', 694; Foxe, *Acts and Monuments*, v. 397; Lambarde, *Perambulation*, 183; Valera, *Two treatises*, 426, 434–6, '455' [= 435].
78. John Gee, *New shreds of the old snare* (London, 1624), 17; cf. id., *The foot out of the snare* (London, 1624).
79. Richard Sheldon, *A survey of the miracles of the church of Rome, proving them to be Antichristian* (London, 1616), 41, 89, 331–3. For some other typical texts, see Hastings, *Apologie*; Texeda, *Miracles unmasked*; Pierre Boquin, *A defense of the olde, and true profession of Christianitie, against the new, and counterfeite secte of Jesuites, or fellowship of Jesus*, trans. T.G. (London, 1581). On this type of literature, with many more examples, see Walsham, *Providence*, 226–32, and for the reinterpretation of medieval miracles, see Helen Parish, ' "Then May the Deuyls of Hell Be Sayntes Also": The Mediaeval Church in Sixteenth-Century England', *Reformation*, 4 (1999), 71–91; ead., ' "Lying Histories Fayning False Miracles": Magic, Miracles and

Mediaeval History in Reformation Polemic', *Reformation and Renaissance Rev.* 4 (2002), 230–40; ead., *Monks, Miracles and Magic: Reformation Representations of the Medieval Church* (London, 2005), *passim*.
80. Mark 13: 22: 'For false Christs and false prophets shall rise, and shall shew signs and wonders, to seduce, if it were possible, even the elect'; Matthew 24: 24 (virtually the same text): 2 Thessalonians 2: 3, 9, 11: 'Let no man deceive you by any means, for that day shall not come, except there come a falling away first, and that man of sin bee revealed, the son of perdition, . . . Even him, whose coming is after the working of Satan with all power and signs, and lying wonders, . . . And for this cause God shall send them strong delusion, that they should believe a lie.'
81. Lambert Daneau, *A treatise, touching antichrist*, trans. [J. Swan] (London, 1589), 145, 92 (orig. pub. in Latin and then French).
82. Jewel, 'Exposition', in *Works*, ii. 923, and see 920–4 for Jewel's complete commentary on the subject of Antichrist's miracles.
83. Clark, *Thinking with Demons*, 335–45, offers a brief summary; see also Walker, 'Cessation of Miracles', 115–17.
84. St Augustine, *The City of God*, trans. John Healey (1610) (2 vols.; Edinburgh, 1909), ii. 272.
85. William Sclater, *A briefe exposition with notes, upon the second epistle to the Thessalonians*, 2nd edn. (London, 1629), 149.
86. Daneau, *Treatise*, 145–6.
87. Heinrich Bullinger, *A commentary upon the seconde epistle of S. Paul to the Thessalonians*, trans. R.H. (London, 1538), 48v–9r (orig. in Latin, 1536, and also pub. in German); Rudolph Walther (Gualtherus), *Antichrist*, trans. J[ohn] O[lde] (London, 1556), 156r (also pub. in Latin, German, and Dutch); George Pacard, *Description de l'antechrist, et de son royaume* (Niort, 1604), 264–5; Georg Sohn, *A briefe and learned treatise, conteining a true description of the Antichrist*, trans. N. G[rimald] (Cambridge, 1592), 18r (orig. in Latin); Jewel, 'Exposition', in *Works*, ii. 922–3; Thomas Tymme, *The figure of Antichriste, with the tokens of the end of the world* (London, 1586), sig. G4v; Robert Rollock, *Lectures upon the first and second epistles of Paul to the Thessalonians*, ed. Henry Charteris and William Arthur (Edinburgh, 1606), 83 (also pub. in Latin); Thomas Thompson, *Antichrist arraigned* (London, 1618), 74.
88. Nicolas Vignier, *Théatre de l'Antechrist* (n.p., 1610), 547–8 (Vignier became a Catholic late in his life); cf. Caesare Baronio, *Annales ecclesiastici* (12 vols.; Antwerp, 1612, 1597–1609), x. 471 ('Nec praedicta tabula a quoquam tangi audetur, videri autem omnibus hominibus conceditur').
89. More details and examples in Clark, *Thinking with Demons*, 340–4.
90. Franciscus Suárez, *De Antichristo*, in id., *Opera omnia*, ed. Michael André (28 vols.; Paris, 1856–78), xix. 1037 ('res . . . phantasticae'); José de Acosta, *De Christo revelato . . . simulque de temporibus novissimis* (Lyons, 1592), 509–12; Sebastian Verron, *Chronica ecclesiae et monarchiarum a condito mundo* (Freiburg, 1599), 491–2; Peter Stevart, *Commentarius in utramque D. Pauli apostoli ad Thessalonicenses, epistolam* (Ingolstadt, 1609), 265.
91. Robert Bellarmine, *Tractatus de potestate summi pontificis in rebus temporalibus et de Romani Pontificis ecclesiastica hierarchia*, in *Bibliotheca maxima pontificia*, ed. Juan Tomas de Rocaberti (21 vols.; Rome, 1698–9), xviii. 601–2; cf. Georg Scherer, *Bericht ob der Bapst zu Rom der Antichrist sey* (Ingolstadt, 1585), 73–5; Alessio Porri, *Vaso di*

Verità, nel quale si contengono dodeci resolutioni vere a dodeci importanti dubbi fatti intorno all'origine nascita vita opere e morte dell'Antichristo (Venice, 1597), sig. Kiv^{r-v}; Honofre Manescal, *Miscellánea de tres tratados, de las apariciones de los espíritus el uno, donde se trata cómo Dios habla a los hombres, y si las almas del Purgatorio buelven: De Antichristo el segundo, y de sermones predicados en lugares señalados el tercero* (Barcelona, 1611), pt. 2, 66–7 (sep. pag.).

92. Arethas, Archbishop of Caesarea in Cappadocia, 'Arethae . . . coacervatio enarrationum ex variis sanctis viris in Johannis . . . Apocalypsim', in *Enarrationes vetustissimorum theologorum* (Antwerp, 1545), ccxl (col. 2); Florimond de Raemond, *L'Antichrist* (Lyons, 1597), 396, 401; cf. Nicholas Sanders, *De visibili monarchia ecclesiae* (Louvain, 1571), 778–9 (bk. 8, ch. 30), and for Protestant replies, William Whitaker, *Ad Nicolai Sanderi demonstrationes quadraginta . . . responsio* (London, 1583), 180–6 (to Sanders); Robert Abbot, *Antichristi demonstratio* (London, 1603), 208–20 (to Bellarmine).
93. Thomas Malvenda, *De Antichristo* (Rome, 1604), 385–93 (quotations at 391, 393).
94. Vignier, *Théatre de l'Antechrist*, 553.
95. Scribner, *Religion and Culture*, 121–3, 132; see also Ch. 3 above.
96. On the relevance of optics to attacks on 'enthusiasm', see Adrian Johns, 'The Physiology of Reading and the Anatomy of Enthusiasm', in Ole Peter Grell and Andrew Cunningham (eds.), *'Religio Medici': Medicine and Religion in Seventeenth-Century England* (Aldershot, 1996), 136–70.
97. A point reiterated by Zika, *Exorcising our Demons*, 484–5.
98. For Ridley, see Francis Clark, *Eucharistic Sacrifice and the Reformation* (London, 1960), 159, and cf. 64–5 for a similar remark by Cranmer. For the tradition of tracing *all* the sacraments to the Eucharist, see Scribner, *Religion and Culture*, 107.
99. Diehl, *Staging Reform*, 100, and 94–124 *passim*.
100. Camille, 'Before the Gaze', 209. For one thoroughly optical conception of eucharistic theology from later 14th-century Oxford, see Heather Phillips, 'John Wyclif and the Optics of the Eucharist', in Anne Hudson and Michael Wilks (eds.), *From Ockham to Wyclif* (Oxford, 1987), 245–58.
101. Miri Rubin, *Corpus Christi: The Eucharist in Late Medieval Culture* (Cambridge, 1991), *passim*, esp. 49–82 (quotation at 55). On the elevation, see also Scribner, *Religion and Culture*, 89–91, 105–11, 130–1; Ann Eljenholm Nichols, *Seeable Signs: The Iconography of the Seven Sacraments 1350–1544* (Woodbridge, 1994), 257–9; and on 'seeing the host', C. W. Dugmore, *The Mass and the English Reformers* (London, 1958), 65–72.
102. Foxe, *Acts and Monuments*, vi. 406–7.
103. Dugmore, *Mass*, 107.
104. Rubin, *Corpus Christi*, 308, cf. 121–2, 308–10; Christine Göttler, 'Is Seeing Believing? The Use of Evidence in Representations of the Miraculous Mass of Saint Gregory', *Germanic Rev.* 76 (2001), 125; Koerner, *Reformation of the Image*, 355, cf. 117–18, 355–8. A guide to these particular images is Uwe Westfehling (ed.), *Die Messe Gregors des Grossen. Vision, Kunst, Realität. Katalog und Führer zu einer Ausstellung im Schnütgen-Museum der Stadt Köln* (Cologne, 1982).
105. Göttler, 'Is Seeing Believing?', 137; Göttler reproduces a late 15th-century version by Master IAM of Zwolle (Johan van den Mynnesten), describing him as an artist interested in the representation of visual illusions. Much the same point about

eucharistic painting is made in Catherine Gallagher and Stephen Greenblatt, *Practicing New Historicism* (Chicago, 2000), 75–109, see esp. 83 (discussing the Flemish painter Joos van Gent's altarpiece *Communion of the Apostles*): 'The *painting* of this particular doctrine is in tension with its doctrinal point—that one should learn to look with the eyes of faith past appearances to a reality invisible to the senses—because it is, after all, a painting, an image that appeals to the senses even as it tries to limit the authority of their testimony' (authors' emphasis). This tension is driven to the point of paradox by the depiction of the consecrated host itself, where visual representation has to 'refuse to happen' (84). Gallagher and Greenblatt have invaluable things to say about 'the ocular proof that tantalized Christianity in the wake of the elaboration of Eucharistic orthodoxy', an orthodoxy that obliged the faithful to accept that 'what they saw (. . .) was not what it manifestly appeared to be; that their direct experience was at the utmost remove from the truth', leaving 'an intense residual desire for confirmation' (98). Their theme, accordingly, is 'the gap between aesthetic illusion and the Real Presence' (102). For parallel arguments about the capacity of early witchcraft theory to help verify the reality of transubstantiation, see Stephens, *Demon Lovers*, 180–240.

106. For this reading of *The Conjuror*, I follow Jeffrey Hamburger, 'Bosch's *Conjuror*: An Attack on Magic and Sacramental Heresy', *Simiolus*, 14 (1984), 4–23.
107. Christopher Elwood, *The Body Broken: The Calvinist Doctrine of the Eucharist and the Symbolization of Power in Sixteenth-Century France* (Oxford, 1999), 62–3; cf. Robert Whalen, *The Poetry of Immanence: Sacrament in Donne and Herbert* (Toronto, 2002), 3–21 ('The Eucharist and the English Reformation').
108. Edmund Gurnay, *The demonstration of Antichrist* (London, 1631), 3.
109. Elwood, *Body Broken*, 46–7; Aston, *England's Iconoclasts*, 7.
110. Quoted by Silvia Berti, 'Unmasking the Truth: The Theme of Imposture in Early Modern European Culture, 1660–1730', in Force and Katz (eds.), *Everything Connects*, 26–7.
111. Henry More, *A modest enquiry into the mystery of iniquity* (London, 1674), 437. The Catholic retort was that juggling could not be an issue here since that involved changing forms without changing substances, not the opposite, which no juggler could achieve; see, for example, Thomas Dorman, *A proufe of certeyne articles in religion, denied by M. Iuell [Jewell]* (Antwerp, 1564), sigs. V1v–V2r.
112. Quotations in Elwood, *Body Broken*, 38–9.
113. Walther, *Antichrist*, 157r.
114. Jean Calvin, 'The Necessity of Reforming the Church', in *Calvin: Theological Treatises*, ed. J. K. S. Reid, Library of Christian Classics xxii (London, 1954), 204–5; cf. the idea that the body of Christ became 'nothing but a phantom' and was enclosed 'fantastically under the bread', in id., 'Short Treatise on the Holy Supper', also in *Calvin: Theological Treatises*, 158–9; Diehl, *Staging Reform*, 29.
115. Jewel, 'Reply to M. Harding's Answer', in *Works*, ii. 562; cf. Richard Preston, *Short questions and answers, plainely opening and explaining both the nature and also the use of the sacraments of baptisme and the Lords supper* (London, 1621), 13.
116. Atterroll, *New goonomm. WD CHr Chmaduon* and the Eucharist controversy, see Michalski, *Reformation and the Visual Arts*, 179–80.
117. On the insistence on sensory realism in Calvin's *Inventory of Relics*, see Eire, *War against the Idols*, 230–1; on transubstantiation in particular, see Iliffe, 'Lying Wonders', 194.

118. John Bradford, *Two notable sermons . . . the one of repentance, the other of the Lordes supper* (London, 1581), sigs. Fviiiv–Gir (1st pub. 1574); cf. the opinion of 'Verity' in 'A fruitful dialogue declaring these words of Christ: "This is my body" ', in Foxe, *Acts and Monuments*, vi. 344: 'It feedeth, it tasteth like bread, it looketh like bread, the little silly mouse taketh it for bread, and, to be short, it hath all the properties and tokens of bread: ergo, it is bread.'
119. Calvin, *Institutes*, ii. 1378.
120. Attersoll, *New covenant*, 359.
121. Jewel, 'Reply to M. Harding's Answer', in *Works*, ii. 564; id., 'A Treatise of the Sacraments', in *Works*, ii. 1114. The Augustine statement is in his 'Ad infantes, de sacramento' (Sermon 272), *Opera omnia* (11 vols.; Paris, 1836–8), v, pt. 1, col. 1614: 'Quod ergo videtis, panis est et calix; quod vobis etiam oculi vestri renuntiant.' For the reply that seeing was not required for believing, see Dorman, *Proufe of certeyne articles*, sig. V1v: 'Wilt thow first see blood and taste it as did the children of Israel the water, and then after beleve? O notable faithe . . . whose guides the eyes and other fallible senses be.'
122. Attersoll, *New covenant*, 364, citing Aristotle, *De anima*, 418a, 10–20; cf. John Madhew (speaking at a Cambridge disputation on 20 June 1549) in Foxe, *Actes and Monuments*, vi. 306–7: 'Seeing then that our eyes do behold nothing but bread and wine, it must needs follow that it is so indeed, or else our senses be deceived in their known proper object, which cannot be by any reason or natural philosophy.'
123. Gurnay, *Demonstration*, 8–9.
124. Thomas Cranmer, 'An answer to a crafty and sophistical cavillation devised by Stephen Gardiner', in *Writings and Disputations of Thomas Cranmer . . . Relative to the Sacrament of the Lord's Supper*, ed. John Edmund Cox (Cambridge, 1844), 255–63.
125. Thomas Becon, *The displaying of the popish mass* (1559), in *Prayers and Other Pieces of Thomas Becon*, ed. John Ayre (Cambridge, 1844), 267, cf. 272; Frith in Foxe, *Acts and Monuments*, v. 12–13; Jewel, 'Reply to M. Harding's Answer', in *Works*, ii. 569.
126. Calvin, *Institutes*, ii. 1371.
127. Jewel, 'Reply to M. Harding's Answer', in *Works*, i. 467.
128. Dugmore, *Mass*, 147.
129. Calvin, *Institutes*, ii. 1376.
130. Roger Hutchinson, *A faithful declaration of Christes holy supper* (1560), in id., *The Works of Roger Hutchinson*, ed. J. Bruce (Cambridge, 1842), 238 (quotation), 245–6.
131. For the value of seeing the sacrament after the English Reformation, see Arnold Hunt, 'The Lord's Supper in Early Modern England', *Past and Present*, 161 (1998), 57–60.
132. Calvin, 'Short Treatise', 158; id., 'Necessity', 204; both in *Calvin: Theological Treatises*. Cf. Du Plessis-Mornay, *Foure bookes*, 410.
133. Elwood, *Body Broken*, 101, citing Beza's *Confession de la foy chrestienne*; cf. the similar remark of Bullinger's that the Lord's Supper laid Christ's gifts 'before our senses', cited in Clark, *Eucharistic Sacrifice*, 173.
134. In the sacrament, as in the image, 'the visible seen was transmuted into an unseen but visualized spiritual reality': see Aston, *England's Iconoclasts*, 6–7, on the 'close connection' in Christian belief between images and sacraments.

135. Jewel, 'Reply to M. Harding's Answer', in *Works*, i. 575, 579; id., 'Treatise of the Sacraments', in *Works*, ii. 1117.
136. Pierre Viret, *The cauteles, canon, and ceremonies, of the most blasphemous, abhominable, and monstrous popish masse*, trans. T. Sto[cker] (London, 1584), 134 (orig. pub. as *Les Cauteles et canon de la Messe*, Lyon, 1563).
137. Camille, 'Before the Gaze', 209.
138. For Maignan, see Ch. 3 above, and Malcolm, *Aspects of Hobbes*, 210–11, who gives references to the dispute that ensued with the Jesuit Théophile Raynaud; cf. Rodis-Lewis, 'Machineries et perspectives curieuses', 471–3; Baltrušaitis, *Anamorphic Art*, 69; Stafford and Terpak, *Devices of Wonder*, 239–40. For Descartes, see Ch. 10 below.
139. Jean La Placette, *Traité de l'autorité des sens contre la transsubstantiation* (Amsterdam, 1700), *passim*, see esp. 25–6, 183–5.

6

Apparitions: The Discernment of Spirits

The debate on apparitions, by which are meant not just ghosts but spirit manifestations and visions in general, extended unbroken through the early modern centuries, intensifying during and after the Protestant Reformation. Ostensibly, it was a theological debate—the sort of thing provoked by the ghost that returns to speak with Hamlet. But it was also fundamentally concerned with the organization of human vision—an issue better represented (as we shall see in the next chapter) by the sights that torment and confuse Macbeth. Apparitions, after all, are things that appear, and spectres things that are seen. In the Roman world, according to a sixteenth-century expert, a *spectrum* signified 'a shape or forme of some thing presenting it selfe unto our sight'.[1] Spirits, by definition, were substances without bodies, their very visibility a problem. For ghosts to *be* ghosts they had to be correctly identified, not just as persons but as phenomena, and this was even more true of appearances of dead saints, angels and demons, the Virgin Mary, even of Christ himself. Their religious roles as apparitions presupposed a perceptual judgement, essentially visual in character, about just what they were.

Of course, not all visions were present to the eyes. Most educated Europeans worked with the threefold distinction established by St Augustine in his commentary on Genesis between the 'bodily' vision (*visio corporalis*), when present objects were seen with the external sense of sight, the 'spiritual' vision (*visio spiritualis*), consisting of images seen imaginatively without any accompanying body (for instance in ecstasies and in dreams), and the 'intellectual' or mental vision (*visio intellectualis*), which involved no kind of imaging or representation at all. This hierarchy of supernatural seeing made possible the cultivation and achieving of visionary experiences at levels of certainty and purity far above those of mundane sight—in the kind of imageless devotion often aimed at by mystics, for example. Yet because it was mapped on to the hierarchy present in natural seeing—in *vision* as well as in visions—it allowed for corporeality both in the external and internal senses, and in the example offered by Augustine presupposed an initial engagement with the external world that was assumed to be reliable: 'When we read this one commandment, *You shall love your neighbour as yourself,* we experience three kinds of vision: one through the eyes, by which we see the

letters; a second through the spirit, by which we think of our neighbour even when he is absent; and a third through an intuition of the mind, by which we see and understand love itself.' Up to the 'spiritual' level at least, visions consisted of corporeal images and imaginations, even if each level presupposed the one above it for full intelligibility and benefit (in a sense, full *visibility*). In theory, therefore, mistaken perceptual judgements were always a risk at the lower levels of the hierarchy, and as soon as we discover that the causes of 'bodily' and 'spiritual' visions extended to the human (fevers, and so on) and the demonic, as well as the divine, we can be certain that they had to be allowed for in practice too.[2]

It will be the argument of this chapter that making perceptual judgements in this area of religious life—like those surveyed in the previous chapter—became vastly more complex and precarious during the sixteenth and seventeenth centuries than ever before. The new theological and confessional arguments were themselves partly—and jointly—to blame. For Protestants to attribute apparitions and visions to the impostures of priests, the fabrications of the devil, or the effects of nature made their visual identification profoundly ambiguous. As Keith Thomas once said: 'although men went on seeing ghosts after the Reformation, they were assiduously taught not to take them at their face value.'[3] But Catholics, too, conceded demonic interference and natural causes, redoubling the uncertainty by undermining even their own capacity to identify ghosts as souls of the dead. On top of this were the more thoroughgoing claims that orthodox churchmen of both denominations had to take notice of—the claims of those they saw as 'materialists' and 'atheists' that apparitions and visions could *always* be explained away in terms of the hallucinations caused by mental or physical illnesses, or the tricks played by nature on the senses and by the imagination on the mind, or the artifice of magicians and clergy. Once the debate was fully under way—let us say by the opening of the seventeenth century—nobody fully engaged in it could ignore these various challenges to the veracity of seeing ghosts, spirits, and visions of all kinds or fail to interpret them in terms of the more general problems to do with visual reality that plagued and intrigued the age. Indeed, their writings became the occasion for some of the most sustained and sophisticated of the early modern discussions of truth and illusion in the visual world.

Those who believe in the return of the dead must grant them independent existence and initiative, even if these conform to a divine purpose. For the historian this has to be reversed, with the living 'imagining and telling' the dead, making them move and speak.[4] The history of the afterlife is thus a social history, dealing with the relationships between the one group and the other. In the European past some of these relationships have been very special—with supernatural beings like the saints, the Virgin, and Christ. Others have been more mundane—with the ordinary dead and the recently departed. The latter are the ghosts of Christianity, and their history is a history of the societies in which they appeared. Who they were and what they said and did tell us about the groups and

communities they once belonged to—the family and the kin, the village and the parish, the monastery and the church. Sixteenth- and seventeenth-century English ghosts, like those in other cultures, were important in the precise matter of obligations towards ancestors but also served to underline moral standards in general by 'sustaining good social relations and disturbing the sleep of the guilty'.[5] For Jean-Claude Schmitt, medieval ghosts reflected a whole range of changing social needs and helped to meet them, at once expressing and reshaping the social ties that bound those they revisited.[6]

Religions, likewise, arrange the world of the hereafter in different ways according to changing ideas and beliefs. They too are constantly reworking their relationships with the dead and their commitment to apparitions. In an economy of remembering and forgetting that stretched from St Augustine to the eve of the Reformations, Schmitt describes how, from about the twelfth century onwards, medieval Christianity moved away from an early rejection of ghosts as relics of paganism into dialogue with them. The development of the system of saying masses for the dead and making offerings in their memory unified them with the living and made each group beneficial to the other. So did the idea of Purgatory, where souls stained with only venial sins remained, pending full satisfaction for them. In effect, Purgatory Christianized ghosts. In asking for masses, prayers, and alms, the dead guaranteed the earthly institutions and liturgies that provided them; in granting their requests, the living gave spiritual succour to the dead, demonstrated their own piety, and helped ease their future journeys into the afterworld. Ghosts also resumed their ancient role as messengers from beyond the grave. They gave advice and warnings, made announcements, and answered questions. So too did the other apparitions that featured in medieval religion and its culture of visions. In the villages of fifteenth-century Castile and Catalonia, for example, divine figures—usually Mary but sometimes a saint or angels—appeared in response to ordinary lay people's prayers and instructed them about communal morality and the need for penance, often in the face of plague or other disasters. Typically, this led to the setting up of new shrines or the revival of old ones. It was thus one of the chief occasions for reform and the renewal of devotion in the later medieval Spanish countryside.[7]

Yet while each one of them had to survive some sort of test of authenticity, the ghosts and apparitions of the high Middle Ages do not seem to have suffered from a major crisis of identity. On the whole, the individuals and communities that encountered them knew what they were seeing—however disturbing or terrifying—and the clerics and theologians who discussed them knew what they meant. Few seem to have suggested that they were an impossibility.[8] But from the end of the thirteenth century onwards there are signs of a debate, theological in inspiration, which reflected growing uncertainties about their genuineness. At first it took the form of the 'discernment of spirits' (*discretio spirituum*), a type of contemplative theology, inspired by 1 John 4: 1 ('Beloved, believe not every spirit, but try the spirits whether they are of God') and designed to establish criteria for

distinguishing between true and false visions and their good and evil instigators. Growing fears of demonic contamination, a much higher incidence of prophecy, and the cases of visionaries like Bridget of Sweden and Jeanne d'Arc were the main occasions for this literature, and Jean Gerson its most notable early contributor.[9]

With the Protestant Reformation itself came the first major onslaught on the spiritual and ecclesiastical system that had made ghosts an integral part of medieval Christianity. The Catholic Church and its opponents now disagreed crucially over the distribution and activities of spirits, and the apparitions debate duly intensified to the point where it became fundamental to confessional polemics.[10] There was no real dispute about good and bad angels or about the souls of the damned; most accepted that the first could really appear to men and women, while the second—imprisoned perpetually in Hell—usually could not. At issue were the behaviour of the blessed and the very existence of Purgatory. Protestants believed that it was unnecessary for those in Heaven to appear again on earth, and by denying altogether the existence of Purgatory they also made it impossible for human souls to return after death to seek expiation for their sins. Both kinds of apparitions—if they were still real phenomena in the sense of being presented externally to consciousness—could be explained away as priestly deceptions, as spirits, usually evil ones, masquerading as saints and ghosts, or as natural effects wrongly interpreted. Otherwise, they were not real phenomena at all and attributable instead to human imaginings, themselves naturally caused. Anyone who continued to believe in the genuine reappearance of the dead—and many, of course, did—became 'credulous' and 'superstitious' in Protestant eyes. In 1563, after an angel appeared three times to a woman living near Dürrmenz in Württemberg, it was decided that she was either deceived by the devil or insane; '[t]here was no longer any room for theophany here', comments Bob Scribner.[11]

The author who published the best-known version of the reformers' arguments was the Zurich pastor Ludwig Lavater, whose *Von Gespaenstern* (*De spectris*) appeared first in 1569.[12] Spirits and other 'straunge sightes' did sometimes appear, he said, and 'in verye deede'. There were too many examples of reliable eyewitness reports given by trustworthy authorities and other 'honest and credible persons', from the Bible onwards, to doubt that they could be 'sensibly' seen as true apparitions. Omens that accurately heralded notable public events, including 'whole armies of men encountring togither' in the skies, were also correctly seen (and heard) by those 'perfectly in their wits'. The experience had been more common during the days of popery and was still more likely among the superstitious. It was even true that one man might see an apparition while the person next to him did not. Still, it was evident that 'walking spirits' and other strange sights could really present themselves to human eyes.[13] What could not be granted was that they were really ghosts. The concept of Purgatory impugned the redemption of Christ, perverted the notion of merit, and had no basis in Scripture. 'Ghosts' were not a proof of its existence but a product of its invention, and, in turn, the false foundation for most contemporary Catholic rites and institutions—for

'masses, images, satisfaction pilgrimages for religion sake, relikes of saints, monasticall vowes, holidaies, auricular confession, and other kinds of worshippings and rites . . . chapels, alters, monasteries, perpetuall lights, anniversaries, frieries, and such like'.[14] Once the idea 'that mens soules did walke after their death' took hold, said Lavater, the clergy's power over the laity became complete. The truth was that the fate of the dead was decided by the conduct of their own lives, not by the prayers or gifts of those they left behind. Human souls went on immediately to an everlasting life beyond any human aid or to eternal torments beyond any human relief. Satisfaction after death was therefore an irrelevant concept. A 'ghost' could always, without exception, be explained as something else:

If it be not a vayne persuasion proceeding through weakenesse of the senses through feare, or some suche like cause, or if it be not deceyte of men, or some naturall thing . . . it is either a good or evill Angell, or some other forewarning sent by God.[15]

Appearances of angels 'in visible shape' had in fact become rare since the days of miracles; devils, by contrast, could adopt the exact shape of any Christian—apostle, prophet, martyr, or ordinary worshipper, whether dead or alive—and 'appeare in their lykenesse'.[16] This was what most ghosts were—shapes of the dead shown demonically to the living.[17]

Catholics replied by reaffirming the doctrine of Purgatory and the duty of living Christians to make votive offerings to the dead, although they too allowed for the real appearance of angels and demons acting as apparitions in human form (the latter deceptively), for misinterpretations of nature, and for the role of self-deception and the imaginary. Because penance was less able to cleanse the soul than baptism, a dying individual could be left with sins that were not fully satisfied by earthly penalties but which prevented immediate entry into Paradise. Purgatory was the place for the atonement that remained and prayers, masses, pilgrimages, and other aids for the dead were a way of effecting their release from its retributions. Rarely, in fact miraculously, their souls might return in material shapes to ask for assistance, as well as to admonish, counsel, or comfort the living. In these last respects, they joined with the many other returning beings whose salvation was already secure—angels and saints being the most numerous. The difficulties for a pious person were thus twofold: first, to distinguish between the ghosts from Purgatory and these other visitors from the afterlife, and then to separate both these categories of genuine apparitions from the false ones. These latter were either demonic impersonations, which were real as apparitions but false in the sense of not being who they appeared to be, or the products of the human imagination, which were simply false phenomena from the start. The world of Catholic apparitions had greater variety in it than the Protestant and therefore greater choice, but it was not necessarily more populous; Protestants may have disallowed many more appearances on theological grounds but they then expanded the plentiful category of the demonic and the riches of the human fantasy in order to explain them away.

It was a French Capuchin from the Normandy town of Pontoise, Noel Taillepied, who answered Lavater most directly. Modelling his *Psichologie ou traité de l'apparition des esprits* derivatively on Lavater's *De spectris*, and plagiarizing most of its proofs, examples and citations, Taillepied simply repeated all the evidence given in the earlier work for the real appearance of spirits and then insisted that some of them were ghosts after all, occupying aerial bodies made into 'a form more agreeable than frightening and hideous'.[18] He then added the necessary purgatorial theology. Otherwise, apparitions were 'visions of apostles, bishops, martyrs, confessors, virgins and other Saints', or demons in disguise.[19] Provided good spirits were distinguished from bad ones—and Taillepied provided the criteria—and no sorcery or necromancy was involved, then ghosts might even be asked to appear to tell of dead parents, relations, friends, or benefactors who needed spiritual help. To think otherwise—to do away with disembodied souls—was indeed to strike at the root of Catholic piety, at 'masses, prayers, intercessions and orisons for the dead'. Why else would such things be practised if not because, again and again, souls had appeared to ask for them, along with the discharging of obligations and the restitution of property?[20]

Clearly the issue had become entangled with some of the most sensitive areas of religious dispute; apparitions were now theologically compromised. What is less obvious is the way they had also turned into visual puzzles. If they were not always what they seemed—if they included real appearances with a false content and false appearances that were altogether imaginary—then their visual status was compromised too. Potentially, this had been true of the cases considered by Gerson, yet around 1400 the 'visuality' of visions was not explored in any depth and the criteria for true visions adopted by Gerson were moral in nature, not optical or cognitive (we will return later to the issue of whether cognitive criteria *ever* became central to the discernment of spirits). In one of the earliest Protestant treatises against apparitions, Joannes Rivius of Attendorn was likewise able to attribute them to demonic illusion and the corruption of the human imagination, without exploring any of the visual implications in any way.[21] By the later sixteenth century the situation had drastically changed. Moreover, this was a matter on which both sides in the confessional dispute *agreed*. Despite their dramatic theological differences, Protestants and Catholics adopted a common epistemology of the visual sense and its deceptions, grounded in common readings of Aristotle and the psychology of the 'sensible soul'. Since Lavater and Taillepied shared a belief in the genuineness of some apparitions and the illusory nature of others, each had to begin by considering the same evidence for deception in this particular visual field, before going on to disagree over what kinds of apparitions to apply the evidence to. Their treatises therefore open with virtually identical sequences of chapters exploring this theme, the second book largely repeating the contents of the first.

The clearest cases were those of imaginary phenomena, when illness, madness, or just fear made people see completely non-existent things or interpret real things

in utterly fanciful ways. It was fearfulness, for example, that made women invent visual phenomena more often than men. But even those with sound wits might still have weak senses. 'We many time suppose those things which we see, to be farre otherwise than in deede they are', wrote Lavater, citing the oar 'bent' by refraction and the square tower that seemed 'round' at a distance.[22] There was also the example, noted by Aristotle (and cited throughout the early modern texts), of Antiphontis, a man who was led everywhere by an apparition that turned out to be his own reflection; this merely showed 'that some menne through the feeblenesse of their sight, beholding in the aire neere unto them (as it were in a glasse) a certaine image of them selves, suppose they see their owne angels or soules'.[23] Juggling and magical trickery of the eyes raised the same issues. To be deceived into thinking that someone could swallow a sword, or vomit money, or cut off 'his felowes head, which afterwardes he setteth on agayne' was to believe 'thyngs utterly false, to be very true'.[24] Those who were ignorant of the causes of strange effects in the natural world could mistake things like wonderful beasts and fiery exhalations for visions or spirits. Sometimes, indeed, apparitions were not just optical delusions but delusions of optics. According to Taillepied, the 'art of perspective' itself took advantage of the constructed nature of vision to create its own apparitions:

Optics also has wonderful effects, such that in artificial mirrors one will see various images: sometimes they seem to show people that one recognises, or they make others that one does not know appear to be outside [their surfaces], which is done by illusion of the sense and the imaginative power, which sees in the mirror what it imagines is there, especially at night.

Pythagoras, added Taillepied, was right to forbid his disciples to gaze into mirrors at night lest they saw evil spirits. The human senses were so fallible that 'one accepts what is not, and rejects what is true'.[25]

These explanations, as the supporting examples show, reflected the growing philosophical scepticism of the later sixteenth century, as well as the renewed interest in the manipulation of vision shown by natural magicians like Agrippa and Della Porta (the latter's *Magiae naturalis* appeared first in 1558). They had only been hinted at by Gerson nearly two centuries before. Taillepied sounds exactly like a sceptic when he says that, taken together, instances of visual delusion explained why it was believed that seeing a spirit or phantom might not involve a real body but 'only various imaginations in the understanding of men' (it was the Bible that proved instead that it could be real).[26] Aristotle's 'Thasian' man, 'to whom it seemed that a human phantom was all the time leading him around', had been cited as an instance of visual relativity by Sextus Empiricus himself, in his second trope, and the oar and the tower were likewise standard cases.[27] More recently, Agrippa had noted in his *De occulta philosophia* that 'by the artificialness of some certain looking-glasses, may be produced at a distance in the aire, beside the looking-glasses, what images we please; which when ignorant men see, they

think they see the appearance of spirits, or souls; when indeed they are nothing else but semblances kin to themselves, and without like'.[28] Della Porta, as we saw earlier, was another enthusiast for the 'hanging' image, an optical phenomenon also popularized by sixteenth-century editions of Witelo.

But the Zwinglian Lavater and the Capuchin Taillepied also agreed that there was a further source of visual deception that affected the reality of apparitions even more profoundly. Their arguments in this respect stemmed not from cognitive philosophy, epistemology, or natural magic but from a shared demonology—a demonology which permitted to demons the assumption of bodies that were, as one discussion put it, 'solid to the senses'.[29] If Satan was able to transform himself into an 'angel of light' (2 Corinthians 11: 14), he could easily 'represente the lykenesse of some faithfull man deceased', counterfeiting in outward show 'his words, voice, gesture, and suche other things'.[30] Devils could feign themselves to be dead men brought back from Hell and represented 'unto our sighte' by magic, and they could also 'bleare and beguyle the outward eyes', just as easily as dazzling the inward sight of the mind.[31] They could take the shape of any holy persons and make people 'see them in verie deede', or, alternatively, like jugglers, 'deceyve the eye sight, and other senses of man, and hide those things which are before our face, and convey other things into their places'.[32] The only aspect of visual deception on which the two men disagreed, predictably, was the question of whether priests too were responsible for false apparitions. Lavater accused them of adding to the confusion—and to the credulity of Catholics—by peddling 'false miracles, vayne apparitions, and suche other lyke trumperie', with or without the aid of sorcery.[33] Taillepied just as strenuously denied this, although he recognized in principle the role of human artifice in the creation of false appearances.

It seems, then, that as the nature and content of apparitions became more and more important, so their very identification as visual phenomena became less and less secure. By the end of the sixteenth century, they had come to raise crucially divisive doctrinal and pastoral issues that their own precariousness in optical terms then made it impossible to settle. Lavater may well have tried, as Bruce Gordon has said, 'to explain what people saw when visited by apparitions', but the explanation must have left them with many doubts.[34] It may be, in part, an additional sign of this radical uncertainty that, in England at least, ghosts and phantoms came to enjoy very great popularity as subjects for the stage, where their insubstantiality and illusoriness could be fittingly explored.[35] This vogue followed a long period of absence and lasted for a further century or so, before declining once more.

Some of the cases which Lavater and Taillepied considered could not have been more striking in their implications. When the apostles saw Christ walking on water (Matthew 14: 26) they were 'marvelously appalled', thinking they saw a spirit.[36] Even his Resurrection confused them, since, according to the Gospel of Luke at least, they again assumed 'that they had seen a spirit' (Luke 24: 37). Through fear, wrote both sixteenth-century authors, his very disciples thought that the Lord

himself was an apparition.[37] Such instances clearly showed that it was possible to 'mistake one man for an other, and perswade our selves that we have seene spirits, whereas no suche were'. Of course, they also demonstrated that spirits—for Lavater, only good or evil angels; for Taillepied, ghosts too—did actually appear in visible form, since otherwise the apostles could not have supposed they saw one. By not denying this, and instead only 'putting a difference betwene him selfe, and spirits or vaine apparitions', Christ drove home the point.[38] Still, the choice of examples like these to illustrate how easily the eyes could be mistaken underlines in itself, albeit unintentionally, the very serious consequences of visual deception. One might have imagined that the Resurrection, in particular, would have been exempted from visual ambiguity—as, indeed, had been the case in the medieval literature on ghosts.[39]

One might have imagined this even more, given that there was a second and deeper level at which apparitions had become vital test cases of belief. Here, the battle-lines were differently drawn, though religion was still at stake—indeed, more fundamentally. Despite their own differences of opinion, Protestants and Catholics were united against a further position they both found obnoxious—the attack on the very existence of souls and spirits by the sundry philosophers, ancient and modern, who, at one point or another, were deemed to be the enemies of religion itself. Lavater and Taillepied both referred to the Sadducees of Acts 23: 8 and the Epicureans of ancient Greece as those who had classically denied the existence of spirits altogether, and Taillepied (like most others in the apparitions debate) thought that the case of Aristotle too had to be carefully considered if he were to be recruited for orthodoxy. He commented that the Epicurean sect treated stories of apparitions as a way of 'terrifying the ignorant and little children', adding that comparable denials were to be found among modern-day 'atheists' like the followers of Machiavelli, Rabelais, and (somewhat improbably) Calvin.[40] For both him and his Protestant opponents this obviously struck at the very heart of their faith—nothing less than the existence of the deity and the immortality of the soul were at stake. In this context, apparitions became a proof of fundamental truths common to all Christians and, consequently, were impossible to disallow.

Those who did disallow them—completely—in the early modern period were virtually always said to include Pietro Pomponazzi, Giulio Cesare Vanini (whom Mersenne liked to call the 'Julius Caesar' of atheists),[41] and, later, Thomas Hobbes. Pomponazzi, whose book on the immortality of the soul was published in Bologna in 1516 and then burned in Venice, was the key figure here. He was admired and followed—indeed, virtually plagiarized—by Vanini, and his arguments were offered in the guise of strict Aristotelianism. If Aristotle was right about the mortality of the soul—and Pomponazzi, despite disclaimers, clearly thought he was—ghosts could *always* be explained away as fabulous or illusory, or be attributed to natural effects. In 1520, in a book on incantations, Pomponazzi suggested that Aristotle was also right about the non-existence of angels and

demons, which meant their removal from the spirit world too. It is hardly surprising that he came to be seen as representative of an extreme naturalism among those who thought differently.[42]

A century later, Vanini reinserted Pomponazzi's views into the debate in a chapter on apparitions in his *De admirandis naturae reginae deaeque mortalium arcanis libri quatuor*. This time the book itself was not burned but its author was; Vanini was executed in Toulouse in 1619. Initially, he dismissed apparitions as political fakes, contrived by rulers who wished to keep their subjects in a state of credulous fear—like Numa Pompilius, who, in Machiavelli's seminal account, claimed to have received laws from the gods by communicating with a nymph. But it did not take long for Vanini to turn to more elaborately visual explanations of the issues involved. For once again, as in the confessional polemics of the reformers, a dispute with dramatic theological and philosophical implications had come to hinge on what was visually uncertain. Taillepied himself understood this to be the implication of ancient Epicureanism, citing at the very outset of his *Traité* a remark by one of its followers (taken from Plutarch's *Life of Marcus Brutus*) concerning the powers of the imagination to construct visual (and tactile) experiences: 'In our secte, Brutus, we have an opinion, that we doe not always feele, or see, that which we suppose we doe both see and feele: but that our senses beeing credulous, and therefore easily abused (when they are idle and unoccupied in their owne objects) are induced to imagine they see and conjecture that, which they in truth doe not.' According to Plutarch, Taillepied added, the Epicureans thought that apparitions never appeared to those with sound minds, but only to small children, old women, and men who were sick.[43]

Those who were taken to be the Epicureans' modern equivalents were able to offer much more evidence for the visual uncertainty of apparitions. Pomponazzi had acknowledged that if the souls of the dead wandered visibly in graveyards, or appeared to the living in their dreams, this was a powerful objection to what he took to be Aristotle's position. But he had also pointed out that Aristotle himself had shown (*Meteorologica*, iii) that heavy air could behave like a mirror and (*De somno et vigilia*) that fear and sickness made waking men imagine nonexisting things. Evil priests, too, were not beyond such illusory tricks. Vanini took the argument further, largely by adding the opinions of Agrippa and Girolamo Cardano. Leaving political duplicity aside, which nevertheless had its own visual dimension (Vanini used the verb *fascinare* for the deceiving done by princes), aerial spectres were created either by vapours or by mirrors—or by vapours that acted like mirrors. Rising vapours could assume the shapes of apparitions, or carry with them the shapes of the earthly things that emitted them. The ghosts seen in cemeteries, for example, were simply corruptions of the air formed by vapours leaking from fresh bodies buried in shallow graves and cremation would soon put a stop to them. Vapours could even reproduce the contents of the imaginations of human beings, like the foetuses imprinted with forms imagined by their mothers. Smoke could carry the images of any objects it enveloped up into the air, where

they retained enough density to be seen. Apparitional armies fighting battles in the skies were reflections of real armies fighting battles on earth, 'mirrored' (as Agrippa too had suggested) by the effects of condensation and cloud formation.[44] To the objection that the souls of the dead talked with human voices, Vanini (decrying the 'atheistical' opinion that these were inventions of priests for gain) reported Cardano's interpretation of a ghost story told by Misaldus. Finally, he pointed, like everyone else in the debate, to the ability of the imagination to 'present' objects to sight and to Aristotle's 'Thasian' man, duped by an overheated brain, feeble eyesight, and, once again, the catoptric powers of vapours. The only other explanation for apparitions, the one offered by Pomponazzi ('the prince of the philosophers of our age'), was that they were caused by the superior spirits and intelligences that moved the heavens and wished thereby to instruct and guide us in our affairs.[45]

The impact made on the apparitions debate by this more radical and inclusive visual reductionism—and by the philosophical scepticism we will be looking at in a later chapter—is best seen in Pierre Le Loyer's *Quatre livres des spectres*, perhaps the most substantial and wide-ranging contribution to the whole literature.[46] Le Loyer was a lawyer from Angers who served as *conseiller au siège présidial* of the city and who otherwise wrote and translated poetry. His aim was to defend the Catholic position on ghosts against Lavater—that there are spectres and that they consist either of angels and demons or of souls of the dead. This is the argument of books 2, 3, and 4 of the treatise, the last of which is a guide for distinguishing between demonic apparitions and those of souls, based on a reading of the 'witch' of Endor episode in 1 Samuel 28. But as had Lavater (and as would Taillepied) Le Loyer introduced his discussion with several chapters on the problems of vision; he, like them, realized that it had become impossible to do otherwise. In his case, however, they occupy the whole of a substantial first book and they range far more broadly across the history and philosophy of visual perception.

His very topic, he begins, is defined by criteria of visibility; a spectre or apparition is an 'imagination of [we might say, 'that which is signified by'] a substance without a bodie [we might say, after Shakespeare, a 'sightless substance'], the which presenteth it selfe sensibly unto men, against the order and course of nature, and maketh them afraid'.[47] Spectres, explains Le Loyer, do really present themselves to perception and are 'plainely and manifestly seene'. There is no necessity, therefore, for them always to be attributed to sensory corruption or deception; they are, literally, strange sights, with a will to appear or not. A 'phantosme', by contrast, is a false phenomenon, 'a thing without life, and without substance' (and without will), because no object corresponding to it presents itself to the eyes; it is 'an imagination of things which are not indeede, and doth proceede of the senses being corrupted'. Following St Augustine, Le Loyer divided 'Visions' between the body ('done by the eyes of the body'), the imagination ('when our thought is ravished unto heaven, and wee see nothing by the exteriour

senses: but we imagine onely by some divine and heavenly inspiration'), and the intellect ('done onely in the understanding'), adding his own categories of visions while dreaming ('when one dreameth, or seemeth to behold any thing, which shall betide and happen in very deede according as was dreamed') and visions between sleeping and waking ('when partly in sleeping, and partly with the bodily eyes waking, one seeth any thing to appear before him'). In line with contemporary psychology, the 'Fantasie' is defined in relation to the visual faculty—as an imagining (imaging) of forms and shapes, known personally or described by others, 'without any sight had of them' at the time. We imagine the things we know corporeally in terms of our previous visual experiences of them, and we imagine the things we know 'spiritually', or have gathered from 'demonstrations', by means of similarities, analogies, translations, compositions, or contraries to do with things that are corporal.

In some respects, Le Loyer was only offering much fuller accounts of issues already raised by previous writers on apparitions. Among his chapters are several that recapitulate exactly the debates we too have been considering, conceding, in turn, that 'many things being meerely naturall are taken by the sight or hearing being deceived, for specters and things prodigious' (ch. 7), 'that things artificiall, as well as things naturall, may sometimes deceive the senses of the sight, and of the hearing, and drive men into a passion of feare and terrour' (ch. 8), 'that the senses being altered and corrupted, may easily bee deceived' (ch. 9), 'that the fantasie corrupted doth receive many false impressions and specters, as well as the senses' (ch. 10), and that 'the divell doth sometimes convey and mingle himselfe in the senses being corrupted, and in the phantasie offended, contrarie to the opinion of the naturall philosophers' (ch. 12). This bare list hides an enormous amount of detail; Le Loyer's text, like Hakewill's, is a compendium of the visual discourses of his age. Included in the treatise is a fresh survey of all the philosophers who had denied or questioned the possibility of apparitions—the Sadducees, the Epicureans, the Aristotelians, Galen, Pomponazzi, Cardano, and so on. And in almost every case, the discussion resolves itself into a debate about vision, simply because to deny or question apparitions, and spirits generally, on account of either their non-existence or their non-corporeality, necessarily involved redistributing the relevant sensory phenomena, wholly or partly, to some other source. To take just one example, Le Loyer reconsiders the 'Epicurean' theory that apparitions are nothing more than images that are 'reverberated and beaten back, from the Chrystall and transparant Ayre' and the view of Averroes that they are the false products of melancholy.[48]

In chapter 6, moreover, there is a new and original attempt to review—and eventually, to answer—the entire tradition of philosophical scepticism regarding the senses, concentrating on the Pyrrhonist claim that all objects are differently perceived, even when the eyes are 'sound and entire'.[49] From first to last, then, book 1 of Le Loyer's treatise on apparitions—the only portion of it to be translated into English—is concerned with the unreliability of visual perception. In the rest of his tract, Le Loyer went on to take a more positive view, but its opening

arguments allow for so many problems with what is supposed to be 'the most excellent, lively, and active' sense—enthusiastically adding cases of visual deception from his own experience to those of the classical sceptics—that it seems to become altogether the most uncertain one.[50]

For at least another century and a half, apparitions were high on the intellectual agenda. Spectres were regularly debated in the theological and philosophical faculties of Europe's universities and by some of the most prominent scholars of the age—men like Petrus Thyraeus at Mainz, Gijsbert Voet at Utrecht, and Johann Eberhart Schwelling at Bremen.[51] Restoration England saw a new flourishing of arguments about the manifestations of the spirit world, centred on the writings of Royal Society divines like Henry More and Joseph Glanvill, and the sharing of this interest with the Massachusetts intellectuals Increase and Cotton Mather made this a transatlantic phenomenon. By the middle of the eighteenth century the French abbé Nicolas Lenglet du Fresnoy had collected twenty-six reports or discussions of apparitions dating from 1609 onwards for inclusion in a compendium of writings on apparitions, visions, and dreams.[52] A medical professor at Wittenberg, Tobias Tandler, delivered a public address on the topic in 1608 and published it as *Oratio de spectris, quae vigilantibus obveniunt*. Specialist monographs were issued by the Lutheran pastor of Tachov in Bohemia, Sigismund Scherertz, in 1621, by one of his colleagues in Frankfurt, Bernhard Waldschmidt, in 1660, by Johann Heinrich Decker of Hamburg in 1690 and Carolus Fridericus Romanus of Leipzig in 1703, and by another French abbé, the Benedictine Augustin Calmet of Senones in Lorraine, in 1746. Apparitions continued to find a place in most general treatments of demonology and witchcraft and in accounts of the 'miracles' of the dead, but also in more specialized areas like meteorology.[53] Meanwhile, the standard texts from the late sixteenth century remained in heavy demand. Lavater's original treatise seems to have been reissued in seven Latin, two German, two French, and two English editions, and in single editions in Spanish, Italian, and Dutch,[54] Taillepied's in no fewer than seven additional French editions, and Le Loyer's in enlarged French editions in 1605 and 1608. A large collection of ghost stories edited by the Protestant publisher Henning Grosse in Eisleben in 1597 appeared subsequently in German in 1600 and in English in 1658, having been reissued in Latin in Leiden in 1656 with Le Loyer's arguments against Sadduceeism added, without acknowledgement, as an appendix.

Little was left to chance in this copious literature. Medical experts discussed the many illnesses—including afflictions of the eyes—resulting from the terror of seeing spectres, among them ulcers and contusions, fevers and deliriums, palpitations, epilepsy, pestilence, and melancholy.[55] Jurists argued over the legal complications that arose when spectres intruded into marriages, divorces, and the buying and selling of houses.[56] What was not required was any further modification to the confessional positions taken up by the end of the sixteenth century, which later protagonists needed only to reproduce in each new context. The later

Lutherans and Calvinists therefore added nothing new to the arguments of Rivius and Lavater. They continued to insist that apparitions could be real visual phenomena, which waking people might see under normal visual conditions. These 'struck' the eyes and the other senses, said Tandler, and in such a manifest way that they appeared 'to exist'. They were never what they seemed, however, and certainly not ghosts of the dead. Even if seen normally, they were demonic simulations of visible forms, while *ab*normal conditions could easily be created by the artificial manipulation of visual objects, by alterations to the visual medium, and by the malfunctioning of the organs of perception.

For Tandler, therefore, all spectres fell into three categories; they were caused when the healthy were deceived by artifice and magic ('per artem praestigiatoriam'), when the sick were deceived by their own corrupted faculties, and when both were deceived by Satanic illusions.[57] For those who followed him, such as Voet and Decker, the first and second cases were better thought of in naturalistic terms; they were instances of what spectres were *not*. The problem was to explain why people in their right minds and in ordinary visual contexts reported that they saw ghosts, without conceding that these might be spirits of the departed. This made the last category—where the *phantasmata* were particularly faithful to the objects perceived, and in that sense were most real—the most significant in religious terms. By 1637 Voet was defining a spectre as 'an external apparition of the devil, troubling to men', in which he was later followed by Decker.[58] In 1693, in a routine expression of Lutheran opinion in the medical faculty at Jena, spectres were once again defined as 'false and unnatural representations offered to the senses, being whole, by means of satanic illusion'.[59] Protestants continued to pay lip service to the possibility that apparitions might be of good angels but, in effect, they had narrowed spectral visual phenomena almost entirely to the realm of the demonic: the title of Scherertz's book, for example, was *Libellus consolatorius de spectris, hoc est, apparitionibus et illusionibus daemonum*. Such phenomena involved the correct perception of substantial bodies presented manifestly to the organs of sense and the faculties of the mind. They were nevertheless frauds and simulations because they were not the things they seemed to be, and certainly not the embodied souls of the dead.

Catholic opinion during the seventeenth century and beyond also followed the pattern established in the decades after the Council of Trent, enshrined as it was not only in Taillepied and Le Loyer, but in Petrus Thyraeus and Martín Del Río. Purgatorial theology continued to provide the intellectual cornerstone for the defence of ghosts, while leaving room for plenty of other apparitions, some real, some false, to be distinguished on largely non-theological grounds. In the 1660s Gaspar Schott was only repeating the arguments of the editor Joannes Prätorius when he insisted on both the genuine return of the dead and the sighting of false spectres. Mental pathologies, physical illnesses, impairments to eyes, contrivance and trickery, ignorance of how air and vapours behaved—all these, alone, combined, or manipulated by demons, meant that some apparitions were only

real as artificial or natural *phantasmata* while others were simply a kind of mockery (*ludibria*) of the senses. Catholics had to pay careful attention to these alternatives before a true spectral presence could be confirmed. To the key question at issue—what such true spectres *were*—Schott answered as usual that they were appearances of either angels (good or bad) or human souls.[60]

It was, of course, possible to bring a developing technology of optical devices and instruments to bear on the subject of contrived apparitions, although here too the debate was not changed in essence, only weighted towards naturalistic explanations of greater complexity. John Gadbury was still appealing to the natural magic of Agrippa when, in 1660, he wrote of 'certain glasses and instruments, made according to the secret knowledge of the optiques; which teacheth by divers refractions and reflections of the beams, how most visions and apparitions are represented'.[61] Others, however, were more up to date and more sophisticated. Marin Mersenne had to devote a large portion of his *Quaestiones celeberrimae in Genesim* (1623) to showing that the catoptrics of parabolic mirrors (derived from his own work and that of Claude Mydorge and Emmanuel Maignan) was an effective refutation of 'deists' because it proved that they could not be used to simulate apparitions of angels.[62] Apparitional mirror images, suspended or 'flying' outside the surfaces that produced them, continued to feature in advanced catroptrics—for example, in the work of Ambrosius Rhodius, the Wittenberg astronomer—and Athanasius Kircher felt the need to debunk them in his *Ars magna lucis et umbrae*, anxious, like Mersenne, about their potential support for 'atheism' and also keen to display his own mathematical and optical expertise (Fig. 18).[63] It may represent some kind of event in the history of visual culture when Robert Boyle, looking back from the sureties of corpuscularianism, can say this about the 'flying' apparition:

And when we see the image of a man cast into the air by a concave spherical looking-glass, though most men are amazed at it, and some suspect it to be no less than an effect of witchcraft, yet he that is skilled in catoptrics will, without consulting Aristotle or Paracelsus, or flying to hypostatical principles and substantial forms, be satisfied that the phenomenon is produced by the beams of light reflected, and thereby made convergent, according to optical and consequently mathematical laws.[64]

Indicative of a trend towards the mathematization of apparitions is the fact that Schott's account of spectres appeared not in a directly religious work but in his *Physica curiosa*. Instead of discussing again the man-made optical illusions often mistaken for spectral appearances he directed his readers to an earlier work, his *Magia universalis*, which in the 1677 edition opens with a 500-page treatise on optics. He also referred them to the many optical devices exhibited in Kircher's museum in Rome, themselves the subject of much of the same treatise. Unlike Del Río, who had in fact neglected this aspect of the subject seventy years before, and whatever his own theological convictions as a Jesuit, Schott clearly felt that this was the context in which apparitions now belonged—among the optical wonders

'of nature and art'. At crucial points in Johann Heinrich Decker's 'philosophical' account of the subject, entitled *Spectrologia* and explicitly directed against 'atheists' like Hobbes, he was even prepared to abandon its theology altogether, although his position is recognizably the Protestant one. To others, he said, could be left even questions like what distinguished angelic apparitions from demonic copies—as well as what kind of spectre had been summoned by the 'witch' of Endor. His own questions, meanwhile, were couched overwhelmingly as enquiries about the visual experience of seeing apparitions: were they real objects of vision or, as the sceptics and atheists claimed, products of the imagination and of melancholy or of other illnesses; could they result from atmospheric conditions or be simulated by art; were they natural effects mistaken for supernatural ones, or optical illusions created by Satan; how was it possible for a spirit to become visible, and to whom; how, of two people, was it possible for one to see a spectre and the other not; what visible forms did spectres take; and how did they play tricks on the external sense of vision?[65]

Much the same was true of Carolus Fridericus Romanus, a senior figure in the Leipzig legal establishment, who in what was essentially an attack on Balthasar Bekker's views on spirits and spectres defined the latter as 'external apparitions and frights of the devil, whose bodily shapes he assumes, or something else that strikes the senses, so that he may trouble people, animals, and whatever else'. As had always been the case, this allied the controversy about apparitions to one about the visibility of demons—the ideological coordinates of which were not necessarily the same. But for their ability to assume and change bodily form Romanus chose the analogy of a seventeenth-century optical experiment that combined the roles of the camera obscura and the magic lantern, citing a famous letter on the subject sent by Cornelis Drebbel to his friend and promoter Constantijn Huygens. That Romanus should have selected this particular comparison shows how the apparitions debate had come to turn on the technicalities of contemporary optics and the visual puzzles they might generate; in effect, his attempt to answer Bekker ended by reinforcing the idea of deception, not undermining it.[66]

It is thus no coincidence that the early history of the anamorphic and projected image should be populated by apparitional beings. One of the first of the sixteenth-century anamorphic designs, an anonymous work from the southern Netherlands, is a depiction of the old Testament story that (as we shall see again in the next chapter) featured more than any other example in the literature of apparitions: Saul and the 'witch' of Endor (1 Samuel 28). The scene contains a witches' sabbat, a windswept landscape, and, in anamorphic distortion, Saul falling on his own sword after his predicted defeat by the Philistine army.[67] Of the designs for filling rooms—using the walls, floors, ceilings, and furniture—with different types of conical and pyramidal anamorphoses, included in Jean Dubreuil's *La Perspective pratique* (1640–9), Baltrušaitis remarked that the result must have seemed like 'rooms of ghosts in which faces rise up on every side and vanish as one moves about' (Figs. 19–20).[68] The camera obscura and the early magic lanterns

were likewise frequently described or depicted as means for projecting images of ghosts, skeletons, souls in Purgatory, or just monsters.[69] By 1728, necromancy itself could be explained away as the workings of a magic lantern set in a dark room, projecting larger than life 'spectres' through two convex lenses onto a white cloth at a distance of eighteen to twenty paces, with a few shrouds and a coffin thrown in for good measure. Mechanics, mathematics, and optics had finally turned the raising of the dead into the projection of their images—with the French curé Jean Pierquin using the verb *susciter* to describe both.[70]

But if the confessional arguments stood still, and the technology of artificial apparitions changed only in complexity, not in kind, the more profound challenges to the reality of apparitions certainly did not. Once again, the contrasting theological responses of authors were not as significant as their common need to find an answer to something more fundamental. The seventeenth century was richer still in 'atheism', 'Sadduceeism', and 'libertinism' and in philosophical systems that cast radical doubts on spectral phenomena in yet more visually reductive ways. These became the shared targets of Anglicans like More and Glanvill and the Benedictine abbé Calmet. To Pomponazzi and Vanini (as well as Reginald Scot and David Joris from the sixteenth century), Decker, whose discourse on spectres appeared in 1690, added the names of Thomas Hobbes and John Webster in England and Descartes in the Netherlands. Of these, Hobbes and Descartes were undoubtedly the more far-reaching. Webster's outright attack on witchcraft beliefs led him to question many things about spirits but not, ultimately, their corporeality nor the capacity of the 'astral' or 'sydereal' soul (made up of air and fire—a Paracelsian notion) to wander through the air after death and make 'strange apparitions'. Apparitions should not really be used, he said, to prove the existence of angels and devils, since most of them—even of armies recently seen fighting each other in the English skies—had natural or artificial causes. They were, indeed, just that; things that appeared, like the 'idola, images, or species that we see in glasses', or the comets, stars, meteors, multiple suns, and rainbows that graced the heavens. More simply still, they included sightings of the middle creatures who Webster (again like Paracelsus) thought populated the intermediate world between angels and humans. Even so, good and evil angels might still take visible form, if rarely, and perform supernatural operations 'as matters of fact' that could not be explained according to 'the supposed principles of matter and motion'. Webster was evidently neither radically unorthodox on this issue nor unaware of those who were; such operations, he said (in a significant phrase), would convince 'the most deep-sighted naturalist', as well as his atheist allies.[71]

To convince either Descartes or Hobbes on this point would have been difficult. Hobbes, in particular, provides a sophisticated example of how the religious and optical aspects of apparitions had become indistinguishable by the middle of the seventeenth century. He allowed in principle that God might produce

'unnaturall apparitions' but in the same spirit as he allowed him to perform miracles.[72] Otherwise, apparitions ceased to be an issue in his thought, except as the trappings of 'daemonological' religions and, thus, obstacles to civil obedience. In some respects, Hobbes's reasons for discounting them were entirely familiar and uncontentious, at least in a Protestant context: apparitions seen in dreams were accepted as real by those who were unaware that they slept; the timorous and the gullible imagined that they saw 'spirits and dead mens ghosts walking in church-yards'; 'knaves' might dress up in the night to haunt superstitious fools. The belief in spectres had been encouraged, said Hobbes, 'to keep in credit the use of exorcisme, of crosses, of holy water, and other such inventions of ghostly men', and the world would be fitter for citizenship without it.[73] But the argument was far more subversive than this. It was not just that entire religions—gentile as well as Catholic—and swathes of popular belief rested on the failure to distinguish dreams and fancies from waking reality. More profoundly still, they rested on ignorance of 'the nature of sight',[74] the causes of which Hobbes made the starting point not only for his hostile account of 'daemonology' but for *Leviathan* as a whole. What led men to believe in apparitions was their confusion over the nature of 'apparence' *itself*.

Sensation, explained Hobbes in the very opening chapter, results from a mechanical sequence of motions caused by action and reaction. External objects exert inward pressure, via the sense organs, on the brain and heart, which resist by exerting a corresponding counter-pressure in an outward direction. The sensation—the phantasm or idea of the object—that results, precisely because it is the last event in a chain of outward motions, is an experience of something outside the organ of sense. The 'endeavour', says Hobbes, 'because outward, seemeth to be some matter without', in the case of vision 'a light, or colour figured' (a lucid object). The crucial point is that this only *seems* to be the case. Sensible qualities, such as colours, are no more than motions in the objects that cause them, as well as in the organs that sense them. Only our fancy—literally our 'seeming'—senses them otherwise, as it does too when no external objects act on us at all and the motions required for sensation arise elsewhere, for example in dreaming or when the eye is rubbed or struck and the ear pressed. In certain conditions, an object may seem to be invested with 'the fancy it begets in us', but we know simply from using mirrors that appearance and object can always be separated. In this respect, the mirror is an emblem of Hobbes's model of perception. The object, he insists, is one thing, the image or fancy is another.[75]

It is exactly this account of sensation, but now focused entirely on vision, that, later in *Leviathan*, is used to explain the conventional belief in apparitions and ghosts and, indeed, all religious and political systems founded on demonology. Hobbes says again that the visual image of an external object seems not to be, in the usual sense of the word, purely imaginary but rather 'the body it selfe without us'. But the fact that this sensation can occur when there is no such body (as in dreaming or the artificial manipulation of the eye) proves that sight consists nevertheless

in images generated internally by the mind by motion in the interior organs. This it is that the ancients never knew, finding it therefore impossible 'to conceive of those images in the fancy, and in the sense, otherwise, than of things really without us: . . . [not] idols of the braine, but things reall, and independent on the fancy'.[76] They therefore had no other way of accounting for images that were fleeting and evanescent than as incorporeal or spiritual things, such as colours and figures without bodies, or bodies made of air or clothed in it—in a word, the demons of the Greeks and Jews: 'As if the dead of whom they dreamed, were not inhabitants of their own brain, but of the air, or of heaven, or hell; not phantasmes, but ghosts.' One might as well say, said Hobbes, that a man sees his own ghost in a mirror or the ghosts of the stars in a river, or call the sun's appearance 'of the quantity of about a foot' the ghost of the real thing.[77]

In effect, Hobbes had arrived at the ultimate argument for interpreting apparitions as visual phenomena: they were nothing else—nothing *but* phenomena. This was not because there was something especially intractable about them; they were no more nor less intractable than anything else in the visual world. We are said to understand a thing, he wrote, 'when we have the phantasma or apparition of it'.[78] Everything sensed was an appearance, an apparition, and the traditional belief in ghosts had only been able to flourish because this truth had been unknown or ignored. In this way, Hobbes's theory of sensation, and others like it, made apparitions the subject of mainstream philosophy and optics, where they have become part of the history of the concept of 'appearance' itself. But his remarks about ghosts and demons were also a direct challenge to the narrower orthodoxies of the post-Reformation apparitions debate and reactions to it from this quarter are noticeable too. The sense that apparitions (as traditionally conceived) had become visually paradoxical remained, in consequence, acute.

In view of this, it might be worth speculating, finally, over whether intellectuals involved in the 'discernment of spirits'—the subject we have effectively been concerned with throughout this discussion—ever did arrive at criteria for distinguishing the genuine and allowable from the false and evil versions *on visual grounds*; whether, indeed, visions ever regained visual credibility? Without this, they risked joining the swelling ranks of visual experiences unable to guarantee their own veridicality. The literature that emerged on the topic was certainly vast, expressing by its very extent what was obviously a theological and practical absorption—and, it seems, an intractable problem. Here was a traditional set of questions that received such intense and sustained treatment throughout the sixteenth and seventeenth centuries that Terence Cave has called this a 'symptôme de l'angoisse qui entoure l'incertitude à cette époque'.[79] At the very least, discussions stretched from Gerson's attempt to improve the canonization processes at the Council of Constance in the early fifteenth century to Prospero Lambertini, later Pope Benedict XIV's similar campaign in the 1730s (the latter's *De servorum Dei*

beatificatione et beatorum canonizatione, 1734–8, was perhaps the eighteenth century's most exhaustive attempt to codify standards of Catholic sanctity). Because 'discerning' spirits meant separating the good from the bad wherever they might manifest themselves, the subject—besides inspiring many specialized treatments, like those by the Neapolitan Dominican and Thomist Domenico Gravina, or Giorgio Polacco, or the Cistercian Giovanni Bona[80]—entered extensively into general angelography, pneumatology, and demonology, the literature (and practices) relating to possession and exorcism, the widespread discussions of revelations, prophecies, ecstasies, raptures, and dreams, and the numerous treatises for the guidance of inquisitors, priests, confessors, and other spiritual directors (which often dealt with all of these topics, especially in the decades after the Council of Trent).[81] Naturally, true or false sainthood was in dispute on many occasions—occasions as influential as the visions and visitations of Bridget of Sweden and Teresa of Avila—and female spirituality in particular was often the subject of especial scrutiny, whether in theoretical terms, or in the context of specific investigations of alleged 'pretence of holiness', or by female *beatas* and visionaries themselves, fully conscious (like Teresa herself) of the uncertainties surrounding what they were doing.[82] But the issue arose whenever anyone sought validity, personal or public, for interactions with the divine, and it is not an exaggeration to say that it 'struck at the heart of the institutional church's role in mediating the presence of God to Christians'.[83] The 'spiritual exercises' of St Ignatius included an exposition—and were, indeed, a result—of the discernment of spirits, displaying their origins in mysticism and helping to explain their enormous success. So too, in a completely different medium, were the many depictions by early modern artists of the temptation of St Anthony.[84]

Although far too enormous a field to survey properly here, there are indications that debate centred on what might be called the theological or moral reasons for deciding whether a particular spirit or vision was a reliable and acceptable thing to have seen, rather than attempting to sort out the purely visual trustworthiness of the experience. This, in turn, prompts the thought that, given the developments dealt with in this chapter—and given the range and effectiveness of the natural, artificial, and demonic powers to produce simulations of the real available in early modern culture—this kind of trustworthiness had become unattainable *anyway*. Addressing his colleagues in the Holy Office and running the usual gamut of possibilities, an Italian cardinal wrote:

Given the devil's deceits and subtle stratagems, it is very difficult to determine which apparitions and revelations are divine and which are [diabolical] illusions, and similarly, [to tell] which ecstasies are caused by God, distinguishing them from that lulling of the senses brought about by the devil, [natural] indisposition, or the imbalance of tempers, termed 'ecstasy' (*extases*) or 'rapture due to weakness' (*raptus ab aegritudine*).[85]

Giovanni Bona, also a cardinal, conceded that, while human perception could normally tell the difference between the present and the absent, there were occasions

when, through fixation, mental illness, or the attentions of good or evil angels, 'images of corporeal things are represented in the mind just as if one sees them with the bodily eyes, [and] we cannot distinguish those presented to our vision from those only in our imagination' ('tunc inter ea quae visui et quae imaginationi occurrunt, non discernimus').[86] In seventeenth-century Utrecht, the Calvinist intellectual Gijsbert Voet expressed the problem even more acutely: how in practice could one separate the 'internal' spectres of the diseased imagination from the external prestiges of demons and magicians, when 'by the ears, eyes, touch, and everything else they are perceived in the same way' ('quae auribus, aut oculis, aut tactu, aut omnibus simul percipiuntur')?[87] In the particular area of possession—diabolic *or divine*—it became impossible, in one recent view, 'to determine the origins and identity of the possessing entity merely by observing the external behaviours of the possessed person'.[88] This was a point made at the time, and with some force, by the French Minim Claude Pithoys in his *La Descouverture des faux possedez* (1621):

> It is a very difficult matter to distinguish properly between a genuine possession and a diabolic illusion—[this is because] demons are invisible and can be present without being seen, and are so agile and subtle that, in next to no time, they can be wherever they want and pass through anything without resistance; they know so many things and can reveal them to whoever they wish, and can produce so many wonderful effects, and cause so many marvels in an individual without, however, there being any real demonic possession of him, but only illusions and satanic enchantments.[89]

The French popularizer of beliefs Pierre de La Primaudaye hoped that men's judgements might be sound enough 'to discerne the images of those things, which [God] representeth to their mindes, from all Diabolicall illusions', but in England John Webster challenged the idea that the devil could create any apparition by saying that, in that case, 'the world would be full of nothing almost but apparitions'. How, he asked, would anyone 'know a true natural substance or body, from these fictitious apparaitions [*sic*]'?[90] By avoiding this issue and emphasizing instead the non-visual criteria for the true and the real, the 'discerners' of spirits may only have been acknowledging (if not explicitly) the situation I have tried to describe—one where the religious apparition had become yet another of early modern Europe's 'vanities' of the eye.

This might seem a somewhat strained interpretation, given that the highest form of Augustinian vision was imageless and that the 'spirits' whose discernment was at issue were often treated in the texts not as visible entities but—as in the writings of Loyola and Bona—as the divine, demonic, or merely human inspirations behind internal motions of the soul, impelling it in contrary directions. This was a difficult approach to maintain in practice, however, when so many encounters with spirits took the form of something that was undoubtedly *seen* and not just experienced at the level of spiritual disposition; even Loyola talked of baits for the senses, which the devil 'incessantly places before the eyes'.[91] It scarcely

PLATE 1. Jan Br[u]egel the Elder, *The Sense of Sight*, 1617. By permission of the Museo el Prado, Madrid. An encyclopaedic allegorical and literal inventory of sight, seeing, and optics.

PLATE 2. Marten de Vos (engraved by Adriaen Collaert), *Visus*, 1575. By permission of the Albertina Museum, Vienna. Part of a typical series of depictions of the five senses and their allegorical attributes.

PLATE 3. Laurens van Haecht Goidtsenhoven (Haechtanus), *Microcosmos. Parvus mundus*, trans. Henricus Costerius, engraving by Gerard de Jode (Antwerp, 1592), 74r. By permission of the British Library. Shelfmark: C. 125. c. 31. Emblem entitled 'Homines atque folucres picturis decipiuntur (Men and birds are deceived by paintings)'.

PLATE 4 (*right*). Johannes David, *Veridicus Christianus* (Antwerp, 1601), opp. 218. By permission of the British Library. Shelfmark: C. 27. k. 9. Engraving by Cornelius Galle entitled 'Adspectus incauti dispendium (The cost of careless looking)'.

PLATE 5 (*far right*). 'F. B.' (Franz Isaac Brun), *Mezmolia*, 1561. © Copyright the Trustees of The British Museum. A woman representing melancholia sits in an interior with linear perspective, and a sphere and square on the floor.

PLATE 6. Hieronymus Bosch (after), *The Conjuror*, late 15th century. By permission of the Musée municipal, Saint-Germain-en-Laye (photography by L. Sully-Jaulmes and Roger Davies). Satirical allegory on the perils of conjuring with cups and balls.

PLATE 7 (*above*). Jean-François Nicéron, *Thaumaturgus opticus, seu admiranda optices . . . catoptrices . . . et dioptrices* (Paris, 1646), plates lxvi and lxvii. By permission of the British Library. Shelfmark: 48. h. 2. Nicéron's anamorphic design for a fresco depicting St John the Apostle at Patmos, executed in the monastery of the Minims attached to the church of Santa Trinità dei Monti, Rome, 1642, and later in Paris.

PLATE 8 (*left*). Jacques Ozanam, *Recreations mathematiques et physiques* (Paris, 1696), opp. 157. By permission of the British Library. Shelfmark: 8531. aaa. 23. Anamorphic design for a human eye.

PLATE 9. Jean-François Nicéron, *La Perspective curieuse ou magie artificiele [sic] des effets merveilleux* (Paris, 1638), title-page. By permission of the British Library. Shelfmark: L. 35/44. Two anamorphic designs involving a conical and a cylindrical mirror, with putti observing another optical effect through a tube with a faceted lens in it directed at images on a plaque hung on the vertical surface of the left-hand pedestal.

PLATE 10. Athanasius Kircher, *Ars magna lucis et umbrae* (Rome, 1646), Iconismus xxviii, opp. 806. By permission of the British Library. Shelfmark: 536. l. 25. Camera obscura device.

PLATE 11. Athanasius Kircher, *Ars magna lucis et umbrae* (Rome, 1646), Iconismus xxxiii (fig. 4), opp. 900. By permission of the British Library. Shelfmark: 536. l. 25. Catoptric machine for achieving 'metamorphoses' of humans into animals.

PLATES 12 and 13. Mario Bettini, *Apiaria universae philosophiae mathematicae* (2 vols.; Bologna, 1642), i. 'Apiarium quintum', 28-9. By permission of the British Library. Shelfmark: 1605/110. 'Tabula scalata' device for depicting the Resurrection.

PLATES 14 to 17. [Nicolaus Manuel], *Die war histori von den vier ketzern prediger ordens (...) zu Bern ... verbrannt* (n.p., n.d., 1510?), no pagination. By permission of the British Library. Shelfmark: 1369. g. 7. False miracles allegedly perpetrated by the Dominicans of Berne: (14) one of the Fathers appears as a 'spirit' in the cell of the novice Hans Jetzer; (15) the sub-prior Franciscus Ulschi dresses up as a 'spirit' and torments the novice; (16) a false Virgin and child appears to the novice; (16) an image of the Virgin is made to weep and to talk.

PLATE 18. Athanasius Kircher, *Ars magna lucis et umbrae* (Rome, 1646), Iconismus xxxiii (fig. 1), opp. 900. By permission of the British Library. Shelfmark: 538. i. 25. Catoptrical device for producing a 'flying' mirror image.

PLATES 19 and 20.
[Jean Dubreuil], *La Perspective pratique*, 2nd edn. (3 vols.; Paris, 1651), iii. 112 and 122. By permission of the British Library. Shelfmark: 50. d. 19. Designs for projecting anamorphic images in rooms.

PLATE 21. Salvator Rosa, *Saul e la pitonessa*, 1668. © Musée du Louvre, © Direction des Musées de France, 1999 (photography by Roger Davies). Saul bows in false worship before 'Samuel'.

PLATE 22. Jacques de Gheyn II (after), engraved by Andries Stock (?), *The Preparation for the Witches' Sabbath*, c.1610, published in Delft by Nicolaes de Clerck. By permission of the Bibliothèque nationale de France, Paris. Scene depicting the horrific but perhaps imaginary character of witchcraft.

PLATE 23. Jacob Cornelisz van Oostsanen (also known as Jacob van Amsterdam), *Saul and the Witch of Endor*, 1526. By permission of the Rijksmuseum, Amsterdam. A magic mirror suggests the visual artifice in the witch of Endor's necromantic art.

PLATE 24. Taddeo Zuccara, *Sleep*, 16th century. © Musée du Louvre département des Arts graphiques, © Direction des Musées de France, 1996 (photography by Roger Davies). A 'witch' lies asleep grasping poppy stalks in one hand and a broom stick in the other, and dreaming of the sabbat.

PLATES 25 and 26. Michel de Marolles, 'The Palace of Sleep', *Tableaux du temple des muses* (Paris, 1655), plate lviii. By permission of the British Library. Shelfmark: 1869. e. 11. (25) The Palace of Sleep with its two doors: on the right, dreams that come true; on the left, dreams of things 'that never had a being,' (26) Detail of a naked 'witch' riding off to meet the goddess Diana.

PLATE 27 [René Descartes], *L'Homme de René Descartes et La formation du foetus,* 2nd edn. (Paris, 1677), 67. By permission of the British Library. Shelfmark: C. 131. k. 8. Diagram of Descartes's visual system as far as the pineal gland, added by Louis De La Forge to Claude Clerselier's posthumous editions of *L'Homme.*

needs adding that the depiction of spirits and apparitions as sensible objects provided multitudes of early modern painters with both an unmissable opportunity and an awkward technical problem.[92] In any case, the formal classifications of how supernatural revelations (however unlikely) were achieved invariably made provision for apparitions visible to the eyes, in which case the intelligibility of what was physically seen was an essential preliminary to what, ultimately, was spiritually at stake. In Neapolitan theological circles in the seventeenth century, for example, Francesco Maria Filomarino included two kinds of 'corporeal' vision in his typology, the one having no mystical significance (i.e. purely natural vision) and the other, like the burning bush seen by Moses, having a good deal. The other major authorities, Gravina and Bona, followed the more prevalent Augustinian (and Gersonian) model which, as we saw at the outset of this chapter, also found a place for 'corporeal' visions, perceptible to the senses, which were vehicles for a higher mystical meaning, the burning bush being again the key instance. The discerners of spirits were, it seems, not lost for categories. Their difficulty lay, rather, in applying them in a representational system where the divine, the demonic, and the human, though formally distinct, might yield identical perceptions in both the outer and inner senses, leaving only Augustine's highest tier of vision, the definitionally uncontaminable and divinely sourced *visio intellectualis* as the final guarantor of intelligibility.

Confirmation of this from the mid eighteenth century—at a point where we must leave the subject—comes in the form of Lenglet Du Fresnoy's other main work in the field (other than the *Recueil de dissertations*), his *Traité historique et dogmatique sur les apparitions, les visions et les révélations particulières* (1751). This begins as a direct commentary on Augustine's model but advocates suspension of judgement and reasonable doubt as the only proper responses to most apparitions and revelations. Both 'corporeal' and 'spiritual' visions could be profoundly misleading and detrimental to the spirit, leaving only 'intellectual' visions—dependent neither on objects nor their representation but only on 'intellectual' *species*—as free from error:

> The external senses often deceive us, when on their report alone we claim to know and grasp an object completely, because the object's different positions make it appear in different and even quite opposite ways. The imagination also falls into misapprehension because it can only represent an object on the report of the senses; thus, it needs to be corrected by the understanding, which in investigating the matter discovers, by the various positions in which the object is placed, that the source of the error is that uniformity of judgment which an individual who is biased and seduced by his imagination or by his external senses, forms of an object, however differently considered. Thus, appearance, or corporal vision, is subject to error, and it makes the mind fall imperceptibly into error too, if care is not taken to examine by right and wise reflection the truth or falsity of the things represented to it.[93]

As an internal sense, but still a *sense*, the *phantasie* was vulnerable to impressions of such strength that the images, resemblances, representations, and appearances generated there were often taken for real bodies. In short, nothing was more subject to illusion than the senses and the imagination, leaving questions of

motive, interest, circumstance, psychological traits, and conformity to Scripture as the only guides to authenticity.[94]

Guides to the practice of discernment do therefore depend on what I would still like to call (for the moment at least) non-visual criteria; indeed, they may even be said to take this dependence for granted. Gerson's *De probatione spirituum* (written in 1415 and still being recommended by Du Fresnoy in 1751) begins with Satan's most audacious impersonation of all—of Christ 'before the very eyes of St Martin'—and with the visions of Christ, Mary, and the saints supposedly seen by Bridget, but it eventually concentrates on questions of a different sort: 'Who is it to whom the revelation is made? What does the revelation itself mean and to what does it refer? Why is it said to have taken place? To whom was it manifested for advice? What kind of life does the visionary lead? Whence does the revelation originate?' Gerson was clearly most interested in the character, disposition, experience, and lifestyle of visionaries, in the variables of sex, age, health, wealth, position, and emotional state, in 'education, habits, likes, associations', and, above all, in purpose and motive. The reason why a vision occurs must be determined, he shrewdly insists, 'particularly not only for what proximate end, and much less for the obvious one, but even more for the unexpressed and ultimate objective'. His earlier tract, *De distinctione verarum visionum a falsis* (1401) reinforces these impressions. Here, the rules for discerning 'angelical revelations from demoniacal illusions' (the latter including the tricks of magicians and the 'fancies and illusions' of the Antichrist) were to be drawn from five disposing virtues present (or absent) in the person and the vision in question: humility, discretion (willingness to accept counsel), patience, truth, and charity.[95]

By the time of the seventeenth century, discernment had settled upon three of Gerson's main themes: the personal attributes and conduct of the man or woman involved, the circumstances surrounding their experience, and the character of the things revealed to them.[96] Discussions of these themes certainly dealt with all the complex ways in which a person, a set of events, or a vision itself might raise the issues of visual illusion. Indeed, we are faced again with a genre of writing that is full of all the usual debating points: the dangers of the imagination, the visual hallucinations traceable to madness and melancholy, the capacity of demons and magicians to interfere in the senses, the virtual worlds of the witch, the dreamer, and the ecstatic, and the borderlines between sleep and wakefulness. Francesco Maria Guazzo spoke of the need to discern the health of visionaries, since melancholy (aided by the devil) might make them 'think they see, hear or taste that which is not there to be seen or heard or tasted'. His compatriot Francesco Maria Filomarino allotted part of his *Tractatus de divinis revelationibus* (1675) to the role of the female humours and imagination in the illusions of women.[97] But these were diagnoses of a problem, not solutions to it. They indicated that the visual components of an encounter with spirits ought not to be trusted, not what criteria might eventually be devised for trusting them nevertheless.[98] 'Unless it is proved by clear signs', wrote Gravina, without apparently offering any, 'that such

a motion of the senses comes about by virtue of an angel or God, one must assume that it is the work of the devil or, since there is doubt, at least suspend judgement and incline rather to rejecting it.'[99] Since looking at a spirit manifestation was of no help, it was better, for example, to gauge whether the encounter began in fear and terror and ended in joy (angel) or the other way round (demon). To identify a spirit, the sign of the cross, the name of Jesus, and the brandishing of relics or holy water all produced better results than the naked eyes.[100]

It is tempting to conclude, therefore, that between the Reformation and the publication of Augustin Calmet's *Dissertations sur les apparitions des anges, des démons et des esprits* (1746), apparitions were made visually ambiguous to such an extent that, at the level of theory at least, no criteria for deciding their reality on visual grounds alone could easily be offered. They became visually paradoxical—supposedly objects of sense but whose truth or falsity it was either difficult or impossible to establish simply by looking at them. Sounding remarkably like Gerson three centuries or so earlier, both Glanvill and Calmet alike concluded that the truth of apparitions derived not from their appearance but from the qualities of those who witnessed them, the circumstances and events that accompanied them, and the fact that they did things against the interests of demons. Glanvill was particularly explicit on this point—the '*best* notes of distinction between true miracles and forgeries, divine and diabolical ones', he said (mentioning apparitions, witchcraft, and 'diabolical wonders'), were 'the circumstances of the persons, ends, and issues'.[101]

Nevertheless, neither man was devoid of a post-Cartesian faith in appearances, buttressed in each case by what Glanvill called the 'vital' interests of religion. Well aware of both the general Hobbesian idea that fear and fancy might 'make Devils now, as they did Gods of old' and also the specific threat to things like a visible Resurrection, Glanvill sought to establish the visual, as well as the circumstantial, credentials of 'matters of fact'—the visual, as well as the social, criteria for reliable testimony. He insisted, moreover, that objects of plain sense, and all the other matters of 'daily converses' could never, in a world ruled by 'infinite wisdom and goodness', be the occasion for 'unavoidable deception'.[102] Above all, as we shall eventually see, interpretations of how the human senses functioned were changing in any case. The processes of sensation were increasingly described in mechanical terms and their effects on the eyes (and the mind) seen as more and more remote from the things that caused them. As we saw in the case of Hobbes, this turned all objects of vision into 'apparitions'.

Calmet, too, who was familiar with the same range of arguments but wished to retain apparitions for the sake of religious orthodoxy, saw the danger that visual deception posed and spoke of it with post-Cartesian emphasis:

if once we open the door to this fascination, everything which appears supernatural and miraculous will become uncertain and doubtful. It will be said that the wonders related in the Old and New Testament are in this respect, in regard both to those who were witnesses of them, and those to whom they happened, only illusions and fascinations: and whither

may not these premises lead? It leads us to doubt everything, to deny everything; to believe that God, in concert with the devil, leads us into error, and fascinates our eyes and other senses, to make us believe that we see, hear, and know, what is neither present to our eyes, nor known to our mind, nor supported by our reasoning powers, since by that the principles of reasoning are overthrown.

It was the principles of religion, rather than the determinations of science—of optics—that allowed Glanvill and Calmet to go on speaking of the reality and truth of apparitions. Those who explained them away in terms of visual delusions could not resolve this issue, wrote Calmet; they made greater difficulties for themselves 'than those who admit simply that apparitions appear by the order or the permission of God'. In essence, they were 'certified by the belief, the prayers, and the practice of the Church, which recognises them, and supposes their reality'.[103]

From an unashamedly modern perspective, there is, of course, a way of turning the argument round, finally, and asking not whether the discerners of spirits ever succeeded in identifying 'purely visual' criteria for good and bad visions but what it means to talk of 'purely visual' criteria in the first place. I have contrasted the visual experience itself with its supposedly non-visual ingredients—the moral and psychological state of the persons involved, their credibility, the situation and context, the impact and aftermath: all features on which, I have argued, the early modern literature of discernment concentrated. And most of these features of seeing *do* seem to be altogether non-visual in character; for example, the credibility of a person who reports a vision and their motives for doing so. But what about bodily condition, emotional state, age, and sex? Much of the modern discourse on vision would implicate these in the act itself, making them intrinsic to what is seen and the way it is seen. We would not expect this of the early modern theologians who, in the main, constituted the discerners of spirits. But their appeal to such categories was nevertheless close to the use made of them by some at least of their contemporaries—especially the philosophically sceptically minded among them who, in line with the tropes of the ancient Greek 'Pyrrhonists', argued precisely that what was seen was *always* relative to a person's physical and emotional state, age, and sex—such that sight never took place outside such conditioning variables. Even the theologians, by the very act of discernment itself, were insisting that human vision was, in principle, interpretable. The discerner was empowered by Scripture, learning, status, expertise, and, of course, grace, to interpret something not otherwise intelligible. Seeing was not a natural process, the theologians at least implied, its sense being immediately, automatically, and indiscriminately available to every spectator; it was, instead, a matter of considerable cultural complexity, requiring charismatically inspired analysis. What the epistemologically more sceptical made of this we must soon enquire, therefore. But first there is the case to consider of a man who failed miserably as a discerner of spirits: Macbeth.

NOTES

1. Lavater, *Of ghostes*, 1, citing also a statement attributed to Scaliger that a *spectrum* was 'a thing which offereth it selfe to be seene, eyther truely, or by vaine imagination'. Cf. Erastus, *Theses de melancholia*, 255, who in comparing things that appeared to dreamers and to the waking melancholic called them all simply 'spectra'.
2. St Augustine, *The Literal Meaning of Genesis*, trans. and ed. J. H. Taylor (2 vols.; New York, 1982), ii. 185, and 185–98 *passim*; Sixten Ringbom, 'Devotional Images and Imaginative Devotions: Notes on the Place of Art in Late Medieval Private Piety', *Gazette des beaux-arts*, 76 (1969), 159–70, esp.162; Jean-Michel Sallmann et al., *Visions indiennes, visions baroques: les métissages de l'inconscient* (Paris, 1992), 99.
3. K. V. Thomas, *Religion and the Decline of Magic* (London, 1971), 590.
4. Jean-Claude Schmitt, *Ghosts in the Middle Ages: The Living and the Dead in Medieval Society*, trans. Teresa Lavender Fagan (London, 1998), 221, 223–4, cf. 1.
5. Thomas, *Religion and the Decline of Magic*, 595–606, quotation at 602.
6. Schmitt, *Ghosts*, 223–4 and *passim*.
7. William A. Christian, Jr., *Apparitions in Late Medieval and Renaissance Spain* (Princeton, 1981), *passim*; for comparable cases in Italy, see 79–80, 150–1. Typical examples of more secular apparitions are in Ottavia Niccoli, 'The Kings of the Dead on the Battlefield of Agnadello', in Edward Muir and Guido Ruggiero (eds.), *Microhistory and the Lost Peoples of Europe*, trans. Eren Branch (Baltimore, 1991), 71–100.
8. Claude Lecouteux, *Fantômes et revenants au Moyen Âge*, 2nd edn. (Paris, 1996), 51–61, argues that controversy was limited to the earliest discussions of what apparitions were by Augustine and Tertullian and that the categories established by these authors were then left largely undebated. A similar impression is given by Schmitt, *Ghosts*, but see Stephen Greenblatt, *Hamlet in Purgatory* (Princeton, 2001), 105–33, for a particularly disturbing early 14th-century haunting, and Peter Dinzelbacher, *Vision und Visionsliteratur im Mittelalter* (Stuttgart, 1981), 57–64 ('Fälschungen'). On the dangers of underestimating the perplexity aroused by medieval ghosts among percipients, see Peter Marshall, *Beliefs and the Dead in Reformation England* (Oxford, 2002), 245, 262.
9. Revd P. Boland, *The Concept of 'Discretio spirituum' in John Gerson's 'De probatione spirituum' and 'De distinctione verarum visionum a falsis* (Washington, 1959), *passim*; the two treatises are dated to *c*.1415 and *c*.1401 respectively. See also Schmitt, *Ghosts*, 155–9; Christian, *Apparitions*, 188–203 (on Jeanne d'Arc). For *discretio spirituum* before Gerson, see Anna Morisi Guerra, 'Il silenzio di Dio e la voce dell'anima da Enrico di Langenstein a Gerson', *Cristianesimo nella storia*, 17 (1996), 393–413.
10. The theological arguments in England are summarized by Thomas, *Religion and the Decline of Magic*, 587–95. See also May Yardley, 'The Catholic Position in the Ghost Controversy of the Sixteenth Century', in Lavater, *Of Ghostes*, 221–51 (largely a summary of Le Loyer's arguments); G. Bennett, 'Ghost and Witch in the Sixteenth and Seventeenth Centuries', *Folklore*, 97 (1986), 3–14; Walsham, *Providence*, 28; Marshall, *Beliefs and the Dead*, 232–64 (with a wealth of references), and on the controversy over Purgatory, 47–123; Marshall comments (235) that for many Protestants, 'ghosts were not some accidental waste-product of the popish purgatory, but the foundation of the whole edifice'. For Germany, see Craig M. Koslofsky,

The Reformation of the Dead: Death and Ritual in Early Modern Germany, 1450–1700 (Houndmills, 2000), 19–39.
11. Scribner, *Religion and Culture*, 103.
12. The full title is *Von Gespaenstern, unghüren, faeln, und anderen wunderbaren dingen, so merteils wenn die menschen sterben soellend, oder wenn sunst grosse sachennd enderungen vorhanden sind, beschaehend, kurtzer und einfaltiger bericht*. The Latin edn. followed immediately in 1570 (Zurich): *De spectris, lemuribus et magnis atque insolitis fragoribus, variisque praesagitionibus quae plerunque obitum hominum, magnas clades, mutationesque imperiorum praecedunt, liber unus*. The work appeared in English (trans. Robert Harrison) in 1572, entitled *Of ghostes and spirites walking by nyght, and of strange noyses, crackes, and sundry forewarnynges, which commonly happen before the death of menne, great slaughters, and alterations of kyngdomes*. I have used the 1929 Shakespeare Association edn. by J. Dover Wilson and May Yardley (see Ch. 5, n. 60 above).
13. Lavater, *Of ghostes*, 9, 71, 77, 81, 88, 97.
14. Ibid. 111.
15. Ibid. 160.
16. Ibid. 145, 163.
17. Bruce Gordon, 'Malevolent Ghosts and Ministering Angels: Apparitions and Pastoral Care in the Swiss Reformation', in id. and P. Marshall (eds.), *The Place of the Dead: Death and Remembrance in Late Medieval and Early Modern Europe* (Cambridge, 2000), 87–109, sees Lavater's treatise in an essentially pastoral context, as a post-Reformation version of the 'discernment of spirits' aimed at helping Protestants who continued to see ghosts and believe in their mediating role. There is a similar approach to Lavater's condensed in Scot, *Discoverie*, 461–3.
18. Noel Taillepied, *Traité de l'apparition des esprits* (Rouen, 1600), 172, cf. 197–200 (1st pub. in Paris in 1588). I have consulted the trans. by Montague Summers, *A Treatise of Ghosts* (London, 1933), but it is so unreliable that I prefer to give my own.
19. Ibid. 212.
20. Ibid. 245.
21. Joannes Rivius, *De conscientia libri iiii. Eiusdem de spectris et apparitionibus umbrarum, seu de veteri superstitione liber i* (Leipzig, 1541), sigs. Biiiir–viiiv; cf. the much fuller discussion of the cognitive aspects of the subject in the final pages of Joannes Benedictus, *De visionibus et revelationibus naturalibus et divinis* (Cracow, 1545), sigs. Ciir–ivr.
22. Lavater, *Of ghostes*, 18, and on women, 14.
23. Ibid. 18; cf. Aristotle, *Meteorologica*, iii. 4, trans. E. W. Webster, in *Works of Aristotle*, ed. Ross, iii. 373a, 35–373b, 10: 'Sight is reflected from all smooth surfaces, such as are air and water among others. Air must be condensed if it is to act as a mirror, though it often gives a reflection even uncondensed when the sight is weak. Such was the case of a man whose sight was faint and indistinct. He always saw an image in front of him and facing him as he walked. This was because his sight was reflected back to him. Its morbid condition made it so weak and delicate that the air close by acted as a mirror, just as distant and condensed air normally does, and his sight could not push it back.'
24. Ibid. 18–19, cf. 168–9, 170.
25. Taillepied, *Traité*, 66; cf. Lavater, *Of ghostes*, 52: 'The arte perspective doth also worke this wonderfull feate, that divers and sundrie shapes will appeare in glasses, made and

sette togither after a certeyne artificiall sorte: some times they will seeme to go out of the dores, and resemble menne of oure familiar acquayntaunce.'
26. Taillepied, *Traité*, 196–7.
27. Sextus Empiricus, *Outlines of Pyrrhonism*, i. 84, in *The Skeptic Way: Sextus Empiricus's 'Outlines of Pyrrhonism'*, trans. and ed. Benson Mates (Oxford, 1996), 100; cf. Taillepied, *Traité*, 31–2, 44–6. Sextus Empiricus and early modern scepticism are fully considered below in Ch. 8.
28. Heinrich Cornelius Agrippa (Von Nettesheim), *Three books of occult philosophy*, trans. J[ohn] F[rench] (London, 1651), 15–16.
29. Tanner, *Disputatio de angelis*, in *Diversi tractatus*, 75–86, quotation at 76. In his treatise on witchcraft trials, Tanner remarked on the stories that showed how the devil could 'represent' the persons of saints, Christ, and the Virgin; see id., *Tractatus theologicus*, in *Diversi tractatus*, 17.
30. Lavater, *Of ghostes*, 140–1.
31. Ibid. 140.
32. Ibid. 163, 167; cf. Taillepied, *Traité*, 283–6.
33. Lavater, *Of ghostes*, 45, cf. 9, 23–44. For another, unpublished, Elizabethan treatise stressing the demonic origins of spectres, see Virgil B. Heltzel and Clyde Murley (trans.), 'Randall Hutchins' *Of Specters* (ca. 1593)', *Huntington Library Quart.* 11 (1947–8), 407–29.
34. Gordon, 'Malevolent Ghosts', 99; cf. Marshall, *Beliefs and the Dead*, 262 (cf. 249–52), on how the meanings of ghosts remained 'open, hazardous, and uncertain, both at the level of official theory, and among those who actually found themselves confronted in the night with a "questionable shape" '. The dead were, indeed, 'disorderly'.
35. The most exhaustive study of this subject is now Pierre Kapitaniak, 'Spectres, fantômes et revenants: phénomène et représentation dans le théâtre de la Renaissance anglaise', thèse doctorale (Université Paris IV—Sorbonne, 2001), see esp. 467–533 on the types of illusoriness explored in representations of the spectral on stage. I am most grateful to Dr Kapitaniak for making a copy available to me.
36. A 'fantosme', in Taillepied's orig. French: see id., *Traité*, 42.
37. 'Spirit' in Lavater, *Of ghostes*, 16; 'esprit' in Taillepied, *Traité*, 42.
38. Lavater, *Of ghostes*, 16, 85, 148; cf. Taillepied, *Traité*, 42–3, 68–9, 227–8.
39. Jean-Claude Schmitt, 'Le Spectre de Samuel et la sorcière d'En Dor: avatars historiques d'un récit biblique: I Rois 28', *Études rurales*, 105/6 (1987), 39–41, says that Matthew 14: 25–6 was never used in medieval discussions of apparitions, and that Luke 24: 37 (the only Gospel to refer to 'spirit') was not thought to be significant either. The crucial text in medieval discussions of ghosts was 1 Samuel 28: 3–25 on Saul and the 'witch' of Endor, which continued to be much analysed in the early modern period too (see Ch. 7 below). For the Matthew passage, the term for 'spirit' in the Vulgate was *phantasma*, and in Luther's translation, *Gespenst*.
40. Taillepied, *Traité*, 5, 8–9, cf. 230.
41. Robert Lenoble, *Mersenne ou la naissance du mécanisme* (Paris, 1943), 173.
42. Pietro Pomponazzi, *Tractatus de immortalitate animae* (Bologna, 1516), id., *De naturalium effectuum causis sive de incantationibus* (Basel, 1556).
43. Taillepied, *Traité*, 7. I have inserted the trans. by Thomas North (from Jacques Amyot) in *The Lives of the Noble Grecians and Romanes* (5 vols.; London, 1929–30), iv. 464 (orig. pub. 1579).

44. Agrippa, *Three books*, 15, had said that clouds, acting like 'looking-glasses', could reflect 'representations at a great distance of castles, mountains, horses, and men'.
45. Giulio Cesare Vanini, *De admirandis naturae reginae deaeque mortalium arcanis libri quatuor* (Paris, 1616), 368–79; cf. Cardano, *De subtilitate*, bk. 4: 'De luce et lumine', in *Opera omnia*, iii. 417–34; id., *De rerum varietate*, bk. 14, ch. 69 (Misaldus); bk. 8, ch. 43 (imagination and sight), in *Opera omnia*, iii. 273–5, 160–5; cf. on spectres and 'false' vision, id., *De rerum varietate*, bk. 15, ch. 86, in *Opera omnia*, iii. 301–3, which begins 'Omne spectrum sit mutato sensu, aut medio, aut re: neque enim plures modos est invenire.'
46. The work was first pub. in French in 1586 and the first of its four books was trans. (by Zachary Jones) as *A treatise of specters or straunge sights, visions and apparitions appearing sensibly unto men. Wherein is delivered, the nature of spirites, angels, and divels: their power and properties: as also of witches, sorcerers, enchanters, and such like* (London, 1605). It later appeared in greatly expanded French versions in 1605 and 1608.
47. For all the citations in this paragraph, see Le Loyer, *Treatise of specters*, sigs. 1ʳ–3ᵛ.
48. Ibid. 26ᵛ, 33ᵛ–6ʳ.
49. Ibid. 61ᵛ.
50. Ibid. 1ʳ; Terence Cave, *Pré-histoires: textes troublés au seuil de la modernité* (Geneva, 1999), 71: 'Très orthodoxe, donc, Le Loyer se livre pourtant à un examen approfondi de toutes les possibilités d'erreur dans la perception de ces phénomènes.'
51. For a typical sample see the volume in the witchcraft collection in the Olin Library at Cornell University entitled *Dissertationes de spectris*, containing nineteen dissertations debated at Leiden, Leipzig, Jena, Wittenberg, Giessen, Dorpat, and Uppsala between 1646 and 1753. There are many other individual examples both from these universities and from Halle, Mainz, Rostock, Bremen, Rudolstadt, and Danzig, and further listings in Diethelm, *Medical Dissertations*, 126–8.
52. Nicolas Lenglet Du Fresnoy, *Recueil de dissertations, anciennes et nouvelles, sur les apparitions, les visions et les songes* (2 vols. in 4 pts.; Avignon, 1752), see esp. i, pt. 2; ii, pt. 1 (the collection contains 46 items in all, and in ii, pt. 2, 223–92, a substantial bibliography).
53. For texts in the *miraculis mortuorum* tradition, and the debate over demonically reanimated corpses in particular, see J. S. W. Helt, 'The "Dead Who Walk": Materiality, Liminality and the Supernatural World in François Richard's *Of False Revenants*', *Mortality*, 5 (2000), 7–17.
54. Gordon, 'Malevolent Ghosts', 95 mentions the Spanish and Italian versions, and Johann Georg Theodor Grässe, *Bibliotheca magica et pneumatica* (Leipzig, 1843), gives the Dutch one. Lea, *Materials*, ii. 547, suggests sixteen edns. over a century.
55. Georg Detharding, *praeses* (Georgius Erhard von Gehren, *respondens*), *Scrutinium medicum de morbis a spectrorum apparitione oriundus, Von Gespenstern . . .* (Rostock, 1729); for effects on the eyes, see 9.
56. Joannes Samuel Stryk, *praeses* (Andreas Becker, *respondens*), *Disputatio juridica de jure spectrorum* (Halle, 1700); extensively summarized in Lea, *Materials*, iii. 1411–15.
57. Tobias Tandler, *Oratio de spectris, quae vigilantibus obveniunt*, in id., *Dissertationes physicae-medicae* ([Wittenberg], 1613), 7 and *passim*; for the views of a Catholic physician on apparitions, see Guibelet, *Trois discours*, 273ᵛ, 274ᵛ–5ʳ.
58. Voet, 'De spectris', in id., *Selectarum disputationum theologicarum*, i. 987; Johann Heinrich Decker, *Spectrologia* (Hamburg, 1690), 90. Cf. Fridrich Balduin, *Tractatus . . . casibus*

nimirum conscientiae summo studio elaboratus (Wittenberg, 1654), 609–33 ('De casibus conscientiae circa spectra').

59. Georg Wolfgang Wedel, *praeses* (Ernst Heinrich Wedel, *respondens*), *Dissertatio medica de spectris*, 3rd edn. (Jena, 1710), 8.
60. Gaspar Schott, *Physica curiosa* (Würzburg, 1667), 196–350 (bk. 2: 'De mirabilibus spectrorum'), esp. 196, 215–25, 240–59 (first published in shorter form in 1662); cf. Del Río, *Disquisitionum magicarum*, 225–316 (bk. 2, qq. 25–9).
61. John Gadbury, *Natura prodigiorum: or, a discourse touching the nature of prodigies* (London, 1660), 155–9, quotation at 156; cf. [Trenchard], *Natural history of superstition*, 17.
62. Marin Mersenne, *Quaestiones celeberrimae Genesim* (Paris, 1623), cols. 497–538, esp. 512 ff.; Lenoble, *Mersenne*, 478–82.
63. Kircher, *Ars magna*, 897–901; Chevalley, 'L'*Ars magna*', 103–4; cf. Ambrosius Rhodius, *Optica, cui additus est tractatus de crepusculis* (Wittenberg, 1611), 324–6; Marin Mersenne, *L'Optique et la catoptrique* (Paris, 1651), 119–23.
64. Robert Boyle, 'About the Excellency and Grounds of the Mechanical Hypothesis', in *Selected Philosophical Papers of Robert Boyle*, ed. M. A. Stewart (London, 1979), 140.
65. Decker, *Spectrologia, passim*.
66. Carolus Fridericus Romanus, *Schediasma polemicum, expendens quaestionem an dentur spectra, magi, et sagae, una cum recensione historica plurimarum hac de re opinionum* (Leipzig, 1703), 2, 19. Romanus also cited an experiment (no. 37) from Robert Boyle's *New experiments physico-mechanical, touching the spring of air* (1660); indeed, his tract ends up referring to all the important contemporary authorities on the subject. For Romanus' defence of the belief in witchcraft 'based on the philosophy and physical science of the period', see Lea, *Materials*, iii. 1416–17.
67. Leeman, *Hidden Images*, plate 44 (indicating that in 1976 the panel was in a private collection in Germany).
68. [Jean Dubreuil], *La Perspective pratique*, 2nd edn. (3 vols.; Paris, 1651), iii. 112, 122 (only vol. i is a 2nd edn; vols. ii and iii repeat the edns. of 1647 and 1649 respectively); Gilman, *Curious Perspective*, 40–8.
69. Stafford, *Artful Science*, 45; Hankins and Silverman, *Instruments and Imagination*, 44–7; Marina Warner, *Fantastic Metamorphoses, Other Worlds* (Oxford, 2002), 166–79; Vermeir, 'Magic of the Magic Lantern', 132–6.
70. Jean Pierquin, 'Réflexions philosophiques de M. Pierquin, sur l'évocation des morts', in Lenglet Du Fresnoy, *Recueil de dissertations*, ii, pt. 1, 147–8.
71. Webster, *Displaying*, 103–6, 41–2, 294 (and 288–320 *passim*), cf. also 197–215 (ch. 10).
72. Thomas Hobbes, *Leviathan*, ed. Richard Tuck (Cambridge, 1991), 19 (all subsequent citations from this edn.).
73. Ibid. 18–19.
74. Ibid. 440.
75. Ibid. 13–15.
76. Ibid. 440, 442.
77. Ibid. 441.
78. Cited by Jan Prins, 'Hobbes on Light and Vision', in Tom Sorell (ed.), *The Cambridge Companion to Hobbes* (Cambridge, 1996), 131; the locution is probably easier in Latin, as in the phrase 'phaenomena, sive apparitiones', in Scheiner, *Oculus*, 'Praefatio'. For more on Hobbes and vision, see Ch. 10 below.

79. Cave, *Pré-histoires*, 71.
80. Domenico Gravina, *Ad discernandas veras a falsis visionibus et revelationibus* (2 vols.; Naples, 1638), ii, pt. 2; Giorgio Polacco, *Pratiche per discerner lo spirito buono dal maluagio e per conoscer gl'indemoniate e maleficiate* (Bologna, 1638); Giovanni Bona, 'De discretione spirituum in vita spirituali deducendorum', in id., *Opera omnia* (Antwerp, 1677), 221–322 (orig. pub. separately in 1671).
81. For some typical examples outside the monographic treatments, see Guazzo, *Compendium maleficarum*, 136–47; Pierre de Lancre, *L'Incredulité et mescreance du sortilege plainement convaincue. Ou il est amplement et curieusement traicté . . . des apparitions* (Paris, 1622), 435–44; id., *Tableau*, 370–9.
82. See, in particular, Anne Jacobson Schutte, *Aspiring Saints: Pretense of Holiness, Inquisition, and Gender in the Republic of Venice, 1618–1750* (Baltimore, 2001), esp. 42–59; Rosalynn Voaden, *God's Words, Women's Voices: The Discernment of Spirits in the Writing of Late-Medieval Women Visionaries* (Woodbridge, 1999), *passim*, esp. 41–72; Teresa of Avila, *The Life of Teresa of Jesus: The Autobiography of St Teresa of Avila*, ed. E. Allison Peers (New York, 1960), 267, 291, 261, 262–3; Alison Weber, 'Saint Teresa, Demonologist', in Anne J. Cruz and Mary Elizabeth Perry (eds.), *Culture and Control in Counter-Reformation Spain* (Minneapolis, 1992), 171–95; Gillian T. W. Ahlgren, *Teresa of Avila and the Politics of Sanctity* (Ithaca, 1996), 97–104.
83. Ahlgren, *Teresa of Avila*, 97.
84. [Ignatius Loyola], *Manresa: or the spiritual exercises of St Ignatius* (London, n.d.), 263–70. The best place to start with this very large subject is *Dictionnaire de spiritualité ascétique et mystique, doctrine et histoire*, dir. Marcel Viller et al. (17 vols.; Paris, 1937–95), iii, 'Discernement des esprits', esp. cols. 1261–91 ('Le 15e siècle' and 'Période moderne'), followed by Sallmann et al., *Visions indiennes*, 91–116 (ch. 4: 'Théories et pratiques du discernement des esprits'). The scholar currently doing most to rediscover the subject is Moshe Sluhovsky: see his 'Spirit Possession as a Self-Transformative Experience', in David Shulman and Guy Stroumsa (eds.), *Self-Transformation in World Religions* (Oxford, 2002), 150–70; id., 'The Devil in the Convent', *American Hist. Rev.* 107 (2002), 1379–411; id., *'Believe Not Every Spirit': Possession, Mysticism, and Discernment in Early Modern Catholicism* (Chicago, 2007), ch. 4. Cf. Kapitaniak, *Spectres*, 408–18, and on discernment in *Hamlet*, ch. 10.
85. Cardinal Desiderio Scaglia, cited by Schutte, *Aspiring Saints*, 70–1.
86. Bona, 'De discretione spirituum', 285.
87. Voet, 'De spectris', 1012.
88. Sluhovsky, 'Devil in the Convent', 1407.
89. P. J. S. Whitmore (ed.), *A Seventeenth-Century Exposure of Superstition: Select Texts of Claude Pithoys (1587–1676)* (The Hague, 1972), 10.
90. La Primaudaye, *French academie*, 415; Webster, *Displaying*, 175–6.
91. [Loyola], *Manresa*, 263–4. Here and in what follows I follow Sallmann et al., *Visions indiennes*, 97–100.
92. On this subject, see Victor Stoichita, *Visionary Experience in the Golden Age of Spanish Art* (London, 1995); Hubert Damisch, 'Figuration et représentation: le problème de l'apparition', *Annales ESC* 26 (1971), 664–80.
93. Nicolas Lenglet Du Fresnoy, *Traité historique et dogmatique sur les apparitions, les visions et les révélations particulières* (Avignon, 1751), 5–6.
94. Ibid. 6–11, 59, 60–226.

95. Boland, *Concept of 'Discretio spirituum'*, 25–38, 76–107, for trans. of both texts.
96. Sallmann et al., *Visions indiennes*, 104–11. For the closely allied subject of ecstasies and raptures, see François de Sales, *St Francis de Sales: Treatise on the Love of God*, trans. H. B. Mackey (2 vols.; London, 1932–3), ii. 298–303.
97. Guazzo, *Compendium maleficarum*, 137; Francesco Maria Philomarino, *Tractatus de divinis revelationibus* (Naples, 1675), 146–51.
98. A study of Gerson reaching a conclusion parallel to mine is Dyan Elliott, 'Seeing Double: John Gerson, the Discernment of Spirits, and Joan of Arc', *American Hist. Rev.* 107 (2002), see esp. 27 on the consequences of the 'reversal' and 'doubling' dealt with by the discourse of discernment: 'Far from providing a mechanism for distinguishing counterfeit from genuine spirituality, spiritual discernment emerges as an inadvertent abettor of confusion in categories.'
99. Cited in Sallmann et al., *Visions indiennes*, 105.
100. For some indication that the visible 'figure' of an apparition could nevertheless help to decide its provenance, see Valderrama, *Histoire generale du monde*, bk. 3, 325, on monstrosity (or imperfection) and the choice of animal shapes as distinguishing features of the demonic. These were widely shared opinions: other examples are Lea, *Materials*, i. 292 (Alphonsus de Spina), Binsfeld, *Tractatus*, 65–6; Torreblanca, *Daemonologia*, 274–83 (bk. 2, chs. 27–8).
101. Glanvill, *Saducismus triumphatus*, 104 (my emphasis); cf. 103: '[Providence] will without question take such care, that the works wrought by divine power for the confirmation of divine truth, shall have such visible marks and signatures, *if not in their nature*, yet in their circumstances, ends, and designs, as shall discover whence they are, and sufficiently distinguish them from all impostures and delusions' (my emphasis).
102. Ibid. 66, 102–3. For the wider importance of establishing matters of fact relating to spirit testimonies, see Simon Schaffer, 'Making Certain', *Social Stud. of Science*, 14 (1984), 137–52, and id., 'Godly Men and Mechanical Philosophers: Souls and Spirits in Restoration Natural Philosophy', *Science in Context*, 1 (1987), 55–85.
103. Augustin Calmet, *The Phantom World; or, The Philosophy of Spirits, Apparitions, etc*, trans. and ed. Henry Christmas from the 3rd French edn. of 1751 (2 vols.; London, 1850), i. 340–2.

7

Sights: King Saul and King Macbeth

In the first scene of Act 2 of *Macbeth*, Macbeth seems to see his celebrated dagger—a dagger that, unlike the 'weïrd sisters', or the ghost of Banquo, or the show of kings, we in the audience do not usually see.[1] Macbeth is not sure that he sees something real himself. 'Come, let me clutch thee', he says: 'I have thee not, and yet I see thee still. | Art thou not, fatal vision, sensible | To feeling as to sight?' (2. 1. 34–7).[2] Whatever else we make of this moment, its immediate surface concern is obviously with the very reliability of sight itself.[3] We know this from the two further questions that Macbeth asks of his 'fatal vision'; are his eyes making fools of his other senses (or being made fools by them; either reading works), and is the dagger perhaps a 'dagger of the mind'—a 'false creation', a purely mental image produced by his bloody intention to murder King Duncan? This is, in fact, what he concludes: 'There's no such thing: | It is the bloody business which informs | Thus to mine eyes' (2. 1. 47–9). This contrasts with what happens in *Hamlet*, where, although there is a debate about whether the ghost of Hamlet's father is an illusion, this is not the main issue. In that play, Horatio, sceptical at first, eventually says something very different about his visual experience of the ghost's reality: 'Before my God, I might not this believe | Without the sensible and true avouch | Of mine own eyes' (1. 1. 56–8).[4]

Moreover, when we start to think about *Macbeth* as a whole, the entire play seems to be preoccupied by the workings of human vision. Its action repeatedly involves seeing and things seen (or not seen, or withheld from sight and reported to the visual imagination of characters and audience instead); its poetry is rich in the language of the eyes and eyesight; and its drama relies heavily both on visual parallels and contrasts and, more famously, on the impact of spectres and apparitions and the workings of optical illusions.[5] It evokes a world caught between the actual and the virtual, where (it has repeatedly been said) the difference between appearance and reality is constantly and radically undermined.[6] If it deals with the enigmatic and the equivocal, then this certainly embraces things visual; and if with taboo and transgression, then this reaches equally surely to things that should not be seen. From the 1980s onwards critical opinion has made these aspects of *Macbeth* central to our understanding of the play. In 1982 D. J. Palmer argued that it gave special significance to the faculty of seeing, and in 1987 Marjorie Garber made 'transgressive sight' one of its

obsessions.[7] Nicholas Brooke's 1990 edition for the Oxford Shakespeare series draws heavily on the idea that illusion—mostly visual illusion—is 'not merely a utility, but a central preoccupation of the play'.[8] In a particularly interesting reading of this kind in an essay of 1983, Huston Diehl suggests that *Macbeth* is 'perhaps the most visual of Shakespeare's tragedies' and that it is centrally concerned with 'the problematics of vision': 'It examines the act of seeing and interpreting an uncertain visible world. This uncertainty, and the epistemological questions it raises, sustain the play dramatically and motivate the action.'[9]

In this interpretation the fortunes of the play's main characters are governed by their various failures to achieve what, according to Diehl, the visual culture of the Renaissance required of readers of images—an essentially ethical engagement with them as potential signs of abstract moral and spiritual truths and other universal ideas and concepts kept in the memory by virtue of their visual associations, like items in an emblem book. In a fallen world, all men and women might misunderstand what they saw or be morally blinded by the visual temptations of the devil, but in *Macbeth* the fallibility of seeing is played out with particular force and is central to its conflicts. Thus, Duncan, Lady Macbeth, and Macbeth himself:

pervert the interpretive process, ignoring potential meanings in the things they see, imposing their own wilful desires onto the visual world, and forgetting traditional symbolic associations of the visual images which appear to them their eyes deceive and delude them because these characters do not actively interpret what they see.[10]

Duncan perceives only what is on the surface while Lady Macbeth refuses (until she becomes insane) to indulge in symbolic interpretation at all: ''tis the eye of childhood | That fears a painted devil' (2. 2. 57–8). Macbeth, by contrast, interprets all the time, but incorrectly—that is, unethically and destructively, by breaking the established visual codes that conventionally joined specific images to specific values or truths and seeing in these images only what he wants to see in them instead.

The proposal that the theme of vision is central to *Macbeth* is not, however, without difficulties. One of them lies in the suggestion that the ethical value of visual images was codified to such an extent in Renaissance Europe that interpretation was only a matter of getting their moral significance right or wrong—precisely as in reading an emblem book. In the case of the visual images of witchcraft in the play, for example, Stephen Greenblatt has shown just how ethically contentious these would have been in the context of Renaissance demonology and the contemporary arguments for and against witch trials.[11] This was presumably the case with other themes too: the ethical judgements required in seeing were never settled or objective.

The second problem is more far-reaching. Stressing what visual images meant—or, even, were supposed to mean—once they had been interpreted is to neglect the extent to which the act of seeing itself was problematic—both in

Macbeth and in late Renaissance culture more generally.[12] Unsure of how to read, or unsuccessful in reading, the hidden morality signified in the things they see, the characters in the play are even more radically unsure about just what it is that they are seeing in the first place—and, above all, of course, whether these are real phenomena at all.[13] Called upon to make ethical judgements, they must first make perceptual judgements, the uncertainty of which is, if anything, greater still. This is not to suggest that such perceptual judgements lack a moral dimension of their own; on the contrary, as this book is attempting to show, many decisions about the reality or otherwise of what was seen in Renaissance Europe had enormous moral consequences in the fields of religion and politics. In consequence, they were equally contestable: perceptual judgements too were never settled or objective, even if there were powerful new pressures to make them so. What we have seen is that intellectuals were rethinking the fundamentals of vision, debating, in effect, the ways in which sight was a medium constructed in terms of perceptual systems—vision regimes, as we have learned to call them. At the very heart of this debate, too, was the question of the visual status of preter- and supernatural phenomena, especially those associated with magic, witchcraft, apparitions and ghosts, and demonic activity in general. This is the debate that finds reflection in the thematic attention given to vision in *Macbeth* and in many of its visual effects. Thus, when it is said, again by Diehl, that this play, 'in itself an illusion, plays with illusions, presenting all kinds of ambiguous "sights" ', it should be added that it is not just the substantive ambiguity of these sights as things seen that is at issue—it is the nature of visual uncertainty itself that is being explored.[14]

For this reason, Lucy Gent's analysis of this aspect of the play, dating again from the early 1980s, seems more helpful. She turns not to the codified, supposedly objective, morality of the emblem books but to the super-scepticism of the first of Descartes's *Meditations on First Philosophy* (1641), where early modern Europe's philosophically most significant version of total perceptual delusion is set out in the form of the famous 'demon hypothesis'.[15] Her suggestion is that *Macbeth*, from its very first scene, is a play that explores what the consequences of the demon hypothesis might be; equivocation *is* the 'very condition of the play' and visual equivocation means that at any moment 'the visual world could turn into a snare'. Macbeth himself acts out the possibility, says Gent, 'that what we perceive as an apparent fact may turn out to be mendacious, perhaps the more mendacious the more it appears to be a part of nature'. It is in this sense that his eyes 'are made the fools o'th'other senses, | Or else worth all the rest' (2. 1. 44–5). His very first words in the play—'So foul and fair a day I have not seen' (1. 3. 36)—commit him, she argues, to living in a world which he assumes works one way but which actually works quite differently, while the aside 'nothing is, | But what is not' (1. 3. 140–1) captures both the nature of evil and the nature of visual illusion, by now inextricably combined. This is why this last remark is 'the quintessence of the play'.[16] *Macbeth*, we might say, is a Cartesian drama, in a double sense: first, it is

concerned not only with the illusory nature of particular things in the external world but with illusion itself as a fundamental epistemological challenge; and second, it interprets this challenge hyperbolically as demonic.

Two other readings add powerfully to this interpretative framework. One is Greenblatt's own argument that *Macbeth* manipulates precisely those verbal and visual illusions that Reginald Scot had blamed for the belief in witches in his *The discoverie of witchcraft* (1584)—a belief that Scot saw as both socially disruptive and profoundly irreligious. Shakespeare, in Greenblatt's view, 'is staging the epistemological and ontological dilemmas that in the deeply contradictory ideological situation of his time haunted virtually all attempts to determine the status of witchcraft beliefs and practices'. Since witchcraft and the theatre were both constructed along the borderland between fantasy and reality, witches were ideal subjects for a drama that explored the uncertain means for securing that border—speech and sight.[17] The powerful dramatic potential of sight's uncertainty, in particular, emerges also from Iain Wright's recent suggestion that the staging of both the dagger scene and the procession of kings may have been directly dependent on the optical technologies of contemporary natural magic—known to Shakespeare and his company through the experiments with lenses and mirrors of experts like Giambattista della Porta, John Dee, and Cornelis Drebbel and the extensive literature that accompanied them. An uncanny resemblance links Macbeth's encounter with the dagger not merely to the juggling tricks expounded by Scot but to the floating apparitions—daggers prominent among them—achieved with concave mirrors and described in Della Porta's *Magiae naturalis* and the preface to Dee's translation of Euclid, the latter virtually 'an analogue' of Shakespeare's scene. For Wright, the parade of kings, concluding with images seen in a 'glass', suggests a similar debt to the optical devices of Drebbel, which were available for use in the court theatre of the time to project illusionistic figures in an early version of the magic lantern principle. Shakespeare may have succeeded in actually employing such techniques on stage, or he may simply have invoked them in language and thought. Either way, their impact on the meaning of the drama remains the same: like the experiments in Francis Bacon's 'houses of deceits of the senses', they suggest a knowing display of visual contrivance in the service of a wider scepticism.[18]

Taking these additional steps back from the dagger speech and moving out from the play as a whole into late Renaissance culture enables us to relate its concern with 'sights' and 'sightlessness' more particularly to the post-Reformation controversies we have just been surveying. Macbeth's dagger was obviously an apparition and, as we have seen, it was the problem of apparitions and of ghosts and spectres in general, that, in the view of many of Shakespeare's contemporaries, exemplified above all by Pierre Le Loyer, had perhaps the clearest implications for the whole question of visual reality. Moreover, the debates they conducted hinged crucially on the interpretation of a story with an outline very similar to Macbeth's, which

was already widely known in Elizabethan and Jacobean England, although it had nothing to do with medieval Scotland. It goes like this: a man favoured for his bravery and leadership becomes the ruler of an embattled people but is then overtaken by his own ambitions and fears. He becomes filled with suspicion, jealousy, and hatred. He is torn between outbursts of activity and fits of depression and melancholy. He makes enemies of all those around him and then pursues them relentlessly and with horrible cruelty. An army invades his kingdom. Forsaken by God and apprehensive about defeat, he seeks out a sorceress and demands that she summon a spirit to tell him the outcome of the battle. The spirit appears and promises disaster, but equivocates over the king's ultimate fate—in terms that prove to be neither wholly true nor wholly false. The next day, the king loses both the battle and his life and his head is cut off by his foes.

This, of course, was the story of Saul, Israel's first Old Testament king, told in the first book of Samuel and endlessly retold in Shakespeare's age. 'A choice young man, and a goodly' (1 Samuel 9: 2), Saul was made ruler to save Israel from the Philistines and then spent the rest of his days in war against them. Originally anointed by Samuel he was then rejected by him, and by God, and threatened with replacement by David for not obeying the divine commandments: 'The Lord hath rent the kingdom of Israel from thee this day', he was told, 'and hath given it to a neighbour of thine, that is better than thou' (15: 28). Saul 'became David's enemy continually' (18: 29) and made repeated attempts to kill his rival and anyone associated with him, including his own son Jonathan, who survived, and virtually the entire family of Ahimelech the priest, who were slaughtered with 'both men and women, children and sucklings' in their city (22: 18–19). Saul's sorceress was the 'witch' of Endor, to whom he went disguised and at night, asking to speak to the dead Samuel. Samuel duly appeared, complaining that he had been 'disquieted', and was told by Saul: 'I am sore distressed; for the Philistines make war against me, and God is departed from me, and answereth me no more, neither by prophets nor by dreams: therefore I have called thee, that thou mayest make known unto me what I shall do' (28: 15). Samuel's reply was to forecast defeat but with this additional prediction: 'and to morrow shalt thou and thy sons be with me.'[19] Saul did indeed lose this last encounter with his enemies, with David now among them, and fell on his own sword when his armour bearer refused to kill him. His severed head was then paraded around the land of the Philistines as a trophy. With him died his sons, ending any possibility of a line of descent.

The two stories were certainly not similar in every way—nor need they have been, given what has been called Shakespeare's 'analogical thinking' across roughly parallel, if otherwise disparate, texts.[20] Saul owed his royal power to popular demand and divine nomination, not regicide, and he began by acting like a genuine prophet. The power itself was ambiguously held, in the sense that God was reluctant to grant the Israelites a monarchy at all and then inflicted Saul's evils on them as a punishment for asking for it in the first place. It was lost when God found him not too ruthless but not ruthless enough—in not totally destroying the

Amalekites. Despite their enmity, Saul and David also enjoyed moments of reconciliation. The 'witch' of Endor was less a witch than a woman with a 'familiar spirit', a 'pythoness' in the vocabulary of magic,[21] and Saul's request to speak to a holy man and a prophet was morally sound even if the medium he chose was not.

Nevertheless, there are so many pre-echoes of *Macbeth* in 1 Samuel that it would have been difficult for Shakespeare's contemporaries not to associate them. Saul and Macbeth are alike creatures of military and civil conflict, given stature in and by a violent world, and both end up acknowledging the disastrous errors that this induces. The nature of lineage and succession and the transmission of power are their common preoccupations and their politics is captured by the same metaphors of demonology and witchcraft. Saul's most vicious moments occur when an evil spirit is upon him, and it was to Samuel's indictment of his disobedience that the political moralists and commentators of early modern Europe traced one of their own most cherished and enduring sentiments: 'For rebellion is as the sin of witchcraft, and stubbornness is as iniquity and idolatry' (15: 23: 'Quoniam quasi peccatum ariolandi est, repugnare: e quasi scelus idololatriae, nolle acquiescere'). The biblical text also repeatedly raises the issue of the inviolability of 'the Lord's Anointed'—hardly less pervasive in both *Macbeth* and the political culture of its time, where David's refusal to harm Saul was always cited in arguments about tyrannicide (24: 6–10; 26: 23). David, for his part, was not without blemish, likening him in some respects to Malcolm, a similar 'flawed' avenger. Both eventually become invaders of realms and David's apparent decision to side with Achish and the Philistines in Saul's last battle drew attention from the commentators and invariably had to be explained away. In the end, Macbeth rejects falling on *his* own sword as the act of a 'Roman' fool (5. 8. 1–2), yet even this recalls Saul's 'I have played the fool, and have erred exceedingly' (26: 21), a prelude to his own suicide by the same means.[22]

Above all, there is a crucial symmetry in the urgent resort to magic on the eve of battle, in the kind of magic it is, and even in its deceptive outcome.[23] Biblical scholars in particular were quick to spot the seeming equivocation—even the play on words—in 'to morrow shalt thou and thy sons be with me'. The great Lutheran biblicist and commentator Andreas Osiander thought that it was a splendid example of a demonic lie, since while 'the true Samuel was now entering life through death, Saul was about to enter into eternal damnation.'[24] Of Samuel's 'paltering' remark, the London Puritan pastor and President of Sion College, Arthur Jackson, was to say, later in the seventeenth century, that the devil spoke not merely 'darkly and deceitfully' through Samuel (since 'tomorrow' might mean any period of time) but 'ambiguously'. ' "Thou and thy sonnes shall be with me" ', he wrote, 'might either be meant of their dying onely, as spoken with respect to Samuel, or of being with Sathan'—or, as others noted, of being with God, assuming that Saul believed he spoke with the spirit of a real prophet.[25] In more general terms, the devil was universally assumed to prophesy deceptively; according to Innocent Gentillet, for example, the answers he gave to those who consulted the

pagan oracles of antiquity were 'commonly ambiguous, in two sences'.[26] Even John Webster, who thought of the episode as a dissembling by the 'witch', not the devil, called the pronouncement 'a piece of ambiguous equivocation'.[27]

Irrespective, then, of intention or influence, and despite the enormous disparities of genre and language, these were two texts—or rather two stories—that obviously intersected, particularly in their final moments. This has long been realized in Shakespeare criticism, although little seems to have been made of it.[28] Yet those who were exposed to *Macbeth* would certainly have known 1 Samuel, even if the reverse is much less likely. We need to look, therefore, at how Saul's dealings with the 'witch' of Endor and the 'ghost' of Samuel were interpreted in the literature of moral guidance available in Shakespeare's time. What issues did they raise for the many biblical commentators, writers on witchcraft and magic, and experts on apparitions who sought to regulate the way this 'proof-text' on ghosts and Purgatory was understood?[29] What meanings were extracted from it and made available to audiences and readers of the play? What is striking is that these turn out to be focused on the visual aspects of the episode—on Saul's encounter with Samuel as a profoundly questionable visual experience. What is more, no other biblical episode was as closely analysed in the literature dealing with apparitions. Given the parallels with *Macbeth* this can only reinforce the latter's critical reputation as a 'vision-centred' drama.

Everything depended on what, first the 'witch', and then Saul himself, had actually seen.[30] More general questions were clearly involved too; whether the dead could return to the living and in what circumstances, whether the future could be known with any certainty, and what legitimacy, if any, was attached to magic. But none of them could be confronted without a decision over whether it was Samuel himself, or his soul or spirit, or some illusory likeness of him that had appeared. In patristic and medieval literature the matter had never been resolved; the writings of St Augustine alone showed that each version of events had something to commend it.[31] Nevertheless, once the Reformation was under way, the arguments tended to become semi-confessional, with Catholic opinion remaining divided and Protestants becoming convinced that Samuel was an illusion. That he was not was still a convincing option for many Catholic theologians. A literal reading of a later text in Ecclesiasticus 46: 20, which referred to Samuel prophesying 'after his death', supported this interpretation; so too did the frequent naming of Samuel in 1 Samuel 28, his complaint at being summoned, and the fact that his predictions were all accurate. Even 'to morrow shalt thou and thy sons be with me' was not untrue of Jonathan with regard to destination or simply death itself and, so, not necessarily a piece of demon-speak—ambiguous (as Noel Taillepied put it) 'with double meanings' ('à deux ententes').[32] The whole episode was the result of God's direct handiwork—and so not, of course, of the sorceress's magic—undertaken to punish, warn, and terrify Saul. This was a conclusion that had the endorsement of heavyweights like St Thomas Aquinas

and, later, of Cardinals Cajetan and Bellarmine and the distinguished theologians Franciscus Suárez and Martín Del Río. More than anything else, however, it helped in the defence of Purgatory. Many Catholics were therefore able to go on insisting that Samuel had really appeared to Saul, not some feigned resemblance of him.[33]

Protestants saw so many objections to this version of events, and to the purgatorial theology that lay behind it, that none was prepared to defend it. For the real Samuel to have returned at the joint request of a man rejected by God and already denied access to his truths and a practitioner in the forbidden art of necromancy, in order to deliver genuine prophecies to them, was judged to be morally unacceptable. The raising of Samuel himself was unlikely as a divine miracle, improbable as the work of the devil, and impossible as an effect of enchantment. The real Samuel would not have returned voluntarily or involuntarily. Nor would he have allowed Saul to commit an act of idolatry in adoring him; according to the text, Saul 'stooped with his face to the ground, and bowed himself' when he realized who had appeared (28: 14).

Instead, most Protestant and some Catholic commentators explained what had happened in terms of a demonic illusion.[34] It was not the real Samuel who appeared but a visual (and aural) counterfeit, a demon taking on the exact likeness and 'similitude' of Samuel in order to present him as a phantom or image—the sort of thing, it was said, that might be seen in a dream. This account was not without its own problems, above all, the question of how the devil had managed to predict future events correctly. Here, the presence in the text of a statement that was neither true nor false helped considerably, since it exactly matched the kind of duplicity—the 'subtlety'—expected of the 'father of lies'. According to James VI and I, for example, writing with Saul and Samuel very much in mind, the devil's 'schollers' were able to 'creepe in credite with princes, by fore-telling them manie greate thinges; parte true, parte false: For if all were false, he would tyne [lose] credite at all handes; but alwaies doubtsome [ambiguous], as his oracles were.'[35] A century later, the spectrologist Johann Heinrich Decker noted that whenever the devil had to predict contingent things he resorted to 'Homonymiae' and 'Amphiboliae', statements which could be read *in utramque partem*.[36]

Otherwise, demonic illusion had many advantages as an explanation. It was by far the most appropriate way of dealing with what, after all, seemed to be the product of sorcery; it provided a fitting end to what was, in many ways, the reign of a demonic ruler and a sufferer from melancholy; it was consistent with the way the text spoke as if the real Samuel had appeared—as in, for example: 'And when the woman saw Samuel . . . ' (28: 12); and it was even anticipated in Saul's own attempt at deception by arriving at Endor in disguise. In addition, it enjoyed support from powerful backers, such as St Augustine and Tertullian, the former of whom had written that it was the easiest and simplest solution to an otherwise intractable puzzle. Once the Geneva Bible had appeared in 1560, orthodox anglophone Protestants really had no option but to accept its marginal gloss on the moment when Saul first thought that Samuel had appeared. The recognition,

it said, was 'To his imaginacion, albeit it was Satan, who to blinde his eyes toke upon him the forme of Samuel, as he can do of an Angel of light.'[37]

The result was a generally accepted reading of 1 Samuel 28, both in Protestant Europe and elsewhere, in which visual paradox played a central role; in 1610 it was said to be 'the common opinion of theologians ancient and modern'.[38] The exponent most cited in England was probably Ludwig Lavater, by virtue of his *Von Gespaenstern*, published in translation in two editions in 1572 and 1596. But his popularity must have been closely challenged by Petrus Martyr's, whose *Loci communes* appeared twice in Latin in 1576 and (enlarged) in 1583, and then in translation in 1583, and provided Elizabethans with stock Protestant opinions on a huge variety of subjects, including this one. Martyr's 'three questions' on 1 Samuel 28 circulated widely in Europe in other forms, since they originated in his own Latin commentary on both the books of Samuel published in Zurich in 1567 and 1575 and were also added as an appendix to the French editions of Lavater in 1571 and 1581.[39] This conjunction of texts is alone highly significant. Not only was Saul's encounter with Samuel the most frequently discussed biblical episode in the entire literature of apparitions, but contributors to this literature—as we saw in the last chapter—also invariably saw their subject as having important implications for the nature and reliability of vision.

What Saul saw, wrote Lavater (citing Augustine), was not Samuel 'truly, and in deed raysed up from his rest, but rather some vayne vision and counterfet illusion ... brought to passe by the devils practise'—even though Saul thought that it was the real Samuel. Exactly how the devil 'praticed' the feat was supplied by Martyr in the passage from the answer to the second of his three questions that we noticed in Chapter 4, when considering the demonic manipulation of visual *species*. Drawing on both conventional demonology and conventional psychology and cognition theory, he explained that Satan could not only interfere with externally visible objects and with the physical functioning of the eyes but could also create visual phenomena in the brain itself. Normally, the images ('imagines') of objects passed via the sensory organs to the 'common' sense, and then on through the 'phantasie' into the memory, being 'imprinted and graven in everie of these parts, as it were in waxe'. But when the reverse process took place and images returned from the memory to the senses, carrying with them 'the verie same seales' ('sigilla'), the sensory organs could seem to perceive things which were not in fact present to them. The 'phantasie', in particular, could deceive in this way, as in the case of dreams and with those who were 'frantike'. All the devil had to do was to imitate nature and 'call backe the images of things from the memorie unto the phantasie, or unto the sense, and so deceive the eies of men', and this is what had happened to Saul and the 'witch' of Endor, 'so that the seelie witch thought she saw Samuel himselfe'. This was an Aristotelian account of visual perception and its corruption by demonic means and Martyr cited *De somno et vigilia* in support of it.[40]

According to Lavater, the biblical text spoke of the apparition as 'Samuel' simply because the images and 'similitudes' of things are always referred to by the

names of the things they represent, as are actors playing someone else's part in a play. Indeed, this was no more than an instance of 'tropicall and figurative' speech—metonymy, to be precise—a common usage that no one usually felt it necessary to explain. 'Samuel' was Samuel in the same sense that a painting of Rome was 'Rome', represented to those who saw him not in line and colour but by what Justin Martyr had called a dazzling of their eyes, 'that it seemed unto them, they sawe Samuell him selfe, when in very deed he was not there'. It was no difficult matter, Lavater commented, for the devil 'to bleare and beguile the outward eyes, who can easily darken and dazell the inward sight of the mynde'.[41]

At the heart of this argument, which Lavater and Petrus Martyr both derived from a reading of Tertullian's *De anima* (or perhaps from a reading of each other), lay the conceit of a double idolatry expressed in terms of the corruption of vision. Idolatry occurred in its primary form when the devil convinced people that he was a god by blinding their understanding—occupying the inner eyes of their minds. But there was a second idolatry to match the first, and just as dangerous. Here the devil took on the visual appearance of holiness—as an angel, say, or as one of the dead—in a pretence that was physical rather than conceptual. Adoration was again the aim and blinding the means, although this time it was the eyes of the body that were 'occupied'. In this way, visual deception, actual as well as metaphorical, was the key to his entire strategy, not just an ancillary technology. The devouring by Moses' real serpents of the copies produced by the magicians of Pharaoh, which only 'seemed to the Egiptians to be bodies', became a vision-centred account of the victory of divine truth over demonic falsehood. In the case of Saul, caught in idolatrous recourse to magic, and whose transgression (stubbornness, in the 1611 Authorized Version) the living Samuel had already likened to idolatry, it was entirely fitting that what he saw was 'but an imagination' of the dead prophet—before which he then committed idolatry *again*. In effect, as Tertullian had said, Satan already resided in Saul; the same spirit therefore produced the visual imposture itself and then the inclination in Saul to see it as something real. For Augustine, too, idolatry was the reason behind the deception: 'thinking him to be Samuel, [Saul] adored the Devil, so that Satan reaped the benefit of his deceit.'[42]

The entire episode at Endor was as popular with artists and illustrators as with preachers and moralists, and the later Latin editions of Lavater's own text carried an engraving of Saul recoiling in horror from the ghost he had asked to meet.[43] But no one captured its defining moment more theatrically than Salvator Rosa in his *Saul and the Pythoness*, first displayed in Rome in 1668 in an exhibition whose patron was Pope Clement IX (Fig. 21). There is still terror in Rosa's painting— Saul's hair stands on end—but it focuses nevertheless on the precise moment when he 'stooped' and bowed himself in false worship (28: 14). The demonic deception that made this possible is repeated pictorially by means of the visually flawless appearance of the prophet, depicted by Rosa as Saul saw him. That this *was* a deception only becomes clear from the hellish things placed elsewhere in the

scene, visible to us but not to Saul. Various animal skeletons (including those of a horse and a monkey) and the forms of an owl and a gigantic moth lurk in the gloomy recesses of the witch's dwelling, while she herself sets light to a peacock's feather to keep the forces of evil and the spectre at bay.[44]

The reading of 1 Samuel 28 recommended by Lavater and Martyr was widely adopted within and beyond Shakespeare's England. By 1677 John Webster could say that it was 'the opinion of all, or the most of the learned divines of the Reformed churches'.[45] William Perkins directed it both at those who defended Purgatory and at those who doubted witchcraft, insisting that 'Samuel' was neither real nor the product of merely human trickery but a demonic counterfeit, the devil 'framing to himselfe a bodie in the likenesse of Samuel, wherein he spake'.[46] In a biblical commentary published by the Jacobean divine Andrew Willet in 1607, a little closer to the first stagings of *Macbeth*, the 'Samuel' who appeared at Endor was said to be 'phantastical', a 'counterfeit representation' of the real man made possible by the devil's ability to 'assume unto himselfe the likenes of any bodie ... which yet is no true bodie, but onely in outward shape and appearance'. Like clouds forming impressions in the skies, Satan had made the colour and shape of 'Samuel' by 'disposing and gathering the aire together'.[47] Willet in turn cited the commentary of Osiander, who referred simply to 'Samuelem fictitium', and to Osiander we might add another Lutheran authority, Kaspar Peucer, who spoke of the devil providing the *species* of Samuel.[48] Repeatedly debated by writers on apparitions, this interpretation supported their conviction—some Catholics among them—that many sightings of ghosts and spirits were simply demonic simulacra. In demonology more generally, the episode at Endor was an example of the failure of necromancy and a demonstration of the devil's extraordinary powers of illusion—'to counterfeit any form, to forge and imitate anything whatsoever', as Johann Weyer put it.[49] James VI and I, who virtually began his *Daemonologie* with it, saw it as evidence of the very existence of witchcraft but also of the devil's power to impersonate.[50]

The story of Saul and the 'witch' of Endor appears, therefore, to link a vision-centred play to a vision-centred debate. But what else connects *Macbeth* and the literature of apparitions? Pierre Le Loyer's *Treatise of specters* has often been cited in a traditional way as a possible source for the play. The date of the English version, 1605, is suggestive, coming just before its composition, and Le Loyer does give examples of tyrants who are visited at supper by the ghosts of those they have slain, notably the Gothic King of Italy Theodoric who had murdered two Roman senators and former consuls, Simmachus and Boetius. As he ate, 'it seemed unto him, that hee saw in the head of a fish served in upon the table, the face of Simmachus in a most horrible shape and fashion ... looking awry upon him'.[51] In his chapter on Pyrrhonism, Le Loyer also dealt with both sleepwalking and armies who were defeated because they fled after seeing 'strange sights'. In Holinshed's chronicle, Macbeth loses his final battle because he first flees from Dunsinane castle after realizing how large Malcolm's army really is once it has cast off its boughs.[52]

But whatever the relevance of Le Loyer for *Macbeth* (his anecdotes were, after all, well-used ones) there can be no doubt at all about the relevance of Macbeth for Le Loyer. For Le Loyer actually tells Macbeth's story. This is not in the first book of his treatise, which was the only part translated into English, but in chapter 4 of book 2, in the part that remained in French—where it seems to have remained unnoticed. Le Loyer is explaining at this point that devils can appear as spectres by taking on bodies formed from air and that they do this in order to presage important, usually disastrous, political events. There was nothing unusual about this idea; it was, in fact, the normal interpretation of many ghostly phenomena— including Samuel's appearance to Saul.[53] However, among Le Loyer's examples are the death of King Alexander III of Scotland, signalled by the appearance at the feast for his third wedding of 'an effigy of the dead ... all emaciated', and the three unknown women who appear to Macbeth and Banquo and predict the subsequent descent of the monarchs of Scotland down to Mary Stuart. Le Loyer loyally adds the information that Mary herself is 'at the moment a prisoner in England' (the first French edition of his treatise appeared in 1586).[54]

To find the story of Macbeth told in this sort of context is instructive. Critics have understandably concentrated on the way its transmission in the chronicles of medieval and early modern Scotland (in Boece, Holinshed, Leslie, and Buchanan) makes political history and ideology, together with dynastic themes, the materials out of which *Macbeth* is eventually constructed. In this setting themes to do with vision are not entirely absent but they are not conspicuous either.[55] Holinshed merely described Macbeth's and Banquo's encounter with the 'three women in strange and wild apparell' as 'a strange and uncouth woonder' which 'they attentivelie beheld, woondering much at the sight'. After the women 'vanished immediatlie out of their sight' (marginal comment: 'A thing to wonder at'), they were 'reputed at the first but some vaine fantasticall illusion'. Holinshed also attributes Macbeth's general descent from nobility to cruelty to 'illusion of the divell', but without elaboration. To Buchanan the witches were a dream, and to Leslie devils disguised in female form. In other respects too, Leslie's account is the one closest to that in Le Loyer and in other apparitions texts.[56]

In the literature on apparitions, by contrast, the Macbeth story circulated, not surprisingly, as a ghost tale. It is probable that Le Loyer found it in Girolamo Cardano's *De rerum varietate* of 1557 (taken from Boece), where it occurs in a chapter on apparitions entitled 'Daemones et mortui'. It appeared again in 1597 in the compilation of ghost stories made by the Leipzig publisher Henning Grosse, and twice more in 1656 and 1658 when Grosse's book was reprinted in Latin and then translated into English.[57] In such contexts, it took on resonances different from those afforded by the writers of chronicle. As we saw earlier in this book and again in connection with Saul, the apparitions debate, whatever its ostensible character as a theological dispute, was fundamentally concerned with vision. To find the Macbeth story as one of its ingredients is to confirm that story's potential as a vehicle for the dramatization of 'strange sights'.

Turning the three sisters into apparitions made of air, as Le Loyer did, was also to suggest important connections between what Macbeth might have seen and the visual theories of Renaissance demonology and spectrology. As we also know from a previous chapter, it was a commonplace of the time that one of the means adopted by devils for appearing, as the English title of Le Loyer's tract put it, 'sensibly unto men' was to manufacture any bodily shape they chose from thickened air. Among the many forms of visual delusion occurring spontaneously in nature, and known not just to Le Loyer but to all the other participants in the apparitions debate, were the 'spectres' created by the reflective qualities of air, this time (as he put it) 'formed in a thicke ayre', acting like some gigantic looking-glass.[58] Air, like the other three elements, was recognized as a medium for divination in Shakespeare's world, in its case by virtue of the many aerial things—clouds, thunder, lightning, the flight of birds, and so on—that could be seen as auguries and portents. But 'aeromancy' was also specific to apparitions and spectres, as strange visions in and of the air yielding important messages. The most influential exponent of the subject of divination in early modern Europe, Kaspar Peucer, spoke of aeromancy as divining by means of the warnings afforded by 'spectres that appear in the air', and he was followed, among many others, by the French magistrate and witchcraft writer Pierre De Lancre and the Spanish jurist Francesco Torreblanco.[59]

In one sense, air was simply one of the mediums through which, in the Aristotelian model of cognition, intentional *species* passed in their normal transit from visible objects to the eyes of percipient human beings. But strange things could happen to them on the way. According to Cornelius Agrippa, in one of the best-known Renaissance discussions of air, airborne images could take on 'impressions' from the heavens, be reflected in the clouds, and gather enough strength to 'work wonderfull things upon us'. The air was thus an element of sleights and tricks, not one of transparency and truth, the location for deceptive images of spirits and souls that appeared to be separate from the 'looking-glasses' that produced them. The camera obscura was another example of this, said Agrippa, and so was the communication at a great distance of painted images or written letters by means of their 'multiplication' and transmission by the beams of the full moon—a technique useful to besieged cities. Like visual echoes, all these various forms of 'resemblance' were due to 'the very nature of the Aire' and its mathematical and optical properties. In effect, air carried with it the visual (and aural) images of all things, carrying them into the bodies of men and women through their pores to create dreams and divinations. The reason why they felt fear and dread in a place of death was because its air was literally full of the *species* of slaughter, which troubled them as they literally breathed them in.[60]

All this is strongly evocative of *Macbeth*, as well as of later medieval perspectivalism, especially Roger Bacon's version of it. With respect to the four elements of Renaissance cosmology this is undoubtedly a play of the air—a play in which 'the sightless couriers of the air' can carry the *species* of a 'horrid deed', and the pity it

evokes, into 'every eye' (1. 7. 23–4). The effect of the sisters' iconic line: 'Hover through the fog and filthy [= murky, thick⁶¹] air' (1. 1. 13), and Macbeth's reply to Banquo's 'Whither are they vanished? | 'Into the air, and what seemed corporal, | Melted, as breath into the wind' (1. 3. 78–80: cf. 1. 5. 4–5: 'they made themselves air, into which they vanished') is to turn all the many reiterations of the word 'air' later in the play into reminders of witchcraft and its deceits. Moreover, in the theory of magic and the discernment of spirits, impermanence and evanescence were two of the surest signs of the *praestigium*. To call Macbeth's visionary dagger 'air-drawn', as Lady Macbeth does in the banquet scene (3. 4. 62), is both to remind us of its movement in 'marshalling' Macbeth towards Duncan and at the same time to suggest its creation as an image made of and in the air. There is wholesome air in *Macbeth* too—indeed, as Werner Habicht has put it, a whole 'dramaturgy of complex air'—but it is the thick air of illusion that allows Shakespeare to create 'an oppressive atmosphere of corruption, and of infected fantasies emerging from it, whether or not the latter take the visible shape of ghosts or witches or bloody daggers'.⁶² Above all, there are the dissembling fumes of the cauldron scene. In the play, of course, these lead 'by magic sleights' specifically to the apparitions that will draw Macbeth to his 'confusion' (3. 5. 26–9), but they also point to a possibility evident throughout representations of witchcraft in the period, artistic and otherwise: that the clouds and vapours emitted by a witches' cauldron were signs not of witchcraft's reality as female *maleficium* (in producing destructive storms, for example) but of the deceiving images swirling around in the diseased brains of those who only imagined they were stirring it. As Claudia Swan has recently argued, this turns depictions of *The Preparation for the Witches' Sabbath* made by (or after) Jacques de Gheyn II in Holland early in the seventeenth century into 'images of images'—pictorializations of the *phantasmata* formed, according to those convinced of the fictive nature of witchcraft, in the dysfunctional imaginations of female melancholics (Fig. 22).⁶³

Agrippa's allusion to 'looking-glasses' capable of projecting images and 'semblances' into the adjacent or distant air was itself a reference to an artificial form of visual delusion known to every participant in the apparitions debate—and, as we saw earlier, to everyone interested in the technology of optical natural magic as set out by Della Porta.⁶⁴ '[H]ow many things', wrote Le Loyer, giving details of them, 'may a man forme by the art optique, with mirrors or steele-glasses . . . and make them to represent faces and figures, quite in an other forme than the mirror doth receive them?'⁶⁵ In 1557, in a preface to the first Latin edition of Euclid, the mathematics professor at the Collège Royal in Paris, Joannes Peña, even suggested that *all* apparitions and spectres could be attributed to the natural effects of mirrors. The ghost of Samuel, for example, was neither a simple hallucination produced by Saul's own disturbed vision, nor a real spirit summoned by means of a mirror purified and empowered by prayer. Mirrors were probably involved, but their effects were entirely natural, not mystical or spiritual; the 'witch' of Endor had arranged them so that they projected images into the surrounding space instead of retaining

them on their own surfaces. Peña pointed out that the thirteenth-century optics expert Witelo had described such effects in his *Perspectiva* (printed in 1535, 1551, and 1572), including a cylindrical mirror that produced 'ghosts' from what were, in effect, just statues or children acting the part, and a combination of flat mirrors that sent the images of those who looked into them 'flying off' into the sky. Apparitions, said Peña, had nothing to do with material causes or sorcery. The laws of optics accounted for everything and the 'witch' of Endor had merely used a specular device.[66]

This association of 1 Samuel 28 with specular illusion finds its way into another contemporary painting of the episode by the northern Netherlands artist Jacob Cornelisz van Oostsanen (also known as Jacob van Amsterdam). His *Saul and the Witch of Endor* of 1526 (Fig. 23) was one of the most radical of the early modern attempts to 'demonologize' the story of Saul by linking it with the kind of witchcraft familiar from contemporary witch trials and witchcraft treatises—hence the prominence on the right of the composition of the four witches seated on goats and cooking and drinking, the presence of other witch figures flying through the air and of various demonic animals and monsters, and the many references to the sexual aspects of witchcraft. The witch of Endor is herself portrayed as a powerful necromancer invoking demonic powers, whereas Saul is relegated to the far left of the scene, enquiring after her, and Samuel to the middle distance, where he clambers out of his tomb.[67] But, in addition, Jacob van Oostsanen manages to cast doubt on the reality of the entire scene and the exact identity of 'Samuel' by positioning a convex mirror (held by a scaly monster) in the immediate left foreground—and perhaps even slightly in front of the picture plane—where it can comment, so to speak, on what it 'sees'. Mirrors were among the perfectly traditional tools of the magician, where, as Agrippa makes perfectly clear, they combined a supposedly real power to reveal and project with a suggestion of magic's own illusoriness. This mirror, placed in this way, seems to be reminding us that what is reflected in it—both the raising of Samuel and the wider world of witchcraft and magic—may be real but might also be wholly artificial.

In this broader context—the history of early modern visual artifice—the most emblematic moment in *Macbeth* is the appearance in Act 4, Scene 1 of the three apparitions and the eight kings, the last 'with a glass in his hand', followed by a reappearance of Banquo's ghost (see the stage direction following 4. 1. 110, with its own reference to the sisters departing 'like shadows'). Critics have given ingenious explanations for this detail, among them the idea that the 'glass' was a mirror in which James I—possibly present at an early, or even the first, performance—might catch his own reflection as the ninth Stuart king of Scotland.[68] More likely, the intention was to continue the sense of the line of kings as a vision of the future, seen in a magic crystal or mirror.[69] The same stage directions speak of what was seen as 'a show', and the sisters introduce it with the incantatory 'Show! Show! Show!' and the words 'Show his eyes . . . ' (4. 1. 106–9). Macbeth's angry question, 'Filthy hags, | Why do you show me this?' (4. 1. 114–15), revisits once

more the 'filthy air' of Act 1, Scene 1, as well as echoing and reiterating the noun 'show' in its verbal form (and one of Banquo's first questions to the sisters in the play: 'I'th'name of truth | Are ye fantastical, or that indeed | Which outwardly ye show?': 1. 3. 50–2). The 'glass' itself 'shows' Macbeth many more kings, including possibly James (with 'two-fold balls and treble sceptres' (4. 1. 120), signifying the union of the realms in 1603), and his reactions throughout the scene are couched in the language of vision: 'eyeballs', 'eyes', 'see' (three times), and 'sight'. Indeed, this is a visual spectacle that Macbeth describes for us in verbal cues; the audience is compelled to see the illusion as he sees it, through his eyes, rather than via any physical representation of it on stage.[70]

In obvious ways, this display of royal spectres—both with the 'glass' and in the 'glass'—was not an illusion at all. It had to be historically correct, whether James VI and I was actually present at its performance or not. It also had the necessary dramatic function of confirming to Macbeth the prophecy delivered to Banquo in Act 1: 'Thou shalt get kings, though thou be none' (1. 3. 65). Before it begins, Macbeth demands to know 'shall Banquo's issue ever | Reign in this kingdom?' (4. 1. 101–2), and when it concludes his question 'What, is this so?' receives the answer 'Ay, sir, all this is so' (4. 1. 123–4). If we discount what are probably Thomas Middleton's additional lines at 4. 1. 124–31, when the sisters dance their 'antic round',[71] virtually their last words to Macbeth in the play are 'Show his eyes and grieve his heart' (4. 1. 111), imperatives that attempt to locate in its accuracy (and its taboo) the effect on him of what he is about to see.[72]

But genealogically true or otherwise, this particular set of apparitions had many wider and more unsettling implications. It was associated, via the mirror, with the visual ambiguity that Renaissance writers detected in all specular images and with the duplication that, according to one modern critic, 'opens a spect[re] of uncontrolled resemblance rendering difference problematic' and, in so doing, subverts any form of hegemonic imposition, genealogical or otherwise.[73] Whether by aeromancy or catoptromancy, it was produced improperly by a form of divination practised by witches, by what Hecate calls 'magic sleights' (3. 5. 26). In the universal opinion of the age, it was thus not merely illusory but idolatrous and demonic—as Saul's consultation at Endor had been, whatever the accuracy of the outcome. Indeed, as a visual echo of Saul's sighting of 'Samuel', Macbeth's 'show' was redolent not only of an act of pure deception but of the religious and political crimes that had brought the deceit about. Given the fundamental doubts and hesitations about the reality of apparitions that had marked European culture for a century, it was now probably impossible to represent them on stage (*especially* on stage) in any officially countenanced or otherwise incontestable manner. In any case, the line of kings was preceded by other apparitions—the 'armed Head', the 'bloody Child', and the 'Child crowned, with a tree in his hand'—each of them equivocal in visual as well as verbal terms and, thus, a link to the play's many other visual and verbal paradoxes. We recall again Rosalie Colie's description of the mirror as the paradox's visual emblem, not merely because of duplication and

circularity, but because its images are themselves 'reflections' and 'speculations', and thus an invitation to thought on the part of those observing them.[74]

Thus, just as the mirror inserted by Jacob van Oostsanen into his painting acts as a commentary on the whole scene and its subject, so the 'glass' placed by Shakespeare in the hands of the eighth of the kings of Scotland comments on the entire play of *Macbeth* and its exploration of themes from the literature of apparitions.[75] 'Show his eyes and grieve his heart' may turn out to be the key to this particular relationship between the text and Shakespeare's culture—a kind of motto for the play in its historical setting.

Saul's experiences at Endor, encapsulating his misdeeds as a king and reflecting their nature, rested on two paradoxes, one verbal and the other visual. The prophecy he heard was equivocal and the prophet he saw was a simulacrum—equivisual, so to speak. Both would have been demonic in origin in the view of most Protestant scholars, even if God had a purpose in allowing them. Of the first, Henry Holland wrote that the devil could 'speake sugred words, and mean Sathanically'.[76] The second, according to William Perkins, was achieved 'so lively and cunningly, as well in forme of bodie, as in attire and voice, that Saul thought verily it was the Prophet'—good enough reason, he added, for never accepting the reality of any apparition, however authentic it seemed.[77] The two paradoxes were, of course, related as well. 'To morrow shalt thou and thy sons be with me' was straightforwardly true if spoken by the real Samuel or even by an obvious demon (the blunt Geneva Bible gloss was: 'Ye shal be dead'[78]). It only became simultaneously true and false, as well as mimicry of Christ's 'To day shalt thou be with me in paradise' (Luke 23: 43), when spoken by a demon masquerading as Samuel (you will be with me in death *but in Hell*). Even then, it seemed true (but was really false) as long as Saul saw 'Samuel' as Samuel, as he does in Rosa's painting, and could not become completely paradoxical until he realized his mistake. In fact, there is no indication in the biblical text that Saul ever did realize the mistake that so many Renaissance commentators were convinced he made. The whole point of their intervention between the text and its readers was to expose his complete deception and its paradoxical implications. For him the apparition *was* Samuel; for them and their intended audience it was a devil that was visually undetectable.

For some time critics have seen verbal paradox in *Macbeth* as a crucial indicator—and indeed instigator—of the play's preoccupations. It is now commonplace to remark on the many juxtapositions of words and phrases with contradictory meanings, on the abundance of rhetorical figures evoking opposition, inversion, or antiphony (antithesis, oxymoron, chiasmus, and so on), and on the pervading sense of irony. The specific riddles and equivocations that open the play and later drive it forward are taken to be the most audible expressions of a general linguistic ambiguity, of language 'at cross-purposes with itself'.[79] In turn, these various poetic values are said to match the moral values at issue in the drama. They reflect and amplify the conflicts in Macbeth's conscience and

realm, the hypocrisy and dissembling inherent in betrayal, and the confusion that results from regicide.

Above all, double meanings inhere in the duplicity of the traitor. *Macbeth* was written at a time when rebellions were generally associated with ambiguous prophecies and riddles, and staged just after one of them, the Gunpowder Plot, had issued in equivocal language in the courtroom. Notoriously, Henry Garnett and his co-conspirators were accused of invoking the principle of mental reservation (*restrictio mentalis*) when swearing oaths, thereby turning them into mixed propositions that said one thing and meant the opposite. An oath sworn with unspoken reservations was both true and misleading—a truthful statement if completed mentally but otherwise a lie, and yet deemed to be truthful by those misled by it. The swearer was thus saved from possible destruction without betraying his conscience. This was not merely lying, where thought and utterance were one and the same, but lying 'like truth'—equivocation, indeed. It involved retaining mentally 'one-half of a proposition in order to delude the hearer by that half which is spoken', and the rest of Shakespeare's contemporaries associated it unreservedly with the devil.[80] Indeed, this is why they reacted as they did to Samuel's 'to morrow shalt thou and thy sons be with me', a classic example of a mixed proposition of which only the spoken part was available to Saul, who was thus misled in relation to its whole sense. This had been a prophecy not an oath, and its duplicity was redoubled by the ambiguity of the word 'me' when spoken by a devil counterfeiting a man. But it was still a case of words being deliberately and duplicitously at odds with a retained meaning—what Banquo calls an 'undivulged pretence' (2. 3. 124) and Macbeth 'th'equivocation of the fiend' (5. 5. 42).

All Tudor and Stuart traitors, but particularly the Jesuits among them, were caught, as Steven Mullaney has put it, 'in an equivocal space between the truth and a lie'.[81] Their figure of speech was *amphibologia*, called by George Puttenham 'the *Ambiguous*', and described in his *The arte of English poesie* (1589) as '[w]hen we speake or write doubtfully and that the sence may be taken two ways', and linked by Puttenham to the 'doubtfull speaches' of the pagan oracles and other false prophets of antiquity—as well as to the 'blind prophecies' that had inspired recent rebels like Jack Cade and Robert Kett.[82] The direct reference is made twice in *Macbeth*, singly in Lady Macduff's definition of the traitor as 'one that swears and lies' (4. 2. 47), and in multiple form in the Porter scene, with its traitorous (and Jesuit) 'equivocator that could swear in both the scales against either scale' (2. 3. 7–8) and its heavily punning joke about drink equivocating with lechery and 'giving him the lie' (2. 3. 29–30). But it could be said that the entire play confronts these themes, making it, in Mullaney's terms, 'the fullest literary representation of treasons's amphibology in its age'.[83] Thus, the witches' first set of prophecies count technically as equivocation in the sense of being true with mental reservation. The unspoken assumptions and secret conditions behind them act terribly on Macbeth's conscience and more overtly on his wife's determination to override it, and then, eventually, drive him to seek the sisters a

final time, whereupon, like Saul, he is again offered, and accepts as true, propositions that are a mixture of the spoken and the unspoken. It is Banquo who remarks of all this—almost like a theologically orthodox commentator on 1 Samuel 28—that often, 'The instruments of darkness tell us truths; | Win us with honest trifles, to betray's | In deepest consequence' (1. 3. 123–5).

What is suggested by the story of Saul, as it was usually read in Shakespeare's age—and hopefully supported by the arguments elsewhere in this book—is that the visual paradoxes in *Macbeth* are the exact parallels of the verbal, and as important to the play's interests. Here also there is the exact equating of contradictory things, the sense of things being turned in two ways at once, and the inability to decide which it is best to settle on. Many of the verbal paradoxes in the play themselves invoke visual ambiguity or even duplicity, including Macbeth's own opening remark 'So foul and fair a day I have not seen' (1. 3. 36), his later couplet 'Away, and mock [= deceive] the time with fairest show, | False face must hide what the false heart doth know' (1. 7. 81–2), and Lady Macbeth's 'The sleeping and the dead | Are but as pictures' (2. 2. 56–7). Needless to say, 'Macbeth shall never vanquished be until | Great Birnam Wood to high Dunsinane hill | Shall come against him' (4. 1. 91–3) involves a visual dissembling that is the exact counterpart of the verbal pun, and this is only slightly less true of 'none of woman born | Shall harm Macbeth' (4. 1. 79–80). It is not, then, just a question of poetic language that repeatedly makes the 'visualization of an image difficult'.[84] The uncertainty works in the opposite direction as well; encounters with visual images (witches, daggers, ghosts) and with visual instruments (mirrors, the imagination) cannot be resolved in language—'reconciled', in Macduff's terms (4. 3. 139)—because they too 'lie like truth', leaving the observer unsure which way to interpret them.

It might be tempting to think that in *Macbeth*, as in 1 Samuel 28, because appearance and reality cannot often be visually distinguished, the playwright, like the biblical commentator, has to step in and alert us to the paradoxes that arise and their possible resolutions. Macbeth, like Saul, may remain unaware of all the implications of what he sees until the final scenes of the play, when the visual ambiguities that have helped to destroy him are indeed 'reconciled' with brutal naturalism and he begins 'To doubt th'equivocation of the fiend | That lies like truth' (5. 5. 42–3).[85] But from the very outset we in the audience are drawn dramatically and poetically into the realization that all is not what it visually seems. Nevertheless, Shakespeare shows little interest in the doctrinal sureness of the commentators or in what, ultimately, might be real or unreal about things like witches and apparitions. Instead, the play offers visual uncertainty *itself* as an accompaniment to political treason and moral turmoil. Witches and apparitions are chosen as suitable vehicles for expressing this kind of uncertainty, and everything about the way these two subjects were debated in the sixteenth and seventeenth centuries confirms the aptness of the choice. Macbeth comes momentarily to terms with both dagger (as hallucination) and ghost (as 'horrible

shadow, | Unreal mock'ry': 3. 4. 106–7) but his dilemmas on seeing them and his failure to register an absolute distinction between the real and the virtual are more revealing of what the ultimate outcome of his reign—like that of Saul's—will be.

To hypocrisy in word and deed, then, *Macbeth*—a work preoccupied 'with irreducible forms of equivocation'[86]—adds a kind of hypocrisy of the eyes, where what appears as one thing might very well be (and thus mean) another, where images as well as words 'palter with us in a double sense' (5. 8. 20), where false appearing matches what Malcolm calls 'false speaking' (4. 3. 130), and where juggling (as in 'juggling fiends': 5. 8. 19) stands metaphorically for both. Indeed, we do better to transfer to the play's field of vision the rhetorical categories that critics usually reserve for its poetry, particularly those to do with riddling, punning (amphibology), and irony and their subversive and undisciplined outcomes. As Lucy Gent remarks, visual appearances too can be equivocal; 'in *Macbeth* equivocation infects not only the witches' prophecies, a number of Macbeth's own statements, and the characteristic auditory rhythms of the play, but also what is seen.'[87] Of this equivocation and the visual puns that express it, witchcraft is one suitable emblem and the 'glass' in Act 4, Scene 1 is another. The witches in *Macbeth* are both 'imperfect speakers' and, like those we discussed in a previous chapter, visually ambiguous. Witchcraft may very well have entered the play as 'a central political issue in Scotland' in the 1590s,[88] but by that date too it had also become a subject, like apparitions, that was closely identified with, and perhaps even reducible to, debates about the reliability of vision—itself a political issue.[89] Like puns, mirror-images rely on the confusion and circularity of likeness and difference; precisely because of a supposed exactness of reflection, they too can 'lie like truth'.

Even in a culture so fundamentally committed to biblical narratives, the story of King Saul stood out as one of the best known of all Old Testament histories. Many general lessons could be derived from his tragic career and its denouement, not least the principle, which Jean Bodin reported as an infallible rule of the ancients, that 'of two warring princes, the one who avails himself of witches will be defeated, [since] the prince who asks the devil about his estate and his successors will perish miserably along with all his own'.[90] Nearer to home, the royal chaplain and Dean of Windsor, Anthony Maxey, preaching a Lenten sermon to James VI and I's council at Whitehall sometime between 1610 and 1614, said that Saul's story displayed 'a godly King, and the glory of Israell, raysed by God, standing in prosperitie, falling into sinne, reproved by Samuel, neglecting repentance, and thereupon utterly forsaken of God; shewing to us all, a rare and fearefull example of his judgement'.[91] Maxey saw the first book of Samuel as a before-and-after chronicle of Saul's moral and psychological condition, pivoting on chapter 16, verse 14: 'But the Spirit of the Lord departed from Saul, and an evil spirit from the Lord troubled him.' Saul began as a virtuous and peaceful man and he 'rejoyced

before God'; after his transformation, his mind became 'set upon murder' and he descended into bitterness, despair, and, above all, suspicion and mistrust:

> he breaketh his oath, he regardeth not his promise, hee staineth his honour, hee accuseth his dearest friends, he refuseth his meat, he wallowes on the ground, he cannot rest on his bed, hee runs up and downe the mountaines boiling in malice, and his thoughts [are] pursued with such terrour, that his conscience is like a bloody field, where all hope and comfort lieth slaine.[92]

Maxey was evidently prepared to confront the Jacobean political aristocracy—even the King himself—with 1 Samuel because it focused so clearly on the religious responsibilities of rulers and on the consequences of disavowing God in public affairs.

Saul's life had many noteworthy features, therefore, besides the visual encounter that helped to bring it to a close. Even so, the particular visual dilemma he faced—did he see the real Samuel or a visual image that was indistinguishable from him?—was not unrelated to his larger fortunes. Indeed, in many ways it was entirely appropriate to them and a vital indicator of what they meant. To attribute the deception to the devil was to underline the more general deceptions of Saul's idolatry and the cause of his damnation. Maxey too preached that 'Satan having disquieted [Saul's] conscience within, dazeled his eyes with false and fearefull objects without.'[93] Martyr allotted his three questions on 1 Samuel 28 to the chapter in his *Commonplaces* on the 'appeerings of divels; of their answers, and sundrie illusions' but the wider context was the need to acknowledge the God of Scripture. Saul was many things to early modern commentators, but what ultimately mattered was that he became the kind of man who thinks 'he seeth that which he seeth not'.[94]

The more general implications of seeing 'that which he seeth not' seem important in the case of Macbeth too. One critic relates his temptations quite specifically to Elizabethan ideas about cognition, perception, and the wayward workings of the imagination, particularly under demonic influence; another argues that to cast the 'interpretative and sexual uncertainty' that surrounds him as a matter of vision, and specifically of rapture, was to draw on the representational failures that (in an account such as Timothy Bright's) defined Elizabethan melancholy.[95] The strangeness of sight may not have been the *subject* of *Macbeth*; its subject, self-evidently, was politics and political morality. But to problematize sight—as did the play, the debate on apparitions, and the visual culture of early modern Europe in general—was to problematize the positive things with which sight was symbolically and metaphorically associated, including many of the values of orthodox politics and political morality. Again, this is not a question of the associations of particular things seen (or of particular images). The dagger may very well have been 'conventionally an emblem of betrayal, treachery, and sin', or 'a stock republican emblem of tyrannicide and the vigilant defense of liberty'.[96] More important are the symbolic and metaphorical associations of sight itself,

of *seeing*, of Macbeth's questioning of the 'folly' of his eyes. Quite simply, a man who cannot see properly—as Macbeth cannot—is unlikely to show the qualities or achieve the things that contemporaries associated with clear and perspicuous vision. John Dee, the very writer who, in Iain Wright's view, may have inspired the dagger scene, put it exactly when he asked: 'is it not, greatly, against the soveraity of mans nature, to be overshot and abused, with thinges (at hand) before his eyes?'[97] In Lavater and Le Loyer, and throughout the apparitions debate, it was always said that the first to be visually deceived were the weak, the sick, the guilty, the foolish, those with frantic imaginations or perturbed by fear, the mad, the melancholic, women and children. 'They whiche are of stout and hautie corage', wrote Lavater, '[and] free from all feare, seldome tymes see any spirits.'[98] If vision was supposed to be the most certain and most noble sense, then to acknowledge its *un*certainty in fundamental ways was to dislodge particular political, religious and moral values and question their certainty too; it was to make the problems of vision a vehicle for the exploration of the problems of politics and religion. The reliability of vision became itself a political issue. In particular, visual illusion became (according to the prejudices of the day) an emblem of femininity and ignobleness, a matter of things seen the way women, or children, or peasants see them. This is emphatically what occurs in *Macbeth* and to Macbeth—witness the many, much-analysed references by Lady Macbeth to Macbeth's femininity and childishness in the banquet scene, a scene dominated by an apparition—but not to Banquo, whose different reactions to the initial prophecies suggest that Shakespeare was exploring the way things seen 'take their character from the psychological disposition and feelings of the persons to whom they appear'.[99]

Banquo's ghost returns during the banquet scene, at what many readers have noted is the exact midpoint of the play (3. 4. 36), turning the moment into yet another equivisual episode. Political values are here coded by the references to sitting, standing, toasting, place, society, and state, and their disruption by the abrupt contradiction between Macbeth's initial command to his courtiers: 'You know your own degrees, sit down, at first and last, the hearty welcome' (3. 4. 1–2) and Lady Macbeth's final one: 'At once, good night. | Stand not upon the order of your going, | But go at once' (3. 4. 118–20). In this emblematic transition from order to confusion, only one visual experience matters, and it was one adequately allowed for in early modern spectrology—that one person might see a real apparition while another might not. For Macbeth, Banquo's apparition is not, like the dagger, an internal fooling of his senses; it is a true ghost (despite Macbeth's parting 'Unreal mock'ry hence': 3. 4. 107). For his wife it is merely 'the very painting' of a fear; 'When all's done', she says with brutal realism, 'You look but on a stool' (3. 4. 61, 67–8).[100] This difference and its political overtones are captured best of all not in any of her remarks but in a single question asked of Macbeth by the Thane of Ross—a compromising, even derisory, query that juxtaposes the visual equivocation of the moment with a title of honour. There have been some intriguing speculations about this ostensibly minor character in the play, focusing

on awareness: how much did Ross—an ironic, knowing, politically shrewd and pragmatic survivor, a man outwardly pliant but inwardly self-serving, and without ties, actually know about the assassination of Duncan?[101] He may have been just the person, therefore, to comment incisively on the politics of vision in *Macbeth*. The (unanswered) question he put to its tragic hero was this: 'What sights, my lord?' (3. 4. 116).

NOTES

1. For exhaustive traditional accounts of the production of these scenes, see Marvin Rosenberg, *The Masks of Macbeth* (Berkeley, 1978), 298–309 (dagger), 439–68 (Banquo's ghost), 514–26 (apparitions). Iain Wright is currently undertaking a complete re-examination of the techniques originally used and the visual issues raised by them: see n. 18 below.
2. All quotations are from the New Cambridge Shakespeare edn., ed. A. R. Braunmuller (Cambridge, 1997).
3. On the dagger as good, rather than distorting, fantasy, and as vision rather than hallucination, see N. Mellamphy, 'Macbeth's Visionary Dagger: Hallucination or Revelation?', *English Stud. in Canada*, 4 (1978), 379–92.
4. While merely seen, the ghost may be illusory, but from the moment it talks it becomes the ghost of Hamlet's father; R. A. Foakes, ' "Forms to his Conceit": Shakespeare and the Uses of Stage Illusion', *Procs. of the British Academy*, 66 (1980), 114–15.
5. The visual aspects of action and drama in *Macbeth* are conveniently summarized in D. J. Palmer, ' "A New Gorgon": Visual Effects in *Macbeth*', in J. R. Brown (ed.), *Focus on Macbeth* (London, 1982), 54–69, supplemented by Leon Harold Craig, *Of Philosophers and Kings: Political Philosophy in Shakespeare's 'Macbeth' and 'King Lear'* (Toronto, 2001), 80–4.
6. Starting in modern criticism with L. C. Knights's 1933 essay 'How Many Children Had Lady Macbeth?', in id., *Explorations* (London, 1946; repr. 1964), 29–48, on deceitful appearance as one of three principal themes in the play. A recent summary of the discrepancies between appearance and reality in *Macbeth*, stressing the prevalence of 'intentional manipulations of appearances, refined to the point of art', and the consequent profusion of 'seemings', is Craig, *Philosophers and Kings*, 54–6. For the prominence of the eye in *Troilus and Cressida*, see François Laroque, 'Perspective in *Troilus and Cressida*', in John M. Mucciolo (ed.), *Shakespeare's Universe: Renaissance Ideas and Conventions* (Aldershot, 1996), 224–42.
7. Palmer, ' "A New Gorgon" ', *passim*; Marjorie Garber, *Shakespeare's Ghost Writers: Literature as Uncanny Causality* (London, 1987), 87–123, esp. 95: 'The whole play is in one sense at least a parade of forbidden images gazed upon at peril, and it inscribes an awareness of this, a preoccupation with it.' Cf. Pye, *Regal Phantasm*, 157, on sight as one of the play's 'central preoccupations'.
8. Nicholas Brooke (ed.), *The Tragedy of Macbeth* (Oxford, 1990), 1–6 (quotation at 1), and cf. Brooke's 1977 Shakespeare Lecture, 'Shakespeare and Baroque Art', *Procs. of the British Academy*, 63 (1977), 53–69. On similar themes, see François Laroque, '*Macbeth*: The Theatre of Baroque Illusion?', in Roy T. Eriksen (ed.), *Contexts of Baroque: Theatre, Metamorphosis, and Design* (Oslo, 1997), 99–118.

9. Huston Diehl, 'Horrid Image, Sorry Sight, Fatal Vision: The Visual Rhetoric of *Macbeth*', *Shakespeare Stud.* 16 (1983), 191.
10. Ibid. 193.
11. Stephen Greenblatt, 'Shakespeare Bewitched', in J. N. Cox and L. J. Reynolds (eds.), *New Historical Literary Study: Essays on Reproducing Texts, Representing History* (Princeton, 1993), 108–35, esp. n. 32.
12. Diehl touches on this point but only in passing, in connection with the apparitions scene (4. 1); see Diehl, 'Horrid Image', 199: 'Even the act of seeing is, in this play, problematic.'
13. Hence the continued relevance of a debate that, to many, seems outmoded or without point or resolution—the debate about whether the 'strange sights' in *Macbeth* are real or imaginary. What is wrong with this question is the intrusion of modern criteria of visual reality in answers to it; asking it of Shakespeare's characters and their audience, and applying *their* criteria to it, still seems to be important.
14. Diehl, 'Horrid Image', 201.
15. For Descartes and the 'demon hypothesis', see Chs. 9 and 10 below.
16. Lucy Gent, 'The Self-Cozening Eye', *Rev. of English Stud.* 34 (1983), 421–4; cf. Stanley Cavell, *Disowning Knowledge in Six Plays of Shakespeare* (Cambridge, 1987), 3: 'My intuition is that the advent of scepticism manifested in Descartes's *Meditations* is already in full existence in Shakespeare, from the time of the great tragedies in the first years of the seventeenth century.'
17. Greenblatt, 'Shakespeare Bewitched', 123–4, 126. For the further significance of perceptual illusion in *Macbeth*, see Garber, *Shakespeare's Ghost Writers*, 96–123, who turns transgressive vision in the play into an indicator of gender undecidability via the myth of the Medusa head and Freud's notion of the 'uncanny'; K. S. Coddon, ' "Unreal Mockery": Unreason and the Problem of Spectacle in *Macbeth*', *ELH* 56 (1989), 485–501, who sees the doubts about what Macbeth sees as an indicator of treason's lack of containment or fixity in either the play or Jacobean England, and says of the witches that 'they immediately problematize the visual and the cognitive' (see esp. 491–2); and Ann Thompson and John O. Thompson, 'Sight Unseen: Problems with "Imagery" in *Macbeth*', in Lynette Hunter (ed.), *Toward a Definition of Topos: Approaches to Analogical Reasoning* (London, 1991), 45–65, who survey all the eye tropes in *Macbeth* in order to defend the idea that imagery may function independently of visualization.
18. Full details in Iain Wright, 'All Done with Mirrors: Macbeth's Dagger Discovered', *Heat* (Sydney), 10, NS (2005), 179–200; id., ' "Come like Shadowes, so Depart": The Ghostly Kings in *Macbeth*', *Shakespearean International Yearbook*, 6 (2006), forthcoming. I am most grateful to Prof. Wright for making these essays available to me before publication.
19. The version in the Latin Vulgate reads: 'Cras autem tu, et filii tui mecum eritis.'
20. Robert S. Miola, *Shakespeare's Reading* (Oxford, 2000), 6.
21. In the Vulgate, the woman of Endor is called *pythonissa*, from the late Latin *pytho*, meaning a familiar spirit or demon that possessed a soothsayer; see L. Normand and G. Roberts, *Witchcraft in Early Modern Scotland: James VI's 'Demonology' and the North Berwick Witches* (Exeter, 2000), 358 (note), and 335–7.
22. For Malcolm's ambiguities, see Millicent Bell, *Shakespeare's Tragic Skepticism* (New Haven, 2002), 231–2. Jane H. Jack, 'Macbeth, King James, and the Bible', *ELH* 22

(1955), 184–5, suggests that the Saul/David relationship finds some reflection in the Malcolm/Macduff altercation in *Macbeth*, 4. 3.
23. Macbeth admitted to his wife that he 'burn'd in desire' to question the sisters further (1. 5. 3–6) and his last meeting with the witches (unlike the others, but like Saul's) was both initiated by him and also located in their domain; see Martha Tuck Rozett, ' "How Now Horatio, You Tremble and Look Pale": Verbal Cues and the Supernatural in Shakespeare's Tragedies', *Theatre Survey*, 29 (1988), 135.
24. Andreas Osiander (the younger), *Biblia sacra* (Frankfurt, 1611), 111ʳ; cf. Martinus Chemnitius, *Examinis Concilii Tridentini* (Frankfurt, 1596), pt. 3 (sep. pag.), 115ᵇ.
25. Arthur Jackson, *Annotations upon the remaining historicall part of the Old Testament* (Cambridge, 1646), 328–9.
26. Innocent Gentillet, *A discourse upon the meanes of wel governing and maintaining in good peace, a kingdome, or other principalitie*, trans. Simon Patericke (London, 1602), 119; cf. the orig. version of 1576 which reads: 'souvent ambigus et à deux sens'; *Anti-Machiavel*, ed. C. Edward Rathé (Geneva, 1968), 233. For other examples of the devil giving 'doubtful' (i.e. ambiguous) answers to questions about the future, see Lavater, *Of ghostes*, 137.
27. Webster, *Displaying*, 167. For one of the lengthiest discussions of 'diabolus mendax' in this context, see Waldschmidt, *Pythonissa Endorea*, 651–71, esp. 657–60.
28. Rosenberg, *Masks of Macbeth*, 527, 557, 663; Jack, 'Macbeth', 181–5; Peter Stallybrass, '*Macbeth* and Witchcraft', in Brown (ed.), *Focus on Macbeth*, 202–3; N. Shaheen, *Biblical References in Shakespeare's Tragedies* (Newark, Del., 1987), 168; and, above all, H. N. Paul, *The Royal Play of Macbeth* (New York, 1948; repr. 1978), 53, 260, 282–3. The question is ignored in S. Marx, *Shakespeare and the Bible* (Oxford, 2000), but there is a 19th-century acknowledgement in James Bell, *Biblical and Shakespearian Characters Compared* (Hull, 1894), 65–101.
29. The phrase is Marshall's: *Beliefs and the Dead*, 235.
30. There was some uncertainty over whether Saul only heard Samuel (at least at first), together with the witch's description of him, while she actually saw him. Tertullian (see n. 42 below) had said that the devil tricked the eyes of the woman and the ears of Saul, allowing some early modern commentators to offer a ventriloquistic explanation for the deception. For Reginald Scot it was merely 'right ventriloquie'—an 'illusion or cousenage practiced by the witch', who, 'speaking as it were from the bottome of hir bellie, did cast hir selfe into a transe, and so abused Saule, answering to Saule in Samuels name, in hir counterfeit hollow voice'; see Scot, *Discoverie*, 139–55, esp. 150; and for the same view, Webster, *Displaying*, 165–83. Most assumed, however, that Saul eventually spoke face to face with Samuel. For the demonological background to interpretations of this biblical episode, see Ch. 4 above.
31. Full details of the debate are given by Schmitt, 'Spectre de Samuel', 37–64, who argues (53) that from the 15th century onwards, the demonic explanation for the episode becomes the favoured one; cf. Kapitaniak, 'Spectres', 89–92.
32. Taillepied, *Traité*, 272 (calling the woman of Endor a 'witch'—*sorcière*), and Cornelius à Lapide, *Commentarius in Josue, Judicum, Ruth, iv libros Regum et ii Paralipomenon* (Antwerp, 1718), 354 (1st pub. 1623).
33. See, for example, Pererius, *Adversus fallaces et superstitiosas artes*, 62–5; Gaspar Sanctius, *In quatuor libros Regum et duos Paralipomenon commentarii* (Antwerp, 1624), cols. 483–99; Manescal, *Miscellánea de tres tratados*, pt. 1, 160–8 (sep. pag.); Brognolo, *Alexicacon*, 111;

Del Río, *Disquisitionum magicarum*, 113, 114–15 (bk. 2, q. 6), allowing for a confusing variant in which God allowed Samuel's soul really to appear but the devil deceived the senses of the 'witch' by making his soul appear to obey her commands. For Aquinas's not unambiguous opinion, allowing that Samuel 'might also' have been an impersonation, see *St Thomas Aquinas: Summa theologica*, Blackfriars edn. (60 vols.; London, 1964–6), xlv. 85–9 (2 (2), q. 174, art. 5); cf. Franciscus Suárez, *Commentariorum ac disputationum in tertiam partem divi Thomae* (4 vols.; Lyons, 1613–14), ii. 436–7; Robert Bellarmine, 'De Purgatorio', in id., *Disputationes*, ii, cols. 633–4.
34. Kapitaniak, 'Spectres', 665–71, summarizes forty-eight contributions to the debate between 1486 and 1636, showing that the Catholic writers on witchcraft tended to side with their Protestant counterparts in tracing the episode to a demonic illusion.
35. James VI and I, *Daemonologie* (Edinburgh, 1597), 22.
36. Decker, *Spectrologia*, 106.
37. *The Geneva Bible*, introd. Lloyd E. Berry (Madison, 1969), 134v (facsimile of 1560 edn.).
38. Heinrich Kornmann, *De miraculis mortuorum* (n.p. [Augsburg?], 1610), sig. B7v.
39. Petrus Martyr (Vermigli), *In duos libros Samuelis prophetae . . . commentarii* (Zurich, 1575), 160v-168v; id., *Sommaire des trois questions proposes et resolues par M. Pierre Martyr*, in Ludwig Lavater, *Trois livres des apparitions* ([Geneva], 1571), 234–304. The three questions were: who was it who appeared to Samuel; is the devil able to appear to human beings and tell them accurately about the future; and is it permitted to consult him in this way?
40. Martyr, *Commonplaces*, 89^{a-b}; cf. id., *Loci communes* (London, 1583), 44–59, quotations at 57.
41. Lavater, *Of ghostes*, 131, 135, 139, 141; cf. Martyr, *Commonplaces*, 73b.
42. Lavater, *Of ghostes*, 141–2; Martyr, *Commonplaces*, 76b; Tertullian, *De anima*, 57. 6–9, ed. J. H. Waszink (Amsterdam, 1947), 77–8, 583–4; Pseudo-Augustine, *Quaestiones veteris et novi testamenti cxxvii*, ed. Alexander Souter, in *Corpus scriptorum ecclesiasticorum latinorum*, vol. 50 (Vienna, 1908), 55.
43. See, for example, the editions at Gorinchem, 1683, facing p. 187, and at Leiden, 1687, facing p. 187. The image is repeated, with slight variations, in the German edn. of Rémy: Nicolas Rémy, *Daemonolatria, oder: Beschreibung von Zauberern und Zauberinnen* (Hamburg, 1693), pt. 2 (sep. pag.), facing p. 480. For a list of artistic treatments of 1 Samuel 28, see Pigler, *Barockthemen*, i. 144–6.
44. Jonathan Scott, *Salvator Rosa: His Life and Times* (London, 1995), 181; Luigi Salerno, *Salvator Rosa* (Florence, 1963), 113 and plate 24. For a very similar depiction by the German painter and draughtsman Johann Heinrich Schönfeld, completed in Augsburg in the 1670s, see Herbert Pée, *Johann Heinrich Schönfeld: Die Gemälde* (Berlin, 1971), 233 and plate 219. Here too Saul does homage on his knees in front of 'Samuel', amidst a scene meant to be one of contemporary witchcraft. Other comparable depictions of Saul's idolatry occur in the work of Jan van Boeckhorst, Dominicus van Wynen, and John Michael Rysbrack.
45. Webster, *Displaying*, 175.
46. Perkins, *Discourse*, 23–4, 108–20, quotation at 118. Cf. Henry Holland, *A treatise against witchcraft* (Cambridge, 1590), sigs. C1v–C2v; Cooper, *Mystery* (1617), 150–4.
47. Andrew Willet, *An harmonie upon the first booke of Samuel* (Cambridge, 1607), 313, 316, 326; cf. Jackson, *Annotations*, 327–8.
48. Osiander, *Biblia sacra*, 110v; Peucer, *Commentarius*, 121v.

49. Weyer, *De praestigiis daemonum*, Mora edn., 129.
50. James VI and I, *Daemonologie*, 2–5; cf. [Gilpin], *Daemonologia sacra*, 38–9.
51. Le Loyer, *Treatise*, sig. 112ᵛ, in the section on 'the feares and terrours of tyrants and usurpers of estates' in the chapter entitled 'What persons are most commonly subject to receive false Imaginations and Phantosmes, and to have the Braine troubled and distracted'. The passage is noted by Paul, *Royal Play of Macbeth*, 58–59; Kenneth Muir, *Shakespeare's Sources*, i: *Comedies and Tragedies* (London, 1957), 176–7; id. (ed.), *Macbeth*, The Arden Shakespeare (London, 1977), 91; Willard Farnham, *Shakespeare's Tragic Frontier: The World of his Final Tragedies* (Berkeley and Los Angeles, 1963), 113; Geoffrey Bullough, *Narrative and Dramatic Sources of Shakespeare*, vii: *Major Tragedies* (London, 1973), 463. For Shakespeare's possible reliance on Lavater in *Hamlet*, see Muir, *Shakespeare's Sources*, i. 121; F. W. Moorman, 'Shakespeare's Ghosts', *Mod. Language Rev.* 1 (1905–6), 198–9.
52. Le Loyer, *Treatise*, sigs. 52ʳ⁻ᵛ, 55ᵛ–7ʳ; Bullough, *Narrative and Dramatic Sources*, 505. For further mention of military stratagems involving visual deception, and an army used against William the Conqueror 'with young trees, or big boughs in their hand', such that he thought 'hee had seene a wood before him', see Hakewill, *Vanitie*, 85.
53. Franciscus Vallesius, *De iis quae scripta sunt physice in libris sacris, sive de sacra philosophia* (Lyons, 1595), 219.
54. Pierre Le Loyer, *IIII livres des spectres ou apparitions et visions d'esprits, anges et demons se monstrans sensiblement aux hommes* (Angers, 1586), 416–56 (Macbeth story at 453–4).
55. Nor are they, consequently, in modern discussions of the politics of the play; see, for example, David Norbrook, '*Macbeth* and the Politics of Historiography', in K. Sharpe and S. N. Zwicker (eds.), *Politics of Discourse: The Literature and History of Seventeenth-Century England* (London, 1987), 78–116.
56. Bullough, *Narrative and Dramatic Sources*, 494–5, 505, 440, 441; Farnham, *Shakespeare's Tragic Frontier*, 82–93. Holinshed offered 'necromanticall science' as one explanation for the initial prophecies to Macbeth and Banquo, and attributed the final prophecies about Macduff and Birnam wood not to the three sisters but to 'a certeine witch, whom [Macbeth] had in great trust', offering an even closer parallel with 1 Samuel 28.
57. Girolamo Cardano, *De rerum varietate*, bk. 16, ch. 93, in *Opera omnia*, iii. 324; Grosse (ed.), *Magica* (1597), 6–7; repr. Leiden, 1656 as *Magica de spectris et apparitionibus spirituum*, see 8–9, and in English trans. by T[homas] B[romhall], *A treatise of specters. Or, an history of apparitions* (London, 1658), 4–5. Cf. *Der bösen Geister und gespensten wunder-seltzahme Historien und nächtliche Erscheinungen*, pub. as pt. 2 (sep. pag.) with Rémy, *Daemonolatria, oder: Beschreibung von Zauberern*, 7–8.
58. Le Loyer, *Treatise*, sig. 30ʳ.
59. Peucer, *Commentarius*, 126ʳ; Pierre De Lancre, *Du sortilège* (n.p., 1627), 80; Torreblanca, *Daemonologia*, 113–14. See also Del Río, *Disquisitionum magicarum*, 547 (bk. 4, ch. 2, q. 6, sect. 4, para. 7); Weyer, *De praestigiis daemonum*, Mora edn., 136; Johann Ellinger, *Hexen Coppel* (Frankfurt am Main, 1629), 23–5; and for aerial spectres themselves, Decker, *Spectrologia*, 134–6.
60. Agrippa, *Three books*, 14–16, cf. 168 on 'miracles of images . . . and opticks', for more mirrors that fill the air with phantoms and visions.
61. Braunmuller (ed.), *Macbeth*, 103 (note to this line); Rosenberg, *Masks of Macbeth*, 15, on the witches staged to appear as if floating in air.

62. Werner Habicht, ' "And Mock our Eyes with Air": Air and Stage Illusion in Shakespearean Drama', in Frederick Burwick and Walter Pape (eds.), *Aesthetic Illusion: Theoretical and Historical Approaches* (Berlin, 1990), 310, 306–7; cf. Craig, *Philosophers and Kings*, 100–1.
63. Swan, *Art, Science, and Witchcraft*, 123–56, esp. 136–48; cf. Zika, *Exorcising our Demons*, 503–5. Cole, 'Demonic Arts', 623–9, also has much on the qualities and potentialities of air.
64. For example, Raphaël Mirami, *Compendiosa introduttione alla prima parte della specularia* (Ferrara, 1582), 4; Hanss Jacob Wecker, *Eighteen books of the secrets of art and nature*, trans. and augmented R. Read (London, 1660), 226–7 (1st pub. 1582); Rhodius, *Optica*, 324; for Della Porta, see Ch. 3 above.
65. Le Loyer, *Treatise*, 58[r].
66. Joannes Peña, *Euclidis optica et catoptrica* (Paris, 1557), 'De usu optices', sigs. Bbiiii–Cci[v]; Baltrušaitis, *Le Miroir*, 217–18. Peña's preface to Euclid was reprinted many times with later treatises on optics, particularly those of Frederic Risner and Johann Kepler.
67. Charles Zika, 'Les Parties du corps, Saturne et le cannibalisme: représentations visuelles des assemblées des sorcières au xvie siècle', in Nicole Jacques-Chaquin and Maxime Préaud (eds.), *Le Sabbat des sorciers (xve–xviiie siècles)* (Paris, 1993), 394–5; Schmitt, 'Spectre de Samuel', 53; J. L. Carroll, 'The Paintings of Jacob Cornelisz. Van Oostsanen (1472?–1533)', Ph.D. thesis (University of North Carolina, Chapel Hill, 1987), 90–104.
68. With various consequences; see Garber, *Shakespeare's Ghost Writers*, 116–18; Steven Mullaney, 'Lying Like Truth: Riddle, Representation and Treason in Renaissance England', *ELH* 47 (1980), 40–1 (repr. in id., *The Place of the Stage: License, Play, and Power in Renaissance England* (Chicago, 1988), 116–34); Bullough, *Narrative and Dramatic Sources*, 520–3.
69. Wright, ' "Come Like Shadowes, so Depart" ', is now essential reading on this issue and the stage technology associated with it. See also id., 'Perspectives, Prospectives, Sibyls and Witches: King James Progresses to Oxford', in Jan Lloyd Jones and Graham Cullum (eds.), *Renaissance Perspectives* (Melbourne, 2006), 109–53.
70. Rozett, ' "How Now Horatio" ', 136.
71. So cheering Macbeth's spirits, as the 'witch' of Endor comforts Saul's after *his* 'Horrible sight' (by offering him food; 1 Samuel 28: 21–5); on this parallel, see Shaheen, *Biblical References*, 168.
72. For this line, Shaheen, loc cit., suggests God's warnings to Eli in 1 Samuel 2: 33 (Geneva version): 'To make thine eyes to faile, and to make thine heart sorowfull', although the King James version (post-dating *Macbeth*) is actually closer: 'to consume thine eyes, and to grieve thine heart'.
73. Jonathan Goldberg, 'Speculations: *Macbeth* and Source', in Jean E. Howard and Marion F. O'Connor (eds.), *Shakespeare Reproduced: The Text in History and Ideology* (London, 1987), 242, and cf. 251–2 on the possibility of the spectral identification of King James and Macbeth in the 'mirroring moment' provided by the 'glass'. Coddon, ' "Unreal Mockery" ', 497, also sees the show of kings as a 'parodic play-within-a-play that ostensibly compliments the Stuart line but whose medium and manner of production remain ambiguous. The Stuart succession may itself be unequivocal, but the spectacle that presents it is not.
74. Colie, *Paradoxia epidemica*, 6, 22, 280–2.

75. Oostsanen's painting and Shakespeare's 'glass' are linked, although not in quite this manner, by G. F. Hartlaub, *Zauber des Spiegels: Geschichte und Bedeutung des Spiegels in der Kunst* (Munich, 1951), 130.
76. Holland, *Treatise*, sig. C2v.
77. Perkins, *Discourse*, 120.
78. *Geneva Bible*, 134v.
79. Margaret D. Burrell, '*Macbeth*: A Study in Paradox', *Shakespeare Jahrbuch*, 90 (1954), 169, and *passim* for many examples; cf. G. I. Duthie, 'Antithesis in *Macbeth*', *Shakespeare Survey*, 19 (1966), 25–33.
80. Frank L. Huntley, '*Macbeth* and the Background of Jesuitical Equivocation', *Procs. of the Mod. Language Association*, 79 (1964), 390–400 (quotation at 398). I rely here and in what follows on both Huntley and, more especially, Mullaney, 'Lying Like Truth', *passim*. The parallels made with 1 Samuel 28 are my own. For additional contemporary information about equivocation, see Paul, *Royal Play of Macbeth*, 237–47; Perez Zagorin, *Ways of Lying: Dissimulation, Persecution, and Conformity in Early Modern Europe* (Cambridge, Mass., 1990); Arthur F. Kinney, *Lies Like Truth: Shakespeare, Macbeth, and the Cultural Moment* (Detroit, 2001), 233–42, and two tracts by the future Bishop of Durham, Thomas Morton: *An exact discoverie of Romish doctrine in the case of conspiracie and rebellion* (London, 1605), '43'[41]–3, and id., *A full satisfaction concerning a double Romish iniquitie; hainous rebellion, and more then heathenish aequivocation* (London, 1606), pt. 3 (sep. pag.), 47–103.
81. Mullaney, 'Lying Like Truth', 35.
82. Puttenham, *Arte*, 260.
83. Mullaney, 'Lying Like Truth', 38.
84. Ibid. 41–2.
85. For the way, in the play's final act, naturalism 'functions to contain and circumscribe the disorderly spectacular', see Coddon, ' "Unreal Mockery" ', 497–8; the parallel displacement of potential deception by rational sight is argued by Brooke (ed.), *Macbeth*, 5.
86. Pye, *Regal Phantasm*, 161.
87. Gent, 'Self-Cozening Eye', 422.
88. Norbrook, '*Macbeth*', 105.
89. For an exploration of the way the witchcraft debate was a debate about the problems of vision (and about the power of language), see Greenblatt, 'Shakespeare Bewitched'. It is my contention that the question of whether or not witchcraft was illusory was, in effect, a question about visual perception.
90. Jean Bodin, *De la démonomanie des sorciers* (Paris, 1580), 139v; Bodin added the example of a contemporary ruler who, wanting to survey the armies of his enemy by illicit means and know the outcome of the battle from a *devin*, was given an ambiguous reply ('a double sens') by Satan and was defeated as a result (140r).
91. Anthony Maxey, 'The copie of a sermon preached in Lent before the Lords of the Councell, at White-hall', in id., *Five sermons preached before the king. Viz . . . 5. The vexation of Saul* (London, 1614), 2.
92. Ibid. 20, 26–7. For a sermon likening the inauguration of James to the acclamation given initially to Saul by the Israelites, see John Rawlinson, *Vivat rex. A sermon preached at Pauls Crosse on the day of his Majesties happie inauguration, March 24 1614* (Oxford, 1619), esp. 1–2.

93. Ibid. 26.
94. Martyr, *Commonplaces*, 89ª.
95. Respectively, Kurt Tetzeli von Rosador, ' "Supernatural Soliciting": Temptation and Imagination in *Doctor Faustus* and *Macbeth*', in E. A. J. Honigmann (ed.), *Shakespeare and his Contemporaries: Essays in Comparison* (Manchester, 1986), 42–9; Pye, *Regal Phantasm*, 164–5.
96. Diehl, 'Horrid Image', 199; Norbrook, '*Macbeth*', 101.
97. Cited by Wright, 'All Done with Mirrors', 179–200.
98. Lavater, *Of ghostes*, 16.
99. Rozett, ' "How Now Horatio" ', 132.
100. On the banquet scene, see esp. ibid. 134–5; G. R. Elliott, *Dramatic Providence in Macbeth* (Princeton, 1960), 125–43; Knights, 'How Many Children', 36–7.
101. See esp. Craig, *Philosophers and Kings*, 39–48.

8

Seemings: Philosophical Scepticism

The oldest roots of early modern anxieties about visual reality lay in the philosophical scepticism of the ancient Greeks, although this did not become fully apparent until after the 1560s, when for at least a century and a half 'Pyrrhonism' came to exert an unprecedented influence over European intellectuals. Turning finally to philosophy might seem discontinuous with the subjects discussed so far—with madness, magic, anamorphic art, demons, miracles, and the rest (and with one subject yet to come: dreams). But turning to *sceptical* philosophy could not, in fact, be more apt, resting as it did on epistemological issues. The emergence of Pyrrhonism as a major force in intellectual life can be seen as a yet further—indeed, in early modern terms, the last—occasion for the de-rationalization of sight that we have been considering. The early modern Pyrrhonists, like their Greek heroes, were nothing if not opposed to the Aristotelian (or 'dogmatic') model of cognition, and they aimed explicitly to demolish the kind of epistemology that accompanied the doctrine of visible *species*—as at the opening of the essay on Pyrrhonism by one of its leading exponents in seventeenth-century France, François de La Mothe Le Vayer.[1] But even more importantly, Pyrrhonism acted as a commentary on what had already taken place (and was continuing to take place) in the visual culture of the age. It is uncanny how many of the dilemmas we have already addressed recur in the pages of its adherents and investigators, the *Essais* of Montaigne alone providing striking examples; how, too, these dilemmas seem, in consequence, to have anticipated or prepared the conceptual ground for the philosophical arguments that men like Montaigne eventually formulated.

Scepticism therefore underlined the de-rationalization of sight at the theoretical level, formalizing a process that was already under way. In particular, its rediscovery of the Greek 'tropes' for doubting served to codify contemporary visual relativisms of many kinds. It was, in a sense, the perfect philosophy for the conditions I have so far described—a philosophy of relativism and paradoxes. According to La Mothe Le Vayer: 'Les paradoxes que la sceptique examine sans s'étonner d'aucun, sont d'autant plus tolerables, que n'estant pas plus pour l'affirmative que pour la negative de ce qu'ils contiennent, l'on ne sçauroit dire qu'elle les autorise.'[2] This was exactly commensurate with the state of paradoxical indecision produced by conditions of radical visual uncertainty. From this indecision was supposed to emerge not resolution, of course, but a kind of psychological and

cognitive repose. And of this, as well as the anticipations of Pyrrhonism I am indicating, nothing is more suggestive than the melancholic fever of which Henri Estienne claimed to be cured after he encountered the work he published as *Sexti philosophi Pyrrhoniarum hypotyposeon libri III* in Paris in 1562—a work which itself, says Terence Cave, expressed a 'feverish and hallucinatory' philosophy.[3] The aim in what follows is not, therefore, to trace an author-by-author reception of Pyrrhonism (a probably endless task) but to examine how sceptics made a virtue, so to speak, of many of the specific visual irresolutions we have already encountered and of visual *acatalepsis* as such. In this way, I try to follow the example of Cave's *Pré-histoires* (1999) in locating both topics and texts in an intellectual world already marked by 'troubles épistémologiques'. He writes: 'Le pyrrhonisme s'y mêle à d'autres phénomènes déconcertants, intellectuals et autres, qui attirent l'attention des "curieux" de la seconde moitié du seizième siècle.'[4]

The origins of much that follows lay in the tropes on the relativity of sense perception listed by Diogenes Laertius in his life of Pyrrho, and also by Aenesidemus of Alexandria, and then definitively formulated in the *Outlines of Pyrrhonism* compiled by an obscure Hellenistic physician of the second century CE, Sextus Empiricus.[5] At the heart of all forms of Greek scepticism was the denial that sensory experience could lead straightforwardly to true knowledge of the external world—that one could pass confidently from the phenomenal to the real. The distinction assumed here between appearance and an objective, mind-independent world was not itself questioned, nor even, as a principle at least, the so-called 'dogmatic' idea that veridicality consisted in the first corresponding with the second. Both distinction and principle were taken for granted throughout Greek philosophy, as, indeed, was some degree of inadequacy on the part of the senses in copying with reality: scepticism was itself a product of this customary conceptual vocabulary.[6] What the sceptics proposed instead was that these conditions for true knowledge could never be fulfilled—that veridicality was an impossible epistemological goal and should be abandoned in favour of non-certaintist ways of believing and living. If the world could only be apprehended via the senses (an admittedly empiricist starting point that set sceptics apart from Greek rationalism), then correspondence could neither be proved nor disproved without the aid of the very things that were being assessed. In these circumstances, it was impossible to be certain about whether a sensory experience of an object was a copy of it or not. In traditional epistemological language, therefore, the real nature of the external world was unknowable. The terms 'true' and 'false' were usually applied to propositions about objects and states of affairs in that world, but no single proposition of this sort could actually be shown to *be* true or false. This has led many philosophers to see in ancient scepticism an analogue of modern anti-realism.[7]

What occasioned doubts about veridicality in the field of vision specifically was the existence in common experience of very different but equally convincing

accounts of what was visually real. Thus, one of the arguments 'on both sides' used by the Academic sceptics Arcesilas and Carneades was that the Stoic claim to have found a criterion of truth in *phantasiai kataleptikai* (sense impressions that were clear and compelling because they copied the objects that caused them and could not originate or be experienced in the same way if they did not) was erroneous because for every cataleptic impression deemed to be true it was always possible to experience a false impression that was indistinguishable from it. False impressions could be just as 'perspicuous' or 'evident' as true ones. Renaissance readers found Academic scepticism summarized in Cicero's *Academica*, where Lucullus gives an account of Antiochus' objections to it and Cicero replies to them. Here, the argument against *phantasiai kataleptikai* appears as a syllogism, where the term 'perceived' should be taken to mean 'perceived as true as a cataleptic impression'. The first premiss of the syllogism states what appears to be the Stoic claim and the position from which the Academic is at least prepared to start:

Some presentations are true, others false; and what is false cannot be perceived. But a true presentation is invariably of such a sort that a false presentation also could be of exactly the same sort; and among presentations of such a sort that there is no difference between them, it cannot occur that some are capable of being perceived and others are not. Therefore there is no presentation that is capable of being perceived.[8]

There was, then, no alternative to the sceptical assertion, that all 'presentations' were equally unreliable as guides to truth; they might all be false, without, as Antiochus hostilely put it, 'any mental process being able to distinguish them'.[9] According to Cicero, Arcesilas framed the fundamental challenge to Stoic epistemology in the same way. To Zeno's definition of a true presentation as one 'impressed and sealed and moulded from a real object, in conformity with its reality' he had replied that 'no presentation proceeding from a true object is such that a presentation proceeding from a false one might not also be of the same form'.[10] Even more striking is the further designation of false visual presentations by Cicero himself as 'precisely' corresponding to true ones, like strands of hair, grains of sand, or statues made from the same mould.[11] As examples of this, the *Academica* referred to imaginary objects, dream experiences, and hallucinations brought on by insanity or too much wine—instances, objected Antiochus, 'taken from dreamers, lunatics and drunkards'. Also cited were the many instances of visual puzzles and failures found throughout the literature of Greek epistemology, like the oar 'broken' by its immersion in water, the uncertainty about the colours of the feathers on a pigeon's neck, and the difference between the real and the apparent size of the sun, together with the two further optical illusions created when painters gave 'depth' to flat canvases and parallax led to the sensation of 'moving' landscapes. The point was not, as the enemies of scepticism countered, that the difference between such false experiences and perspicuously true ones could be quickly determined once they were re-examined by the self-conscious, the fully awake, or the experts on astronomy and art—that is to say, in conditions

of normality. Cicero conceded precisely such re-examinations. It was that *at the time when they were seen*, and whatever the occasion for them, they were perspicuous enough to compel assent and govern action. 'How would he have believed these things more if they had really been true', asked Cicero of the madman Alcmaeon, 'than he actually did believe them because they seemed to be?' This by itself invalidated the Stoic argument that cataleptic impressions guaranteed their own truth.[12]

To pair supposedly true with actually false visual experiences of equal force in this way was to give philosophical form to a dilemma that must often have been confronted in the conditions of actual visual dislocation created by early modern culture—conditions we are exploring in this book. The clarity and conviction carried by striking visual experiences was never alone sufficient, the philosophical argument effectively said, to distinguish those that were true from those that were false—the real from the virtual—and compel assent only to the former. This particular sceptical paradox, the most destructive the New Academy could devise and the one that dominates book 2 of the *Academica* (the 'Lucullus'), encapsulated what visual uncertainty in the period after the development of artists' perspective, the flourishing of demonology, and the onset of the Reformation must often have meant. The fact that the epistemological challenges contained in this text made little impact on medieval readers but seriously concerned their early modern successors is an indication of a philosophical theory becoming increasingly relevant to lived experiences. By 1548, Francesco Robortello at the University of Pisa could characterize the Academics as those who maintained that 'nothing can be perceived'.[13]

Nevertheless, there were limits to scepticism of this sort, in both its nature and its influence, that eventually made it less significant to the sixteenth century's epistemological turn than that embodied in the tropes of the Pyrrhonians. The argument against cataleptic impressions does, after all, adopt both the concept and the terminology of the 'false' sensory experience; the sceptical paradox involved depends precisely on making this identification. But how is this possible without a comparison between what the senses report about the world and the world itself? What enables us to say that dreams, hallucinations, and illusions, despite compelling assent 'at the time', are nevertheless false visual phenomena? What allows the Academic sceptics even to adopt the first premiss of their syllogism as a starting point? The answer given by Carneades—one which necessarily mitigated his scepticism but met with Cicero's approval—was that, while the senses could never be relied on for absolute certainty, they could merit acceptance or rejection according to what Charles Schmitt has called a 'calculus of probabilities'.[14] This derived not from matching impressions with anything external to the percipient (an impossibility), but from how they concurred with each other according to the percipient (a possibility) to provide a sequence of plausible, testable, and so apparently trustworthy deductions. The man who mistakes a coil of rope in an unlit room for a snake looks again to see if it moves and then prods it

to determine that it is inert. Qualified assent can thus be given to assertions based on visual experiences as long as they take the form of 'subjectively convincing hypotheses'.[15] This attempt to reintroduce a criterion of true perception and justified belief not dependent on correspondence with the world did not satisfy Cicero's Renaissance critics any more than those in the ancient world. The two major sixteenth-century commentators on the *Academica*, the Italian Giulio Castellani and the German Joannes Rosa, both asked how it could ever be possible to talk of the probability or verisimilitude of human perceptions without begging questions about the true objects or states of affairs of which these perceptions were supposed to be plausible approximations.[16] In this, as we shall see, they were later to be followed by Montaigne.

More than anything else, however, it was the publication of the first Latin edition of the *Outlines of Pyrrhonism* by Henri Estienne in 1562 that eclipsed Cicero's *Academica* as the major source for ancient scepticism in the later years of the Renaissance. A much more detailed, more sophisticated, and more extreme form of the doctrine became the touchstone for European debates about visual reality.[17] Indeed, the *Outlines of Pyrrhonism* occasioned a new phase of sceptical debate in early modern Europe of such seriousness that Richard Popkin once labelled it a 'crisis of Pyrrhonism'. It had implications throughout the worlds of humanism, religious reformation, and natural philosophy—good reason, it seems, for Pierre Bayle's view that Sextus Empiricus was the father of modern philosophy. Not all the Pyrrhonian arguments, like not all the Academic ones, were about sense experience. But they were nevertheless grounded again in radical doubts about whether assertions concerning the external world could be based on the evidence of the human senses, chiefly the eyes. According to Marin Mersenne (reports Richard Tuck), of the basic arguments in favour of this form of scepticism—that is, the tropes—'virtually all of them depended on Optics'.[18]

It is tempting to think of Pyrrhonian scepticism as yet another attack on the *accuracy* of the senses—a statement of their fallibility as reliable reporters of the world. The aim it shared with the New Academy was, after all, to destroy a traditional confidence in them as sources of knowledge. But it is important not to set up the problem the Pyrrhonists confronted in a manner that they themselves were anxious to avoid—and the Academics, perhaps, were unable to avoid. To describe it as a problem of accuracy implies the prior existence of truths about objects and states of affairs in the external world and then a judgement about how successfully the human senses grasp these truths. No fundamental questioning of reality need take place, only a debate about whether, or to what extent, sense experience fails to capture it. The consequence is that all manner of individual sensory weaknesses may be insisted upon without this compromising the general principle that sees accuracy as the criterion of sensory success and measures it in terms of fidelity to an external reality. But in the Pyrrhonism formulated by Sextus Empiricus and inherited by the later sixteenth century, this is a measurement that can never take

place. No one can compare his or her sense experiences with things in the real world to see if they fit, since this itself requires further sensory judgements and, thus, an infinite criterial regress; 'it is absurd', he says, 'to try to settle the matter in question by means of the matter in question'.[19] It is not, then, the inaccuracy of sensory experiences when compared to the external world that is crucial; it is their *difference* when compared to each other.

At this point, Pyrrhonists parted company with the probabilism of the New Academy. Their scepticism rested not on a criterion but precisely on the lack of one, not on a dilemma that might provisionally be settled but on one that would always remain unresolved. True scepticism, wrote Sextus, arises from *aporiai*, from being at a complete loss when faced by sense impressions (*phantasiai*) of equal weight but opposing content. The true sceptic surmounts his own and other people's ordinary-language failures to apply the criterion of accuracy and arrive at 'dogmatic' statements, and also the Academics' need for plausibility. He seeks not to resolve the inconsistencies of sense, or even simply to 'doubt', but to multiply them, and in so doing reach first the intellectual state of *epochē*, of being able neither to affirm nor deny, and eventually the psychological and moral state of *ataraxia*—'an untroubled and tranquil condition of the soul'.[20]

At the heart of Sextus' exposition lay the ten 'tropes' or modes of argument for bringing about suspension of judgement, focusing almost entirely on sense perception, and at the heart of these lay not visual delusions but visual dilemmas. Again, the distinction is important, because many of Sextus' examples, or examples like them, were common to Academic scepticism and could also be found in the mainstream literature on optics, ancient, medieval, and early modern, where they were usually discussed as visual errors (*fallaciae, illusiones*), accountable in terms of conventional optical laws.[21] For Sextus, by contrast, they were simply instances of difference—of different appearances. For example, there were 'illusionists ('praestigiatores'), who 'by treating lamp wicks with copper rust and cuttle fish ink, make the bystanders appear now copper-coloured and now black, just by a slight sprinkling of the mixture'. There were, too, the strange images produced by various kinds of mirrors. Both of these cases suggested that similar variations might be caused by the different construction of animal and human eyes, since 'in each case what is seen depends on the imprint created by the eye that receives the appearance.'[22] What, therefore, were strange but ultimately explicable aberrations in one context, became contrasting or conflicting appearances in the other. Such appearances were no longer to be judged as true or false, correct or mistaken, but only related to the circumstances in which they arose. For the central claim of Pyrrhonism in the field of vision was that visual experience of the external world was neither constant nor unmediated: it was, precisely, an *experience*, something experienc*ed*. Like the 'illusions' of the prestigiator or the 'distortions' of mirrors it was always contingent upon different and changing circumstances. Here, magic and catoptrics—optical magic and magical optics—ceased to be models of unreality, where transparency could be restored

by an explanation of error in terms of the laws of optics, and became striking preternatural paradigms for the *in*constancy and non-transparent nature of visual experience.

They were, in fact, only especially forceful examples of a principle that informed every ordinary visual encounter with the world—the principle that to any single visual description of external reality, another that was opposite in content yet equal in descriptive force could always be contrasted. This is the same as the Academic argument 'on both sides', but without the designations 'true' and 'false'. With no means for choosing ultimately between such descriptions—no criterion of either visual reality or even visual plausibility—the sceptical observer is left only with canonical statements of the type 'it appears that' or 'what seems to me here and now to be the case'. He or she cannot say how anything *is*, only how it is experienced in sense. Honest assent to such statements can still be given with confidence, because appearances, unlike visual 'truths', are not only evident but involuntary things. Pyrrhonists, said Sextus, were not questioning appearances, only what was said about their relationship to reality: nobody, he wrote, 'disputes about whether the external object appears this way or that, but rather about whether it is such as it appears to be'.[23] To be 'dogmatic' about the external world—even to treat it as a coherent concept—was to give assent to non-evident things and, at the same time, to deny that they are known only in terms of this relationship. To be a Pyrrhonist, by contrast, was to 'announce' or 'chronicle' appearances.[24]

The visual dilemmas of the tropes are presented in the form of statements concerning how everything about vision 'is in relation to something' and how nothing about vision is, in consequence, absolute. The aim is to multiply instances of visual anomalies, most of them assumed to be already generally known and accepted, but to give them a collective conceptual force that they do not normally possess as individual cases. To start with, there are the different— indeed, conflicting—*phantasiai* that arise from the fact that the bodies, and especially the visual organs, of animals and humans vary in their construction. The experience of visual fields differs qualitatively, for example, according to the shape of the eye and its various parts, and in the case of humans, according to both humoral variations and preferences originating in the soul. It also differs, naturally, from the experiences obtained from the other senses, so that we cannot be sure that each object of sensation really has five and only five qualities or has only one quality which appears in five different ways or has 'other qualities, affecting other sense organs which we lack and for which we consequently cannot perceive any corresponding objects'.[25] A further set of variables stems from the circumstances of vision, circumstances from which we can never, without absurdity, expect to escape. Things strike us visually in dissimilar ways depending on whether, for example, we are awake or asleep, healthy or sick, young or old, and drunk or sober, and also in relation to our emotional states, and yet we are always in one or more of these subjective conditions. The various positions, distances,

locations, and quantities of viewed objects, their relationships with each other, and the frequency or rarity of their occurrence are, likewise, features intrinsic to every viewing experience and yet, again, responsible for striking differences of opinion about what is visually the case. There is, in sum, no way of reaching agreement about visual perception independently of these various conditions and relationships, and manifestly no way of doing this once they are agreed to pertain.

One important consequence of arguing in this manner was to rule out the counter-argument, present to an extent in the Academics' 'calculus of probabilities' and certainly in ordinary Aristotelian attempts to distinguish between veridical and illusory vision, that the eyes, like the other senses, might be trusted in normal circumstances and that it was only in manifestly abnormal situations—illness, drunkenness, or whatever—that they proved to be unreliable. For the Pyrrhonists, to say that bodily humours produced distorted perceptions in sick persons was to exemplify how humours influenced the perceptions of *all* persons, sick and healthy alike. The healthy might just as well be perceiving things other than they were, and the sick perceiving them correctly:

For to give the power of altering the external objects to some humours but not to others is arbitrary; since just as the healthy in a natural state have the nature of the healthy and in an unnatural state of the sick, so too the sick in an unnatural state have the nature of the healthy and in a natural state that of the sick.[26]

The same principle applied to all other contrasts between supposedly normal and abnormal states; both were *states*, even as usually understood, and as such influenced perception in contingently equal ways. 'The waking person', for example, 'cannot compare the *phantasiai* of sleepers with those of people who are awake' (a case we will return to in the next chapter).[27] Those who claimed—as Aristotelians also did—that the senses gave reliable access to reality in normal circumstances were, like all percipients, influenced by circumstances. To prioritize any set of perceptions as normal and thus reliable in this respect was to intrude a criterion of value where no criterion was possible at all.

It would be difficult not to call this extreme visual relativism and Sextus himself insists that we do. 'Relativity (*ex relatione ad aliquid*)' enjoys a trope of its own, one that argues that no object can be seen except in relation to a percipient and no observation take place except in relation to what is observed. In uncannily modern terms, we are told that if all things are what they are, and are called what they are called, 'by virtue of a difference', then relativity is a universal condition.[28] For this reason, the entire series of tropes can also be subsumed under it, referring as they all do either to what does the sensory judging, or to what is judged, or to both; 'the force of all the arguments', it has been said by Charlotte Stough, 'rests on the epistemological relation between subject and object.'[29] We can never make a visually grounded statement about what a thing is in its own nature and absolutely, only one about 'how, in relation to something, it appears to be'.[30] This, moreover, is a relativism that, unlike many other forms, is not self-contradictory.

All the statements made in the *Outlines of Pyrrhonism* are explicitly or implicitly of the 'what seems to be' type, including those made about the 'sceptic way' itself. Even the slogans of the sceptic, such as 'Nothing more' ('not more this than that'), make no claim to be true, only to report an affect. The entire debate is conducted in the domain of appearances and is intended to be self-referential. There is, indeed, no escape from self-referentiality, because there is simply no criterion available that does not beg the very question it is designed to resolve. Regarding visual experiences, therefore:

> there is no way of saying whether one is to deem all *phantasiai* true, or some true and some false, or all false, since we have no agreed-upon criterion by means of which we shall make our proposed determinations, nor are we even provided with a true proof that has been determined to be such, since we are still in search of the criterion of truth by means of which the purported true proof should be appraised.[31]

Faced with infinite circularity or regression the sceptic cannot determine whether vision is veridical or not; he or she cannot infer any reality from appearances.

Most of the variables that bring this situation about stem, in Sextus Empiricus' text, from the physical environment of seeing—from its physiology and its location in space and time. But it is important to note that sight is also said to be related to emotional and cultural conditions that similarly render it an entirely relativized experience. Although not developed at any length, these serve considerably to deepen the sceptical analysis and explain its disruptive potential, as well as raising suggestive parallels with our own theories of vision. Among the circumstances that affect how we perceive the world are the psychological states associated with hatred and love, courage and fear, distress or cheerfulness. 'The same thing', says Sextus, 'seems frightful and terrible to the timid but not at all so to the bold.'[32] More embracing still are the 'ethical' influences listed in the final trope of the *Outlines*. 'Ethics' was, in any case, crucial to the broader sceptical strategy that opposed phenomena and noumena to one another 'in any way whatever'—that is, objects of sense perception to each other, objects of thought to each other, and objects of sense perception to objects of thought. So far we have seen Sextus doing the first of these; the tenth trope does the second and hints at the third. It sets up direct 'noumenal' oppositions between the customs, laws, 'ways of life', myths, and dogmas of different peoples and cultures in order to show that 'ethics' too— living, acting, legalizing, punishing, believing, asserting, and so on—is never an absolute matter but always contingent upon circumstances. Here too, we are in a world of appearances, but of appearances of *value*, where the same action or belief appears good to some and bad to others. Some peoples make sacrifices, others do not; some believe in immortality of the soul and in divine providence, others do not; some tattoo their babies, others do not. This, then, is another main route to the desired suspension of judgement and, so, to moral *ataraxia*.

The tenth trope ends, however, by contrasting these noumenal matters not just with each other but with perceptions of the external world, including, of course,

those made by the eyes. It now appears that such perceptions differ from one another not just for reasons to do with physics and physiology, or even the emotional states of individuals, but because they are the product of 'ethical' choices acting, in the case of vision, through the perceptual processes that turn visual rays into value-judgements about the contents of the real world. Thus, we cannot say 'how any external object or state of affairs is in its nature, but only how it appears *in relation to a given way of life or law or custom, and so forth*. And so because of this mode, too, we must suspend judgement about the nature of the 'external "facts" '.[33] It might seem that the objects and states of affairs referred to here are meant to be things like the notion of a deity or of justice, for instance. And, indeed, they mostly are. But the tenth trope explicitly extends this point to matters of scientific knowledge—to statements of natural fact—by citing contrasting beliefs about the number of elements as an example of 'ethical' oppositions in the area of dogma. Although it is mainly a trope to do with ethical scepticism itself, it also concerns the way ethical conditions affect perceptions of the physical world.[34]

Here lay a potentially enormous field of cultural criticism of the sort that we like to think of as a modern—even a post-modern—invention. Sextus was not only saying that judgements of value were no more reliable as guides to ethical reality than perceptual statements were as guides to physical reality—both being equally conditioned by circumstances. He was saying in addition that judgements of value—amounting to what we would now call 'ideology'—helped to construct perceptual experiences and make them what they were. Such judgements differed from each other but also produced corresponding differences in the way physical reality was seen. Thus, the existence and attributes of visual objects in the external world were not just unknowable for perceptual reasons; they were unknowable for noumenal reasons too. It followed (although this is not spelt out in the text) that any claim to ground a belief—religious, political, scientific, or whatever—in an undisputed fact about visual reality had to face the charge of circularity—of constructing that reality in accordance with the belief in the first place. Any claim to state what *was* (or was *not*) an undisputed fact about visual reality invited the corresponding question 'in relation to what religious, political, scientific, or other belief is this claim being made?' When 'dogmatists' claimed to decide the visual facts, they were not just, themselves, party to the dispute and so ineligible to decide; their dogmatism was also implicated in what counted as a visual fact in the first place—and, as we have seen, in what counted as the normal circumstances for correctly perceiving it. Back and forth along the lines of sight that connected observers to observed operated the endless mediations of culture.

Between the 1570s, when Montaigne wrote his long essay 'An Apology for Raymond Sebond', and the 1630s, when Descartes composed the first of his *Meditations*, the ten tropes of the *Outlines of Pyrrhonism* entered the French philosophical mainstream. And for early modern sceptics the lack—or, indeed,

rejection—of a criterion was just as apparent in ethical and political matters as in epistemology, leading in these areas to the same relativism and suspension of dogmatic judgement. The adoption of the tropes was largely Montaigne's own contribution, emulated by a string of later admirers and imitators. Scepticism in all its forms was fundamental to the spirit of his *Essais*, above all their commitment to paradox and contradiction, their relativism, and their investment in the subjective.[35] But radical Pyrrhonism, in particular, marked the first edition of 1580 and Montaigne seems to have favoured it epistemologically on the usual grounds that the slightest inclining even to one probability rather than another tipped the scales of *epochē* decisively towards some recognition of truth. 'Either we can judge absolutely', he famously insisted, 'or we absolutely cannot.'[36] Even if the New Academy helped him to formulate both a general anti-dogmatism and some specific attacks on sense perception, especially in the later editions of 1588 and 1595, his overall position in the 'Apology' still seems closest to Sextus': 'That things do not lodge in us in their own form and essence, or make their entry into us by their own power and authority, we see clearly enough. Because, if that were so, we should receive them in the same way: . . . Thus external objects surrender to our mercy; they dwell in us as we please.'[37]

Towards the end of the text, having 'defended' Sebond on the grounds that all human reasoning, not just Sebond's own, was hopelessly flawed and inadequate, Montaigne made good this claim about 'external objects' by turning to 'the greatest foundation and proof of our ignorance'—the senses—and deploying a wide range of Pyrrhonian claims. Despite the supposed pre-eminence and certainty of the senses, it was impossible to know even if human beings possessed the right number of them since no absent sense could reveal its own absence or have it revealed by the others. We might be experiencing only an approximation of the real world, in which 'the greater part of the face of things is hidden from us', without any means of determining if this was so. Truth was credited to the concurrence of five senses, whereas eight or ten might be needed 'to perceive it certainly and in its essence'.[38] As for the senses we did possess, the 'schools' that questioned human knowledge—the sceptics—did so 'principally' because of the uncertainties that afflicted them. It was, indeed, 'desperate and unphilosophical' to suppose, with the Epicureans, that the senses could always be trusted and were not 'uncertain and deceivable in all circumstances', rendering us necessarily 'stupid'. According to Montaigne, the senses and the rational soul tried to outdo each other in mutual deception. The eyes 'mastered' reason by compelling it to accept impressions that it knew to be false, while they in return were stupefied by the effects of the passions.

Otherwise, following the tropes, Montaigne alluded to the various different physiological accidents of visual perception—relative to humans and animals, health and sickness, sanity and madness, youth and age, and so on—that precluded uniform judgements about the 'real essences' of things. One man sees (hears, tastes, etc.) the world differently from another, depending on conditions

that he cannot escape: 'We receive things in one way and another, according to what we are and what they seem to us.'[39] It can even be said that we *make* the objects we perceive, fashioning them out of the qualities that belong intrinsically to perception, not to themselves. And this is the normal state of affairs, not one pertaining only to supposedly abnormal states:

is it not likely that our normal state and our natural disposition can also assign to things an essence corresponding to our condition, and accommodate them to us, as our disordered states do? And that our health is as capable of giving them its own appearance as sickness? Why should the temperate man not have some vision of things related to himself, like the intemperate man, and likewise imprint his own character on them?[40]

Montaigne's conclusions all derived, accordingly, from the sceptical separation of the appearances of objects from the objects themselves. The 'Apology for Raymond Sebond' ends by stating that perceptual judgements were based on the first not the second, that such judgements had nothing to do with resemblance (there being no way of ascertaining this), and that no other criterion existed for choosing between them.

A succession of writers followed Montaigne in reproducing all or part of these arguments. They included Pierre Charron, Catholic priest and supporter of Henri IV, and author of one of the most influential and contentious books of the early seventeenth century, *De la sagesse* (1601); Jean-Pierre Camus, first a lawyer, then a clergyman, and from 1608 Bishop of Belley; Léonard Marandé, who served as private secretary on French ambassadorial staffs in England and Venice and as royal almoner, as well as becoming a priest and anti-Jansenist theologian; and François de La Mothe Le Vayer, writer for Richelieu, tutor to the Duc d'Anjou (brother of Louis XIII), and an intellectual in the circle of Gassendi, Mersenne, and Naudé. La Mothe Le Vayer, Charron, and Camus, for example, all puzzled over the paradox of a person never knowing, as Charron put it, 'the want of that sense which he hath never had' and thus remaining unknowingly ignorant of many of 'the works of Nature'. Charron also admitted, even though continuing confidently to use the notion of 'deceit' by the senses, that it was a self-contradictory one, 'considering that by them we begin to learne and to know', no other test of whether they deceive us or not being available.[41] Otherwise, all these sceptical authors elaborated on the 'tropical' features of sight that were crucial to classical Pyrrhonism and re-expounded by Montaigne—the inevitable contingency of visual perception relative to specific conditions, the way in which visual experience was constructed subjectively by each percipient, and the impossibility in these conditions of ever grasping some kind of objective visual reality or 'essence' in things. Marandé, for example, described how the mind made 'new knowledge' of the things perceived by the senses, divesting them of their own qualities 'at [their] entrance' and impressing them with other qualities 'as shee pleaseth'. He spoke at length of how 'true reality' would always elude the understanding, because whereas 'the [true] image ought still to be the resemblance of

the thing', the sense of sight (like all the others) introduced a gap between image and object that resemblance could never be brought in to close. Though every art and science was put at risk by this, sensory experience could not be reduced to anything else—it was without an 'arbitrator'. Images were simply 'estranged' from the objects they represented, and thinking about the latter was nothing more than grasping at shadows or trying to measure a straight line with a crooked ruler. To persist in claiming to know was 'to give more beliefe to dreames, then watchings, and more to prise and value apparance and shewe, yea of not being, then of the true being of the thing it selfe'. The senses, in short, cast 'great mists betweene the true and false, and betweene the object and the thought'.[42]

Naturally, such views were attacked by the philosophical realists of the age, men with an essentially Aristotelian understanding of visual perception and truth—like Pierre Chanet, Yves de Paris, Jean Bagot, Charles Sorel, and Jean de Silhon. Essentially, their response consisted in reaffirming the reliability of the senses in ordinary, everyday conditions. In the case of eyesight, it was said that provided the eyes were functioning in a healthy and normal state, that the visual object was physically perceivable, and that the intervening medium did not prevent this, then visual certainty could be achieved. Although errors and deceptions undoubtedly occurred, they could all be attributed to corresponding abnormalities in these three traditional aspects of the visual act and explained in terms of the laws of optics or the pathologies of the human body. As Antiochus had insisted, 'dreamers, lunatics and drunkards' were to be discounted, along with all the other optical illusions in the literature. The human understanding, with the aid of the 'common sense', had no real difficulty in adjusting to variations in visual perception and, in particular, sorting out visual aberrations from visual truths. It was possible after all, then, to distinguish between veridical and non-veridical appearances of objects in the real world and, in the case of the former, to determine the qualities of these objects as they actually were.[43] But if this was the counter-argument for orthodox epistemology, and Aristotelian visual theory in particular, it was also an attempt to rescue learning as a whole—the 'arts and sciences' so often said to be threatened by scepticism. More than that, it was declared to be a means to restore all the certainties of ethics, politics, and religion. Again and again, the ancient and modern sceptics were accused of overturning human values and menacing the faith. Sorel said that their indifference to truth 'tended to the undermining of the sciences, of politics, and of religion'. In the most intemperate attacks of all, like those made by the Jesuit François Garasse, scepticism was routinely condemned for irreligion, atheism, and libertinism.[44] In fact, early seventeenth-century French intellectual life came to be preoccupied with this question.

What is significant here is not just that early modern scepticism after Montaigne should have produced unorthodox ethical, political, and religious positions, for it could hardly have done otherwise. Rather, it is the manner in which a radically anti-realist view of *vision* in particular may have contributed to innovations in

these broader areas, and been affected by them in return. In the *Outlines of Pyrrhonism*, after all, visual relativism was the most powerful ingredient in an epistemology that led, ineluctably it was said, to the withholding of assent to *any* dogmatic belief and then to a way of life 'in accordance with appearances'—that is, in conformity with the customs, laws, and institutions that happened to define what amounted to piety and impiety in the conduct of life in any country at any time. Such ethical definitions were themselves very likely to rest on the dogmatic notion that good and bad were absolute terms, based in nature, and that conduct was thus an absolute, not a relative matter (just as they were very likely to rest epistemologically on the dogmatic notion that true and false were absolute terms in the realm of sense perception). But the whole point of scepticism was to avoid the pain and strife that this caused. By treating good and bad as, instead, culturally relative terms, the sceptic could continue to act in a world committed to absolute values while preserving his or her own *ataraxia*:

> Thus the S[c]eptic, seeing so much anomaly in the matters at hand, suspends judgment as to whether by nature something is good or bad or, generally, ought or ought not to be done, and he thereby avoids the Dogmatists' precipitancy, and he follows, without any belief, the ordinary course of life.[45]

But the 'ordinary course of life' was anything but ordinary, and to follow it 'without any belief' was to challenge orthodoxy in a fundamental way. From the perspective of the sixteenth and seventeenth centuries, one is struck, above all, by the inclusion among Sextus' examples dealing with controverted ethical dogmas of all aspects of organized religion—theology and cosmology, forms of sacrifice and worship, dietary laws, treatment of the dead, and so on.[46] But scepticism embraced every value and every institution that made up human society; nothing escaped its relativizing power.

To an extent, as we saw in connection with the tenth trope, this was the product of simply opposing ethical positions to each other—objects of thought to objects of thought (noumena to noumena). We do this, said Sextus, 'when, in reply to one who infers the existence of divine providence from the order of the heavenly bodies, we oppose the fact that often the good fare ill and the bad fare well, and deduce from this that divine providence does not exist'.[47] Indeed, the world was full of sharply contrasting views on every conceivable ethical topic and it was the task of scepticism to make this apparent. The tenth trope deals mostly with this kind of opposition, and book 3 of the *Outlines* adds many more examples. But Sextus also made explicit provision for oppositions between objects of thought and objects of sense (noumena to phenomena), 'as when Anaxagoras argued, in opposition to snow's being white, that snow is frozen water and water is dark in colour, and therefore snow is dark in colour'.[48] As we also saw, the tenth trope touches only briefly on this further kind of opposition but it does imply that ethics and vision not only interact but—in the world of contradictions and anomalies that is scepticism—can conflict. Ethical conditions, like physical conditions, affect the perception of objects of sense and vice versa; external objects appear

visibly the way they do 'in relation to a given way of life or law or custom' and this same way of life, law, or custom appears the way *it* does in relation to the visual phenomena that warrant or otherwise accompany it. But what happens when an object of vision fails, phenomenologically, to live up to ethical expectations or becomes sufficiently contested not to be able to perform its ethical function? Or when an ethical position itself becomes so unstable, through controversy, perhaps, or some other cause, that this endangers the credibility of the visual phenomena related to it? These are questions that this book has attempted continually to explore—appealing historically to cases from the visual culture of the age when Pyrrhonism was rediscovered to such effect. What, then, of the matching philosophical question of how scepticism about sense objects issues in scepticism about thought objects—beyond making a general contribution to the 'sceptical way'— and how similar influences work in the reverse direction as well? The problems attaching to true and false in the field of vision were clearly homologous to those attaching to good and bad in the field of ethics. Just as dogmatic philosophers, notably the Aristotelians, combined absolute visual certainty with absolute ethical values, so the sceptics offered the same combination of their relativist equivalents. Precisely how, then, did visual *aporia* lead on to the relativizing of ethical matters; and how did ethical *aporia* affect the things sceptical people saw? Such questions become especially worth asking of the period after the recovery of the Pyrrhonian texts, with Western Europe already entered on a period of fundamental ethical controversy, notably in the fields of politics and religion.

The answer that Richard Tuck has given for politics is largely a negative one. Both in the ancient world and in early modern Europe, he suggests, powerful versions of epistemological scepticism and ethical scepticism coexisted but *without* the first leading necessarily to the second. It was possible, that is, to be a relativist in morals without arguing for this on epistemological grounds. Indeed, in his view, Renaissance scepticism, like its Greek and Roman precursors, 'was not fundamentally an *epistemological* position, but rather a *psychological* one'.[49] A 'new humanism' emerged when, from the 1570s onwards, those involved in government and public affairs realized that rapidly changing conditions, notably the catastrophic civil wars in France and the Netherlands, raised questions about the preservation of individuals and states that the old humanism had never had to confront and so was unable to resolve. A social morality based on Cicero's *De officiis* and committed to the values of constitutionalism and the duty to put communal needs before private ones was inadequate in the new circumstances. What was required instead was a more unscrupulous, instrumentalist ethic—almost an anti-ethic, says Tuck— which permitted citizens and their princes to concentrate on their own interests, effectively self-preservation, at the expense of traditional norms. For the individual, this meant aiming at a form of psychological self-control in which the beliefs and passions likely to lead to conflict or other forms of harm were avoided. Political detachment was the best way to achieve this, especially in the face of intractable

public disputes. The analogue for rulers was the maintenance of their own power by arms and money and the disciplining of their unruly subjects according to the needs of public security and civil peace. Notoriously, religion, along with laws and constitutions, might be subordinated to the demands of political necessity—of 'reasons of state'. Such views were pioneered, above all, by Montaigne and Lipsius, but they also featured in the writings of men like Giovanni Botero, Pierre Charron, Paolo Sarpi, and Francis Bacon. Tacitus and Seneca (not Cicero) were their preferred Roman ideologues and Stoicism, in particular, was vital to the elaboration of the doctrine of the control of the passions. The scepticism of Pyrrho and Sextus Empiricus was also fundamental, with its endless relativism concerning the moral beliefs and practices of different cultures and its promise of the protective wisdom and peace of mind (*ataraxia*) that went with intellectual and psychological disengagement. Sextus was highly effective, for example, in describing the tribulations of the dogmatist: 'the person who believes that something is by nature good or bad is constantly upset', he wrote memorably.[50] Nevertheless, the scepticism that mattered here, in Tuck's view, was that of the tenth trope, not that of the other nine—it was about conduct, not perception.

Perhaps it is difficult—before Hobbes, at least—to see how a sceptical epistemology could have contributed directly to this innovatory political style—how uncertainties about visual experiences specifically associated with moral and political conduct could have undermined the values of the old humanism, along with those of traditional ethics and politics in general, and helped to establish a different set. Even so, it is worth remembering that Montaigne, Lipsius, and Charron were not just disenchanted with Cicero; they were virulently opposed to Aristotle too, an Aristotle partly appropriated, as Tuck himself shows, by fifteenth-century Italian humanists. And, while rejecting the substantive doctrines of Aristotle's ethical and political science, they also rejected the *idea* of science itself. It was impossible, they argued, to construct bodies of knowledge based on necessary principles and procedures and grasped in terms of canons of human rationality. This anti-philosophical, anti-rationalist view had always been part of scepticism; 'it was against sciences of the Aristotelian kind that the sceptic had always directed his most strenuous arguments.'[51] But sciences of this kind, both physical and human, rested on more than the rules of logic and a faith in reason. They rested too on a dogmatic epistemology—and, in particular, on a dogmatic theory of vision based on the doctrine of *species*. They were committed, that is, to an account of how, in the right conditions, human vision yielded certain information about the world. In adopting an anti-Aristotelian philosophy of knowledge, the sixteenth- and seventeenth-century sceptics, in principle at least, made a non-dogmatic theory of vision part of their ethical and political campaigns.

We can begin to see what this may have meant if we concentrate instead on religious matters, where, as we saw in earlier chapters, visual experience was undoubtedly supposed to be central to orthodox beliefs and practices on Aristotelian grounds. Religion can hardly be said to stand apart from debates about ethical and political

behaviour, although the new humanists sometimes talked as if it might. The values of traditional Christianity often seem remote from their readings of the favoured Roman authors, their emphasis on self-interested prudence, their political realism, and their analysis of contemporary conflicts—which were, ostensibly at least, religious wars. The concept of 'reason of state' could be put to work in the interests of the great Catholic powers—the Habsburgs, France, even the papacy—but religion still invariably became an item of public policy, and not necessarily its spiritual rationale. Lipsius spent time at both Catholic and Protestant intellectual centres, was a member of the Family of Love, and in his *Politicorum libri sex* argued that religious uniformity might be adopted or not according to circumstances; Charron, though a priest, sometimes talked as if religion was a matter of self-interest, chosen from a repertoire of feelings and followed for reasons to do with the control of emotion and the securing of psychological advantages; he and Sarpi both considered the possibility of moral atheism, that is, the idea that religion was a means of social control achieved through its stress on supernatural rewards and punishments, and might therefore be replaced by some other set of opinions with the same function; and Bacon thought that atheism had moral and political advantages over superstition.[52]

'Superstition' may in fact hold the key to the relationship between scepticism and the debates about the visual components of early modern religion, if not among all the European intellectuals discussed by Richard Tuck then certainly among the French philosophers and theologians who found Pyrrhonism so appealing. None of them was a 'free-thinker' or 'atheist', although often accused of being so. All insisted on their own religious commitments and employed Pyrrhonist arguments to strengthen the 'fideistic' argument that religious belief was beyond demonstration either by the senses or by reason. This enabled the French sceptics, in particular, to maintain their Catholicism, despite accusations of atheism, while rejecting what to them were its dogmatic and superstitious elements. Among these were the pre-eminently visual experiences associated with (some) miracles, apparitions, spirit possession, and witchcraft that in orthodox terms acted as 'proofs' of religious truths, but which, to the fideists, were themselves visually uncertain, as well as morally dubious. There was thus a strong link between Pyrrhonian scepticism and the new humanism, on the one hand, and an indifference to, or a reductionist treatment of, the visual manifestations of the miraculous and the supernatural on the other.

This was founded on a distinction between the public character of organized religion and the private world of faith. Publicly, religion had to figure among the calculations that determined the policies of statesmen, and in this context it might indeed be subordinated to 'reasons of state'. Most cynically of all, it became merely an instrument in the preservation of social order. Here, superstition was actually an asset to rulers because it made for more abject religious observance. Charron, who saw it as the main obstacle to the piety of the wise man, condemned the superstitious person in *De la sagesse* as someone terrified and disturbed by a God apprehended as 'anxious, spitefull, hardly contented, easily moved, with

difficulty appeased, examining our actions after the humane fashion of a severe Judge, that watcheth our steps'.[53] It was not surprising that the politicians knew how to take advantage of such weakness and insecurity. Recognizing in superstition 'a very fit instrument to leade a people withall', they encouraged it where it existed and invented new forms of it where it did not. But this view did not prevent Charron, along with Montaigne and Lipsius, arguing for both their own personal religious views and the importance of others; indeed, it helped them to disengage from the harmful effects of religion while recommending outward conformity to its public forms.

What caused the superstitious to think as they did, besides ignorance, was related, again, to the difference between religion as 'externall and corporall service' and as the internal and private conduct of the soul. With a good deal of pointed anthropological 'detachment', that nevertheless enabled him, like Sextus, to ridicule the vast array of fantastical deities and absurd devotions, Charron surveyed the common features of the world's religions. The chief feature was that they were all very strange—repugnant, indeed, to common sense—and thus impossible to grasp by 'naturall and humane meanes'. This was as true of Catholicism, the religion that Charron wished to recommend to the wise man, as of any other. Only 'extraordinarie and heavenlie revelation' direct from God, matched by their own spiritual contemplations, could lead men and women to true Catholic piety; outward human observances got in the way, even though moderate use of ceremonies might underline a faith already achieved. Above all, Charron insisted that God could not be known; it was the task of Pyrrhonism to make the pious aware of their fundamental limitations in this respect and prepare them for divine inspiration instead—for a religion like that of the angels, he said. Superstition arose, conversely, whenever the only kind of knowledge available to fallible human beings—stemming from their own 'carnall, earthly, and corruptible' imaginations—was applied, crudely and anthropomorphically, to the deity.

There can be no doubt that Charron thought of superstition in visual terms. An 'idea' of God might be had, but certainly not an image. Yet, like all its predecessors, Catholicism had become a religion of visible effects. It rested on outward signs that enslaved the believer to phenomena, to objects of sense, in a superstitious way. In stark contrast to his own views, there were those:

who will have a visible Deitie, capable by the senses, which base and grosse error hath mocked almost all the world, even Israel in the desert, in framing to themselves a molten calfe. And of these they that have chosen the sunne for their god, seeme to have more reason than the rest, because of the greatnes, beautie, and resplendent and unknowne vertue thereof. The eye seeth nothing that is like unto it, or that approcheth neere unto it in the whole universe, it is one sunne, and without companion.

Christianity had tried to adopt a middle course, mixing 'the sensible and outward with the insensible and inward', but there were still far too many people—children, women, old men, the sick, 'and such as have been assaulted with some

violent accident'—who participated in 'outward and vulgar deformities'. All religions, said Charron, extending his argument to visual deception, had gained credit by promoting sometimes false phenomena, 'revelations, apparitions, prophets, miracles, prodigies, holie mysteries, Saints'. What the superstitious man did was to continue the practice: 'he faineth to himselfe miracles, [and] easily beleeveth and receiveth such as are counterfetted by others.'

Religion, at least in its degenerate form, was therefore doubly implicated in the visual Pyrrhonism of the sceptical tropes—the tropes that Charron had already acknowledged in the early chapters of book 1 of *De la sagesse*. Attempts to *see* God, to make him an object of sense, reduced the idea of the deity to utter fallibility; something beyond description or imagination or even belief became something 'full of deceit and weaknesse'. Charron proposed that the man of wisdom should take an altogether different route to piety. But more than this, the religions of the world, aided and abetted by the politicians, had promoted many visual experiences that were pure fictions. They had manufactured objects of sense according to ideological demand. Given that there were many different religions, a situation had arisen, full of potential for superstition, in which no one could be sure of the reality of many religious phenomena—including even miracles. 'How many fables, false and supposed miracles, visions, revelations, are there received in the world that never were?', demanded Charron elsewhere in the book.[54] And yet certainty about such things was deemed a matter of religious truth and error, a matter, indeed, of life and death. It had to be decided, absolutely and (again) publicly, whether such phenomena were true or false, visually speaking, for organized religion to succeed in retaining its believers and imposing itself on others.

In these circumstances, Pyrrhonism was attractive for reasons that were not just to do with psychology. It listed the infinite variations between the contents of the world's religions and described the blissful state of not having to pay attention to any of them except as a matter of mere conformity—'without any belief'. Everything about religion and the gods, Sextus had said, was 'conventional and relative', including whether there were any gods at all and certainly what they looked like. Things were either holy or unholy, allowed or prohibited, according to custom; if they arose naturally we would all agree about them. But Pyrrhonism also had a vital epistemological bearing on what people like Montaigne and Charron were saying. It provided the indispensable foundation for fideism by removing any confidence in the ability of reason or the senses to underpin true piety, leaving fully intact the idea of a faith lying beyond such weak supports—*beyond* belief—and 'emptying' the sceptical person so that he or she was ready to receive it. And in the matter of vision, specifically, it destroyed the idea that the truth or falsity of religious phenomena could be decided with certainty—superstitious certainty, Charron would have said. It destroyed, as it were, any trust in those aspects of Catholicism that had to be seen to be believed. Of course, scepticism had this effect on *all* religious phenomena, whether they were thought to be deceptions or not. The tropes, we recall, relativized visual perception to the

healthy as well as the sick, to normal as well as abnormal states. All religions, true or false, and all religious doctrines and practices, sincere or feigned, filtered external objects and states of affairs in a manner that was relative to them. It was just that there were now many different religions each claiming a monopoly on visual certainty. Inter-confessional accusations of visual error and deceit—as we saw in Chapter 5—had become commonplace. The members of one religion saw things that the members of others did not; objects of sense that were real to some were unreal to others. Finally, there were the sceptical philosophers like Montaigne and Charron—as well as more suspect 'libertines' like Machiavelli, Vanini, and others—who felt that visual tricks were a part of every religion's repertoire. In the language of Sextus, then, phenomena and noumena were everywhere in outright opposition; the visual world of sixteenth- and seventeenth-century religion was full of what he called 'anomalies'. 'Ethical' instability had spawned perceptual instability, and vice versa. Charron's examples are, in fact, particularly telling, in historical terms; visions, apparitions, prodigies, and, above all, miracles, were among the most contentious and divisive phenomena of the age, the things that set religions apart from each other. We would probably want to add other items; witchcraft, demonic possession, and the like.[55] The situation described in the tenth trope had come about in early modern Europe.

The fideism of Montaigne and his followers and its general relationship to their philosophical scepticism have long been recognized. The part played by visual relativism in their thought and in their attitudes to things like miracles and witchcraft is less well known, but serves, again, as a philosophical commentary on the matters we are examining in this book. At the end of the 'Apology for Raymond Sebond' Montaigne first summarized the Pyrrhonian tropes and then drew the fideist conclusion that human access to God was an impossibility. 'Man' can rise to God only if God lends him a helping hand: 'he will rise by abandoning and renouncing his own means, and letting himself be raised and uplifted by purely celestial means.'[56] A lengthy attack on rational theology could only close in this manner. If all human knowledge 'made its way' via the senses, then rational theology was, initially but unavoidably, a theology of the senses; it derived from perceptions of the sensible world. In consequence, it was vulnerable in a radical way to the tropes.[57] This was not just a matter of religion being 'repugnant to sense', as Charron was to say, but of its inadequacy when thought of 'sensibly'. How could the truth and certainty of *religion* rest on anything as subjective or as fleeting as appearances? Montaigne used the tropes to make a fundamental distinction between the religion of faith and the religion of rational belief—the one, divine, absolutely certain, universal, and unchanging, the other, merely human, relative, and in a state of permanent flux. Pyrrhonism was, in effect, a way of making the concept of the criterion irrelevant to true religious experience—something that it necessarily transcended and had no need to confront. Faith, by definition, operated without one, and the truly religious person, as a sceptic,

behaved according to the customs of his or her community without according them any assent. Strictly speaking, as with Charron, this left no room for deciding the certainty of those religious phenomena that most of Montaigne's contemporaries deemed to be crucial to religion but which they also argued over endlessly. This is one reason why his Catholicism, and perhaps his Christianity, seem simultaneously both genuinely sincere and radically unorthodox. In Pyrrhonist fashion, he himself could only write about how religion appeared ('selon moi'), exempting what it *was* from enquiry or discourse. This meant deploying the relativism and irony of the tropes to all their veiled but deconstructive effect and then leaving things in a state of *aporiai*, all the while enjoining complete submission to ecclesiastical authority. Religion comes to be something that, in its public form, appears customary and contingent, uncertain and aporetic. It nevertheless requires our outward conformity for the sake of the public peace and our own tranquillity. Privately, we respond to altogether different imperatives.[58]

What faith could not do was rest on decisions about whether religious phenomena were visually real or not; no ultimate decision on the matter was possible and faith lay beyond such contingencies in any case—it was, so to speak, non-sensory as well as non-rational. This left questions about specific phenomena free for analysis in terms of the visual anomalies of the tropes. In 'Of the power of the imagination', for example, Montaigne explored the idea that the human imagination was capable of producing apparently real, correctly observable physical effects, usually as a consequence (as it happens) of striking visual perceptions. One of his examples, much discussed by his contemporaries too, was of pregnant women whose visual impressions were imprinted on the bodies of their unborn children for everyone to see. But the imagination could also account for the visual construction of contentious religious phenomena, in a way that made their reality wholly uncertain. Switching suddenly from the real to the unreal, he wrote:

It is probable that the principal credit of miracles, visions, enchantments, and such extraordinary occurrences comes from the power of imagination, acting principally upon the minds of the common people, which are softer. Their belief has been so strongly seized that they think they see what they do not see.[59]

As always, it remains unclear whether Montaigne was regretting a situation that he thought required redress or attempting to demolish a central ingredient of contemporary Catholicism for good. His remarks, like similar ones by Charron, had a habit of working in the 'wrong' direction, as when implied comparisons of Christianity and Catholicism with 'false' or 'pagan' religions hinted unflatteringly, even mockingly, at the latter's advantages or at absurdities and follies common to them all. Even in this instance, the very abruptness of the remark and the transition it forces on us cast doubt on the examples of supposedly real transitive effects immediately preceding it, including cases of priests in genuine trance states, 'without breath and without sensation', but also no less than the stigmata of St Francis (examples which, *in any case*, represent a diminution of the miraculous in the

sense that Montaigne is explaining them away in terms of a natural cause—that is, the imagination working naturally on bodies to produced levitation and stigmata). What is striking for the moment, however, is the suggestion that the belief that something is real can alone be strong enough to induce the believer to see it. This is not a theological argument about miracles but, again, an epistemological and psychological one, drawn from the study of human nature and the tropes of Sextus Empiricus, where Montaigne felt much more at home. The fourth trope spoke of hating and loving as 'circumstances' conditioning perception. What Montaigne seems to be doing with this idea, in the view of Claude-Gilbert Dubois, is turning the natural wish to understand into a malign force. Unaware of its own limitations it degenerates into a desire powerful enough to give visibility to anything it wishes to believe is real– even a dream or a phantom. What is real here, in fact, is not the thing itself but the longing to know it, transferred from subject to object. When this transference takes place unconsciously we can speak of illusion, when it takes place consciously of fraud. Either way, the reality of all religious phenomena, extraordinary or otherwise, is thrown into doubt.[60]

Montaigne's remarks about miracles pushed, typically, in two directions at once. Yet according to another Montaigne scholar, Gérard Ferreyrolles, they were less contradictory remarks than remarks about a contradiction. The dilemma lay in wishing to accept the reality of some miracles without transforming them in the process and challenge the rest without being rationalistic.[61] Montaigne said that we should take some on faith and others on credit and authority (whereupon a criterion does creep back in, in the impeccable form of St Augustine, whose testimony 'that he saw' miracles Montaigne accepts unreservedly).[62] Scepticism taught that incomprehensibility did not mean non-existence any more than existence; that something was contrary to reason and the senses did not mean necessarily that it did not happen. Miracles were no more improbable than our own being, which we were in no position to affirm or deny, only acquiesce in. To explain them as products of the imagination was to risk reducing something divine to the level of human inventiveness. In the end, then, credulity was probably a better reflection of human ignorance than incredulity. In the essay 'It is folly to measure the true and false by our own capacity', Montaigne wrote that he had once condemned all reports of 'returning spirits, prognostications of future events, enchantments, sorcery' as false.[63] Experience had not suggested otherwise, but reason had since taught him

> that to condemn a thing thus, dogmatically, as false and impossible, is to assume the advantage of knowing the bounds and limits of God's will and of the power of our mother Nature; and that there is no more notable folly in the world than to reduce these things to the measure of our capacity and competence. If we call prodigies or miracles whatever our reason cannot reach, how many of these appear continually to our eyes![64]

To say something was impossible, Montaigne added later in the essay, was a claim to know the limits of possibility, the 'limits of truth and falsehood'. It was better to

leave the matter in suspense, 'unresolved and undecided', neither believing rashly nor disbelieving easily.

His very next remark, on the other hand, although presented as an elaboration of what he has just said, immediately undercuts the belief in miracles. The last sentence in the quotation above suggests that what makes everyday things miraculous, if only we could grasp this, is that our reason cannot 'reach' them either. But the next sentence shifts attention to their familiarity, not their resistance to rational explanation. If disbelievers in miracles confuse the impossible with the unusual, in the sense of failing to see the miraculous in many of the things around them, then it is clearly only familiarity that takes away their strangeness; 'presented to us for the first time, we should find them as incredible as any others, or more so.' This point is precisely the argument of the ninth trope. External objects appear 'marvelous' or otherwise according to the frequency or infrequency of their occurrence. Comets are seen as divine portents because they are rare; the sun, far more astonishing, is never seen in such terms.[65] But what kind of an argument is this? Switched like a gestalt, it works in a quite opposite way, to the disparagement of the miracle. If people see comets as divine portents *only* because they are unusual, then they are clearly not divine portents. Once again, a meaning is being given to an 'external object' not because it is intrinsic to it but because that is the way it is seen by the viewing subject.

Still, we are not confronted here by the reality or unreality of a phenomenon, only by differences in interpreting its significance. But intimated, too, in the reference to the limits of the power of 'our mother Nature' was another strategy destructive to miracles—or rather, one that helped further to corral the genuine among them. It was not in any way restricted to sceptics like Montaigne and Charron, or to philosophical scepticism itself, although it was covered by the rubrics of the tenth trope. This was the claim that what seemed supernatural to the feeble intellects and fallible senses of human beings was not actually beyond or above nature at all, but part of it. It was linked to the negative side of the argument about familiarity, since it was a further way to explain the miraculous as the unexpected and to elevate nature, including human nature, to the status of a perpetual wonder. But it was concerned more with ignorance, whether as something wilful or unavoidable in the face of the world's sheer complexity.

Above all, miracles became precarious as real things in Montaigne's essays (Ferreyrolles shows) because, insofar as they were physical events with observable features, they were bound to fall under the epistemology of the tropes. Mainly, they ran up against the impossibility of ever going beyond the subjective and perpetually changing visual experiences of different observers, some of whom on some occasions would, inevitably, think particular miracles to be false. If even commonplace visual experiences were relative and inconstant in this way, then certainly none of the extraordinary ones could be guaranteed. Nothing, therefore, could be miraculous to everyone all the time. And in this case, as in all others, no judge existed capable of arbitrating between the different perceptions. It was no wonder that people

believed in miracles, for it was belief that created them—and it was no 'miracle', indeed, that quite ordinary perceptions might turn out to be contentious in the manner Sextus had indicated in the celebrated example of the colour of snow:

> We receive things in one way and another, according to what we are and what they seem to us. Now since our seeming is so uncertain and controversial, it is no longer a miracle if we are told that we can admit that snow appears white to us, but that we cannot be responsible for proving that it is so of its essence and in truth; and, with this starting point shaken, all the knowledge in the world necessarily goes by the board.[66]

Montaigne's reluctance to accept the reality of modern miracles—or marvels, at least—appears most clearly in the famous essay 'Of cripples', written in 1585 and directed mostly at the belief in witchcraft.[67] This essay mixes academic and Pyrrhonist doubt with an incisive analysis of the psychological mechanics of supposedly infallible belief and dogmatic persuasion working together on behalf of the supernatural. It has been said to rest on the opposition between fiction and reality—'la dissociation nette entre ce qui est fabrication, convention, illusion, artifice, et ce qui est vérité tangible'[68]—and scepticism about vision is certainly prominent. Montaigne prepares the ground by an attack on human reason that contrasts what it does with subjects like witchcraft with what it ought to do. He clearly had the kind of rationality embodied in contemporary demonology in mind. What reason does is ask how such a thing happens; what it should do is question whether it happens at all. Reason invents an 'other world' that is rationally coherent, complete with reasons and causes, but without foundation or substance. This warrants statements of fact that command assent, supported by visual testimony. Few people fail, Montaigne says, 'especially in things of which it is hard to persuade others, to affirm that they have seen the thing or to cite witnesses whose authority stops us from contradicting'. The result is that 'we know the foundations and causes of a thousand things that never were'. In a passage from the *Academica* added after 1588, he cites Cicero's statement of the 'academic' principle that true and false sense impressions are indistinguishable from each other, adding his own version: 'Truth and falsehood are alike in face, similar in bearing, taste, and movement; we look upon them with the same eye.' The result is deception and vanity. Miracles and 'strange events' are an example of this, because their dissemination and reception give them, in a visual metaphor derived from the fifth trope, an impression of solidity when viewed from afar that dissolves on closer inspection: 'Thus our sight often represents strange images at a distance, which vanish as they approach.'[69] As an antidote, Montaigne proposes that 'we should suspend our judgment, just as much in the direction of rejecting as of accepting'. Our motto should derive from the legal style in ancient Rome where 'even what a witness deposed to having seen with his own eyes ... was drawn up in this form of speech: "It seems to me."'[70]

Armed with these cautions, the sceptical person wants to ask of a subject like witchcraft: 'But does it happen?' Instead, witches are in danger of their lives every

time some author 'attests to the reality of their visions'. Montaigne clearly thought that witchcraft was imaginary or derived from dreams, that its narratives were 'astonishing', and that the confessions of witches, since they had no supernatural approbation, were quite unreliable. The visual testimony of witnesses, when not actually mendacious, stemmed from deranged minds: 'How much more natural that our understanding should be carried away from its base by the volatility of our untracked minds than that one of us, in flesh and bone, should be wafted up a chimney on a broomstick by a strange spirit!' Marvels were either not supernatural at all, but natural, or they were illusions, of which men and women were well capable. Montaigne offered his own visual testimony of imprisoned witches whom he had examined, as the basis for his suggestion that they were mad. But 'experience and fact' were things with 'no end to take hold of'—they were, in the language of the tropes, without a criterion and so subject to infinite circularity. He could only offer this testimony in a sceptical spirit as an opinion based on appearances and on his 'musings' upon them. Pledged, again like the true Pyrrhonian sceptic, to conform to the conventions of his society, he did not think they should prejudice even 'the pettiest law, or opinion, or custom' in a village. 'I guarantee no certainty', he concluded, 'except that it is what I had at the time in my mind.'[71]

Montaigne's application of Pyrrhonism to a subject like witchcraft—and to the miraculous in general—underlines the manner in which this particular philosophy of the senses found so much to capitalize on in sixteenth-century conditions. Up to a point, any philosophical tradition creates its own momentum, sustained by the internal dynamics of ideas and arguments. But it obviously also responds to historical cases, just as they gain more meaning in the light of analysis in its terms. Richard Popkin's achievement was to relate the new scepticism to the grandest polemical disputes of the Reformation, of humanism, and of the 'new' science; Richard Tuck's to draw out its implications for late Renaissance political philosophy; and Terence Cave's to detect the signs of an epistemological uncertainty already at work in sixteenth-century literary texts, where it created rhetorically detectable 'faultlines' and 'perturbations' that half-consciously prefigured the onset of full-scale, programmatic doubt. But we should also recognize the fruitful breeding grounds for Pyrrhonism in the contexts we have been discussing in this book—in the hallucinations of the melancholic, in the illusions of magicians, artists, and demons, and in lying images, false miracles, and empty visions. Significantly, Cave does indeed recruit the texts of demonology, notably Bodin's *Démonomanie* and the comments on witchcraft by Cardano, Weyer, Le Loyer, and Montaigne, to show just how disconcerting the subject could be in an epistemological sense—revealing, as he says 'les paramètres d'une épistèmè visiblement perturbée'.[72] He even singles out the 'prestiges' of the devil and the repeated invocation of illusion, confirming the havoc these caused with the organizing categories of contemporary ontology and epistemology, and underlining the sense of uncertainty and paradox that ensued.[73]

As was suggested earlier, Pyrrhonism offered a sophisticated conceptual account of what was implied in precisely those visual dilemmas and paradoxes that marked sixteenth-century experience; this was its relevance in the historical conditions of the age. Significant, too, is the way the opponents of Pyrrhonism can be found defending the same visually controverted phenomena, rescuing not just the senses themselves but the objects of sense required by—in the case of French orthodoxy—the Catholic Church. The context for Jean de Silhon's defence of the idea that angels, though incorporeal, could act in the corporeal, empirically verifiable world was witchcraft and Montaigne's suggestion that witchcraft was illusionary; one of the contexts for his defence of the soul's immortality was 'the experience of the senses' offered by miracles and Montaigne's rejection of the senses in favour of revelation.[74] Similarly, the moment when Charles Sorel chose to intrude his views about demonology, witchcraft, and the reality of the sabbat into his *La Science universelle* coincided exactly with his most direct refutation of Pyrrhonism.[75] Among the other anti-Pyrrhonists and Aristotelian defenders of the senses, conventional angelography, demonology, and the reality of witchcraft and possession were acknowledged by Yves de Paris, François Garasse, and Jean Boucher.[76]

Certainly, Montaigne was not alone in reading witchcraft as a subject ripe for 'tropical' analysis. Other professional sceptics were attracted to demonology's casting of so much doubt on the correct functioning of the human mental faculties and senses. One of Spain's most prominent students of Sextus Empiricus, and a commentator on Cicero's account of philosophical scepticism in the *Academica*, was the humanist Pedro de Valencia, who submitted a report on witchcraft similar to Alonso de Salazar's to the Spanish Inquisitor General in April 1611. Asked for his views on the reality of the crime, De Valencia singled out demonic impersonation as the crux of the issue, noting that the counterfeiting of real witches in their beds or of innocent ones at the sabbat made the phenomenon impossible to verify.[77] Montaignian scepticism and hostility to witchcraft belief came together in two of France's seventeenth-century *libertins érudits*, Guy Patin and Cyrano de Bergerac, and the country's most eminent sceptical philosopher after Descartes, Nicolas Malebranche, included a chapter on sorcerers and werewolves in his Cartesian treatise of 1674–5, *De la recherche de la vérité*, calling fear of ghosts, charms, lycanthropes, werewolves, and everything else thought 'to depend upon the power of the devil', 'the most extreme effect of the force of the imagination'.[78] Conversely, witchcraft writers themselves became aware of the adverse comment their subject was arousing among such philosophers. By 1580 Jean Bodin was already considering (and rejecting) the possibility that Pyrrhonism might offer a theory of knowledge capable of making sense of witchcraft, and by 1599 Del Río could refer almost casually to disbelievers in witchcraft's reality as 'Pyrrhonii'.[79]

Gabriel Naudé was not perhaps as straightforward a Pyrrhonist as Montaigne but he certainly a great admirer of the essayist and of Charron. He

recommended the *Outlines of Pyrrhonism* to librarians, and he had a major reputation, as did many of the sceptics, of being a *libertin*. His view of witchcraft was one of extreme scepticism and he accused many of its creators, including Bodin, De Lancre, Le Loyer, Del Río and Godelmann, of holding false opinions and peddling suspect stories.[80] He was also highly critical of episodes of witchcraft prosecution, like those in Artois in the late fifteenth century and Labourd in the early seventeenth. The demoniacs of Loudun interested him especially and were explained by him in medical terms as melancholics. It was madness, illness, force, or fraud that, in his view, accounted for most of the symptoms of possession and bewitchment, and dreaming and the imagination for the visual experiences that seemed to warrant belief in the witches' sabbat. All this was entirely congruent with Naudé's political views, in which—like many of the 'new humanists' discussed by Tuck—he saw ordinary citizens as gullible and easily duped by clever politicians and beliefs in supernatural realities as the occasion for feats of state-building. In the *Considérations politiques sur les coups d'état*, in particular, he referred to magicians and demons as things useful ('expédient') to the Catholic religion in its battle against atheism, a statement capable of orthodox interpretation but clearly in line with his general principle that religions and states alike benefited from fictional supernaturalisms. The sabbat of the witches, for example, was only another example of the credulity and 'imbecility' of the people, on which Machiavelli had taught the modern age to build equivalents of the *coups d'état* that had always defined the tradition of 'secrets of state'.[81]

The same general point about scepticism's philosophical relevance might be made in connection with the other varieties of visual dislocation that occurred in early modern Europe. As we have seen, the philosophical implications of such things as madness, optical illusion, and visual artifice were already being examined by the earliest Greek sceptics. Even so, the scale on which these matters were available for discussion by their early modern descendants or by those others familiar with scepticism must have been quite different. And the extent to which the disputed visual experiences integral to religious practice—especially miracles—were available for philosophical dissection by intellectuals like Montaigne and Charron was altogether unprecedented. Le Loyer makes this point for us by including in the first book of his treatise on apparitions the chapter dealing with 'the opinions of the followers of Pirrhon, [the] Sceptiques, and Aporretiques, and what they alleadge to shew, that the humane senses and the imaginative power of man are false'. Cave argues that this chapter sets the tone for the whole of book 1, and judges the treatise itself a key text in the late sixteenth century's 'angoisse accrue en ce qui concerne les phénomènes paranormaux', examining as it does 'toutes les possibilités d'erreur dans la perception de ces phénomènes'. 'L'incertitude exacerbée', he writes, 'que Le Loyer s'efforce de cerner et de maîtriser est donc bien un phénomène d'époque.'[82] In Jean-Pierre Camus's 'Essay sceptique' there is an account of the relativities of seeing that instances the phenomenon of refraction, the meteorology of apparitions, the dioptrics of

mirrors, the effects of magic or enchantment 'that make things appear to our eyes that do not exist . . . or as otherwise than they are', and the 'illusions, phantoms, and chimeras that appear to the eyes of women, children, and the vulgar poor'. Camus singles out what he calls the 'inventions' with which painters 'abuse the feebleness and incertitude of our sight [by] making the same figure appear to us in different ways and postures, depending on our position'. He refers also to:

> the deception in those landscapes that appear to our eyes to have depth (*qui paroissent enfoncez à nos yeux*), the marks and dots that we take to be birds, horses, [and] houses, . . . the shadings and foreshortenings by which all the trickery is achieved, [which] in a word, is to make appear to our eyes that which is not.

It is surely difficult to see this as merely a recital of the ancient tropes, adopted without any amplification from the discussions of these same matters in Camus's own culture.[83]

In many ways, it is Descartes, above all, who pulls together under the Pyrrhonist rubric the themes discussed in this book, a point reinforced in both the next chapter and then the final one. He most certainly brought together philosophical scepticism and demonology, by supposing, in the notorious 'demon hypothesis' of the first of the *Meditations on First Philosophy*, that an 'evil genius' ('genium aliquem malignum') might be blamed for turning every experience into an illusion. This too was not, in essence, a new idea; the implications of an all-embracing delusion by deity or demon had long been debated, returning us again to the arguments in Cicero's *Academica* (and pointing forward to modern philosophy's interest in the 'brains in a vat' problem).[84] But those among Descartes's near contemporaries who were doubtful of witchcraft's reality as a crime—as well as intellectuals interested in 'demonic epistemology' in general— had taken at least the principle of total mental and sensory delusion to new levels.[85] The consequence was that even if Descartes himself thought the idea 'metaphysical' and 'hyperbolic', he succeeded in giving it a greater philosophical force and a more influential outcome than it had ever had before: possession, as Michael Cole has written, had become 'an art of absolute fiction'.[86] Moreover, Descartes arrived at it—as we noted briefly in Chapter 2—after having discarded the bizarre hallucinations of the melancholic as a potentially serious competitor for philosophical attention. Simultaneously, he made optical illusion and its remedies a specific focus of his epistemology, suggesting to many recent commentators both a link between Cartesian scepticism and the wider visual culture of the prestige and a reading of his *Optics*, published in 1637, as an attempted solution to the twin problems of veridicality and paradoxicality in early modern vision.[87]

Before we reach that text, however, there is a last case study to be made of visual experiences that proved to be conceptually troublesome in early modern Europe and it concerns the other main contender for the sceptic's attention in the first of

the *Meditations*: dreaming. As old as scepticism itself, the idea that the experiences of the dreamer could be as clear and compelling as those of waking life was yet another paradox that took on new vitality and significance in the conditions of the fifteenth to seventeenth centuries, with the consequence that sleep became more of an epistemological issue than it had ever been before. The principal reason for this lay, again, in the demonology that informed so much of the intellectual culture of the time. A consideration of demonic dreams, in particular, will therefore enable us to complete the demonology of the senses we broached in Chapter 4 and serve as a bridge between the Pyrrhonism of Sextus *redivivus* (and of his disciples Montaigne and Charron) and the post-sceptical cognition theories with which this book closes.

NOTES

1. François de La Mothe Le Vayer, 'Opuscule ou petit traitté sceptique sur cette commune façon de parler, n'avoir pas le sens commun', in id., *Œuvres* (15 vols.; Paris, 1669), ix. 227 ff.
2. Ibid., sig. Tiiiv, cf. 292: 'je soûtiens que le paradoxe n'a rien en soi de mauvais.'
3. Cave, *Pré-histoires*, 31–2; Emmanuel Naya, 'Traduire les *Hypotyposes pyrrhoniennes*: Henri Estienne entre la fièvre quarte et la folie chrétienne', in *Le Scepticisme au XVIe et au XVIIe siècle: le retour des philosophies antiques à l'Âge classique*, vol ii, ed. Pierre-François Moreau (Paris, 2001), 48–101. Cave comments (32): 'Il y a donc complicité entre la fièvre et le pyrrhonisme, puisque l'ouvrage de Sextus est le seul livre qu'il trouve supportable malgré sa maladie; mais cette complicité finit par guérir la fièvre, qui, sur le plan de l'allégorie qu'Estienne développe ici, doit représenter un désir de connaissance excessif et obsessionel. Le pyrrhonisme, philosophie fiévreuse et hallucinante, prolonge ce désir, le réduit à l'absurde, et—tel un médicament homéopathique—lui enlève ce qu'il a de nocif.'
4. Cave, *Pré-histoires*, 73.
5. I have used the edn. and trans. by Mates in id., *Skeptic Way*.
6. These are the themes of Charlotte L. Stough's *Greek Skepticism: A Study in Epistemology* (Berkeley and Los Angeles, 1969), *passim* esp. 147–60, who concludes that scepticism did, nevertheless, undermine the dualism between reality and appearance. For the view that Sextus Empiricus, in particular, found the concept of 'external objects' in a mind-independent world incoherent, and employed the terminology only because it was philosophically important to those he criticized, see Mates, *Skeptic Way*, 54–5.
7. Notably, Leo Groarke, *Greek Scepticism: Anti-Realist Trends in Ancient Thought* (London, 1990), 3–30, 143–54, and *passim*.
8. *Academica*, ii. 40–1, in Cicero, *De natura deorum. Academica*, trans. Rackham, 519. It is Antiochus' claim in the dialogue that the first premiss is also a sceptical belief, in which case the syllogism appears self-contradictory; see *Academica*, ii. 44, ed. cit., 523–5, and ii. 83, ed. cit., 571–3, for Cicero's admission that this premiss is admitted by the philosophers on both sides of the argument.
9. Ibid. ii. 27, ed. cit., 501.
10. Ibid. ii. 77–8, ed. cit., 565.
11. Ibid. ii. 83, ed. cit., 573.

12. Ibid. ii, 51, 53, 48, 79–96, ed. cit., 531, 535, 527, 567–91. For commentary, see Stough, *Greek Skepticism*, 46–50.
13. Cited by Charles B. Schmitt, *Cicero scepticus: A Study of the Influence of the 'Academica' in the Renaissance* (The Hague, 1972), 70 and n. 126: 'Academicorum olim fuit decretum insigne, qui asserebant, nihil posse percipi, quod sane multis admirabile, nonnullis etiam ridiculum est visum.'
14. Ibid. 21; see also Stough, *Greek Skepticism*, 50–64.
15. The phrase is taken from Groarke, *Greek Scepticism*, 120.
16. Schmitt, *Cicero scepticus*, 123, 149–50; cf. *Academica*, ii. 32–3, ed. cit., 509–11.
17. [Sextus Empiricus], *Sexti philosophi Pyrrhoniarum hypotypωseωn libri iii* (n.p. [Paris], 1562), see esp. 17–44 (bk.1, ch. 14), 'de modis decem epoches'. See Schmitt, *Cicero scepticus*, for a full account of how, after 1562, the material in the *Academica* became a 'few ancillary notes' (66) to the much fuller source of sceptical ideas in Sextus Empiricus; cf. id., 'The Recovery and Assimilation of Ancient Scepticism in the Renaissance', *Rivista critica di storia della filosofia*, 27 (1972), 363–84. Details of the manuscript Latin translations of Sextus' works available before Estienne's edn. of the *Outlines* are brought up to date by Luciano Floridi, 'The Diffusion of Sextus Empiricus's Works in the Renaissance', *J. Hist. of Ideas*, 56 (1995), 63–85, and id., *Sextus Empiricus: The Transmission and Recovery of Pyrrhonism* (Oxford, 2002), *passim*. Floridi suggests that it was not absence of knowledge of Sextus Empiricus that marked the Renaissance down to 1562, but lack of interest in the 'anti-epistemological' character of his arguments.
18. Marin Mersenne, *La Verité des sciences. Contre les s[c]eptiques ou Pyrrhoniens* (Paris, 1625), 148: 'Ce 6. fondement [i.e. trope], aussi bien que les precedens, & presque tous les autres, dependent de l'Optique'; cited by Richard Tuck, 'Optics and Sceptics: The Philosophical Foundations of Hobbes's Political Thought', in E. Leites (ed.), *Conscience and Casuistry in Early Modern Europe* (Cambridge, 1988), 238 n. 7.
19. *Outlines of Pyrrhonism*, i. 61, ed. cit., 97.
20. Ibid. i. 10, ed. cit., 90.
21. Typical examples from medieval and early modern optical theory are bk. 3 of Alhazen's *Perspectiva*, in Federicus Risnerus, *Opticae thesaurus Alhazeni Arabis libri septem . . . item Vitellonis Thuringopoloni* (Basel, 1572), 75–102; François d'Aguilon (Aguilonius), *Opticorum libri sex* (Antwerp, 1613), 195–355 (bk. 4: 'De fallaciis aspectus'); and T[homas] P[owell], *Elementa opticae* (London, 1651), 83–103 (ch. 6: 'De visus hallucinationibus'). Commentary in Lindberg and Steneck, 'Sense of Vision', 33–5; Summers, *Judgment of Sense*, 42–9.
22. *Outlines of Pyrrhonism*, i. 46, 48–9, ed. cit., 95.
23. Ibid. i. 22, ed. cit., 92.
24. Groarke, *Greek Scepticism*, 136–9.
25. *Outlines of Pyrrhonism*, i. 97, ed. cit., 102.
26. Ibid. i. 103, ed. cit., 102–3.
27. Ibid, i. 113, ed. cit., 104.
28. Cave, *Pré-histoires*, 35: 'le pyrrhonisme relativise tout ce à quoi il touché.'
29. Stough, *Greek Skepticism*, 74.
30. *Outlines of Pyrrhonism*, i. 140, ed. cit., 107. The issue of whether, in speaking of 'the same thing(s)' appearing in different ways, Sextus was implicitly using a realist formulation that was incompatible with his own extreme scepticism is considered by

Stough, *Greek Skepticism*, 124–5, and Mates, *Skeptic Way*, 232–3. Mates again argues (cf. n. 6 above) that it is not the sceptic but the dogmatist who has to confront the problem of sameness in objects and differences in their appearances: Sextus is using a 'dogmatic' formulation in order to reveal its incoherence.
31. *Outlines of Pyrrhonism*, ii. 53, ed. cit., 134.
32. Ibid. i. 111, ed. cit., 103.
33. Ibid. i. 163, ed. cit., 110 (my emphasis).
34. This is not apparent from the detailed analysis in Julia Annas and Jonathan Barnes, *The Modes of Scepticism: Ancient Texts and Modern Interpretations* (Cambridge, 1985), 156–71.
35. On paradox, see Colie, *Paradoxia epidemica*, 374–95, and Malloch, 'Techniques and Function', 202; on subjectivity, see Elaine Limbrick, 'La Relation du scepticisme avec la subjectivité', in Eva Kusher (ed.), *La Problématique du sujet chez Montaigne* (Paris, 1995), 73–85.
36. Montaigne, *Essays*, 422.
37. Ibid. The idea reappeared in Francis Bacon's Pyrrhonian depiction of the 'Idols of the Tribe' in his *Novum organum*, *Works*, iv. 54: 'all perceptions as well of the sense as of the mind are according to the measure of the individual and not according to the measure of the universe.' Richard Sayce, *The Essays of Montaigne: A Critical Exploration* (London, 1972), 160–201, sees Pyrrhonism as constant throughout the versions of the *Essais*, whereas Elaine Limbrick, 'Was Montaigne Really a Pyrrhonian?', *Bibliothèque d'humanisme et Renaissance*, 39 (1977), 67–80, suggests an evolution of Montaigne's scepticism from an early Pyrrhonian phase, through the probabilism of the New Academy, to a version closest to the spirit of Socrates. Frédéric Brahami, by contrast again, argues that Montaigne was, strictly speaking, more Pyrrhonist than the Pyrrhonists, since his view that the human mind was in a permanent state of flux, or *astasia*, meant the rejection of the very first stage of Pyrrhonism, the weighing of stable, equally poised, or *isostatic* representations—itself a rationalist notion; see id., *Le Scepticisme de Montaigne* (Paris, 1997), 63–70, 104–7. For another statement that Montaigne always remained a Pyrrhonist, see André Tournon, 'L'Argumentation pyrrhonienne: structures *d'essai* dans le chapitre "Des boîteux" ', in *Montaigne, les derniers essais*, Cahiers Textuels 2 (Paris, 1986), 73–85, and for a survey of the debate, see Markus Wild, 'Les Deux Pyrrhonismes de Montaigne', *Bulletin de la Société de Amis des Montaigne*, 8th ser. 19–20 (2000), 45–56.
38. *Essays*, 443, 445, 446.
39. Ibid. 452.
40. Ibid. 453 (last sentence added after 1588).
41. Pierre Charron, *Of wisdome*, trans. Samson Lennard (London, n.d. [before 1612]), 37–8, 40; Jean-Pierre Camus, 'Essay spectique' [*sic*], in id., *Diversitez*, iv (with added title page and place of pub. as Douai), 206–7, and (on the sense of sight) 207–14.
42. Léonard Marandé, *The judgment of humane actions*, trans. John Reynolds (London, 1629), 38–40, 42–3, 74; 1st pub. in French 1624. On this author, see Alan M. Boase, *The Fortunes of Montaigne: A History of the Essays in France, 1580–1669* (London, 1935), 195–208; Richard Popkin, *The History of Scepticism from Erasmus to Descartes*, rev. edn. (Assen, 1964), 100–2.
43. The arguments of these authors are summarized by Popkin, *History of Scepticism*, chs. 6 and 8; see esp. 121–3 (Chanet), 125–9 (Sorel), and 165–74 (Silhon).

44. Ibid. 114–18; Sorel cited at 128.
45. *Outlines of Pyrrhonism*, iii. 235, ed. cit., 210; cf. i. 17, i. 24, ii. 246, and iii. 179–237, ed. cit., 91, 92, 169, 202–10.
46. See esp. ibid. iii. 218–32, ed. cit., 207–9.
47. Ibid. i. 32, ed. cit., 93.
48. Ibid. i. 33, ed. cit., 93–4.
49. Richard Tuck, *Philosophy and Government 1572–1651* (Cambridge, 1993), p. xiii (author's emphases); cf. id., 'Optics and Sceptics', 241–2.
50. *Outlines of Pyrrhonism*, i. 27, ed. cit., 93.
51. Tuck, *Philosophy and Government*, 14, cf. 49 on Montaigne's and Lipsius' view 'that Aristotelian science was entirely incompatible with true humanism'.
52. I take all these points, and much else in this paragraph, from Tuck, *Philosophy and Government*, esp. 59, 86–7, 98–9, 110. For the issues surrounding moral atheism, see David Wootton, 'The Fear of God in Early Modern Political Theory', in Canadian Historical Association, *Historical Papers 1983* (Ottawa, 1984), 56–80.
53. Charron, *Of wisdome*, 274–90 (all quotations from these pages unless otherwise indicated).
54. Ibid. 157.
55. On possession and the sense of hearing, see *Outlines of Pyrrhonism*, ii. 52, ed. cit., 134: 'And those who are divinely possessed or raving seem to hear people conversing with them, while we do not.'
56. *Essays*, 457.
57. This is made clear by Elaine Limbrick, 'Le Scepticisme provisoire de Montaigne: étude des rapports de la raison et de la foi dans l'*Apologie*', in Pierre Michel (ed.), *Montaigne et les Essais 1580–1980* (Paris, 1983), 168–78.
58. Esp. helpful on these themes is Sayce, *Essays of Montaigne*, 202–32, who stresses the subversiveness of Montaigne and suggests that fideism is never wholly supportive of Christianity. He argues for the existence of deistic and pantheistic themes in the *Essais* instead.
59. *Essays*, 70; the reference to miracles was removed from the 1595 edn.
60. Claude-Gilbert Dubois, 'Montaigne et le surnaturel', in Ilana Zinguer (ed.), *Le Lecteur, l'auteur et l'écrivain: Montaigne 1492-1592-1992* (Paris, 1993), 41–53.
61. Here I follow, in particular, Gérard Ferreyrolles, 'Lecture pascalienne des miracles en Montaigne', in Michel (ed.), *Montaigne et les Essais*, 120–34; see also Dubois, 'Montaigne et le surnaturel', *passim*, and Sayce, *Essays of Montaigne*, 218–20.
62. *Essays*, 134.
63. Ibid. 132. Montaigne adds a quotation from Horace listing: 'Dreams, witches, miracles, magic alarms, | Nocturnal spect[re]s, and Thessalian charms.'
64. Loc. cit.
65. *Outlines of Pyrrhonism*, i. 141–4; ed. cit., 107–8.
66. *Essays*, 452–3.
67. Ibid. 784–92, for all quotations; analysis by Géralde Nakam, *Les 'Essais' de Montaigne, miroir et procès de leur temps: témoignage historique et création littéraire* (Paris, 1984), 377–97, who also figuratively considers Montaigne's own 'optics'—his particular way of looking at things—at 16–21, 460–2. The classic account is Alan M. Boase, 'Montaigne et la sorcellerie', *[Bibliothèque d']humanisme et Renaissance*, 2 (1935), 402–21.

68. Nakam, '*Essais*', 394.
69. The fifth trope was the trope of 'positions, distances, and locations': *Outlines of Pyrrhonism*, i. 118–23; ed. cit., 104–5.
70. Cf. Cicero, *Academica*, ii. 146, ed. cit., 655–7; Limbrick, 'Was Montaigne Really a Pyrrhonian?', 79–80.
71. On this particular style of argument, see Tournon, 'L'Argumentation pyrrhonienne', 73–85.
72. Cave, *Pré-histoires*, 66, and 59–73, 77–84 *passim*.
73. Ibid. 73–6.
74. Jean de Silhon, *Les Deux vérités de Silhon, l'un de Dieu et de sa Providence, l'autre de l'immortalité de l'âme* (Paris, 1626; repr. 1991), 89–103, 187; Gilbert Picot, *Jean de Silhon (1594?–1667) ou la Recherche des certitudes en religion et en politique* (Nancy, 1995), 307–8.
75. Charles Sorel, *La Science universelle* (4 vols.; Paris, 1668), iii, pt. 2, bk. 2, ch. 1, 311–41 (Pyrrhonism), and ch. 8, 488–532 (demonology and witchcraft).
76. Yves de Paris, *La Théologie naturelle* (4 vols.; 1633–7), ii (2nd edn., 1638), 493–628; François Garasse, *La Doctrine curieuse des beaux esprits de ce temps, ou pretendus tels* (Paris, 1623), 793–946 (see esp. 811–14 on Christian belief and the sense of sight).
77. Gustav Henningsen, *The Witches' Advocate: Basque Witchcraft and the Spanish Inquisition (1609–1614)* (Reno, Nev., 1980), 6–9; on the issue, see Ch. 4 above. For De Valencia's studies of Greek scepticism, see his *Academica sive de iudicio erga verum ex ipsis primis fontibus* (Antwerp, 1596), and Schmitt, *Cicero scepticus*, 74–5.
78. Nicolas Malebranche, *The Search after Truth/Elucidations of the Search after Truth*, trans. Thomas M. Lennon and Paul J. Olscamp, comment. Thomas M. Lennon (Columbus, Oh., 1980), 191.
79. Bodin, *Démonomanie*, sigs. Í iv–iir; Del Río, *Disquisitionum magicarum*, 182 (bk. 2, q. 16); the same reference is in Perrault, *Demonologie*, 14. On Pyrrhonism and Bodin, see Cave, *Pré-histoires*, 63–4.
80. Boase, *Fortunes of Montaigne*, 242–9; Gabriel Naudé, *The history of magick by way of apology*, trans. John Davies (London, 1657), 302; cf. id., *Apologie pour tous les grands personnages qui ont esté faussement soupçonnez de magie* (Paris, 1625), '608–9' = 642–3.
81. Robert Mandrou, *Magistrats et sorciers en France au xviie siècle* (Paris, 1980), 124, 281, 298–301, 310, 334, 336; Marianne Closson, *L'Imaginaire démoniaque en France (1550–1650): genèse de la littérature fantastique* (Geneva, 2000), 55–8; Gabriel Naudé, *Considérations politiques sur les coups d'état*, ed. Frédérique Marin and Marie-Odile Perulli, with an introductory lecture by Louis Marin (Paris, 1988), 76, 140; Tuck, *Philosophy and Government*, 93.
82. Le Loyer, *Treatise*, 49r–61v; Cave, *Pré-histoires*, 70–3. In a letter to Marin Mersenne, Le Loyer admitted to being a follower of the New Academy and of Carneades: see *Correspondance du P. Marin Mersenne*, ed. C. de Waard, B. Rochot, and A. Beaulieu (16 vols.; Paris, 1945–88), i. 521.
83. Camus, 'Essay spectique' [*sic*], in id., *Diversitez*, 212–14.
84. For the possibility that discussions similar to Descartes's 'demon hypothesis' were 'common fare in the works of sceptical philosophers' and that he probably derived his arguments, including those relating to dreams, from Academic scepticism, see Leo Groarke, 'Descartes' First Meditation: Something Old, Something New, Something Borrowed', *J. Hist. of Philosophy*, 22 (1984), 281–301. The main difference seems to

be that earlier versions of the argument dealt with divine, not demonic deception, suggesting that Descartes was led to the 'demon hypothesis' in particular by debates nearer to his time. For 'brains in a vat', see Hilary Putnam, *Reason, Truth and History* (Cambridge, 1981), 1–21.
85. Geoffrey Scarre, 'Demons, Demonologists and Descartes', *Heythrop J.* 31 (1990), 3–22.
86. Cole, 'Demonic Arts', 621.
87. For details, see Ch. 10 below, nn. 30–5.

9

Dreams: The Epistemology of Sleep

At either end of a fifty-year period of European intellectual history, Montaigne and Descartes made celebrated statements about the implications of dreaming. In the 1588 edition of his *Essais*, Montaigne remarked that:

> Those who have compared our life to a dream were perhaps more right than they thought. When we dream, our soul lives, acts, exercises all her faculties, neither more nor less than when she is awake; but if more loosely and obscurely, still surely not so much so that the difference is as between night and bright daylight; rather as between night and shade.

In later versions Montaigne added the slightly stronger observation that: '[s]leeping we are awake, and waking asleep. I do not see so clearly in sleep; but my wakefulness I never find pure and cloudless enough.'[1] Descartes, writing in the first of his *Meditations on First Philosophy*, published in 1641, made the philosophically (and theologically) notorious statement that he wished to suppose that:

> some malicious demon of the utmost power and cunning has employed all his energies in order to deceive me. I shall think that the sky, the air, the earth, colours, shapes, sounds and all external things are merely the delusions of dreams which he has devised to ensnare my judgement.[2]

Neither of these statements was supposed to be metaphorical. Montaigne certainly refers to the conceit of life as a dream but he mentions it only to dismiss it. It is too close to the literal truth to be a good metaphor. Instead, as we saw in the previous chapter, he was engaged in systematically doubting the evidence of the senses and the capacities of reason. In this context, dreams were epistemologically significant, and quite precisely so. Montaigne's remark comes at a point, late in the 'Apology for Raymond Sebond', where he is defending the earlier claim that 'external objects surrender to our mercy; they dwell in us as we please'. He has reached the point of suggesting that the senses and the rational soul often succeed only in deceiving each other—hence making it thinkable that sleeping and waking are not such different experiences after all. The passage we began with continues by posing this paradox:

> Since our reason and our soul accept the fancies and opinions which arise in it while sleeping, and authorize the actions of our dreams with the same approbation as they do those of the day, why do we not consider the possibility that our thinking, our acting, may be another sort of dreaming, and our waking another kind of sleep?[3]

Descartes's argument in the first of the *Meditations* is even better known—a kind of super-Pyrrhonism in which he attempted to bring the entire history of philosophical scepticism to a resolution by presenting the most forceful case imaginable for the uncertainty of knowledge—again, an argument beginning with the senses. In conventional terms, he said, a man would have to be mad to doubt having hands or a body, or being seated 'by the fire, wearing a winter dressing-gown, holding this piece of paper in [his] hands, and so on'. Yet in dreams were represented not merely things stranger than the insane took for real but precisely these mundane realities that they might well insist were false—being seated in a particular place, dressed in a certain way, and so on. In conventional terms, again, these mundane representations *were* false, when compared to lying undressed and asleep in bed. Reality and what happened in sleep *did* seem to be distinct. But, exclaimed Descartes:

> As if I did not remember other occasions when I have been tricked by exactly similar thoughts while asleep! As I think about this more carefully, I see plainly that there are never any sure signs by means of which being awake can be distinguished from being asleep. The result is that I begin to feel dazed, and this very feeling only reinforces the notion that I may be asleep.[4]

Even if we were always asleep and subject to 'visions', Descartes went on, we might still suppose that their basic ingredients, at least, were still real and true—eyes, hands, and bodies, and beyond these, things like colour, extension, quantity, magnitude, number, place, and time. Hence the need to suppose, for the sake of total doubt, that an all-powerful deity—or since this might be unacceptable, an all-powerful demon—had turned all these too into illusions and made everything uncertain. Assuming such an intervention, the distinction between wakefulness and sleeping—and, indeed, between sanity and insanity—ceased to matter. 'I shall consider myself', concluded Descartes, 'as not having hands or eyes, or flesh, or blood or senses, but as falsely believing that I have all these things.'[5]

What thinking with dreams meant for both these authors, therefore, was a radical calling into question of assumptions about the truth, certainty, and objectivity of sensory knowledge.[6] Here was an opportunity to give the commonplace (but erroneous) coupling of *songe* and *mensonge* new force. All the senses were implicated in this challenge, of course, but sight was the sense in which dream experiences were most frequently said to be experienced and it was therefore at the centre of the argument. The dream proper, in Aristotle's definition in his treatise *De somniis*, was an image—'a presentation based on the movement of sense impressions, when such presentation occurs during sleep'. Dream sensations were caused by traces of the *species* left behind in the internal senses by the waking perceptions of the external ones, once the latter were no longer active; such 'impressions' were still, in other words, 'objects of perception' and, indeed, were perceived 'with even greater impressiveness'. The imagination was the main faculty involved, since it was clear 'that the faculty by which, in waking hours,

we are subject to illusion when affected by disease [and even, Aristotle added, when 'in excellent health'], is identical with that which produces illusory effects in sleep'. Distortions originated from the physiology of sleep, notably the movement of the blood, the 'eddies' and 'collisions' of the animal spirits, and the digestion of food, and, in the absence of any true impressions from outside, remained uncorrected. To dream was to mistake 'an impulse that is merely like the true [objective] impression', for the true impression itself, the effects of sleep being so great that for the dreamer, mostly unaware that he dreams, there is nothing 'which will contradict the testimony of the bare presentation'.[7] Such, in essence, was the view also repeated in the textbooks of the early modern period, like the guide to the dreaming state and its 'visions, apparitions, and images' offered by the French Aristotelian Scipion Dupleix. In essence, dreams were explained in terms of a change in the balance of power among the faculties and senses; the imagination, more or less free from the controlling influence of reason, was able to present images to the 'common sense', which, unoccupied with any impressions from the outside world, had no option but to 'see' them.[8]

The assumption that dreams are primarily visual in character is so general as to suggest an instinctive response to the experience. It hardly needs to be illustrated here, except to confirm that pre-modern dreamers and dream analysts were no exception in this respect. In the ancient world, Greeks spoke typically of 'seeing' dreams (*Blepō oneiron*), while Latin authors, although they used the sense-neutral noun *simulacrum* to describe the things perceived in dreams, chose *visus est mihi* (or less frequently simply *video*) for the act of perceiving them.[9] Likewise, the most important dream treatise of the Elizabethan age, Thomas Hill's *The moste pleasaunte arte of the interpretacion of dreames* (1576), adopted 'similitude' for the contents of dreams but described dreaming itself as 'a fantastical appearaunce, which the persone sleapynge conceiveth'. His entire book, said Hill, consisted either 'of thinges seene, or of the maner of seeynge . . . of the dreaminges'.[10] In the mid seventeenth century, the Hertfordshire preacher Philip Goodwin again reminded his readers that, besides being dilations *of* thought, dreams were also appearances ('apparitions') *to* it:

A dreaming man (. . .) he thinks he sees the sun, though the sun he sees not. As there may appear some things to our eyes, as armies in the air, fighting-men, and flying-horses which are no realities, only apparitions. So to a man in a dream, such things and persons appear but they are no realities, only fictions in his fancy. Philo (de Joseph) observes, that some awake are like men asleep, [and] while they think they perceive such things, do but deceive themselves, taking the signs of things, for the natures of things, meer shadows for substance. In a dream are thoughts of things, not the things thought.

Thus, dream thoughts, like waking ones, had their visual 'representation'; dreams were only 'the thought-works of the waking mind, in the sleeping-man'.[11] In 1567 Jean Fernel's *Physiologia* explained the dream as 'a vision and phantom', and in the early seventeenth century another Frenchman, Dupleix, defined it as 'a vision

presented to the interior senses'. In eighteenth-century England, the case that dreams were visible rather than auditory experiences was defended again by David Hartley.[12] Comparisons of dreams to pictures and picture-writing were apparently both frequent and convincing enough throughout this period to produce visual 'culture-patterns' among dreamers.[13] In 1665, the author of an important Calvinist treatise on divine dreams concluded that these visions could result from images from the Bible being 'painted' in the minds of dreamers.[14] The dream paradox posed by Montaigne and Descartes, we can therefore say—the paradox of not being able to distinguish between waking and sleeping—was, in effect, a visual paradox—the paradox of not being able to tell the difference between true and false visual experiences.

Now that the issue was once again in the public domain, philosophically speaking, it was rehearsed by any number of later authors. There are similar expressions of the dream paradox by Phineas Fletcher and Blaise Pascal—the latter of whom wrote: 'No one can be sure whether he sleeps or wakes, seeing that during sleep we believe so firmly that we are awake'—and, later, by Joseph Addison (appropriating Pascal) and James Beattie (alluding to Berkeley's remarks on the verisimilitude of dreams).[15] *A treatise concerning eternal and immutable morality* (1731), a posthumously published work by Ralph Cudworth, explained that when a waking fantasy led straight to sleep, the corresponding dream would 'appear not as phantasms or imaginations only of things nonexistent, but as perceptions of things really existent, that is, as sensations'. Unlike those produced artificially by paintings or poetry, such sensations were 'true', said Cudworth, because 'the soul is as really affected, and hath as lively images, ideas and phantasms of sensible things as existent then, as when we are awake'. Others who explored the apparent reality of dreams were Thomas Hobbes, Henry More, Joseph Glanvill, Thomas Tryon, Timothy Nourse, and Samuel Parker. In 1692, the question behind all these reflections was put with mock gravity by Charles Gildon: 'if there be so great an uncertainty in our knowledge, of our being asleep or awake, that it was worth the disquisition of so great a philosopher as Des Cartes, with so solemn a face of seriosity, I know not, whether there be so material a distinction betwixt our dreams, and being awake, as the generality of the World imagines.'[16] The outright rejection of this possibility likewise attests to its intellectual currency. The French writer Charles Sorel, who wished to defend the authority of the senses against Pyrrhonism, attacked the idea that there was as much truth in what was done and seen in dreams 'as in anything that happens while we are awake' and dismissed them as 'manifest' illusions during which sleepers 'act by the soul alone and, staying immobile in bed, think they are doing what they are not'.[17]

In sharp contrast to this stream of commentary, however, this was not the issue that dominated discussions of dreams between Montaigne and Descartes, or, indeed, during the sixteenth and seventeenth centuries as a whole. Nor does it figure prominently in the long intellectual history of commentaries on dreams and their

interpretation during antiquity and the medieval period. In the ancient world and down to the Renaissance what mattered most about dreams—and influenced all attempts to classify and interpret them—were their origins, their premonitory value, and their morality. Did they stem from the human spirit, other immortal spirits, or the gods (the choice in Cicero's *De divinatione*, i. 64) or were they instigated by the human soul, demons, or God himself (as in Tertullian's *De anima*, 45–9)? Were they perhaps the products of physical states of the human body, a naturalistic explanation stressed by the Epicureans and by Aristotle, made the subject of diagnostic accounts of dreams by Hippocrates and Galen, and later added to Christian typologies? Were their meanings clear, or enigmatic and needing interpretation? And above all, did they accurately foretell the future? Many attempts to make sense of the contents of individual dreams in terms of their fulfilment were 'Artemidorian' in spirit, after the dream readings and dream typologies established by Artemidorus of Daldis in the second century CE. This was because the only condition of the sleeping mind that really interested Artemidorus was *oneiros*, which called the dreamer's attention to the future state of affairs.[18]

A distinction between true and false was fundamental to many of these questions, but it was not the one explored by Montaigne and Descartes.[19] In book 19 of the *Odyssey*, and later in Virgil, the dreams that emerged from Hades via the 'gate of horn' were true because they *came* true and those that emerged via the 'gate of ivory' were false and deceptive because they did not. In the fivefold classification found in the early Christian era (in the pagan Macrobius' highly influential *Commentarii in somnium Scipionis*, i. 3 for example), only the purely illusory *visum* (or *phantasma*) seems to suggest visual paradox.[20] The other categories comprised true dreams (that is to say, premonitory dreams, with a meaning and utility) that were either enigmatic (*somnium*), clear (*visio*), or divine but enigmatic (*oraculum*), and false dreams (non-premonitory, without meaning or utility) that referred to past events of no consequence (*insomnium*).[21] When Christianity made all dreams meaningful and prohibited dream divination (oneiromancy), their truth or falsity became solely a matter of their origin and morality. True dreams were good dreams that came from God (or angels) and were spiritually improving, even revelatory, and might lead to conversion; false dreams were evil ones sent by the devil to tempt and corrupt (the human body and soul might give rise to mixed sorts). Again, epistemological status was not the main issue. What was false about demonic dreams was that they led the dreamer astray with illusory promises and deceptive, perhaps heretical, visions—not that they made the distinction between true and illusory perception *itself* undecidable. Tertullian, for example, called them 'vain, deceptive, disturbing, and lubricious'.[22]

Nevertheless, the epistemological implications of dreams were certainly not ignored in the ancient world, and in its philosophy, at least, they became crucial to various forms of scepticism. 'As an experience of virtual reality', it has been said, they called into question 'the validity of sensory perception and the human sense of reality'.[23] There is, for example, the passage in Plato's *Theaetetus*, where dreams

are said not merely to compromise the principle that 'everything is which appears' but also to raise the question of how we determine 'whether at this moment we are sleeping, and all our thoughts are a dream; or whether we are awake, and talking to one another in the waking state', since 'in both cases the facts precisely correspond'.[24] If we turn from Cicero's *De divinatione* to his *Academica*, we find (as we did in the previous chapter) dreams among the examples used by the 'academic' sceptics against the Stoic doctrine of 'cataleptic' impressions. For every one of these deemed to be true, we recall the sceptics saying, it was always possible to experience a false impression that was indistinguishable from it—in the case of dreams because they were just as 'perspicuous' or 'evident' as waking experiences.[25] This idea was to be the starting point for St Augustine's discussion of dreams and he responded to it in his *Contra academicos*, where it assumed the same paradoxical form: if the mind thinks that the images of sleep are real, how can it be sure that those of the day are not unreal? In his *De Genesi ad litteram* (xii. 2), moreover, Augustine related a dream of his own that underlined the dilemma, but made him all the more determined to resolve it in favour of the existence of truths—intellectual, if not sensible—that were independent of either the waking or the sleeping condition. Discussing St Paul 'seeing' Paradise while in an apparently ecstatic state, he insisted that waking up was normally enough to convince a man that the bodies seen in sleep (or ecstasy) were not real, even though 'when he saw them in his sleep he was not able to distinguish them from corporeal objects seen in his waking hours':

Still I know from my own experience (. . .) that while seeing an object in sleep I was aware that I was dreaming. I was fully convinced, even in my sleep, that the images that ordinarily deceive the imagination were not real bodies but only the phantasies of a dream. Sometimes, however, I have been misled in my attempts to persuade a friend whom I saw in a dream that the objects we were seeing were not bodies but only the images of dreamers—all the while he himself appeared among them as a mere dream image. Still I would tell him it was not true that we were even speaking to one another, and I would say that he at that moment was seeing something else in his sleep and that he had no knowledge at all of the fact that I was seeing these objects. But whenever I made an effort to persuade him that he was not real, I was partly inclined to believe that he was, since I should not be speaking to him if I really felt that he was not real. Hence, my soul, which in some mysterious way was awake while I slept, was necessarily affected by the images of bodies, just as if they were real bodies.[26]

Above all, there is the attention given to dreams in the sceptical tropes of Sextus Empiricus, which we also examined earlier. For Sextus, visual encounters with the world that were opposite in content yet equal in descriptive weight were just further examples of the kind of irreconcilable dilemmas (or paradoxes) that drove the true sceptic towards *ataraxia*. Dreaming and wakefulness were simply two of the many contrasting conditions in which the world was experienced—that is, seen in relation to something, not absolutely:

For when we are awake we do not imagine what we imagine when we are asleep, nor when we are asleep do we imagine what we imagine when awake, so that whether the *phantasiai*

are the case or are not the case is not absolute but relative, that is, relative to being asleep or awake. It is fair to say, then, that when asleep we see things that are not the case in the waking state, though not absolutely not the case. For they are the case in our sleep, just as what we see in our waking state is the case, though not in our sleep.[27]

Of necessity, men and women were always in one or other of these conditions and therefore, by definition, without a criterion for deciding between them. This was certainly a very different way of talking about the status of dreams from the one that was usual in the second century.

In general terms, then, the dominant tradition of dream thought in the ancient world and later was oneirocritical, in the sense that it focused on Macrobius' true but possibly enigmatic *somnium* and, thus, on the origin, the moral character, and, above all, the interpretation of premonitory dreams, while a less prominent philosophical debate raised quite different questions about their epistemological implications. This was also the case in the sixteenth and seventeenth centuries. Most theoretical discussions of dreams continued to focus on how they originated, what they might mean, if anything, and whether it was legitimate to base divination on them. Whether they were true or false was overwhelmingly a matter of their outcome and internal morality. Artemidorus himself was strongly represented, in the form of editions in Latin, French, German, Italian, and English— twenty-four of the latter down to 1740—and at least one part translation into Welsh.[28] So was his approach: Thomas Hill, whose treatise on (and of) dream readings was intended to create an equivalent Elizabethan art of 'foresyghte', spoke of dreams almost entirely as 'signifiers of matters to come' and judged them as either true or 'vain' accordingly.[29] On waking, many individual dreamers must surely have wondered, as did a woman at Utrecht in the later seventeenth century, whether the very 'plainness' of the objects seen in their dreams meant that they were not in fact dreams at all.[30] Others may have had lucid dreams that allowed them to ask this sort of question even while they were asleep. Intriguingly, Roger Ekirch has argued that a prevalence of segmented sleep in pre-industrial societies may have made the first of these possibilities much more likely than it has become since. This is because the dream images of 'first' sleep would have seemed much more vivid, long-lasting, and 'real' during the quiet wakefulness of the night than if reflecting on them had been delayed until dawn.[31] Be that as it may, the books written and read on the subject of dreams and the recordings of them made by serial dreamers seem far more concerned with whether and how they might be fulfilled and what, therefore, the coded messages contained in them might foretell—issues, admittedly, that might also have been thought about in the dead of night. There are plentiful indications of this, both in whole traditions of scholarship, such as that of the *clés des songes*, and also in the interests of particular enthusiasts like Girolamo Cardano, Archbishop Laud, or Elias Ashmole.[32] Most ordinary individuals, if they paid any attention to them at all, saw dreams as a kind of prophecy.[33]

At the same time, the very legitimacy of interpreting dreams in this way—and of divination in general—was a preoccupation of the vast literature of religious guidance that accompanied the Protestant and Catholic Reformations in the form of general theology and specialized casuistry and catechesis. In this context, the analysis of dreams, at whatever level, was an alarming opportunity for superstition; what they were taken to signify could easily lead dreamers and their analysts away from the correct sources of guidance about future conduct, as well as away from the correct opinions about dreams—which were activities of the soul, after all. Dream analysis, writes Peter Holland of Catholic Spain, was thus 'trapped between the strong popular fascination with dreams, ably supported by the economics of the profession of oneiromancy, and the equally strong religious culture which wished their study to be placed within the bounds of the Church and hence the state'.[34]

As one parallel indication of what was attempted in Protestant cultures, we might take the most popular standard Lutheran account of dreams offered by Kaspar Peucer in his *Commentarius de praecipuis divinationum generibus*, first published in Wittenberg in 1553. Peucer cites the Homeric distinction between dreams of 'horn' and dreams of 'ivory', he summarizes Artemidorus, he invokes Macrobius' fourth-century classification, and then himself divides dreams into the, by now, usual natural, divine, and demonic types. The emphasis is very much on causation and meaning. Peucer does talk briefly about natural dreams that represent things so clearly that they seem to be 'really present before the eyes' and of 'melancholics' that see things in their dreams that are relative to their condition, but he is far more interested in how this comes about physiologically than in what it implies for the reliability of visual perception. Demonic dreams are impostures and illusions because they are secured by pagan sacrifices and trance states, or designed to lead 'enthusiasts' and 'anabaptists' astray. They are rarely true, but in the sense of being ambiguous and doubtful and full of evil, impiety, and superstition. Witches, for example, are 'mocked' by them into enjoying empty sexual and other pleasures. In the end, the main reason for condemning them is that 'under an appearance of religion, they require things that are contrary to the Law and the Gospel'. Clearly, demonic dreams were continuing to be judged as *somnium*.[35]

Yet just as in the ancient world, the epistemological implications of dreaming were nevertheless discussed in this later period too, if only because of the publication of the *Outlines of Pyrrhonism* in 1562. Amongst the tropes, as we have seen, dreams featured specifically as one of the occasions for visual paradox, and so for the relativizing of vision. This accounts for their appearance in the specialist treatises on scepticism published in the seventeenth century by writers like Charron, Marandé, and La Mothe Le Vayer, the first of whom remarked typically on the power of the dreamer's imagination almost to work 'that within in the understanding, which the object doth without in the sense'.[36] Alluding to what was, by then, fast becoming a sceptical commonplace, Thomas Hobbes remarked in his *Elements of Philosophy* (1656) that experience showed that dreams were

'clearer than the imaginations of waking men, except such as are made by sense itself, to which they are equal in clearness'.[37]

It is possible, therefore, to speak of two main forms of dream commentary—the moral and symbolic (or Artemidorian), and the epistemological—belonging to two traditions.[38] However, it is never the case that moral and epistemological considerations are entirely separate, without influence on one another. And what the intellectual debates about vision surveyed in this book suggest is the possibility of their convergence.[39] As we have already seen, visual paradox was a topic of discussion in a much wider range of contexts than that provided by philosophical scepticism—some of them embracing dreams. In the fields of medicine and psychology, for example, the debates we considered earlier about both the general power of the human imagination to influence visual perception and the specific delusions of melancholics (often compared to dreamers) and lycanthropes had obvious implications for dreaming as an image-making activity. The controversies about the visual reality of miracles and apparitions, likewise, led to concessions on both sides of the Reformation that included their attribution to dreaming. Amongst the series of chapters on the unreliability of visual perception that began Le Loyer's *Quatre livres des spectres*, there were discussions of the 'visions' which appeared during dreaming and between sleeping and waking.[40] And in England, in particular, the literature directed against religious 'enthusiasm' was heavily indebted to the, again essentially epistemological, idea that would-be visionaries, prophets, and other undesirable sectaries were literally dreaming the experiences they recounted, without, as Henry More put it, 'any check or curb of dubitation concerning the truth and existence of the things that then appear'. Since the 'true and reall seat' of sense was in the brain, not in the external organs, it was no surprise that 'the soul conceits her dreams while she is a dreaming, to be no dreams but reall transactions'.[41] Meanwhile, in another context still—in the vast early modern literature devoted to rhetoric and linguistics—the power of oratorical description, or *enargeia* (when, says Stephen Greenblatt, 'language achieves visibility'), was said to reside in its dream-like capacity to give the listener or reader the illusion of seeing what was not present before their eyes.[42]

However, the subject that seems to have had the greatest influence on the convergence of the moral and the epistemological traditions of dream commentary was demonology. To begin with, we should recall what was at stake—that is to say, two different ways of talking about the truth or falsity of dreams, one concerned with what they meant, the other with how they were experienced. The dream *world* was either morally true or morally false; according to the universally adopted early modern categories, dreams were either sent by God for a good purpose or sent by the devil for an evil one, or produced by morally neutral (or at least ambivalent) natural causes. Their truth, summarized Scipion Dupleix, 'depended on the outcome of things'.[43] The dream *state*, on the other hand, was epistemologically paradoxical; it consisted of experiences, predominantly visual,

which seemed to be true (in the sense of being real) but were objectively false (at least in conventional terms—the *un*conventional philosophers, as we have seen, took this as an opportunity to question what objectively perceived truths might mean in any case). Now although this epistemological paradox was applicable, in principle, to all dreams, to apply it to divine ones was clearly a dangerous matter. This is why we find only thinkers with a reputation for atheism and irreligion taking this step—subversives like Thomas Hobbes, who in *Leviathan*, for example, argued that the inability to distinguish between sleeping and waking visual experiences was one of the reasons for the flourishing of religion in the first place. For a man to say that God 'hath spoken to him in a dream', said Hobbes candidly, was 'no more then to say he hath dreamt that God spake to him'.[44] The same difficulty made Descartes draw back from the suggestion that the total doubt suggested by the concept of dreaming might be the direct work of a deity, only for his detractors to respond that it could not be an indirect one either.

To apply the epistemological paradox to natural dreams was perfectly safe but of limited scope. This is because the naturalistic criteria for attributing the falsity of dreams to involuntary physical or mental processes yielded—for Aristotelians at least (such as Peucer)—equally good criteria for resolving the epistemological paradox and deciding between sleep and wakefulness. For example, in his *Occulta naturae miracula* (1559), the Netherlands physician (and another Aristotelian) Levinus Lemnius offered a typical account of how the 'imaginations and such representations as we see in dreams' were caused by the state of the body's spirits and vapours. One and the same explanation enabled him to account for the specific contents of dreams and for the dreaming state itself. Those who were weary or drunk or had eaten too much scarcely dreamed at all or only obscurely; if they did, they saw 'filthy[,] terrible and horrible visions', full of sex and violence. Those who were more moderate had clear, lively, and 'peaceable' dreams; when the body was quiet and well adjusted, only the day's residues appeared at night:

> So drunken and feavourish people use to be disquieted with absurd dreams, so that many think they see terrible visions, hobgoblins, ghosts, scritch-owls, harpies, and what is peculiar to melancholique people, dead men, and sorrowfull faces. But they that abound with yellow choler conceive they see firebrands, slaughters, burnings, fightings, brawlings, and scolding, as sanguin people dream of dancing, singing, sporting, laughing, and all lascivious matters; and flegmatique people dream of abundance of water.

Beyond the subjective instant, there was simply no space in Lemnius' very conventional argument for mistaking a resemblance of something for the thing it resembled. Indeed, like most other dream theorists of the period (and in line with medical tradition going back to Hippocrates and Galen), he suggested that dreamers should report to physicians what and how they dreamed so that the true condition of their bodily humours might be revealed.[45]

Only in the case of *demonic* dreams, then, could the paradox be both safely and also fully explored—safely, because there was no religious or ethical risk in

reducing them to epistemological uncertainty, and fully because the Christian devil had powers to create delusions that were all but total and usually lasting. In Christian demonology, as we saw in Chapter 4, the devil was a master of the virtual and its paradoxes. This extended, without question, to his manipulation of dreams; although he could not supposedly implant into the human brain the visual *species* of anything it had not previously observed (a blind man, according to Aquinas, could not be made to dream of colours), he could still see every phantasm already stored in the imagination well enough to reproduce it in a dream sequence.[46] This is why demonology, and only demonology, combined both the (strongest) senses in which dreams could be true or false.

In what particular context, then, did the demonic dream impinge most significantly on early modern epistemology? Where was the paradox of not being able to tell the difference between dream experiences—which were predominantly visual experiences—and waking experiences most fully explored? The answer lies in the debate about witchcraft—and specifically in connection with an aspect of witchcraft that I left undiscussed in Chapter 4: the witches' attendance at their 'sabbat'. Significantly, Peucer gets closest to Macrobius' *visum*—the non-signifying illusion or 'phantasm'—when describing the dreams of witches. Witchcraft in general, as we saw before, was a subject where supposedly real events were repeatedly attributed to demonic deception and where the boundaries between truth and illusion were constantly at issue. Not all the delusions experienced by witches were thought to occur in demonic dreams but many were (and, in any case, as will become apparent, the complete deluding of the senses of a waking witch was tantamount to causing her to dream). The demonic dreams of witches were thus both morally false, being sent by the devil, and epistemologically paradoxical, leaving the dreaming subject unable to tell the difference between dreaming experiences and waking ones. To put this in Macrobian terms, it was in witchcraft theory that the features of the dream as *somnium* (having a meaning, in this case morally false) and as *visum* (having no meaning and illusory) could be brought together. Indeed, by 1606, the Frenchman Scipion Dupleix, who later included a substantial demonology in his popular textbook the *Corps de philosophie*, felt the need to make one of the few early modern adjustments to Macrobius' fivefold dream typology by turning the 'songes diaboliques' discussed by Peucer and others into a distinct sixth category—situated, perhaps symbolically, midway between the true and signifying dreams (*somnium, visio, oraculum*) and the false and non-signifying ones (*insomnium, visum*).[47]

This development did not occur only when witchcraft prosecutions were at their height. We are easily persuaded that by the close of the sixteenth century many were becoming doubtful about the reality of witchcraft and arguing that the things attributed to witches could be ascribed to dreams and other forms of delusion. But the issue had arisen right at the start too—witchcraft was *always* a contentious matter. It arose quite precisely in the 1430s when demonological treatises dealing with the witches' sabbat first started to be written. This is because

one of the first things these treatises had to confront was the view found in a ninth-century capitulary known as the *Canon episcopi*:

that some wicked women, perverted by the Devil, seduced by illusions and phantasms of demons, believe and profess themselves, in the hours of the night, to ride upon certain beasts with Diana, the goddess of pagans, and an innumerable multitude of women, and in the silence of the dead of night to traverse great spaces of earth, and to obey her commands as of their mistress, and to be summoned to her service on certain nights.

This experience was in fact imposed on their minds, said the *Canon*, by 'the malignant spirit' who transformed himself into the 'species and similitudes' ('species atque similitudines') of various people and exhibited other delusory things to them while they were asleep. 'Who is there', the text declared, 'that is not led out of himself in dreams and nocturnal visions, and sees much when sleeping which he had never seen waking?'[48]

Discussions of the *Canon episcopi*, focusing on the nocturnal flight ('transport' or 'transvection') of witches to their sabbats, were very common in this first phase of early modern demonology and they dominated the way the issue of witchcraft's very reality was raised—as well as helping to situate an engraving like Agostino Veneziano's *Lo stregozzo* (on the cavalcade or ride of witches) at 'a very rare intersection between heretical and artistic instances of *fantasia*'.[49] Quickly, the *Canon* became synonymous with the suspicion that witchcraft might turn out to be a demonically induced figment of the dreaming imagination, a position it retained throughout the early modern centuries. It is indicative of this that Johannes Nider, who appears to have accepted the force of the *Canon*'s argument, first raised the issue of witchcraft not in book 5 of his *Formicarius* (dating from around 1437, and subtitled *De visionibus ac revelationibus*) but in chapter 4 of book 2. Here his topic was the different types and causes of dreams and the possibility of being so deceived by them after waking that dreamers thought they had really seen 'what ha[d] passed only in the interior consciousness'.[50] Writing in 1458, the French Dominican Nicolas Jacquier, who very definitely did not accept the *Canon*'s apparent implications, still thought it important to begin his *Flagellum haereticorum fascinariorum* with a general chapter on 'illusion' ('Quid sit illudere[?]'), followed immediately by another on how demons could deceive the sleeping by 'false representations'. The human body itself caused 'appearances' ('apparitiones') and 'similitudes' ('similitudines') to occur in dreams, giving the mind internal impressions of a seemingly present reality, and all the demons had to do was use the same method. By this means the deception of the sleeping person as to his or her real state could be complete. Even so, Jacquier went on to insist, demons could still really appear in the waking world and to the *exterior* senses ('secundum experientiam realem sensuum exteriorum') and so have real dealings with real witches. Demons, in other words, were properly perceptible, in one form or another, as well as being merely the *phantasmata* of the sleeping. There was, therefore, a difference between the cases covered by the *Canon* and those of the 'modern

witches' dealt with in the courts; witchcraft was not an imaginary thing after all. Naturally, the devil could still deceive the waking, not just morally but by creating things that appeared falsely to them as well; there was, nevertheless, a clear distinction between appearances that were 'perceptible, visible, and palpable' to the external senses ('sensu perceptibilia, visibilia, et palpabilia') and those made in dreams ('fiunt per somnia'). Of this, the sexual and other exertions of the sabbat were physical confirmation.[51]

Discussions whose terms, if not their complexity or outcome, were similar to these recur in Girolamo Visconti's *Lamiarum sive striarum opusculum*, written about 1460, and in Bernard of Como's *Tractatus de strigibus*, written around 1510. In 1489, in Ulric Molitor's *De lanijs et phitonicis mulieribus*, the three (real) participants in an imaginary debate reached the conclusion that witches 'do not travel many miles by night or meet together; but only in dreams, by impressions caused by the devil, these and other things appear to them, and afterwards when awake they are deluded into thinking them to have happened'. The Franciscan Samuel de Cassini and the Dominican Vincente Dodo clashed over the *Canon episcopi*'s implications in the first decade of the sixteenth century, and another cycle to the debate occurred in the 1520s between Paolo Grillando (*Tractatus de sortilegiis*, written c.1525) and Mazzolini Da Prierio's successor (and disciple) at Rome, Bartolommeo Spina (*Quaestio de strigibus*, 1523, and *Apologia de lamiis contra Ponzinibium*, 1525), both of whom argued that sabbats and sabbat attendance were real and not done through 'the power of illusion in dreams', and Gianfrancesco Ponzinibio (*Tractatus de lamiis*, written c.1520), who took the opposite view.[52]

Grillando's version of the issues at stake is probably typical of how the argument stood by the middle of the sixteenth century, as well as being a record, apparently, of his own conversion regarding this 'very difficult and notorious' question ('quaestio . . . multum ardua, et famosa'). He had formerly believed, as he said most of the jurists did, that the *Canon* ruled out witchcraft's contemporary reality. Now, however, he sided with the theologians in accepting that Satan had both the incentive and the natural powers to make witchcraft a physical possibility. This did not negate what the *Canon* had actually said; it simply meant that it applied to a different historical case—not to *this* sect of witches but to an earlier one that had indeed been deceived in sleep. Its members, Grillando readily conceded, while never leaving their beds, had been so effectively tricked by the 'figures' and 'images' placed in their dreams by the devil that even though these were seen only with 'the eye of the mind' ('oculo mentis') they were taken to be solid and true and, so, firmly believed to be real.[53]

From the 1560s onwards it was probably Johann Weyer's adoption of the dream explanation in his *De praestigiis daemonum* (which we will look at shortly) that gave the arguments of the *Canon episcopi* most currency, along with the support that Weyer received from other sceptics like Johann Georg Godelmann. But they

had already become a standard ingredient of witchcraft theory and there was virtually no subsequent contribution to the witchcraft debate that did not pay some attention to them. There is a major survey of the arguments by the early seventeenth-century German theologian Adam Tanner, and the Spanish canon lawyer Pedro Antonio Jofreu still felt the need to add a lengthy defence of the *Canon* to his annotated edition of Ciruelo's *Reprobación de las supersticiones y hechicerías* in 1628.[54] In 1587, in his *Pneumalogie: discours des esprits*, the French Dominican Sebastien Michaëlis (who was involved in witchcraft trials at the time) even wrote that the question of 'whether that which sorcerers do depose do happen unto them by dreames and diabolicall illusions, or whether they really practise the same' was 'the very knot of the difficulty' raised by the whole subject of witchcraft. He also noted, significantly, that, thus far, no author, ancient or modern, had managed to solve it.[55] Nicolas Rémy, the *procureur général* of Lorraine, said much the same thing in the 1590s—that a great controversy had arisen over whether witches really went to their assemblies or were 'only possessed by some fantastic delusion, and, as happens when the empty mind is filled with dreams at night, merely imagine that they are so present', and that there were good arguments on both sides of the dispute.[56] And one does get the impression that by this time many writers on witchcraft were fudging the issue anyway, conceding that while many cases of nocturnal transvection to the witches' sabbat (and the sabbat itself) were undoubtedly true occurrences, others were indeed the product of dreaming. By so doing they were able to absorb the arguments of the *Canon episcopi* without this threatening the fundamentals of their demonology.[57]

Some of the confusions and ambiguities that resulted are worth noting. In a chapter entitled 'Whether Witches are Really Transported from Place to Place to their Nightly Assemblies', Francesco Maria Guazzo, who was definitely a fudger on the issue, admitted that witches were 'very often the victims of illusion' but not 'always so'. They were therefore sometimes

> actually present at the Sabbat; and often again they are fast asleep at home, and yet think that they are at the sabbat; for the devil deceives their senses, and through his illusions many imaginings may enter the minds of sleepers, leaving them with a conviction of their reality when they awake, as if it were not a dream but an actual experience and an undoubted physical action.

There was an added complication; witches might *choose* to attend 'only in dream'. To do this they went to sleep on their left sides.[58] They could also stay awake and yet see what was going on at the sabbat from afar: 'by some devils' work they send a thick vapour from their mouths, in which they can see all that is done as if in a mirror.'[59]

Likewise, for Rémy, who accepted both waking and sleeping sabbats, the idea that witches could be 'merely visited in their sleep by an empty and vain imagination' rested on the devil's power to impress images on their minds. This was in line, he said, with the optical theories mentioned in Aristotle's *De sensu et sensibili*,

whereby objects were said to be perceived by the eyes and then communicated to the brain 'not by the penetration of rays but by the reception of images, as in the case of a mirror'.[60]

The great Jesuit authority on witchcraft, Martín Del Río, tried to be categorical about the difference between the sleeping and waking experiences of witches but ended up by confusing them. To the idea that witches should be thought of 'as being like those who sleep' he responded that they did virtually everything while they were awake. In any case, things done while asleep were not blameless because they were premeditated. Witches did sometimes think that something had happened to them while they were awake, although they were dreaming at the time. But in the case of the sabbat they did everything that witches normally did in order to attend and so were still culpable. Besides, the thing one person dreamed might sometimes 'actually happen' and be seen by someone else. And the sorts of visual deceptions that the devil inflicted on people who were awake were also best compared to what 'usually happens to a sleeper in dreams' ('in somnis accidere dormienti').[61]

One of the most extensive discussions of this sort was offered by Michaëlis himself, citing as his contemporary target only one work—Godelmann's Rostock disputation of 26 February 1584 (an early version of his *De magis, veneficis et lamiis* of 1591). 'Those things which are dreames to some', wrote Michaëlis, 'are truthes to others', in the sense that one person may dream of something that another actually carries out. This meant that 'those things which are reported of sorcerers might bee both dreamed and done', making the *Canon episcopi* redundant. At the same time, 'men may thinke they see the body of a man, when it is nothing so, and having their eyes dazeled and disaffected, they may mistake one thing for another'. There were thus three possibilities with regard to the witches' sabbat:

for either they sleepe and dreame, or they goe thither really, or the Divell putteth himselfe in their place, and carrieth them some where else. Thus may these sundry waies be all true, and such an accident may happen either meerely in a dreame, or really and indeed; or else the body which appeareth to lie asleepe may prove a phantasme, although it may so fall out, that sometimes it is the true body of him, whose wee thinke it to bee: The difficulty then lyeth in the distinguishing and discerning when such a thing really is acted, or when there is but an apparancy of the same by dreames and impostures.[62]

Quite so! But amidst this muddle, epistemological problems were clearly being raised alongside the moral ones. Many 'demonologists' had to deal with both of these in any case, simply because they usually discussed divination in all its forms, including oneiromancy (the 'observation of dreams'), as well as the issues raised by the *Canon episcopi*—albeit often in different parts of their texts. But whether they fully embraced the sceptical implications of reducing witchcraft experiences to dreams or fudged the issue by assigning some of them to waking reality as well, the same paradox kept recurring. Over and over again, witches were said to be utterly convinced that what they had seen and done in dreams were true experiences, indistinguishable from their waking equivalents. The manner in which this was

insisted upon needs to be emphasized, so important is it to the argument of this chapter. Around 1460 Girolamo Visconti of Milan (who nevertheless accepted the independent reality of the sabbat) said that witches, when awake, 'firmly believe [their dreams] all to be true and take delight in it', earning punishment not for the dreams themselves but for this act of rational assent to the imaginary. Perhaps a decade later Giordano da Bergamo wrote that the belief in the reality of dreamed sabbats persisted until a witch's death. Ciruelo thought that witches accepted them 'because they have dreamed the experience and can relate its content'. According to Petrus Thyraeus, late in the sixteenth century, any witch suffering from the delusory *species* described in the *Canon episcopi* could 'scarce persuade herself' that she was not at the sabbat. Pierre de La Primaudaye was thus only reflecting the general opinion when he included in his popular compendium of general knowledge, the *Academie françoise*, the statement that the minds of 'sorcerers' were so troubled by 'sundry strange illusions, that they verily thinke that they have seene, heard spoken, and done that which the divell representeth to their fantasie . . . and yet all that while they stir not out of their bed, or out of some one place'. These impressions were so strongly imagined 'that they can not thinke otherwise but it is so, that they have done such things, and that they were awake when indeed they slept'. In mid seventeenth-century France, François Perrault repeated the idea that sabbats imagined in dreams seemed real on awakening because the memory 'represented' images of them to the exterior senses. Meanwhile, in Germany, Adam Tanner concluded that such was the extent to which witches related dream experiences for facts ('delusae somnia pro factis narrent') and 'most firmly believed dreams to be bodily translations' ('corporales translationes esse firmissime sibi persuaserunt'), that none of them could be trusted to distinguish real sabbats from imaginary ones. Testimony from them on the subject was therefore useless, a point which was reiterated by Increase Mather, still citing the *Canon episcopi*, in New England in 1692.[63]

Writers on witchcraft may have put this idea to different, even contradictory, uses, but this did not detract from its significance as an expression of a visual paradox. They did the same with a story that was often told to illustrate it—a narrative so repetitive and formulaic that one immediately suspects the textual artifice involved. It described (in various versions and modulations) a woman who claimed to attend the sabbat, or who was accused of attending it, being isolated in a room, made to smear herself with the witches' ointment (or becoming insensible by some other means), and then watched over by those—usually men—who regarded her as deluded. On waking up, she was then told what her 'witchcraft' had amounted to—a 'proof' usually underlined by the marks of injuries inflicted on her or suffered by her while asleep. This was the story-type that Nider chose for his analysis of the *Canon*, and it reappeared throughout the early modern period, in one form or another, whenever witchcraft theorists wished to establish that the devil, as Nider had himself said, 'impresses the fantasm [the *phantasmata* of witchcraft] so strongly on the soul that it can recognize nothing else'.[64] It seems to be

the inspiration for the Italian Mannerist painter Taddeo Zuccaro's *Sleep*, depicting a sleeping 'witch' who grasps poppy stalks in one hand and a broomstick in the other, while dreaming of the wild extravagances of the sabbat (Fig. 24). And in the early seventeenth century it was ridiculed by Cervantes in his *The Dogs' Colloquy*, in the form of this reported but highly revealing statement by a 'witch':

> Some people think we go to these gatherings only in our imagination, and that through it the devil presents to us images of all those things which we say afterwards have happened to us. Others deny this, and say that we really go, body and soul. I myself hold that both these views are true, for we don't know whether we go in imagination, or in reality, because everything that happens to us in our imagination happens in such an intense way that it can't be distinguished from the times when we go really and truly.[65]

Clearly, the *Canon* itself had no difficulty in separating dreaming from wakefulness, describing as 'stupid and foolish' those who could not. Nor presumably did those writers who were sceptical of witchcraft's reality who later cited it or took up a similar position, or, again, those who sat on the fence. The thoroughly sceptical Englishman Reginald Scot, for example, who agreed 'that witches nightwalkings are but phantasies and dreames', thought it incredible '(if those things happened in dreames, which neverthelesse the witches affirme to be otherwise) that when those witches awake, they neither consider nor remember that they were in a dreame'.[66] Nevertheless, both the *Canon* itself and those who later applied it to all forms of witchcraft ended up giving the devil the kind of power that could subvert the very distinction they were insisting upon. Even the fudgers fell into this danger. Not only did they undercut their own insistence that sabbat attendance really happened by conceding that sometimes it was dreamed; they also explained the dreamed instances by saying that, through them, the devil wished to encourage sceptics to write witchcraft off as imaginary so that he could get on with his evil work more effectively. The only consistently realist position (as we might term it today) was to refuse to concede that *any* aspect of witchcraft was dreamed, a possibility that few seem prepared to insist upon. Short of this, men who presumably adopted Aristotelian criteria for distinguishing between sleeping and waking ended up sounding like Aristotle's Pyrrhonist (or at least academic) opponents. In effect, the witchcraft debate reminded early modern intellectuals—intellectuals like Montaigne and Descartes—that demonic dreams could be epistemologically paradoxical *as well as* morally worthless.

Sometimes, indeed, witchcraft theorists could sound exactly like Descartes (and even, perhaps, a little like Wittgenstein) when they discussed the dreams of witches, even if the outcome was not supposed to be epistemological scepticism. Silvestro Mazzolini Da Prierio, who was vicar-general of the Lombard Dominicans and inquisitor in Milan in 1508–11, then professor of philosophy and theology in Rome and a papal official and apologist, was actually an authority on Aristotle—although not on his theories of perception.[67] But in both the entry for 'Heresy' in his alphabetical *summa* of the cases of conscience faced by

Catholics and also in his later demonology *De strigimagarum, daemonumque mirandis*, completed in 1520, he made what look like dangerous concessions to sensory uncertainty. Witches, he said, were sometimes ('mostly' in the earlier book) carried to their sabbats only in their imaginations ('in spiritu, id est phantasia'), and yet sometimes really and corporally. Otherwise, a great many of the Inquisition's witchcraft verdicts would turn out to be false (including many of Da Prierio's own) and its very jurisdiction would lose validity. At the same time, the witches themselves would be denied the ability to make a distinction that was essential to everyone's sensory experience—the distinction between waking and sleeping. They themselves insisted that they were carried off to their sabbats while they were awake, a use of language that possessed a kind of intrinsic sense. Finally, the evidence of the senses would be undermined:

> For there are many things known by experience regarding this matter, which cannot rationally be denied to be truly done any more than that I am now writing, which someone can of course if he so wish deny, saying that I and others are deluded by trickery (*praestigio*), and that it [only] appears that I write, whereas I do not.

This is striking enough, even without the further complication that, while witches were sometimes 'really' carried off ('realiter et vere'), this could also happen 'invisibly during the day'. Where, then, did this leave the evidence of the senses?[68]

If greater clarity on the issue is to be found anywhere in the literature of witchcraft, we should probably look for it, finally, in the writings of those who were undoubtedly most conscious of what was at stake—the so-called witchcraft 'sceptics'. Well before either Montaigne or Descartes, Johann Weyer—for whom the demonic pact was a fable and sabbats were just phantasms or dreams—was describing sensory delusion in a manner that made no distinction between the waking and sleeping state. Witches, he said in his 'Preface', were women who,

> being by reason of their sex inconstant and uncertain in faith, and by their age not sufficiently settled in their minds, are much more subject to the devil's deceits, who, insinuating himself into their imagination, *whether waking or sleeping*, introduces all sorts of shapes, cleverly stirring up the humours and the spirits in this trickery.[69]

The accusation that they stole children's bodies from graves was 'nothing but a suggestion of the Devil, stemming from imaginative powers which have been corrupted or else impaired by profound sleep'. Despite this, witches ' "know" these things just as if they were true ... through forms impressed upon their powers of imagination. Therefore, ... they openly acknowledge as their own crimes [those] which are known to them only by dreams and images.'[70] '[T]hey are devoutly confident that all the forms imposed by him upon their powers of imagination and fantasy exist truly.' Indeed!

> they cannot do otherwise, since from the time of their first assent he has corrupted their mind with empty images, lulling or stirring to this task the bodily humors and spirits, so

that in this way he introduces certain specious appearances (*species aliquas*)[71] into the appropriate organs, just as if they were occurring truly and externally; and he does this not only when people sleep, but also when they are awake. In this manner, certain things are thought to exist or to take place outside of the individual which in fact are not real and do not take place, and often do not even exist in the natural world.[72]

This particular form of visual paradox was entirely consistent with the behaviour of the imagination when impaired, and it was supported by Aristotle's writings on sleep and dreams. Weyer cited *De somno et vigilia* to show that demons could 'move the humo[u]rs and spirits of sensations both interior and exterior and thus bring certain forms and appearances to the sense-organs as though the objects themselves were truly presenting themselves to us from without'. Again, he insisted that this could happen '*in sleep or wakefulness*'.[73] From *De somniis* came further useful ideas about 'the images which appear in dreams'—for example, that they took on various forms through mental 'exhalations', with demon-images being produced by 'black and melancholic' vapours into which the devil insinuated himself in order to perform his 'mocking illusions'. The things 'thus seen' were believed to be true because the 'sentient soul' was 'imprinted' with forms 'as though with the things themselves'. In effect, witches experienced when waking 'what others see in sleep'; Varro called such images *imagines somnorinae*, added Weyer—'that is, images "seen in sleep" '. In them, forms of non-existent things were 'apprehended as real objects'.[74]

Friedrich Spee von Langenfeld, whose *Cautio criminalis* appeared at Rinteln in 1631, was another who pondered the significance of dreams from a position hostile to the culpability of any witch. To grant, as even his adversaries did, that the devil could plant 'phantasms' in the heads of witches, to make them think 'that they were, saw, and did what has never been seen or done anywhere' was tantamount, he thought, to dreaming—that is, experiencing 'images and not real things'. No judge could accept testimony from someone so deceived as to be incapable of distinguishing 'with sufficient certainty between phantasms and real things' ('inter phantasmata et res veras'). It might seem implausible 'that somebody could not know how to distinguish between those things which he really experienced and those in his imagination, for even if we are sure we are awake in a dream when we are actually sleeping, once we wake up, however, we can perceive quite clearly that we were only sleeping'. Spee's answer was that while, ordinarily, we can distinguish adequately between dreaming and waking when we are awake, the devil still had the ability to confuse men and women so completely—whether waking or sleeping—that 'they cannot distinguish between true and false'.[75]

This alarmingly sceptical conclusion was confronted in England too, in the most explicitly epistemological account of witchcraft written by an Englishman, the Puritan physician from Nottingham John Cotta. His *The Triall of Witch-Craft* (1616) is in fact a careful study of the criteria for establishing certain knowledge of a subject like witchcraft by means of sensory perception, rational judgement,

and probable conjecture. In chapter 6, Cotta discusses 'such supernaturall workes as are offered by the Divell . . . unto the outward sense' in which 'man hath an interest and propertie by contract'. Examples were the vision of Samuel raised by the 'Witch of Endor', of which the eyes and ears of King Saul were 'certaine witnesses', and the feats of the sorcerers of Egypt seen by Pharaoh 'with his eyes'.[76] Apparitions of the dead and the transportations of witches were in the same category; they were things which 'whether true or no, cannot be knowne, but to him that doth himselfe behold, and can from his owne sight avouch them really true, and not imaginarie'.[77] What happened, then, when the same person was seen in two different places at once? In such cases, the devil, like a juggler, was able to counterfeit 'the lively shape and pourtraiture' of a man in one location, adding exactly the right 'speech and gesture', while his true substance was 'certainely and truely seene in another place'. What happened, too, when a man dreamed about being transformed into an ass and this very same thing, 'at the same time, [and] in the same manner', was seen to occur by those who were awake? In this instance, the answer lay in the devil's ability to

fasten such dreames . . . upon men, and according to those dreames to cause the things dreamed, by the witnesse and testimony of other beholders, to bee brought to passe in so lively likenesse and similitude, as cannot bee discerned and discovered otherwise then the very same that they were in dreame likewise beleeved.

In other words, things that seemed manifest to the sense of sight might turn out to be only 'deceits of the imagination and illusion' and therefore not certain 'unto the outward sense' after all.[78]

This is a doubt that, even though he mentions it, Cotta cannot really allow. His discussions about people being seen in two places at once and about dreaming and waking experiences being indistinguishable are a *digression* from his main interest—demonic works that are both possible in nature and 'manifest to sense' and with which human beings collude. There should, then, be a way of distinguishing (as in the case of apparitions) between 'only illusion and imagination [and] some thing truely and really visible unto the outward sense'. In one respect, says Cotta, there is no problem at all. In Aristotelian terms, the true and natural visual object is only ever 'the outward shape and figure, and proportion of any substance' ('rerum species') and not the substance ('res') itself. Thus, in counterfeiting apparitions by offering 'outward lively pourtraitures' of them, the devil is indeed presenting 'true, reall, and naturall objects, certaine and assured unto the eye and sight'. In this respect he acts like a 'cunning Painter'—in fact, like any user of a mirror; in offering the true shape, he offers a true and perfect object, manifest to at least the eyes.[79] As for the deceits that are purely illusions of the imagination, the answer is again Aristotelian although more straightforward. A person would have to be sick in body or mind (or both), says Cotta, not to be able to distinguish between 'when he doth see a certain object offered unto his sight from without, and when he is incountred only with a resemblance thereof from within his fancie

and imagination'. Nevertheless, what he says next does suggest that he was aware of the sceptical direction the witchcraft debate would take if this answer was *not* given:

> If men could not certainly discerne betweene that which they do really see, and that they falsely imagine in visions, dreames and fancie, then were the life of man most miserable, there could be no certainty of truth, no excelling in knowledge or understanding. All men should be a like unable to distinguish, whether we live in dreames only, or in wakefull deed.[80]

These were some of the ways in which Renaissance witchcraft theory, which was perhaps at its most intense in the period between Montaigne and Descartes, created opportunities for discussing demonic dreams as epistemological and visual paradoxes—the sorts of paradoxes usually reserved for philosophical discussion. We may even be witnessing a general shift from one kind of dream distinction, the theological true/false, to another, the positivistic *rêve/réalité*.[81] Be that as it may, these discussions offer further help in understanding why Montaigne should have applied the scepticism regarding dreaming and waking that he outlined in the 'Apology for Raymond Sebond' in book 2 of his essays to the subject of witchcraft, tackled in the later essay entitled 'Des boîteux' ('Of cripples') that appears in book 3—where, as we have already seen, witchcraft is attributed in part to dreaming. They may also help to clarify both why Descartes should have attributed (even 'hyperbolically') the state of total doubt arising from the inability to distinguish truth from illusion to an 'evil genius', and also why modern commentators on the 'demon hypothesis' regard this as the ultimate expression of sceptical doubt.[82] Descartes's later comments to Frans Burman on this crucial step in his own argument were that he was trying to throw his readers into as much doubt as possible, preparatory to rescuing them from it: 'This is why [the author] raises not only the customary difficulties of the sceptics but every difficulty that can possibly be raised; the aim is in this way to demolish completely every single doubt. And this is the purpose behind the introduction of the demon, which some might criticize as a superfluous addition.'[83] This is not a legacy of the 'witch craze' that either historians of witchcraft or historians of philosophy have cared to notice, but it seems exactly fitting that the demonology that began to be written in the 1430s should have ended up in this role two centuries later.

There are, moreover, two further instances that illustrate this point, taken from the period when the intellectual developments discussed in this chapter might be said to have been completed. In 1674–5, exactly a hundred years after the composition of the 'Apology for Raymond Sebond', Nicolas Malebranche published his *De la recherche de la vérité*. By any standards this was a major contribution to seventeenth-century epistemology, a work by a (somewhat unorthodox) Cartesian philosopher, premised on the assumption that radical scepticism about human knowledge, starting with the errors of the senses and their incapacity to represent bodies truly, must precede any serious search after truth. In analysing

these errors Malebranche speaks of 'experiences in sleep' disallowing any necessary connection 'between the presence of an idea to a man's mind and the existence of the thing the idea represents'. He also later subscribes to the Cartesian idea that all inferences drawn from simple perception fall down before the possibility 'that there is an evil genius who deceives us'. In these circumstances, it is impossible to prove that there is a world:

For we could always conceive that this evil genius would give us sensations of things that would not exist (as sleep and certain illnesses make us see things that never were), and even make us actually feel pain in imaginary members we no longer have or that we never had.

However, at the close of his account of the imagination, and immediately following a discussion of Montaigne's essays (to which he clearly owes a great deal), Malebranche inserts a chapter devoted to 'People Who Imagine Themselves to be Sorcerers and Werewolves'. Epistemology and demonology have become one subject. Like many participants in the witchcraft debate we have been examining, Malebranche noted that sorcerers were so convinced of attending the sabbat that 'although several persons watched them and assured them that they never left their beds, they could not accept their testimony'. The important point was that such a man 'thinks he sees things in the night that are not there and . . . , upon awakening, cannot distinguish these dreams from the thoughts he has had during the day'. The reason for this is that sabbats are by definition nocturnal:

The chief cause that prevents us from taking our dreams for reality is that we cannot connect our dreams with the things we have done while awake, for this is how we recognize that they are only dreams. Now imaginary witches cannot recognize by this means that their witches' sabbath is a dream, for they go to the witches' sabbath only during the night, and what happens at the sabbath cannot be connected to other actions during the daytime. Hence, it is morally impossible to disabuse them in this way.[84]

Twenty years previous to this, in 1655, another Frenchman, Michel de Marolles, Abbé de Villeloin, published a collection of mythographical designs based on the fables of Ovid. He was also just about to publish a collection of *Mémoires* (1656–7) that expressed his own reservations concerning the belief in sorcery and other forms of superstition, and included a tract by the translator of Sextus Empiricus into French, Samuel Sorbière, entitled *Discours sceptique*. The title of the collection of designs was *Tableaux du temple des muses* and it concludes with one for 'The Palace of Dreams', based on book 19 of the *Odyssey* and book 6 of the *Aeneid* (Fig. 25). Two doors represent the contrasting uses that the gods have chosen for dreams. On the right, there is a glimpse of dreams that will come true, symbolized by the horns of the bull; on the left, are dreams that will not come true, symbolized by the ivory tusks of the elephant. On the right, 'real miseries and dreary phantoms'; on the left, 'a multitude of grotesque figures, and fantastic images of things that never had a being, the emptiness of which is represented by

castles built in the clouds'. The statue of Diana or the Moon rises on the roof above, over the gate of ivory, 'because she generally appears during those hours designed for sleep'.[85] But Diana was also the goddess of the witches in the *Canon episcopi*, and below her, among the things 'that never had a being', there is a naked hag with hanging breasts and a wild look on her face, riding off, perhaps to meet her (Fig. 26). In this representation of the falseness of dreams, their immorality and their failure to come true had converged with their ability to cast doubt on the notion of visual reality itself.

NOTES

1. *Essays*, 451.
2. Descartes, 'Meditations on First Philosophy', in *Philosophical Writings*, ii. 15.
3. *Essays*, 451, cf. 422; commentary in Gisèle Mathieu-Castellani, 'Veiller en dormant, dormir en veillant: le songe dans les Essais', in Françoise Charpentier (ed.), *Le Songe à la Renaissance* (Saint-Étienne, 1989), 231–8.
4. Descartes, 'Meditations', in *Philosophical Writings*, ii. 13. There are similar remarks in 'Principles of Philosophy', pt. 1, principle 4 (*Philosophical Writings*, i. 194); 'Discourse on Method', pt. 4 (*Philosophical Writings*, i. 130–1); and 'The Search after Truth' (*Philosophical Writings*, ii. 408).
5. 'Meditations', *Philosophical Writings*, ii. 15. Descartes's epistemology of dreaming is discussed by his modern counterparts in Charles E. M. Dunlop (ed.), *Philosophical Essays on Dreaming* (Ithaca, NY, 1977).
6. For the view that it is *only* the senses at which the first of the *Meditations* is directed, see Frankfurt, *Demons, Dreamers, and Madmen*, 3–87.
7. Aristotle, *De somniis*, in *Parva naturalia*, 458b–462b.
8. Scipion Dupleix, *Les Causes de la veille et du sommeil, des songes, et de la vie et de la mort* (Paris, 1606), 63r–150v, who also conveniently sums up all the various theoretical opinions about the causation of dreams available at the time.
9. David Shulman and Guy G. Stroumsa (eds.), *Dream Cultures: Explorations in the Comparative History of Dreaming* (Oxford, 1999), 6; Martine Dulaey, *Le Rêve dans la vie et la pensée de Saint Augustin* (Paris, 1973), 18–19.
10. Thomas Hill, *The moste pleasaunte arte of the interpretacion of dreames* (London, 1576), sigs. Biiv, Dvii^{r-v}; to the question why dreamers see (or hear) things at all, Hill gave Aristotle's answer: that 'the motion ceassing by whiche the formes are troubled, the similitude then of the matter which was seene doth represente the acte of seeying, and heard, the act of hearing, by whiche they were caused' (sig. Ciii^{r-v}).
11. Philip Goodwin, *The mystery of dreames, historically discoursed* (London, 1657), 11–12, 13.
12. Fernel, *'Physiologia'*, 343; Dupleix, *Causes de la veille*, 65v, 66v; Hartley cited in Carole Susan Fungaroli, 'Landscapes of Life: Dreams in Eighteenth-Century British Fiction and Contemporary Dream Theory', Ph.D. dissertation (University of Virginia, 1994), 29.
13. Alice Browne, 'Dreams and Picture Writing: Some Examples of this Comparison from the Sixteenth to the Eighteenth Century', *J. of the Warburg and Courtauld Inst.* 44 (1981), 90–100.

14. Moyse Amyraut, *Discours sur les songes divines dont il est parlé dans l'Écriture* (Saumur, 1665), trans. James Lowde as *A discourse concerning the divine dreams mention'd in Scripture* (London, 1676).
15. For Fletcher and Pascal, see Roger Ekirch, 'Sleep We Have Lost: Pre-Industrial Slumber in the British Isles', *American Hist. Rev.* 106 (2001), 381 n. 116. For Addison ('The Theatre of Dreams', *Spectator*, 487, 18 Sept. 1712) and Beattie ('Of Dreaming', in *Dissertations Moral and Critical*, London, 1783) see Fungaroli, 'Landscapes of Life', 58, 70–1.
16. [Charles Gildon], *The post-boy rob'd of his mail: or, the pacquet broke open* (London, 1692), 109, cited by Janet E. Aikins, 'Accounting for Dreams in *Clarissa*: The Clash of Probabilities', in Christopher Fox (ed.), *Psychology and Literature in the Eighteenth Century* (New York, 1987), 176. I also owe the quotations from Cudworth and the list of other interested authors to Aikens, who provides full references; see ibid. 175–6, 194: nn. 25–7. For Hobbes, see Ch. 10 below.
17. Charles Sorel, *La Science universelle* (1634–41), cited in Roger Ariew et al. (eds.), *Descartes' 'Meditations': Background Source Materials* (Cambridge, 1998), 228–9.
18. S. R. F. Price, 'The Future of Dreams: From Freud to Artemidorus', *Past and Present*, 113 (1986), 3–37.
19. At least in the works cited: in November 1619 Descartes experienced dreams that he interpreted in a purely traditional Macrobian manner as reliable prognostications 'from above' ('somnia') of his own intellectual career as a philosopher. On this and the modern literature relating to it, see Stephen Gaukroger, *Descartes: An Intellectual Biography* (Oxford, 1995), 104–11; John R. Cole, *The Olympian Dreams and Youthful Rebellion of René Descartes* (Urbana, Ill., 1992); and Fernand Hallyn, 'Olympica: les songes du jeune Descartes', in Charpentier (ed.), *Le Songe*, 41–51. Hallyn wonders how, for Descartes, 'le songe peut-il, du temps de la plus haute certitude, devenir celui de la plus grande vraisemblance?' (51). See also Peter Holland, ' "The Interpretation of Dreams" in the Renaissance', in Peter Brown (ed.), *Reading Dreams: The Interpretation of Dreams from Chaucer to Shakespeare* (Oxford, 1999), 127, for the fact that Descartes even said that a 'Spirit' ('Génie') had predicted the dreams—the 'Spirit of Truth'. Montaigne, by contrast, 'claimed to have had few dreams to record' and had little interest in them except as conceptually paradoxical; see ibid. 132–3.
20. Macrobius, *Commentary on the Dream of Scipio*, ed. and trans. W. H. Stahl (New York, 1952; repr. 1990), 88–9: 'The apparition (*phantasma* or *visum*) comes upon one in the moment between wakefulness and slumber, in the so-called "first cloud of sleep." In this drowsy condition he thinks he is still fully awake and imagines he sees spectres rushing at him or wandering vaguely about, differing from natural creatures in size and shape, and hosts of diverse things, either delightful or disturbing.'
21. For this point and much else in this and the preceding paragraph, I rely on Jacques Le Goff, 'Christianity and Dreams (Second to Seventh Centuries)', in id., *The Medieval Imagination*, trans. Arthur Goldhammer (Chicago, 1988), 193–231; see also on Macrobius and the *visum*, Steven F. Kruger, *Dreaming in the Middle Ages* (Cambridge, 1992), 21–3. For another survey of ancient dream theory, see Patricia Cox Miller, *Dreams in Late Antiquity: Studies in the Imagination of a Culture* (Princeton, 1994).
22. Le Goff, 'Christianity and Dreams', 208 (for Tertullian); Kruger, *Dreaming*, 44–50; Guy G. Stroumsa, 'Dreams and Visions in Early Christian Discourse', in Shulman and Stroumsa (eds.), *Dream Cultures*, 189–212, esp. 196–7. See also in the same essay

collection Jean-Claude Schmitt, 'The Liminality and Centrality of Dreams in the Medieval West', 274–87; and for later medieval dream theory, particularly in Avicenna, see Kemp, *Cognitive Psychology*, 95–101.

23. Christine Walde, 'Dream Interpretation in a Prosperous Age? Artemidorus, the Greek Interpreter of Dreams', in Shulman and Stroumsa (eds.), *Dream Cultures*, 122.
24. Plato, *Theaetetus*, 158, in *Dialogues*, iv. 212–13. Cf. Steven S. Tigner, 'Plato's Philosophical Uses of the Dream Metaphor', *American J. of Philology*, 91 (1970), 204–12, and the statement in Plato's *Republic*, 476: 'Reflect: is not the dreamer, sleeping or waking, one who . . . puts the copy in the place of the real object?': *Dialogues*, iii. 174.
25. *Academica*, ii. 40–1 and, on dreams specifically, ii. 51–2, where the idea debated is that 'at the time when we are experiencing them the visions we have in sleep have the same appearance as the visual presentations that we experience while awake': ed. cit., 517–19, 531–3.
26. Augustine, *Literal Meaning of Genesis*, ii. 179–80; Dulaey, *Le Rêve*, 74–6 (citing the same dream relation), 89–93 (on Augustine's dream classification); Kruger, *Dreaming*, 35–56.
27. *Outlines of Pyrrhonism*, i. 104, ed. cit., 103. For the suggestion that Artemidorian oneirocriticism might itself have been influenced by scepticism, see Artemidorus, *The Interpretation of Dreams: Oneirocritica by Artemidorus*, trans. and ed. Robert J. White (Park Ridge, NJ, 1975), 9–10.
28. Price, 'Future of Dreams', 32. The Welsh version is [Thomas Jones], *Gwir ddeongliad breuddwydion (A true interpretation of dreams)* ([Shrewsbury], 1698); I owe this reference to the kindness of Lisa Tallis.
29. Hill, *Moste pleasaunte arte*, Dedication. On Hill (whose arguments are difficult to follow without help), see Holland, ' "Interpretation of Dreams" ', 142–4.
30. Patricia Crawford, 'Women's Dreams in Early Modern England', *Hist. Workshop J.* 49 (2000), 138.
31. Ekirch, 'Sleep We Have Lost', *passim*, esp. 344, 381–2, with examples in n. 116.
32. F. Berriot, 'Clés des songes françaises à la Renaissance', in Charpentier (ed.), *Le Songe*, 21–32; on Cardano and dreams, see Alice Browne, 'Girolamo Cardano's *Somniorum synesiorum libri iiii*', *Bibliothèque d'humanisme et Renaissance*, 41 (1979), 123–45, summarizing much of Renaissance dream theory; Carol S. Rupprecht, 'Divinity, Insanity, Creativity: A Renaissance Contribution to the History and Theory of Dream/Text(s)', in ead. (ed.), *The Dream and the Text: Essays on Literature and Language* (Albany, NY, 1993), 112–32; Eamon, *Science and the Secrets of Nature*, 280–1; Peter Burke, 'The Cultural History of Dreams', in id., *Varieties of Cultural History* (Cambridge, 1997), 23–42.
33. Typical examples in Thomas, *Religion and the Decline of Magic*, 128–30.
34. Holland, ' "Interpretation of Dreams" ', 140.
35. Peucer, *Commentarius*, 185^{r-v}, 197^{r-v}, 200v–203r. All later Lutherans and many Calvinists followed Peucer; see, for example, Bernhard Albrecht, *Magia; das ist, Christlicher Bericht von der Zauberey und Hexerey ins gemein* (Leipzig, 1628), 139–65 (ch. 12: 'Die Träumer'). The association of dreaming with 'Anabaptist' error is also in Philipp Melanchthon, *Commentarius de anima* (Wittenberg, 1540), fo. 151v ('De somniis'). The Church of England clergyman Goodwin, *Mystery of dreames*, 27–85, employed the true/false distinction in a similarly non-epistemological way, with many

attributions of false dreams to the religious radicals and 'enthusiasts' of the 1640s and 1650s. For Catholic versions, see Del Río, *Disquisitionum magicarum*, 590–8 (bk. 4, ch. 3, q. 6: 'De coniectatione ex somniis'), and Torreblanca, *Daemonologia*, 140–8 (bk. 1, ch. 25).

36. Charron, *Of wisdome*, 45–6; cf. Marandé, *Judgment of humane actions*, 43; La Mothe Le Vayer, 'Opuscule ou petit traitté sceptique', 239.
37. Thomas Hobbes, *Elements of Philosophy*, in *The English Works of Thomas Hobbes of Malmesbury*, ed. William Molesworth (11 vols.; London, 1839–45), i. 400; cf. id., *Leviathan*, ed. cit., 17–19.
38. The Spanish theologian Pedro Ciruelo reserved the term 'moral' for those dreams caused by the previous day's preoccupations; see id., *A Treatise Reproving all Superstitions and Forms of Witchcraft*, trans. E. A. Maio and D'O. W. Pearson, ed. D'O. W. Pearson (London, 1977), 160–1.
39. Quite apart from what follows in the rest of this chapter, the relationship between dreaming and waking reality was obviously of considerable appeal in many literary contexts; see the essays in Brown (ed.), *Reading Dreams*, and Peter Holland's Oxford Shakespeare edn. of *A Midsummer Night's Dream* (Oxford, 1994). For the opportunities afforded by dream states and waking illusions for transformative exchanges of reality and illusion throughout Shakespeare's plays, see Marjorie B. Garber, *Dream in Shakespeare: From Metaphor to Metamorphosis* (New Haven, 1974), esp. ch. 2 on *A Midsummer Night's Dream*, where Garber remarks that this is a play that 'reverses the categories of reality and illusion, sleeping and waking, art and nature, to touch upon the central theme of the dream which is truer than reality' (59).
40. Le Loyer, *Treatise*, 2^{r-v}, cf. 55^{r-v}; cf. id., *IIII livres des spectres*, 594–642, and the much-expanded later edition, *Discours des spectres* (Paris, 1608), 422–76. For Le Loyer, see Ch. 6 above.
41. [More], *Enthusiasmus triumphatus*, 3–4, cf. 27; Casaubon, *Treatise concerning enthusiasme*, 58–9.
42. Perrine Galand-Hallyn, 'Le Songe et la rhétorique de l' "enargeia" ', in Charpentier (ed.), *Le Songe*, 125–35; Greenblatt, 'Shakespeare Bewitched', 121.
43. Dupleix, *Causes de la veille*, 130r.
44. Hobbes, *Leviathan*, 17–19, 77, 257.
45. Lemnius, *Secret miracles of nature*, 140–1. For another resolutely reductionist version of the argument, see Vanini, *De admirandis naturae reginae deaeque mortalium arcanis*, 480–95 (Dialogus LX 'De insomniis'), esp. 484–5. On physicians' opinions concerning diagnosis by dreams, see Karl H. Dannenfeldt, 'Sleep: Theory and Practice in the Late Renaissance', *J. of the Hist. of Medicine and Allied Sciences*, 41 (1986), 431–2.
46. Aquinas, *Summa theologica*, pt. 1, q. 111, art. 3, in *Basic Writings*, i. 1028. Ch. 4 above suggests that this was not the limitation it at first sight seems, but it was nevertheless repeatedly taken up: see, for example, Sebastien Michaëlis, *Pneumalogy, or discourse of spirits*, in id., *Admirable historie*, 108; Robert Jenison, *The height of Israels heathenish idolatrie* (London, 1621), 35; [Gilpin], *Daemonologia sacra*, 25.
47. Dupleix, *Causes de la veille*, 80r, 111v–118r. For studies of the witches' dream, see Patrizia Castelli, ' "Donnaiole, amiche de li sogni" ovvero i sogni delle streghe', in *Bibliotheca Lamiarum: documenti e immagini della stregoneria dal Medioevo all'età moderna*, Biblioteca Universitaria di Pisa (Pisa, 1994), 35–85; James S. Amelang,

'Durmiendo con el enemigo: el Diablo en los sueños', in María Tausiet and James S. Amelang (eds.), *El Diablo en la edad moderna* (Madrid, 2004), 327–56.
48. The English text of the *Canon episcopi* is given in Edward Peters, *The Magician, the Witch, and the Law* (Brighton, 1978), 73–4, and in Lea, *Materials*, i. 178–80; Latin text in Hansen (ed.), *Quellen und Untersuchungen*, 38–9. The English rendering 'species' is obviously open to ambiguity, and 'image' would be more accurate, since the Latin word used in the *Canon* clearly refers to the Aristotelian theory of *species*.
49. Emison, 'Truth and *Bizzarria*', 623 and *passim*. On the broader discussions, see Werner Tschacher, 'Der Flug durch die Luft zwischen Illusionstheorie und Realitätsbeweis', *Zeitschrift der Savigny-Stiftung für Rechtsgeschichte*, 116, Kanonistiche Abteilung 85 (1999), 259–75; Stephens, *Demon Lovers*, 125–44; Swan, *Art, Science, and Witchcraft*, 175–8.
50. Lea, *Materials*, i. 260. There is an important reminder of this early alignment of witchcraft with dreams in the Latin–French edition of the relevant sections of Nider's *Formicarius* included in Martine Ostorero et al. (eds.), *L'Imaginaire du sabbat* (Lausanne, 1999), see esp. 122–43; see also Stephens, *Demon Lovers*, 157–8.
51. Jacquier, *Flagellum*, 1–51, 61–72, 182–3 (chs. 1–7, 9, 28). Stephens, *Demon Lovers*, 21–2 stresses the sexual proof more than the epistemological claim.
52. For Visconti, Bernard of Como, and Molitor, see Lea, *Materials*, i. 295–6, 370–3, 348–53 (quotation at 352). Stephens, *Demon Lovers*, 139, cites Molitor as follows: '[Witches see only] the representation of the similitudes of the appearances of things (*per representationem specierum similitudinarium*).' For the De Cassini and Dodo exchange, and for Ponzinibio and Spina, see Frédéric Max, 'Les Premières Controverses sur la réalité du sabbat dans l'Italie du XVIe siècle', in Nicole Jacques-Chaquin and Maxime Préaud (eds.), *Le Sabbat des sorciers* (Paris, 1993), 55–62.
53. Grillandus, *Tractatus de sortilegis*, in *Tractatus duo*, 87–8. The argument that the *Canon* was correct about delusion but referred to an earlier and unrelated sect was often used; for examples, see Arnaldo Albertini and Martín Del Río (Lea, *Materials*, ii. 452–4, 646).
54. Tanner, *Disputatio de angelis*, in *Diversi tractatus*, 59–69 ('De translatione sagarum ad earundem conventicula'); Ciruelo, *Treatise*, 246–9 (*summary* only; Jofreu's defence is at 251–64 of the Barcelona, 1628 edn.). For other contributions to the debate in Spain, see Amelang, 'Durmiendo con el enemigo', *passim*.
55. Michaëlis, *Pneumalogy*, 94.
56. Rémy, *Demonolatry*, 47.
57. For typical examples, see Philipp Ludwig Elich, *Daemonomagia* (Frankfurt am Main, 1607), 129–42; Arnaldo Albertini, *De agnoscendis assertionibus Catholicis et haereticis tractatus* (3rd edn.; 1572), in Lea, *Materials*, ii. 450–1, 454.
58. It was common, following Aristotle, to recommend lying on the right side for normal, healthy sleeping, at least initially.
59. Guazzo, *Compendium maleficarum*, 33, 37, 39.
60. Rémy, *Demonolatry*, 51–2.
61. Del Río, *Disquisitionum magicarum*, 659, 766, 315 (bk. 5, sect. 16; bk. 2, q. 29, sect. 2); cf. Maxwell-Stuart, *Martín Del Rio*, 227–8, 231, 230, 114. That a dream might be realized simultaneously in the waking world was allowed for in Artemidorian theory; see Artemidorus, *Interpretation of Dreams*, 15: '*Oneiros* is a movement or condition of the mind that takes many shapes and signifies good or bad

things that will occur in the future. Since this is the case, the mind predicts everything that will happen in the future, whether the lapse of time in between is great or small, by means of images of its own . . . [N]o one will ever deny that, directly after the vision itself or without even a short interval of time, such things happen. And, indeed, some of them come true at the very moment of perception, so to speak, while we are still under the sway of the dream-vision. Hence, it bears its name not without reason, since it is simultaneously seen and comes true.' For another much-cited text dealing with this possibility, see Augustine, *City of God*, ii. 174–5 (bk. 18, ch. 18); cf. Dupleix, *Causes de la veille*, 98ᵛ.

62. Michaëlis, *Pneumalogy*, 96, 98, 99, 100.
63. Lea, *Materials*, i. 295 (Visconti), 302 (Da Bergamo); Ciruelo, *Treatise*, 118; Petrus Thyraeus, *De variis tam spirituum, quam vivorum hominum prodigiosis apparitionibus, et nocturnis infestationibus* (Cologne, 1594), 107; La Primaudaye, *French academie*, 415; Perrault, *Demonologie*, 108; Tanner, *Disputatio de angelis*, in *Diversi tractatus*, 66; Mather, *A further account*, 35–6. For other similar statements, see Lea, *Materials*, i. 303 (Jean Vincent), and Jacquier, *Flagellum*, 182–3.
64. Lea, *Materials*, i. 271–2 (summarizing from Johannes Nider, *Praeceptorium divinae legis* (c.1470), ch. 10, which opened with a discussion of dreams); cf. id., *Formicarius*, in Ostorero et al. (eds.), *L'Imaginaire du sabbat*, 135–7 (bk. 2, ch. 4). There was a much cited version in Giambattista della Porta, *Magiae naturalis, sive de miraculis rerum naturalium* (Naples, 1558), 100–2 (reported as his experiment by, for example, Weyer, *De praestigiis daemonum*, Mora edn., 225–6; Michaëlis, *Pneumalogy*, 98–9; Godelmann, *Tractatus*, bk. 2, ch. 4, n. 22 (sep. pag.), 38–9, and Spee von Langenfeld, *Cautio criminalis*, 186), and another reported by the physician Andrés de Laguna. On Della Porta, see Giovanni Aquilecchia, 'Appunti su G. B. Della Porta e l'Inquisizione', *Studi secenteschi*, 9 (1968), 3–31, and on Laguna, see H. Friedenwald, 'Andres a Laguna, a Pioneer in his Views on Witchcraft', *Bull. of the Hist. of Medicine*, 7 (1939), 1037–48. On the story and its uses, see Stephens, *Demon Lovers*, 145–79, and for yet further versions, see Tanner, *Disputatio de angelis*, in *Diversi tractatus*, 66–7.
65. Quoted by Stephens, *Demon Lovers*, 145–6; see also Julio Caro Baroja, *The World of the Witches*, trans. O. N. V. Glendinning (London, 1964), 219–21.
66. Scot, *Discoverie*, 185–6.
67. Charles H. Lohr, 'Renaissance Latin Aristotle Commentaries: Authors Pi–Sm', *Renaissance Quart*. 33 (1980), 671–2.
68. Silvestro Mazzolini Da Prierio, *De strigimagarum*, 130–1; cf. id., *Summae Sylvestrinae*, 436.
69. Johann Weyer, *De praestigiis daemonum, et incantationibus, ac veneficiis* (Basel, 1583), 'Praefatio de totius operis argumento', 8 (this preface is not included in the 1991 translation). My emphasis.
70. Weyer, *De praestigiis daemonum*, Mora edn., 176.
71. The rendering of this phrase as 'specious appearances', which I give from the 1991 trans., is obviously quite inadequate to convey the full technical force of Weyer's reference to Aristotelian *species* in this and similar passages; for his Latin, see id., *De praestigiis daemonum*, 1583 edn., col. 253.
72. Weyer, *De praestigiis daemonum*, Mora edn., 101.
73. Ibid. 188. My emphasis.
74. Ibid. 189.

75. Spee von Langenfeld, *Cautio criminalis*, 185–6.
76. John Cotta, *The triall of witch-craft* (London, 1616), 31.
77. Ibid. 39.
78. Ibid. 33, 35, 36, 41.
79. Ibid. 37–8.
80. Ibid. 41–2; there are similar remarks in id., *A short discoverie of the unobserved dangers of severall sorts of ignorant and unconsiderate practisers of physicke in England* (London, 1612), 51–4.
81. As suggested by S. Perrier, 'La Problématique du songe à la Renaissance: la norme et les marges', in Charpentier (ed.), *Le Songe*, 14; cf. Schmitt, 'Liminality and Centrality of Dreams', 280–1 (who speaks of a 'great heuristic change'). For wide variations in views about the reality or non-reality of dream experiences in different modern societies, see Barbara Tedlock (ed.), *Dreaming: Anthropological and Psychological Interpretations* (Cambridge, 1987).
82. Groarke, 'Descartes' First Meditation'; Geoffrey Scarre has also linked 'demonic epistemology' in the previous century and a half, including its attribution of witch-craft to dreams, to Descartes's discussion of the 'evil deceiver'; see his 'Demons, Demonologists and Descartes', *passim*. According to Steven Nadler, exactly the same philosophical problem arises in the epistemology of the madness of Don Quixote, who likewise traced his visions to an 'evil enchanter' ('el maligno encantador'); see id., 'Descartes's Demon', 41–55.
83. 'Conversation with Burman, 16 April 1648', in *Philosophical Writings*, iii. 333.
84. Malebranche, *Search after Truth*, 48, 481, 192, 193, 194.
85. Michel de Marolles, *Tableaux du temple des muses* (Paris, 1655), 459–60; quotations from the anonymous English trans., *The temple of the muses* (London, 1738), 319–21. The engraver was Abraham van Diepenbeeck and the publication was based on a collection of drawings held by the jurist and poet Jacques Favereau. All the other 'tableaux' were inspired by scenes from *Metamorphoses*, but not, it seems, 'The Palace of Dreams', since Ovid (bk. 2) includes a 'house of sleep' but this does not draw on Homer or Virgil.

10

Signs: Vision and the New Philosophy

If, between the fifteenth and seventeenth centuries, as I have argued, European visual culture experienced not so much the rationalization as the de-rationalization of sight, it is important to ask what attempts were made to resolve the issue and restore visual confidence. To an extent, the matter was addressed semi-independently by the transmutation or decline of much of the intellectual activity that had brought it about. This was especially true of some of the main historical developments that I have highlighted. However one explains and dates this, the conviction ultimately went out of the belief that the devil intervened physically in human affairs and manipulated them to the point of absurdity. As Europe became more accustomed to confessional pluralism, the religious controversies about images, miracles, and apparitions also lost much of their earlier ferocity, even if they did not disappear. (The 'discernment of spirits' remains, in principle, essential to every attempt to rationalize religion.) At the same time, the general trend in philosophy and science became 'post-sceptical', in the sense that innovative seventeenth- and eighteenth-century intellectuals no longer felt they had to confront the challenges of Pyrrhonism as their more traditional colleagues had done: as something to be defeated. Rather, these challenges were absorbed by epistemologies that made doubt a presupposition of knowledge. As we shall see in a moment, this last transition was very far from being independent of theorizing about vision, but there is still a sense in which, in all these areas, threats to the rationality of sight (as traditionally understood) were lessened by changing historical circumstances rather than by self-adjustment.

The histories of the other features of de-rationalized seeing that were treated in earlier chapters tell a similar story of growing irrelevance. The mad continued (and continue) to see strange sights but no longer under the auspices of the melancholy imagination and with a perceived impact on the wider dynamics of sight that diminished in direct relation to their more secular diagnosis and differing institutional confinement. While dream interpretation continued to flourish, dream explanation took on a more and more naturalistic character that removed its subject matter from the realms of the divine and the demonic (and from prophecy altogether) and aligned it instead with the irrational and with mental illness. This neutralized its epistemological appeal, as did the growing resort to the most mundane of all views of dreams, expressed by Locke, that they were no more

than reordered waking experiences. In one typical modern opinion, '[a] view of dreaming as a process of external origin with intimations for an often collective future gives way to an increasing sense of dreaming as an internally generated phenomenon tied to the personal past of the individual dreamer'.[1]

In perhaps the best-studied case of all, the magical and artistic contrivances we explored in Chapter 3 relinquished their high intellectual and moral seriousness and aristocratic cachet and became more widely dispersed and routine forms of demonstration and entertainment. The subject of 'natural magic' itself lost whatever integrity it had enjoyed as a discipline, being either absorbed by mainstream natural philosophy, diverted into visual and mathematical recreation, or just quietly forgotten. Visual artifice and deceitful optical technology shifted in social location and appeal, becoming essential ingredients of what Barbara Maria Stafford has called 'artful science'. During the eighteenth century and after, the optical marvel retained all its sense of ingenuity and cognitive surprise, and remained, in Stafford's view, a vehicle for 'high-order thinking'. The verification of authentic visual experiences could still be an issue, as in any culture; in many of the contexts she explores, '[e]mpiricism unsettlingly resembled pseudoempiricism'.[2] Even so, one does not sense any continuing challenge to the visual and cognitive presuppositions of a whole era (what Stafford laments is the eventual eclipse of 'visual aptitude' *itself*). The illusory in vision became something that was instructive and improving—in some contexts, no more than playful—and was now much more safely enclosed than before within the needs of pedagogy, consumerism, or sheer amusement.

In this visual environment, the techniques for achieving anamorphisms, 'now stripped of their philosophic and legendary quality', took on the character of scientific curiosities and artistic diversions—particularly pure examples of 'mathematical recreation'.[3] The 'magic lantern' came to lose precisely its association with magic and with the apparently inexplicable optical wonder and, alongside its perennial entertainment value, became an instrument for demonstrating the experimental physics of optics.[4] The projected image in general moved from the preternatural world of natural magic into the domains of natural philosophical illustration and public entertainment. In the 1650s, Thomas White remarked on how common it had once been that in 'Prismaticall glasses . . . we are pleas'd to know ourselves delightfully cosen'd'.[5] In Della Porta's well-known mid sixteenth-century description of the camera obscura, there was still a strong sense of the marvellous. He talked of artificially creating the scene to be projected inside the device, as if it were a piece of theatre, and of filling it with natural features, animals, children, hunters, and music. Those observing the 'prestige' (*praestigium*) were not able to tell whether all this was true or false; indeed, boasted Della Porta, 'I could hardly by natural reasons, and reasons from the opticks remove them from their opinion, when I had discovered the secret.'[6] Even Nicéron called this sort of thing a deception by 'natural magic', while Kircher and Schott both discussed the device very obviously as a natural magical wonder. Others saw the

camera obscura as a medium for fortune-telling and an opportunity to witness spirits which vanished 'as in the witches sabbath' when more light was let in.[7] But between Kepler and the end of the seventeenth century it became so commonplace to use the camera obscura as the model for normal retinal vision that all sense of deception and insubstantiality was effectively removed from it, enabling it to stand in many modern accounts of the history of vision as paradigmatic of 'classical' seeing.[8] The themes we dealt with earlier do seem, then, to have declined in significance or been endowed with significance of a different order. For Rosalie Colie, paradox was 'a major mode of expression' that characterized Renaissance creativity but declined to the point of being mere recreation thereafter.[9] Kircher's historical moment, it has been said, was at 'the end of an intellectual tradition', and even by the early eighteenth century he was a 'forgotten writer'.[10]

Unreason and instability never disappear from visual cultures, and no amount of intellectual effort could have banished them during the seventeenth century; we should not, therefore, expect any kind of closure, only mutation. In another study of the visual instabilities of an age, Kate Flint speaks very much as I have done of a fascination 'with the act of seeing, with the question of the reliability—or otherwise—of the human eye, and with the problems of interpreting what they saw': she is talking, however, about the Victorians.[11] Nevertheless, we are still left with a central question: what adjustments did early modern intellectuals attempt to make to visual theory *itself* in response to the tribulations experienced by the inherited model? How did they intend to put an end to these cognitive difficulties? The story told in my earlier chapters is essentially that of a theory of seeing, transmitted from the ancient world by the medieval 'perspectivists', that proved incapable of dealing with the problems and demands of the visual culture that began to emerge in the early fifteenth century and, especially, with the manner in which that culture was subjected to the forces of aesthetic, religious, and philosophical reformation over the next two hundred and fifty years. Based on the principle of resemblance—of the world being essentially what it appeared to be in human consciousness—it was fundamentally ill equipped to account for the vastly multiplied instances of visual experiences where appearance and reality bore little or no resemblance to each other, or to survive the rebirth of a sceptical philosophy, encapsulated in the tropes of Sextus Empiricus, that denied the possibility of establishing cognitive resemblance altogether. If (as has been said of this issue) seeing an object was by means of 'an intentional form which the object gave off and which exactly resembled it', there should not have been significant 'mismatches' between objects and visual perceptions.[12] Visual perception, as we noted at the outset, was deemed in later medieval theory to be naturally guaranteed—that is, secured by the behaviour of *species* acting as the naturally transmitted images ('simulacral conveyances', in one recent account[13]) of their objects. Mismatches, however, there were—in unprecedented number and intensity: mismatches, moreover, that arose from situations that implied that vision was very

far from being naturally guaranteed—and was, instead, the occasion for social and cultural mediation. What then was to be put in place of the inherited model?

The seriousness of the question and the urgent need to answer it can be gauged in part by the extraordinary prominence achieved by theories of vision and the cognitive aspects of optics in seventeenth-century European philosophy—rivalled only by the attention paid to them in later medieval thought, at precisely the point when the 'resemblance' model of cognition whose historical inadequacy we have been tracing was finally assembled.[14] It is as if philosophers—ever alert, by definition, to the most profound conceptual dilemmas of their age—came to see this model as the major obstacle that had to be confronted and overcome before anything else could be achieved. The agenda for all really serious thought was being set, we might say, by the problematics of vision. As many have noted, the list of all the seventeenth-century intellectuals who planned or published works on the subjects of optics and vision would be very lengthy, encompassing, for example, the many Jesuits who specialized in this area, some of whom we have already encountered. Not all these, of course, were potential solvers of the problem I am concerned with; indeed, some (like Kircher and Schott) were partly responsible for it. But Charles Du Lieu was attempting to write up his optical interests (which included, significantly, 'the modification of intentional species') at the invitation of the Chancellor of France Pierre Séguier in the 1640s; Jan Marcus Marci, a physician to the Habsburgs, who joined the order as he lay dying, published his *Thaumantias liber de arcu coelesti* in Prague in 1648, containing studies of the spectrum; Nicola Zucchi of Parma, professor of mathematics at Rome, published a two-volume 'philosophy' of optics in the 1650s, surveying every aspect of light, the eyes, and vision; Francesco Eschinardi was working in Rome on the subject in the 1660s; and Francesco Maria Grimaldi of Bologna divided his *Physico-mathesis de lumine, coloribus, et iride* (which appeared posthumously in 1665) between experiments with light and the 'arguments and discourses' ('discursus') of sight.[15] Among non-Jesuits, Marin Mersenne (a Minim), devoted sections of *La Vérité des sciences contre les s[c]eptiques* to perception and the senses and left a treatise entitled *L'Optique et la catoptrique* to be published posthumously in 1651 (in later editions, joined by Nicéron's *La Perspective curieuse*); Nicolas Claude Fabri de Peiresc left a large manuscript treatise dealing with mirrors, spectacles, eyes, and vision;[16] Malebranche's writings were 'replete with references to optics and the physiology of vision, to eyes, mirrors, and magnifying lenses, to illusions and visual deceptions';[17] the Aberdeen mathematician James Gregory disclosed the 'secret mysteries' of reflection and refraction in his *Optica promota* (London, 1663); and Ismael Boulliau issued his *De natura lucis* in Paris in 1638. More familiar, of course, are the researches and publications in the field of men like Robert Hooke, Christiaan Huygens (whose *Traité de la lumière* appeared in Paris in 1690), Isaac Barrow (whose optical lectures were edited by Newton and John Collins), and George Berkeley. Newton's early notebooks show that his prism experiments began in the mid 1660s (when he was in his twenties), while papers

by him on optical subjects began to appear in the publications of the Royal Society from 1671.[18]

Most revealing of all is the way two of the truly major philosophical innovators of the century, Descartes and Hobbes, saw the need, early on in their intellectual careers, to become experts in the fields of optics and cognition theory. Apart from his study of the passions, 'the combined physiological and mental phenomenon to which Descartes devoted the largest measure of attention', according to one authority, 'was sense perception, and vision in particular'.[19] His interest in the optics of shadows and mirrors appears in the *Cogitationes privatae* (1619–22), compiled between the ages of 23 and 26, and he wrote a lost treatise entitled *Thaumantis regia*, 'describing artificial optical marvels', on which he worked in the 1620s. He was clearly concerned from an early stage with the theoretical implications of optical illusions, and began work on the *Optics* in Paris between 1625 and 1628, while in close contact with Mersenne and Claude Mydorge.[20] His *The World or Treatise on Light* (composed between 1629 and 1635) involved the first use of light and vision as major themes in the exposition of the new mechanics of perception, and his *Optics*, published in 1637, apart from its more straightforward purpose of improving philosophy's 'mastery' over nature, was appended to the *Discourse on the Method* as an example of how Descartes proposed scientific enquiry should henceforth proceed.[21]

Of all the issues that have informed recent Hobbes scholarship, the role of optics in his intellectual career is surely one of the most important. In one summary of his views on the topic, sensory perception is said to have been the first philosophical problem he considered and the explanation of light and vision the model for his more general conviction 'that all natural phenomena could be reduced to local motion of material bodies'.[22] The Hobbes expert Noel Malcolm writes that of all the sciences, 'optics was the one that most strongly engaged Hobbes's attention, because of its implications for epistemology'.[23] Since the arrangement of Hobbes's master works proceeds with rigorous logic from epistemology, through human nature and ethics, to political philosophy—the pattern common to *The Elements of Law Natural and Politic* (completed in 1640), *Leviathan* (1651), and, with some initial adjustment, the *summa* that encompassed them both, the *Elements of Philosophy*—we can safely say that the entire Hobbesian project was built on the foundations of a theory of vision. It needs constantly to be remembered that *Leviathan* opens with a chapter entitled 'Of Sense', just as *Elements of Law* had begun with cognition. Indeed, strictly speaking, *Leviathan* opens with the image engraved on its title page, a design expressing Hobbes's concept of the sovereign as bearing the person of every subject which, in Malcolm's intriguing argument, was inspired by the effect created by one of the optical devices we noticed earlier in this book. This was Nicéron's viewing tube containing a polygonal or faceted lens that presented to the eye one composite 'master' image of Louis XIII of France made up of portions of the dispersed portraits of fifteen Ottoman sultans. Hobbes almost certainly came to know

Nicéron and, between 1641 and 1644, visited Mersenne in the Minim convent in Paris where the device was housed.[24]

Hobbes himself claimed to have been interested in the subjects of both light and sound from as early as 1630, and an anonymous work from that period containing arguments about light and sensation, 'A Short Tract on First Principles', has often been attributed to him.[25] He was discussing the optics of refraction with Walter Warner during 1634 and also in contact with Mydorge, one of the French experts in the field. From 1636, there are letters by Hobbes expressing views about the nature and transmission of light and colour, and about perception. A long letter to Mersenne of 5 November 1640 commenting on Descartes's *Optics* was followed by an argument with its author conducted via Mersenne which lasted until 1641. A short essay on optics by Hobbes was published by Mersenne in 1644 as part of the latter's *Universae geometriae mixtaque, synopsis*, and a considerably longer and more sophisticated English manuscript entitled 'A Minute or First Draught of the Optiques' dates from 1645–6.[26] According to Richard Tuck, both this manuscript and another discovered by Ferdinand Tönnies and given the title of 'Tractatus Opticus' by him are earlier drafts of the second part of the proposed *Elements of Philosophy*, which eventually appeared as *De homine* in 1658, where eight chapters are again devoted to optics. The relationship between all these writings is not fully clear or agreed, but it seems very likely that Hobbes's natural philosophy, heavily dependent as it was on issues to do with optics and visual cognition, was in as developed a form as his political philosophy from the early 1640s onwards. At the close of the English treatise he was even able to say—aligning his own work in a manner that will be important to us later on—that he hoped to deserve the reputation 'of having been the first to lay the grounds of two sciences; this of optiques, the most curious, and the other of natural justice, which I have done in my booke De Cive'.[27]

Nor was any of this philosophizing far removed from precisely the issues and topics we have been exploring. Every student of Descartes knows that his arguments involved teasing out the cognitive and epistemological implications of madness and magic, demonology and dreams, references to which lie scattered through his writings. Of his relationship to Pyrrhonism one can only say that it was constitutive of everything he attempted.[28] In addition, he was famously embroiled in a dispute with Antoine Arnauld over the implications of his ontology for the Eucharist, Arnauld objecting that the separation of substances from accidents would become impossible to conceive if there were no sensible qualities but only 'various motions in the bodies that surround us' and if shape, extension, and mobility were unintelligible 'apart from some substance for them to inhere in'.[29] We have already encountered all of these matters in previous chapters, but it is worth dwelling for a moment on the question of illusion in magic and art as a Cartesian issue, since, in recent years at least, much has been made of it. In one way, the subject represented a threat; Dalia Judovitz has written of the Cartesian

project: 'illusion in all its forms, be it reflection, *trompe-l'oeil* or artifice, threatens by its deceptive character to impede the search for truth.'[30] However, this is better expressed as a philosophical challenge—the challenge of arriving at an epistemology where 'mismatches' no longer undermined an entire cognitive paradigm. Descartes evidently tried to live up to the programme outlined by 'Eudoxus' in an unpublished work called, precisely, *The Search for Truth*: 'After causing you to wonder at the most powerful machines, the most unusual automatons, the most impressive illusions and the most subtle tricks that human ingenuity can devise, I shall reveal to you the secrets behind them.'[31] In September 1629, he wrote to Mersenne that there was a branch of mathematics, 'which I call the science of miracles, because it teaches how to make use of air and light so fittingly that by its means one can cause to appear all the same illusions that magicians are said to produce with the help of demons'.[32] Evidently, Descartes derived a good deal of inspiration from the early seventeenth-century vogue for automata and for the paradoxes and illusions of both 'legitimate' perspective and anamorphosis. Baltrušaitis even spoke of Descartes, Mersenne, Nicéron, Maignan, and Salomon de Caus constituting a 'movement' of like-minded intellectuals in this respect, as well as pointing out that an artistic practice that made the true appear false and the false appear true revived sceptical arguments as old as Plato's *Sophist*.[33] In more recent commentary it has been suggested that it was perspective's freeing of images from the need to exactly resemble their objects that encouraged the general Cartesian attack on 'resemblance', and that anamorphosis in particular recalls the fifth Pyrrhonist trope which concludes that while 'of any given thing we are able to say of what sort, relative to its particular position, distance, and place, it appears to be . . . we cannot state of what sort it is in its nature'.[34]

In undoubtedly the most important argument of this sort, Lyle Massey successfully displaces the conventional claim that Descartes's philosophy was simply 'perspectivalist' and suggests that anamorphosis matches much better the essential features both of Cartesian doubt and the Cartesian *cogito*.[35] Even without the challenges posed to it by anamorphosis, she argues, strict perspective could never have offered Descartes an ontological or epistemological paradigm, especially since he rejected the idea that either certainty or clarity could be achieved via the senses. Indeed, what Descartes recognized in perspective was its *lack* of correspondence with things, not its rational presentation of them: 'For Descartes perspective neither rationalized vision nor did it stand in metaphorically for the mind's rational view of the world.' Anamorphosis, on the other hand, precisely in its exaggerations of perspective's deceptions, acted (as Baltrušaitis too argued) as the 'visual counterpart of Descartes's doubt', reinforced his view (which we will shortly explore) that there was no place for the principle of resemblance in visual cognition, and helped to define Cartesian subjectivity in terms of the temporal, the contingent, and the performative.

Hobbes presents a slightly different case, if only because his ambition to discuss comprehensively the philosophies of nature, man, and civil society could hardly

have failed to connect him to most of the debates of his age. Yet we noticed in earlier chapters how the issue of 'apparitions', strictly interpreted, was related fundamentally to the first principles of his philosophy, and how the phenomenon of dreaming encouraged in him psychological and epistemological reflection. His treatment of both these topics also links him to the traditions of English Protestant iconoclasm regarding images and the figurative arts.[36] The subjects of witchcraft and demonology (to which, redefined in Hobbesian terms, he devoted a substantial portion of *Leviathan*) have had to be reinserted in Hobbes scholarship, notably by Ian Bostridge, but they too act as an obvious bridge with the arguments of this book.[37] Above all, Hobbes's corpuscularian response to scepticism made him, along with, first, Gassendi and, then, Descartes, a member of what Richard Tuck has dubbed the 'Mersenne group', each of whom accepted the Pyrrhonist challenge to Aristotelian cognition but was determined to find an answer to it in a new, mechanistically grounded, theory of perception that would be invulnerable to the charges brought against Aristotle. At the heart of this theory, which Tuck presents as more crucial to the 'new' philosophy than mechanism itself (and as 'the invention of modern philosophy'), was an attack on the 'literally representational theory of perception'—on the idea that objects in the external world resemble what we perceive them to be. For sense perceptions to inform the new natural knowledge, they had to be seen as the *signs*, not the images (*species*), of natural events—caused by them but not picturing them or having any straightforward correspondence with them, and standing in relation to them 'as the conventional sign for a word stands for the word, or as words themselves may signify objects'. All that was otherwise required was for an observer to have immediate and necessarily veridical knowledge of the sense impressions in his or her field of vision—and, of course, to give up what Malebranche was to call 'the source of all the other most general errors of school physics', the 'prejudice common to all men, that their sensations are in the objects they sense'.[38]

In a moment, we will see in more detail how two of the 'Mersenne group', Descartes and Hobbes, argued the case for the new theory. But it is important first to appreciate fully what was at stake. Familiar, as I have said, with the contexts in which they had occurred—and, it appears, inspired by some of them—these two thinkers were attempting to make philosophically irrelevant all the many 'mismatches' we have come across in the visual culture of early modern Europe. They did so by rejecting the cognitive doctrines (as well as the wider metaphysics of real qualities) which made them 'mismatches' in the first place. Since they claimed that the world was *never* what it appeared to be, it could hardly matter that individual visual perceptions repeatedly failed to live up to its 'reality'. If all was illusory—if, as Judovitz puts it, illusion could be relegated 'to the status of an objectless perception'—then specific illusions lost all their force.[39] The mismatches to be discerned in, say, the hallucinations of the madman or in dreams could be given an utterly mechanical explanation, in terms of the physiology of the sense organs and the brain. But the question that had troubled European

intellectuals for two centuries—that, on the grounds of perception alone, there was often nothing to distinguish the visually true from the visually false—became simply a non-issue. This did not, of course, have the absurd consequence that the distinction itself could no longer be made—quite the reverse, in a theory tied so self-consciously to the needs of natural philosophy. Instead, the distinction was to be made elsewhere and in another way. What was now explicitly insisted upon was what, in a sense, had been implicit all along—implicit, that is, in the many instances when, as we have seen, ideological and cultural changes produced contentious descriptions of the visual world. It was that the truth or falsity of visual experiences was not a question of natural conformity or unconformity between the sensible soul and the outside world but a matter for language and, thus, for convention—a kind of interpretative skill acquired socially and learned through experience, like language itself.[40]

This last outcome is perhaps best seen in the form Bishop George Berkeley gave to it in his *An Essay towards a New Theory of Vision* (1709), prevailing as it did as the dominant account until at least the end of the nineteenth century.[41] Berkeley shared the same essential doctrines of optics and physiology that we are about to discuss, although he emphasized to a greater degree the psychology of seeing and he substituted judgements made from experience for all those perceptions that Descartes still attributed to the natural geometry of vision. Above all, he resorted to the 'language metaphor' to explain visual cognition and the learning of it through processes proper to language, such as arbitrary association (*not* resemblance), the reading of cues, social custom, and experience. For example, the key relationship between visual ideas and retinal images (which were not visual but tactual), was like that between words and their referents. Berkeley, says Pastore, 'maintained [that] percepts are acquired in the "same manner" as are the meanings for spoken or written words', inviting this comment from Voltaire: 'We learn to see precisely as we learn to speak and to read.'[42] Here is Berkeley towards the end of the *Essay*, in a passage that owes much to the cognitive psychology of Descartes, to whose detailed arguments I turn next:

Upon the whole, I think we may fairly conclude that the proper objects of vision constitute an universal language of the author of nature, whereby we are instructed how to regulate our actions in order to attain those things that are necessary to the preservation and well-being of our bodies, as also to avoid whatever may be hurtful and destructive of them. It is by their information that we are principally guided in all the transactions and concerns of life. And the manner wherein they signify and mark unto us the objects which are at a distance is the same with that of languages and signs of human appointment, which do not suggest the things signified by any likeness or identity of nature, but only by an habitual connexion that experience has made us to observe between them.[43]

In the third of his *Meditations on First Philosophy* Descartes described the cognitive assumption of resemblance—'that there were things outside me which were the sources of my ideas and which resembled them in all respects'—as a once-held

opinion now reduced to uncertainty.[44] One of its apparent merits had been the seemingly obvious judgement that an object in the external world would transmit to an observer 'its own likeness rather than something else'. Yet the sensory perception that the sun was very small and the rational calculation that it must be very large were two different ideas that could not both resemble their external source, and the one that seemed 'to have emanated most directly from the sun itself [had] in fact no resemblance to it at all'.[45] Later, in the sixth of the *Meditations*, after reviewing his former faith in sensory perception and subsequent reasons for calling it into doubt, Descartes sought to resolve this uncertainty. He recalled again that it had once seemed reasonable to assume the existence of his own and other material bodies, distinct from thought, which not only produced the ideas he had of them but also seemed to resemble those ideas. This last supposition could now be shown to be untenable. Physical bodies might exist and have differences corresponding to those perceived by the senses, 'though perhaps not resembling them'. But beliefs such as:

that the heat in a body is something exactly resembling the idea of heat which is in me; or that when a body is white or green, the selfsame whiteness or greenness which I perceive through my senses is present in the body; or that in a body which is bitter or sweet there is the selfsame taste which I experience, and so on; or, finally, that stars and towers and other distant bodies have the same size and shape which they present to my senses

were merely ill-considered judgements, made from childhood onwards without any rational basis. Fire might cause feelings of heat and pain without resembling them, just as the feelings of hunger or thirst bore no resemblance to the objective body states that caused them, or the sensation of tickling to any feather. Physical sensations and the disposition to act on them were linked by arbitrary, not necessary (or natural), relations, secured by a divinely ordered regularity. To treat sensory perceptions as 'reliable touchstones for immediate judgements about the essential nature of the bodies located outside us' was likewise to misunderstand them. Perceptions of the external world were no more copies of material things—pictures or images of them—than were feelings of hunger or thirst copies of body states. Both kinds of resemblance collapsed before the intervention of the intellect and the realization that sensations and perceptions were there primarily 'to inform the mind of what is beneficial or harmful for the composite of which the mind is a part' and, to this extent and for this purpose (and *only* this extent and purpose), 'are sufficiently clear and distinct'.[46]

Precisely how the Cartesian intellect intervened in cognitive theory—quite independently of the senses—was, of course, by insisting on a mechanistic and corpuscularian account of perceptual cognition in which the essence of matter became extension and its only properties the geometrically derived ones of shape, size, position, and motion. On this account, the colours of different objects consisted in the purely mechanical impacts of variations in their surfaces on adjacent particles of light, which were then transmitted to the human nervous

system via air and eyes and eventually perceived by the soul as 'red', or 'white', or whatever. Colours were precisely that, *perceptions*, not qualities that existed in objects. The same sort of processes explained the phenomena of sound, taste, smell, and touch; all were produced by local motion. But what *resemblance* could there possibly be, asked Descartes again, between the physical collisions and motions of particles and what we perceive as a colour? '[W]e cannot find any intelligible resemblance', he wrote in *Principles of Philosophy*, 'between the colour which we suppose to be in objects and that which we experience in our sensation.'[47] The physics of colour was one thing (a mode of matter), the understanding of it entirely another (a mode of mind). Descartes chose to expound this crucial difference in kind by comparing it, at the opening of *The World or Treatise on Light* (published posthumously in 1664), to the functioning of linguistic signs, a formulation that has led modern commentators to call his cognitive theory 'semantic' (or 'symbolic', or 'significatory') in character.[48] Descartes had already begun the treatise by saying that the difference between the sensation we have of light and what it is in the objects that produce this sensation is the 'first point' he wished to insist upon, even though 'everyone is commonly convinced that the ideas we have in our mind are wholly similar to the objects from which they proceed'. He then continues:

Words, as you well know, bear no resemblance to the things they signify, and yet they make us think of these things, frequently even without our paying attention to the sound of the words or to their syllables. Thus it may happen that we hear an utterance whose meaning we understand perfectly well, but afterwards we cannot say in what language it was spoken. Now if words, which signify nothing except by human convention, suffice to make us think of things to which they bear no resemblance, then why could nature not also have established some sign which would make us have the sensation of light, even if the sign contained nothing in itself which is similar to this sensation?[49]

Our modern-day familiarity with the arbitrariness of the sign helps a good deal in grasping the challenge offered to traditional cognitive psychology in this passage.[50] Of course, causation, and a fortiori mechanical causation, brought its own kind of correspondence nonetheless, and with it a sometimes confusing Cartesian vocabulary of 'copies' and 'images'. The Aristotelian senses might function to support 'childish' suppositions about resemblance, by inserting qualities into objects that were not in them at all and speaking of knowing them in pictorial terms. But their Cartesian alternatives still had to provide accurate reports of the properties that matter did have, and some variation on the terminology of copying was not totally inappropriate for the correct operation of machines. To some extent, the problem of how to formulate the new relationship between objects, brain images, and mental percepts was eased by the fact that shape, size, position, and motion were not sense-derived in the first instance at all, being grasped clearly and distinctly by the unaided intellect as the essential attributes of extended matter. These were properties that bodies could actually have, not false

ones invented by the senses. There was thus no question of trusting the senses to provide anything but specific information about the empirical consequences of truths known by other means. Descartes clearly believed that such information would be true in the right conditions given that a non-deceiving God had given men and women senses in the first place and that metaphysics taught them how to correct their sensory errors.[51] He also reserved a considerable role for the intellect even in the perception of the size, distance, and shape of physical objects, saying in his replies to the sixth set of objections to the *Meditations* that these could be 'perceived by reasoning alone, which works out any one feature from the other features' and then referring the objectors to his *Optics* for further details. Descartes added that many of these rational calculations were wrongly assigned to the senses simply because they were habitual and made at great speed.[52]

In fact, strictly speaking, sense perception (sensation) was limited to two prior stages (or 'grades') of response to the external world.[53] The first, entirely material, consisted of 'the immediate stimulation of the bodily organs by external objects', amounting only to 'the motion of the particles of the organs, and any change of shape and position resulting from this motion'. When I see a stick, explained Descartes in the same set of replies, intentional forms (*species*) do not 'fly off the stick towards the eye'; rather, rays of light are reflected off it and set up corresponding local motions in both the filaments of the optic nerves and the parts of the brain connected to them. Secondly, in a stage that is mind–body interactive, effects are produced in the mind which again correspond exactly to these motions, occasioning 'mere' perceptions of things like the colour and light reflected from the stick, as well as bodily sensations of pain, pleasure, thirst, hunger, etc. In both these stages, assuming normal conditions, certainty is guaranteed by the regularities and correspondences of mechanical physiological sequences; 'no falsity can occur in them', Descartes states. To place the stick in water and say that it appears bent by refraction is only to say that its appearance might lead to the *judgement* that it was so bent—in this case, a judgement based on childishness or preconceived opinion.[54] More generally, Descartes relied on a distinction between seeing and judging that enabled him to show that all supposed deceptions of sense involve an error of judgement concerning the appearances of external things. The appearances themselves, as facts of consciousness, could never be questioned. Without judgements determining the difference between waking and sleep, and between sanity and madness, the objects seen in dreams or hallucinations could never be disputed.[55]

In these ways, accurate copying does—and, of course, must—take place in Cartesian sense perception, even if this is a way of referring not to pictorial resemblance but to the exact and automatic (machine-like) reflection of causes by their effects and the resulting correlations. One could say that Descartes is asking us to think about vision as if it worked like one of the non-visual senses. And indeed, he offers a comparison with the soul of a blind man feeling his way with a stick who has sensory perception 'of just as many different qualities in [the objects

he touches] as there are differences in the movements caused by them in his brain', a fact occasioned only by motions transmitted from objects to brain via stick, hand, and nerves.[56] Obviously, this comparison with the literally non-visual (and non-resemblance-based) processes of touch was only intended for the final stages of visual perception, since literal picturing entered into its early stages with new and dramatic force. Descartes famously accepted Kepler's analogy between the retinal image and the images created by the camera obscura and demonstrated its validity by experiments with animal and human eyes. These proved that 'the objects we look at do imprint quite perfect images of themselves on the back of our eyes'.[57] Imperfections and defects were involved, notably reversal and curvature, but still the principle of the otherwise exact visual replica 'in natural perspective' held good. He also argued that such pictures of the external world (with their imperfections) were transmitted mechanically, via the motions of the fibres and tiny tubes of the two optic nerves and the brain's animal spirits (also physical entities), to the surface of the pineal gland (also the 'common sense'), where they still bore 'some resemblance' to the objects that had originally produced them.[58] The diagram (Fig. 27) of Descartes's visual system as far as the pineal gland, added by Louis La Forge to the posthumous editions of *L'Homme* (1664), was, thus, an attempt to show how a figure 'corresponding' to an object striking the eyes must, in Descartes's words 'be traced on the internal surface of the brain'.[59] For this further process, moreover, the metaphor of the seal (the retinal image) impressing itself in wax (the pineal gland) was still deemed appropriate, as it was for the creation of the initial retinal image itself.[60]

As every commentator has noted, this sounds almost scholastic. Yet Descartes, while admitting that he was using familiar terms, insisted that he meant something 'entirely different' by them—especially by the term: 'image'. Aristotelian philosophers usually took mental images to be 'little pictures formed in our head' from the *species* emitted by objects ('those little images flitting through the air, called "intentional forms" ') and transmitted by the senses—'as if there were yet other eyes within our brain with which we could perceive' them.[61] For Descartes, the 'images' formed on the pineal gland are the movements of animal spirits passing through its pores and the only form of resemblance to those on the retina is that of exactly proportional neurological correlation—in other words, they are neural images, not pictorial ones.[62] Adopting the camera obscura model for retinal vision, therefore, did not mean using it to claim veridicality or abandoning the principle of non-resemblance itself.[63] As in *The World*, so in his *Optics* Descartes suggests that images in the brain are most like 'signs and words' and convey meaning as they do—without 'in any way' resembling what they signify (also a departure from Kepler). The only problem is to know how such signs are themselves correlated with mental perceptions and so come to have the meaning they do ('how they can enable the soul to have sensory perceptions of all the various qualities of the objects to which they correspond').[64] In this third and last stage, then, visual perception *is* like the perceptions of the blind man with his

stick. What Descartes says about the correlations that finally turn brain events into *seeing* is not particularly helpful in explaining how they occur, but it is this: 'we must hold that it is the movements composing [the image on the pineal gland] which, acting directly on our soul in so far as it is united to our body, are ordained by nature to make it have such sensations.' This natural 'ordination' (elsewhere, 'institution') seems, in fact, far from natural; it is again an arbitrary relationship, established by God (and called 'occasionalist' by some philosophers), by which 'an "appropriate" mental state occurs on the occasion of a given bodily configuration'—or, as we would say, a meaning accompanies a sign.[65]

Despite some overlap in terminology, therefore, no one has ever suggested that Descartes was attempting anything less than a cognitive revolution. Even his retinal image, although pictorial to a new and higher degree and conforming to existing geometrical optics, was achieved by physical processes far removed from those talked of by Aristotelians when they described the transmission of *species* from object to eye.[66] Again, it is a comparison with a blind man that opens the *Optics* where Descartes argues in purely mechanistic terms that the movement that conveys light to our eyes behaves just like 'the movement or resistance of the bodies encountered by a blind man' when they pass to his hand via his stick.[67] Though hints of picturing are never entirely removed from the operations of the pineal gland, these too are supposed to be micro-mechanical events which must accurately reflect or copy (be a pattern of) those preceding them in the causal change that is sensation but need have no other kind of resemblance to them. To this point, the brain receives only information, neutrally conveyed, first to the eye, and then beyond it to the gland, by interactions between particles of matter obeying physical laws and having no other properties but extension. Sensing is occurring, but not perception—not 'seeing'—the functioning of a machine (which, by definition, is without judgement), not the understanding of a thinking mind: '[I]t is the soul which sees', declared Descartes famously, 'and not the eye; and it does not see directly, but only by means of the brain.'[68] Here, in the last stages of cognition, the correlations that matter are like those that link signs (motions in the gland) to meanings in a language: as he again insists, 'in order to have sensory perceptions the soul does not need to contemplate any images resembling the things which it perceives'.[69] Reinforcing this break with the past, he said:

We must take care not to assume—as our philosophers commonly do—that in order to have sensory perceptions the soul must contemplate certain images transmitted by objects to the brain; or at any rate we must conceive the nature of these images in an entirely different manner from that of the philosophers.[70]

Between the literal representation of the world on the retina (eye events) and its partially literal copy on the pineal gland (brain events or cerebral images), on the one hand, and the representation of objects by the brain to the soul (mental events), on the other, lay the gulf that was Cartesian dualism.[71]

It followed, finally, that true perception consisted not in the matching up of percepts with the things perceived (which Descartes accepted as an impossibility on Pyrrhonist grounds) but in behavioural or practical trial and error—the 'ordination' of nature—warranted by how successful or unsuccessful our behaviour is in securing pleasure and avoiding pain in the face of the things we perceive (how appropriately we act and make inferences in the environment we think we see). The correctness of percept of even objects that seem obviously to correspond to our perceptions of them is always practical. Here was another radical break with the past—a new kind of certainty based not on the literal representation or misrepresentation of the external world in mental images, but on the necessary accuracy of regular, automatic, and mechanical pieces of physiological motion and the existence of a God not willing to allow us to be fundamentally deceived.

Descartes's theories of vision have, of course, achieved almost foundational status among interpreters of the broad trajectories of modern thought. But too often the view has been that the model of the camera obscura helped him to retain a representational account of visual cognition (albeit in a new guise), with unfortunate consequences for the future of philosophy, epistemology, and much else. Martin Jay's use of the label 'Cartesian perspectivalism' to describe modern visuality and Richard Rorty's castigation of the Cartesian mind as a 'mirror' of nature are probably the most influential examples.[72] What matter to my argument, by contrast, are the ways in which Descartes thought that perceptions did *not* mirror nature—and, more broadly, the ways in which, as Catherine Wilson has said, 'visual mechanisms, processes, and results are explicitly held by seventeenth-century theorists of the visual who reject visual species theory to be disanalogous to this kind of copying from exterior to interior'.[73] For Kepler, Descartes, and many others, the camera obscura was the model for the formation of retinal images, not for vision as such. Post-retinal transmission in Kepler was consistent with a traditional physiology in allowing 'visual spirit' to carry the retinal picture (or 'immaterial image') onwards to the 'common sense', where visual judgements based on the principle of the simulacrum still occurred. In the case of Descartes, the very insistence with which he agreed on the formation of 'perfect' optical images at the back of the eye only serves to heighten the *contrast* with what he thought happened beyond the pores and nervous fluids of the surface of the pineal gland. The entity transmitted from the retina to this surface was still material—a pattern of motions bearing a one-to-one correspondence; vision, however, consisted of 'all the judgements about things outside us which we have been accustomed to make from our earliest years—judgements *which are occasioned by* the movements of these bodily organs'.[74] The key difference lies in the insertion of the idea that it is language which is the model for making such judgements—in effect, for reading or decoding signs. Up to this point—as one would expect from a tradition deriving from Aristotle—vision was a natural process. With however many hesitations and ambiguities, and despite his commitment to the 'natural geometry' of seeing, Descartes at least began the process of turning it into something discursive—into 'visuality'.

As early as October 1636, in a letter to the Earl of Newcastle, Hobbes, too, was rejecting the Aristotelian doctrine that *species* emanated from objects and insisting instead on the 'mediumistic' transmission of light, a view from which he never subsequently departed. There was no need for any kind of transmission of the images, or even the particles, of luminous bodies to the eye; instead, their actions (which Hobbes came to think of as permanently radiating dilations and contractions) were transmitted solely by the kinetics of the medium, with vision resulting from correspondingly aroused but outwardly directed reactionary motions in the human sensorium.[75] In the same letter he stated that 'light and colour are but the effects of . . . motion in the brayne', thus committing himself to what Richard Tuck calls 'the crucial issue in the new philosophy'—that '[t]here is nothing *really* in the external world which in any way resembles what we think we perceive'.[76] Roughly a decade later, in 'A Minute or First Draft of the Optiques', Hobbes again aligned himself with Descartes by commenting that all writers on the subject except him had 'supposed light and colour, that is to say the appearance of objects which is nothing butt our fancy to bee some accident in the object it selfe'. Only Descartes, he went on, 'hath sett forth the true principles of this doctrine, namely that the images of objects are in the fancie, and that they fly not through the aire, under the empty name of *species intentionales* but are made in the braine by the operation of the objects themselves'. The essential point was that 'light is a fancy in the minde, caused by motion in the braine, which motion againe is caused by the motion of the parts of such bodies as we call *lucid*', transmitted via the medium.[77]

However, it was in *The elements of law natural and politic*, completed in 1640 and dedicated to Newcastle, that Hobbes offered perhaps his clearest version of the non-resemblance theory of vision, as well as a first account of its necessary links with his political philosophy, later to be expressed again in *Leviathan*. Required (as usual) to begin with human cognition, his very first step is to attack the opinion that the colours and shapes that make up the images and conceptions of the visual sense 'are the very qualities themselves' of the objects of that sense. To argue the contrary seems 'a great paradox' but not as absurd as 'the introduction of species visible and intelligible . . . passing to and fro from the object'. Hobbes then enumerates categorically the four basic principles of the new philosophy of seeing:

(1) that the subject wherein colour and image are inherent, is not the object or thing seen. (2) That that is nothing without us really which we call an image or colour. (3) That the said image or colour is but an apparition unto us of that motion, agitation, or alteration, which the object worketh in the brain or spirits, or some internal substance of the head. (4) That as in conception by vision, so also in the conceptions that arise from other senses, the subject of their inherence is not the object, but the sentient.[78]

Reflections of images and the seeing of two images of the same directly visible object were sufficient to prove the first point, and the obvious non-location of

images on or behind the surfaces (or in the substances) that reflected them enough to prove the second. The fact that physical violence to brain or eye itself produced a sensation of light showed that the latter was 'nothing but motion within', induced under normal conditions as a kind of kinetic reaction to motions originally derived from lucid bodies, then transmitted through the medium by each of its parts '[beating] back the other to the very eye', and finally carried by the optic nerve to the brain. In responding to this external stimulus by *returning* motions back through the nerve to the eye, the brain was responsible for the common conceptual mistake; 'we not conceiving [this response] as motion or rebound from within, think it is without, and call it light'—what Hobbes called an 'apparition' of light. All vision, he nevertheless insisted, derived from the processes he was describing, 'colour and light differing only in this, that the one is pure, the other a perturbed light'.

Recognizable in all this are, of course, the challenges of scepticism, evident in the choice of instances of perception that would have counted in the Aristotelian tradition as true or false but in the sceptical tradition simply as different. 'It is apparent enough', says Hobbes of the other senses, 'that the smell and taste of the same thing, are not the same to every man, and therefore are not in the thing smelt or tasted, but in the men.' Indeed:

whatsoever accidents or qualities our senses make us think there be in the world, they are not there, but are seemings and apparitions only. The things that really are in the world without us, are those motions by which these seemings are caused. And this is the great deception of sense, which also is by sense to be corrected. For as sense telleth me, when I see directly, that the colour seemeth to be in the object, so also sense telleth me, when I see by reflection, that colour is not in the object.[79]

There is considerable irony in this choice of the familiar trope of the deceptions of sense being corrected *by* sense. For what Hobbes was proposing was very definitely not the way in which Aristotelian sense conventionally neutralized its own errors—that is, by providing ways for discounting unreliable correlations between mental representations and real objects by substituting reliable ones (e.g. those of the healthy for those of the sick; those of the sober for those of the inebriated; those of the pious for those of the superstitious). Instead, Hobbes was turning his back on that kind of veridicality altogether—recruiting sense in order to show that mental representations and real objects can never be matched up. The 'deception' he is talking about is not the failure of sense to report accurately on real accidents and qualities, but the deception of supposing there to *be* such a form of accurate reporting in the first place. And its 'correction' consists not in compensating for representational failures with representational successes, but in abandoning this distinction itself. By this means, Hobbes, like Descartes, surmounted the dilemma that set Aristotelianism against Pyrrhonism and in one theoretical step moved beyond the debates about vision that we have been surveying in this book. Most often, these focused on the question of illusion. For these two 'new'

philosophers this was not a problem for which a solution had eventually to be found; rather, it was a presupposition of thinking about vision—the point from which they started. 'In a sense', it has indeed been said, 'both Hobbes and Descartes consider the relationship between vision and the visible as the product of an illusion.'[80]

In what way, then, could vision be relied on? Convinced of the existence of material objects and their capacity to undergo motion—of which human vision was itself an example—Hobbes granted visual conceptions the status only of appearances—'seemings' and 'apparitions' whose meanings, like those of all signs, were given them solely by linguistic convention. Thus, a blind man suddenly cured of his affliction would be able to distinguish between the conceptions of different colours 'yet he could not possibly know at first sight, which of them was called green, or red, or by other name'. Sensation was quite separate from 'knowledge of the truth of propositions, and how things are called', which Hobbes termed 'understanding'. Both were a matter of experience, the first, of 'the effects of things that work upon us from without', and the second, 'the experience men have of the proper use of names in language'.[81] Having reliable (or unreliable) visual experiences was tantamount, on this account, to knowing how to name them correctly in language, an acquired skill, equivalent to that of learning language itself, based on the case-by-case testing of notions and inferences and the piecemeal accumulation of grasp of the visual environment. From this, it is not difficult to see why Hobbes saw natural philosophy, and physics in particular, as a suppositional, non-demonstrable knowledge of appearances, in which explanations about how visible phenomena were caused might be hypothetically true but actually false. The most we can have, he said on more than one occasion, is 'such opinions, as no certaine experience can confute, and from which can be deduced by lawfull argumentation, no absurdity'.[82]

There were, nevertheless, dramatic ethical and political consequences of this initial epistemological relativism, making Hobbes's celebrated political philosophy ultimately a derivation from his theory of vision. Hobbes, Richard Tuck has convincingly argued, 'treated *moral* terms in exactly the same way as he had treated colour terms'—not as pertaining to real and objective properties in external objects but as mental constructs.[83] The motion that caused an 'apparition' did not stop with the head; it moved on to the heart, helping or hindering vitality: 'when it helpeth, it is called delight, contentment, or pleasure, which is nothing really but motion about the heart, as conception is nothing but motion within the head . . . but when such motion weakeneth or hindereth the vital motion, then it is called pain.' It followed that, whatever the socially shared language involved, '[e]very man, for his own part, calleth that which pleaseth, and is delightful to himself, good; and that evil which displeaseth him: insomuch that while every man differeth from other in constitution, they differ also one from another concerning the common distinction of good and evil.'[84] It is no more than a truism to say that Hobbes's theory of the state and of civil society was arrived at as

an attempt to create artificial moral consensus out of the radical instabilities of the condition of natural liberty—the condition in which men and women found themselves as a result of their uniform desire for self-preservation and their very different, independent perceptions of when and for what reasons to preserve themselves. The more crucial point, for the present, is that Hobbes thought that this moral relativism about good and evil was comparable to, and could be traced to, a prior epistemological relativism—that is, a relativism in human sense perception and, in particular, in human vision. Thus, Hobbes's state theory was based on his ethical theory and this in turn was based on an epistemology in which optics and the nature of vision were the key enquiries. The conclusions of *Leviathan* are already contained in the claim made in its very first chapter; that 'the object is one thing, [and] the image or fancy is another'.[85]

An account of how seventeenth-century natural philosophy in general adapted to cognitive and epistemological scepticism is beyond the scope of this study, yet non-representational theories of seeing clearly played a major part in this.[86] We may turn then, if only very briefly, to the question of how it was proposed to reconstruct natural knowledge in the wake of both the sceptical arguments about vision themselves and, by implication, the wider uncertainties in early modern visual culture that helped to make them so relevant. One broad answer can still be found in what Richard Popkin called 'constructive' or 'mitigated' scepticism, a position originating with Mersenne and Gassendi that was able to 'accept the full force of the sceptical attack on the possibility of human knowledge, in the sense of necessary truths about the nature of reality, and yet allow for the possibility of knowledge in a lesser sense, as convincing or probable truths about appearances'.[87] The aim was to steer a middle path between dogmatism and doubt by securing scientific truths on the pragmatic and anti-metaphysical grounds provided by experience and the verification or falsification of hypotheses. In England, in particular, this coincided with the emergence of the idea of degrees of certainty and probability and, with it, of variations in levels of assent. Between the extremes of mathematical necessity and mere opinion lay a middle ground occupied by 'moral certainty', resting on such things as weight of testimony, sufficient assurance, and reasonable proof. This kind of certainty was good enough for science. Natural philosophy took on the character of a provisional and conjectural enquiry that recognized that many aspects of natural reality remained unknown and might be unknowable, and that belief might, therefore, be preferable to knowledge.[88]

This way of characterizing natural knowledge was thought to have enormous religious, political, and social advantages in the historical conditions of mid and late seventeenth-century England. What was aimed at by the Royal Society and its membership of (what Boyle called) 'Christian virtuosi' was a non-contentious securing of assent that would protect the religious and political consensus thought to be necessary to preserve society in peace and conformity. Naturally, the

upheavals of the 1640s and 1650s were mainly responsible for this but it is also worth recalling that fears about the social consequences of error and deceit were a legacy of the Reformation and of anti-Catholicism. The new natural philosophy had an even wider remit of responsibilities than one first imagines as the authoritative provider of solutions to the uncertainties and duplicities that had plagued intellectual, and especially religious, life for a century and a half.[89] In this context, the rationality of visual experience was, again, a key issue. 'Only the Protestant natural philosopher', writes Rob Iliffe, 'was fit to tell the godly whether what they saw was what really existed in nature.'[90] Intrinsic to this entire knowledge campaign was the achieving of a series of balances in the sphere of vision—between sensory and other forms of understanding, between the strengths and weaknesses of individual senses like the eyes, between properly and improperly conducted (and direct and virtual) eyewitnessing, and between edifying experimental display and vulgar spectacle.[91]

Running through the debates that made up this new chapter in the socialization of vision are two themes relating to seeing and knowing that had a considerable impact on the outcome. One was the post-sceptical idea that, whatever their weaknesses and failings, the senses had not been providentially provided to cause only error and that, within suitably acknowledged limits and aided by all the latest optical technology, they were reliable enough sources of information to justify ocular enquiry and demonstration. A forceful account of this theme appears, predictably, in the preface to Robert Hooke's *Micrographia* (1665), but it can be traced throughout seventeenth-century writings from Francis Bacon onwards and was reinforced even by Descartes. The second and complementary assumption was that natural knowledge was now restricted anyway to what Sprat in his *History of the Royal Society* (1667) called 'present appearances'—phenomena. This was obviously consonant in a broad way with the non-resemblance theory of cognition and, along with the choice of light behaviour as a key subject for corpuscularianism, it explains the attention given to the production of the quintessential secondary quality—colour—and the consequent resort to working with prisms in contemporary experimental research. English natural philosophers came to adopt the anti-scholastic view that colour was an apparent, not real, quality of bodies, traceable to sense impression itself. Newton, above all, took Descartes's work on refraction, colour, and other aspects of the behaviour of light as his starting point, along with Descartes's Keplerian account of the workings of the eye and the processes of vision as equivalent to those of the camera obscura.[92] We therefore recognize immediately the language used in the *Opticks* to attribute the phenomenon of colour to the reflection by objects of various dispositions of rays which then lead to the 'sensations of those motions under the form of colors'.[93]

Many of these themes were enshrined in Locke's *Essay concerning human understanding* where they naturally came to exercise an enormous influence on subsequent thinking. Non-resemblance in particular became canonical in Locke's account of the simple ideas of all but the primary qualities of bodies, along with its

corollary: the 'semantic' account of cognition. Provided sensations were not mistaken for what they could not be—copies of real essences, rather than appearances produced by powers of motion—they could be accepted as reliable and could not intelligibly be called false.[94] Real essences were unknowable; what were known were their 'nominal' equivalents—known by being named—and naming did not confer any kind of resemblance:

> [W]e may not think (as perhaps usually is done) that they [ideas] are exactly the images and resemblances of something inherent in the subject; most of those of sensation being in the mind no more the likeness of something existing without us, than the names, that stand for them are the likeness of our ideas, which yet upon hearing, they are apt to excite in us.[95]

Names 'made at pleasure' could neither alter things nor provide any other kind of understanding of them except as signs of (and standing for) our 'determined ideas' of them.[96] Like most other innovators in this respect, Locke acknowledged the extraordinary difficulty in dislodging the old cognitive assumptions:

> Flame is denominated hot and light; snow, white and cold; and manna white and sweet, from the ideas they produce in us. Which qualities are commonly thought to be the same in those bodies, that those ideas are in us, *the one the perfect resemblance of the other*, as they are in a mirror; and it would by most men be judged very extravagant, if one should say otherwise.[97]

Men, he added, could hardly be brought to think that sweetness and whiteness are not really in manna: 'which are but the effects of the operations of manna, by the motion, size, and figure of its particles on the eyes and palate; as the pain and sickness caused by manna are confessedly nothing, but the effects of its operations on the stomach and guts, by the size, motion, and figure of its insensible parts'.[98] The problem arose from the way in which the senses were unable 'to discover any unlikeness between the idea produced in us, and the quality of the object producing it'. Thus, men easily imagined that their ideas were 'resemblances of something in the objects, and not the effects of certain powers, placed in the modification of their primary qualities, with which primary qualities the ideas produced in us have no resemblance'.[99] In sum, simple ideas were the constant and regular, but ultimately arbitrary, accompaniment of the particular sensations produced by real things and this was enough to procure understanding.[100]

Joseph Glanvill, apologist for Anglicanism, the Royal Society, and the new natural philosophy, exemplifies so many of the changes in scientific culture in England after the Restoration that his writings can be taken as a final guide to how seeing and knowing were realigned following the upheavals in visual culture that I have been examining.[101] Glanvill was born in Plymouth in 1636 into a Puritan upbringing, educated in Oxford between 1652 and 1658, and elected to the Royal Society in 1664, becoming familiar with its many luminaries and their intellectual work. For most of his later years he held the living of the abbey church in Bath and

he eventually died there in 1680. His first book, *The vanity of dogmatizing*, appeared in 1661 but was rewritten and republished in two later versions, first as *Scepsis scientifica* (1665) and finally as the *Essay against confidence in philosophy, and matters of speculation* which appeared in the essay-form collection of his principal writings entitled *Essays on several important subjects in philosophy and religion* in 1676.[102] On these three occasions, over fifteen years—as well as in a further *Essay of scepticism and certainty*—Glanvill voiced with some success the classic arguments of constructive scepticism, above all the insistence that overconfident assertion and dogmatic belief must be abandoned in favour of the more modest levels of certainty appropriate to acceptable natural knowledge. 'The knowledge I teach', he wrote, addressing the readers of *The vanity of dogmatizing*, 'is ignorance.'[103] The point of this paradox was to show that expressing total intellectual commitment to what were in fact uncertainties—as traditional knowledge claims did—stood in the way of ever arriving at a proper appreciation of certainty itself; knowing was the correlative of not-knowing. The early chapters of the book and its successors were filled, accordingly, with sobering instances of how little was known about the human and natural worlds, ranging from the nature of the soul and its relations with the body to the divisibility of matter and the motion of the wheel.

This situation owed much to the Fall, the difficulties intrinsic to knowledge-making, and the errors of the imagination, the intellect, and the 'affections'—the last, a category embracing many of Francis Bacon's 'Idols'. But Glanvill also had much to say about what he called (in the *Essay against confidence in philosophy*) the 'malign influence' of the human senses and this particular ingredient of his scepticism seems on occasion even to overpower the rest of his argument. Here, at the very heart of scientific innovation, were all the tropes and paradoxes of a by-now standard Pyrrhonism. The transmission of images by the senses might be indispensable to thought, and the best kind of philosophy be based on 'the phœnomena, as [the senses] present them to us'. Yet they were simply not up to the task; their capacities were incommensurate with the subtleties and complexities of natural operations, the 'finer threads' of which were performed by 'invisible, insensible agents'. The world of the senses could never be the same as the 'world of God', the world of created reality. To depend on sense impressions was thus to be like the inhabitants of Plato's cave, condemned to perceive only shadows. Even the enhancement of sight by microscopy underlined the same point, revealing creatures previously never seen and promising others as yet invisible. Glanvill sounds at this point much like Montaigne questioning whether we even have the number of senses we require: 'Many, the greatest, and the best of [nature's] objects', he says, 'are so remote that our senses reach them not by any natural or artificial helps.' Indeed, the inescapable implication of using the microscope was that 'we scarce yet see any thing as it is'.[104]

The senses were also deceptive in ways that sceptics had always seized on, and Glanvill admitted to retaining the 'common way of speaking' about their errors and

citing 'vulgar instances' of these. In his *Essay against confidence in philosophy* the senses are still depicted misrepresenting straight sticks and square towers to the healthy and the colours and tastes of other objects to the sick. It was no good arguing, he added—echoing again the Pyrrhonian tropes—that such errors were rectified by the return of normal conditions, since there were many other cases, rarer and more esoteric, when the senses provided no contrary evidence to 'disabuse' us; cases where the 'due medium, and distance, and temper' required by each sense might always be absent. Besides, '[w]hat medium, what distance, what temper is necessary to convey objects to us just so, as they are in the realities of nature?' This, by definition, was a question that could not be answered without invoking precisely the conditions under which each sense normally operated, raising yet again the ancient problem of the criterion. What, in any case, constituted normal operation? To 'play the sceptick' still further, Glanvill raised again the visual relativisms of the tradition, reinforced by recent optical innovations. How do we know that objects of sense appear in the same way to each individual percipient? The usual examples suggesting that they do not were objects seen through coloured glass, distortions caused by pressure on the eyeball, colours changing according to position and lighting, and so on—the familiar litany of the tropes dealing with seeing 'in relation to something'. Now there was the further evidence of the 'optick tube', through which things appeared otherwise than with the naked eye. It was reasonable to suppose, therefore, that comparable differences in the organs of sense, the constitutions of brains, and the nerves, humours, and spirits connecting the two caused 'great diversity' in the perceptions of individuals. It followed that 'every man knows, how things appear to himself, yet what impressions they make upon the so different senses of another, he only knows certainly, that is conscious to them'. Giving them common names was no help either, since names were merely the conventional signs for objects that were assumed to appear in the same way to all men and women but which might in fact not do so.[105]

As if it was not enough to repeat the secular scepticism of the Greeks and their late Renaissance followers, the new Pyrrhonians, Glanvill had the advantage (in *The vanity of dogmatizing* at least—this was removed from the later versions) of being able to add striking comparisons between the visual capacities of the fallen and those of Adam, who, given the acuteness of his 'natural opticks', enjoyed 'pure un-eclipsed sensations' conveyed without 'spot or opacity'. His was a moment of instantaneous sensible perception of the causes of all natural effects without corruption or error; knowledge 'completely built, upon the certain, extemporary notice of his comprehensive, unerring faculties'. The unfallen Adam had no need of Galileo's 'tube'—not even a pair of spectacles, in one of Glanvill's more memorable statements—since the 'circumference' of his senses was indeed commensurate 'with that of natures activity'. Glanvill conceded that it might be thought incredible that eyes that had 'no greater diametrical wideness of the pupil, no greater distance from the cornea to the retiformis, and no more filaments of the optick nerves of which the tunica retina is woven' than ours have were able

nevertheless to respond to visual angles (made by distant bodies like the sun and stars) far more minute than those magnified with the help of the telescope. Apparently, Adam's superior 'animadversive' powers and his better 'spirits' made up for this, and Glanvill gave the details. Once lost to sin, however, his eyes were opened to his shame and disgrace but closed to everything else. There was now as much difference between his prelapsarian visual powers and those of Glanvill's contemporaries as between the 'opticks of the eagle' and those of the 'blind bat'.[106]

Scepticism was thus of central importance to Glanvill's natural philosophy, nowhere more so than in his view of the sense of sight. Nevertheless, it was still a scepticism that was mitigated. Glanvill denied being a sceptic himself (in response to Thomas White) and described the scientific practices of the Royal Society as, in essence, 'equally an adversary to scepticism and credulity'.[107] He also wrote in outspoken terms on behalf of the advancement of science on Baconian lines. One of his other writings is an apologia for the Royal Society and for scientific modernism in general, almost a supplement to Sprat's *History*, entitled *Plus ultra: or, the progress and advancement of knowledge since the days of Aristotle* (1668), in which all manner of positive achievements and concrete additions to knowledge, including the fields of optics and cognition theory, are listed and lauded. Moreover, when we look at how Glanvill proposed to secure the new forms of non-dogmatic natural knowledge, we discover a post-Cartesian account of vision, one in which 'all action worked by propagation of moving matter and all sense data were due to motions in the sensorium'.[108] In the *Essay against confidence in philosophy*, Glanvill was only able to retain the 'common way of speaking' about the senses making 'errors' because he added a Cartesian disclaimer. He did not want to be accused of making the philosophical mistake of supposing that the senses *themselves* committed any errors at all, since they did not; they only gave occasion to our minds to mislead us:

> [the senses] indeed represent things truely as they appear to them and in that there is no deception; but then, we judge the exterior realities to be according to those appearances, and here is the error and mistake. But because the senses afford the ground and occasion, and we naturally judg[e] according to their impressions, therefore the fallacies and deceits are imputed to their misinformations.[109]

The first version of this argument in *The vanity of dogmatizing* is wordier but also more detailed. Sensations, says Glanvill, no more 'resemble' things than an effect resembles its cause, but it is judgement that denies this, not our senses:

> We feel such, or such a sentiment within us, and herein is no cheat or misprision: 'tis truly so, and our sense concludes nothing of its rise or origine. But if hence our understandings falsly deduct, that there is the same quality in the external impressor; 'tis it is criminal, our sense is innocent. The apparitions of our frighted phancies are real sensibles: but if we translate them without the compass of our brains, and apprehend them as external objects; it's the unwary rashness of our understanding deludes us.

When the eye sees the stick bent in water, it 'sees aright' and should see nothing else; the mistake lies elsewhere, in the 'ill management of sensible informations'.[110]

Likewise, among the many forms of ignorance catalogued initially in *The vanity of dogmatizing* as a warning against overconfidence in knowledge are those to do with sensation and perception, in the description of which Glanvill again reveals his own positive views. In the preface, he had already noted that 'we see, we hear, and outward objects affect our other senses' without our knowing anything about the 'immediate reasons of most of these common functions',[111] and in chapter 4 he again remarks on the lack of any scientific account of even the most knowable of our faculties, the senses. The foundations of knowledge remain themselves unknown: 'Our eyes, that see other things, see not themselves.'[112] But none of this means that Glanvill lacked a cognitive hypothesis of his own, and everything else suggests that it was the one offered by the new philosophers of the 'Mersenne group'. 'Sense', he declared, 'is made by motion, caus'd by bodily impression on the organ, and continued to the brain, and centre of perception. Hence it is manifest that all bodies are in themselves sensible, in as much as they can impress this motion, which is the immediate cause of sensation.' That only the soul perceived, making the body simply 'the receiver and conveyer of corporeall impressions', was a truth so obvious to Glanvill and demonstrated so clearly by 'that wonder of men, the great Des-Cartes' that he thought it pointless even to discuss it. The real mystery was 'how the pure mind can receive information from that, which is not in the least like it self, and but little resembling what it represents'—how, in other words, the soul could 'read that such an image or stroke in matter ... signifies such an object' without some kind of 'alphabet' to guide it.[113] Glanvill resorted to the same semantic parallel in the further statement: 'That by diversity of motions we should spell out figures, distances, magnitudes, colours, things not resembled by them; we must attribute to some secret deduction.'[114] Though couched as questions with uncertain or hypothetical answers, these formulations of the problems of cognition reveal that Glanvill, like many of his contemporaries, was committed to both the principle of non-resemblance between sensations and the objects from which they originated and the consequent equivalence between mental perception and the grasping of meanings in linguistic signs. Sascha Talmor has called this a theory of perception based on representation, developed by Descartes in opposition to the 'presentative' theory of scholasticism 'in which the sensation or Phantasma participates in both the mental and the physical world'.[115]

Later in *The vanity of dogmatizing*, the philosophy that derives 'all sensitive perception from motion, and corporal impress', though not Hobbes's version of it, receives even fuller endorsement from Glanvill. The senses deceive not just in Pyrrhonian but in Cartesian ways too, persuading their users to cling onto the doctrine of 'species'. If representations of objects to the soul are made solely by different motions in the instruments of sense which are then conveyed to the brain, then the different effects which (say) fire and water have on us can only 'result from the so differing configuration and agitation of their particles: and not from, I know not what chimerical beings, supposed to inhere in the objects, their

cause, and thence to be propagated by many petty imaginary productions to the seat of sense'. What we call heat and cold (so ran the new orthodoxy) are not, therefore, qualities in bodies, but rather 'names expressing our passions . . . not strictly attributable to any thing without us, but by extrinsick denomination, as vision to the wall'. Disabusing ordinary percipient humans of their opposite but universal belief was tantamount to saying that snow was not white, yet their confidence—another piece of dogmatizing, of course—stemmed merely from a 'delusory prejudice' and 'misapplyed sensations'.[116]

It was consistent with this account of perception, and with his general stance of reserved judgement, provisional assent, and probable truth, that Glanvill could go on to endorse a dependence on the senses that was well founded enough to justify what he called 'indubitable certainty' in natural knowledge. This is the purpose of the *Essay of scepticism and certainty*, where that which there is no reason to doubt (but which could possibly be otherwise) is distinguished from that which is infallibly known (to God only), and then traced in part to 'certainties arising from the evidence of sense'. The senses confirm that the world consists of matter and motion, and, although they can mislead 'when they are not in their due circumstances, of right disposition, medium, distance, and the like', are otherwise worthy of full assent.[117] They can also be enhanced mechanically; in the third of the *Essays on several important subjects in philosophy and religion* (entitled 'Modern improvements of useful knowledge' and based on *Plus ultra*), Glanvill recommends aiding them with 'instruments, that may strengthen and rectifie their operations' and help compensate for their 'very defective and unaccurate reports, and many times very deceitful and fallacious ones'.[118] All this might seem like a retreat from Glanvill's 'play' with scepticism; the concept of 'due circumstances' is essentially that of Aristotle's *De anima*.[119] Yet even here there is the sceptic's sense of making do with all there is: external appearances. 'This fulness of assent', adds Glanvill, 'is all the certainty we have, or can pretend to; for after all, 'tis possible our senses may be so contrived, that things may not appear to us as they are: But we fear not this and the bare possibility doth not move us.' This was the maximum level of certainty required for socially acceptable knowledge based on observed phenomena.[120]

On other occasions and in other contexts, Glanvill may well have toned down his enthusiasm for Descartes or made it less explicit, but there is no indication that his attempt at a 'discreet modest aequipoize of judgement' in the making of knowledge was based on anything but the cognitive theories of the 'new' philosophy.[121] Undoubtedly one of its proponents in England, he recommended to the leading natural philosophers of his time—as well as absorbing from them—an account of visual perception that supposedly moved beyond the irreconcilable positions of old Aristotelianism and new Pyrrhonism. His views were indeed shared by many of his Royal Society colleagues, including Wilkins, Boyle and Newton.[122] He stands, as it were, at the point where European intellectuals began to emerge from the debates surveyed in this book with a new interpretation of the relationship

between seeing and knowing, hoping to make it more stable than at any time during the previous two centuries. Another way to put this is in terms of the relationship between seeing and *not* knowing. Sight can never be free from error, but the assumption that there was a correspondence between appearance and reality had hitherto led to one set of visual errors: the theory that sought to replace it rendered these redundant and established a different set of its own.

It is noticeable in this respect that Glanvill too had an interest in precisely those controversies and issues from which so many of the arguments and uncertainties about vision had arisen. Immersed, as we have just seen, in the technicalities of early modern philosophy and knowledge-theory, he was naturally familiar with faculty psychology, devoting sections of *The vanity of dogmatizing* and its later versions to the 'fallacies' and 'deceptions' of the imagination.[123] Melancholy appeared here in one familiar form, as the source of the visions, voices, and revelations which the religious 'enthusiast' judged to be 'exterior realities; when as they are but motions within the cranium', and it appeared in Glanvill's witchcraft writings in another, as the natural explanation offered by non-believers for demonic phenomena as 'representations' taken to be 'real and external transactions, when they are only within our heads'.[124] Glanvill was, indeed, an accomplished demonologist, regarding witchcraft as a kind of *experimentum crucis* in the defence of Anglican and new scientific values, but also as a guarantor of styles of weighing evidence and judging the phenomena of sense. It is tempting to think that confidence in vision might have been restored because invisible things like apparitions and witchcraft were declining in importance. But in English intellectual circles at least the opposite was true until well into the eighteenth century—making Glanvill in this respect very unlike Thomas Hobbes. In fact, both the development of mitigated scepticism in natural philosophy and the establishing of criteria for witnessing experimental practices came together after 1660 precisely because some of their leading exponents—notably Glanvill and Robert Boyle—still believed it crucial to find a place for manifestations of spirit in a world threatened socially and politically by materialism and atheism. The debates on witchcraft that still flourished during the period between the 1650s and the 1730s thus help to illustrate a more general preoccupation with the grounds for credulity and incredulity. In these debates, what the eyes could be relied upon to report accurately about the spirit world continued to be a major issue. Witchcraft, insisted Glanvill against John Webster, was an issue of *fact*, and matters of fact could 'only be proved by immediate sense, or the testimony of others, divine or humane'. Not all human testimony was uncertain, since the senses did 'sometimes' report the truth. At the same time, Glanvill's scepticism enabled him to defend witchcraft belief as immune from reasonable doubt—along with the acceptance of most natural things, whose 'modus' was unknown and whose intelligibility was beset with 'inextricable difficulties'.[125]

That Glanvill, as a clergyman, could not have deployed all the arguments concerning images and miracles that came to the fore during the years of Reformation and Counter-Reformation is unthinkable; one of his tracts was *An earnest*

invitation to the sacrament of the Lord's supper (1672). About apparitions and spirits he had a very considerable amount to say, linked again to his battles over atheism and the immortality of the soul. Glanvill was one of the many who closely analysed the 'witch' of Endor story for its religious and philosophical significance, both in *Some philosophical considerations* and (rewritten and enlarged) at the outset of part 2 of *Saducismus triumphatus* ('Proof of Apparitions etc. from Holy Scripture'). Finally, on the subject of dreams, Glanvill shared all the usual concerns of those who saw sleep as epistemologically significant. We spend half our lives, he noted in the 'Preface' to *The vanity of dogmatizing*, in a state about which we know virtually nothing but which has the profoundest implications for the workings of the soul and the nature of sensation and perception. We cannot even discover the nature of nocturnal illusions; on this subject, 'our most industrious conceits are but like their object, and as uncertain as those of midnight'.[126]

Like the George Hakewill of 1608, then, the Joseph Glanvill of the 1670s seems to offer a compendium of the intellectual history of vision, paused at a moment in time. They even read like each other on occasions, in detailing the consequences of the Fall for human vision or remarking that literally and metaphorically the eyes can see everything but themselves. Both men knew the tropes of scepticism and the topics of demonology and magic, and placed seeing very firmly in these settings. One wonders whether Glanvill perhaps read *The vanitie of the eie* in the library of Exeter College, where Hakewill was fellow and rector, at least nominally, until his death in 1649. There is nevertheless a significant change of mood and direction. Hakewill's treatise appeared at almost the midpoint of a sixty-year period marked by a pervasive sense of vision's precariousness and fallibility—a feeling that it was not only the noblest of the five senses and the key to all forms of wisdom and enlightenment but also the most vulnerable, the most unreliable, and the most problematic. One reads the essays of Montaigne, Pierre Le Loyer's *Quatre livres des spectres*, Martín Del Río's 'disquisitions' on magic, Shakespeare's *Macbeth*, the optical works of Nicéron, Robert Burton's *Anatomy of melancholy*, and at least the first of Descartes's *Meditations on first philosophy* and comes away feeling that these were contributions to the same somewhat troubled conversation. By the 1670s, the old question of whether human vision gave reliable access to the real world—of whether vision was veridical—had certainly not been settled. But it had been made at least temporarily redundant by a new acceptance, from the second of the *Meditations* onwards, that visual reality was not so much something grasped by human sensory perception as construed by it.

NOTES

1. Rupprecht, 'Divinity, Insanity, Creativity', 112; cf. Aikins, 'Accounting for Dreams in *Clarissa*', 170–80; Fungaroli, 'Landscapes of Life', 15–18 (on Locke).
2. Stafford, *Artful Science, passim*, quotations at pp. xxiii–xxiv. See also ead. and Terpak, *Devices of Wonder*, 1–142; Mannoni, et al., *Eyes, Lies and Illusions*, 16–17, 19–23, 41–52.

3. Baltrušaitis, *Anamorphic Art*, 115–19.
4. Hankins and Silverman, *Instruments and the Imagination*, 37–71; Vermeir, 'Magic of the Magic Lantern', 159.
5. Quotation in Simon Schaffer, 'Glass Works: Newton's Prisms and the Uses of Experiment', in David Gooding et al. (eds.), *The Uses of Experiment: Studies in the Natural Sciences* (Cambridge, 1989), 73.
6. Della Porta, *Natural magick*, 364–5, cf. 363–4.
7. Don Slater, 'Photography and Modern Vision: The Spectacle of "Natural Magic" ', in Chris Jenks (ed.), *Visual Culture* (London, 1995), 229; Kemp, *Science of Art*, 188–93.
8. Most obviously in Crary, *Techniques of the Observer*, 25–66. On the 'Kepler' model and its reception, see Alpers, *Art of Describing*, 26–71; Stephen Straker, 'The Eye Made "Other": Dürer, Kepler, and the Mechanisation of Light and Vision', in Louis A. Knafla, Martin S. Staum, and T. H. E. Travers (eds.), *Science, Technology, and Culture in Historical Perspective* (Calgary, 1976), 7–24; A. C. Crombie, 'Expectation, Modelling and Assent in the History of Optics—ii: Kepler and Descartes', *Stud. in the Hist. and Philosophy of Science*, 22 (1991), 89–115.
9. Colie, *Paradoxia epidemica*, 508 ff.
10. Evans, *Making of the Habsburg Monarchy*, 435, 442.
11. Kate Flint, *The Victorians and the Visual Imagination* (Cambridge, 2000), 1, cf. 37 and 1–39 *passim*; many of the issues raised in this brilliant book have parallels in early modern visual culture.
12. Betsy Newell Decyk, 'Cartesian Imagination and Perspectival Art', in Stephen Gaukroger, John Schuster, and John Sutton (eds.), *Descartes' Natural Philosophy* (London, 2000), 456.
13. Swan, *Art, Science, and Witchcraft*, 197.
14. Tachau, *Vision and Certitude*, p. xvi; Knecht, 'Fonctionnement de la science baroque', 678. For the 'dominance' of the theory of vision in seventeenth-century epistemology and the 'ocular emphasis' in metaphysics, see Catherine Wilson, 'Discourses of Vision in Seventeenth-Century Metaphysics', in David M. Levin (ed.), *Sites of Vision: The Discursive Construction of Sight in the History of Philosophy* (Cambridge, Mass., 1997), 117–38.
15. Malcolm, *Aspects of Hobbes*, 220 (Du Lieu); Evans, *Making of the Habsburg Monarchy*, 323, 336–7 (Marci); Nicola Zucchi, *Optica philosophia experimentis et ratione a fundamentis constituta* (Lyons, 1652, 1656); Francesco Eschinardi, *Centuriae opticae* (Rome, 1664); id, *Centuria problematum opticorum* (Rome, 1666); Francesco Maria Grimaldi, *Physico-mathesis de lumine, coloribus et iride* (Bologna, 1665), sig. b2ʳ.
16. Details in Pierre Humbert, 'Les Études de Peiresc sur la vision', *Archives internationales d'histoire des sciences*, 4 (1951), 654–9.
17. Wilson, 'Discourses of Vision', 117.
18. See esp. Richard S. Westfall, *Never at Rest: A Biography of Isaac Newton* (Cambridge, 1980), 156–62.
19. Gary Hatfield, 'Descartes' Physiology and its Relation to his Psychology', in John Cottingham (ed.), *The Cambridge Companion to Descartes* (Cambridge, 1992), 350.
20. Descartes, 'Early Writings', in *Philosophical Writings*, i. 3; Malcolm, *Aspects of Hobbes*, 210.
21. On this last point, see Neil M. Ribe, 'Cartesian Optics and the Mastery of Nature', *Isis*, 88 (1997), 42–61.

22. Prins, 'Hobbes on Light and Vision', 129.
23. Malcolm, *Aspects of Hobbes*, 218.
24. Ibid. 200–33 (ch. 7: 'The Title Page of *Leviathan*, Seen in a Curious Perspective'); cf. Martin Windisch, ' "When There is no Visible Power to Keep them in Awe" ', *Zeitsprünge: Forschung zur frühen Neuzeit*, 1 (1997), 117–65, esp. 129–34.
25. Prins, 'Hobbes on Light and Vision', summarizes its contents and assumes it is by Hobbes. Ferdinand Tönnies published it as Hobbes's in 1889, but Richard Tuck doubts the attribution. For fuller details of Hobbes's optical texts and their bibliography and chronology, see Prins, 'Hobbes on Light and Vision'; Richard Tuck, 'Hobbes and Descartes', in G. A. J. Rogers and Alan Ryan (eds.), *Perspectives on Thomas Hobbes* (Oxford, 1988), 11–27; Tuck, *Philosophy and Government*, 284 ff.
26. Tuck says of the 1644 publication that it was the first appearance in print of Hobbes's general philosophy: see id., 'Optics and Sceptics', 237.
27. Malcolm, *Aspects of Hobbes*, 146, from *English Works*, ed. Molesworth, vii. 471.
28. Elaine Limbrick, 'Doute sceptique, doute méthodique: vers la certitude subjective', in Lane M. Heller and Felix R. Atance (eds.), *Montaigne: regards sur les 'Essais'* (Waterloo, 1986), 47–59.
29. 'Fourth Set of Objections' to the *Meditations*, in *Philosophical Writings*, ii. 153, and for Descartes's reply, 173–8.
30. Dalia Judovitz, 'Vision, Representation, and Technology in Descartes', in David Michael Levin (ed.), *Modernity and the Hegemony of Vision*, 63.
31. 'The Search for Truth' (unpublished until 1701), in *Philosophical Writings*, ii. 405; cf. Anthony Kenny, *Descartes: A Study of his Philosophy* (Bristol, 1993), 218–19: 'Descartes arrived at his position by taking seriously optical illusions and errors of sense.'
32. *Œuvres de Descartes*, ed. Charles Adam and Paul Tannery (12 vols.; Paris, 1897–1910), i. 21.
33. Baltrušaitis, *Anamorphic Art*, 61–70, 111, followed by Rodis-Lewis, 'Machineries et perspectives curieuses', *passim*; Kemp, *Science of Art*, 211–12.
34. Decyk, 'Cartesian Imagination', 451–82; Thorne, *Vision and Rhetoric*, 138–9; Judovitz, 'Vision', 64–9; *Outlines of Pyrrhonism*, i. 123, ed. cit., 105.
35. Massey, 'Anamorphosis through Descartes', *passim* (I offer only the briefest account of an essay that deserves the closest attention).
36. Richard Woodfield, 'Thomas Hobbes and the Formation of Aesthetics in England', *British J. of Aesthetics*, 20 (1980), 146–52.
37. Ian Bostridge, *Witchcraft and its Transformations c.1650–c.1750* (Oxford, 1997), 38–52.
38. Tuck, 'Hobbes and Descartes', 31–2, and cf. 17, 27–31; his account is repeated in id., 'Optics and Sceptics', 235–63, and id., *Philosophy and Government*, 284–304, and is underlined independently by Giorgio Stabile, 'Teoria della visione come teoria della conoscenza', in 'La visione e lo sguardo nel Medio Evo, i/View and Vision in the Middle Ages, i', special issue of *Micrologus*, 5 (1997), 225–7. For Malebranche, see *Search after Truth*, 74–5.
39. Judovitz, 'Vision', 63.
40. For medieval discussions of the language analogy for cognition (in the context of non-resemblance theories of mental representation), see the account of William of Auvergne in Pasnau, *Theories of Cognition*, 101–5.
41. I rely on the following: Nicholas Pastore, *Selective History of Theories of Visual Perception, 1650–1950* (London, 1971), 71–99 (esp. 84–8); Margaret Atherton, 'How

to Write the History of Vision: Understanding the Relationship between Berkeley and Descartes', in Levin (ed.), *Sites of Vision*, 139–59 (Atherton brings together all the references in Berkeley to the 'language-based model' of visual cognition but puzzlingly sees this as a radical *departure* from Descartes, even though he also adopts it); Hatfield and Epstein, 'Sensory Core', 379–82. See also G. N. Cantor, 'Berkeley, Reid, and the Mathematization of Mid-Eighteenth-Century Optics', in John W. Yolton (ed.), *Philosophy, Religion and Science in the Seventeenth and Eighteenth Centuries* (Rochester, NY, 1990), 433–5, 446, and 443–5, on Thomas Reid's use of the 'language metaphor' in his *An Inquiry into the Human Mind* (1764). C. M. Turbayne, *The Myth of Metaphor*, rev. edn. (Columbia, SC, 1970), 101–37, 141–217, offers valuable extended reflections on the nature and history of the language model of vision.

42. Pastore, *Selective History*, 84–5.
43. George Berkeley, *An Essay towards a New Theory of Vision*, sect. 147, in *The Works of George Berkeley Bishop of Cloyne*, ed. A. A. Luce and T. E. Jessop (London, 1948–57), i. 231.
44. The resemblance/non-resemblance issue is discussed throughout Descartes scholarship, but, bearing in mind that many analyses are largely philosophical in character, I have found the following especially useful: Ann Wilbur MacKenzie, 'Descartes on Life and Sense', *Canadian J. of Philosophy*, 19 (1989), 163–92; Margaret D. Wilson, 'Descartes on Sense and "Resemblance" ', in John Cottingham (ed.), *Reason, Will, and Sensation: Studies in Descartes's Metaphysics* (Oxford, 1994), 209–28; Gaukroger (trans. and ed.), *A. Arnauld: 'On True and False Ideas'*, 14–26; id., *Descartes*, 158–72; Judovitz, 'Vision', *passim*; Massey, 'Anamorphosis through Descartes', 1155–9.
45. 'Third Meditation', in *Philosophical Writings*, ii. 25–7.
46. 'Sixth Meditation', in *Philosophical Writings*, ii. 56, 56–7, 57–8, 57; cf. 'Principles of Philosophy', in *Philosophical Writings*, i. 224. On the teleological implications in this argument, see Alison Simmons, 'Sensible Ends: Latent Teleology in Descartes' Account of Sensation', *J. of the Hist. of Philosophy*, 39 (2001), 49–75.
47. 'Principles of Philosophy', in *Philosophical Writings*, i. 218.
48. Catherine Wilson, *Descartes's 'Meditations': An Introduction* (Cambridge, 2003), 199–200, 212, calls Descartes's attack on resemblance a 'semantic' theory of sensory experience, according to which '[s]omeone who was convinced that P-F-E-R-D was intrinsically similar to or resembled a living horse would be under the spell of the same illusion as the naïve theorist who supposes that our experiences of corporeal things are similar to or resemble them as they are in themselves'. The word 'symbolic' is adopted by Crombie, 'Expectation, Modelling and Assent', 113, and by Brian S. Baigrie, 'Descartes's Scientific Illustrations and "la grande mécanique de la nature" ', in id. (ed.), *Picturing Knowledge*, 115, who also concludes (129 n. 2): 'The position that squares with the vast majority of Descartes's statements is that our perceptions have a purely mental status—that is, they *do not resemble* any quality that exists in the world' (author's emphasis). Cf. Sascha Talmor, *Glanvill: The Uses and Abuses of Scepticism* (Oxford, 1981), 25: 'There is between the sensible quality and the real object a relation of purely arbitrary representation, just as words, which are man-made and arbitrary signs, represent or signify objects and ideas'; Judovitz, 'Vision', 64, on Descartes's establishment of 'the arbitrary relation between the object of vision and the impression that object generates . . . by analogy to language'.
49. 'The World or Treatise on Light', in *Philosophical Writings*, i. 81; Gaukroger (trans. and ed.), *A. Arnauld: 'On True and False Ideas'*, 24; Tuck, 'Hobbes and Descartes', 34.

50. For discussions of the 'semantic' elements in Descartes's theory of perception, filtered through the equivalent interests in modern philosophy, see the 'Symposium on Descartes on Perceptual Cognition' involving David Behan, Peter Slezak, Celia Wolf-Devine, Yasuhiko Tomida, and John Yolton, in Gaukroger, Schuster, and Sutton (eds.), *Descartes' Natural Philosophy*, 524–87.
51. Gary Hatfield, *Descartes and the 'Meditations'* (London, 2003), 262–3.
52. 'Author's Replies to the Sixth Set of Objections' to the *Meditations*, in *Philosophical Writings*, ii. 295. Margaret D. Wilson, 'Descartes on the Perception of Primary Qualities', in Stephen Voss (ed.), *Essays on the Philosophy and Science of René Descartes* (Oxford, 1993), 162–76; Ann Wilbur MacKenzie, 'The Reconfiguration of Sensory Experience', in Cottingham (ed.), *Reason, Will, and Sensation*, 251–72.
53. For a valuable account of visual experience in Descartes based mainly on a reading of the 'three grades of sensory response' (in the 'Sixth Set of Replies'), see Hatfield, 'Descartes' Physiology', 350–8. Hatfield (354) does highlight a tension in Descartes between two versions of the mind–body relationship in seeing: the 'interaction' and the 'inspection' versions. In the first (which I am stressing in my account in order to underline Descartes's novelty), 'mental events are paired with bodily processes in an arbitrary fashion by an "institution of nature"'; in the second, more traditional in character, 'the content of the mental event is determined by what the mind "sees" in the body, by direct inspection of a pattern in the brain (as it were)'. Hatfield wonders whether Descartes, since he invoked 'interaction' often, repeatedly insisted on the principle of 'no resemblance', and was certainly not naive about 'inspection', may have slipped into the 'inspection' terminology through carelessness. For further instances of Descartes on 'inspection', see N. K. Smith, *New Studies in the Philosophy of Descartes: Descartes as Pioneer* (London, 1952), 139–60; and for discussion of the same two models of visual perception in Descartes, see Celia Wolf-Devine, 'Descartes' Theory of Visual Spatial Perception', in Gaukroger, Schuster, and Sutton (eds.), *Descartes' Natural Philosophy*, 506–23. Also helpful on the three 'grades' is Ronald Arbini, 'Did Descartes Have a Philosophical Theory of Sense Perception?', *J. Hist. Philosophy*, 21 (1983), 317–37.
54. 'Sixth Set of Replies', in *Philosophical Writings*, ii. 294–6.
55. Pastore, *Selective History*, 34–5.
56. 'Optics', in *Philosophical Writings*, i. 166.
57. Ibid. 166; Lindberg, *Theories of Vision*, 200–2, and n. 98 on Kepler's interchangeable use of the terms *pictura, idolum, imago,* and *species*.
58. 'Optics', in *Philosophical Writings*, i. 167.
59. 'Treatise on Man', in *Philosophical Writings*, i. 105.
60. 'Rules for the Direction of the Mind', in *Philosophical Writings*, i. 40; Judovitz, 'Vision', 74–80.
61. 'Optics', in *Philosophical Writings*, i. 165, 153–4.
62. Esp. helpful on these processes is Pastore, *Selective History*, 19–26.
63. For this point and its damaging consequences for the arguments in Crary, *Techniques of the Observer*, see Atherton, 'How to Write the History of Vision', 139–48.
64. 'Optics', in *Philosophical Writings*, i. 166.
65. Ibid. 167; Hatfield, 'Descartes' Physiology', 350; John W. Yolton, *Perception and Reality: A History from Descartes to Kant* (Ithaca, NY, 1996), 67–83; Judovitz, 'Vision', 72, on Descartes's 'nonmimetic and, ultimately, nonreferential model' of vision: 'While nature provides us with visible signs, the attempt to decipher them no longer

demands that this process take place within the register of the visible. Like speech, the visible becomes legible at the moment that it becomes something different from itself. Once the visible is reduced to a sign, what matters is not its relation to what it ostensibly signifies, but its function in the order of signification.'

66. See esp. Kenny, *Descartes*, 219: 'What, then, differentiates the Aristotelian view from Descartes' view that secondary qualities are "powers that objects have"? For Descartes the power was to set our nerves in motion; for Aquinas it was to produce likenesses of themselves.'
67. 'Optics', in *Philosophical Writings*, i. 153.
68. Ibid. 172.
69. Ibid. 166.
70. Ibid. 165.
71. Pastore, *Selective History*, 18, gives a helpful summary. Lindberg, *Theories of Vision*, 202–5, says of Kepler and others like him that they, by contrast with Descartes, failed to distinguish between the optical and psychological aspects of seeing. They assumed that *species* were seen rather than interpreted and, therefore, like all resemblance theorists, regarded the inversion of the retinal image as a major problem.
72. Jay, *Downcast Eyes*, 69–82 (esp. 69: 'Descartes was a quintessentially visual philosopher, who tacitly adopted the position of a perspectivalist painter using a camera obscura to reproduce the observed world'); Richard Rorty, *Philosophy and the Mirror of Nature* (Princeton, 1980), 45–69.
73. Wilson, 'Discourses of Vision', 122 (my emphasis). For 'post-retinal transmission' in Kepler and Descartes, I have relied on Hatfield and Epstein, 'Sensory Core', 371–9.
74. 'Sixth Set of Replies', in *Philosophical Writings*, ii. 295 (my emphasis).
75. There are references to 'species' in 'A Short Tract on First Principles' (*c*.1630), but quite apart from the fact that this may not be by Hobbes, they are set in the context of sense being nothing but the local motion of material bodies; see Prins, 'Hobbes on Light and Vision', 129–31, 146–7, emphasizing Hobbes's 'mechanization of optics' (147).
76. Tuck, 'Hobbes and Descartes', 16–17 (author's emphasis); Prins, 'Hobbes on Light and Vision', 131–2, and cf. 134: 'visual images are not real things existing in the outside world but only motions within the perceiving subject.'
77. All quotations from Tuck, 'Hobbes and Descartes', 25–6, 28. The treatise is in Harleian MS 3360 and was partially printed by Molesworth, *English Works*, vii. 467–71; nine of its chapters represent longer precursors of the eight chapters on vision in Hobbes's *De homine* (1658). For his views on light from 1643, see Thomas Hobbes, *Thomas White's 'De mundo' Examined*, trans. Harold Whitmore Jones (London, 1976), 99–113.
78. Thomas Hobbes, *The Elements of Law Natural and Politic*, ed. Ferdinand Tönnies, 2nd edn. with introd. by M. M. Goldsmith (London, 1969), 3–4.
79. Ibid. 7, and 4–7; commentary in Tuck, 'Hobbes and Descartes', 37–9; id., *Philosophy and Government*, 298–300.
80. Prins, 'Hobbes on Light and Vision', 138.
81. Hobbes, *Elements of Law*, 18–19.
82. Tuck, 'Hobbes and Descartes', 37–41 (esp. 38, citing 147 of the Alessio edn. of Harleian MS 6796, called 'Tractatus Opticus' by Tönnies and thought by Tuck to be an early draft of *Sectio secunda* of Hobbes's master work *The elements of philosophy, De homine*: 'Nothing further is required in Physics, therefore, than that the motions we suppose or imagine are conceivable, that the necessity of the phenomenon can be

demonstrated from them, and that nothing false can be derived from them'); cf. Tuck, *Philosophy and Government*, 299–303.
83. Richard Tuck, *Hobbes* (Oxford, 1989), 53 (author's emphasis); cf. id, *Philosophy and Government*, 304: 'Just as conventional Aristotelian properties, such as colour, were not really properties of objects, but attributed to them on the basis of an observer's perceptions, so were *moral* properties' (author's emphasis).
84. Hobbes, *Elements of Law*, 28–29.
85. Hobbes, *Leviathan*, 14 (pt. 1, ch. 1).
86. For a striking instance of how literal picturing could persist as the model for sensation, see Thomas Willis, *Cerebri anatome* (1664), cited by G. S. Brett, *A History of Psychology* (3 vols.; London, 1912–21), ii. 191: 'It seems allowable to conceive of the middle regions of the brain constituting an inner chamber of this [corporeal] soul fitted with dioptric mirrors, as with windows. The pictures or images of all sensible things admitted into these secret places by means of the ducts of the nerves, as by means of tubes or narrow opening, first pass through the corpora striata, and then are represented on the corpus callosum as on a whitened wall.'
87. Popkin, *History of Scepticism*, 132.
88. Barbara J. Shapiro, *Probability and Certainty in Seventeenth-Century England* (Princeton, 1983), esp. 15–73.
89. Iliffe, 'Lying Wonders', 189, 206–9.
90. Ibid. 207.
91. These issues have come to inform much of the scholarship on late 17th-century English natural philosophy, but see esp. Shapin and Schaffer, *Leviathan and the Air-Pump*, passim, esp. 22–79; Steven Shapin, *A Social History of Truth: Civility and Science in Seventeenth-Century England* (Chicago, 1994), esp. chs. 4 and 5; Barbara J. Shapiro, *A Culture of Fact: England, 1550–1720* (Ithaca, NY, 2000), esp. 105–67; Hankins and Silverman, *Instruments and the Imagination*, 38–43, 50–3.
92. Simon Schaffer, 'Regeneration: The Body of Natural Philosophers in Restoration England', in Christopher Lawrence and Steven Shapin (eds.), *Science Incarnate: Historical Embodiments of Natural Knowledge* (Chicago, 1998), 90–4; Tuck, 'Hobbes and Descartes', 16–7; Schaffer, 'Glass Works', 73–4; A. Rupert Hall, *All Was Light: An Introduction to Newton's 'Opticks'* (Oxford, 1993), 12–13. For Descartes's influence on Boyle and Hooke in the area of visual perception, see J. J. MacIntosh, 'Perception and Imagination in Descartes, Boyle and Hooke', *Canadian J. of Philosophy*, 13 (1983), 327–52.
93. Cited by Wilson, *Invisible World*, 247.
94. Locke, *Essay*, ed. Nidditch, 388–90 (bk. 2, ch. xxxii, 14–16).
95. Ibid. 134 (bk. 2, ch. viii, 7).
96. Ibid. 174 (bk. 2, ch. xiii, 18).
97. Ibid. 137 (bk. 2, ch. viii, 16); my emphasis.
98. Ibid. 138 (bk. 2, ch. viii, 18).
99. Ibid. 142 (bk. 2, ch. viii, 25).
100. Ibid. 372–3 (bk. 2, ch. xxx, 1–2). I have been guided to these passages in Locke by Talmor, *Glanvill*, 42–8, and Pastore, *Selective History*, 64–6. See also Michael Jacovides, 'Locke's Resemblance Theses', *Philosophical Rev.* 108 (1999), 461–96, and on the 'arbitrariness' of the relation between secondary properties and their corpuscularian causes, Wilson, *Invisible World*, 246.

101. The two major studies of Glanvill are Jackson I. Cope, *Joseph Glanvill Anglican Apologist* (St Louis, 1956), and Talmor, *Glanvill*.
102. The three texts are brought together in Joseph Glanvill, *The Vanity of Dogmatizing: The Three Versions*, ed. Stephen Medcalf (Hove, 1970); the original pagination is retained.
103. Glanvill, *Vanity*, sig. A6v; on constructive scepticism in Glanvill, see Popkin, *History of Scepticism*, 15–16, 217; Henry G. Van Leeuwen, *The Problem of Certainty in English Thought, 1630–1690* (The Hague, 1970), 71–89; Beverley C. Southgate, 'Excluding Sceptics: The Case of Thomas White, 1593–1676', in Richard A. Watson and James E. Force (eds.), *The Sceptical Mode in Modern Philosophy: Essays in Honor of Richard H. Popkin* (Dordrecht, 1988), 76–81.
104. Glanvill, *Essay*, 16–17; cf. *Vanity*, 67–8.
105. Glanvill, *Essay*, 17–20; cf. *Vanity*, 69–74, 218–23 (where Glanvill 'personates' the sceptic by adopting many of the tropes of Pyrrhonism).
106. Glanvill, *Vanity*, 'Preface', sigs. B1v–B4v, and 1–11; Schaffer, 'Regeneration', 93–4.
107. Joseph Glanvill, *A praefatory answer to Mr. Henry Stubbe* (London, 1671), 143–4.
108. Schaffer, 'Regeneration', 94; cf. Glanvill, *Vanity*, ed. Medcalf, 'Introduction', p. xxiv.
109. Glanvill, *Essay*, 17–18.
110. Glanvill, *Vanity*, 92, 92–3, 93–4.
111. Ibid., 'Preface', sigs. A6v–A7r.
112. Ibid. 27.
113. Ibid. 8, 28, 30; cf. *Scepsis*, 21; *Essay*, 6: 'how the pure mind can receive information from things that are not like it self, nor the objects they represent'.
114. Glanvill, *Vanity*, 30; cf. *Essay*, 6.
115. Talmor, *Glanvill*, 26, adding that Glanvill did not 'realise or work out all the implications of this hypothesis' and then gave it up in favour of a return to the 'material phantasms' of scholasticism (26–30, cf. 42–8). Talmor fails to appreciate (1) that Glanvill's use of the semantic vocabulary of 'naming', 'reading', and 'spelling' in itself undermines his claim that 'the analogy Descartes makes between the purely representational power of language and of ideas never occurs to Glanvill' (27), and (2) that Glanvill's remark about returning to 'material phantasms' (*Vanity*, 67, cf. *Scepsis*, 50, *Essay*, 17) is meant to indicate a temptation that ought to be resisted because it derives from an ignorance about cognition that the 'new philosophy' will dispel. What *kind* of a language Glanvill meant to invoke and where he located it ('some secret deduction', *Vanity*, 30, *Scepsis*, 22, *Essay*, 6; 'some implicit inference', *Vanity*, 30, *Scepsis*, 22; 'some unknown way of learning', *Essay*, 6) are less important for my purposes than the linguistic analogy itself, which guarantees (in Talmor's own formulation) 'the representative character of ideas as arbitrary signs construed on the analogy of language (words)' (33).
116. Glanvill, *Vanity*, 87–9; cf. *Scepsis*, 64–5, 67, *Essay*, 21.
117. Glanvill, *Essays on several important subjects*, 48–9.
118. Glanvill, 'Modern improvements of useful knowledge', in ibid. 23 (sep. pag.); cf. id., *Plus ultra: or, the progress and advancement of knowledge since the days of Aristotle* (London, 1668), 52–3.
119. Van Leeuwen, *Problem of Certainty*, 86.
120. Glanvill, 'Of scepticism and certainty', in *Essays*, 49.
121. Glanvill, *Vanity*, 223; Cope, *Joseph Glanvill*, 16, 64.

122. Van Leeuwen, *Problem of Certainty*, 50–71 (Wilkins), 91–106 (Boyle), 106–20 (Newton).
123. Glanvill, *Vanity*, 95–105; id., *Scepsis*, 70–7; id., 'Against confidence in philosophy', ed. Medcalf, 22. On the powers of the imagination, see Glanvill, *Vanity*, 195–201.
124. Glanvill, *Vanity*, 99; on melancholic delusion and religious enthusiasm in Glanvill, with full citations, see Cope, *Joseph Glanvill*, 56–8, and for an example, see the passage on 'deliquiums of sense' in 'Antifanatick theologie, and free philosophy', in id., *Essays*, 28–9 (sep. pag.). On melancholy and explanations of witchcraft (as well as of 'enthusiasm'), see *A blow at modern sadducism in some philosophical considerations about witchcraft* (London, 1668), 101–2.
125. Glanvill, *Saducismus triumphatus*, 273–4, cf. 67; see also id., 'Against modern Sadducism in the matter of witches and apparitions', in id., *Essays*, 2–3, 7–8, 17. On the connection between witchcraft and issues of testimony and proof, see Talmor, *Glanvill*, 60–1. On the witchcraft debates more generally, see Bostridge, *Witchcraft*, 53–84; Clark, *Thinking with Demons*, 294–311.
126. Glanvill, *Vanity*, A7[v]–A8[r]; id., *Scepsis*, 10.

Bibliography

ITEMS BEFORE 1800

Abbot, Robert, *Antichristi demonstratio* (London, 1603).
Accolti, Pietro, *Lo inganno de gl'occhi, prospettiva pratica* (Florence, 1625).
Acosta, José de, *De Christo revelato . . . simulque de temporibus novissimis* (Lyons, 1592).
Adams, Thomas, *Mystical bedlam, or the world of mad-men* (London, 1615).
Ady, Thomas, *A candle in the dark; or, a treatise concerning the nature of witches and witch-craft* (London, 1656).
[——] *The doctrine of devils, proved to be the grand apostacy of these later times* (London, 1676).
Agrippa (Von Nettesheim), Heinrich Cornelius, *Three books of occult philosophy*, trans. J[ohn] F[rench] (London, 1651).
—— *Of the vanitie and uncertaintie of artes and sciences*, trans. Ja[mes] Sanford, ed. C. M. Dunn (Northridge, Calif., 1974).
Aguilon (Aguilonius), François d', *Opticorum libri sex* (Antwerp, 1613).
Ainsworth, Henry, *An arrow against idolatrie* (n.p. [Amsterdam?], 1611).
Alberti, Leon Battista, *On Painting*, trans. and ed. J. R. Spencer, rev. edn. (New Haven, 1966).
Albrecht, Bernhard, *Magia; das ist, Christlicher Bericht von der Zauberey und Hexerey ins gemein* (Leipzig, 1628).
Alsted, Johann Heinrich, *Encyclopaedia* (Herborn, 1630).
Amyraut, Moyse, *Discours sur les songes divines dont il est parlé dans l'Écriture* (Saumur, 1665), trans. James Lowde as *A discourse concerning the divine dreams mention'd in Scripture* (London, 1676).
Aquinas, St Thomas, *Basic Writings of Saint Thomas Aquinas*, ed. A. C. Pegis (2 vols.; New York, 1945).
—— *St Thomas Aquinas: Summa theologica*, Blackfriars edn. (60 vols.; London, 1964–6).
—— *De regimine principum ad regem Cypri . . .* , ed. J. Mathis, 2nd edn. (Turin, 1971).
Aretaeus, *Of the Causes and Signs of Acute and Chronic Disease*, trans. T. F. Reynolds (London, 1837).
Arethas, Archbishop of Caesarea in Cappadocia, 'Arethae . . . coacervatio enarrationum ex variis sanctis viris in Johannis . . . Apocalypsim', in *Enarrationes vetustissimorum theologorum* (Antwerp, 1545).
Aristotle, *The Works of Aristotle*, ed. W. D. Ross (12 vols.; Oxford, 1908–52).
Armo, Giovanni Francesco, *De tribus capitis affectibus, sive de phrenetide, mania, et melancholia liber* (Turin, 1573).
Ars magica sive magia naturalis et artificiosa (Frankfurt am Main, 1631).
Artemidorus, *The Interpretation of Dreams: Oneirocritica by Artemidorus*, trans. and ed. R. J. White (Park Ridge, NJ, 1975).
Attersoll, William, *The new covenant, or a treatise of the sacraments*, 2nd edn. (London, 1614).
Augustine, St, *The City of God*, trans. John Healey (1610) (2 vols.; Edinburgh, 1909).

Augustine, St, 'Ad infantes, de sacramento' (Sermon 272), *Opera omnia* (11 vols.; Paris, 1836–8), v, pt. 1.
—— *The Literal Meaning of Genesis*, trans. and ed. J. H. Taylor (2 vols.; New York, 1982).
—— *Confessions*, trans. and ed. H. Chadwick (Oxford, 1991).
[Pseudo-Augustine], *Quaestiones veteris et novi testamenti cxxvii*, ed. A. Souter, in *Corpus scriptorum ecclesiasticorum Latinorum*, vol. 50 (Vienna, 1908).
Bacon, Francis, *Works*, ed. J. Spedding, R. L. Ellis, and D. D. Heath (14 vols.; London, 1857–74).
Balduin, Fridrich, *Tractatus . . . casibus nimirum conscientiae summo studio elaboratus* (Wittenberg, 1654).
Bale, John, *The actes of Englysh votaryes* ('Wesel' [i.e. Antwerp], 1546).
Banister, Richard, *Breviary of the eyes*, in id., *A treatise of one hundred and thirteene diseases of the eyes, and eye-liddes* (London, 1622).
Barbaro, Daniele, *La pratica della perspettiva* (Venice, 1568).
Baronio, Caesare, *Annales ecclesiastici* (12 vols.; Antwerp, 1612, 1597–1609).
Barrough, Philip, *The method of phisick, containing the causes, signes, and cures of inward diseases in mans body from the head to the foote*, 3rd edn. (London, 1596).
Bartisch, Georg, *Ophthalmodouleia, That is the Service of the Eyes*, trans. D. L. Blanchard (Ostend, 1995).
[Batman (or Bateman), Stephen], *Batman uppon Bartholome, his booke De proprietatibus rerum* (London, 1582).
Battie, William, *A Treatise on Madness by William Battie, M. D. and Remarks on Dr. Battie's Treatise on Madness by John Monro, M. D.: A Psychiatric Controversy of the Eighteenth Century*, ed. R. Hunter and I. Macalpine (London, 1962).
Baxter, Richard, *The unreasonableness of infidelity* (London, 1655).
—— *Preservatives against melancholy and overmuch sorrow. Or the cure of both by faith and physick* (London, 1713).
Bayfield, Robert, *Tes iatrikes kartos, or, a treatise de morborum capitis essentiis et pronosticis* (London, 1663).
Beaumont, John, *An historical, physiological and theological treatise of spirits, apparitions, witchcrafts, and other magical practices* (London, 1705).
Beauvois de Chauvincourt, Sieur de, *Discours de la lycantropie ou de la transmutation des hommes en loups* (Paris, 1599).
Becon, Thomas, *The displaying of the popish mass* (1559), in *Prayers and Other Pieces of Thomas Becon*, ed. J. Ayre (Cambridge, 1844), 251–86.
Bekker, Balthasar, *Le Monde enchanté* (4 vols.; Amsterdam, 1694).
Bellarmine, Robert, *Disputationes de controversiis Christianae fidei, adversus huius temporis haereticos* (4 vols.; Paris, 1608).
—— *Tractatus de potestate summi pontificis in rebus temporalibus et de Romani Pontificis ecclesiastica hierarchia*, in *Bibliotheca maxima pontificia*, ed. Juan Tomas de Rocaberti (21 vols.; Rome, 1698–9), xviii. 365–691.
Benedictus, Joannes, *De visionibus et revelationibus naturalibus et divinis* (Cracow, 1545).
Benoist, René, *Response a ceux qui appellent idolatres les chrestiens et vrays adorateurs* (Paris, 1566).
Berkeley, George, *An Essay towards a New Theory of Vision*, in *The Works of George Berkeley Bishop of Cloyne*, ed. A. A. Luce and T. E. Jessop (London, 1948–57), i. 141–239.
Bernard, Richard, *A guide to grand-jury men*, 2nd edn. (London, 1630).

Bettini, Mario, *Apiaria universae philosophiae mathematicae* (2 vols.; Bologna, 1642).
Beyerlinck, Laurentius, *Magnum theatrum vitae humanae* (8 vols.; Lyons, 1678).
[Bèze, Théodore de], *A confession of fayth, made by common consent of divers reformed churches beyonde the seas* (London, n.d. [1568]).
[Bible, Geneva], *The Geneva Bible*, introd. L. E. Berry (Madison, 1969); facsimile of 1560 edn.
Binsfeld, Petrus, *Tractatus de confessionibus maleficorum et sagarum* (Cologne, 1623).
Blackmore, Richard, *A treatise of the spleen and vapours: or, hypocondriacal and hysterical affections* (London, 1725).
Bodin, Jean, *De la démonomanie des sorciers* (Paris, 1580).
Boguet, Henri, *An Examen of Witches*, trans. E. A. Ashwin, ed. M. Summers (London, 1929).
Bona, Giovanni, *De discretione spirituum in vita spirituali deducendorum*, in id., *Opera omnia* (Antwerp, 1677), 221–322.
Boquin, Pierre, *A defense of the olde, and true profession of Christianitie, against the new, and counterfeite secte of Jesuites, or fellowship of Jesus*, trans. T.G. (London, 1581).
Borde, Andrew, *The breviary of helthe* (London, 1547).
—— *A compendyous regyment or a dyetary of healthe* (London, 1547).
B[oyle], R[obert], *A disquisition about the final causes of natural things . . . To which are subjoyn'd, by way of appendix some uncommon observations about vitiated sight* (London, 1688).
—— 'About the Excellency and Grounds of the Mechanical Hypothesis', in *Selected Philosophical Papers of Robert Boyle*, ed. M. A. Stewart (London, 1979), 138–54.
Bradford, John, *Two notable sermons . . . the one of repentance, the other of the Lordes supper* (London, 1581).
Brathwaite, Richard, *Essaies upon the five senses* (London, 1620).
Brevint, Daniel, *Saul and Samuel at Endor* (Oxford, 1674).
Bright, Timothy, *A treatise of melancholie* (London, 1586).
Brightman, Thomas, *A revelation of the Apocalyps* (Amsterdam, 1611).
Brognolo, Candido, *Alexicacon hoc est opus de maleficiis, ac morbis maleficis* (Venice, 1668).
Bullinger, Heinrich, *A commentary upon the seconde epistle of S. Paul to the Thessalonians*, trans. R.H. (London, 1538).
—— *Catechesis pro adultioribus scripta, de his potissimum capitibus* (Zurich, 1559).
Buonanni, Filippo, *Musaeum Kircherianum sive musaeum a P. Athanasio Kirchero in collegio Romano societatis Jesu iam pridem incoeptum nuper restitutum, auctum, descriptum, et iconibus illustratum etc.* (Rome, 1709).
Burton, Robert, *The Anatomy of Melancholy*, ed. H. Jackson, with new introd. by W. H. Gass (New York, 1932, 2001).
Butler, Samuel, *Characters*, ed. C. W. Daves (Cleveland, 1970).
Caldera de Heredia, Gaspar, *Tribunal magicum, quo omnia quae ad magiam spectant, accurate tranctantur et explanantur, seu tribunalis medici [pars secunda]* (Leiden, 1658).
Calmet, Augustin, *The Phantom World; or, The Philosophy of Spirits, Apparitions, etc*, trans. and ed. H. Christmas from the 3rd French edn. of 1751 (2 vols.; London, 1850).
Calvin, Jean, *Calvin: Theological Treatises*, ed. J. K. S. Reid, Library of Christian Classics xxii (London, 1954).
—— *Institutes of the Christian Religion*, ed. J. T. McNeill, trans. F. L. Battles (2 vols.; London, 1961).
Camus, Jean-Pierre, *Les Diversitez de Messire Jean-Pierre Camus* (11 vols.; Paris, 1612–20).

The Canons and Decrees of the Council of Trent, trans. T. A. Buckley (London, 1851).
Cardano, Girolamo, *Opera omnia* (10 vols.; Lyons, 1663).
Casaubon, Meric, *A treatise concerning enthusiasme, as it is an effect of nature: but is mistaken by many for either divine inspiration, or diabolical possession*, 2nd edn. (London, 1656).
—— *A treatise proving spirits, witches and supernatural operations by pregnant instances* (London, 1672).
Casmann, Otto, *Psychologia anthropologica; sive animae humanae doctrina* (Hanau, 1594).
—— *Angelographia* (Frankfurt am Main, 1605).
Castaldi, Giovanni Tommaso, *De potestate angelica sive de potentia motrice, ac, mirandis operibus angelorum atque d[ae]monum, dissertatio* (3 vols.; Rome, 1650–2).
Caus, Salomon de, *La Perspective, avec la raison des ombres et miroirs* (London, 1611).
Certain Sermons or Homilies Appointed to be Read in Churches (Oxford, 1832); 1st pub. 1563.
Charron, Pierre, *Of wisdome*, trans. Samson Lennard (London, n.d. [before 1612]).
Chemnitius, Martinus, *Examinis Concilii Tridentini* (Frankfurt, 1596).
Chirino de Salazar, Fernando, *Expositio in Proverbia Salomonis* (2 vols.; Paris, 1619).
Cicero, *Tusculan Disputations II and V with a Summary of III and IV*, ed. and trans. A. E. Douglas (Warminster, 1990).
—— *De natura deorum. Academica*, trans. H. Rackham (London, 1933).
Ciruelo, Pedro, *A Treatise Reproving all Superstitions and Forms of Witchcraft*, trans. E. A. Maio and D'O. W. Pearson, ed. D'O. W. Pearson (London, 1977).
Coëffeteau, Nicolas, *Tableau des passions humaines, de leurs causes et de leur effets* (Paris, 1620), trans. Edward Grimeston, as *A table of humane passions. With their causes and effects* (London, 1621).
[Collegium Conimbricense], *Commentarii . . . in octo libros physicorum* (Cologne, 1609).
Cooper, Thomas, *The mystery of witch-craft* (London, 1617).
C[otgrave], J[ohn], *Wits interpreter, the English Parnassus* (London, 1655).
Cotta, John, *A short discoverie of the unobserved dangers of severall sorts of ignorant and unconsiderate practisers of physicke in England* (London, 1612).
—— *The triall of witch-craft* (London, 1616).
Cranmer, Thomas, 'An answer to a crafty and sophistical cavillation devised by Stephen Gardiner', in *Writings and Disputations of Thomas Cranmer . . . Relative to the Sacrament of the Lord's Supper*, ed. J. E. Cox (Cambridge, 1844), 1–367.
Crooke, Helkiah, *Microcosmographia* (London, 1615).
Daneau, Lambert, *A dialogue of witches*, trans. attrib. to Thomas Twyne (London, 1575).
—— *A treatise, touching antichrist*, trans. [J. Swan] (London, 1589).
Da Prierio, Silvestro (Mazzolini), *De strigimagarum, daemonumque mirandis* (Rome, 1575).
—— *Summae Sylvestrinae quae summa summarum merito nuncupatur* (Antwerp, 1581).
David, Johannes, *Veridicus Christianus* (Antwerp, 1601).
Day, Richard, *A booke of Christian prayers* (London, 1578).
Deacon, John, and Walker, John, *Dialogicall discourses of spirits and divels* (London, 1601).
Decker, Johann Heinrich, *Spectrologia, haec est, discursus ut plurimum philosophicus de spectris* (Hamburg, 1690).
Della Porta, Giambattista, *Magiae naturalis, sive de miraculis rerum naturalium* (Naples, 1558).
—— *Magiae naturalis* (Naples, 1589).
—— *De refractione optices parte* (Naples, 1593).

—— *Natural magick*, trans. anon. (London, 1658).
Della Torre, Raffaele, *Tractatus de potestate ecclesiae coercendi daemones circa obsessos et maleficiatos*, in *Diversi tractatus*.
Del Río, Martín Antonio, *Disquisitionum magicarum* (Mainz, 1617).
—— *Martín Del Rio: Investigations into Magic*, ed. and trans. P. G. Maxwell-Stuart (Manchester, 2000).
Descartes, René, *Œuvres de Descartes*, ed. C. Adam and P. Tannery (12 vols.; Paris, 1897–1910).
—— *The Philosophical Writings of Descartes*, trans. and ed. J. Cottingham, R. Stoothoff, and D. Murdoch (3 vols.; Cambridge, 1984).
Detharding, Georg, *praeses* (Georgius Erhard von Gehren, *respondens*), *Scrutinium medicum de morbis a spectrorum apparitione oriundus, Von Gespenstern* (Rostock, 1729).
Dissertationes de spectris, Olin Library, Cornell University, BF 1445 D61, nos. 1–19.
Diversi tractatus de potestate ecclesiastica coercendi daemones circa energumenos et maleficiatos, ed. and pub. Constantin Munich (Cologne, 1629).
Dod, John, and Cleaver, Richard, *A plaine and familiar exposition: of the eighteenth, nineteenth, and twentieth chapters of Proverbs* (London, 1611).
Dorman, Thomas, *A proufe of certeyne articles in religion, denied by M. Iuell [Jewell]* (Antwerp, 1564).
Drayton, Michael, *The Works of Michael Drayton*, ed. J. W. Hebel (5 vols.; Oxford, 1961).
[Dubreuil, Jean], *La Perspective pratique*, 2nd edn. (3 vols.; Paris, 1651).
Du Laurens, André, *Discours de la conservation de la veuë: des maladies melancholiques: des catarrhs: et de la vieillesse* (Paris, 1597); trans. Richard Surphlet, *A discourse of the preservation of the sight: of melancholike diseases; of rheumes, and of old age* (London, 1599).
[Duncan, Marc], *Discours de la possession des religieuses Ursulines de Lo[u]dun* (n.p., 1634).
Dupleix, Scipion, *Les Causes de la veille et du sommeil, des songes, et de la vie et de la mort* (Paris, 1606).
—— *Corps de philosophie* (Paris, 1627), pt. 2 ('La Physique').
Du Plessis-Mornay, Philippe, *Foure bookes, of the institution, use and doctrine of the holy sacrament of the Eucharist in the old church, as likewise, how, when, and by what degrees the masse is brought in, in place thereof*, trans. R.S. (London, 1600).
Durastantes, Janus Matthaeus, *Problemata* (Venice, 1567).
Elich, Philipp Ludwig, *Daemonomagia* (Frankfurt am Main, 1607).
Ellinger, Johann, *Hexen Coppel* (Frankfurt am Main, 1629).
Erastus, Thomas, *Theses de melancholia*, in id., *Comitis Montani Vicentini novi medicorum censoris, quinque librorum de morbis nuper editorum viva anatome* (Basel, 1581).
—— *Repetitio disputationis de lamiis seu strigibus*, trans. Simon Goulart as *Deux dialogues... touchant le pouvoir des sorcieres*, in Jean Wier [Johann Weyer], *Histoires, disputes et discours, des illusions et impostures des diables*, ed. D. M. Bourneville (2 vols.; Paris, 1885).
Eschinardi, Francesco, *Centuriae opticae* (Rome, 1664).
—— *Centuria problematum opticorum* (Rome, 1666).
Espich, Valentino, *De melancholia medicae theses*, in id., *De errore externo* (Wittenberg, 1591).
Fernel, Jean, *The 'Physiologia' of Jean Fernel (1567)*, introd. J. Henry and J. M. Forrester, trans. J. M. Forrester (Philadelphia, 2003).
[Filmer, Robert], *An advertisement to the jury-men of England, touching witches* (London, 1653).

Foxe, John, *The Acts and Monuments of John Foxe*, ed. S. R. Cattley (8 vols.; London, 1841–89).
Frommann, Johann Christian, *Tractatus de fascinatione novus et singularis* (Nuremberg, 1675).
Fuchs, Leonhard, *De curandi ratione libri octo* (Lyons, 1548).
Gadbury, John, *Natura prodigiorum: or, a discourse touching the nature of prodigies* (London, 1660).
Garasse, François, *La Doctrine curieuse des beaux esprits de ce temps, ou pretendus tels* (Paris, 1623).
Garzoni, Tomaso, *The hospitall of incurable fooles*, trans. Edward Blount [?] (n.p. [London], 1600).
Gaule, John, *Select cases of conscience touching witches and witchcrafts* (London, 1646).
Gee, John, *New shreds of the old snare* (London, 1624).
—— *The foot out of the snare* (London, 1624).
Geiger, Malachias, *Microcosmus hypochondriacus; sive, de melancholia hypochondriaca* (Munich, 1652).
Gellius, Joannes, *Sugetesis medica de internis oculorum affectibus*, in id., *Decas (vii.) disputationum medicarum select.* (Basel, 1621), no. 27.
Gentillet, Innocent, *A discourse upon the meanes of wel governing and maintaining in good peace, a kingdome, or other principalitie*, trans. Simon Patericke (London, 1602).
—— *Anti-Machiavel*, ed. C. E. Rathé (Geneva, 1968).
Gerhard, Andreas (Hyperius), 'Whether that the devils have bene the shewers of magicall arts', in *Two commonplaces taken out of Andreas Hyperius*, trans. R.V. (London, 1581).
Gerson, Jean, *De probatione spirituum* and *De distinctione verarum visionum a falsis*, in P. Boland, *The Concept of 'Discretio spirituum' in John Gerson's 'De probatione spirituum' and 'De distinctione verarum visionum a falsis'* (Washington, 1959), 25–38, 76–107.
[Gilpin, Richard], *Daemonologia sacra: or, a treatise of Satans temptations* (London, 1677).
Glanvill, Joseph, *Saducismus triumphatus: or, full and plain evidence concerning witches and apparitions*, 3rd edn. (1689), ed. C. O. Parsons (Gainesville, Fla., 1966).
—— *A blow at modern sadducism in some philosophical considerations about witchcraft* (London, 1668).
—— *Plus ultra: or, the progress and advancement of knowledge since the days of Aristotle* (London, 1668).
—— *A praefatory answer to Mr. Henry Stubbe* (London, 1671).
—— *Essays on several important subjects in philosophy and religion* (London, 1676).
—— *The Vanity of Dogmatizing: The Three Versions*, ed. S. Medcalf (Hove, 1970).
Godelmann, Johann Georg, *Tractatus de magis, veneficis et lamiis, deque his recte cognoscendis et puniendis* (3 vols. in 1; Frankfurt am Main, 1591).
Goodcole, Henry, *The wonderful discovery of Elizabeth Sawyer, a witch* (1621), in P. Corbin and D. Sedge (eds.), *The Witch of Edmonton* (Manchester, 1999), 135–49.
Goodwin, Philip, *The mystery of dreames, historically discoursed* (London, 1657).
Goulart, Simon, *Admirable and memorable histories, containing the wonders of our time*, trans. Edward Grimeston (London, 1607).
Gravina, Domenico, *Ad discernandas veras a falsis visionibus et revelationibus* (2 vols.; Naples, 1638).
Greenham, Richard, 'Of the government of the eyes', in *Workes*, 5th edn. (London, 1612), 675–8.

Greville, Fulke, 'A Treatie of Humane Learning', in *Poems and Dramas of Fulke Greville First Lord Brooke*, ed. G. Bullough (2 vols.; Edinburgh, n.d. [1938]), i. 154–91.

Grillandus, Paulus, *Tractatus de sortilegis*, in *Tractatus duo: unus de sortilegis D. Pauli Grillandi . . . alter de lamiis et excellentia iuris utriusque D. Ioannis Francisci Ponzinibii . . .* (Frankfurt am Main, 1592).

Grimaldi, Francesco Maria, *Physico-mathesis de lumine, coloribus et iride* (Bologna, 1665).

Grosse, Henning (pub.), *Magica; seu mirabilium historiarum de spectris et apparitionibus spirituum* (Eisleben, 1597); reissued as *Magica de spectris et apparitionibus spirituum* (Leiden, 1656); trans. T[homas] B[romhall], *A treatise of specters. Or, an history of apparitions* (London, 1658); and as *Der bösen Geister und gespensten wunder-seltzahme Historien und nächtliche Erscheinungen*, as pt. 2 of Rémy, *Daemonolatria, oder: Beschreibung von Zauberern*.

Guazzo, Francesco Maria, *Compendium maleficarum*, ed. M. Summers, trans. E. A. Ashwin (London, 1929).

Guibelet, Jourdain, *Trois discours philosophiques . . . le troisième de l'humeur mélancolique* (Évreux, 1603).

Guillemeau, Jacques, *A worthy treatise of the eyes*, trans. A.H. (London, 1587), reissued by Richard Banister (with Banister's *Breviary of the eyes*), as *A treatise of one hundred and thirteene diseases of the eyes, and eye-liddes* (London, 1622).

Gurnay, Edmund, *The demonstration of Antichrist* (London, 1631).

Gutherius, Jacobus, 'Encomium caecitatis', in anon., *Admiranda rerum admirabilium encomia* (Nijmegen, 1666), 245–76.

Haecht Goidtsenhoven (Haechtanus), Laurens van, *Microcosmos. Parvus mundus*, trans. into French Henricus Costerius (Antwerp, 1592).

Hakewill, George, *The vanitie of the eie*, 4th edn. (Oxford, 1633).

Hall, Joseph, *Salomons divine arts* (London, 1609).

Harsnet, Samuel, *A declaration of egregious popish impostures* (1603), in F. W. Brownlow, *Shakespeare, Harsnett and the Devils of Denham* (London, 1993), 191–335.

Hastings, Francis, *An apologie or defence of the watch-word* (London, 1600).

H[eath], R[obert], *Paradoxical assertions and philosophical problems* (London, 1659).

Heerbrand, Jacob, *praeses* (Caspar Arcularius, *respondens*), *De miraculis disputatio ex cap. 7. Exo.* (Tübingen, 1571).

—— *praeses* (Nicolaus Falco, *respondens*), *De magia disputatio ex cap. 7. Exo.* (Tübingen, 1570).

Hildesheim, Franz, *De cerebri et capitis morbis internis spicilegia* (Frankfurt, 1612).

Hill, Thomas, *The moste pleasaunte arte of the interpretacion of dreames* (London, 1576).

Histoire d'une apparition avec des réflexions, qui prouvent la difficulté de sçavoir la verité sur le retour des esprits (Paris, 1722).

Historia und warhaffte Geschicht der vier Kätzer Mönch Prediger-Ordens (Magdeburg, 1551).

Hobbes, Thomas, *The English Works of Thomas Hobbes of Malmesbury*, ed. W. Molesworth (11 vols.; London, 1839–45).

—— *The Elements of Law Natural and Politic*, ed. F. Tönnies, 2nd edn. with introd. by M. M. Goldsmith (London, 1969).

—— *Thomas White's 'De mundo' Examined*, trans. H. Whitmore Jones (London, 1976).

—— *Leviathan*, ed. R. Tuck (Cambridge, 1991).

Holland, Henry, *A treatise against witchcraft* (Cambridge, 1590).

Hondorff, Andreas, *Theatrum historicum illustrium exemplorum* (Frankfurt am Main, 1575).

Huarte, Juan, *Examen de ingenios. The examination of mens wits*, trans. (from the Italian version by Camillo Camilli) R[ichard] C[arew] (London, 1594).

Huret, Grégoire, *Optique de portraiture et peinture* (Paris, 1670).

[Hutchins, Randall], *Tractatus de spectris*, in V. B. Heltzel and C. Murley (trans.), 'Randall Hutchins' *Of Specters* (ca. 1593)', *Huntington Library Quart.* 11 (1947–8), 407–29.

Hutchinson, Francis, *An historical essay concerning witchcraft*, 2nd edn. (London, 1720).

Hutchinson, Roger, *A faithful declaration of Christes holy supper* (1560), in id., *The Works of Roger Hutchinson*, ed. J. Bruce (Cambridge, 1842).

[Isidore of Seville], *Isidori Hispalensis episcopi etymologiarum sive originum libri xx*, ed. W. M. Lindsay (2 vols.; Oxford, 1911).

Jackson, Arthur, *Annotations upon the remaining historicall part of the Old Testament* (Cambridge, 1646).

—— *Annotations upon the five books, immediately following the historicall part of the Old Testament . . . To wit, the Book of Job, the Psalms, the Proverbs* (London, 1658).

Jacquier, Nicolas, *Flagellum haereticorum fascinariorum* (Frankfurt am Main, 1581).

James VI and I, *Daemonologie* (Edinburgh, 1597).

Jenison, Robert, *The height of Israels heathenish idolatrie* (London, 1621).

Jewel, John, *The Works of John Jewel*, ed. J. Ayre (4 vols.; Cambridge, 1845–50).

[Jones, Thomas], *Gwir ddeongliad breuddwydion (A true interpretation of dreams)* ([Shrewsbury], 1698).

Kircher, Athanasius, *Ars magna lucis et umbrae* (Rome, 1646).

—— *Ars magna sciendi, in xii libros digesta* (Amsterdam, 1669).

—— *Ars magna lucis et umbrae*, 2nd edn. (Amsterdam, 1671).

—— *Phonurgia nova* (Kempten, 1673).

Kornmann, Heinrich, *De miraculis mortuorum* (n.p. [Augsburg?], 1610).

[Krämer, Heinrich (Institoris)], *Malleus maleficarum*, ed. and trans. M. Summers (London, 1928; repr. 1948).

Lambarde, William, *A perambulation of Kent* (London, 1576).

La Mothe Le Vayer, François de, 'Opuscule ou petit traitté sceptique sur cette commune façon de parler, n'avoir pas le sens commun', in id., *Œuvres* (15 vols.; Paris, 1669), ix. 219–96.

Lancre, Pierre de, *Tableau de l'inconstance des mauvais anges et demons, ou il est amplement traicté des sorciers et de la sorcelerie* (Paris, 1612).

—— *L'Incredulité et mescreance du sortilege plainement convaincue. Ou il est amplement et curieusement traicté . . . des apparitions* (Paris, 1622).

—— *Du sortilège* (n.p., 1627).

[Landi, Ortensio], *The defence of contraries*, trans. A[nthony] M[unday] (London, 1593); also issued in 1602 by Thomas Lodge as *Paradoxes against common opinion*, and trans. Charles Estienne as *Paradoxe qu'il vaut mieux estre pauvre que riche* (Caen, 1554).

Langius, Paulus, *Chronicon Citizense (Episcoporum Citicensis ecclesiae historia)*, in Johannes Pistorius, *Illustrium veterum scriptorium* (2 vols.; Frankfurt, 1583).

Lapide, Cornelius à, *Commentarius in Josue, Judicum, Ruth, iv libros Regum et ii Paralipomenon* (Antwerp, 1718).

La Placette, Jean, *Traité de l'autorité des sens contre la transsubstantiation* (Amsterdam, 1700).

La Primaudaye, Pierre de, *The French academie*, trans. Thomas Bowes (London, 1618).
Lavater, Ludwig, *Of ghostes and spirites walking by nyght, and of strange noyses, crackes, and sundry forewarnynges, which commonly happen before the death of menne, great slaughters, and alterations of kyngdomes*, trans. Robert Harrison (London, 1572), repr. in Shakespeare Association edn., 1929, ed. J. Dover Wilson and M. Yardley.
Lawson, Deodat, *Christ's fidelity the only shield against Satans malignity*, 2nd edn. (Boston, 1693).
Le Clerc, Joannes, *Disputatio medica inauguralis, de melancholia* (Leiden, 1633).
Le Loyer, Pierre, *IIII livres des spectres ou apparitions et visions d'esprits, anges et demons se monstrans sensiblement aux hommes* (Angers, 1586).
—— *A treatise of specters or straunge sights, visions and apparitions appearing sensibly unto men. Wherein is delivered, the nature of spirites, angels, and divels: their power and properties: as also of witches, sorcerers, enchanters, and such like*, trans. Zachary Jones (London, 1605).
—— *Discours des spectres* (Paris, 1608).
Lemnius, Levinus, *The touchstone of complexions*, trans. Thomas Newton (London, 1576).
—— *The secret miracles of nature*, trans. anon. (London, 1658).
Lenglet Du Fresnoy, Nicolas, *Traité historique et dogmatique sur les apparitions, les visions et les révélations particulières* (Avignon, 1751).
—— *Recueil de dissertations, anciennes et nouvelles, sur les apparitions, les visions et les songes* (2 vols. in 4 pts.; Avignon, 1752).
Locke, John, *An Essay Concerning Human Understanding*, ed. P. H. Nidditch (Oxford, 1975).
Lodge, Thomas, *The divel conjured* (London, 1596).
Lomazzo, Giovanni Paolo, *A tracte containing the artes of curious paintinge*, trans. Richard Haydocke (London, 1598).
[Loyola, Ignatius], *Manresa: or the spiritual exercises of St Ignatius* (London, n.d.).
Macrobius, *Commentary on the Dream of Scipio*, ed. and trans. W. H. Stahl (New York, 1952; repr. 1990).
Maignan, Emmanuel, *Perspectiva horaria, sive de horographia gnomonica* (Rome, 1648).
Malebranche, Nicolas, *The Search after Truth/Elucidations of the Search after Truth*, trans. T. M. Lennon and P. J. Olscamp, comment. T. M. Lennon (Columbus, Oh., 1980).
Malleus judicum, das ist: Gesetzhammer der unbarmherzigen Hexenrichter (1627), in Johann Reiche (ed.), *Unterschiedliche Schrifften von Unfug des Hexen-Processes* (Halle, 1703).
Malvenda, Thomas, *De Antichristo* (Rome, 1604).
Manescal, Honofre, *Miscelánea de tres tratados, de las apariciones de los espíritus el uno, donde se trata cómo Dios habla a los hombres, y si las almas del Purgatorio buelven: De Antichristo el segundo, y de sermones predicados en lugares señalados el tercero* (Barcelona, 1611).
[Manuel, Nicolaus], *Die war histori von den vier ketzern prediger ordens... zu Bern... verbrannt* (n.p., n.d. [1510?]).
Marandé, Léonard, *The judgment of humane actions*, trans. John Reynolds (London, 1629).
Marolles, Michel de, *Tableaux du temple des muses* (Paris, 1655).
—— *The temple of the muses*, trans. anon. (London, 1738).
Marolois, Samuel, *Perspective contenant la théorie et pratique d'icelle* (The Hague, 1614).
Marston, John, *The Plays of John Marston*, ed. H. H. Wood (3 vols.; Edinburgh, 1938).

Martyr, Petrus (Vermigli), *In duos libros Samuelis prophetae . . . commentarii* (Zurich, 1575).
—— *Sommaire des trois questions proposes et resolues par M. Pierre Martyr*, in Ludwig Lavater, *Trois livres des apparitions* ([Geneva], 1571).
—— *The commonplaces of . . . Peter Martyr*, trans. Anthonie Marten (n.p. [London], n.d. [1583]).
—— *Loci communes* (London, 1583).
Mason, James, *The anatomie of sorcerie* (London, 1612).
Mather, Cotton, *The wonders of the invisible world; being an account of the tryals of several witches, lately executed in New-England* (London, 1693).
Mather, Increase, *A further account of the tryals of the New-England witches . . . To which is added, cases of conscience concerning witchcrafts and evil spirits personating men* (London, 1693).
Maurolico, Francesco, *Photismi de lumine et umbra ad perspectivam, et radiorum incidentiam facientes*, ed. and trans. H. Crew, *The Photismi de lumine of Maurolycus* (New York, 1940).
Maxey, Anthony, 'The copie of a sermon preached in Lent before the Lords of the Councell, at White-hall', in id., *Five sermons preached before the king. Viz . . . 5. The vexation of Saul* (London, 1614).
Melanchthon, Philipp, *Commentarius de anima* (Wittenberg, 1540).
Mercuriale, Girolamo, *Medicina practica* (Frankfurt, 1602).
Mersenne, Marin, *Quaestiones celeberrimae Genesim* (Paris, 1623).
—— *La Verité des sciences. Contre les s[c]eptiques ou Pyrrhoniens* (Paris, 1625).
—— *L'Optique et la catoptrique* (Paris, 1651).
—— *Correspondance du P. Marin Mersenne*, ed. C. de Waard, B. Rochot, and A. Beaulieu (16 vols.; Paris, 1945–88).
Meyfart, Johann Matthäus, *Die hochwichtige Hexen-Erinnerung* (Leipzig, 1666).
Michaëlis, Sebastien, *Pneumalogy, or discourse of spirits*, in *The admirable historie of the possession and conversion of a penitent woman*, trans. W.B. (London, 1613).
[Milles, Thomas], *The treasurie of auncient and moderne times* (London, 1613).
Mirami, Raphaël, *Compendiosa introduttione alla prima parte della specularia* (Ferrara, 1582).
Monro, John: see Battie, William.
Montaigne, Michel de, *The Complete Essays of Montaigne*, trans. D. M. Frame (Stanford, Calif., 1958).
Montalto, Philotheus Elianus, *Archipathologia, in qua internarum capitis affectionum essentia, causae, signa, praesagia, et curatio accuratissima indagine edisseruntur* (Paris, 1614).
[More, Henry], *Enthusiasmus triumphatus, or, a discourse of the nature, kinds, and cure, of enthusiasme* (London, 1656).
—— *A modest enquiry into the mystery of iniquity* (London, 1674).
More, Thomas, 'A Dialogue Concerning Heresies', in T. M. C. Lawler, G. Marc'hadour, and R. C. Marius (eds.), *The Complete Works of St. Thomas More*, Yale Edition, vol. 6 (2 vols.; New Haven, 1981).
Morhof, Daniel Georg, *praes* (Andreas Plomann, *respondens*), *Dissertatio de paradoxis sensuum* (Kiel, 1685).
Morton, Thomas, *An exact discoverie of Romish doctrine in the case of conspiracie and rebellion* (London, 1605).
—— *A full satisfaction concerning a double Romish iniquitie; hainous rebellion, and more then heathenish aequivocation* (London, 1606).
Moxon, Joseph, *Practical perspective: or, perspective made easie* (London, 1670).

Naudé, Gabriel, *The history of magick by way of apology*, trans. John Davies (London, 1657); orig. pub. as *Apologie pour tous les grands personnages qui ont esté faussement soupçonnez de magie* (Paris, 1625).

—— *Considérations politiques sur les coups d'état*, ed. F. Marin and M.-O. Perulli, with an introductory lecture by L. Marin (Paris, 1988).

Nicéron, Jean François, *La Perspective curieuse ou magie artificiele [sic] des effets merveilleux* (Paris, 1638).

—— *Thaumaturgus opticus, seu admiranda optices . . . catoptrices . . . et dioptrices* (Paris, 1646).

Nider, Johannes, *Praeceptorium legis sive expositio decalogi* (Cologne, 1470?).

—— *Formicarius*, in Ostorero et al. (eds.), *L'Imaginaire du sabbat*, 122–99.

Nymann, Hieronymus, *Oratio de imaginatione*, in Tandler, *Dissertatio de fascino*, 47–80.

Nynauld, Jean de, *De la lycanthropie, transformation et extase des sorciers* (1615), ed. N. Jacques-Chaquin, M. Préaud, et al. (Paris, 1990).

Osiander, Andreas (the younger), *Biblia sacra* (Frankfurt, 1611).

Ozanam, Jacques, *Recréations mathematiques et physiques* (4 vols.; Paris, 1735).

Pacard, George, *Description de l'antechrist, et de son royaume* (Niort, 1604).

Paleotti, Gabriele, *Discorso intorno alle immagini sacre e profane* (1582), ed. S. della Torre et al. (Vatican City, 2002).

Paré, Ambroise, *The workes*, trans. Th[omas] Johnson (London, 1634).

Paris, Yves de, *La Théologie naturelle* (4 vols.; 1633–7).

[Parker, Robert], *A scholasticall discourse against symbolizing with Antichrist in ceremonies: especially in the signe of the crosse* (n.p. [Middelburg], 1607).

Passerat, Jean, 'De caecitate oratio' (Paris, 1597) and in Caspar Dornavius, *Amphitheatrum sapientiae socraticae joco-seriae* (2 vols. in 1; Hanau, 1619), ii. 262–4.

Peña, Joannes, *Euclidis optica et catoptrica* (Paris, 1557).

Pererius, Benedictus (Benito Pereira), *Adversus fallaces et superstitiosas artes, id est, de magia, de observatione somniorum, et, de divinatione astrologica* (Ingolstadt, 1591).

Perkins, William, *A discourse of the damned art of witchcraft*, pub. Thomas Pickering ([Cambridge], 1610).

Perrault, François, *Demonologie*, 2nd edn. (Geneva, 1656).

Petraficta, Sebastianus, *De sensuum externorum usu, affectionibusque . . . tractatus* (Venice, 1594).

Peucer, Kaspar, *Commentarius de praecipuis divinationum generibus* (Wittenberg, 1553).

—— *Liber quintus chronici Carionis a Friderico secundo usque ad Carolum quintum* (Frankfurt am Main, 1566).

Philomarino, Francesco Maria, *Tractatus de divinis revelationibus* (Naples, 1675).

Pico della Mirandola, Gianfrancesco, *On the Imagination*, trans. and ed. H. Caplan (New Haven, 1930).

Pierquin, Jean, 'Réflexions philosophiques de M. Pierquin, sur l'évocation des morts', in Lenglet Du Fresnoy, *Recueil de dissertations*, ii, pt. 1, 144–50.

Pithoys, Claude: see Whitmore (ed.), *Seventeenth-Century Exposure of Superstition: Select Texts*.

Plato, *The Dialogues of Plato*, trans. B. Jowett (5 vols.; Oxford, 1892).

Platter, Felix, Cole, Abdiah, and Culpeper, Nicholas, *Platerus golden practice of physick* (London, 1664).

Pliny the Elder, *Natural History*, trans. H. Rackham (10 vols.; London, 1938–63).

Plutarch, *The Lives of the Noble Grecians and Romanes*, trans. Thomas North (from Jacques Amyot) (5 vols.; London, 1929–30), orig. pub. 1579.

Polacco, Giorgio, *Pratiche per discerner lo spirito buono dal maluagio e per conoscer gl'indemoniate e maleficiate* (Bologna, 1638).

Pomponazzi, Pietro, *Tractatus de immortalitate animae* (Bologna, 1516).

—— *De naturalium effectuum causis sive de incantationibus* (Basel, 1556).

Porri, Alessio, *Vaso di verità, nel quale si contengono dodeci resolutioni vere a dodeci importanti dubbi fatti intorno all'origine nascita vita opere e morte dell'Antichristo* (Venice, 1597).

P[owell], T[homas], *Elementa opticae* (London, 1651).

Pratensis, Jasonis (Jason van de Velde), *De cerebri morbis* (Basel, 1549).

Preston, Richard, *Short questions and answers, plainely opening and explaining both the nature and also the use of the sacraments of baptisme and the Lords supper* (London, 1621).

Prieur, Claude, *Dialogue de la lycanthropie ou transformation d'hommes en loups, vulgairement dits loups-garous, et si telle se peut faire* (Louvain, 1596).

Puttenham, George, *The Arte of English Poesie*, ed. G. D. Willcock and A. Walker (Cambridge, 1936; 1970).

De quattuor heresiarchis ordinis Praedicatorum de Observantia nuncupatorum, apud Suitenses in civitate Bernensi combustis, anno Christi MDIX (n.p. [Berne?], n.d. [1509?]).

Raemond, Florimond de, *L'Antichrist* (Lyons, 1597).

Raleigh, Walter, *The history of the world* (London, 1614).

Rawlinson, John, *Vivat rex. A sermon preached at Pauls Crosse on the day of his Majesties happie inauguration, March 24 1614* (Oxford, 1619).

Rémy, Nicolas, *Demonolatry*, ed. Montague Summers, trans. E. A. Ashwin (London, 1930), orig. pub. as *Daemonolatreiae libri tres* (Lyons, 1595).

—— *Daemonolatria, oder: Beschreibung von Zauberern und Zauberinnen* (Hamburg, 1693).

[Renaudot, Eusèbe], *A general collection of discourses of the virtuosi of France, upon questions of all sorts of philosophy, and other natural knowledge*, trans. George Havers (London, 1664).

—— (ed.), *Recueil général des questions traitées és conférences du Bureau d'Adresse, sur toutes sortes de matières* (6 vols.; Lyons, 1666).

Reynolds, Edward, *A treatise of the passions and faculties of the soule of man* (London, 1640).

Rhodius, Ambrosius, *Optica, cui additus est tractatus de crepusculis* (Wittenberg, 1611).

Rid, Samuel, *The art of juggling, or legerdemaine* (London, 1614).

Riolan, Jean, *Opera omnia* (Paris, 1610).

Risnerus, Federicus, *Opticae thesaurus Alhazeni Arabis libri septem . . . item Vitellonis Thuringopoloni* (Basel, 1572).

Rivius, Joannes, *De conscientia libri iiii. Eiusdem de spectris et apparitionibus umbrarum, seu de veteri superstitione liber i* (Leipzig, 1541).

Rollock, Robert, *Lectures upon the first and second epistles of Paul to the Thessalonians*, ed. Henry Charteris and William Arthur (Edinburgh, 1606).

Romanus, Carolus Fridericus, *Schediasma polemicum, expendens quaestionem an dentur spectra, magi, et sagae, una cum recensione historica plurimarum hac de re opinionum* (Leipzig, 1703).

S.S., *Paradoxes or encomions in the praise of being lowsey. Treachery. Nothing. Beggery. The French pox. Blindnesse. The Emperor Nero. Madnesse* (London, 1653).

Salazar Frías, Alonso de, 'Second report to the Inquisitor General' (Logroño, 24 Mar. 1612), in G. Henningsen (ed.), *The Salazar Documents: Inquisitor Alonso de Salazar Frías and Others on the Basque Witch Persecution* (Leiden, 2004), 266–349.

Sales, François de, *St Francis de Sales: Treatise on the Love of God*, trans. H. B. Mackey (2 vols.; London, 1932–3).
Samson, Hermann, *Neun ausserlesen und wolgegründete Hexen Predigt* (Riga, 1626).
Sanctius, Gaspar, *In quatuor libros Regum et duos Paralipomenon commentarii* (Antwerp, 1624).
Sanders, Nicholas, *A treatise of the images of Christ, and of his saints* (Louvain, 1567).
—— *De typica et honoraria sacrarum imaginum adoratione libri duo* (Louvain, 1569).
—— *De visibili monarchia ecclesiae* (Louvain, 1571).
Sayer, Gregory, *Clavis regia sacerdotum, casuum conscientiae* (Venice, 1615).
Scheiner, Christophorus, *Oculus, hoc est: fundamentum opticum* (Innsbruck, 1619).
Scherer, Georg, *Bericht ob der Bapst zu Rom der Antichrist sey* (Ingolstadt, 1585).
Scherertz, Sigismund, *Libellus consolatorius de spectris, hoc est, apparitionibus et illusionibus daemonum* (Wittenberg, 1621).
Schott, Gaspar, *Physica curiosa* (Würzburg, 1667).
—— *Magia optica, das ist, geheime doch naturmässige Gesicht- und Augen-Lehre*, trans. M.F.H.M. (Bamberg, 1671).
—— *Magia universalis* (4 vols.; Bamberg 1674–7).
Schubart, Johann Christoph, *praeses* (Paulus Nicolaus Einert, *respondens*), *Dissertatio de potentia diaboli in sensus* (Erfurt, [1707]).
Sclater, William, *A briefe exposition with notes, upon the second epistle to the Thessalonians*, 2nd edn. (London, 1629).
Scot, Reginald, *The discoverie of witchcraft* (London, 1584).
Scultetus, Abraham, *A short information, but agreeable unto scripture: of idol-images* (n.p. [London?], 1620).
Sennert, Daniel, *Opera omnia* (3 vols.; Paris, 1641).
Sepibus, Georgius de, *Romani collegii societatis Jesu musaeum celeberrimum . . . novis et raris inventis lucupletatum* (Amsterdam, 1678).
[Sextus Empiricus], *Sexti philosophi Pyrrhoniarum hypotypωseωn libri iii* (n.p. [Paris], 1562).
—— *Outlines of Pyrrhonism*, in *The Skeptic Way: Sextus Empiricus's 'Outlines of Pyrrhonism'*, trans. and ed. B. Mates (Oxford, 1996).
Shakespeare, *Macbeth*, New Cambridge Shakespeare edn., ed. A. R. Braunmuller (Cambridge, 1997).
Sheldon, Richard, *A survey of the miracles of the church of Rome, proving them to be Antichristian* (London, 1616).
Siglicius, Joannes, *praeses* (Joannes Leopoldus, *respondens*), *De melancholia morbo, disputatio pathologica* (Leipzig, 1613).
Silhon, Jean de, *Les Deux vérités de Silhon, l'un de Dieu et de sa Providence, l'autre de l'immortalité de l'âme* (Paris, 1626; repr. 1991).
Sinclair, George, *Satan's invisible world discovered*, orig. edn. 1685 (Gainesville, Fla., 1969).
Sohn, Georg, *A briefe and learned treatise, conteining a true description of the Antichrist*, trans. N. G[rimald] (Cambridge, 1592).
Sorel, Charles, *La Science universelle* (4 vols.; Paris, 1668).
Spee von Langenfeld, Friedrich, *Cautio criminalis, or a Book on Witch Trials*, trans. and ed. M. Hellyer (Charlottesville, Va., 2003) : Latin orig., [Friedrich Spee], *Cautio criminalis, seu de processibus contra sagas* (Rinteln, 1631).
Spenser, Edmund, *The Faerie Queene*, in *The Poetical Works of Edmund Spenser*, ed. J. C. Smith (3 vols.; Oxford, 1909, repr. 1961), vols. ii–iii.

Spina, Alphonsus de, *Fortalitium fidei* (Strasburg, n.d. [before 1471]).
Stearne, John, *A confirmation and discovery of witch craft* (London, 1648).
Stevart, Peter, *Commentarius in utramque D. Pauli apostoli ad Thessalonicenses, epistolam* (Ingolstadt, 1609).
Stryk, Joannes Samuel, *praeses* (Andreas Becker, *respondens*), *Disputatio juridica de jure spectrorum* (Halle, 1700).
Stumpf, Johannes, *Johannes Stumpfs Schweizer- und Reformationschronik*, ed. E. Gagliardi, H. Müller, and F. Büsser (2 vols.; Basel, 1953).
Sturm (Sturmius), Johann Christian, *Mathesis juvenalis* (Nuremberg, 1704).
Suárez, Franciscus, *Commentariorum ac disputationum in tertiam partem divi Thomae* (4 vols.; Lyons, 1613–14).
—— *De Antichristo*, in id., *Opera omnia*, ed. M. André (28 vols.; Paris, 1856–78), xix. 1025–44.
Taillepied, Noel, *Traité de l'apparition des esprits* (Rouen, 1600), 1st pub. in Paris in 1588.
Tandler, Tobias, *Dissertatio de fascino et incantatione* (Wittenberg, 1606).
—— *Oratio de spectris, quae vigilantibus obveniunt*, in id., *Dissertationes physicae-medicae* ([Wittenberg], 1613).
Tanner, Adam, *Tractatus theologicus de processu adversus crimina excepta, ac speciatim adversus crimen veneficii* (1617), in *Diversi tractatus*, 1–48 (2nd pagination).
—— *Disputatio de angelis* (1617), in *Diversi tractatus*, 49–99 (2nd pagination).
Teresa of Avila, *The Life of Teresa of Jesus: The Autobiography of St Teresa of Avila*, ed. E. Allison Peers (New York, 1960).
Tertullian, *De anima*, ed. J. H. Waszink (Amsterdam, 1947).
Texeda (or Tejeda), Fernando de, *Miracles unmasked. A treatise proving that miracles are not infallible signes of the true and orthodox faith: that popish miracles are either counterfeit or divellish*, trans. by author (London, 1625).
Thomas, William, *The Pilgrim: A Dialogue of the Life and Actions of King Henry the Eighth*, ed. J. A. Froude (London, 1861).
Thompson, Thomas, *Antichrist arraigned* (London, 1618).
Thumm, Theodor, *Tractatus theologicus, de sagarum impietate, nocendi imbecillitate et poenae gravitate* (Tübingen, 1621).
Thyraeus, Petrus, *De variis tam spirituum, quam vivorum hominum prodigiosis apparitionibus, et nocturnis infestationibus* (Cologne, 1594).
Torreblanca, Francisco, *Daemonologia* (Mainz, 1623).
Trapp, John, *Solomonis panaretos: or, a commentarie upon the books of Proverbs, Ecclesiastes, and the Song of Songs* (London, 1650).
[Trenchard, John], *The natural history of superstition* (London, 1709).
Tryon, Thomas, *A treatise of dreams and visions* (London, 1689).
Tymme, Thomas, *The figure of Antichriste, with the tokens of the end of the world* (London, 1586).
Vairo, Leonardo, *De fascino* (Venice, 1589).
Valderrama, Pedro de, *Histoire generale du monde, et de la nature*, trans. Sieur de La Richardière (2 pts.; Paris, 1617–19).
Valencia, Pedro de, *Academica sive de iudicio erga verum ex ipsis primis fontibus* (Antwerp, 1596).
Valera, Cipriano de, *Two treatises: the first, of the lives of the Popes, and their doctrine. The second, of the Masse . . . Also, a swarme of false miracles, wherewith Marie de la Visitacion,*

prioresse de la Annuntiada of Lisbon, deceived very many: and how she was discovered and condemned, trans. John Golburne (London, 1600), 420–38; repr. in Cipriano de Valera, *Los dos tratados, del Papa y de la Misa* (Madrid, 1851; facs. repr. Barcelona, 1982), 554–94.

Vallesius, Franciscus, *De iis quae scripta sunt physice in libris sacris, sive de sacra philosophia* (Lyons, 1595).

Vanini, Giulio Cesare, *De admirandis naturae reginae deaeque mortalium arcanis libri quatuor* (Paris, 1616).

Van Swieten, Baron Gerard, *The Commentaries upon the Aphorisms of Dr. Herman Boerhaave . . . concerning the knowledge and cure of the several diseases incident to human bodies*, trans. anon., 2nd edn. (18 vols.; London, 1771, 1744–73).

Vaulézard, J.-L., le Sieur de, *Perspective cilindrique et conique; ou traicté des apparences veuës par le moyen des miroirs cilindriques* (Paris, 1630).

Verron, Sebastian, *Chronica ecclesiae et monarchiarum a condito mundo* (Freiburg, 1599).

Vignier, Nicolas, *Théatre de l'Antechrist* (n.p., 1610).

Vignola, Jacopo, *Le due regole della prospettiva pratica* (*c*.1530–40), pub. with comm. by Ignazio Danti (Rome, 1583).

Viret, Pierre, *The cauteles, canon, and ceremonies, of the most blasphemous, abhominable, and monstrous popish masse*, trans. T. Sto[cker] (London, 1584); orig. pub. as *Les Cauteles et canon de la Messe* (Lyon, 1563).

Visconti, Girolamo, *Magistri Hieronymi Vicecomitis Lamiarum sive striarum opusculum ad illustrissimum Mediolani ducem Franciscum Sfortiam Vicecomitem* (Milan, 1490).

Vitoria, Franciscus a, *Relectiones theologicae* (Lyons, 1587).

Voet, Gijsbert, *G. Voetii . . . selectarum disputationum theologicarum* (Utrecht, 1648–69).

Voight, Caspar, *Psychologia per theses succinctas de anima humana eiusque potentiis et operationibus* (Stettin, n.d. [1650?]).

Vorstius, Adolfus, *praeses* (Johannes ab Hoobroeck, *defendens*), *Disputatio medica inauguralis de melancholia* (Leiden, 1660).

Wagstaffe, John, *The question of witchcraft debated. Or a discourse against their opinion that affirm witches*, 2nd edn. (London, 1671).

Waldschmidt, Bernhard, *Pythonissa Endorea, Das ist: Acht und zwantzig Hexen- und Gespenstpredigten* (Frankfurt am Main, 1660).

Walkington, Thomas, *The optick glasse of humors, or the touchstone of a golden temperature* (London, 1607).

Waller, William, *The tragical history of Jetzer: A faithful narrative of the feigned visions, counterfeit revelations, and false miracles of the dominican fathers of the covent of Berne in Switzerland, to propagate their superstitions. For which horrid impieties, the Prior, Sub-Prior, Lecturer, and Receiver of the said Covent were burnt at a stake, Anno Dom. 1509* (London, 1679).

Walther, Rudolph (Gualtherus), *Antichrist*, trans. J[ohn] O[lde] (London, 1556).

Wanley, Nathaniel, *The wonders of the little world; or, the general history of man* (London, 1678).

Webster, John, *The displaying of supposed witchcraft* (London, 1677).

Wecker, Hanss Jacob, *Eighteen books of the secrets of art and nature*, trans. and augmented R. Read (London, 1660).

Wedel, Georg Wolfgang, *praeses* (Ernst Heinrich Wedel, *respondens*), *Dissertatio medica de spectris*, 3rd edn. (Jena, 1710).

Weyer, Johann, *De praestigiis daemonum, et incantationibus, ac veneficiis* (Basel, 1583).
—— *De praestigiis daemonum* (1583), in George Mora (gen. ed.), J. Shea (trans.), et al., *Witches, Devils, and Doctors in the Renaissance: Johann Weyer, 'De Praestigiis Daemonum'* (Binghamton, NY, 1991).
Whitaker, William, *Ad Nicolai Sanderi demonstrationes quadraginta . . . responsio* (London, 1583).
[Wilcox, Thomas], *The works of that late reverend and learned divine, Mr. Thomas Wilcocks . . . containing an exposition upon the whole booke of David's Psalmes, Salomons Proverbs* (London, 1624).
Willet, Andrew, *An harmonie upon the first booke of Samuel* (Cambridge, 1607).
[Willis, Thomas], *Dr Willis's practice of physick* (London, 1684).
Wilson, Thomas, *The arte of rhetorique* (London, 1553).
Wirsung, Christoph, *Praxis medicinae universalis; or, a generall practise of physicke*, trans. Jacob Mosan (London, 1598).
Witelo, *Vitellonis Thuringopoloni opticae libri decem*, in Federicus Risnerus, *Opticae thesaurus Alhazeni Arabis libri septem . . . Item Vitellonis Thuringopoloni libri x* (Basel, 1572).
Wither, George, *A collection of emblems, ancient and moderne* (London, 1635).
Wright, Thomas, *The passions of the minde* (London, 1601).
Wriothesley, Charles, *A Chronicle of England during the Reigns of the Tudors from AD 1485 to 1559*, ed. W. D. Hamilton, Camden Series, NS 11 and 20 (2 vols.; London, 1875–7).
Zanchy, Hieronymus, *De operibus Dei intra spatium sex dierum creatis*, in id., *Operum theologicorum* (8 vols. in 3; Geneva, 1605), i (vol. 3).
Zucchi, Nicola, *Optica philosophia experimentis et ratione a fundamentis constituta* (Lyons, 1652, 1656).

ITEMS AFTER 1800

Ackerman, J. S., 'Leonardo's Eye', *J. Warburg and Courtauld Inst.* 41 (1978), 108–46.
Agamben, G., *Stanzas: Word and Phantasm in Western Culture*, trans. R. L. Martinez (Minneapolis, 1993; orig. pub. 1977).
Ahlgren, G. T. W., *Teresa of Avila and the Politics of Sanctity* (Ithaca, NY, 1996).
Aikins, J. E., 'Accounting for Dreams in *Clarissa*: The Clash of Probabilities', in C. Fox (ed.), *Psychology and Literature in the Eighteenth Century* (New York, 1987), 167–97.
Alpers, S., *The Art of Describing: Dutch Art in the Seventeenth Century* (London, 1983).
Amelang, J. S., 'Durmiendo con el enemigo: el Diablo en los sueños', in M. Tausiet and J. S. Amelang (eds.), *El Diablo en la edad moderna* (Madrid, 2004), 327–56.
Anderson, C., 'The Secrets of Vision in Renaissance England', in Massey (ed.), *Treatise on Perspective*, 322–47.
Annas, J., and Barnes, J., *The Modes of Scepticism: Ancient Texts and Modern Interpretations* (Cambridge, 1985).
Aquilecchia, G., 'Appunti su G. B. Della Porta e l'Inquisizione', *Studi secenteschi*, 9 (1968), 3–31.
Arbini, R., 'Did Descartes Have a Philosophical Theory of Sense Perception?', *J. Hist. Philosophy*, 21 (1983), 317–37.
Ariew, R., et al. (eds.), *Descartes' 'Meditations': Background Source Materials* (Cambridge, 1998).

Ashworth, W. B., Jr., 'The Habsburg Circle', in B. T. Moran (ed.), *Patronage and Institutions: Science, Technology, and Medicine at the European Court, 1500–1750* (Woodbridge, 1991), 137–67.

Aston, M., *England's Iconoclasts*, i: *Laws against Images* (Oxford, 1988).

Atherton, M., 'How to Write the History of Vision: Understanding the Relationship between Berkeley and Descartes', in Levin (ed.), *Sites of Vision*, 139–65.

Babb, L., *The Elizabethan Malady: A Study of Melancholia in English Literature from 1580 to 1642* (East Lansing, Mich., 1951).

Baigrie, B. S. (ed.), *Picturing Knowledge: Historical and Philosophical Problems Concerning the Use of Art in Science* (Toronto, 1996).

—— 'Descartes's Scientific Illustrations and "la grande mécanique de la nature"', in id. (ed.), *Picturing Knowledge*, 86–134.

Baltrušaitis, J., *Anamorphic Art*, trans. W. J. Strachan (Cambridge, 1977).

—— *Le Miroir* (Paris, 1978).

Banks, M., and Morphy, H. (eds.), *Rethinking Visual Anthropology* (New Haven, 1997).

Baroja, J. C., *The World of the Witches*, trans. O. N. V. Glendinning (London, 1964).

Battafarano, I. M., 'Die Imagination in Hexenlehre, Medizin und Naturphilosophie', *Morgen Glantz*, 13 (2003), 73–96.

Baxendall, M., *Painting and Experience in Fifteenth-Century Italy* (Oxford, 1971).

Behan, D., et al., 'Symposium on Descartes on Perceptual Cognition', in Gaukroger, Schuster, and Sutton (eds.), *Descartes' Natural Philosophy*, 524–87.

Beinlich, H., et al. (eds.), *Magie des Wissens: Athanasius Kircher 1602–1680. Universalgelehrter, Sammler, Visionär* (Dettelbach, 2002).

Bell, J., *Biblical and Shakespearian Characters Compared* (Hull, 1894).

Bell, M., *Shakespeare's Tragic Skepticism* (New Haven, 2002).

Belting, H., *Likeness and Presence: A History of the Image before the Era of Art*, trans. Edmund Jephcott (Chicago, 1994).

Bennett, G., 'Ghost and Witch in the Sixteenth and Seventeenth Centuries', *Folklore*, 97 (1986), 3–14.

Bensimon, M., 'Modes of Perception of Reality in the Renaissance', in R. S. Kinsman (ed.), *The Darker Vision of the Renaissance: Beyond the Fields of Reason* (Berkeley, 1974), 221–72.

Berger, J., *Ways of Seeing* (London, 1972).

Berriot, F., 'Clés des songes françaises à la Renaissance', in Charpentier (ed.), *Le Songe à la Renaissance*, 21–32.

Berti, S., 'Unmasking the Truth: The Theme of Imposture in Early Modern European Culture, 1660–1730', in Force and Katz (eds.), *Everything Connects*, 21–36.

Besançon, A., *The Forbidden Image: An Intellectual History of Iconoclasm*, trans. J. M. Todd (Chicago, 2000).

Bessot, D., 'La Perspective de Nicéron et ses rapports avec Maignan', in M. Bucciantini and M. Torrini (eds.), *Geometria e atomismo nella scuola Galileiana* (Florence, 1992), 147–69.

Biernoff, S., *Sight and Embodiment in the Middle Ages* (London, 2002).

Boase, A. M., *The Fortunes of Montaigne: A History of the Essays in France, 1580–1669* (London, 1935).

—— 'Montaigne et la sorcellerie', *[Bibliothèque d']humanisme et Renaissance*, 2 (1935), 402–21.

Bostridge, I., *Witchcraft and its Transformations c.1650–c.1750* (Oxford, 1997).
Boyer, P., and Nissenbaum, S. (eds.), *Salem-Village Witchcraft: A Documentary Record of Local Conflict in Colonial New England* (Belmont, Calif., 1972).
Brahami, F., *Le Scepticisme de Montaigne* (Paris, 1997).
Brann, N. L., *The Debate over the Origin of Genius during the Italian Renaissance: The Theories of Supernatural Frenzy and Natural Melancholy in Accord and in Conflict on the Threshold of the Scientific Revolution* (Leiden, 2002).
Brennan, T., and Jay, M. (eds.), *Vision in Context: Historical and Contemporary Perspectives on Sight* (New York, 1996).
Brett, G. S., *A History of Psychology* (3 vols.; London, 1912–21).
Brooke, N., 'Shakespeare and Baroque Art', *Procs. of the British Academy*, 63 (1977), 53–69.
—— (ed.), *The Tragedy of Macbeth* (Oxford, 1990).
Brown, J. R., *Focus on Macbeth* (London, 1982).
Brown, P. (ed.), *Reading Dreams: The Interpretation of Dreams from Chaucer to Shakespeare* (Oxford, 1999).
Browne, A., 'Girolamo Cardano's *Somniorum Synesiorum libri iiii*', *Bibliothèque d'humanisme et Renaissance*, 41 (1979), 123–45.
—— 'Dreams and Picture Writing: Some Examples of this Comparison from the Sixteenth to the Eighteenth Century', *J. of the Warburg and Courtauld Inst.* 44 (1981), 90–100.
Brusati, C., *Artifice and Illusion: The Art and Writing of Samuel van Hoogstraten* (Chicago, 1995).
Bryson, N., *Vision and Painting: The Logic of the Gaze* (London, 1983).
—— 'The Gaze in the Expanded Field', in H. Foster (ed.), *Vision and Visuality* (Seattle, 1988), 87–108.
—— and Bal, M., 'Semiotics and Art History', *Art Bull.* 73 (1991), 174–208.
Bullough, G., *Narrative and Dramatic Sources of Shakespeare*, vii: *Major Tragedies* (London, 1973).
Bundy, M. W., *The Theory of Imagination in Classical and Medieval Thought* (Urbana, Ill., 1927).
Burke, P., 'The Cultural History of Dreams', in id., *Varieties of Cultural History* (Cambridge, 1997), 23–42.
Burrell, M. D., '*Macbeth*: A Study in Paradox', *Shakespeare Jahrbuch*, 90 (1954), 167–90.
Camerota, F., 'Ricostruire il Seicento: macchine ed esperimenti', in Lo Sardo (ed.), *Athanasius Kircher*, 239–47.
Camille, M., *The Gothic Idol: Ideology and Image-Making in Medieval Art* (Cambridge, 1989).
—— 'Before the Gaze: The Internal Senses and Late Medieval Practices of Seeing', in Nelson (ed.), *Visuality before and beyond the Renaissance*, 197–223.
—— 'The Iconoclast's Desire: Deguileville's Idolatry in France and England', in Dimmick, Simpson, and Zeeman (eds.), *Images, Idolatry, and Iconoclasm*, 151–71.
Candito, C., 'Il Proteo catottrico', in Lo Sardo (ed.), *Athanasius Kircher*, 253.
Cantor, G. N., 'Berkeley, Reid, and the Mathematization of Mid-Eighteenth-Century Optics', in J. W. Yolton (ed.), *Philosophy, Religion and Science in the Seventeenth and Eighteenth Centuries* (Rochester, NY, 1990), 1–20.

Carroll, J. L., ' The Paintings of Jacob Cornelisz. Van Oostsanen (1472?–1533)', Ph.D. thesis (University of North Carolina, Chapel Hill, 1987).
Carruthers, M. J., *The Book of Memory: A Study of Memory in Medieval Culture* (Cambridge, 1990).
Cassanelli, L., 'Macchine ottiche, costruzioni delle immagini e percezione visiva in Kircher', in M. Casciato et al. (eds.), *Enciclopedismo in Roma barocca: Athanasius Kircher e il Museo del Collegio Romano tra Wunderkammer e museo scientifico* (Venice, 1986), 236–46.
Castelli, P., ' "Donnaiole, amiche de li sogni" ovvero i sogni delle streghe', in *Bibliotheca Lamiarum: documenti e immagini della stregoneria dal Medioevo all'età moderna*, Biblioteca Universitaria di Pisa (Pisa, 1994), 35–85.
Castillo, D. R., *(A)Wry Views: Anamorphosis, Cervantes, and the Early Picaresque* (West Lafayette, Ind., 2001).
Cave, T., *Pré-histoires: textes troublés au seuil de la modernité* (Geneva, 1999).
Cavell, S., *Disowning Knowledge in Six Plays of Shakespeare* (Cambridge, 1987).
Ceccarelli Pellegrino, A., 'Iconografie "Malinconiche" dell'immaginario rinascimentale', in Rotondi Secchi Tarugi (ed.), *Malinconia ed allegrezza*, 129–56.
Certeau, M. de, *The Possession at Loudun*, trans. M. B. Smith (Chicago, 2000).
Charpentier, F., *Le Songe à la Renaissance* (Saint-Étienne, 1989).
Chevalley, C., 'L'*Ars magna lucis et umbrae* d'Athanase Kircher: Néoplatonisme, hermétisme et "nouvelle philosophie" ', *Baroque*, 12 (1987), 95–110.
Chidester, D., 'Symbolism and the Senses in Saint Augustine', *Religion*, 14 (1984), 31–51.
Christensen, C. C., *Art and the Reformation in Germany* (Athens, Oh., 1979).
Christian, W. A., Jr., *Apparitions in Late Medieval and Renaissance Spain* (Princeton, 1981).
Christin, O., *Une révolution symbolique: l'iconoclasme huguenot et la reconstruction catholique* (Paris, 1991).
Clark, F., *Eucharistic Sacrifice and the Reformation* (London, 1960).
Clark, S., *Thinking with Demons: The Idea of Witchcraft in Early Modern Europe* (Oxford, 1997).
Closson, M., *L'Imaginaire démoniaque en France (1550–1650): genèse de la littérature fantastique* (Geneva, 2000).
Coddon, K. S., ' "Unreal Mockery": Unreason and the Problem of Spectacle in *Macbeth*', *ELH* 56 (1989), 485–501.
Cole, J. R., *The Olympian Dreams and Youthful Rebellion of René Descartes* (Urbana, Ill., 1992).
Cole, M., 'The Demonic Arts and the Origin of the Medium', *Art Bull.* 84 (2002), 621–40.
Colie, R. L., *Paradoxia epidemica: The Renaissance Tradition of Paradox* (Princeton, 1966).
Collins, D. L., 'Anamorphosis and the Eccentric Observer: Inverted Perspective and the Construction of the Gaze', *Leonardo*, 25 (1992), 73–82.
Cope, J. I., *Joseph Glanvill Anglican Apologist* (St Louis, 1956).
Corbett, M., and Lightbown, R., *The Comely Frontispiece: The Emblematic Title-Page in England 1550–1660* (London, 1979).
Cordaro, M. (ed.), *Mantegna's Camera degli Sposi* (New York, 1993).
Corradino, S., 'L'*Ars magna lucis et umbrae* di Athanasius Kircher', *Archivum historicum Societatis Iesu*, 62 (1993), 249–79.

Cottingham, J. (ed.), *Reason, Will, and Sensation: Studies in Descartes's Metaphysics* (Oxford, 1994).
Craig, L. H., *Of Philosophers and Kings: Political Philosophy in Shakespeare's 'Macbeth' and 'King Lear'* (Toronto, 2001).
Craker, W. D., 'Spectral Evidence, Non-Spectral Acts of Witchcraft, and Confession at Salem in 1692', *Hist. J.* 40 (1997), 331–58.
Crary, J., *Techniques of the Observer: On Vision and Modernity in the Nineteenth Century* (Cambridge, Mass., 1990).
Crawford, P., 'Women's Dreams in Early Modern England', *Hist. Workshop J.* 49 (2000), 129–41.
Crombie, A. C., 'Expectation, Modelling and Assent in the History of Optics—ii: Kepler and Descartes', *Stud. in the Hist. and Philosophy of Science*, 22 (1991), 89–115.
Cummings, B., 'Iconoclasm and Bibliophobia in the English Reformation, 1521–1558', in Dimmick, Simpson, and Zeeman (eds.), *Images, Idolatry, and Iconoclasm*, 185–206.
Damisch, H., 'Figuration et représentation: le problème de l'apparition', *Annales ESC* 26 (1971), 664–80.
Dannenfeldt, K. H., 'Sleep: Theory and Practice in the Late Renaissance', *J. of the Hist. of Medicine and Allied Sciences*, 41 (1986), 415–41.
Daston, L., and Park, K., *Wonders and the Order of Nature 1150–1750* (New York, 2001).
Davey, N., 'The Hermeneutics of Seeing', in I. Heywood and B. Sandywell (eds.), *Interpreting Visual Culture: Explorations in the Hermeneutics of the Visual* (London, 1999), 3–29.
Davidson, C., 'The Anti-Visual Prejudice', in id. and A. E. Nichols (eds.), *Iconoclasm vs. Art and Drama* (Kalamazoo, Mich., 1989), 33–46.
—— ' "The Devil's Guts": Allegations of Superstition and Fraud in Religious Drama and Art during the Reformation', in id. and Nichols (eds.), *Iconoclasm vs. Art and Drama*, 92–144.
Davis, N. Zemon, *Society and Culture in Early Modern France* (London, 1975).
Decyk, B. Newell, 'Cartesian Imagination and Perspectival Art', in Gaukroger, Schuster, and Sutton (eds.), *Descartes' Natural Philosophy*, 447–86.
DePorte, M. V., *Nightmares and Hobbyhorses: Swift, Sterne, and Augustan Ideas of Madness* (San Marino, Calif., 1974).
Desan, P.,'Pour une typologie de la mélancolie à la Renaissance: *Des maladies mélancholiques* (1598) de Du Laurens', in Rotondi Secchi Tarugi (ed.), *Malinconia ed allegrezza*, 355–66.
Dictionnaire de spiritualité ascétique et mystique, doctrine et histoire, dir. M. Viller et al. (17 vols.; Paris, 1937–95).
Diehl, H., 'Horrid Image, Sorry Sight, Fatal Vision: The Visual Rhetoric of Macbeth', *Shakespeare Stud.* 16 (1983), 191–203.
—— *Staging Reform, Reforming the Stage: Protestantism and Popular Theatre in Early Modern England* (Ithaca, NY, 1997).
Diethelm, O., *Medical Dissertations of Psychiatric Interest Printed before 1750* (Basel, 1971).
Dimmick, J., Simpson, J., and Zeeman, N. (eds.), *Images, Idolatry, and Iconoclasm in Late Medieval England: Textuality and the Visual Image* (Oxford, 2002).
Dinzelbacher, P., *Vision und Visionsliteratur im Mittelalter* (Stuttgart, 1981).
Dubois, C.-G., 'Montaigne et le surnaturel', in I. Zinguer (ed.), *Le Lecteur, l'auteur et l'écrivain: Montaigne 1492-1592-1992* (Paris, 1993), 41–53.

Dugmore, C. W., *The Mass and the English Reformers* (London, 1958).
Dulaey, M., *Le Rêve dans la vie et la pensée de Saint Augustin* (Paris, 1973).
Dunlop, C. E. M. (ed.), *Philosophical Essays on Dreaming* (Ithaca, NY, 1977).
Duthie, G. I., 'Antithesis in *Macbeth*', *Shakespeare Survey*, 19 (1966), 25–33.
Dyrness, W. A., *Reformed Theology and Visual Culture: The Protestant Imagination from Calvin to Edwards* (Cambridge, 2004).
Eamon, W., *Science and the Secrets of Nature: Books of Secrets in Medieval and Early Modern Culture* (Princeton, 1994).
Edgerton, S. Y., Jr, *The Renaissance Rediscovery of Linear Perspective* (New York, 1976).
Eire, C. M. N., *War against the Idols: The Reformation of Worship from Erasmus to Calvin* (Cambridge, 1986).
—— 'The Reformation Critique of the Image', in R. W. Scribner (ed.), *Bilder und Bildersturm in Spätmittelalter und in der frühen Neuzeit* (Wiesbaden, 1990), 51–68.
Ekirch, R., 'Sleep We Have Lost: Pre-Industrial Slumber in the British Isles', *American Hist. Rev.* 106 (2001), 342–86.
Elkins, J., *The Poetics of Perspective* (Ithaca, NY, 1994).
Elliott, D., 'Seeing Double: John Gerson, the Discernment of Spirits, and Joan of Arc', *American Hist. Rev.* 107 (2002), 26–54.
Elliott, G. R., *Dramatic Providence in Macbeth* (Princeton, 1960).
Elwood, C., *The Body Broken: The Calvinist Doctrine of the Eucharist and the Symbolization of Power in Sixteenth-Century France* (Oxford, 1999).
Emison, P., 'Truth and *Bizzarria* in an Engraving of *Lo stregozzo*', *Art Bull.* 81 (1999), 623–36.
Evans, R. J. W., *The Making of the Habsburg Monarchy, 1550–1700: An Interpretation* (Oxford, 1979).
Everson, S., *Aristotle on Perception* (Oxford, 1997).
Farnham, W., *Shakespeare's Tragic Frontier: The World of his Final Tragedies* (Berkeley and Los Angeles, 1963).
Ferber, S., *Demonic Possession and Exorcism in Early Modern France* (London, 2004).
Ferino-Pagden, S. (ed.), *Immagini del sentire: i cinque sensi nell'arte* (Cremona, 1996).
Ferreyrolles, G., 'Lecture pascalienne des miracles en Montaigne', in Michel (ed.), *Montaigne et les Essais*, 120–34.
Findlen, P., *Possessing Nature: Museums, Collecting, and Scientific Culture in Early Modern Italy* (Berkeley, 1994).
—— 'Scientific Spectacle in Baroque Rome: Athanasius Kircher and the Roman College Museum', in M. Feingold (ed.), *Jesuit Science and the Republic of Letters* (Cambridge, Mass., 2003), 225–84.
—— (ed.), *Athanasius Kircher: The Last Man Who Knew Everything* (New York, 2004).
Flint, K., *The Victorians and the Visual Imagination* (Cambridge, 2000).
Floridi, L., 'The Diffusion of Sextus Empiricus's Works in the Renaissance', *J. Hist. of Ideas*, 56 (1995), 63–85.
—— *Sextus Empiricus: The Transmission and Recovery of Pyrrhonism* (Oxford, 2002).
Foakes, R. A., ' "Forms to his Conceit": Shakespeare and the Uses of Stage Illusion', *Procs. of the British Academy*, 66 (1980), 103–19.
Force, J. E., and Katz, D. S. (eds.), *Everything Connects: In Conference with Richard H. Popkin. Essays in his Honor* (Leiden, 1999).
Foucault, M., *Power/Knowledge: Selected Interviews and Other Writings 1972–1977*, ed. C. Gordon, trans. C. Gordon et al. (New York, 1980).

Fowler, A., *Renaissance Realism: Narrative Images in Literature and Art* (Oxford, 2003).
Frangenberg, T., '*Auditus visu prestantior*: Comparisons of Hearing and Vision in Charles de Bovelles's *Liber de sensibus*', in C. Burnett, M. Fend, and P. Gouk (eds.), *The Second Sense: Studies in Hearing and Musical Judgment from Antiquity to the Seventeenth Century* (London, 1991), 71–89.
Frankfurt, H. G., *Demons, Dreamers, and Madmen: The Defense of Reason in Descartes's Meditations* (Indianapolis, 1970).
Freedberg, D., 'The Hidden God: Image and Interdiction in the Netherlands in the Sixteenth Century', *Art Hist.* 5 (1982), 133–53.
—— *Iconoclasm and Painting in the Revolt of the Netherlands, 1566–1609* (New York, 1988).
—— *The Power of Images: Studies in the History and Theory of Response* (Chicago, 1989).
—— 'Iconography between the History of Art and the History of Science: Art, Science, and the Case of the Urban Bee', in C. A. Jones and P. Galison (eds.), *Picturing Science/Producing Art* (New York, 1998), 272–96.
Friedenwald, H., 'Andres a Laguna, a Pioneer in his Views on Witchcraft', *Bull. of the Hist. of Medicine*, 7 (1939), 1037–48.
Friedrich, E., *Die Magie im französischen Theater des xvi. und xvii. Jahrhunderts* (Leipzig, 1908).
Frommel, C. L., *Baldassare Peruzzi als Maler und Zeichner* (Vienna, 1968).
Fungaroli, C. S., 'Landscapes of Life: Dreams in Eighteenth-Century British Fiction and Contemporary Dream Theory', Ph.D. dissertation (University of Virginia, 1994).
Galand-Hallyn, P., 'Le Songe et la rhétorique de l'"enargeia" ', in Charpentier (ed.), *Le Songe à la Renaissance*, 125–35.
Gallagher, C., and Greenblatt, S., *Practicing New Historicism* (Chicago, 2000).
Garber, M. B., *Dream in Shakespeare: From Metaphor to Metamorphosis* (New Haven, 1974).
—— *Shakespeare's Ghost Writers: Literature as Uncanny Causality* (London, 1987).
Gaskill, M., *Crime and Mentalities in Early Modern England* (Cambridge, 2000).
Gaukroger, S. (trans. and ed.), *A. Arnauld: 'On True and False Ideas'* (Manchester, 1990).
—— *Descartes: An Intellectual Biography* (Oxford, 1995).
—— Schuster, J., and Sutton, J. (eds.), *Descartes' Natural Philosophy* (London, 2000).
Gent, L., *Picture and Poetry, 1560–1620: Relations between Literature and the Visual Arts in the English Renaissance* (Leamington Spa, 1981).
—— 'The Self-Cozening Eye', *Rev. of English Stud.* 34 (1983), 419–28.
Gilman, E. B., *The Curious Perspective: Literary and Pictorial Wit in the Seventeenth Century* (New Haven, 1978).
—— 'Word and Image in Quarles' *Emblemes*', in Mitchell (ed.), *Language of Images*, 59–84.
Goldberg, J., 'Speculations: *Macbeth* and Source', in J. E. Howard and M. F. O'Connor (eds.), *Shakespeare Reproduced: The Text in History and Ideology* (London, 1987), 242–64.
Gordon, B., 'Malevolent Ghosts and Ministering Angels: Apparitions and Pastoral Care in the Swiss Reformation', in id. and P. Marshall (eds.), *The Place of the Dead: Death and Remembrance in Late Medieval and Early Modern Europe* (Cambridge, 2000), 87–109.
Gorman, M. J., 'Between the Demonic and the Miraculous: Athanasius Kircher and the Baroque Culture of Machines', in Stolzenberg (ed.), *Great Art of Knowing*, 59–83.

—— and Wilding, N., 'Athanasius Kircher e la cultura barocca delle macchine', in Lo Sardo (ed.), *Athanasius Kircher*, 217–37.
Göttler, C., 'Is Seeing Believing? The Use of Evidence in Representations of the Miraculous Mass of Saint Gregory', *Germanic Rev.* 76 (2001), 120–42.
Grabes, H., *The Mutable Glass: Mirror-Imagery in Titles and Texts of the Middle Ages and the English Renaissance*, trans. G. Collier (Cambridge, 1982).
Grässe, J. G. T., *Bibliotheca magica et pneumatica* (Leipzig, 1843).
Grau, O., *Virtual Art: From Illusion to Immersion*, trans. G. Custance (Cambridge, Mass., 2003).
Greenblatt, S., *Renaissance Self-Fashioning: From More to Shakespeare* (London, 1980).
—— 'Shakespeare Bewitched', in J. N. Cox and L. J. Reynolds (eds.), *New Historical Literary Study: Essays on Reproducing Texts, Representing History* (Princeton, 1993), 108–35.
—— *Hamlet in Purgatory* (Princeton, 2001).
Groarke, L., 'Descartes' First Meditation: Something Old, Something New, Something Borrowed', *J. Hist. of Philosophy*, 22 (1984), 281–301.
—— *Greek Scepticism: Anti-Realist Trends in Ancient Thought* (London, 1990).
Grootenboer, H., *The Rhetoric of Perspective: Realism and Illusionism in Seventeenth-Century Dutch Still-Life Painting* (Chicago, 2005).
Guerra, A. M., 'Il silenzio di Dio e la voce dell'anima da Enrico di Langenstein a Gerson', *Cristianesimo nella storia*, 17 (1996), 393–413.
Habicht, W., ' "And Mock our Eyes with Air": Air and Stage Illusion in Shakespearean Drama', in F. Burwick and W. Pape (eds.), *Aesthetic Illusion: Theoretical and Historical Approaches* (Berlin, 1990), 301–12.
Halio, J. L., 'The Metaphor of Conception and Elizabethan Theories of the Imagination', *Neophilologus*, 50 (1966), 454–61.
Hall, A. R., *All Was Light: An Introduction to Newton's 'Opticks'* (Oxford, 1993).
Hall, B., 'The Didactic and the Elegant: Some Thoughts on Scientific and Technological Illustrations in the Middle Ages and Renaissance', in Baigrie (ed.), *Picturing Knowledge*, 3–39.
Hallyn, F., 'Olympica: les songes du jeune Descartes', in Charpentier (ed.), *Le Songe à la Renaissance*, 41–51.
Hamburger, J. F., 'Bosch's *Conjuror*: An Attack on Magic and Sacramental Heresy', *Simiolus*, 14 (1984), 4–23.
—— 'Seeing and Believing: The Suspicion of Sight and the Authentication of Vision in Late Medieval Art and Devotion', in A. Nova and K. Krüger (eds.), *Imagination und Wirklichkeit: Zum Verhältnis von mentalen und realen Bildern in der Kunst der frühen Neuzeit* (Mainz, 2000), 47–69.
Hankins, T. L., and Silverman, R. J., *Instruments and the Imagination* (Princeton, 1995).
Hansen, J. (ed.), *Quellen und Untersuchungen zur Geschichte des Hexenwahns und der Hexenverfolgung im Mittelalter* (Bonn, 1901).
Harris, V., *All Coherence Gone: A Study of the Seventeenth Century Controversy over Disorder and Decay in the Universe* (London, 1966).
Hartlaub, G. F., *Zauber des Spiegels: Geschichte und Bedeutung des Spiegels in der Kunst* (Munich, 1951).
Harvey, E. D. (ed.), *Sensible Flesh: On Touch in Early Modern Culture* (Philadelphia, 2003).

Harvey, E. R., *The Inward Wits: Psychological Theory in the Middle Ages and the Renaissance* (London, 1975).
Hatfield, G., 'Descartes' Physiology and its Relation to his Psychology', in J. Cottingham (ed.), *The Cambridge Companion to Descartes* (Cambridge, 1992), 335–70.
—— 'The Cognitive Faculties', in D. Garber and M. Ayers (eds.), *The Cambridge History of Seventeenth-Century Philosophy* (2 vols.; Cambridge, 1998), ii. 953–1002.
—— *Descartes and the 'Meditations'* (London, 2003).
—— and Epstein, W., 'The Sensory Core and the Medieval Foundations of Early Modern Perceptual Theory', *Isis*, 70 (1979), 363–84.
Helt, J. S. W., 'The "Dead Who Walk": Materiality, Liminality and the Supernatural World in François Richard's *Of False Revenants*', *Mortality*, 5 (2000), 7–17.
Henningsen, G., *The Witches' Advocate: Basque Witchcraft and the Spanish Inquisition (1609–1614)* (Reno, Nev., 1980).
Heyd, M., *'Be Sober and Reasonable': The Critique of Enthusiasm in the Seventeenth and Early Eighteenth Centuries* (Leiden, 1995).
Holland, P. (ed.), *A Midsummer Night's Dream* (Oxford, 1994).
—— ' "The Interpretation of Dreams" in the Renaissance', in Brown (ed.), *Reading Dreams*, 125–46.
Honée, E., 'Image and Imagination in the Medieval Culture of Prayer: A Historical Perspective', in H. van Os et al. (eds.), *The Art of Devotion in the Late Middle Ages in Europe, 1300–1500*, trans. M. Hoyle (Princeton, 1994), 157–74.
Humbert, P., 'Les Études de Peiresc sur la vision', *Archives internationales d'histoire des sciences*, 4 (1951), 654–9.
Hunt, A., 'The Lord's Supper in Early Modern England', *Past and Present*, 161 (1998), 39–83.
Huntley, F. L., '*Macbeth* and the Background of Jesuitical Equivocation', *Procs. of the Mod. Language Association*, 79 (1964), 390–400.
Iliffe, R., 'Lying Wonders and Juggling Tricks: Religion, Nature, and Imposture in Early Modern England', in Force and Katz (eds.), *Everything Connects*, 185–209.
Ivins, W. M., Jr., *On the Rationalization of Sight: With an Examination of Three Renaissance Texts on Perspective* (New York, 1973).
Jack, J. H., 'Macbeth, King James, and the Bible', *ELH* 22 (1955), 173–93.
Jackson, S. W., *Melancholia and Depression from Hippocratic Times to Modern Times* (New Haven, 1986).
Jacovides, M., 'Locke's Resemblance Theses', *Philosophical Rev.* 108 (1999), 461–96.
Jacques-Chaquin, N., 'Nynauld, Bodin et les autres: les enjeux d'une métamorphose textuelle', in Jean de Nynauld, *De la lycanthropie, transformation et extase des sorciers* (1615), ed. N. Jacques-Chaquin, M. Préaud, et al. (Paris, 1990), 7–41.
—— [Jacques-Lefèvre, N.], ' "Such an Impure, Cruel, and Savage Beast . . . ": Images of the Werewolf in Demonological Works', in K. A. Edwards (ed.), *Werewolves, Witches, and Wandering Spirits: Traditional Belief and Folklore in Early Modern Europe* (Kirksville, Mo., 2002), 181–97.
Janson, H. W., 'The "Image Made by Chance" in Renaissance Thought', in M. Meiss (ed.), *De artibus opuscula XL: Essays in Honor of Erwin Panofsky* (2 vols.; New York, 1961), i. 254–66.
Jay, M., *Downcast Eyes: The Denigration of Vision in Twentieth-Century French Thought* (Berkeley, 1993).

Jobe, T. H., 'Medical Theories of Melancholia in the Seventeenth and Early Eighteenth Centuries', *Clio medica*, 11 (1976), 217–31.
Johansen, T. K., *Aristotle on the Sense-Organs* (Cambridge, 1998).
Johns, A., 'The Physiology of Reading and the Anatomy of Enthusiasm', in O. P. Grell and A. Cunningham (eds.), *'Religio medici': Medicine and Religion in Seventeenth-Century England* (Aldershot, 1996), 136–70.
Jones-Davies, M. T. (ed.), *Le Paradoxe au temps de la Renaissance* (Paris, 1982).
Judovitz, D., 'Vision, Representation, and Technology in Descartes', in D. M. Levin (ed.), *Modernity and the Hegemony of Vision* (Berkeley, 1993), 63–86.
Julien, P., 'L'Anamorphose murale du collège jésuite d'Aix-en-Provence: jusqu'à Lisbonne par la barbe de saint Pierre', *Revue de l'art*, 130 (2000), 17–26.
Jütte, R., *A History of the Senses: From Antiquity to Cyberspace*, trans. James Lynn (Cambridge, 2005).
Kapitaniak, P., 'Spectres, fantômes et revenants: phénomène et représentation dans le théâtre de la Renaissance anglaise', dissertation (Université Paris IV—Sorbonne, 2001).
Kauffmann, H., 'Die Fünfsinne in der niederländischen Malerei des 17. Jahrhunderts', in H. Tintelnot (ed.), *Kunstgeschichtliche Studien: Festschrift für Dagobert Frey* (Breslau, 1943), 133–57.
Kaufmann, T. DaCosta, *The Master of Nature: Aspects of Art, Science, and Humanism in the Renaissance* (Princeton, 1993).
Kemp, M., 'Perspective and Meaning: Illusion, Allusion, and Collusion', in A. Harrison (ed.), *Philosophy and the Visual Arts: Seeing and Abstracting* (Dordrecht, 1987), 255–68.
—— *The Science of Art: Optical Themes in Western Art from Brunelleschi to Seurat* (New Haven, 1990).
—— ' "The Mark of Truth": Looking and Learning in Some Anatomical Illustrations from the Renaissance and Eighteenth Century', in W. F. Bynum and R. Porter (eds.), *Medicine and the Five Senses* (Cambridge, 1993), 85–121.
—— 'Temples of the Body and Temples of the Cosmos: Vision and Visualization in the Vesalian and Copernican Revolutions', in Baigrie (ed.), *Picturing Knowledge*, 40–85.
Kemp, S., *Cognitive Psychology in the Middle Ages* (Westport, Conn., 1996).
Kenny, A., *Descartes: A Study of his Philosophy* (Bristol, 1993).
Kermode, J. F., 'The Banquet of Sense', *Bull. of the John Rylands Library*, 44 (1961–2), 68–99.
Kinney, A. F., *Lies Like Truth: Shakespeare, Macbeth, and the Cultural Moment* (Detroit, 2001).
Klibansky, R., Panofsky, E., and Saxl, F., *Saturn and Melancholy: Studies in the History of Natural Philosophy, Religion, and Art* (London, 1964).
Knecht, H. H., 'Le Fonctionnement de la science baroque: le rationnel et le merveilleux', *Baroque*, 12 (1987), 53–70.
Knights, L. C., 'How Many Children Had Lady Macbeth?', in id., *Explorations* (London, 1946; repr. 1964), 13–50.
Koerner, J. L., *The Reformation of the Image* (London, 2004).
Koslofsky, C. M., *The Reformation of the Dead: Death and Ritual in Early Modern Germany, 1450–1700* (Houndmills, 2000).
Kruger, S. F., *Dreaming in the Middle Ages* (Cambridge, 1992).
Laroque, F., 'Perspective in *Troilus and Cressida*', in J. M. Mucciolo (ed.), *Shakespeare's Universe: Renaissance Ideas and Coventions* (Aldershot, 1996), 224–42.

Laroque, F., 'Macbeth: The Theatre of Baroque Illusion?', in R. T. Eriksen (ed.), Contexts of Baroque: Theatre, Metamorphosis, and Design (Oslo, 1997), 99–118.
Lea, H. C., A History of the Inquisition of Spain, (4 vols.; New York, 1922).
—— Materials toward a History of Witchcraft, ed. A. C. Howland, introd. G. L. Burr (3 vols.; London, 1957).
Lecouteux, C., Fantômes et revenants au Moyen Âge, 2nd edn. (Paris, 1996).
Leeman, F. (with Elffers, J., and Schuyt, M.), Hidden Images: Games of Perception, Anamorphic Art: Illusion from the Renaissance to the Present, trans. E. C. Allison and M. L. Kaplan (New York, 1976).
Le Goff, J., 'Christianity and Dreams (Second to Seventh Centuries)', in id., The Medieval Imagination, trans. A. Goldhammer (Chicago, 1988), 193–231.
Leinkauf, T., 'Athanasius Kircher und Aristoteles: Ein Beispiel für das Fortleben aristotelischen Denkens in fremden Kontexten', in E. Kessler, C. H. Lohr, and W. Sparn (eds.), Aristotelismus und Renaissance: In Memoriam Charles B. Schmitt (Wiesbaden, 1988), 193–216.
—— Mundus combinatus: Studien zur Struktur der barocken Universalwissenschaft am Beispiel Athanasius Kircher SJ (1602–1680) (Berlin, 1993).
Lenoble, R., Mersenne ou la naissance du mécanisme (Paris, 1943).
Levack, B. P., 'The Decline and End of Witchcraft Prosecutions', in M. Gijswijt-Hofstra, B. P. Levack, and R. Porter, Witchcraft and Magic in Europe: The Eighteenth and Nineteenth Centuries (London, 1999), 1–93.
Levi, A., French Moralists: The Theory of the Passions, 1585–1649 (Oxford, 1964).
Levin, D. M. (ed.), Sites of Vision: The Discursive Construction of Sight in the History of Philosophy (Cambridge, Mass., 1997).
Lightbown, R., Mantegna (Oxford, 1986).
Limbrick, E., 'Was Montaigne Really a Pyrrhonian?', Bibliothèque d'humanisme et Renaissance, 39 (1977), 67–80.
—— 'Le Scepticisme provisoire de Montaigne: étude des rapports de la raison et de la foi dans l'Apologie', in Michel (ed.), Montaigne et les Essais, 168–78.
—— 'Doute sceptique, doute méthodique: vers la certitude subjective', in L. M. Heller and F. R. Atance (eds.), Montaigne: regards sur les 'Essais' (Waterloo, 1986), 47–59.
—— 'La Relation du scepticisme avec la subjectivité', in E. Kusher (ed.), La Problématique du sujet chez Montaigne (Paris, 1995), 73–85.
Lindberg, D. C., 'Introduction', in Opticae thesaurus [optical works by Alhazen and Witelo, orig. ed. Friedrich Risner, Basel, 1572] (New York, 1972), pp. v–xxv.
—— Theories of Vision from al-Kindi to Kepler (Chicago, 1976).
—— 'The Science of Optics', in id. (ed.), Science in the Middle Ages (Chicago, 1978), 338–68.
—— Roger Bacon's Philosophy of Nature: A Critical Edition, with English Translation, Introduction, and Notes (Oxford, 1983).
—— Roger Bacon and the Origins of 'Perspectiva' in the Middle Ages: A Critical Edition and English Translation of Bacon's 'Perspectiva' with Introduction and Notes (Oxford, 1996).
—— and Steneck, N. H., 'The Sense of Vision and the Origins of Modern Science', in A. G. Debus (ed.), Science, Medicine and Society in the Renaissance: Essays to Honour Walter Pagel (2 vols.; New York, 1972), i. 29–40.
Lobanov-Rostovsky, S., 'Taming the Basilisk', in D. Hillman and C. Mazzio (eds.), The Body in Parts: Fantasies of Corporeality in Early Modern Europe (New York, 1997), 195–217.

Lohr, C. H., 'Renaissance Latin Aristotle Commentaries: Authors Pi–Sm', *Renaissance Quart.* 33 (1980), 623–734.
Lo Sardo, E. (ed.), *Athanasius Kircher: il Museo del Mondo* (Rome, 2001).
Lyons, B. G., *Voices of Melancholy: Studies in Literary Treatments of Melancholy in Renaissance England* (London, 1971).
MacDonald, M., *Mystical Bedlam: Madness, Anxiety, and Healing in Seventeenth-Century England* (Cambridge, 1981).
—— 'Insanity and the Realities of History in Early Modern England', *Psychological Medicine*, 11 (1981), 11–25.
MacIntosh, J. J., 'Perception and Imagination in Descartes, Boyle and Hooke', *Canadian J. of Philosophy*, 13 (1983), 327–52.
Mack Crew, P., *Calvinist Preaching and Iconoclasm in the Netherlands, 1544–1569* (Cambridge, 1978).
MacKenzie, A. W., 'The Reconfiguration of Sensory Experience', in Cottingham (ed.), *Reason, Will, and Sensation*, 251–72.
—— 'Descartes on Life and Sense', *Canadian J. of Philosophy*, 19 (1989), 163–92.
Maiorino, G., *The Portrait of Eccentricity: Arcimboldo and the Mannerist Grotesque* (University Park, Pa., 1991).
Malcolm, N., *Aspects of Hobbes* (Oxford, 2002).
—— 'Private and Public Knowledge: Kircher, Esotericism, and the Republic of Letters', in Findlen (ed.), *Athanasius Kircher*, 297–308.
Malloch, A. E., 'The Techniques and Function of the Renaissance Paradox', *Stud. in Philology*, 53 (1956), 191–203.
Mandrou, R., *Magistrats et sorciers en France au xviie siècle* (Paris, 1980).
Mannoni, L., Nekes, W., and Warner, M., *Eyes, Lies and Illusions* (London, 2004).
Margolin, J.-C., 'Aspects du surréalisme au xvie siècle: fonction allégorique et vision anamorphotique', *Bibliothèque d'humanisme et Renaissance*, 39 (1977), 503–30.
Marshall, P., 'The Rood of Boxley, the Blood of Hailes and the Defence of the Henrician Church', *J. of Ecclesiastical Hist.* 46 (1995), 689–96.
—— *Beliefs and the Dead in Reformation England* (Oxford, 2002).
—— 'Forgery and Miracles in the Reign of Henry VIII', *Past and Present*, 178 (2003), 39–73.
Marx, S., *Shakespeare and the Bible* (Oxford, 2000).
Massey, L., 'Anamorphosis through Descartes or Perspective Gone Awry', *Renaissance Quart.* 50 (1997), 1148–87.
—— (ed.), *The Treatise on Perspective: Published and Unpublished* (New Haven, 2003).
—— 'Configuring Spatial Ambiguity: Picturing the Distance Point from Alberti to Anamorphosis', in ead. (ed.), *Treatise on Perspective*, 161–75.
Mathieu-Castellani, G., 'Veiller en dormant, dormir en veillant: le songe dans les Essais', in Charpentier (ed.), *Le Songe à la Renaissance*, 231–8.
Max, F., 'Les Premières controverses sur la réalité du sabbat dans l'Italie du XVIe siècle', in N. Jacques-Chaquin and M. Préaud (eds.), *Le Sabbat des sorciers (xve–xviiie siècles)* (Paris, 1993), 55–62.
Maxwell-Stuart, P. G. (ed.), *The Occult in Early Modern Europe: A Documentary History* (London, 1999).
Mellamphy, N., 'Macbeth's Visionary Dagger: Hallucination or Revelation?', *English Stud. in Canada*, 4 (1978), 379–92.

Michalski, S., 'Das Phänomen Bildersturm. Versuch einer Ubersicht', in Scribner (ed.), *Bilder und Bildersturm*, 85–107.

—— *The Reformation and the Visual Arts: The Protestant Image Question in Western and Eastern Europe* (London, 1993).

Michel, P. (ed.), *Montaigne et les Essais 1580–1980* (Paris, 1983).

Midelfort, H. C. E., *Mad Princes of Renaissance Germany* (Charlottesville, Va., 1994).

—— *A History of Madness in Sixteenth-Century Germany* (Stanford, Calif., 1999).

Miles, M. R., 'Vision: The Eye of the Body and the Eye of the Mind in Saint Augustine's *De trinitate* and *Confessions*', *J. of Religion*, 63 (1983), 125–42.

—— *Image as Insight: Visual Understanding in Western Christianity and Secular Culture* (Boston, 1985).

Miller, J., *On Reflection* (London, 1998).

Miller, P. Cox, *Dreams in Late Antiquity: Studies in the Imagination of a Culture* (Princeton, 1994).

Miola, R. S., *Shakespeare's Reading* (Oxford, 2000).

Mitchell, W. J. T. (ed.), *The Language of Images* (Chicago, 1980).

Moorman, F. W., 'Shakespeare's Ghosts', *Mod. Language Rev.* 1 (1905–6), 192–201.

Moreau, P.-F. (ed.), *Le Scepticisme au xvie et au xviie siècle: le retour des philosophies antiques à l'âge classique*, vol. ii (Paris, 2001).

Moxey, K., *Pieter Aertsen, Joachim Beuckelaer and the Rise of Secular Painting in the Context of the Reformation* (New York, 1977).

Muir, K., *Shakespeare's Sources*, i: *Comedies and Tragedies* (London, 1957).

—— (ed.), *Macbeth*, The Arden Shakespeare (London, 1977).

Mullaney, S., 'Lying Like Truth: Riddle, Representation and Treason in Renaissance England', *ELH* 47 (1980), 32–47 (repr. in id., *The Place of the Stage: License, Play, and Power in Renaissance England* (Chicago, 1988), 116–34).

Nadler, S., 'Descartes's Demon and the Madness of Don Quixote', *J. of the Hist. of Ideas*, 58 (1997), 41–55.

Nagler, G. K., *Die Monogrammisten* (5 vols.; Munich, 1857–79).

Nakam, G., *Les 'Essais' de Montaigne, miroir et procès de leur temps: témoignage historique et création littéraire* (Paris, 1984).

Napoleone, C., 'Monastic Caprices: The Monastery of Trinità dei Monti: The Anamorphosis by Emmanuel Maignan', *FMR* 71 (1994), 20–30.

Naya, E., 'Traduire les *Hypotyposes pyrrhoniennes*: Henri Estienne entre la fièvre quarte et la folie chrétienne', in *Le Scepticisme au XVIe et au XVIIe siècle: le retour des philosophies antiques à l'Âge classique*, vol. ii, ed. P.-F. Moreau (Paris, 2001), 48–101.

Nelson, R. S., *Visuality before and beyond the Renaissance: Seeing as Others Saw* (Cambridge, 2000).

—— 'Introduction: Descartes's Cow and Other Domestications of the Visual', in id. (ed.), *Visuality before and beyond the Renaissance*, 1–21.

Niccoli, O., 'The Kings of the Dead on the Battlefield of Agnadello', in E. Muir and G. Ruggiero (eds.), *Microhistory and the Lost Peoples of Europe*, trans. E. Branch (Baltimore, 1991), 71–100.

Nichols, A. E., *Seeable Signs: The Iconography of the Seven Sacraments 1350–1544* (Woodbridge, 1994).

Nicolás, C., *Estrategias y lecturas: las anamorfosis de Quevedo* (Salamanca, 1986).

Nolan, E. P., *Now Through a Glass Darkly: Specular Images of Being and Knowing from Virgil to Chaucer* (Ann Arbor, 1990).

Norbrook, D., '*Macbeth* and the Politics of Historiography', in K. Sharpe and S. N. Zwicker (eds.), *Politics of Discourse: The Literature and History of Seventeenth-Century England* (London, 1987), 78–116.

Nordenfalk, C., 'The Five Senses in Late Medieval and Renaissance Art', *J. Warburg and Courtauld Inst.* 48 (1985), 1–22.

—— 'The Five Senses in Flemish Art before 1600', in G. Cavalli-Björkman (ed.), *Netherlandish Mannerism* (Stockholm, 1985), 135–54.

Normand, L., and Roberts, G., *Witchcraft in Early Modern Scotland: James VI's 'Demonology' and the North Berwick Witches* (Exeter, 2000).

Ostorero, M., et al. (eds.), *L'Imaginaire du sabbat* (Lausanne, 1999).

Owen, D. E., 'Spectral Evidence: The Witchcraft Cosmology of Salem Village in 1692', in M. Douglas (ed.), *Essays in the Sociology of Perception* (London, 1982), 275–301.

Palmer, D. J., ' "A New Gorgon": Visual Effects in *Macbeth*', in Brown (ed.), *Focus on Macbeth*, 54–69.

Panofsky, E., 'Die Perspektive als "symbolische Form" ', in *Vorträge der Bibliothek Warburg, 1924–1925* (Leipzig, 1927), trans. with an introd. C. S. Wood, *Perspective as Symbolic Form* (New York, 1997).

Parish, H., ' "Then May the Deuyls of Hell Be Sayntes Also": The Mediaeval Church in Sixteenth-Century England', *Reformation*, 4 (1999), 71–91.

—— ' "Lying Histories Fayning False Miracles": Magic, Miracles and Mediaeval History in Reformation Polemic', *Reformation and Renaissance Rev.* 4 (2002), 230–40.

—— *Monks, Miracles and Magic: Reformation Representations of the Medieval Church* (London, 2005).

Park, K., 'The Imagination in Renaissance Psychology', M.Phil. thesis (University of London, 1974).

—— 'Pico's *De imaginatione* in der Geschichte der Philosophie', in Gianfrancesco Pico della Mirandola, *Über die Vorstellung/De imaginatione*, ed. E. Kessler (Munich, 1984), 16–40.

—— 'The Organic Soul', in C. B. Schmitt, Q. Skinner, et al. (eds.), *The Cambridge History of Renaissance Philosophy* (Cambridge, 1988), 464–84.

—— and Kessler, E., 'The Concept of Psychology', in Schmitt, Skinner, et al. (eds.), *Cambridge History of Renaissance Philosophy*, 455–63.

Parshall, P., 'Imago contrafacta: Images and Facts in the Northern Renaissance', Art Hist. 16 (1993), 554–79.

Pasnau, R., *Theories of Cognition in the Later Middle Ages* (Cambridge, 1997).

Pastore, N., *Selective History of Theories of Visual Perception, 1650–1950* (London, 1971).

Paul, H. N., *The Royal Play of Macbeth* (New York, 1948; repr. 1978).

Pée, H., *Johann Heinrich Schönfeld: Die Gemälde* (Berlin, 1971).

Pérez-Gómez, A., and Pelletier, L., *Anamorphosis: An Annotated Bibliography* (Montreal, 1995).

Perrier, S., 'La Problématique du songe à la Renaissance: la norme et les marges', in Charpentier (ed.), *Le Songe à la Renaissance*, 13–20.

Peters, E., *The Magician, the Witch, and the Law* (Brighton, 1978).

Phillips, H., 'John Wyclif and the Optics of the Eucharist', in A. Hudson and M. Wilks (eds.), *From Ockham to Wyclif* (Oxford, 1987), 245–58.

Phillips, J., *The Reformation of Images: Destruction of Art in England, 1535–1660* (Berkeley, 1973).

Picot, G., *Jean de Silhon (1594?-1667) ou la recherche des certitudes en religion et en politique* (Nancy, 1995).
Pigler, A., *Barockthemen: Eine Auswahl von Verzeichnissen zur Ikonographie des 17. und 18. Jahrhunderts* (3 vols.; Budapest, 1974).
Platt, P. G., ' "The Mervailouse Site": Shakespeare, Venice, and Paradoxical Stages', *Renaissance Quart.* 54 (2001), 121–54.
Popkin, R., *The History of Scepticism from Erasmus to Descartes*, rev. edn. (Assen, 1964).
Porter, R., *Mind-Forg'd Manacles: A History of Madness in England from the Restoration to the Regency* (Harmondsworth, 1990).
—— 'Mood Disorders: Social Section', in G. E. Berrios and R. Porter (eds.), *A History of Clinical Psychiatry: The Origin and History of Psychiatric Disorders* (London, 1995), 409–20.
Price, S. R. F., 'The Future of Dreams: From Freud to Artemidorus', *Past and Present*, 113 (1986), 3–37.
Prins, J., 'Hobbes on Light and Vision', in T. Sorell (ed.), *The Cambridge Companion to Hobbes* (Cambridge, 1996), 129–56.
Putnam, H., *Reason, Truth and History* (Cambridge, 1981).
Pye, C., *The Regal Phantasm: Shakespeare and the Politics of Spectacle* (London, 1990).
Radden, J. (ed.), *The Nature of Melancholy from Aristotle to Kristeva* (New York, 2000).
Rather, L. J., 'Thomas Fienus' (1567–1631) Dialectical Investigation of the Imagination as Cause and Cure of Bodily Disease', *Bull. of the Hist. of Medicine*, 41 (1967), 349–67.
Ribe, N. M., 'Cartesian Optics and the Mastery of Nature', *Isis*, 88 (1997), 42–61.
Ringbom, S., 'Devotional Images and Imaginative Devotions: Notes on the Place of Art in Late Medieval Private Piety', *Gazette des beaux-arts*, 76 (1969), 159–70.
Rodis-Lewis, G., 'Machineries et perspectives curieuses dans leurs rapports avec le Cartésianisme', *XVIIe siècle*, 32 (1956), 461–74.
Roeck, B., 'Wahrnehmungsgeschichtliche Aspekte des Hexenwahns: Ein Versuch', *Historisches Jahrbuch*, 112 (1992), 72–103.
Roper, L., *Witch Craze: Terror and Fantasy in Baroque Germany* (New Haven, 2004).
Rorty, R., *Philosophy and the Mirror of Nature* (Princeton, 1980).
Rosador, K. T. Von, ' "Supernatural Soliciting": Temptation and Imagination in *Doctor Faustus* and *Macbeth*', in E. A. J. Honigmann (ed.), *Shakespeare and his Contemporaries: Essays in Comparison* (Manchester, 1986), 42–59.
Rosenberg, M., *The Masks of Macbeth* (Berkeley, 1978).
Rossi, P., *Francis Bacon: From Magic to Science*, trans. S. Rabinovitch (London, 1968).
Rossky, W., 'Imagination in the English Renaissance: Psychology and Poetic', *Stud. in the Renaissance*, 5 (1958), 49–73.
Rotondi Secchi Tarugi, L. (ed.), *Malinconia ed allegrezza nel Rinascimento* (Milan, 1999).
Rowland, I. D., *The Ecstatic Journey: Athanasius Kircher in Baroque Rome*, introd. F. Sherwood Rowland (Chicago, 2000).
Rozett, M. Tuck., ' "How Now Horatio, You Tremble and Look Pale": Verbal Cues and the Supernatural in Shakespeare's Tragedies', *Theatre Survey*, 29 (1988), 127–38.
Rubin, M., *Corpus Christi: The Eucharist in Late Medieval Culture* (Cambridge, 1991).
Rupprecht, C. S., 'Divinity, Insanity, Creativity: A Renaissance Contribution to the History and Theory of Dream/Text(s)', in ead. (ed.), *The Dream and the Text: Essays on Literature and Language* (Albany, NY, 1993), 112–32.
Salerno, L., *Salvator Rosa* (Florence, 1963).

Salkeld, D., *Madness and Drama in the Age of Shakespeare* (Manchester, 1993).
Sallmann, J.-M., et al., *Visions indiennes, visions baroques: les métissages de l'inconscient* (Paris, 1992).
Sayce, R., *The Essays of Montaigne: A Critical Exploration* (London, 1972).
Scarre, G., 'Demons, Demonologists and Descartes', *Heythrop J.* 31 (1990), 3–22.
Scavizzi, G., *The Controversy on Images from Calvin to Baronius* (New York, 1992).
Schaffer, S., 'Making Certain', *Social Stud. of Science*, 14 (1984), 137–52.
—— 'Godly Men and Mechanical Philosophers: Souls and Sprits in Restoration Natural Philosophy', *Science in Context*, 1 (1987), 55–85.
—— 'Glass Works: Newton's Prisms and the Uses of Experiment', in D. Gooding et al. (eds.), *The Uses of Experiment: Studies in the Natural Sciences* (Cambridge, 1989), 67–104.
—— 'Regeneration: The Body of Natural Philosophers in Restoration England', in C. Lawrence and S. Shapin (eds.), *Science Incarnate: Historical Embodiments of Natural Knowledge* (Chicago, 1998), 83–120.
Schiesari, J., *The Gendering of Melancholia: Feminism, Psychoanalysis and the Symbolics of Loss in Renaissance Literature* (Ithaca, NY, 1992).
Schleiner, W., *Melancholy, Genius, and Utopia in the Renaissance* (Wiesbaden, 1991).
Schmitt, C. B., *Cicero scepticus: A Study of the Influence of the 'Academica' in the Renaissance* (The Hague, 1972).
—— 'The Recovery and Assimilation of Ancient Scepticism in the Renaissance', *Rivista critica di storia della filosofia*, 27 (1972), 363–84.
Schmitt, J.-C., 'Le Spectre de Samuel et la sorcière d'En Dor: avatars historiques d'un récit biblique: I Rois 28', *Études rurales*, 105/6 (1987), 37–64.
—— *Ghosts in the Middle Ages: The Living and the Dead in Medieval Society*, trans. T. Lavender Fagan (London, 1998).
—— 'The Liminality and Centrality of Dreams in the Medieval West', in Shulman and Stroumsa (eds.), *Dream Cultures*, 274–87.
Schutte, A. Jacobson, *Aspiring Saints: Pretense of Holiness, Inquisition, and Gender in the Republic of Venice, 1618–1750* (Baltimore, 2001).
Scott, J., *Salvator Rosa: His Life and Times* (London, 1995).
Scribner, R. W. (ed.), *Bilder und Bildersturm in Spätmittelalter und in der frühen Neuzeit* (Wiesbaden, 1990).
—— 'Ways of Seeing in the Age of Dürer', in D. Eichberger and C. Zika (eds.), *Dürer and his Culture* (Cambridge, 1998), 93–117.
—— *Religion and Culture in Germany (1400–1800)*, ed. L. Roper (Leiden, 2001).
Segall, M. H., Campbell, D. T., and Herskovits, M. J., *The Influence of Culture on Visual Perception* (New York, 1966).
Sena, J. F., 'Melancholic Madness and the Puritans', *Harvard Theological Rev.*, 66 (1973), 293–309.
Sepper, D. L., *Descartes's Imagination: Proportion, Images, amd the Activity of Thinking* (Berkeley, 1996).
Shaheen, N., *Biblical References in Shakespeare's Tragedies* (Newark, Del., 1987).
Shapin, S., *A Social History of Truth: Civility and Science in Seventeenth-Century England* (Chicago, 1994).
—— and Schaffer, S., *Leviathan and the Air-Pump: Hobbes, Boyle, and the Experimental Life* (Princeton, 1985).
Shapiro, B. J., *Probability and Certainty in Seventeenth-Century England* (Princeton, 1983).

Shapiro, B. J., *A Culture of Fact: England, 1550–1720* (Ithaca, NY, 2000).
Shuger, D., 'The "I" of the Beholder: Renaissance Mirrors and the Reflexive Mind', in P. Fumerton and S. Hunt (eds.), *Renaissance Culture and the Everyday* (Philadelphia, 1999), 21–41.
Shulman, D., and Stroumsa, G. G. (eds.), *Dream Cultures: Explorations in the Comparative History of Dreaming* (Oxford, 1999).
Simmons, A., 'Sensible Ends: Latent Teleology in Descartes' Account of Sensation', *J. of the Hist. of Philosophy*, 39 (2001), 49–75.
Slater, D., 'Photography and Modern Vision: The Spectacle of "Natural Magic" ', in C. Jenks (ed.), *Visual Culture* (London, 1995), 218–37.
Sluhovsky, M., 'Spirit Possession as a Self-Transformative Experience', in D. Shulman and G. Stroumsa (eds.), *Self-Transformation in World Religions* (Oxford, 2002), 150–70.
—— 'The Devil in the Convent', *American Hist. Rev.* 107 (2002), 1379–411.
—— *'Believe Not Every Spirit': Possession, Mysticism, and Discernment in Early Modern Catholicism* (Chicago, 2007).
Smith, A. M., 'Getting the Big Picture in Perspectivist Optics', *Isis*, 72 (1981), 568–89.
Smith, B. R., *The Acoustic World of Early Modern England: Attending to the O-Factor* (Chicago, 1999).
Smith, N. K., *New Studies in the Philosophy of Descartes: Descartes as Pioneer* (London, 1952).
Snyder, J., 'Picturing Vision', *Critical Inquiry*, 6 (1980), 499–526, repr. in Mitchell (ed.), *Language of Images*, 219–46.
Southgate, B. C., 'Excluding Sceptics: The Case of Thomas White, 1593–1676', in R. A. Watson and J. E. Force (eds.), *The Sceptical Mode in Modern Philosophy: Essays in Honor of Richard H. Popkin* (Dordrecht, 1988), 76–81.
Speak, G., 'An Odd Kind of Melancholy: Reflections on the Glass Delusion in Europe (1440–1680)', *Hist. of Psychiatry*, 1 (1990), 191–206.
Spolsky, E., *Satisfying Skepticism: Embodied Knowledge in the Early Modern World* (Aldershot, 2001).
Stabile, G., 'Teoria della visione come teoria della conoscenza', in 'La visione e lo sguardo nel Medio Evo, i/View and Vision in the Middle Ages, i', special issue of *Micrologus*, 5 (1997), 225–46.
Stafford, B. M., *Artful Science: Enlightenment Entertainment and the Eclipse of Visual Education* (Cambridge, Mass., 1994).
—— and Terpak, F., *Devices of Wonder: From the World in a Box to Images on a Screen* (Los Angeles, 2001).
Stallybrass, P., '*Macbeth* and Witchcraft', in Brown (ed.), *Focus on Macbeth*, 189–209.
Stephens, W., *Demon Lovers: Witchcraft, Sex, and the Crisis of Belief* (London, 2002).
Stoichita, V., *Visionary Experience in the Golden Age of Spanish Art* (London, 1995).
Stolzenberg, D., *The Great Art of Knowing: The Baroque Encyclopedia of Athanasius Kircher* (Stanford, Calif., 2001).
—— 'The Connoisseur of Magic', in id. (ed.), *Great Art of Knowing*, 49–57.
Stott, R. T., *A Bibliography of English Conjuring, 1581–1876* (2 vols.; Derby, 1976–8).
Stough, C. L., *Greek Skepticism: A Study in Epistemology* (Berkeley and Los Angeles, 1969).
Straker, S., 'The Eye Made "Other": Dürer, Kepler, and the Mechanisation of Light and Vision', in L. A. Knafla, M. S. Staum, and T. H. E. Travers (eds.), *Science, Technology, and Culture in Historical Perspective* (Calgary, 1976), 7–24.

Stroumsa, G. G., 'Dreams and Visions in Early Christian Discourse', in Shulman and Stroumsa (eds.), *Dream Cultures*, 189–212.
Stump, E., 'Aquinas on the Mechanisms of Cognition: Senses and Phantasia', in S. Ebbesen and R. L. Friedman (eds.), *Medieval Analyses in Language and Cognition* (Copenhagen, 1999), 377–95.
Summers, D., *Michelangelo and the Language of Art* (Princeton, 1981).
—— *The Judgment of Sense: Renaissance Naturalism and the Rise of Aesthetics* (Cambridge, 1987).
Swan, C., 'Eyes Wide Shut: Early Modern Imagination, Demonology, and the Visual Arts', *Zeitsprünge: Forschungen zur frühen Neuzeit*, 7 (2003), 560–80.
—— *Art, Science, and Witchcraft in Early Modern Holland: Jacques de Gheyn II (1565–1629)* (Cambridge, 2005).
Szulakowska, U., *The Alchemy of Light: Geometry and Optics in Late Renaissance Alchemical Illustration* (Leiden, 2000).
Tachau, K. H., 'The Problem of the *Species in medio* at Oxford in the Generation after Ockham', *Mediaeval Stud.* 44 (1982), 394–443.
—— *Vision and Certitude in the Age of Ockham: Optics, Epistemology and the Foundations of Semantics, 1250–1345* (Leiden, 1988).
—— '*Et maxime visus, cuius species venit ad stellas et ad quem species stellarum veniunt*: *Perspectiva* and *Astrologia* in Late Medieval Thought', in 'La visione e lo sguardo nel Medio Evo, i/View and Vision in the Middle Ages, i', special issue of *Micrologus*, 5 (1997), 201–24.
Talmor, S., *Glanvill: The Uses and Abuses of Scepticism* (Oxford, 1981).
Tedlock, B. (ed.), *Dreaming: Anthropological and Psychological Interpretations* (Cambridge, 1987).
Thomas, K. V., *Religion and the Decline of Magic* (London, 1971).
Thompson, A., and Thompson, J. O., 'Sight Unseen: Problems with "Imagery" in *Macbeth*', in L. Hunter (ed.), *Toward a Definition of Topos: Approaches to Analogical Reasoning* (London, 1991), 45–65.
Thorne, A., *Vision and Rhetoric in Shakespeare: Looking through Language* (London, 2000).
Tigner, S. S., 'Plato's Philosophical Uses of the Dream Metaphor', *American J. of Philology*, 91 (1970), 204–12.
Tournon, A., 'L'Argumentation pyrrhonienne: structures *d'essai* dans le chapitre "Des boîteux" ', in *Montaigne, les derniers essais*, Cahiers Textuels 2 (Paris, 1986), 73–85.
Tschacher, W., 'Der Flug durch die Luft zwischen Illusionstheorie und Realitätsbeweis', *Zeitschrift der Savigny-Stiftung für Rechtsgeschichte*, 116, Kanonistiche Abteilung 85 (1999), 225–76.
Tuck, R., 'Optics and Sceptics: The Philosophical Foundations of Hobbes's Political Thought', in E. Leites (ed.), *Conscience and Casuistry in Early Modern Europe* (Cambridge, 1988), 235–63.
—— 'Hobbes and Descartes', in G. A. J. Rogers and A. Ryan (eds.), *Perspectives on Thomas Hobbes* (Oxford, 1988), 11–41.
—— *Hobbes* (Oxford, 1989).
—— *Philosophy and Government 1572–1651* (Cambridge, 1993).
Turbayne, C. M., *The Myth of Metaphor*, rev. edn. (Columbia, SC, 1970).
Van Leeuwen, H. G., *The Problem of Certainty in English Thought, 1630–1690* (The Hague, 1970).
Veech, T., *Dr Nicholas Sanders and the English Reformation 1530–1581* (Louvain, 1935).

Veltman, K. H., 'Perspective, Anamorphosis and Vision', *Marburger Jahrbuch für Kunstwissenschaft*, 21 (1986), 93–117.
Vermeir, K., 'Mirror, Mirror, on the Wall: Aesthetics and Metaphysics of 17th-Century Scientific/Artistic Spectacles', *Kritische Berichte*, 32 (2004), 27–38.
—— 'The Magic of the Magic Lantern (1660–1700): On Analogical Demonstration and the Visualization of the Invisible', *British J. Hist. Science*, 38 (2005), 127–59.
—— 'Athanasius Kircher's Magical Instruments: An Essay on Applied Metaphysics and the Reality of Artefacts', *Studies in Hist. and Philosophy of Science* (forthcoming).
Vescovini, G. F., 'Vision et réalité dans la perspective au xive siècle', in 'La visione e lo sguardo nel Medio Evo, i/View and Vision in the Middle Ages, i', special issue of *Micrologus*, 5 (1997), 161–80.
Vinge, L., *The Five Senses: Studies in a Literary Tradition* (Lund, 1975).
Voaden, R., *God's Words, Women's Voices: The Discernment of Spirits in the Writing of Late-Medieval Women Visionaries* (Woodbridge, 1999).
Walde, C., 'Dream Interpretation in a Prosperous Age? Artemidorus, the Greek Interpreter of Dreams', in Shulman and Stroumsa (eds.), *Dream Cultures*, 121–42.
Walker, D. P., 'The Cessation of Miracles', in I. Merkel and A. G. Debus (eds.), *Hermeticism and the Renaissance: Intellectual History and the Occult in Early Modern Europe* (London, 1988), 111–24.
Wallace, K. R., *Francis Bacon on the Nature of Man* (Urbana, Ill., 1967).
Walsham, A., *Providence in Early Modern England* (Oxford, 1999).
Wandel, L. Palmer, *Voracious Idols and Violent Hands: Iconoclasm in Reformation Zurich, Strasbourg, and Basel* (Cambridge, 1995).
Warner, M., *Fantastic Metamorphoses, Other Worlds* (Oxford, 2002).
Wasser, M., 'The Western Witch-Hunt of 1697–1700: The Last Major Witch-Hunt in Scotland', in J. Goodare (ed.), *The Scottish Witch-Hunt in Context* (Manchester, 2002), 146–65.
Weber, A., 'Saint Teresa, Demonologist', in A. J. Cruz and M. E. Perry (eds.), *Culture and Control in Counter-Reformation Spain* (Minneapolis, 1992), 171–95.
Weber, W., 'Im Kampf mit Saturn: Zur Bedeutung der Melancholie im anthropologischen Modernisierungsprozess des 16. und 17. Jahrhunderts', *Zeitschrift für historische Forschung*, 17 (1990), 155–92.
Wechsler, L., Hoolihan, C., and Weimer, M. F., *The Bernard Becker Collection in Ophthalmology: An Annotated Catalog*, 3rd edn. (St Louis, 1996).
Westfall, R. S., *Never at Rest: A Biography of Isaac Newton* (Cambridge, 1980).
Westfehling, U. (ed.), *Die Messe Gregors des Grossen. Vision, Kunst, Realität. Katalog und Führer zu einer Ausstellung im Schnütgen-Museum der Stadt Köln* (Cologne, 1982).
Whalen, R., *The Poetry of Immanence: Sacrament in Donne and Herbert* (Toronto, 2002).
Wheelock, A. K., Jr, *Perspective, Optics, and Delft Artists around 1650* (New York, 1977).
White, J., *The Birth and Rebirth of Pictorial Space* (London, 1972; orig. edn. 1957).
Whitmore, P. J. S. (ed.), *A Seventeenth-Century Exposure of Superstition: Select Texts of Claude Pithoys (1587–1676)* (The Hague, 1972).
Wild, M., 'Les Deux Pyrrhonismes de Montaigne', *Bulletin de la Société des Amis de Montaigne*, 8th ser. 19–20 (2000), 45–56.
Wilson, C., *The Invisible World: Early Modern Philosophy and the Invention of the Microscope* (Princeton, 1995).
—— 'Discourses of Vision in Seventeenth-Century Metaphysics', in Levin (ed.), *Sites of Vision*, 117–38.

—— *Descartes's 'Meditations': An Introduction* (Cambridge, 2003).
Wilson, M. D., 'Descartes on the Perception of Primary Qualities', in S. Voss (ed.), *Essays on the Philosophy and Science of René Descartes* (Oxford, 1993), 162–76.
—— 'Descartes on Sense and "Resemblance"', in Cottingham (ed.), *Reason, Will, and Sensation*, 209–28.
Windisch, M., ' "When There is no Visible Power to Keep them in Awe" ', *Zeitsprünge: Forschung zur frühen Neuzeit*, 1 (1997), 117–65.
Wittkower, R. and M., *Born under Saturn* (London, 1963).
Wolf-Devine, C., 'Descartes' Theory of Visual Spatial Perception', in Gaukroger, Schuster, and Sutton (eds.), *Descartes' Natural Philosophy*, 506–23.
Wolfson, H. A., 'The Internal Senses in Latin, Arabic, and Hebrew Philosophic Texts', *Harvard Theological Rev.* 28 (1935), 69–133.
Wood, C. S., 'The Perspective Treatise in Ruins: Lorenz Stoer, *Geometria et perspectiva*, 1567', in Massey (ed.), *Treatise on Perspective*, 234–57.
Woodfield, R., 'Thomas Hobbes and the Formation of Aesthetics in England', *British J. of Aesthetics*, 20 (1980), 146–52.
Wootton, D., 'The Fear of God in Early Modern Political Theory', in Canadian Historical Association, *Historical Papers 1983* (Ottawa, 1984), 56–80.
Wright, I., 'All Done with Mirrors: Macbeth's Dagger Discovered', *Heat* (Sydney), 10, NS (2005), 179–200.
—— ' "Come like Shadowes, so Depart": The Ghostly Kings in *Macbeth*', *Shakespearean International Yearbook*, 6 (2006), forthcoming.
—— 'Perspectives, Prospectives, Sibyls and Witches: King James Progresses to Oxford', in J. Lloyd Jones and G. Cullum (eds.), *Renaissance Perspectives* (Melbourne, 2006), 109–53.
Yardley, M., 'The Catholic Position in the Ghost Controversy of the Sixteenth Century', in Lavater, *Of Ghostes*, 221–51.
Yolton, J. W., *Perception and Reality: A History from Descartes to Kant* (Ithaca, NY, 1996).
Zagorin, P., *Ways of Lying: Dissimulation, Persecution, and Conformity in Early Modern Europe* (Cambridge, Mass., 1990).
Zika, C., 'Les Parties du corps, Saturne et le cannibalisme: représentations visuelles des assemblées des sorcières au xvie siècle', in N. Jacques-Chaquin and M. Préaud (eds.), *Le Sabbat des sorciers (xve–xviiie siècles)* (Paris, 1993), 389–418.
—— *Exorcising our Demons: Magic, Witchcraft and Visual Culture in Early Modern Europe* (Leiden, 2003).

Index

Abate, Niccolo dell' 93
Accademia dei Lincei 98
Accademia dei Secreti 98
Accolti, Pietro 91
 Lo inganno de gl'occhi, prospettiva pratica 87
Acosta, José de 181
Adams, Thomas 55
Addison, Joseph 303
Ady, Thomas 137, 141–2, 151–2
 A candle in the dark: on witchcraft as juggling 151
Aenesidemus of Alexandria 267
Agrippa, Heinrich Cornelius 30, 82–3, 213, 214, 218
 on air 248
 De incertitudine et vanitate scientiarum et artium: on perspective as deception 86
 De occulta philosophia 210–11
 on mirrors 210–11, 248–9, 250
Aguilon, François d':
 Opticorum libri sex 105
Ainsworth, Henry 164
air 15, 18, 210, 335
 bodies and shapes formed from 125–6, 132, 135, 182, 246
 in *Macbeth* 248–9
 reflective qualities of 210, 213–14, 215
Alberti, Leon Battista 16, 23, 84, 85, 183
Albertini, Arnaldo 126–7
Albertus Magnus 30, 43, 97, 139
Alcázar 89
Alchemy 100, 101
Alciatus, Andreas:
 on witches' sabbat 144
'Alessio Piemontese' 99
Alexander of Hales 131
Alhazen 16, 18
Alsted, Johann Heinrich 79
anamorphosis 3, 9, 90–6, 104, 219, 330
 demonic use of 132, 136
 and Descartes 335
 double visual order of 92–6
 eye anamorphoses 95–6
 in literary texts 92
 religious symbolism of 94–5, 97
 visual relativism of 91–3, 95, 335
angels 11, 49, 64, 65, 129, 170, 205–8, 220
Antichrist (antichristianism):
 false miracles of 174, 178–82, 226
apparitions 4, 50, 52, 53–4, 59–62, 137, 142, 162, 176, 236, 282, 308, 319, 329, 355–6

in Castile and Catalonia 206
as delusions 47, 101–2, 131, 133, 205–22, 239–58
false 78, 174
ghosts 29, 204–28, 236, 246–7, 257–8
in Hobbes 220–2, 346
natural causes of 205, 207–16
'spectral evidence' 147–50
see also **discernment of spirits**
Aquinas, St Thomas 15, 43, 126, 131, 133, 136, 138, 242–3
 on demonic deception of the senses 125
 De regimine principum 32 n.26
 Summa theologica: on miracles and wonders 124
Arcesilas 268
Archimedes 97, 98
Architas 97
Arcimboldo, Giuseppe 92
Aretaeus of Cappadocia 50, 54, 55, 57
Arethas, archbishop of Cappadocia 181–2
Aristotle (aristotelianism) 1–2, 3, 5, 11, 29, 31, 45, 51, 61, 100, 109–10, 124, 129, 130, 131, 133, 140, 167, 181, 184, 209, 212, 215, 218, 248, 266, 273, 278, 280, 281, 304, 309, 316, 319, 336
 on Antiphontis 210–14
 cognition theory of 14–19
 De anima, 14, 19, 33 n. 33, 42–3, 48, 81, 354
 De memoria 14, 15
 Metaphysica 9
 Meteorologica 28, 213
 Physica 128
 De sensu et sensibili 17, 20–1, 28, 81, 313–14
 De somniis 56, 125, 301–2, 318
 De somno et vigilia 213, 244, 318
Arnauld, Antoine 334
Artemidorus of Daldis 304, 306, 307, 308
Artemidorus the Grammarian 58
Ashmole, Elias 306
Aston, M. 3–4, 7, 162, 165, 166, 168
Athanasius 165
Attersoll, William 187–8
Aubigné, Agrippa d':
 Les Tragiques: on the Last Judgement 24
Augustine, St (Augustinianism) 9, 11, 86, 136, 165, 179, 182, 187, 190, 206, 242–3, 244, 245, 287
 Confessions: on 'ocular desire' 24

Augustine, St (*cont.*)
 Contra academicos: on dreams 305
 De civitate dei: on metamorphosis 139
 De Genesi ad litteram: on a dream experience 305
 on types of vision(s) 204–5, 214, 224–5
 De trinitate : on spiritual seeing 11; on cognition 15
automata 122 n. 150, 335
Averroes 17, 43, 59
Avicenna 43, 55, 56

Bacon, Francis 3, 97, 98, 281, 282, 348, 350
 The advancement of learning: on psychology 42–3
 on the imagination 45
 New Atlantis: natural magic in 97; study of visual delusions in 78–9, 239
 Novum organum 78
 Parasceve ad historiam naturalem et experimentalem: on juggling 79
 Sylva sylvarum: on juggling 79
Bacon Roger 10, 15, 16, 17, 20
 De multiplicatione specierum: on sense impression 15
Bagot, Jean 278
Bale, John:
 The actes of Englysh votaryes: anti-catholicism in 174
Baltrušaitis, J. 7, 87, 91, 92, 93, 219, 335
Banister, Richard 10
baptism 190, 208
Barbaro, Daniele 87, 92, 93
 La pratica della perspettiva: on anamorphosis 90–1; Kemp on 84
Barish, J. 7
Baronius 180
Barrough, Philip 41, 53
 The method of phisick: on the eye 62
Barrow, Isaac 332
Bartholomaeus Anglicus:
 De proprietatibus rerum: on cognition 18; on melancholy 58, 67
Bartisch, Georg 10, 41
 Ophthalmodouleia 40
Bateman, Stephen 67
Battie, William 66
Baxter, Richard 64
Bayfield, Robert:
 on eye disease 41
 on melancholy 57
Bayle, Pierre 270
Beattie, James 303
Beaumont, John 130
Beauvois de Chauvincourt, Sieur de 62–3
 on lycanthropy 140–1

Beckmann, Johann:
 A History of Inventions and Discoveries: on jugglers 83
Becon, Thomas:
 The displaying of the popish mass: on spiritual seeing 189
Bekker, Balthazar 219
 on false appearances in witchcraft 142
Bellarmine, Robert 243
 on Antichrist 181
 on images 166–7
Benedetti, Giovanni Battista:
 Comparatio visus, et auditus: on seeing and hearing 10
Benedictines:
 (individual) 220
Bentham, Jeremy 12
Benoist, René 82
Berger, J. 2
Bergerac, Cyrano de 291
Berkeley, George 303, 332
 An Essay towards a New Theory of Vision: on the 'language' model of vision 337
Bernard, Richard 82–3, 141, 148, 150
 A guide to grand jury-men 150
Berne:
 false miracles at 174–5, 177, 179, 181
Bertani, Giovanni 87
Besançon, A. 172
Bessot, D. 5
Bettini, Mario 3, 97
 Apiaria universae philosophiae mathematicae: eye anamorphoses in 95–6; 'tabula scalata' in 105–6
Beyerlinck, Laurentius 46, 83
Beza, Theodore 186, 190
Bible (Geneva) 243–4, 252
Bible (subjects):
 David and Bathsheba 25
 original sin 24–5, 350–2
 Pharaoh's magicians, *see* magic, magicians
 Saul and the witch of Endor, *see* Saul
Bible (texts):
 Old Testament:
 Genesis 3: 6 24
 Genesis 34: 1–2 25
 Exodus 7, 8, and 9 80
 Exodus 7: 12 127
 Exodus 20 163, 169
 1 Samuel 240–56
 1 Samuel 28 29, 214, 219
 Psalms 94: 9 11
 Proverbs 4: 25 25
 Proverbs 20: 8 12–13
 Ecclesiastes 9: 11 94
 Ecclesiastes 46: 20 242

Isaiah 40: 18 163–4
Book of Wisdom 165
New Testament:
Matthew 5: 28 25
Matthew 14: 26 211
Matthew 24: 24 199 n.80
Mark 13: 22 199 n.80
Luke 11: 34 23–4
Luke 24: 37 211
Acts 23: 8 212
Romans 8: 24–5 28
Romans 13: 5 12
2 Corinthians 4: 18 28
2 Corinthians 5: 7 28
2 Corinthians 11: 14 123, 211
2 Thessalonians 2: 1–11 124, 179, 180, 182, 199 n.80
Hebrews 11: 1 28
1 John 4: 1 206
Revelation 178–82
Bilson, Thomas 164
Binsfeld, Peter:
on reality of witchcraft to the senses 147
blasons du corps feminin 22
blindness 21, 346
as an advantage 21–2, 24, 25–30
blind man in Descartes 340–2
and worship 161
Bodin, Jean 255, 291, 292
De la démonomanie des sorciers 290
Boece, Hector 247
Boerhaave, Herman:
Aphorisms: on melancholy 54
Boguet, Henri:
on metamorphosis as an illusion 138–9
Bona, Giovanni (Cardinal) 223–4, 225
Borde, Andrew 67
Bosch, Hieronymus 82, 185
Bossuet, Jacques Benigne 94
Bostridge, I. 336
Botero, Giovanni 281
Boucher, Jean 291
Boulaese, Jean 143
Bovelles, Charles de:
Liber de sensibus: on seeing and hearing 21
Boulliau, Ismael:
De natura lucis: 332
Boyle, Robert 347, 354, 355
A disquisition about the final causes of natural things: on vitiated sight 40–1
on 'flying' apparitions 218
Bradford, John 187
brains in a vat 293
Brathwaite, Richard 12
Brevint, Daniel:
on false miracles of demons 129–30
Bridget of Sweden 207, 223, 226

Bright, Timothy:
A treatise of melancholie 52
on melancholy 53, 60–2, 67, 256
Brightman, Thomas 175
Brognolo, Candido 137
Brooke, N. 237
Bruegel, Jan the Elder:
The Sense of Sight 13
Brunelleschi, Filippo:
experiments with perspective 87–8
Bryson, N. 1–2, 6–7, 14, 113 n. 28
Buchanan, George 247
Bullinger, Heinrich 179
Burman, Frans 320
Burnet, Gilbert 178
Burton, Robert 108
The anatomy of melancholy 51, 54, 56, 356
on demons 143
on melancholy 53, 54, 55, 56, 58, 60, 64, 67
on witchcraft 141
Butler, Samuel 54, 56

Cade, Jack 253
Cajetan, Tommaso de Vio (Cardinal) 243
Caldera de Heredia, Gaspar 79, 81
Calmet, Augustin 216, 220
Dissertations sur les apparitions des anges etc: defence of apparitions in 227–8
Calvin, Jean 164, 165, 168, 171–2, 181–2, 212
Institutes 190
on the mass and eucharist 186, 187, 190, 191
camera obscura 29, 53, 102, 108, 219–20, 248, 330–1, 341–3, 348
Camille, M. 4, 15, 17–18, 183
Camus, Jean-Pierre 277
'Essay sceptique' 292
Canon episcopi 137, 311–22
Cardano, Girolamo 51, 81, 139, 213–14, 215, 290, 306
De rerum varietate 247
Carneades 268, 269
Casaubon, Meric:
A treatise concerning enthusiasme: on melancholy and enthusiasm 64–5
on demonic illusion 130
Casmann, Otto:
on demons 128, 135
psychology of 42–3
Cassini, Samuel de 312
Castaldi, Giovanni Tommaso 97
Castellani, Giulio 270
cataracts (suffusions) 40–1, 60, 81, 128
catoptrics, *see* mirrors
Cattani da Diaceto, Francesco 135
Caus, Salomon de 335

Cave, T. 222, 267, 290, 292
 Pré-histoires 267
Cennini, Cennino 44
 Libro dell'arte 86
Certeau, M. de:
 on Loudun 142–3
Cervantes, Miguel de:
 The Dog's Colloquy: ridicules witchcraft 316
Chanet, Pierre 278
Charles I (as prince) 26
Charles IX, of France 164
Charron, Pierre 281, 282, 288, 291, 292, 294, 307
 De la sagesse 29, 277, 282, 284
 on religion and superstition 282–5, 286
Cheyney, Richard 184
Chirino de Salazar, Fernando 12–13
Christ:
 apparitions of 205, 226
 ascension 183
 baptism 93
 Crucifixion 106, 170, 188
 images of 164–5
 Incarnation 168, 188–9
 Last Supper 189
 Man of Sorrows 185
 presence in mass 183–92
 Resurrection 105–6, 188, 211–12
 stigmata 176, 287
 visible 169–70
 walking on water 100–1, 211
Cicero:
 Academica: scepticism in 268, 270, 289, 291, 293, 305
 De divinatione 304
 De officiis 280
 Tusculan Disputations 21
Ciruelo, Pedro 315
 Reprobación de las supersticiones y hechicerías 313
Cleaver, Robert 12
Clement IX (Pope) 245
Clement of Alexandria 165
clergy:
 and delusion of eyes, 28, 29, 174, 174–7
Coëffeteau, Nicolas:
 faculty psychology of 42–3
cognition:
 linguistic models of 337–43, 346, 348–9, 353, 363 n.115
 and magic 109–10
 and perspective 85
 theories of:
 ancient and medieval 14–18, 125, 248, 331–2
 early modern 1–2, 18–19, 43–6, 62
 in 'new' philosophy 5–6, 329–56

 see also **Aristotle**; **scepticism**; *species*
Cole, M. 293
Colie, R. 7, 92–3, 95, 96, 97, 251–2, 331
 Paradoxia epidemica: arguments of 107–9
Collaert, Adriaen 13
Collins, John 332
Colonna, Girolamo (Cardinal) 96
Colonna, Michele Angelo 89
colour 14, 101, 221, 310, 334, 348, 351
 in Descartes 338–42
 in Hobbes 344–7
'common sense' 17, 18, 23, 42–3, 131, 133, 244, 302, 343
see also senses
Como, Bernard de 145
 Tractatus de strigibus 312
conjurors, *see* magic, magicians
Conring, Hermann 52
Contzen, Adam 52
Cooper, Thomas 150
Corpus Christi 184
Cosimo II de'Medici 91
Cossart, Gilles 105
Cotta, John:
 The Triall of Witch-craft: on knowledge of witchcraft 318–20
Cranmer, Thomas:
 An answer ... unto a crafty and sophisticall cavillation: on the mass and the senses 188–9, 192
Crary, J. 92
Crespet, Pierre 82
Cromwell, Thomas 177
Crooke, Helkiah 10, 11, 19
Cudworth, Ralph:
 A treatise concerning eternal and immutable morality 303
Cullen, William 76 n. 126
Cusanus, Nicolaus 24
cynanthropy 63, 150

Daedalus 97
Daneau, Lambert 179
Da Prierio, Silvestro (Mazzolini) 126, 312
 De strigimagarum daemonumque mirandis 126, 317
 on reality of witchcraft 316–17
David, Johannes:
 Veridicus Christianus: negative view of senses in 25
Davies, John:
 Nosce teipsum 18
Deacon, John:
 Dialogicall discourses of spirits and divels: on demonic delusion 134
Decker, Johann Heinrich 216, 217, 220, 243
 Spectrologia 219

'Declaration of the Faith' (1539) 177
Dee, John 239, 257
deists 218
Della Porta, Giambattista 3, 100, 103, 110, 139, 153, 211, 239, 249
 on the camera obscura 330
 De refractione 98
 Magiae naturalis: on magical catoptrical effects 98–9, 210
Del Río, Martín Antonio 82, 111, 136, 147, 217, 218, 243, 291, 292
 on demonic visual deceptions 127, 131–3
 Disquisitionum magicarum 80, 124, 356
 on miracles and wonders 124–5
 on witchcraft as dreamed 314
Democritus 21
devil (demons) 20, 47, 49–50, 59, 62, 64, 65, 110, 176–7, 329, 335
 acts within nature 110, 123–4, 124–30
 as angel of light 123, 211
 as artist 135–6
 and delusion of sight 3, 28, 29–30, 80, 123–53, 174, 178, 182, 207–8, 211–19, 223, 243–6
 demonic dreams 140, 294, 308–20
 demonology 3, 123–53, 221–2, 291, 294, 308–20
 exorcism of 29, 135
 and God 123–4
 impersonation by 144–50, 291
 and optics 134, 135, 149, 152
 see also dreams; possession
Descartes, René 4, 5–6, 17, 87, 94, 95, 101, 124, 152, 220, 291, 316, 317, 320, 336, 337, 344, 345–6, 348, 353, 354
 Cogitationes privatae 333
 on cognition 16, 337–43
 on dreams 300–3, 304, 309
 Discourse on the Method 333
 'demon hypothesis' 238, 293, 320
 on the eucharist 191, 334
 and illusion 334–5
 L'Homme 341
 Meditations on First Philosophy 4, 57, 238, 275, 293–4, 300–1, 337–8, 340, 356
 on melancholy 56–7
 Optics 293, 333, 334, 340, 341, 342
 Principles of Philosophy 339
 and scepticism 293–4, 320, 334
 Thaumantis regia 333
 The Search for Truth 335
 The World or Treatise on Light 333, 339, 341
Diehl, H. 237–8
Dinocrates 102
Diogenes Laertius 267

discernment of spirits 4, 49, 140, 206–7, 209, 329
 in early modern Europe 222–3
 and non-visual criteria 226–8
 and pretence of holiness 4, 223
divination:
 aeromancy 248, 251
 catoptromancy 251
 oneiromancy 304, 307, 314
Dod, John 12
Dodo, Vincente 312
Dominicans 174
 (individuals) 80, 126, 136, 137, 145, 176, 223, 313, 316
Donne, John 108
Dovercourt (Essex):
 rood of 166
Drayton, Michael:
 'To the Senses' 23
dreams 5, 20, 47, 50, 56–7, 65, 127, 134, 176, 213, 221, 223, 243, 292, 356
 ancient and medieval theory of 303–6
 clés des songes 306
 demonic 143, 137–8, 304, 307, 309–22
 early modern theory of 306–8
 and epistemology 294, 300–22
 natural dreams 304, 307, 309, 329–30
 and scepticism 268, 273, 294
Drebbel, Cornelis 219, 239
Dubois, C.-G. 287
Dubreuil, Jean:
 La Perspective pratique 219
Du Laurens, André 19, 51, 65
 on eye diseases 40–1
 on melancholy 53, 54, 55, 58, 59–60, 63
Du Lieu, Charles 332
Duncan, Marc 142
Duns Scotus 43
Dupleix, Scipion 18
 Corps de philosophie 310
 on dreams 302, 302–3, 308, 310
Dürer, Albrecht 44

Eden, garden of 13, 93
Edgerton, S. 85
Edward VI 93
Ekirch, R. 306
Elkins, J. 55
enargeia 308
enthusiasm, *see* melancholy
Elwood, C. 186
Epicureans 212–13, 215, 276, 304
Erasmus, Desiderus 29, 161
Erastus, Thomas 51, 53, 136
 on demonic deception 128
 on reality of witchcraft to the senses 140
eschatology 178–82
Eschinardi, Francesco 332

Estienne, Henri 267, 270
 Sexti philosophi Pyrrhoniarum hypotyposeon libri iii 267
Evans, R. J. W. 100
Exeter College, Oxford 26, 356
eyes:
 composition 11, 272, 351–2
 corneal membrane 41
 crystalline humour 12, 16, 18, 19, 22, 41, 60, 81
 optical nerve(s) 12, 15, 16–17, 19, 341
 retina 17, 134, 331, 341–3
 spirits (visual) 16–17, 19, 59–60, 132
 vitreous humour 16, 17
 eye disease 20, 26, 28, 39–40, 40–2, 128
 'eye-service' 27, 161
 of faith 182–91
 'Monoculi' 22
 poetry of 22–3, 236, 255
 position in body 10, 21, 26
 and sin 23–5, 25–8
 trompe l'œil 88–90, 108, 335
see also senses; vision

Family of Love 282
Farel, Guillaume 186
Faustus (Johann Faust) 30
Ferber, S. 143
Ferdinand III, Emperor 105
Ferdinand of Austria, Archduke 105
Fernel, Jean 19, 302
Ferreyrolles, G. 287–8
Fienus, Thomas 19
 De viribus imaginationis 45
Filarete, Antonio 86, 88
Filmer, Robert 151
Filomarino, Francesco Maria 225
 Tractatus de divinis revelationibus 226
Findlen, P. 22, 97
Fletcher, Phineas 303
Flint, K. 331
Floris, Frans 13
Foster, John 148
Foxe, John 166, 174, 175–7
Foucault, M. 9, 13
Fracastoro, Girolamo:
 De sympathia et antipathia rerum 65
Franciscans 174
 (individuals) 137
Frith, John 189
Frommann, Johann Christian:
 Tractatus de fascinatione: on demonic power over the senses 134

Gadbury, John 218
Galen 41, 43, 48, 51, 54, 57–8, 59, 60, 215, 304, 309
 De usu partium 11

Galileo Galilei 2–3, 22, 98
Galle, Cornelius 25
Garasse, François 278, 291
Garber, M. 236–7
Gardiner, Stephen 188–9
Garnett, Henry 253
Garzoni, Tomaso 53–4
 Hospitale de pazzi incurabili 55
Gassendi, Pierre 336, 347
Gaufridy, Louis 135
Gaule, John 129
Gee, John:
 The foot out of the snare 178
 New shreds of the old snare 178
Geiler von Kaiserberg, Johannes 126
Gennings, Edmund:
 miracle at execution of 178
Gent, Joos van:
 Communion of the Apostles 201 n. 105
Gent, L. 7, 90, 238–9, 255
Gentillet, Innocent 241–2
Gerardus of Harderwyck:
 Epitomata seu reparationes totius philosophiae naturalis Aristotelis 19
Gerhard, Andreas (Hyperius):
 on demonic sensory delusion 128–9
Gerson, Jean 4, 207, 209, 210, 222, 225, 227
 De distinctione verarum visionum a falsis: discernment of spirits in 226
 De probatione spirituum: discernment of spirits in 226
Gheyn II, Jacques de:
 The Preparation for the Witches' Sabath 249
ghosts, *see* apparitions
Gifford, George 129
Gildon, Charles 303
Gilman, E. 84
Gilpin, Richard:
 Daemonologia sacra 153
Giordano da Bergamo 315
 Quaestio de strigis 126
Glanvill, Joseph 5–6, 149, 216, 220, 303
 An earnest invitation to the sacrament of the Lord's supper 355–6
 and apparitions 227–8
 Essay against confidence in philosophy etc 350, 351, 352
 Essay of scepticism and certainty 350, 354
 Essays on several important subjects etc 6, 350, 354
 Plus ultra: or, the progress and advancement of knowledge 352, 354
 Saducismus triumphatus 356
 Scepsis scientifica 350
 Some philosophical considerations 356
 The vanity of dogmatizing 350, 351, 352–3, 355
 and witchcraft 152, 355

Glaser, J. H.:
 The Fall 93
Godelmann, Johann Georg 80, 82, 292, 312, 314
 De magis, veneficis et lamiis 314
Golburne, John 176
Goodcole, Henry 151
Goodwin, Philip 302
Gordon, B. 211
Göttler, C. 185
Goulart, Simon 51
Grant, Francis:
 Sadducismus debellatus 152
Gravina, Domenico 223, 225, 226–7
Greenblatt, S. 237, 239, 308
Greenham, Richard 24–5
Gregory, James:
 Optica promota 332
Greville, Fulke 47
Grillando, Paolo:
 Tractatus de sortilegiis: on reality of witchcraft 312
Grimaldi, Francesco Maria:
 Physico-mathesis de lumine, coloribus, et iride 332
Grosse, Henning 216, 247
Guazzo, Francesco Maria 138
 on discernment of spirits 226
 on witches' sabbat 313
Guibelet, Jourdain 41, 51, 58, 59, 143
Guillemeau, Jacques:
 Traité des maladies de l'œil 40
gunpowder plot 253
Gurnay, Edmund 186, 188

Habicht, W. 249
Habsburgs 100
Haecht Goidtsenhoven, Laurens van 23
Hakewill, George 5, 39, 53, 78, 87, 123, 161, 215, 356
 The vanitie of the eie: 5, 356; arguments of 5, 25–31
Harding Thomas 187
Harsdörffer, Georg Philipp:
 Delitiae mathematicae 104
Harsnett, Samuel 59, 178
Hartley, David 303
Harvey, William 50
Hastings, Francis 175
Hatfield, G. 7
Hay, William 82
Haydocke, Richard 87
Heath, Robert 22
Heerbrand, Jacob 128
Henry of Langenstein 17
Herden, Helferich 146
Hermes Trismegistus 27, 100
Hill, Thomas 306
 The moste pleasaunte arte of the interpretacion of dreames 302

Hilliard, Nicholas 87
Hilsey, John 175
Hobbes, Thomas 5–6, 105, 212, 219, 220, 281, 353, 355
 on apparitions 220–2, 227, 336, 344–7
 De homine 334
 on dreams 303, 307–8, 309, 336
 Elements of Philosophy 307, 333, 334
 Leviathan 221, 309, 333–4, 336, 344, 347
 on optics and vision 333, 344–7
 The Elements of Law Natural and Politic 333, 344
Hippocrates 51, 304, 309
Hoffman, Friedrich 56
Holbein, Hans:
 The Ambassadors 92, 92–3
Holinshed, Raphael 246, 247
Holland, Henry 252
Holland, P. 307
Homer 21, 307
 Odyssey 304, 321
Hoobroeck, Johannes ab 53
Hoogstraten, Samuel van 89, 109
Hooke, Robert 332
 Micrographia 348
Hosius, Stanislaus (Cardinal) 168
Huarte, Juan:
 Examen de los ingenios para las sciencias: faculty psychology in 42–3
Huret, Grégoire 93
 Optique de portraiture et peinture 96
Hutchinson, Francis 152
Huygens, Christiaan:
 Traité de la lumière 332
Huygens, Constantijn 219

iconoclasm 162–7, 336
idolatry 3, 25, 90, 162, 162–7, 167–75, 186
 Homily against Peril of Idolatry 163–7, 168, 175
 in *Macbeth* 243, 245–6
Iliffe, R. 348
illusionism in art 87–90
images:
 in Descartes 341–3
 'hanging' or 'flying' 98–9, 103, 211, 218, 250
 phantasiai kataleptikai 268–9, 305
 phantasms (*phantasmata*) 10–11, 15–16, 42, 49, 61–2, 126, 133, 135, 182, 217–18, 249, 311, 315, 318
 religious 27, 29, 161–3, 186, 283–4, 329, 355–6
 defence of 160–72
 fraudulent 174–8, 180
 'lying' 4, 83, 163–5
 lifelike 4, 165–7
 miracles and 162
 see also **apparitions; imagination; mirrors**

imagination (*phantasia*) 5, 10, 17, 19, 21,
 34 n. 46, 39, 131, 133–4, 142, 167–8,
 169, 291
 and apparitions 207–28
 and dreams 301–2
 in early modern Europe 42–3
 and idolatry 167–8
 influenced by demons 125–53, 244
 melancholic 53–67
 Montaigne on 286–9
 negative opinions about 45–50, 350–5
 positive opinions about 43–5
 transitive effects of 44–5, 46–7, 50
 and witchcraft 143, 151, 292
immortality of the soul 212–14, 356
Inquisition, inquisitors 144, 223, 291, 317
 (individuals) 126, 144, 145, 146, 291, 316
intarsia 89
Ishaq ibn Imran 58
Isidore of Seville 131
 Etymologia 79
 Sententiae 24
Ivins, W. M. 1, 2

Jackson, Arthur 12, 241
Jacquier, Nicolas 146–7
 Flagellum haereticorum fascinariorum 311
James VI and I 243, 250–1, 255
 Daemonologie 246
Jay, M. 2, 3, 92, 97, 343
Jeanne d'Arc 207
Jesuits 26, 79, 95, 97, 105, 106, 109, 253
 churches of 89, 94
 Collegium Romanum 99, 100
 (individuals) 12, 25, 80, 97, 99, 131, 146, 278
 and optics 332
Jewel, John 175, 179, 180, 187, 197–8, 189–90, 190–1
Jofreu, Pedro Antonio 313
John the Baptist 93
Johnson, Samuel 62
Joris, David 220
Judovitz, D. 334–5, 336
juggling, jugglers, conjuring 28, 49, 78–9, 110,
 112 n. 17, 129, 131, 132, 136, 141–2,
 153, 182, 188, 210, 211, 239, 255, 319
 devil and 151–2
 criticism of 82–3
 and mass 186–7
 as religious metaphor 4, 83, 174–8

Kauffmann, H. 13
Kemp, M. 7, 83, 84, 86, 89–90
Kepler, Johannes 17, 19, 85, 101, 331, 341, 343
Kestler, Johann Stephan 100

Kett, Robert 253
Kircher, Athanasius 3, 97, 99–111, 330–1, 332
 Ars magna lucis et umbrae 101–4, 105–10, 218
 Ars magna sciendi 109–10
 Ars magnesia 100–1
 Museo Kircheriano 100, 103, 106, 218
Knecht, H. 97
Kramer, Heinrich:
 Malleus maleficarum: 30, 126, 131, 140; on demonic delusion of the senses 131

Lacan, J. 9, 14
Lactantius, Lucius Coelius Firmianus 167
La Forge, Louis 341
Lambarde, William 176–7
Lambertini, Prospero (Pope Benedict XIV):
 De servorum Dei beatificatione et beatorum canonizatione 222–3
La Mothe Le Vayer, François de 266, 277, 307
Lancre, Pierre de 144, 248, 292
Landi, Ortensio:
 Paradossi (*The defence of contraries*) 21
La Palud, Madeleine Demandols de 135
La Placette, Jean:
 Traité de l'autorité des sens contre la transsubstantiation 191–2
La Primaudaye, Pierre de 11, 18, 21, 49, 224
 Academie françoise 10, 46, 315
Lateran Council (1215) 184
Lateran Council (1513) 181
Laud, William 306
Lavater, Ludwig:
 on apparitions 207, 212, 214, 217, 257
 on Saul and Samuel 244–5
 Von Gespaenstern (*De spectris*) 133, 175, 207, 209, 216, 244
Lawson, Deodat 148
Laymann, Paul 146
Le Clerc, Joannes 59
Le Loyer, Pierre 217, 239, 257, 290, 292
 and *Macbeth* 246–8
 IIII livres des spectres 214, 216, 308, 356
 A treatise of specters 246
 on vision 214–16
Lemnius, Levinus 41, 51, 54, 59, 309
 Occulta naturae miracula 309
Lenglet du Fresnoy, Nicolas 216, 226
 Traité historique et dogmatique etc 225
lenses 3, 97–104, 220, 239, 332
 faceted 105
Leominster, holy woman of 175, 177
Leonardo da Vinci 44, 86
 Codex Atlanticus 95
Leslie, John 247
Leurechon, Jean:
 Recréations mathématiques 104

levitation 176, 287
light 11, 13, 16–18, 26, 78, 99–106, 332, 333, 334, 335, 344
Lindberg, D. 7
Lingua, or the combat of the tongue and the five senses 23
Lipsius, Justus 281, 282, 283
 Politicorum libri sex 282
Locke, John:
 on angels 135
 on cognition 358–9
 on dreams 329–30
 Essay concerning human understanding 348
 on madness 55
Lodge, Thomas 129
Lomazzo, Giovanni Paolo 86–7
 Trattato dell'arte della pittura 87
Louis XIII 105, 333
Loyola, Ignatius 24, 223, 224
Luther, Martin (Lutheranism) 161, 167, 171, 181–2
lycanthropy 39, 50, 138–9, 291, 308
 and vision 62–3

Macbeth, see **Shakespeare**
Machiavelli, Niccolo 212, 213, 285, 292
Macrobius 306, 307, 310
 Commentarii in somnium Scipionis 304
magic (magicians, sorcerers):
 and delusion of the eyes 22, 28, 30, 78–83, 135, 150, 178, 182, 271–2, 290, 334–5
 by *magia praestigiatoria* 79–83, 111, 217
 of images 166
 of the mass 186–7
 natural 3, 29, 80, 96–111, 330
 of Pharaoh 30, 80–1, 127–8, 129, 134, 138, 149, 180, 245, 319
 stories about 81–2
 see also **juggling**, **Saul**
magic lantern 103, 219–20, 239, 330
Maignan, Emmanuel 3, 218, 335
 anamorphic design 93–4
 on perspective and transubstantiation 95, 191
Malcolm, N. 333
Malebranche, Nicolas 5, 332, 336
 De la recherche de la verité 291, 320
 on werewolves and witches 63, 291, 320–1
Malleus judicum 146
Malvenda, Thomas:
 on Antichrist 181–2
Manetti, Antonio 88
Manichaeism 123
Mantegna, Andrea
 Camera degli Sposi 88
Manuel, Nicolaus 174

Marandé, Léonard 277–8, 307
Marci, Jan Marcus:
 Thaumantias liber de arcu coelesti 332
Marcionite heresy 187, 188
Marcourt, Antoine 186, 187
Margolin, J.-C. 95
María De La Visitación 176–7, 181
Marolles, Michel de:
 Mémoires 321
 Tableaux du temple des muses: 'Palace of Dreams' 321–2
Marston, John:
 What you will 56
Martyr, Justin 245
Martyr, Petrus (Vermigli):
 on demonic delusion of senses 133–4
 on eucharist 190
 Loci communes 133, 244
 on Saul and witch of Endor 244, 256
Mary Stuart 247
Mason, James 129
mass 4, 83, 162, 173, 174, 176–7
 elevation 161, 183–4, 186
 eucharist replacement for 189–91
 hosts 175, 176, 177
 masses for dead 206, 208–9
 of St Gregory 185
 transubstantiation 162, 174, 183–92
Massé, Pierre 82
Massey, L.:
 on Descartes and anamorphosis 335
Mather, Cotton 148–9, 216
Mather, Increase 152, 216, 315
 An essay for the recording of illustrious providences 149
 on demonic impersonation 149–50
Maurolico, Francesco 19
Maxey, Anthony 255–6
Medusa 58
melancholy 5, 28, 39, 41, 47, 50, 138, 151, 153, 215, 216, 226, 243, 290, 293, 307, 308, 309, 329
 causes 58–62
 different from mania 54–7
 and dreaming 56–7
 in early modern Europe 50–2, 66
 and enthusiasm 52, 64–6, 183, 308, 355
 Melancolia ('F. B.') 55–6
 obsessional 54–7
 and public affairs 52–3
 stories of 57–8
 treatment of 66–7
 and visual delusion 52, 67, 128–9
 and witchcraft and demonism 52, 53, 141–4, 292, 355
 see also **lycanthropy**
memory 14–15, 21–2, 42–4, 53, 131, 133–4, 244

Menghi, Girolamo 135
Menippus 136
Mercatus, Ludovicus 60
Mersenne, Marin 94, 95, 105, 212, 270, 333,
 334, 335, 336, 347, 353
 La Vérité des sciences contre les s[c]eptiques 332
 L'Optique et la catoptrique 332
 Quaestiones celeberrimae in Genesim: on
 parabolic mirrors 218
 Universae geometriae mixtaque, synopsis 334
metamorphosis 137, 250, 319
 as visual delusion 30, 129, 138–40, 143
 machine for visual contrivance of 103–4
meteorology 216
Michaëlis, Sebastien:
 on dreams and witchcraft 314
 Pneumalogie: discours des esprits 313
Michelangelo, Buonarroti 44
microscopy 78, 102, 120 n. 115, 350–1
Middleton, Thomas 251
Midelfort, E. 51
Minims 95, 105
 (individuals) 94, 224
miracles 29, 83, 101, 162, 172, 221, 308, 329,
 355–6
 accompanying images 166
 of dead 216
 false 172–8, 211, 178–87
 and scepticism 282–93
 and wonders 124–30, 138, 153, 173
 see also Antichrist; mass
Mirami, Raphaël 22
mirrors 3, 332
 and apparitions 210–11, 212–14, 218, 220,
 221, 248
 in art 89
 Brunelleschi's use of 87–8
 'Spiegelbilder' 171
 delusion by 28, 132, 177, 271
 in magic 30, 80, 98–9, 101–3, 109, 110
 and function of eye 17
 in *Macbeth* 239, 248–52
 as metaphor for cognition 2, 11–12, 13, 22,
 25, 26, 47–8, 130, 142, 191, 343
 and paradoxy 108
Misaldus 214
Mitelli, Agostino 89
Molanus, Johannes 163, 171
Molina, Luis de 131
Molitor, Ulric 126
 De lanijs et phitonicis mulieribus 145, 312
Monro, John 66
Montaigne, Michel de 4, 5, 6, 39, 108, 270,
 281, 284, 316, 317, 320, 350, 356
 on dreams and waking 300–3, 304, 320
 Essais 266, 276, 300; 'An Apology for
 Raymond Sebond' 4, 275, 276, 277,
 285, 300, 320; 'Of cripples' 289–90,
 320; 'Of the power of the imagination'
 286
 scepticism of 275–94
More, Henry 151–2, 216, 220, 303, 308
 Enthusiasmus triumphatus: on enthusiasm
 and melancholy 65–6
 on transubstantiation 186–7
 on witches 136
More, Thomas 175
Mullaney, S. 253
Munday, Anthony 21
Mydorge, Claude 218, 333, 334
 Prodromi catoptricorum et dioptricorum 105
mystics 204

Napier, Richard 54, 62
Narcissus (legend of) 22, 23
naturalism:
 in art and representation 19–20, 23, 26
Naudé, Gabriel:
 Considérations politiques sur les coups d'état
 292
 on witchcraft 291–2
necromancy 220, 243, 246
Neoplatonism, *see* Plato
Newton, Isaac 332–3, 348, 354
 Opticks 348
Nicéron, Jean François 3, 87, 105, 110, 123,
 330, 335, 356
 anamorphic design by 93–4
 La Perspective curieuse etc 90, 105, 332;
 'Preface' to 96–7
 optical device using faceted lenses 105,
 333–4
 Thaumaturgus opticus 94, 87
Nider, Johannes 126, 131, 139, 315
 Formicarius 311
Nodé, Pierre 82
Nouë, François de la 105
Nourse, Timothy 303
Nymann, Hieronymus 45, 50
Nynauld, Jean de 62–3

Obry, Nicole 143
Ockham, William of 15, 16
Oostsanen, Jacob Cornelisz. van 252
 Saul and the Witch of Endor 250
ophthalmology 10, 40–2, 85
optics 14–19, 29, 63, 106, 184, 189, 210, 219,
 220, 239, 270, 271, 330
 'centric ray' 85, 113 n. 30
 demons' expertise in 132, 134, 135–6, 149,
 152
 in Descartes 337–43
 experiments in Bacon's *New Atlantis* 78
 in Hobbes 220–2, 344–7

instruments of 78, 96, 218–20
 magical 29, 78–82, 96–111, 330
 naturalism 19–20
 in seventeenth-century thought 332–4
 see also camera obscura
Osiander, Andreas 241, 246
Ovid 321
Ozanam, Jacques:
 eye anamorphosis 96
 Recréations mathematiques et physiques 96, 104

Pacard, George 180
Paleotti, Gabriele 163, 171
Palmer, D. J. 236
Palomino, Antonio 89
Panofsky, Erwin:
 'Perspective as Symbolic Form' 85–6
Paracelsus, Theophrastus Bombastus von Hohenheim 218, 220
paradoxes:
 of art 23, 92–3, 95–6, 335
 of blindness 21–2
 Colie on 107–9, 331
 Cretan Liar 96, 107–8
 demonic 124–53
 of dreams 300–22
 in *Macbeth* 252–5
 in scepticism 266–80, 305
 in science 96–111
 of vision 2, 5, 20, 61, 79, 83–4, 86, 106–10, 136, 138, 151, 181, 184–9, 227, 244, 304, 307, 308
Paré, Ambroise 10, 19, 40
Paris, Yves de 278, 291
Park, K. 7, 18, 43
Parker, Robert 166
Parker, Samuel 303
Parrhasius, *see* Zeuxis
Pascal, Blaise 303
Passerat, Jean:
 De caecitate oratio 27
Pastore, N. 337
Patin, Guy 291
Peacham, Henry:
 Art of drawing 87
Pecham, John 17, 55
Peiresc, Nicolas Claude Fabri de 332
Peña, Joannes:
 on apparitions 249–50
 De usu opticae 106–7
Pencz, Georg 13
Pereira, Benito:
 Adversus fallaces et superstitiosas artes 80–1
Perkins, William 148, 150
 on demonic sensory deception 129
 on images and idolatry 165, 168
 on Saul and the witch of Endor 246, 252

Perrault, François 129, 150, 315
perspective 1, 2, 3, 6, 13, 16, 55–6
 anamorphic 90–6, 335
 artists' 83–90, 183
 boxes 89, 109
 used by demons 135–6
 and Descartes 335, 343
 as illusionary 83, 86–90, 101–2, 110
 as objective 83–6
 as 'symbolic form' 85–6
 thresholds 89
Peruzzi, Baldassare:
 Sala delle Prospettiva 88–9
Peucer, Kaspar 246, 248, 309, 310
 Commentarius de praecipuis divinationum generibus: on dreams 307
Pharaoh, *see* magic, magicians
Philostratus:
 Life of Apollonius 136
Phips, William 148
Pico della Mirandola, Gianfrancesco 19, 50, 96
 De imaginatione 47
 on the imagination 44, 45, 47–9
 Strix, sive de ludificatione daemonum 48
Pierquin, Jean 220
Pilet de la Ménardière, Hippolite:
 Traité de la mélancholie 142–3
pineal gland 17, 341–3
Pithoys, Claude 224
Plato 14, 21, 24, 62, 86, 350
 Neoplatonism 14, 24, 43, 100
 Philebus 46
 Sophist 87, 335
 Theaetetus 15, 304–5
 The Republic 21, 135
 Timaeus 9, 21
Platter, Felix 41, 51
Plessis-Mornay, Philippe Du 173
Pliny:
 Natural History 23
Plutarch:
 Life of Marcus Brutus 213
Polacco, Giorgio 223
Pomponazzi, Pietro 220
 on apparitions 212–14, 215
Ponzinibio, Gianfrancesco 146
 Tractatus de lamiis 312
'Popish Plot' 175
Popkin, R. 4, 270, 290, 347
Posidonius 97
possession (demonic) 64, 134, 135, 137, 223–4, 282, 293
 at Loudun 142–3, 292
Pozzo, Andrea 90
 frescoes 89
 Perspectiva pictorum et architectorum 89

Prieur, Claude 62–3
 on demonic delusion 139–40
Proclus 98
providence (divine) 27, 149–50
 eye of 11–12
psychology 10–11
 faculty 2, 14–15, 42–3, 48, 51, 65, 131, 355
 see also cognition; imagination
Purgatory 1, 4, 29, 52, 106, 220, 242–3
 and apparitions 206, 207–9, 217
Puttenham, George 107
 The arte of English poesie 253
Pyrrhonism, *see* scepticism
Pythagoras 210

quadratura 88–9

Rabelais, François 108, 212
Raemond, Florimond de 181
Ralegh, Walter 80
 The history of the world 11
Raphael (Raffaello Sanzio) 88
reason (understanding) 42–3, 47, 48–50, 55, 61, 142–3, 300
Reformation, Catholic (Counter-Reformation) 29, 167, 171, 307
 and Antichrist 181–2
 and apparitions 205
 and illusionism 105–6, 109
Reformation, Protestant 1, 3–4, 52, 109, 242, 269, 348
 and apparitions 204–12, 216–17
 and dreams 307
 and images 163–72
 and miracles 172–4
 and vision 29, 161–3
Reisch, Gregor
 Margarita philosophica 18
Rémy, Nicolas:
 Daemonolatreiae: on impersonation 144
 on witches' sabbat 313–4
 on vision 130
Renaudot, Théophraste:
 Bureau d'Adresse 63
Reynolds, Edward:
 on the imagination 44, 47, 53
Rhodius, Ambrosius 218
Ridley, Nicholas 183
Riolan, Jean 41
Risnerus, Federicus:
 Opticae thesaurus 99, 106
Rivius, Joannes 209, 217
Robortello, Francesco 269
Romanus, Carolus Fridericus 216, 219
rood of Boxley, 175–7
Rorty, R. 9, 343
Rosa, Joannes 270

Rosa, Salvator 252
 Saul and the Pythoness 245–6
Rossky, W. 46
Royal Society 347–8, 349, 352
Rubens, Peter Paul 13
Rubin, M. 184
Rufus of Ephesus 54
Ruscelli, Girolamo:
 Secreti nuovi 99

Sacri Monti movement 89
saints 205
 Ambrose 190
 Anthony 223
 Athanasius 165
 Francis 286
 Francis of Paolo 94
 Jerome 24, 93, 94
 John the Evangelist 94
 Martin 226
 Paul 305
 Peter 94
Salazar, Alonso de 152, 291
 on demonic impersonation 144–5
Salem (Massachusetts) 148–50
Samson, Hermann 130
Sanders, Nicholas 163, 175
 A treatise of the images of Christ, and of his saints 168
 defends images 168–72
Santa Trinità dei Monti, Rome 94
Samuel, *see* Saul
Sarpi, Paolo 281, 282
Saul (King) 29
 and *Macbeth* 240–58
 and witch of Endor 149, 219, 239–46, 249–50, 252, 319, 356; as ventriloquism 260 n. 30
Sawyer, Elizabeth: witch 151
'scenographic' design 89
scepticism 4, 29, 39–40, 56, 192, 210, 214–16, 246, 316
 Academic 21, 29, 268–70, 271, 273, 276, 305
 ancient Greek 267–75
 in early modern Europe 275–94
 and *Macbeth* 238–9
 and political philosophy 278–81
 post-scepticism 329, 336–56
 and religion 281–5
 ten tropes of 4, 210, 228, 266, 271–5, 276–80, 284–5, 285, 287, 288–9, 305, 307, 331, 335, 350–1, 356
 see also Sextus Empiricus
Scheiner, Christoph 41
 Oculus 105
Scherertz, Sigismund 216
 Libellus consolatorius de spectris etc 217

Schmitt, C. 269
Schmitt, J.-C. 206
Schön, Erhard:
 Vexierbilder 93, 94–5
Schott, Gaspar 87, 97, 100, 109–10, 135, 217–19, 330, 332
 Joco-seriorum naturae et artis etc 104
 Magia universalis 105, 107, 111, 218
 Physica curiosa 218
Schwelling, Johann Eberhart 216
Schwenter, Daniel:
 Deliciae physico-mathematicae 104
Scot, Reginald 151, 220
 The discoverie of witchcraft 82, 141, 239
 on juggling 81–2
 and *Macbeth* 239
 on witchcraft 141, 316
Scribner, R. W. 207
Scultetus, Abraham 164
Second Helvetic Confession 167, 171
Séguier, Pierre 332
Seneca 281
Sennert, Daniel 40–1, 51, 55, 56, 59, 67
senses:
 in conflict 48, 236
 defence of 278
 and demons 125–53, 244
 in Descartes 337–43
 hierarchy of 9–13, 20–1, 23
 in Hobbes 221–2, 344–7
 internal 15–19, 42–50, 133
 number of 272, 276, 277
 and religion 161–3
 and miracles 173
 and the mass 188–9
 scepticism about 267–94, 300–1, 350–4
 sensitive soul 2, 42–4, 130, 209
 technological aids for 79, 348, 354
Sextus Empiricus 4, 210, 267–94, 305–6, 321, 331
 Outlines of Pyrrhonism 4, 267, 270, 274, 275, 279, 292, 307
Shakespeare, William:
 Hamlet 54, 204, 236
 Macbeth 98, 204, 228, 236–58, 356
 Richard II 90
 Troilus and Cressida 91
Shaw, Christian 152
Sheldon, Richard:
 A survey of the miracles of the church of Rome 178
Shrimpton, Robert 175
Sigismund of Austria, Archduke 126
Silhon, Jean de 278, 291
sleep 39, 65–6, 125, 294, 300–22
see also dreams
Snyder, J. 16

Sohn, Georg 180
Sorbière, Samuel:
 Discours sceptique 321
Sorel, Charles 278
 on dreams 303
 La Science universelle 291
species 2, 3, 4, 5, 20, 42, 47, 50, 59, 61, 63, 65, 81, 110, 178, 180, 182, 220, 225, 248, 281, 301, 310, 311, 315, 318, 319, 331, 332
 in Aristotelian vision 15–19
 critics of 16, 20
 manipulated by demons 125, 127, 129, 130–3, 135, 139–40, 143, 147, 244, 246
 replaced by signs 329–56
 and transubstantiation 184–91
spectacles 13, 19, 48, 78, 98–9, 189, 332, 351
spectrum 332
Spee von Langenfeld, Friedrich:
 Cautio criminalis 318
 on demonic impersonation 146–7
 on witchcraft and dreams 318
Spenser, Edmund 108
 Faerie Queene 23, 53
Spina, Alphonsus de 126
Spina, Bartolommeo 139, 145–6
 Apologia de lamiis contra Ponzinibium 312
 Quaestio de strigibus 312
Sprat, Thomas:
 History of the Royal Society 348, 352
Stafford, B. M. 83, 109, 110, 330
Stahl, Georg Ernst:
 Lehre von den Temperamenten 50
Stearne, John 83
Stephens, W. 131
Stevart, Peter 181
still life 13, 89, 108
Stoer, Lorenz 84
Stoics 21, 29, 56, 62, 281, 305
 knowledge claims 268
Stough, C. 273
Suárez, Franciscus 181, 243
Summers, D. 86, 91
superstition:
 attacked by sceptics 282–90
 and images 163–7
Swan, C. 53, 249

tabula scalata 105–6
Tachau, K. H. 17, 20
Tacitus 281
Taillepied, Noel 210–14, 242
 Psichologie ou traité de l'apparition des esprits 209, 213, 216, 217
Talmor, S. 353
Tandler, Tobias 217
 Oratio de spectris etc 216

Tanner, Adam 313, 315
 on demonic impersonation 146
telescope 13, 102, 120 n. 115, 351
Ten Articles (1536) 185
Teresa of Avila 223
Tertullian 243
 De anima 245, 304
Tesauro, Emmanuele:
 Il cannocchiale aristotelico 87
theatre 3, 7, 82, 211, 239
Thomas, K. V. 205
Thompson, Thomas 180
Thorne, A. 91
Thumm, Theodor 130
Thyraeus, Petrus 145, 147, 216–17, 315
Toledo, Francisco de 127
Torre, Raffaele della:
 Tractatus de potestate ecclesiae coercendi daemones 136
Torreblanca, Francisco 136, 248
touch 20, 161, 340–3
Trenchard, John 64
Trent, Council of 168
 decree on images 162–3, 169
Trithemius, Johannes 30, 103
Tryon, Thomas 303
Tuck, R. 7, 270, 282, 290, 292
 on Hobbes 334, 336, 344, 346
 on 'new humanism' 280–1
Tymme, Thomas 180

universities 232 n. 51
 Bologna 126
 Bremen 216
 Coimbra 79, 131
 Constance 126
 Evora 131
 Heidelberg 53, 128, 180
 Ingolstadt 146
 Jena 217
 Leiden 53, 59
 Louvain 58
 Mainz 216
 Montpellier 67 n. 4
 Munich 146
 Nantes 142
 Oxford 26, 349, 356
 Padua 126
 Pisa 269
 Salamanca 80, 126
 Saumur 142
 Tübingen 128
 Turin 126
 Utrecht 216
 Wittenberg 40, 50, 73 n. 66, 216
D'Uzès, Duchesse 53

Valderrama, Pedro de 63
Valencia, Pedro de 291
Valera, Cipriano de:
 Enjambre de los falsos milagros etc 176–7
Van der Velde, Jason 51
Vanini, Giulio Cesare 220, 285
 De admirandis naturae etc 213
 on apparitions 212–14
Van Swieten, Gerard 54
Varro 318
Veneziano, Agostino:
 Lo stregozzo 311
Verron, Sebastian 181
Vettori, Benedetto 54
Vignati, Ambrogio de' 126
Vignier, Nicolas 175, 182
 Théâtre de l'Antechrist: arguments of 180–1
Vincent of Beauvais 24
Viret, Pierre 186, 191
Virgil 304
 Aeneid 321
Virgin Mary 166, 174, 177, 180, 205, 206
Visconti, Girolamo 315
 Lamiarum sive striarum opusculum 137, 312
vision (sight):
 compared to blindness 21–2
 compared to hearing 10, 11, 20–1, 26, 161–2
 errors ('fallacies') of 2, 4, 14, 20, 21, 28, 48, 110, 268–9, 271–2
 intromission and extramission 17–18, 20, 24, 130
 natural impediments to 39–67
 naturally guaranteed veridicality of 1, 14–19, 222, 267–8, 278, 293, 331, 343
 as resemblance 2, 14–19, 20, 110, 331–2, 335, 336, 337–54
 negative views of 20–30
 positive views of 9–13
 predominant in dreams 301–2
 rationalization of 1, 85, 98, 329
 de-rationalization of 1, 5, 266, 329, 331–2
 relative 4, 228, 266–93
 because constructed 1, 6–7, 9, 39, 41, 59–60, 238, 271–5, 331–2, 337–56
 and rulership 12–13, 26, 27–8, 257–8, 333–4
 spiritual 11–12, 24, 182–91, 204
 and superstition 283–90
 see also cognition; eyes; optics; senses; *species*
Vitoria, Franciscus a 80
Vives, Juan Luis:
 De anima et vita 19
Voet, Gijsbert 216, 217, 224

Voltaire 337
Volterra, Daniele da 106, 121 n. 129
Vos, Marten de:
 Visus 13
Vredeman de Vries, Hans 89

Wagstaffe, John 142
Waldschmidt, Bernhard 216
Walker, John:
 Dialogicall discourses of spirits and divels 134
Walkington, Thomas 58
Waller, William 175
Walther, Rudolph 175, 179, 187
Warner, Walter 334
wax:
 impressions in as metaphor for perception 2, 14–15, 19, 46, 133–4, 244
Webster, John 142, 151–2, 242, 246, 355
 on apparitions 220, 224
Weyer, Johann 246, 290
 on demonic dreams 312, 317–18
 De praestigiis daemonum 30, 143, 312
 on melancholy 58
White, Thomas 330, 352
Wilkins, John 354
Willet, Andrew 246
Willis, Thomas 66
 Cerebri anatome 362 n. 86
Wilson, C. 7, 343
 The Invisible World 7
Wilson, Thomas 10
Wirsung, Christoph 67
 Artzney Buch 41
The Witch of Endor (anon. tract) 82
witchcraft 50, 82, 110, 218, 219
 dreamed 307, 310–22
 fascination 26
 in Glanvill 355
 in Hobbes 336
 and the imagination 48, 249
 and lycanthropy 62
 in *Macbeth* 237, 249–52
 and melancholy 59, 141–4
 prosecutions for 123, 141, 148–50, 152, 292, 310
 reality and unreality of sabbats 137, 143, 144–7, 249, 292, 310–22
 scepticism about 141–4, 282–93
 and sensory delusion 136–53, 289–93
 see also devil; *Canon episcopi*; metamorphosis
Witekind, Hermann:
 Christlich Bedencken und Erinnerung von Zauberey 30
Witelo 99, 211
 Perspectiva 28, 250
Wither, George 12
Wittgenstein, Ludwig 316
Wren, Christopher 110
Wright, I. 239
Wright, Thomas 19
Wunderkammer (Kunstkammer) 91
Wycliffe, John 161

Zanchy, Hieronymus 128
Zeno 268
Zeuxis and Parrhasius 23, 26, 86, 135, 136, 166–7, 180–1
Zoroaster 111
Zuccaro, Taddeo:
 Sleep 316
Zucchi, Nicola 332